THE HISTORY OF

British Art

David Bindman (*General Editor*)

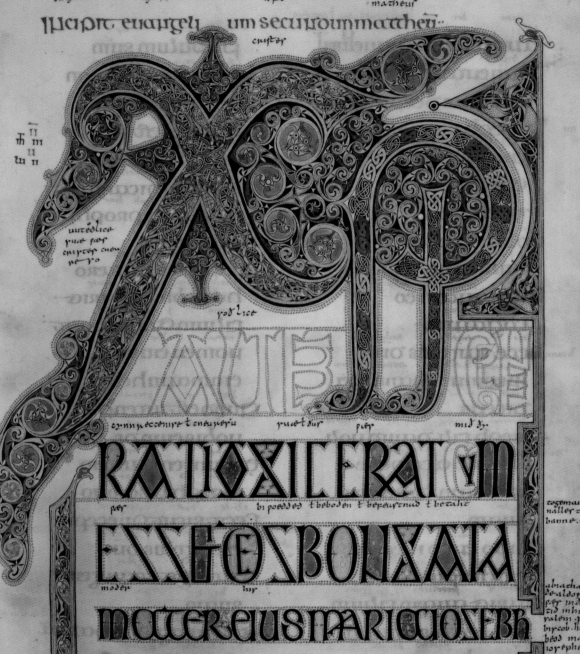

onginneð godspell æft matheus

Incipit euangeli um secundum mattheu·

cnyhter

þ̄
ıı
m̄
ıı
ȷıı

untoðlice
þuæt þær
cnyhter cneu
re ro

godlice

cynn uæ cenre ł cneureðu þuæt ðær þær mið ðy

RATIONIGENERATIONM

togemanne
naller to hab
banne ł þ̄ þ̄ıþ

þær bı poeðeð ł beboden ł bepeurnuð ł betaht

ESSFILISDAVIDFILIIABRAHAM

abraham
ðe aldormon
þær ındæm
tıð ınhıenu
ralem pone
bycob he be
beoð manıa
ıoreþhe to
gemenne y
tob togeong
anıe mıð
claennıꝥꝥ

moder hıſ

MATEREIUSMARIACUIOSEBR

THE HISTORY OF
British Art
600–1600

Edited by Tim Ayers

Yale Center for British Art
Tate Britain

Distributed by Yale University Press

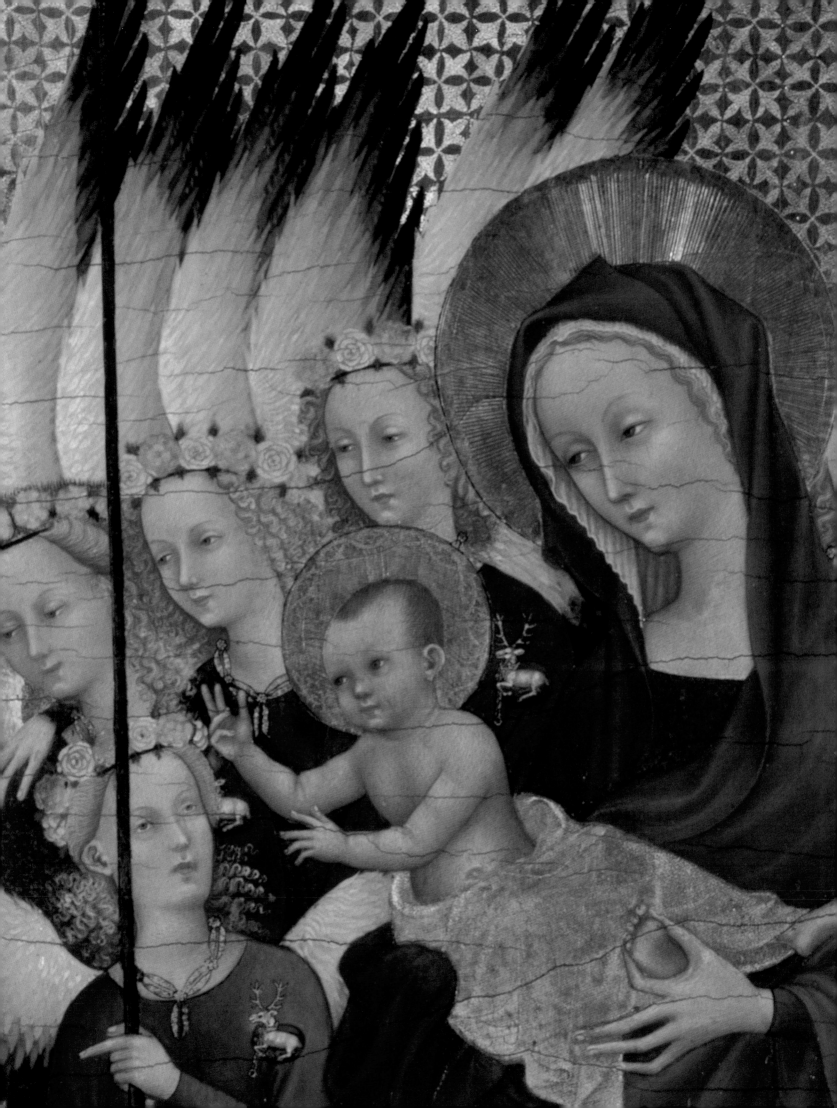

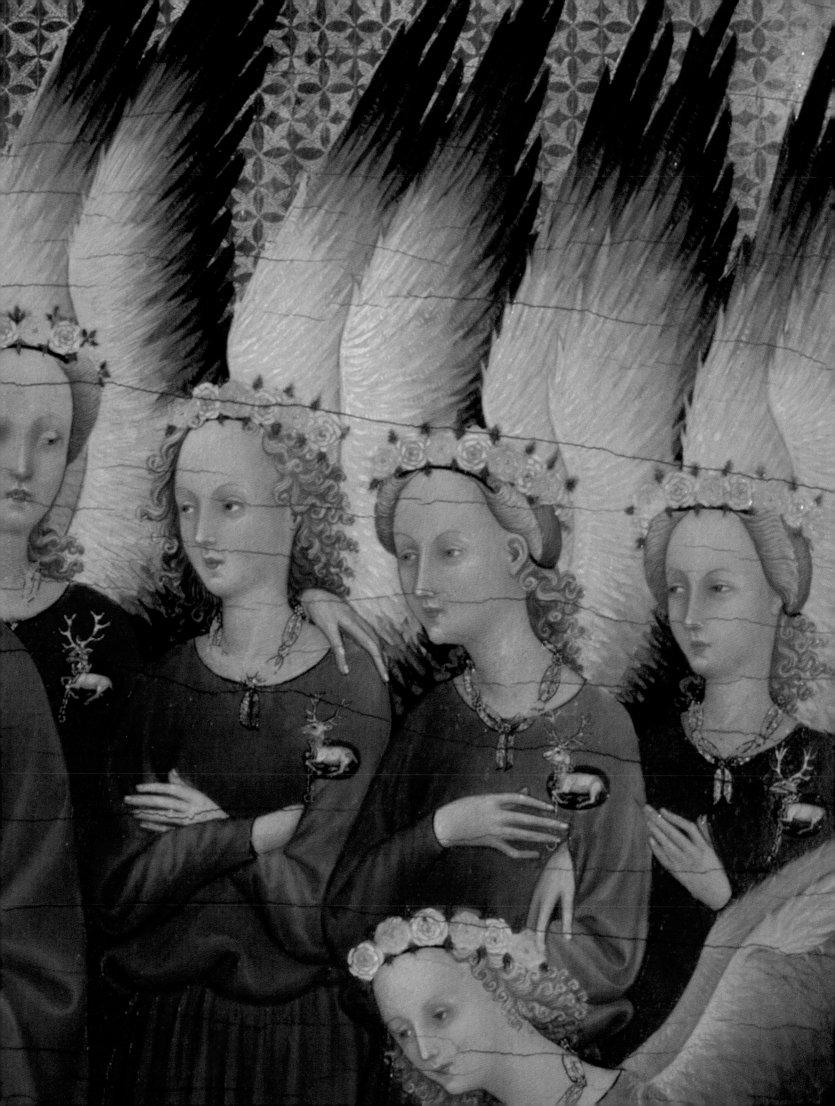

Contents

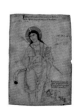

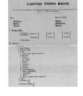

Acknowledgements

In memory of John Higgitt (1947–2006)

I would like to thank all of the authors for their contributions, and those of the longer essays for their constructive engagement in preparatory discussions on the shape of the volume. I am especially grateful to Alexandrina Buchanan for her help at this stage. David Bindman has been an exemplary general editor, in directing the project overall and in giving advice. A one-day symposium, hosted at Tate Britain, proved both enjoyable and useful in shaping ideas across the three books.

John Higgitt played an active part in the planning of the present volume and was drafting an essay for it when he was taken ill. His death, shortly afterwards, was a sad loss to art history and this book is dedicated to John's memory, as a mark of our esteem. I would also like to record my gratitude to Jane Geddes for stepping in at short notice and contributing a splendid piece in his place.

The team at Tate Publishing, under Roger Thorp, has been very effective in the creation of a beautiful book. I owe special thanks to the editors Rebecca Fortey and Katherine Rose, and Tim Holton, production manager, who worked long and hard on the later stages; the designer Philip Lewis of LewisHallam Design; and the picture researcher, Jessica Harrington.

TIM AYERS

Contributors

Tim Ayers is Senior Lecturer in the History of Art at the University of York.

Paul Binski is Professor of the History of Medieval Art at the University of Cambridge.

Alixe Bovey is Lecturer in medieval history at the University of Kent.

Alexandrina Buchanan is Lecturer in Archive Studies in the School of History at the University of Liverpool.

Marian Campbell is Senior Curator of Metalwork at the Victoria and Albert Museum, London.

Nicola Coldstream is a medievalist specialising in architecture and decoration.

Nicholas Cooper is a freelance scholar, formerly of the Royal Commission on Historical Monuments.

Claire Donovan is Deputy Principal at Dartington College of Arts.

Anna Eavis is Head of National Monuments Record Services, English Heritage.

Ute Engel is coordinator of the inter-disciplinary UNESCO Upper Middle Rhine Valley World Heritage Site Research Project, and is German representative of the British Archaeological Association.

Richard Fawcett is Professor in the School of Art History at the University of St Andrews and a Principal Inspector with Historic Scotland.

Richard Gameson is Professor of the History of the Book, Durham University.

Jane Geddes is Senior Lecturer in the History of Art in the School of Divinity, History and Philosophy at King's College, University of Aberdeen.

Heather Gilderdale Scott is working on a joint University of York/University of Cardiff project on the great east window of York Minster.

Miriam Gill is Director of the Certificate in Architectural History and Art History at the University of Leicester.

John A.A. Goodall is Architectural Editor of *Country Life*.

Dillian Gordon is Curator of early Italian paintings up to 1460 at the National Gallery, London.

Tara Hamling is RCUK Research Fellow in the Department of Modern History at the University of Birmingham.

Jane Hawkes is Reader in Medieval Art History at the University of York.

Maurice Howard is Professor of Art History at the University of Sussex and Director of the Society of Antiquaries of London.

Phillip Lindley is Founding Director of the Centre for the Study of the Country House at the University of Leicester and Reader in the History of Art at the University of Leicester.

Julian Luxford is Lecturer in Art History at the University of St Andrews.

Rosalind K. Marshall is a writer and historian.

Robert Mills is Senior Lecturer in English at King's College London, University of London.

Linda Monckton is a Senior Architectural Investigator at English Heritage.

Nigel Morgan is Honorary Professor of the History of Art, University of Cambridge.

Jennifer O'Reilly is Senior Lecturer in Medieval History at University College Cork.

Stella Panayotova is Keeper of Manuscripts and Rare Books at the Fitzwilliam Museum, Cambridge.

Richard Plant is Course Director for Early European Art, Christie's Education, London.

Samantha Riches is Director of Studies for History and Archaeology in Continuing Education at Lancaster University.

Nigel Saul is Professor of Medieval History in the Department of History at Royal Holloway, University of London.

Kay Staniland is an independent scholar.

Foreword

Tate Britain in London and the Yale Center for British Art in New Haven, Connecticut, are the only major public museums in the world solely devoted to the collection, display, preservation and interpretation of British art. Together our resources and our programmes constitute an extraordinary gateway to a rich field, serving the needs of both scholars and the general public in our respective countries. As institutions we collaborate regularly – on exhibitions and on the loan of works of art, for example – and this three-volume *History of British Art* series reflects our ongoing wish to promote the cause of British art together, to as wide an audience as possible.

There have been exciting advances in art history over the past several decades. Whereas the appreciation of art was once conceived only in terms of taste and connoisseurship, confined implicitly to the privileged few, it is now viewed in natural relation to its historical and cultural contexts. Since this has begun to be properly reflected and articulated in exhibitions and displays worldwide, we thought it was time for some of these relatively new ways of thinking to be applied to a general overview of British art's history from its beginnings to the present day. The resulting volumes lay no claim to be comprehensive in their coverage; they aim rather to pose some current questions about British art and to shed fresh light on sometimes familiar ground.

David Bindman kindly took on the task of setting the criteria for the books and organizing the volume editors. Tim Ayers worked with David to shape this volume, as well as coordinating the authors and editing the text. To both of them, to the many distinguished contributors, and to all those who have worked on seeing the books through to publication, we extend our grateful thanks.

STEPHEN DEUCHAR
Director, Tate Britain

AMY MEYERS
Director, Yale Center for British Art

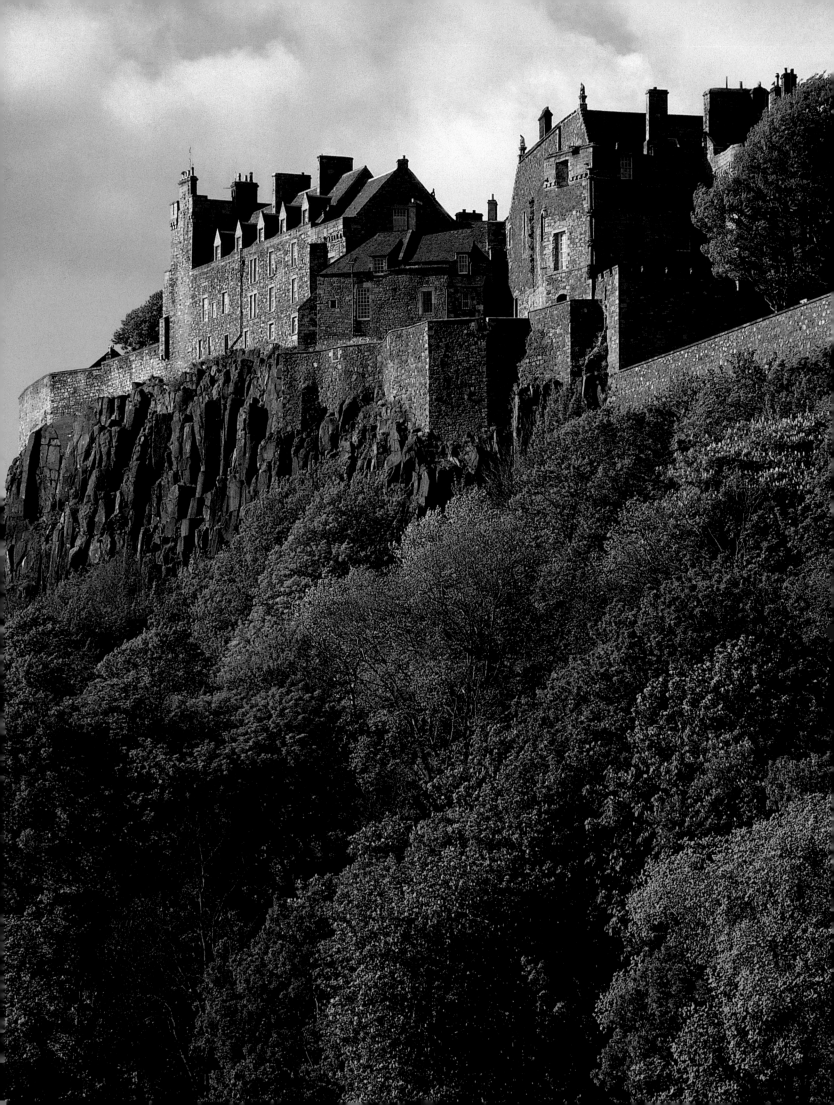

Introduction to *The History of British Art* series

DAVID BINDMAN

This volume is one of a series of three, covering British art from around AD600 until the present day. The series is best seen not as a linear history of British art but as a number of separate though interconnected histories of its ever-changing relationships with the idea of Britain, and of Europe, and of the world beyond Europe. The series also encompasses art's relationship to political, intellectual and social histories, and, where possible, to the lives of artists themselves. These histories reveal a British art that is not inward looking but open to the world beyond, to external events and social pressures. One of the chief aims of these volumes is to reinterpret British art in the light of Britain's inherent instabilities of identity, which still define it in a global world. British art is not, therefore, limited to artists born in Britain, but encompasses art made in Britain, or made abroad by artists resident in Britain or its colonies.

The limits of what constitutes art are inevitably contentious and vary from volume to volume. In the medieval volume, architecture and what we would now call the applied arts play an important part, while for the other two volumes they only appear as part of the background to painting and sculpture. This was essentially a practical rather than an intellectual decision, based on the amount of space available. The divisions between periods also led to much discussion because of the political implications of choosing a particular date. The beginning date of the series, now c.600, was particularly thoroughly argued over, as were the beginning and end dates of the second volume. In the end it was agreed to leave them fluid, and though volume two technically runs from c.1600–c.1870, some essays begin and end both before and after those dates for reasons that should be clear in each case.

The long essays in each volume run parallel to each other chronologically, each following its theme broadly from the beginning to the end of the period. In addition, there are short essays that pick up for more detailed consideration aspects of that theme, and allow for a particular focus on works of art and key episodes.

Though the volumes have been initiated by Tate Britain and the Yale Center for British Art, they are in no sense an 'official' version of British art; the editors of each volume and I have been given complete freedom to choose the topics and the authors, most of whom come from the academic world, though museums are well represented. The volumes do not claim to be encyclopaedic – you are bound to find that some important artists or issues have barely been considered – but they do show the broader concerns of scholars working in the field, the gains in knowledge over the last few years, and indications of future directions for research. Above all, they should convey some of the excitement that scholars feel in pushing back the intellectual boundaries of the study of British art.

Opposite:
Stirling Castle, Stirlingshire

Overleaf:
Christ Feeding the Five Thousand,
detail from the Westminster Retable,
1260s (see pp.74–5, figs.36–8)

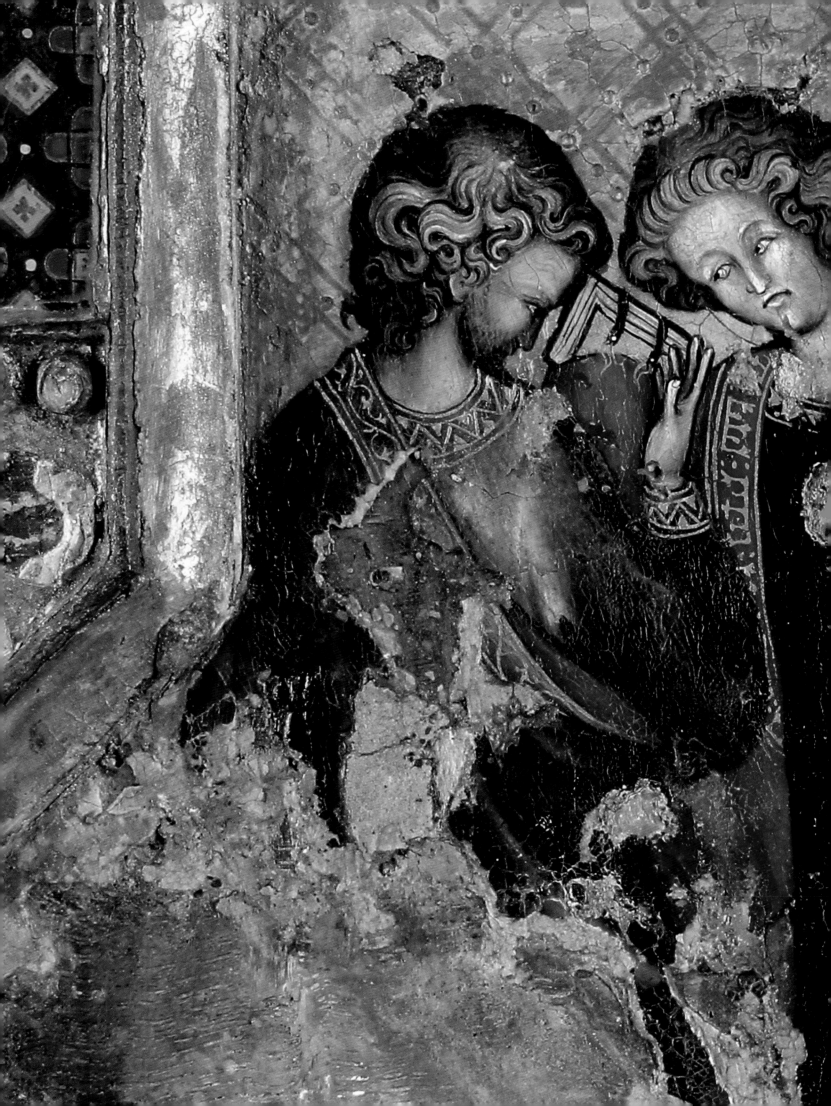

Introduction to *The History of British Art 600–1600*

TIM AYERS

This volume is different from previous surveys of medieval art in Britain. First, it is relatively short. *The Oxford History of English Art* devoted four volumes to its allotted task, and periods of medieval art within Britain and Ireland have been the object of many major exhibitions over the last twenty-five years.[1] A single volume cannot do justice to all of the artistic production and cultural contexts over a period of a thousand years within what we now call Britain, and readers will inevitably find gaps in the coverage. The aim here is rather to offer a series of essays by leading scholars from diverse professional (and geographical) backgrounds, pursuing themes that recur across all three volumes in the series. These themes – geography and identity, patronage and cultural context, meaning and production – are intended as lenses through which to view developments in art, and the history of art, in each period. The authors have been encouraged to develop an argument within their pieces, and have been required only to follow loose geographical and chronological boundaries; the individual contributions are therefore structured in different ways. The overall thematic approach follows a trend away from studies by style, medium or chronology, as can be seen, for example, in the recent *Medieval Art* by Veronica Sekules.[2] An introduction to the historiography of medieval art and architecture is sketched by Alexandrina Buchanan in a shorter essay at the end of the present book (chapter 9).

The geographical extent of the volume posed a challenge upon which the contributors touch often. Some arbitrary geographical boundary had to be drawn for the 'Britain' in the series title, so it excludes Ireland as being beyond the Roman province and entity that gave Britain its name. This issue is explored by Jane Geddes in the opening essay (chapter 1), which reveals the limited relevance of Britain as an idea during the Middle Ages, beyond recollection of a shared Roman past and the mythical history of King Arthur. She adopts an alternative term, 'The Isles', proposed by Norman Davies, as a framework within which to explore the wider exchanges that were taking place between the territories that comprised Wales, Scotland, Ireland and England by the end of the medieval period. Geddes presents ways in which cultural identity was visually affirmed or denied in art, from the identification with rulers and saints to the revival of the Roman personification of Britannia herself in the early seventeenth century. Over a thousand years political and cultural boundaries shifted and overlapped continually, preventing the kind of continuous

narratives that may be possible in the later volumes. This one provides, rather, a long view on the current political preoccupation with Britishness. Ute Engel's shorter essay outlines the no less diverse relationships between component parts of Britain and the Continent, in periods of closeness and isolation (chapter 2).

The chronological extent was set with a number of aims in mind. The dates were meant to be arbitrary and not based on any particular event within the defined geographical sphere, so as to avoid geographical or political specificity within Britain. In this light, the Norman Conquest of England was out of the question, in spite of its longer term repercussions for Ireland, Wales and Scotland. It was also agreed that the political fluidity and artistic productiveness of the period of Insular art (see chapter 1 and Glossary) provided a good case study for consideration of geographical and cultural boundaries. On the other hand, looking beyond the Isles, the extent coincides roughly with a period of engagement with the Roman Church, from Augustine's mission in 597, to disengagement, at the Reformation, in the mid-sixteenth century. The end date of 1600 was set to accommodate responses to changes in religious belief and practice at that time, and in the ecclesiastical establishments within the Isles; but also to allow the exploration of continuities within the secular sphere, set out by John Goodall (chapter 4). Maurice Howard contributes a shorter essay on the Reformation and new kinds of image-making that followed (chapter 8).

Two essays, by Julian Luxford and John Goodall, are concerned with issues of patronage, function and display. They address ecclesiastical and secular patronage respectively, here defined as art and architecture that were made for either an ecclesiastical or a secular context, rather than because of the ecclesiastical or secular status of the patron, or the character of its subject matter; secular rulers were patrons of the Church, and Christian themes are often found in art made for secular settings. Luxford stresses the variety of patrons of the Church, from the elite to many thousands of smaller contributors, as well as corporate endeavours, and charts the shifting objects of their generosity (chapter 3). Analysis of written sources underlines distinctions in purpose, not only practical but also metaphysical; obligational, aesthetic, devotional, salvational, corporate and political motivations were variously (and usually) intertwined. The discussion includes the difference and balance between charitable and self-interested

giving, and the weight to be attributed to the beauty of such gifts. Patrons were no less committed to display in the secular sphere, although the often itinerant lifestyle of elites, and the transient nature of their attendant spectacle, have determined more meagre survivals. Focusing upon the provision of architectural settings and furnishings for the secular household, Goodall stresses continuities over the thousand-year span of the volume (chapter 4). He explores distinctions between function and symbol, and private and public, especially in the better recorded chivalric spectacle of the latter part of the period.

Phillip Lindley's essay considers the production of art, and the social position and organization of its producers (chapter 5). A chronological structure allows the presentation of a shift from monastic to lay craftsmen and craftswomen, working sometimes in towns and often in family groups, with increasing levels of professional organization. Others worked in the train of wealthy patrons or travelled to monumental projects. There is good evidence that excellence in craftsmanship was valued (as Luxford's exploration of aesthetic categories demonstrates), but different attitudes to originality, tradition and copying during this period are a recurring theme, as is the prominent role of patrons in the creative process and the representation of it. A distinction is drawn between the status of most craftsmen and craftswomen in medieval Britain, and the construction of a new status for the 'artist' in Renaissance Italy – as an intellectual and individual genius – which was imported with Italian craftsmen in the employment of Tudor kings. Patterns of loss have distorted our perception of value in the material objects of the Middle Ages. At the beginning of the period, and for long after, the intrinsic value and metaphysical associations of precious metalwork determined that this was the highest form of art, just as it also determined its destruction. On the other hand, if the Roman qualities of stone building gave it a particular allure in the Early and High Middle Ages, the prodigious skill of later master masons, and the scale and permanence of their work, made architecture an essential aspect of display and devotion, for both secular and ecclesiastical patrons.

Another pair of contributions present contrasting, but complementary, ways of looking at medieval figurative imagery. Jennifer O'Reilly considers a central image of the Christian faith, the Crucifixion, in a series of examples (chapter 6). Such images were a focus for the hopes and fears of countless people and very different communities over this period, from the monastic scholars of Northumbria in the eighth century, to the much broader communities of the late medieval parish church. They were the product of Christian communities that took images very seriously. Today, it is not necessary to be Christian to appreciate the astonishingly diverse relationships between images, texts, performance and different audiences in this inheritance, whose interpretation offers rich rewards for the understanding of the potential of the visual. Robert Mills looks at ways in which otherness could be represented in relation to such normative images and values, a rich seam in recent art-historical enquiry – from the politics of gender and sexuality, to the representation of different ethnic or subject groups within The Isles (chapter 7). The visual representation of otherness is presented not only as a 'pictorial code of rejection', produced by dominant ideologies, but also more positively as a strategy for the incorporation of desire and diversity, and 'as images to think with'.

The longer pieces are complemented by picture essays, which focus on individual monuments or works of art. They are presented in relation to the longer texts, to support and supplement the arguments found there. Some of the works or buildings are canonical for British art in the medieval period, necessarily so in a history of this kind, but others are less familiar, such as the recently discovered Macclesfield Psalter, the Dominican Friary in Norwich or the alabaster altarpiece from Borbjerg (Denmark). A number have also been the object of particularly close attention recently, including the Doom painting at St Michael's Coventry, Stirling Castle and the Westminster Retable, which are discussed by scholars closely involved in those projects.

The map on p.287 is marked with many of the places and original locations of objects discussed in both the longer and the shorter essays. A glossary (p.288) provides definitions of any specialist terms used.

1 For example: Caldwell 1982; Backhouse, Turner and Webster 1984; Zarnecki 1984a; Alexander, J.J.G. and Binski 1987; Youngs, S. 1989; Webster, L. and Backhouse 1991; Harbison 1999; Marks and Williamson 2003.
2 Sekules 2001.

1 Ideas and Images of Britain 600–1600

JANE GEDDES

1 Heraldic display on the ceiling
of St Machar's Cathedral,
Old Aberdeen, c.1520

THE WOODEN CEILING of St Machar's Cathedral, Old Aberdeen, is a political statement about the kingdom of Scotland, situated within Christendom, at around 1520 (fig.1). Commissioned by Bishop Gavin Dunbar and carved by James Winter, it is no Sistine Chapel. It presents, in three stark rows, forty-eight carved and painted heraldic shields arranged in a careful hierarchy that sums up the diverse nature of medieval society. The central row, starting near the altar, begins with the arms and tiara of Pope Leo X (1513–21), followed by the archbishops of St Andrews and Glasgow, the bishops of Dunkeld and Aberdeen, finally ending after visiting all the Scottish bishops, with the University of Aberdeen. The northern row ranks the secular rulers of Europe, beginning with the imperial crown of the Holy Roman Emperor Charles V (1519–56), followed by the kings of France, Spain, England and Denmark, eventually reaching the burgh of Old Aberdeen. The southern row begins with the imperial crown of James V, King of Scotland (1513–42), followed by the royal arms of St Margaret of Scotland and then all the Scottish earls, ending in the royal burgh of Aberdeen.[1]

During the medieval period the territories making up Britain continually changed their relationships, variously moving closer and apart. On the Aberdeen ceiling the King of Scotland, with his imperial crown, is ranked alongside the Pope and emperor while Henry VIII, King of England (1509–47), languishes fourth in the row of nations. The Scottish bishops are shown in allegiance to the Pope rather than the king, but many of them were also linked by blood to the row of earls. The strength of provincial identity and pride is demonstrated by the two burghs of Aberdeen and its university, which complete this international constellation. Neatly, these powerful political concepts are not expressed by heaving figural allegory, as produced by the foreign artist Peter Paul Rubens (1577–1640) in the Banqueting House, Whitehall, but by the precise and abstract medieval language of heraldry. If only the whole millennium 600–1600 could be summed up in art with such sparse clarity.

In terms of defining visual 'Ideas of Britain' in the

Middle Ages, the ceiling serves as a useful model. While celebrating the union of Christendom under one roof, these separate lines of potentates are simultaneously held apart and joined by the struts which support the ceiling. In the same way the islands of Britain were held together by their geography and embraced by Christianity, but their component parts continually jostled to establish relationships, sometimes as friends and kinsmen, sometimes as enemies. An initial survey of the material leaves one wondering 'What is medieval *Britain* anyway, and how did anyone attempt to express it visually as an *idea*?' The question itself is perhaps more appropriate for an age like the seventeenth century, when concepts of *La France* and *Le Roi* could be summed up in the construction of Versailles. Until the Union of the Crowns of England and Scotland in 1603, there were no spin doctors creating images of 'Rule Britannia', because the concept of Britain as a whole barely existed.

THE HISTORIOGRAPHY OF BRITAIN

Historians, backed by pressure from the government, have become increasingly concerned with the changing definition of Britain and the identity of its people.[2] Their approach encompasses political events, the definition of boundaries, and concepts concerning the word 'Britain'. These criteria are frequently unhelpful for the analysis of art. They can set up false chronological horizons and geographical boundaries to cultural developments which seep around and beyond political events. As a name, Britain has several meanings, ranging from the limits of the Roman province, to the inclusion of Brittany, and generically to all the islands off the north-west coast of Europe. Diarmaid MacCulloch suggests that the term 'Atlantic Isles' is a neutral as well as a more accurate description, because the term British Isles 'no longer pleases all the inhabitants of the islands'.[3] However, for the period 600–1600 it is more relevant to picture this territory being washed by the North Sea, the Irish Sea and English Channel, busy lanes of communication at a time when land travel was laborious.

Norman Davies, attempting a scrupulous definition of the area, uses the term 'British' only when referring to the pre-Roman tribes, the independent British/Welsh principalities that rose and fell between the fifth and thirteenth centuries (see map, fig.4, p.26), and the subsequent modern existence of Great Britain after 1707. To 'pay due respect to all the nations and cultures' in this geographical region, he settles on 'The Isles' as a suitably neutral term for dealing with a long time span.[4] This inclusive title will be used here for the discussion of art in England, Scotland, Wales and Ireland, because it avoids interrupting the account with semantic diversions, at times when art may indeed be developing in different directions from the obvious political events. Ireland is fundamental to this overview, even though the British title 'no longer pleases all the inhabitants', and Irish art has frequently fallen off the academic horizon in 'mainland' publications.[5] Yet Ireland was a central participant in the creation of the early medieval Insular art, and continued to be a part of the political and artistic exchanges within the Isles. Davies sums up the thoroughly British nature of the conquest of Ireland of 1167–9: led by an Irishman, the invaders (mostly Norman or Welsh) were called English by a French-speaking Irish poet and the battle cry of the invaders was 'St David'. Thereafter, the same patrons, like the Earls of Pembroke, Henry III (1216–72) or Edward I (1272–1307), were building on both sides of the Irish Sea.[6]

POLITICS AND ART

Historical attempts to define Britain are invariably tied up with wars, treaties and political hegemony. The development of art from 600 to 1600 progresses in a different sequence, not necessarily coterminous with political milestones. It is argued that elegant Roman villa life faded gradually after the expulsion of Roman officials in 409, but by 600 the only remains were incomprehensible ruins, subsequently described as 'giant works'.[7] The Viking invasions, for all their political and social disruption, did not destroy the indigenous arts of their conquered lands. Instead, the highly intellectual, figurative Irish stone crosses flourished almost in defiance of the Viking marauders, while in England the Danish King Cnut (1016–35) was a lavish patron of superior Anglo-Saxon craftsmen. The most durable artistic remains from the Vikings are in fact signs of their cultural assimilation and conversion to

Christianity. Their stone crosses, on the Isle of Man,[8] for example, incorporate Viking patterns in a Christian setting, while the Gosforth Cross (Cumbria) combines Christian and pagan Nordic narrative scenes. The absorption of Norman culture had begun a decade before the Battle of Hastings (1066) with Edward the Confessor's construction of Westminster Abbey (c.1050–66) in a style based on the Norman abbey of Jumièges (see Coldstream, pp.106–7). Conversely, the Saxo-Norman overlap style continued after the Conquest, blurring its political immediacy.[9] When King David I (1124–53) set about modernizing and consolidating the Scottish monarchy and Church, the outward manifestation of his achievements was a collection of great buildings in the Norman Romanesque style, like Dunfermline and Jedburgh abbeys (see Luxford, p.92). The influence of western France on Romanesque doorway design all over the Isles had begun long before the marriage of Eleanor of Aquitaine to Henry II (1152).[10]

When English kings were making their most strident claims to French dominion during the Hundred Years War, with both Edward III (1327–77) and Henry V (1413–22) pawning the crowns of the realm to pay for their foreign policy, England was developing the distinct national architectural styles now known as 'Decorated' and Perpendicular'.[11] When Anglo-Scottish diplomatic ties were at their closest during the marriage of James IV and Margaret Tudor (1503–13), artistic influence in Scotland was predominantly from the Netherlands (see Marshall, pp.78–9). When Henry VIII pulled up the Continental drawbridge politically with his Act of Supremacy in 1534, the majority of high-status court artists were foreigners from the Netherlands or the Holy Roman Empire. Our vivid impression of Henry's Tudor world is filtered through the eyes of the German painter Hans Holbein (1497/8–1543; see Engel, p.67).[12]

Although artistic and political influences are frequently counter-cyclic or counter-intuitive, in a few instances politics clearly had an enormous impact. Thus, within a few decades of the Conquest, the entire architectural appearance of England, and later Ireland, was transformed by great new Norman buildings (see Engel, pp.56, 59 and Goodall, pp.130, 132). During the fourteenth and fifteenth centuries, while the Wars of Independence were being waged, both Scotland and Ireland rejected the prevailing English fashions, notably Perpendicular architecture, and developed their own later medieval styles. Henry VIII's withdrawal from Catholic Europe undoubtedly delayed the

arrival of 'correct' classical architecture and effectively brought a halt to church building for almost a century. These generalizations are explored both below and in accompanying chapters (see Howard, pp.234 and Luxford, pp.103–4).

Ideas of the Isles, as an artistic expression, can be defined on two levels, in terms of intention and reception. First, there are symbols of identity, deliberately created to distinguish the owner or bearer. At a national level they include objects like the king's great seal, heraldic blazons and coins. They are frequently self-conscious works of propaganda like the Bayeux Tapestry (see Gameson, pp.46–7) or Edward I's castles: identity is proclaimed by its owner and crafted by his or her image-makers. Second, there is character, something recognized by others, but not consciously constructed. Character makes English cathedrals or decorative ironwork, for instance, look different from their counterparts in France or Germany. Within Britain it allows us to distinguish the fifteenth-century church towers of Somerset from those in Lincolnshire, or the Romanesque sculpture of Yorkshire from that of Herefordshire. To outsiders architecture and settlement patterns provide perhaps the most enduring hallmark of any country, but only a few keynote buildings were specifically constructed in order to proclaim national identity. Most buildings, whether the parish church, the lord's manor house or the yeoman's farm, were built to fulfil the private requirements of the patron, in a local way.[13]

The idea of the Isles is a geo-political concept. It follows that much of the art discussed below is secular, signifying the identity of the ruler and his or her claim to the land. Religious art, primarily created for the greater glory of God or personal piety, is therefore only relevant in this context if the (usually royal) patron used the church or artefact for a political message (see Luxford, p.101, 103). Ecclesiastical art (liturgical equipment, churches), though crucial in the beginning for creating a cultural cohesion, became less important towards the end, as rulers articulated their secular identity in more elaborate ways. An exception was the adoption of national patron saints. In theory, their cult provided a battle-cry, while their images and feast days generated sentiments of collective loyalty, but even here an account of these saints does not provide an entirely clear-cut symbol of the nation in art.

It is notable that the earliest of these great saints transcended subsequent national boundaries. St Columba

(c.521–97) fled from the north of Ireland to Iona (Argyll) and his cult spread from Dalriada through Pictland (approximately western and eastern Scotland) to Ireland. The Monymusk shrine, an eighth-century Pictish casket probably made for St Columba's relics (National Museum of Scotland, Edinburgh), may be the *Breccbennach* carried by the victorious Scottish army at Bannockburn in 1314.[14] The eleventh-century book shrine of St Columba's supposed psalter was known as the *Cathach* or 'Battler' by the thirteenth century. It was the talisman of the O'Donnells of Tyrconnell (County Donegal).[15] St Cuthbert (c.635–87) drew support all across southern Scotland and Northumbria. His banner was used in 1097 by the Scottish King Edgar (1097–1107), son of Malcolm Canmore, in his fight to oust Donaldbane from the throne of Scotland. Thereafter Cuthbert's relics were used by the English against the Scots. In a vision Cuthbert advised the prior of Durham to display the 'corporax cloth' (a cloth used to cover the chalice) at the Battle of Neville's Cross against the Scots 1346, and the English went on to win. The banner of the corporax cloth was also flourished at the English victory over the Scots at Flodden Field in 1513.[16]

Of the familiar quartet of national saints in the Isles, St Patrick (fl. fifth century) was undoubtedly the premier saint of Ireland, but he came from Britain, and his bones were claimed by Glastonbury Abbey (Somerset). Irish saints were generally absent from Irish art before the Gaelic revival in the fifteenth century. The great Gothic cathedral in Dublin, dedicated to Patrick, stands as his major memorial. It was the English bishop Henry of London who elevated the church to cathedral status in c.1220.[17] Apart from his name on the ninth-century high cross at Kells and the plaque on the Domhnach Airgid shrine (National Museum of Ireland, Dublin), St Patrick is not a significant image in surviving medieval Irish art.[18] St David (d.589/601) became patron saint of Wales only in the twelfth century, as part of a move to establish Welsh ecclesiastical independence from Canterbury. Like the Irish, the Welsh rarely depicted their native saints: St David is shown in the Hastings Hours (before 1483), painted first as a bishop and overpainted as a prince (perhaps indicating an intention to present the manuscript to Edward V, while Prince of Wales).[19] The Apostle St Andrew, whose bones were transported to Scotland in the eighth century, became the patron saint in the eleventh century, part of a move to resist the powers of the metropolitan archbishop of York. His cult strengthened

2 Portrait of St Luke from
St Augustine's Gospels, Italy,
6th century
On parchment 25.1 × 19.6 (10 × 7⅝)
Corpus Christi College, Cambridge
(MS 286, f.129v)

during the thirteenth-century wars against England, culminating in the consecration of St Andrews Cathedral, St Andrews, in 1318, after the victory at Bannockburn. There must have been many effigies of St Andrew at his splendid shrine, now lost. One solemn figure of St Andrew, c.1500, from a screen in Fife, survives in the National Museum of Scotland. A painted image is in the book of Hours of James IV and Margaret Tudor, 1503, where King James (1488–1513) is shown kneeling before an altar triptych, of which one leaf depicts St Andrew.[20]

In England two Anglo-Saxon royal saints, Edmund (d.869) and Edward the Confessor (1042–66), were amply illustrated, their most celestial and regal images being on the Wilton Diptych (see Gordon, pp.50–1) alongside King Richard II (1377–99). However, the depictions of St Edmund in his twelfth-century illuminated life, far from showing him as a national icon, were created to

define him as protector of Bury St Edmunds Abbey from the depredations of the king.[21] The cult of St George (d. c.303) developed in England during the thirteenth and fourteenth centuries. As the ideal chivalric warrior, he was also the patron saint of Portugal, Catalonia and Genoa, a far from exclusive national hero. Recorded in the seventh century at Iona, he later became known as the patron saint of soldiers, and was named as the English patron saint in 1351. In 1348 Edward III had founded the Order of the Garter, rebuilding the royal chapel of St Edward at Windsor, which he rededicated to St George as a centre for devotions.[22] He was painted in the stained glass at Heydour parish church (Lincolnshire), c.1360, ranked with Edmund and Edward, all in armour, as the protectors of England. Although Shakespeare's line from *Henry V*, 'Cry "God for Harry, England, and Saint George!"', implies that George was England's premier battle saint before the siege of Harfleur in 1415, Riches points out that the saint was even more the special protector of the king himself. Before departing on the French campaign, Henry V ordered all English people to pray to St George for the personal safety of their king.[23]

Insular Art, from 597 to the Ninth Century

HEIRS OF ROME

The year 597 is a good starting point for a chronological survey of medieval art. St Augustine (d.604) arrived in Kent to convert the pagan Anglo-Saxons and St Columba died at his new monastic foundation on Iona. Pope Gregory the Great (c.540–604) instructed Augustine to install bishops in the old cities of Britannia, revitalizing the former Roman province in Christian terms (see Goodall, pp.118–19 and Luxford, pp.82) while staking out a universal ecclesiastical territory for the Roman Church, which, politically, remained divided for the next millennium. The missionaries brought with them church ornaments, vestments, relics and many books, including, arguably, the so-called St Augustine's Gospels, which was made in Italy in the sixth century (fig.2). Its use, since 1945, for the consecration ceremony of the archbishop of Canterbury, may be a tangible link that binds us to Pope Gregory's original vision of a Roman Christian Britain.[24]

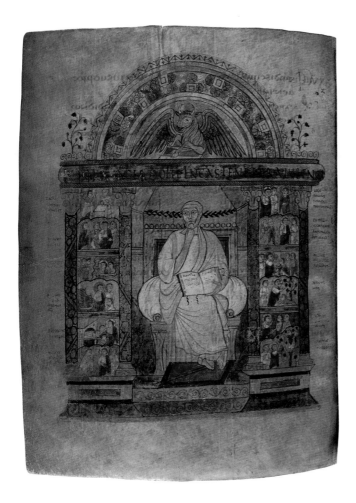

In all parts of the Isles that had experienced the Roman *imperium*, there are signs that local rulers wished to associate themselves with the lost grandeur and stability of the empire.[25] Redwald, 'ruler of all provinces south of the Humber' (d.c.627), was titled *bretwalda* ('power wielder of Britain'). The grave goods found at Sutton Hoo in Suffolk (see Hawkes, pp.44–5), which may have belonged to him, demonstrate the kind of international status to which such rulers aspired. They include quasi-imperial regalia: the helmet based on a Roman parade model, the sceptre, standard, shoulder clasps, belt buckle, purse and coins. The ruler's range of influence is demonstrated by the Swedish shield, the Irish or Scottish hanging bowls, the Byzantine silver and Merovingian coins. The stone of the majestic sceptre came from the north of England or south Scotland, its decoration with numinous heads has parallels in Wales and Scotland, but the facial types are Germanic.[26] Coins play an important role in revived concepts of kingship. Offa, King of Mercia (757–96), used the laurel-wreathed bust from a siliqua of Emperor Honorius (395–423) as a model for his new Anglo-Saxon penny.[27] King Athelstan

(924–39) used the title *Rex Totius Britanniae* on his coins after expelling the Vikings from York in 927. Edgar (959–75), taking the same title, reformed and centralized coin production in c.973 so effectively that, even after 1066, William the Conqueror was content to continue using Anglo-Saxon moneyers.[28]

Imperial pretensions are literally spelt out on the Welsh Pillar of Eliseg, named after an eighth-century prince of Powis (fig.3). The monument is a simple round-shaft pillar, with an impressive genealogy inscribed around the drum, topped by four lunette faces, like a primitive cushion capital. The inscription, devised by Eliseg's great-grandson Concenn, traces the family tree back to King Vortigern and the Roman emperor Magnus Maximus.[29]

The Picts also looked to Rome to express the grandeur and permanence of rulership. A beacon commemorating King Constantin (d.820), the Dupplin Cross in Perthshire dominates the Earn valley and the royal settlement of Forteviot below. It teems with defining features of Pictish kingship, particularly images of the biblical David with lion and harp, supported by massed ranks of soldiers.

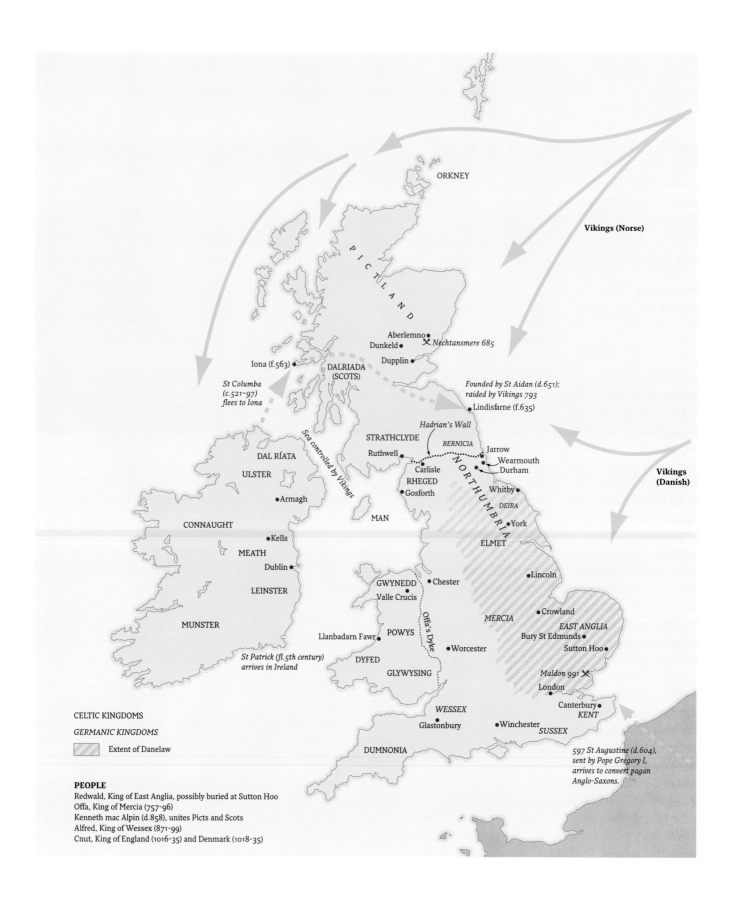

ORKNEY

Vikings (Norse)

P I C T L A N D

Aberlemno
Dunkeld
✗ *Nechtansmere 685*
Dupplin

Iona (f.563)
DALRIADA
(SCOTS)

St Columba (c.521–97) flees to Iona

Founded by St Aidan (d.651); raided by Vikings 793
Lindisfarne (f.635)

Hadrian's Wall

STRATHCLYDE
Ruthwell
BERNICIA
Jarrow
Wearmouth
Durham
Carlisle
RHEGED
Gosforth
N O R T H U M B R I A
Whitby
DEIRA
York

Vikings (Danish)

DAL RÍATA
ULSTER

Armagh

MAN

ELMET

CONNAUGHT
Kells
MEATH
Dublin
LEINSTER

Sea controlled by Vikings

GWYNEDD • Chester
Valle Crucis

Lincoln

MERCIA
• Crowland

EAST ANGLIA
Llanbadarn Fawr
POWYS
Bury St Edmunds
Sutton Hoo

MUNSTER

St Patrick (fl.5th century) arrives in Ireland

DYFED
Offa's Dyke
• Worcester

GLYWYSING

Maldon 991 ✗
London

WESSEX
Glastonbury
•Winchester
Canterbury
KENT
SUSSEX

CELTIC KINGDOMS

GERMANIC KINGDOMS

Extent of Danelaw

DUMNONIA

597 St Augustine (d.604), sent by Pope Gregory I, arrives to convert pagan Anglo-Saxons.

PEOPLE
Redwald, King of East Anglia, possibly buried at Sutton Hoo
Offa, King of Mercia (757–96)
Kenneth mac Alpin (d.858), unites Picts and Scots
Alfred, King of Wessex (871–99)
Cnut, King of England (1016–35) and Denmark (1018–35)

Constantin's name in the inscription indicates the imperial aspirations of his dynasty.[30] The unknown Pictish patron who commissioned the St Andrews Sarcophagus also pictured himself as an heir to King David, clad in a Roman toga, surrounded by exotic flora and fauna from the Mediterranean.[31] Both King Necthan of the Picts and Abbot Benedict Biscop (d.689) at Wearmouth, only too aware of the impermanence of their wooden architecture, sought help to construct stone churches 'in the manner of the Romans'.[32]

CREATING INSULAR ART

Bede (673/4-735) observed the role of Christianity in binding the land together: 'At the present time there are five languages in Britain ... English, British [i.e. Welsh], Irish, Pictish ... and Latin; through the study of the scriptures, Latin is in general use among them all'.[33] In the same way that the 'Isles' is a neutral term for our geographical region, 'Insular art' conveniently defines the hybrid style that developed from the indigenous Britonnic, Anglo-Saxon, Pictish and Irish cultures, and recently imported Roman Christian art. It was during this period of the greatest political flux and diversity that paradoxically an almost universal art style developed throughout most of the Isles.[34] Bede's definition implies how this fusion came about, through the galvanizing power of the Church.

Politically, it would appear that the Synod of Whitby in 664 was an overwhelming triumph for the Romanists over the customs of the Irish Church. However, for art the consequences were far more ecumenical. A fusion of cultures was already taking place. Monks from the Irish/Scottish foundation of Iona had been invited to settle at Lindisfarne in 635. Irish supporters from Lindisfarne retreated to County Mayo in Ireland after the Synod of Whitby. The Northumbrian nobleman Eanmund secured the services of a great Irish scribe for his new eighth-century foundation. This Ultan, 'a blessed priest of the Irish race', could 'ornament books with fair marking and by this art he made the shape of the letters beautiful one by one, so that no modern scribe could equal him'.[35] A new text-based religion required sacred books, and as a result the common parchment of liturgical manuscripts needed to be invested with the glittering status of precious jewels. It was at this stage that designs migrated from the smith to the scribe.

A sequence of manuscripts shows the new style evolving. Within the covers of the mid-seventh-century Book of Durrow are folio designs representing different cultural origins.[36] At the beginning is a cross-carpet page full of interlace, reminiscent of Middle Eastern models; next there is a perfect Celtic page of spirals, peltas and triskeles; the lion symbol takes its clear outline and spiral joints from Pictish art, while the eagle looks like a Visigothic fibula. The book closes with a page full of entwined Germanic ribbon beasts.[37] The Lindisfarne Gospels (see Hawkes,

6 Stone from Aberlemno churchyard,
Angus, with Pictish symbols and a
battle scene, early 8th century
Stone, height 229 (90¼)

pp.198–9) were made to honour Cuthbert, a saint revered for his gentle and loving attitude towards converting the heathen throughout northern Britain. It was fitting that in his book the disparate decorative sources fuse into harmonious rhythms, the Celtic spirals join with the Germanic ribbon beasts, and classically derived figurative models for the Evangelist portraits add to the mix (see frontispiece and fig.113 on pp.198–9).[38] Once this model of fusion was established, the designs were sustained for centuries. The style was so universal that scholars still debate the geographical origin of masterpieces like the Book of Kells and the Lichfield Gospels. One of its later manifestations in the Isles was the Rhygyfarch Psalter of c.1080, made at Llanbadarn Fawr, Wales (fig.5).[39] In Ireland the style saw a revival as late as the convoluted initials in the Book of Ballymote, made around 1391.[40]

Invaded but unconquered by the Romans, the Picts sustained one of the most distinct cultures of the Isles. Their stone carving may have been inspired by Latin lapidary inscriptions along Hadrian's Wall and the Antonine Wall, but their pictorial language of symbols was a unique invention. Exclusive to their own tribes at the time (probably fifth to ninth century), the symbols have remained enigmatic to outsiders ever since. The repertoire of signs includes elegant incised depictions of totemic animals, combined with abstract motifs like the double disc, crescent, Z-rod and V-rod. They are normally well executed to a standardized format, indicating a regulated society,whose members were able to interpret each other's statements, whether in memorials, names or property markers. With the coming of Christianity, Pictish art inspired an animal naturalism within the Insular repertoire and extended its own range of iconography and stone-carving techniques.

Stone slabs, carved in relief, combine both Pictish symbols and Christian iconography, communicating even wider statements about their identity. The Aberlemno churchyard stone reveals an ambivalence towards Northumbria. On its cross face there are designs clearly derived from works such as the Lindisfarne Gospels, while the symbol face illustrates a heroic victory for bare-headed infantry over helmeted cavalry (fig.6). Although contemporary reportage would be unusual at this time, it may depict the rout of the Northumbrian Ecgfrith (d.685) by Pictish Brude mac Bili (d.693) at the battle of Nechtansmere (685).[41] Later stones in eastern Scotland, like many of the

elaborate grave markers at St Vigeans and Meigle (Angus), are without symbols, marking the eventual demise of Pictish hegemony.[42]

Lacking spirals and interlace, the Northumbrian Ruthwell Cross (Dumfriesshire, early eighth century; p.181, fig.99) nonetheless represents the style of Insular art at a deeper level.[43] As a monumental free-standing stone cross, it presents a type of art not seen in Europe since the departure of the Romans. With its figures in classical costume and panels of newly introduced Mediterranean vinescroll, it is a dramatic example of Northumbrian church propaganda situated in the ancient Britonnic kingdom of Rheged. However, the emphasis of its iconography on Celtic values

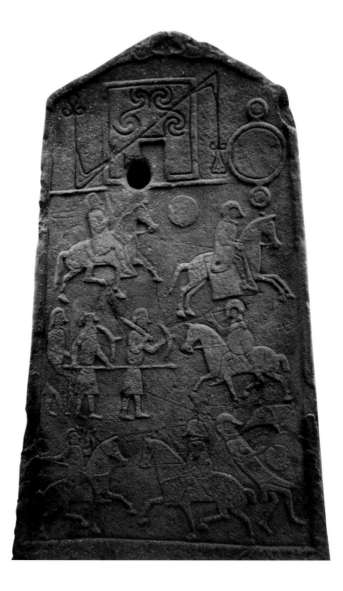

and preferred motifs, such as the desert, women and animals, was arguably intended to make it acceptable to the local audience. Its Latin biblical inscriptions were designed for both the Roman Northumbrian and the Celtic Rheged clergy, while the incised Anglo-Saxon runic poem, 'The Dream of the Rood', appealed to both a secular warrior class and quasi-heathen audience.

All the above-mentioned objects were intended to deliver eye-catching signals about the society that produced them. A more generic form of identity is found in the development of letter forms. Both Celtic Ogham (a type of alphabet used in Ireland, Wales, Dalriada and Pictland) and Germanic runes, with their strictly linear design, show an understanding of the Latin alphabet, but adapted to their own languages, and were generally used for lapidary inscriptions. However, it was for the widespread use of distinct half-uncial and display script throughout the Isles that the term 'Insular' was originally coined by the palaeographer Ludwig Traube.[44] The Lindisfarne Gospels, classed above as a symbolic work, equally stands as a characteristic example of Insular manuscript design, with its carpet pages, Evangelists and Evangelist symbols, and the stately pages of diminishing initials.

Invasions and Divisions: Vikings, Scots and Normans in the Ninth to Twelfth Centuries

In the face of Nordic invaders, political boundaries within the Isles began to harden, consolidating core territory while the periphery was lost. The first Viking raid was on the monastery of Lindisfarne in 793. They gradually swept down the eastern shore of England, grabbed the northern and western islands of Scotland, dominated the Irish Sea, the Isle of Man and Cumbria, and established important trading cities like Dublin and Galway in Ireland. The Scots became separated from their Irish homelands by Viking control of the Irish Sea, while at the same time, under Kenneth mac Alpin (d.858), they moved eastwards from their bases in Argyll from 843, to dominate the Pictish heartlands in central Scotland. Under Egbert, in the 830s, the kingdom of Wessex took over from Mercia in leading Anglo-Saxon opposition to the Vikings. By the end of the century Alfred (871–99) had penned the Danish ruler

Guthrum into the newly formed Danelaw in eastern England, and persuaded him to convert to Christianity.

Under threat of war, people try to save their most precious belongings. For the monks of Lindisfarne this was not just the Lindisfarne Gospels, but the body of St Cuthbert in his coffin, which they carried all over the north of England from 875, finally settling at Durham in 995 (see Plant, pp.48–9). The Irish monks of Iona translated relics of St Columba to Dunkeld in 849, while his shrine, the precious Gospels and personal items were taken over to the Irish foundation at Kells in 878. An early Irish chronicler calls the Book of Kells 'the chief relic of the western world'.[45] These precious objects were vested with a cultural identity from the moment of their creation. They had powers to heal, protect and save. As we shall see, divesting a country of its talismans was also a powerful means of destroying identity.

Although the Vikings occupied separate pockets of land throughout the Isles, and came from different parts of Scandinavia, they created a recognizable culture wherever they settled. Their pagan art forms, expressed ferociously in their swords, were tamed by Christianity, leaving a considerable heritage of Christian monuments in England. In Ireland the presence of Viking neighbours coincided with the greatest development of Irish stone crosses, packed with didactic Christian iconography. Apart from one cross at Kells, mentioned previously, that refers to the Irish saints Patrick and Columba, all of the remaining iconography derives from the Bible or the lives of St Antony and St Paul. Although today the crosses are an important political symbol of Ireland, their iconography indicates that their purpose was first and foremost Christian, perhaps intentionally distinguishing the Irish from their pagan invaders.[46]

Once settled, the Viking populations prospered, peppering The Isles with Scandinavian place names. However, shifting levels of political control meant that elite symbols were rare. The settlers left art flourishing in Scandinavia. Here, statements of identity can be seen in the grave goods of the Oseberg burial near Oslo (c.834) in Norway, and the monumental Jellinge stone in Denmark, raised in honour of King Harald Bluetooth (c.980s). Their art was characterized by writhing animal ornament that covered every surface, but this style did not translate into a unified visual identity for the Viking settlements in the Isles. In fact, to a great extent, their style was assimilated into the local

7 The Isles: key locations and events, 1066 (Norman Conquest) to 1603 (Union of Crowns, England and Scotland)

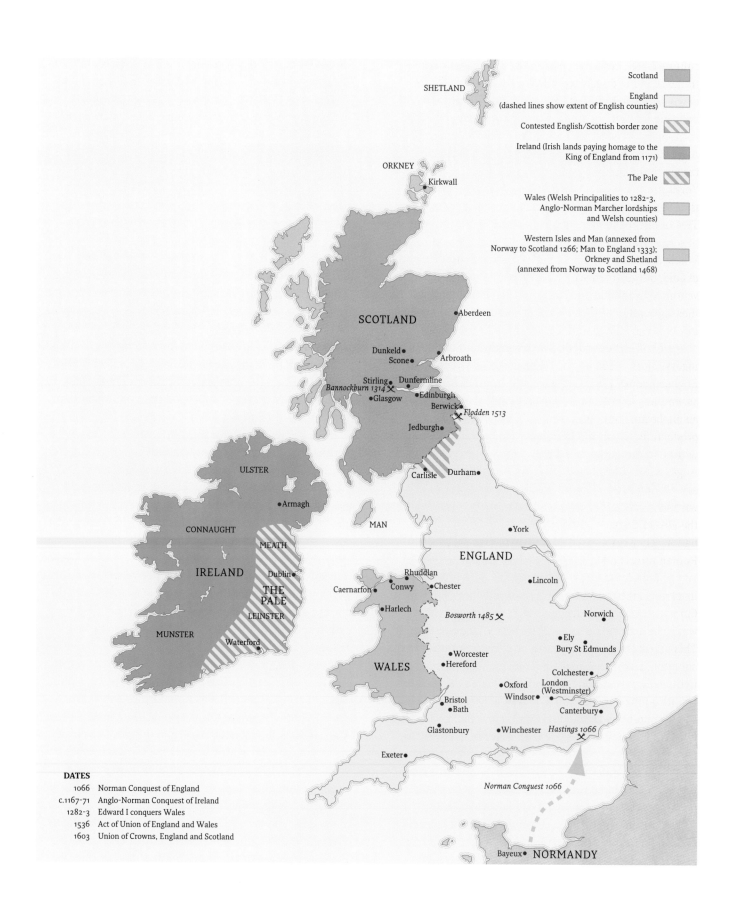

Scotland

England
(dashed lines show extent of English counties)

Contested English/Scottish border zone

Ireland (Irish lands paying homage to the King of England from 1171)

The Pale

Wales (Welsh Principalities to 1282-3, Anglo-Norman Marcher lordships and Welsh counties)

Western Isles and Man (annexed from Norway to Scotland 1266; Man to England 1333); Orkney and Shetland (annexed from Norway to Scotland 1468)

SHETLAND

ORKNEY
Kirkwall

SCOTLAND
Aberdeen
Dunkeld
Scone
Arbroath
Stirling Dunfermline
Bannockburn 1314
Edinburgh
Glasgow
Berwick
Flodden 1513
Jedburgh
Carlisle Durham

ULSTER
Armagh
MAN
York
CONNAUGHT
MEATH
ENGLAND
IRELAND
Dublin
THE PALE
LEINSTER
MUNSTER
Waterford

Rhuddlan
Conwy
Caernarfon Chester
Harlech
Bosworth 1485
Lincoln

Norwich

Ely
Bury St Edmunds

Colchester
WALES
Worcester
Hereford
Oxford London (Westminster)
Windsor
Bristol
Bath
Canterbury
Glastonbury Winchester
Hastings 1066
Exeter

Norman Conquest 1066

Bayeux NORMANDY

DATES
1066 Norman Conquest of England
c.1167-71 Anglo-Norman Conquest of Ireland
1282-3 Edward I conquers Wales
1536 Act of Union of England and Wales
1603 Union of Crowns, England and Scotland

culture. In the eastern counties there had been a strong tradition of making finely carved stone crosses. Under the newly converted Vikings, crosses and slabs continued to be made, but Viking motifs were added to the sculptors' vocabulary. Degenerate Viking beasts and slightly better Anglo-Saxon interlace are carved on the crosses manufactured around quarries in the Vale of Pickering, in east Yorkshire.[47] At Gosforth (Cumbria) the base of the cross is designed to look like tree bark, perhaps Yggdrasil, the Tree of Life in Norse mythology. Above this is a mixture of scenes from the life of Christ and the Norse poem, Völuspá, contrasting the Crucifixion with the death agony of Loki, the god of mischief, bound beneath a snake dripping venom.[48] Even if the art form was Anglo-Saxon and its message essentially Christian, the scenes were expressed in a new way that was meaningful to a Nordic audience.[49]

King Alfred believed that the devastation of the Viking incursions was due to the godless degeneracy of the English people. His response was to fight back, both by assembling a navy and fortifying towns, and by instigating an intellectual renaissance, which greatly increased cultural production. He set up schools and promoted reading and writing in Anglo-Saxon and Latin, and during his reign the Anglo-Saxon Chronicles began to be compiled by clerics in several different monasteries. These historical accounts, written in the vernacular, served above all to promulgate the idea of England, a conscious identity for a beleaguered nation. They recount events of English history from pre-Roman times and their compilation would continue until 1155.[50] In order to fortify his clergy, Alfred was personally involved in the translation of Gregory the Great's *Pastoral Care* into English. Each copy, sent to several bishops, was to be accompanied by an *aestel* worth fifty mancuses. This object is understood to be a decorative book-pointer, something like the Alfred and Minster Lovell jewels now in the Ashmolean Museum, Oxford. The Alfred Jewel has lost its pointer, but the handle is a gold, pear-shaped frame containing the enamel figure of a male holding two floriated rods. He has been interpreted as 'Sight' or perhaps Christ as the Wisdom of God. It is inscribed in Anglo-Saxon, 'Alfred had me made'. The object thus represents the king's personal identification with the revival of English culture.[51]

It is significant that Cnut, whose empire included most of Scandinavia and England, was a devoted patron of Anglo-Saxon art. To represent his aspirations as a ruler,

he chose artists from Wessex to design the *Liber Vitae* of the New Minster in Winchester. The manuscript shows Cnut and his wife Emma of Normandy (or Ælfgifu) presenting a great gold cross to the Minster, in the hope of saving their souls (see Luxford, p.91, fig.45). They are depicted in the sketchy Anglo-Saxon style, with an Anglo-Saxon angel holding Cnut's crown.[52]

The Anglo-Saxons were celebrated artists, but only two types of art, useless to robbers, survive in any quantity: manuscripts and stone carving. Vikings took one tranche of loot and William the Conqueror (1066–87) took the rest to give to his supporters and the Pope, objects like 'extremely large gold Crucifixes, remarkably adorned with jewels . . . pounds of gold or vessels made of the same metal'. William's brother Bishop Odo of Bayeux (d.1097) stole from Durham a pastoral staff 'of extraordinary material and workmanship, for it was made of sapphire'.[53] It is poignant that the undoubted Anglo-Saxon artistic talent of this period is represented by a national icon of the Norman victor, namely the Bayeux Tapestry, probably made for Bishop Odo (see Gameson, pp.46–7).[54]

With hindsight, William the Conqueror's invasion of 1066 is rightly seen as a political watershed, which redefined the lands of the Anglo-Saxons, Welsh and eventually Irish as Norman territory (see map, fig.7). At the time, however, it was seen by the majority of inhabitants as yet another attack by a variety of Northmen. The foreign-speaking overlords only began to see themselves as partly English over a century later; the Plantagenets, Henry II (d.1189), Eleanor of Aquitaine (d.1204), Richard I (d.1199), and King John's wife Isabella of Angoulême (d.1246), buried at their foundation of Fontevrault, were still being interred 'at home'.[55] Draper suggests that it took about three generations for the new Norman buildings to be perceived as an indigenous rather than a foreign style.[56]

Visual domination of the English countryside by the Normans was an indelible feat of propaganda. Within decades of the Conquest, the appearance of every cathedral town and many villages had been transformed by earth mottes, bristling stone keeps, and enormous new churches. Castles, a virtually new architectural form in England, signalled military conquest. The most lavish was the White Tower in London (c.1070–1100; see Goodall, fig.118, p.64), followed by the massive keep at Colchester. These derived from Continental towers like Loches (Indre-et-Loire) and Ivry-la-Bataille (Eure) and their power was reinforced by

Roman associations: the White Tower was linked to the Roman wall of London, while Colchester keep was sited above the Roman temple of Claudius.[57] Even in Scotland, where the builders were allies of the Scottish king, castles appeared as a new form of feudal domination, for instance at the Bass of Inverurie built for David of Huntingdon, and the Doune of Invernochty, Strathdon (Aberdeenshire), for the Earl of Mar.[58] In Ireland John de Courcy made his impression with the massive keeps at Carrickfergus (County Antrim) and Dundrum (County Down), while the keep at Trim (County Meath) was probably begun by King John (1199–1216) and completed by the Lacy family.[59]

All the Anglo-Saxon cathedrals were eradicated and many diocesan centres were moved to new locations. William used his Norman supporters to replace the Anglo-Saxon Church leaders. The great building campaign began symbolically with Battle Abbey (c.1070–94) on the site of his victory. Thereafter, the first generation of Norman churches arose at Canterbury Cathedral, St Augustine's Abbey Canterbury, Lincoln, Worcester and St Albans. These buildings were heavily influenced by designs from the abbey of St-Étienne in Caen and Rouen Cathedral in Normandy, but fuelled by the resources of a greater realm than the Duchy of Normandy, they were much larger. Cathedrals such as Winchester and Durham aspired to the imperial dimensions of Speyer Cathedral on the Rhine, an imperial mausoleum, and Old St Peter's in Rome.[60]

Durham Cathedral (1093–1133) introduces several new ideas about the Isles (see Plant, pp.48–9). Looming above a dramatic cliff (fig.20), it is an overwhelming symbol of Norman domination, built after William had effectively devastated the north of England in 1069. It is flanked by Durham Castle, residence of the Norman prince-bishop. However it is also the shrine of the most prestigious Anglo-Saxon saint, Cuthbert. Its ambitious dimensions and technical virtuosity are a Norman innovation, but its rich use of carved surface decoration reflects a resurgence of the Anglo-Saxon inheritance. As mentioned previously, for most of the Middle Ages people living in the north-east would have identified themselves more with the tutelary sway of the saint, whose lands straddled the border of England and Scotland, than with either country. King David I, wishing to create a similar focus for national worship in Scotland, brought the Durham masons north to build Dunfermline Abbey (begun c.1126) as a shrine for his mother Margaret. She was canonized in 1250 and became

the premier female saint of Scotland (see Luxford, p.92, fig.46). Rognvald, Earl of Orkney, enshrined St Magnus in the cathedral at Kirkwall, a smaller version of Durham begun in 1137. The Durham design therefore provided a prestigious template for churches dedicated to major local and national saints outside England.

The pooling of artistic ideas around the Irish Sea was not limited to the Insular period. In the twelfth century the elegant Viking Urnes style was adopted by the Irish in both metalwork and monumental form (as with the Clonmacnoise Crozier and the Shrine of St Patrick's bell, and the Cashel sarcophagus), and it emerged again in the Herefordshire School of sculpture (at the church of Kilpeck, for example).[61] The Nun's Church at Clonmacnoise has radiating voussoirs of both English and Irish design. It was complete by 1167, two years before the Anglo-Norman invasion.[62] Two churches founded by William Marshall, Earl of Pembroke Lord of Leinster, at Graigenamanagh (County Kilkenny) and St Mary's New Ross (County Wexford) used stone shipped from Bristol.[63] Although this period is characterized by waves of violent political change, there is evidence of art overstepping the harsh political boundaries. Boyle, a Cistercian abbey in County Roscommon, remote from English political sway, none-theless shows an awareness of the latest styles in western England. Roger Stalley points out that common stylistic traits between Irish buildings are less likely due to political patronage than to local schools of masons.[64]

Defining Britain: The Thirteenth Century

The loss of Plantagenet Continental possessions led to aggressive English policies of acquisition within the Isles. In this period of chivalric drama objects of vanquished identity were destroyed and new symbols were created, many of which are still in use today. The English kings, intent on dominating the Isles, developed the symbols of kingship to a new level of display. Smarting from King John's loss of Normandy in 1204, his son Henry III turned towards his English patrimony and sought to enhance his credentials on that front. One strategy for asserting Plantagenet legitimacy was to hijack links to the past: he gave his sons Edward and Edmund Anglo-Saxon names, a first for the Angevin rulers of England.

While seeking to venerate the relics of Edward the

Confessor, Henry built a 'French' church, Westminster Abbey, to house them (c.1245–72; see Coldstream, pp.106–7). His models for the quintessential English coronation church, mausoleum and royal shrine were Reims, Saint-Denis and the Sainte-Chapelle in Paris, respectively. The so-called 'Crown of St Edward' emerges in documents only after Henry III had opened the royal tomb and translated the remains in 1269. It is therefore likely to have been Edward's burial crown, interred at his death along with other insignia. The coronation of Edward I (1272) was the first in which St Edward was invoked and the ceremony included handling the saint's ancient tunicle, coat, sword, mantle, ring, sceptre and rod, which were all likely to have been grave goods. Used in successive coronations, the crown became the great symbol of royal legitimacy until it was 'totallie broken and defaced' in 1649. M.R. Holmes produces tantalizing evidence that the present Crown of St Edward, made for Charles II after the Restoration in 1660, may include the original gold.[65]

Rulers' inauguration ceremonies are key moments for defining national allegiance. There were clear differences between rituals in the Celtic and Anglo-Saxon lands. The Irish and Scots 'married' the new ruler to his land by placing his foot in a print carved into the living rock, as at Dunadd (Argyll) and Clickhimin (Shetland) in Scotland, and at twenty-three sites in Ireland. Inaugurations of this type for Lords of the Isles took place at Finlaggan (Islay) until at least 1449. The Picts placed the ruler on a stone, and the Stone of Scone, used by the subsequent Scottish kings, is likely to have very ancient origins. A good description survives of the inauguration of the child king Alexander III at Scone in 1249. He was placed on the stone and consecrated by the bishop of St Andrews, while nobles cast their clothes before him and a bard recited his genealogy.[66]

Edward I's method for destroying the identity and morale of both Wales and Scotland was to confiscate all their trappings of nationhood. During his tour of Wales in 1284, after a final victorious campaign against the Welsh princes, Edward had the silver of Llywelyn ap Gruffudd (1246–82) made into plate for himself, gave the golden Welsh crown of Arthur to Westminster Abbey and received the Croes Naid (the Cross of Destiny, a treasure of the Hwenydd royal family).[67] Following his Scottish campaign, Edward I presented to the shrine of Edward the Confessor at Westminster the Scottish regalia, namely the stone, crown, sceptre and Black Rood of St Margaret (her personal

relic of the true cross) in 1296. As a gesture of ultimate humiliation, Bishop Wishart of Glasgow was forced to swear an oath of fealty to Edward on the relics of the Black Rood and the Croes Naid.[68] The Coronation Chair was then constructed to supply a wooden seat above an open box displaying the stone (fig.8).[69] The Stone of Destiny, residing in Westminster Abbey for 700 years, became a political pawn once more in the twentieth century. Stolen by patriotic Scottish students and swiftly retrieved in 1950, it was eventually returned to Scotland in 1996. Its current home in Edinburgh Castle alongside the other Scottish regalia, while lacking historic tradition, at least aims to keep the relic secure.[70]

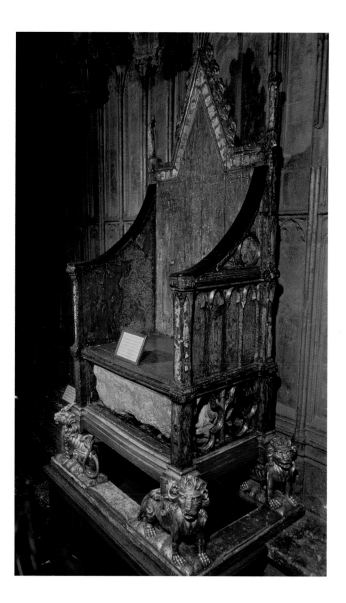

The castle building that accompanied Edward I's conquests in Wales, Scotland and Ireland stamped the military face of English hegemony over all the Isles. However, these latest concepts in defensive engineering were mainly the product of a Savoyard mason Master James of St George, who had worked for Edward's kin and vassals, the Counts of Savoy.[71] The castles were based on new principles, with round towers, massive gateways and curtain walls, either designed symmetrically on flat land, or hugging the contours of more challenging terrain. Rhuddlan and Flint were started after the campaign of 1277, followed by Harlech, Conwy and Caernarfon after the Welsh defeat of 1283. Caernarfon, more than all the others was intended to project an imperial and chivalric message, its striped walls reflecting Roman prototypes. Edward chose Caernarfon as the birthplace of his son in 1284, whom he later created Prince of Wales in 1301 (see Goodall, p.133, fig.73). This was the first building in Wales whose imperial pretensions matched the ambitious Welsh genealogy on the Pillar of Eliseg, harking back to the Roman leader Magnus Maximus.[72] In Scotland Edward destroyed Bothwell (Lanarkshire), the fairest castle in the land in 1301, and moved north to plant a massive gatehouse at Kildrummy (Aberdeenshire) in about 1303, almost identical to the one at Harlech. In Ireland the gateway and curtain walls of Roscommon Castle (Connaught) are also similar to Harlech, although begun three years earlier in 1280.[73]

During the thirteenth century, enjoying investment and economic prosperity, churches in Ireland and Scotland began to look more like those in England. By 1230 six Irish sees were occupied by Anglo-Norman bishops, who were rebuilding to demonstrate a new religious order. Waterford Cathedral (1210) was modelled on Glastonbury Abbey; Christ Church Dublin (1216–34) was designed by a master mason from Worcester Cathedral who made innovative use of the Early English fashion for detached marble shafts; St Patrick's Cathedral in Dublin (c.1220) has stocky clustered piers in the tradition of Wells Cathedral;[74] and Glasgow Cathedral, while politically celebrating its recent diocesan independence from York, allowed the Early English style to flourish, with the clustered columns, rich stiff-leaf foliage capitals, and dazzling stellar vaults in the crypt.[75]

The Welsh are somewhat under-represented in this essay, perhaps because art and architecture do not appear to be their principal means of expression in the middle ages. Gerald of Wales observed in the twelfth century that

his fellow countrymen's great cultural strengths lay in music and poetry, choral singing and word play, and that they preferred to live in little wattle huts rather than great palaces.[76] Some strain of pagan Celtic art seems to survive in the grimly staring heads, frequently grouped together like head-cult objects, that can be found on the font at Llanwenog (Cardiganshire), the stoup from Capel Madog (Radnorshire) and the capital from the Old Rectory at Castlemartin (Pembrokeshire). In his study of the visual culture of Wales Peter Lord refers to the 'permeability of the Welsh border in matters of design', indicating strong English influence, if not English manufacture. Examples are the lead font from Lancaut (Gloucestershire), the Llanfihangel Abercywyn font (Carmarthenshire) deriving from designs at St Augustine's Bristol, and the ten square fonts imported from Devon.[77] Equally, as we have seen, whatever material symbols of identity the Welsh may have had were ruthlessly destroyed by Edward I. When needed, they were expropriated by the English. To emphasize his claims as legitimate heir to Llywelyn ap Gruffudd, the Yorkist Edward IV (1461–83) depicted the Croes Naid three times in St George's Chapel, Windsor, including on a roof boss with the king kneeling beside it. In his colourful genealogical roll of 1461–4 Edward traced his primary descent through Welsh kings, accompanied by lively heraldry, badges and portraits.[78]

Royal seals express subtly changing concepts of identity and rulership from the time of their first appearance under Edward the Confessor.[79] He is shown seated on both sides, bearing an orb and sceptre or sword. William the Conqueror employed a formula that remained in use on almost every royal seal in England and Scotland down to the Union of the Kingdoms in 1707. It shows the king enthroned on one side, symbolizing justice, and on horse-back on the other, symbolizing military might. Seals could embody both political reality and aspirations. During the minority of Alexander III (1249–86) the guardians of Scotland, not wishing to usurp the royal design, used a seal with the royal arms on the front and St Andrew on the back. When Edwards I and II (1307–27) ruled parts of Scotland, the Scottish seal showed the king enthroned, backed by the arms of England: Scotland was not a sepa-rate kingdom but a branch of English government. Edward I melted down the seal matrices of the Welsh leader Llywelyn ap Gruffudd and his wife and brother in order to make a chalice for his own monastic foundation of Vale

9 Horse-trapper embroidered with
the leopards of England, c.1325–50
Silk, silver thread and pearls
59.5 × 130 (23½ × 51¼)
Museé national du Moyen Âge – des
thermes et hôtel de Cluny, Paris

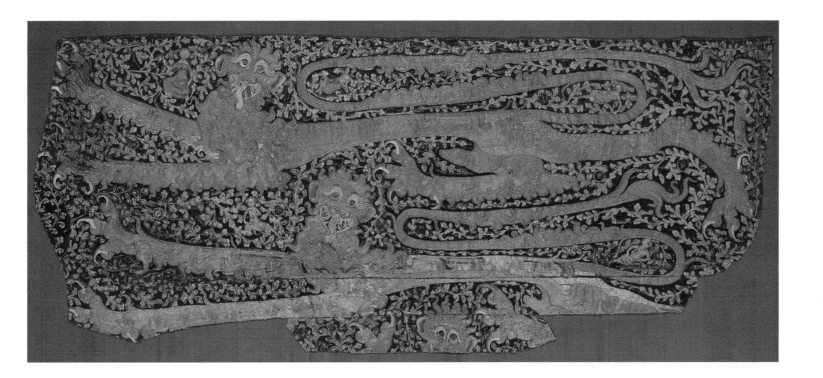

Royal (Cheshire) in 1282. In 1299 he confiscated John Balliol's seal of Scotland, when it was detected in his baggage as he tried to flee from Dover.[80] A sign of the rebellious Owain Glyn Dwr's challenge to English rule in and after 1400 is shown by his seal of an independent Wales, featuring the same regal designs as England, with the ruler on a throne and horse.[81]

Heraldry began in the twelfth century, first depicted on shields as a means of personal identification in battle. Later, the royal arms became one of the clearest symbols of the nation itself. In 1340, to reflect his claim to the throne of France, Edward III (1327–77) changed the English royal arms – three gold leopards on a red ground – by quartering them with the French royal arms of golden fleurs-de-lis (or lilies) on a blue ground. The fleurs-de-lis and the claim to France were only dropped from the royal arms in 1801 by George III. Queen Mary (1553–8) had sometimes impaled her arms with those of her husband Philip of Spain; and James I and VI (1567–1625; 1603–25) quartered the English arms with the lion of Scotland and harp of Ireland. Heraldry was eventually applied to every kind of important possession, including books, plate, glass and monumental brasses. It became a coded language of ownership, status and display,

and was used lavishly on social occasions, such as tournaments. An English horse-trapper embroidered with the three leopards appears to be such a national showpiece, probably used by Edward III on a state visit to the Holy Roman Emperor Ludwig in 1338 (fig.9).[82]

Badges were simpler declarations of identity and allegiance, worn by all who bore a lord's livery.[83] They are worn by the angels in the Wilton Diptych, for example, linking them to Richard II, who wears the same white-hart badge (see Gordon, pp.50–1 and illustration on pp.4–5). This panel painting (c.1395–9) is perhaps the most potent image of England in this account, both for its symbolic content and its breathtaking beauty. Richard, wearing a mantle covered in the Plantagenet family broomcods and his personal white hart, is ushered into the presence of the Virgin by St John the Baptist, and the English saints Edward and Edmund. Above the Virgin flies the banner of St George, and within the orb at the top of the pole we may see a vision of England itself, in Shakespeare's words, 'this royal throne of kings, this sceptered isle', the Virgin's dowry. This painting is a complex symbol of the nation, linking its historic past and eternal future in the person of the king.

10 'Tales from the Founding of Britain', detail from genealogical roll based on the *Historia Regum Britanniae* by Geoffrey of Monmouth, late 13th century
On parchment (six membranes)
416 × 52.3 (163¾ × 20½)
Bodleian Library, Oxford
(MS Bodl. Rolls 3)

The Wars of Independence and the Hundred Years War c.1300–c.1500

'While there exist a hundred of us we will never submit to England ... allow us Scotsmen, who dwell in a poor and remote quarter and who seek for naught but our own, to dwell in peace'.[84] These ringing words from the Declaration of Arbroath (1320) set the tone of Scottish cultural independence from England for the next two hundred years. From the thirteenth century onwards the jockeying for supremacy or independence between England and Scotland prompted the creation of strong visual signals on both sides until the crowns were united in 1603.

Both countries strove to backdate their legitimacy. The English relied on Geoffrey of Monmouth's fabulous English pedigree, in which Britain was divided up between the three sons of the Trojan Brutus. This legend was illustrated in a late thirteenth-century genealogical roll of the kings of Britain, showing the rulers from Brutus to Edward I (fig.10).[85] Meanwhile, the Scots, too, claimed an independent existence back to the mists of antiquity, and their historians also created the evidence. According to John of Fordun in his mid-fourteenth-century chronicle of the Scottish nation, they were descended from Scota, a daughter of the Pharaoh who had drowned in the Red Sea in the time of Moses, and her Greek husband Gathelos. Illustrations start with the voyage from Egypt and end with the Scottish victory at Bannockburn in 1314, and are a clear assertion of Scottish identity (fig.11).[86]

After a burst of innovative architecture in the English style during the thirteenth century, there was less building in Scotland and Ireland during the difficult fourteenth century. When opportunities arose again, the two countries no longer turned to England for inspiration. The dazzling glass boxes of English Perpendicular, with all their delicacy and miniature details, never emerge in the

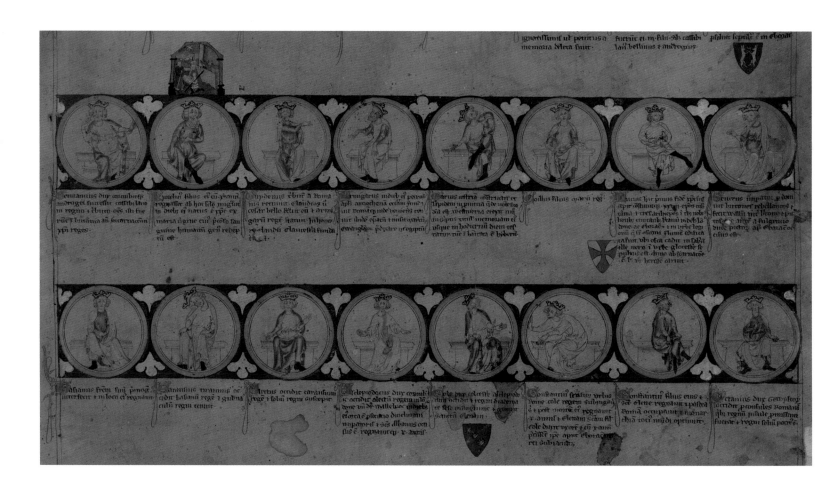

11 Page with illustration of Princess
Scota reaching Scotland in a ship,
from *Scotichronicon*, c.1425
On parchment 29.8 × 10.5 (11⅝ × 4)
Corpus Christi College, Cambridge
(MS 171A, f.35v (14v))

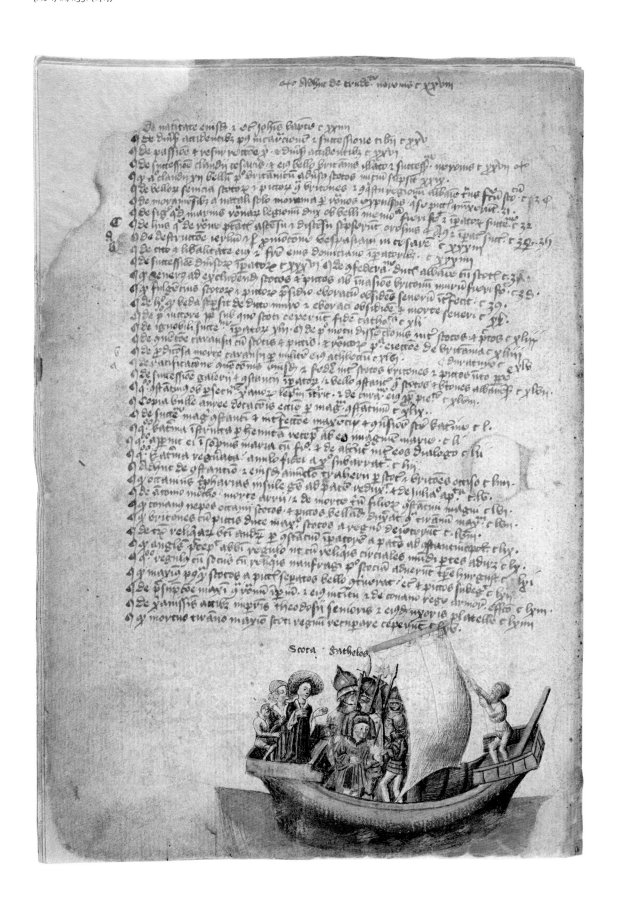

north and west of the Isles. Instead both countries developed styles rooted in their own past. Fifteenth-century Scotland saw the revival of massive cylindrical piers in great churches like Aberdeen and Dunkeld cathedrals. This may demonstrate a knowledge of contemporary developments in the Low Countries, but it is also deliberate archaism, a conscious revival of the Romanesque heritage.[87] Late medieval nostalgia emerges particularly strongly in the western Highlands, where deeply archaizing motifs enjoyed a spectacular revival in sculpture. Celtic interlace smothers the Eglinton and Fife whalebone caskets, in the National Museum of Scotland, made around 1500.[88] A grave slab at Keills (Knapdale, Argyll; fifteenth century) is decorated with an eclectic selection of objects, many of them familiar from earlier monuments: a sword, comb, shears, harp and fabulous beasts. On the tomb of Murchardus Macduffie of Colonsay (Argyll), 1539, there are hunting scenes reminiscent of those on Pictish stones.[89]

The earliest known carvers in this group of Highland sculptures have Irish names, and there was a similar examination of past styles in Ireland.[90] Holy Cross Abbey (Tipperary) has thick walls, heavy battlements and a bleak unarticulated tower (1431), altogether old-fashioned. It is arguable in some cases whether this retro style is just provincial and out of date, or whether it has a more positive agenda. At the beginning of the twentieth century Arthur Champneys referred to this phenomenon in Ireland as the 'Composite National Style',[91] but Roger Stalley points out that there is no evidence that the patrons thought of it in those terms. He sees this as the result of declining English lordship, fewer links with England, and infrequent contacts beyond the Pale (see fig.7).[92] On the other hand, the revival of Celtic interlace in sculpture is a more conscious acknowledgement of an Irish past, seen in buildings like Carlingford Mint (County Louth) of 1467.[93]

Scotland's independence, indicated clearly on the St Machar's ceiling (fig.1), is demonstrated also by its regalia. James III (1460–88) is the first Scottish king to be depicted (on a coin) wearing a closed imperial crown. Mimicking the crown of the Holy Roman Emperor, the arches indicate that the wearer has no feudal superior. The present crown, made for James V in 1540, incorporates the arches from older work (fig.12). Together with the sceptre and sword (gifts from the Popes Alexander VI and Julius II), the Honours of Scotland were first used together at the coronation of Mary Queen of Scots in 1542. When James VI left to become King of England in 1603, these symbols of majesty became a substitute for the royal presence, sitting in Parliament in the king's absence.[94]

The importance attached to the Scottish crown is shown by the clutch of church towers, built around 1500, that are topped by a closed crown created by spectacular flying buttresses. They were made for St Giles in Edinburgh, St Michael's Linlithgow, St Mary's Haddington and St Mary's Dundee (all late fifteenth century) and King's Chapel in Aberdeen University (1500–6). At Aberdeen the open buttresses are topped by a stone sculpture of the Scottish crown itself, honouring James IV, the patron of the university. The irony of this patriotic symbol is that the technology and design came from England, where the crown steeple of St Nicholas, Newcastle upon Tyne, predates the Scottish examples.[95] England's crown (at least Richard III's helm crown) ended up on a thorn bush at the Battle of Bosworth in 1485, a fitting end to the political uncertainties of the Wars of the Roses.

In England these were the centuries when the most national of architectural styles, Decorated and Perpendicular, flourished. From the fourteenth century the king's works (at such buildings as the Palace of Westminster, Westminster Abbey and St George's Chapel at Windsor Castle) served as a central clearing house for architectural ideas, through which many masons passed to further projects around the country. With hindsight, these styles have come to epitomize the most distinctive English buildings, but to what extent can they illustrate 'Ideas of Britain'? We have seen that the Scots and Irish rejected English models in this period of hostility. In a similar negative vein the Norman regime previously imported a new kind of architecture from the Continent in a clear rejection of Anglo-Saxon building. However, there is little contemporary evidence that the English considered any architecture in a national sense, and Christopher Wilson comments on the lack of any tradition of analytical writing on architecture in the Middle Ages.[96] The parallel between the development of Perpendicular architecture and the rise of English as the language of the elite and government is an attractive one, but the whole conceit of architecture as a language and symbol of identity becomes fashionable only after 1600.[97]

When Edward IV wished to adorn a dazzling court, he turned to Burgundy. Experiences during his exile of 1470 in Bruges produced a profound admiration for sophisticated culture and high fashion. Burgundian dress, etiquette

12 The Honours of Scotland, comprising
crown, sceptre and sword; the crown made
for King James V by John Mosman, 1540
Edinburgh Castle

and food were copied. Edward strove to replicate the library
of his cultural mentor Louis de Gruthuyse, governor of
Bruges, book for book, and Louis's private chantry in
the church of Our Lady in Bruges was an inspiration for
Edward's at Windsor.[98] Similarly, the Renaissance court of
James V of Scotland with 'its five-tongue thesaurus (Gaelic,
English, Scots, French, Latin)' was assumed to be architec-
turally polyglot.[99] Its buildings referred to a wide range
of European court architecture, as if to assert the king's
equal status with other monarchs of his time. At Falkland
Palace the influence is French; at Linlithgow, both Italian
and Danish (see Fawcett, p.137); at Holyrood, with its
enormous windows, English Perpendicular.[100]

Renaissance, Reformation, Iconoclasm c.1500–1603

This century saw the Isles being welded together politi-
cally: in 1536 came the Act of Union for England and
Wales; 1541 saw the creation of the kingdom of Ireland,
with a personal union of Crowns under the English
monarch; and the union of the Crowns between England
and Scotland took place under James I and VI in 1603. As
we shall see, by 1603 there was some visual sense of this
achievement.

Henry VII (1485–1509) aimed to heal the divisions of the
previous century's wars within his lands. He also needed

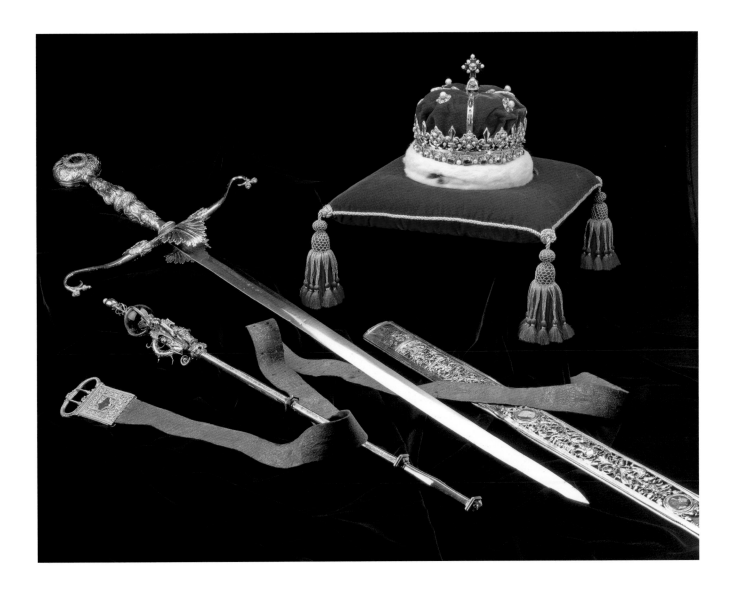

to create an ancient lineage for his new Tudor dynasty. He named his first son Arthur, reflecting the Welsh ancestry through his Tudor father, and married his daughter Margaret to James IV of Scotland. The choir stalls in King's Chapel in Aberdeen University, made 1506–9, are loyally carved with the thistle of Scotland and the rose of England. Henry VII's Chapel in Westminster Abbey sums up his achievements (see Luxford, p.101). The style of the building is the final magnificent flowering of English Perpendicular, light, intricate and covered in surface detail. The King's tomb draws together the national past and looks to the future: the heraldry on the tomb grille displays the Welsh dragon, the Beaufort portcullis (from his Lancastrian mother), the red and white roses of York and Lancaster entwined, the crown on a thorn bush reflecting his victory over Richard III, the Plantagenet leopards and the lilies of France. The effigies of Henry and his queen, Elizabeth, are in the most up-to-date style, convincing portraits enhanced with Italian renaissance putti. It is an irony that this shrine of national identity was made by the Italian sculptor Pietro Torrigiano (1472–1528), and the enclosure by Thomas the Dutchman.[101] Indeed, it is a characteristic of this period around 1500 that so many high-class commissions went to foreign artists (see Engel, p.67; Marshall, pp.78–9 and Lindley, pp.163–4).[102]

National posturing peaked at the Field of Cloth of Gold in 1520 (fig.72, p.132). Here Henry VIII ranged himself against Francis I of France (1515–47) in an extravaganza of consumption. Like London's Millennium Dome of 2000, the event was all about show, with castles made of canvas, silken tents, gargantuan feasts, golden fountains of wine, chivalric displays. Henry's complete suit of gilt armour survives. Symbols were important: 'Divers of the Kynges armes and bestes cast in mouldes' were commissioned, 'which would do great ease and furtherance of the Kynges business'. These were probably large colourful emblems of the Tudors and England, like the King's Beasts outside Hampton Court and the wooden Dacre beasts from Naworth Castle (Cumbria), now in the Victoria and Albert Museum.[103]

In spite of Henry's profligate programme of building castles and palaces, the greatest image he bequeathed was of ruin.[104] Religious reform hit England in the 1530s with the Act of Supremacy, and the Dissolution of the Monasteries (see Howard, p.239). Later, under Edward VI (1547–53), serious iconoclasm began. Familiar monastic landmarks in every locality were pillaged or reused (fig.13). The Reformation created a new generation of people collectively uprooted and alienated from their universal Roman Catholic past. A new religious identity was to be based on the nation, personified by the monarch.[105] Queen Elizabeth (1558–1603) did not have the money to spend on great monuments. She left that to her courtiers, who bankrupted themselves building houses to win her favour. Instead she used herself to symbolize the realm: 'I am already bound to an husband, which is the Kingdom of England.' The Ditchley portrait of Elizabeth (c.1592) carries a latter-day echo of the Scots royal inauguration: she places her feet on her land, wedded to her nation. On her accession-day address in 1590, still bathed in a glow of confidence after the defeat of the Spanish Armada two years previously and the establishment of the new colony in America, she was called 'Elizabeth, great Empress of the World, Britannia's Atlas, Star of England's Globe'.[106] It was in this climate of Roman imperial imagery that the seated figure of Britannia, holding her spear and shield, returned to use.

William Camden's *Britannia* (first edition, 1586) included all of the Isles in his account. He aimed to restore 'Britain to antiquity and antiquity of Britain'. The illustrated 1607 edition included coins, seals, shards and inscriptions, with detailed maps of the counties, Wales and Ireland. His book was a chronography, linking the landscape to monuments, people, heraldry, genealogy, language, customs and laws. The illustrations introduced a sense of time, with vignettes of Launceston Castle (Cornwall) and a map of the Anglo-Saxon heptarchy. On the frontispiece Camden presents illustrations of his antiquities, while Britannia, holding her shield, spear and legion's standard, is seated above the title of the book. She is copied from a coin, illustrated further on, of Emperor Antoninus Pius (AD138–61), struck when the Antonine Wall was erected north of Hadrian's Wall in around AD143.[107] In her first appearance since Roman times, Britannia is not used as an emblem of the nation, but as an advertisement for the antiquities in the book, above a cartouche of Stonehenge (fig.14).

Britannia next appears, wild-haired and dishevelled, repelling a ship from the shore, in Henry Peacham's *Minerva Britannia*, an emblem book of 1612. The poem alludes to the ancient Roman conquest, latterly reversed, as 'usurping Roome standes now in awe of thee'. This

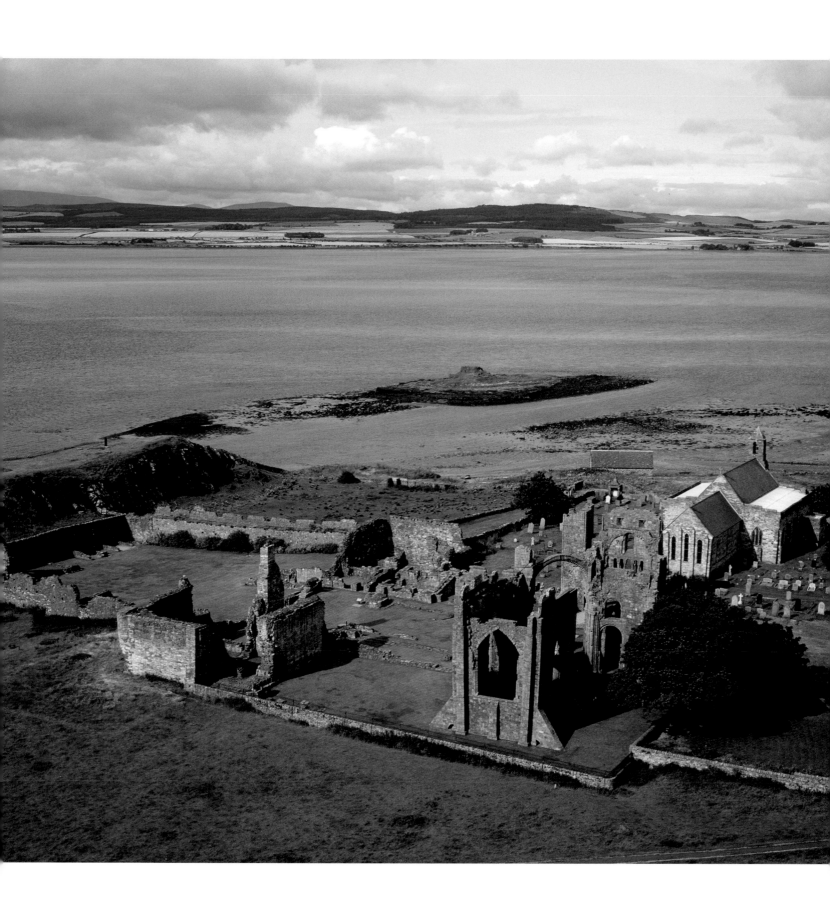

13 Lindisfarne Priory, Northumberland, looking towards the mainland; refounded in 1093, the monastery was suppressed in 1537

14 Frontispiece of William Camden's
Britannia, 1607 edition
33 × 23 (13 × 9)
British Library, London

15 Round Table, dating from the late
13th century, probably painted c.1516
Oak, diameter 550 (216½)
Winchester Castle, Hampshire

time Britannia is not so much the nation as the Protestant ascendancy.[108] An unequivocal symbol of 'Britannia the Nation' seems finally to arrive in Michael Drayton's *Poly-Olbion* of 1612. Knees akimbo, she sits on a plinth labelled 'Great Britain', flanked by her lovers Brute, Caesar, Hengest and William I. She wears a pearl necklace, holds a sceptre and cornucopia, and is crowned with ears of corn. Her dress is 'limm'd with the mappe of England'. But far from being an English invention, her pose and attributes are lifted almost exactly from Astraea, the frontispiece to *L'Histoire de la France* by Pierre Matthieu (Paris, 1605).[109] As frequently demonstrated in this account, what appears to be a powerful icon of the nation is based on a foreign source.

Conclusion: The Elusive Idea

The Isles in the Middle Ages projected a succession of identities. The most important objects associated with identity were often a hostage to fortune: the conqueror would either destroy the symbol of the conquered territory, or turn it into his own propaganda. Thus the unique symbols on stones in Pictland ceased to be used and their meaning was forgotten after the Scots' culture prevailed. Edward I destroyed the seals of John Balliol and Llywelyn ap Gruffudd, but reused the Stone of Scone. Henry VIII destroyed the monasteries and melted down their treasures, but confiscated Cardinal Wolsey's Hampton Court Palace for himself. It is also notable how many of the items discussed have required either foreign inspiration or foreign craftsmen to create a national icon.

It is a strange paradox that, in spite of the heavy burden of historical events, the most enduring 'Idea of Britain', one that essentially spans the whole of the medieval millennium, is the persistent fiction of Arthurian romance. Arthur's legend was used politically both to strengthen dynastic claims and to foster the glamour of chivalry, kindling loyalty from the militaristic ruling class. One of the rare medieval Arthurian illustrations comes from a Welsh redaction of Geoffrey of Monmouth, made c.1500, showing Arthur as a late medieval knight.[110] Thomas Malory's *Morte Darthur* first appeared as an illustrated edition in 1498, with twenty-two woodcuts added by Wynkyn de Worde.[111]

Arthur supposedly lived or fought in England, Scotland, Ireland and Wales, not dying but sleeping in a cave, waiting for the call to save Britain once more. Later kings, striving for legitimacy and respectable credentials, invoked his memory for their own propaganda purposes. The legends were spun in Wales by two great twelfth-century myth-makers, Geoffrey of Monmouth and Gerald of Wales.[112] They were used for aggressive political purposes: to justify Henry II's rights over Ireland (due to Arthur's original conquest); to legitimize Edward I's rights of sovereignty over Scotland (due to his Arthurian ancestry); and to link Edward's conquest of Wales to the court of King Arthur (see Luxford, p.100). The 1278 translation of Arthur's bones at Glastonbury Abbey, in Edward's presence, demonstrated clearly that Arthur was not coming back to help the Welsh. Even though the Irish did not emerge as victors in the legend and did not create any artistic associations, by the

end of the Middle Ages they, too, were devouring versions of the myth in many languages, including their own.[113]

Alixe Bovey has remarked on the scarcity of Arthurian illustrations that survive in Britain (see Bovey, p.136), but Arthurian visual associations were nonetheless important. By the twelfth century Edinburgh Castle was known by its Arthurian name, 'The Castle of the Maidens', overlooking the craggy rock that was eventually called Arthur's Seat. By the fourteenth century it was believed that Stirling Castle was the Arthurian castle of Sinandon and that the Knights of the Round Table had met there. Hector Boece, in the sixteenth century, relates the association between the great Pictish cross slab at Meigle (Angus) and the grave of Arthur's wife Vanora.[114] Further south, Edward I recreated tournaments of Arthurian chivalry at Nefyn in Wales in 1284 and at Falkirk in 1302. For the great tournament at Winchester in 1290, a Round Table was constructed, which arguably may still reside in the great hall of Winchester Castle (fig.15). It was later boldly repainted with Tudor roses to enhance Henry VIII's dynastic credentials.[115] With visions of Camelot emerging at Windsor, Edward III built the House of the Round Table in 1344 as a setting for chivalric events. His original concept of an order of 300

Knights of the Round Table was swiftly superseded by the more exclusive Order of the Garter, founded in 1348.[116]

The mythical British Arthur is a suitable image with which to end this account. Until 1604, when King James I and VI changed his title from 'King of England, Scotland, France and Ireland' to 'King of Great Britain, France and Ireland', Britain did not exist. The Isles were a colourful sum of their parts. Creating a sense of ownership and of 'belonging' to Britain is at the time of writing perceived as a government priority in these parts of the European Union that are 'swamped with foreigners'.[117] A review of the thousand years 600–1600 puts the present situation in perspective. Ethnic, social, political and linguistic divisions created the multi-faceted and sparkling culture of the Isles in the Middle Ages.

Art at Sutton Hoo

JANE HAWKES

The discovery of a seventh-century ship burial at Sutton Hoo, Suffolk, in 1939, provided unprecedented evidence for the use of art in early Anglo-Saxon England. The consensus is that this represents the grave or cenotaph of an East Anglian ruler, perhaps the Redwald (d. c.627) who is mentioned by Bede in his *Historia Ecclesiastica*. The decorated metalwork from this burial is generally discussed in archaeological terms as a collection of objects that combine function with mechanical ingenuity, while displaying exemplary statements of a particular kind of animal ornament known as Germanic Style II. However, like the comparable finds from a princely burial at Prittlewell in Essex (excavated 2003), the most elaborate pieces also demonstrate how art could be used to display and articulate the emerging institution of kingship in a way that drew on a sophisticated vernacular visual tradition, as well as the arts of other cultures.

The great gold buckle seems at first glance to present a swirling mass of interlace, but its decoration comprises thirteen discrete creatures paired and arranged in a symmetrical pattern that emphasizes the overall shape of the buckle plate (fig.17). Difficult to discern, particularly for those more conversant with the classical tradition of realism and naturalism, the creatures can be identified through a series of formulaic devices that define their heads, jaws, bodies, joints and limbs. The design represents an artistic tradition based on symmetry and zoomorphs, the details of which are disguised by pattern and variegated surfaces. This sophisticated art exploits the paradoxical, forcing the eye to focus variously on foreground and background shapes in order to decipher it.

This vernacular artistic tradition is common to the objects from Sutton Hoo, and in some cases is consciously incorporated with designs from other artistic cultures. Thus, the decoration

16 Purse lid from Sutton Hoo, early 7th century
Gold and garnet inlay, length 19 (7½)
British Museum, London

17 Buckle from Sutton Hoo,
early 7th century
Gold and niello
5.6 × 13.2 (2¼ × 5¼)
British Museum, London

of the lid of a purse (filled originally with thirty-seven Merovingian coins and three silver ingots, symbolizing the ruler's ability to dispense wealth from the throne as a reward for faithful service) includes birds of prey, symbolic of social status, as falconry was a pastime of the Anglo-Saxon warrior elite; as well as the motif of two pairs of confronting interlaced beasts, organized as a single plaque of gold and garnet inlay (fig.16). As it is the only single plaque on the lid, the others being paired, it invites attention. In fact, the creatures delineated in this plaque are replicated elsewhere among the finds only on the central boss of the Sutton Hoo shield. The latter, however, is not of Anglo-Saxon manu-facture; rather it is an heirloom, a piece of late fifth-century Scandinavian metalwork, whose decoration was replicated a century later on the Sutton Hoo purse. Thus, the motifs decorating the purse deliberately invoke connections with an ancestral Germanic past, figuring the link between the ruling elite of Anglo-Saxon East Anglia and their Scandinavian heritage. Here art is being used to convey visually notions of ancestry and express an ancient right to rule.

The world of imperial Roman rule is also invoked at Sutton Hoo in the way that the shoulder-clasps (decorated with paired boars and serpents) originally fastened a leather breastplate in the manner of Roman military wear; and the ceremonial helmet, whose decoration incorporates a series of creatures

in the face-mask, recalls the Roman cavalry parade helmet. The sceptre also expresses such links. Although it is an elaborate version of a British status symbol, being crafted of whetstone with human masks, it is unique in its free-standing (bronze) stag finial. Formally, this creature recalls 'Celtic' figurines, but the association of the sceptre with such a terminal recalls the short sceptres of Roman magisterial authority.

The art of Sutton Hoo thus represents a well-established and sophisticated vernacular artistic tradition that was used by Anglo-Saxon rulers of the early seventh century to give visual expression to their power and authority, in a manner that consciously incorporated symbols of British status and Roman rule with references to their own Germanic heritage. As a new power structure gained a foothold in England (the Christian Church from Rome), the Anglo-Saxon secular elite patronized the arts in order to surround themselves with highly visible and artistically symbolic displays of the power and wealth attendant on their status.

FURTHER READING

R.L.S. Bruce-Mitford, *The Sutton Hoo Ship-Burial*, 3 vols., London 1975, 1978, 1983.

M.O.H. Carver, *Sutton Hoo Research Committee Bulletins 1983–1993*, Woodbridge 1993.

M.O.H. Carver, *Sutton Hoo: Burial Ground of Kings?*, London 1998.

A.C. Evans, *The Sutton Hoo Ship Burial*, London 1986.

The Bayeux Tapestry

RICHARD GAMESON

Technically an embroidery made of woollen yarn on a linen ground, deploying ten colours fabricated from three dyes, the Bayeux Tapestry transcends the limitations of its materials to offer a vivid presentation of key events from 1064 to 1066, culminating in the Battle of Hastings, at which point it breaks off incomplete. The work consists of nine separately made sections and, lacking an uncertain quantity at the end, is approximately 70 metres long by half a metre wide. Its size indicates that it was designed for display in a public space, such as a hall or church; in the late Middle Ages it is documented as having been hung annually in the nave of Bayeux Cathedral during the feast of its relics – relics that play a pivotal role in the depicted story (fig.18).

The wealth of circumstantial detail and the attention paid to 'minor' characters suggest it was produced soon after 1066 when Norman interest in celebrating the victory would have been at its height; the broadly favourable portrayal of the Anglo-Saxons may favour a date before the first English revolt in May 1068. The fact that the Tapestry gives Odo, Bishop of Bayeux and half-brother of William the Conqueror, a more prominent role in events than do early written sources, allied to the circumstance that its earliest known provenance

was Bayeux, makes him the leading candidate for patron. Correspondences between motifs in the work and manuscript illuminations associated with the library of St Augustine's Abbey, Canterbury (which was situated in Odo's English lordship as Earl of Kent), would seem to indicate that the designer had some connection with that house. The location of the workshop or shops that actually carried out the embroidery, however, is irrecoverable.

The main story, in the principal field, unfolds on an epic scale: the preparations for the Norman invasion, for instance, are elaborate, the fleet that crosses the Channel is a grand one, and the climactic Battle of Hastings is long and hard-fought. Primary space is also allotted to telling incident and anecdotal detail, such as the human tragedy of an English family whose house is torched by the Normans. Yet, carefully controlled, such episodes enrich rather than overwhelm the principal narrative, enhancing the illusion of a panoramic coverage of events. Moreover, as the poses, glances and gestures of the many figures are calculated to lead the eye 'onwards', the secondary characters contribute physically to the kinetic energy of the work as well as conceptually to its content. The central narrative strip is 'framed' by decorative borders filled with plant-forms, beasts and occasional

human figures, whose import shades from ornamental motif to identifiable fable or vignette with possible relevance to the main scenes. At selected points the main story spills into the borders, as during the Battle of Hastings when they are bestrewn with the carnage of war: such invasions of liminal space add materially to the impact of the events in question.

The designer rose triumphantly to the challenge of recounting in pictorial form a complicated sequence of events, spread across three years and traversing the Channel, suggesting that he was involved in the selection as well as the arrangement of episodes. Whilst human motive is implicit rather than explicit in the depicted story (and the simple legends that are an integral part of the work likewise signal act and identity, not motivation), cause and effect are articulated by juxtaposition, repetition or symbol. That Harold's ascent to the throne in early 1066 led to his downfall, for instance, is indicated by the juxtaposition of the scene of his acclamation as king with the ill-omened

18 Harold swearing an oath to Duke William, detail from the Bayeux Tapestry, second half of the 11th century
Wool embroidery on linen,
approx. 50cm × 70m (19¾in. × 230ft)
Musée de la Tapisserie de Bayeux, Bayeux

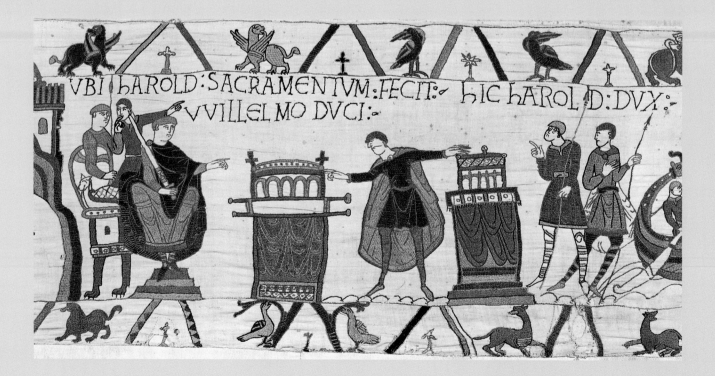

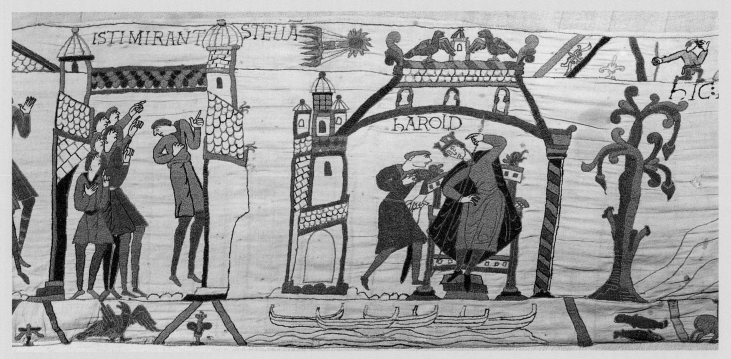

19 Halley's Comet and King Harold with a
messenger, detail from the Bayeux Tapestry,
second half of the 11th century
Wool embroidery on linen,
approx. 50cm × 70m (19¾in. × 230ft)
Musée de la Tapisserie de Bayeux, Bayeux

appearance of Halley's Comet, and this is imme-
diately followed by an image of a seemingly
troubled Harold, below whom appears a fleet of
ships, foretelling nemesis by sea (fig.19). As this
case also illustrates, the designer wove a celestial
dimension into the unfolding earthly events –
whether the hand of God, a portent, a cross
or a clerical blessing – thus underlining the fact
that, by defeating the English at Hastings, the
Normans held England by right of a conquest
that was determined by divine will.

While the physical appearance of characters
may change from one scene to the next, the
status and identity of the protagonists are
clearly indicated by costume, imagery (emblems
such as a bird of prey), action and written
inscription. Moreover, a degree of characteriza-
tion is also achieved. Harold, the lynchpin of
the story, though buffeted by adverse fortune
and compromised by calamitous decisions, is
generally shown to be a strong man – and hence
a worthy opponent. Vanquishing him thus brings
credit to the Normans (Harold's victorious
campaign at Stamford Bridge against Harald
Hardrada of Norway in September 1066 shortly
before he confronted William, a contributory
factor to the Norman success, is conveniently
omitted). Odo of Bayeux appears as a decisive
adviser (urging William to build ships, then
providing counsel for war), a model cleric who
blesses the food of the invasion force (flatter-
ingly, this image of the bishop is modelled on,
and evoked, a depiction of Christ at the Last
Supper), and finally as a brave man of action,

turning the tide of the battle at a critical moment.

All this is achieved with masterful economy of
line – figures, animals, towns, even the chaos of
battle, are delineated with a sure touch – while
the decorative treatment of elements such as
trees and buildings, allied to the non-naturalistic
use of colour, gives the work ornamental verve.
Scale and pictorial space are variables controlled
by the designer to ensure that the principal
subject of the moment, be it a figure, a fleet,
or the assault on a town, fill the main field and
hence are presented as directly as possible to the
beholder. The visual language is a fluid amalgam
of signs, symbols and semi-realistic representa-
tions: certain items may reflect eleventh-century
material culture more or less directly, while
many others are based on artistic conventions,
but collectively they are readily recognizable
evocations of their subjects, telling an intelligible
story in a visually enticing way.

Earlier deployments of textile art to commem-
orate historical events are known: an extant silk
embroidery apotheosizes the submission of
Count Reginar III of Hennegau to the Ottonians
of Germany (958), while a documentary source
records the existence of a lost hanging that
depicted the deeds of Ealdorman Byrhtnoth of
Essex, who died fighting the Vikings at the Battle
of Maldon in 991. Later sources tantalizingly
raise the possibility that there were other textile
versions of the events of 1066: the French cleric
and poet Baudri de Bourgueil (d.1130) imagined
one such work hanging in the chamber of Adela,
daughter of William the Conqueror, while

another is actually recorded in the possession
of the Duke of Burgundy in 1430. Among extant
works from the earlier Middle Ages, however,
the Bayeux Tapestry is unrivalled for scale and
complexity.

Sophisticated yet accessible, with a driving
narrative that is instantly comprehensible but
invites sustained contemplation, the Bayeux
Tapestry elides distinctions between 'high' and
'popular' culture, as between 'art' and 'history'.
Agreements and disagreements with other early
(written) versions of the events neither confirm
nor deny that this was what actually happened,
for the function of such works was less to
record the past than to recreate it. The tapestry
masterfully propagates an epic vision of heroism
and betrayal, of human triumph and suffering,
of divinely sanctioned retribution and conquest,
justifying the Norman victory and celebrating
the role of particular individuals therein, in a way
that is compelling and entertaining and that
transcends barriers of period and knowledge.

FURTHER READING

P. Bouet, B. Levey and F. Neveux (eds.), *The Bayeux
 Tapestry: Embroidering the Facts of History*,
 Caen 2004.
R.G. Gameson (ed.), *The Study of the Bayeux Tapestry*,
 Woodbridge 1997.
L. Musset, *The Bayeux Tapestry*, trans. R. Rex,
 Woodbridge 2005.
F.M. Stenton (ed.), *The Bayeux Tapestry:
 A Comprehensive Survey*, 2nd edn: London 1965.
D.M. Wilson, *The Bayeux Tapestry*, London 1985.

Durham Cathedral

RICHARD PLANT

Durham Cathedral, spectacularly sited over a bend in the River Wear, is the most celebrated of the great churches built in the immediate aftermath of the Norman Conquest of 1066 (fig.20). It housed the shrine of St Cuthbert, one of the most popular saints of medieval England, whose life and career are partly known through three biographies written shortly after his death. Despite his apparent desire for solitude, Cuthbert became Prior and later (briefly) Bishop of Lindisfarne (685–7). His reputation was sealed when, eleven years after his death, his body was removed from its tomb, and found to be undecayed. The community of St Cuthbert was forced by Viking raids to leave Lindisfarne and settled at Durham in 995, taking the saint with them. The body was again found apparently incorrupt and flexible in 1104 when translated into the new cathedral, and again in the late 1530s when the agents of the Reformation came to dispose of both the body and the precious materials that had accumulated around his shrine.

Nineteenth-century investigation of the tomb in which the body was then put found not only bones (of more than one individual), but also fragments of the rich cloth in which he was originally buried, a gold and garnet cross, and parts of the seventh-century wooden coffin, with Christ, the Evangelists, the Virgin Mary and archangels carved on it, the figures identified by Latin and runic inscriptions. The grave also contained a stole, given to the shrine by King Athelstan in the 930s, one of a number of English and Scottish kings to visit the saint's tomb (fig.80, p.144). Other surviving relics of Cuthbert and Lindisfarne include the Lindisfarne Gospels (see Hawkes, pp.198–9).

The Norman Conquest proved particularly devastating to the north of England and, following the murder of the first post-Conquest Bishop of Durham, a trusted associate of William the Conqueror, William of St Calais, was appointed bishop in 1081. The position also brought temporal power over the north-east, a position made clear by the proximity of the castle to the

cathedral. In 1083 St Calais replaced the secular (and often married) clergy of the community by regular Benedictine monks. The active promotion of the St Cuthbert cult in the following century saw histories and miracle collections produced, which recast the saint to fit the changing times and gave him a reputation as a misogynist to justify the exclusion of women from all but the westernmost part of the cathedral. Two illuminated copies of Bede's *Life* survive from this period, but the most enduring testimony to the promotion of the cult is the church, begun in 1093 and almost completed by 1133.

The interior is exceptional for its era, both in its massiveness – the walls are 7 feet (2.1 metres) thick – and the richly carved detail (fig.21). Throughout the church, the supports alternate between piers and columns with incised patterns, and their unusual height contributes to the sense of power of the building. The columns in the eastern arm are all carved with spirals, a form often used to denote particular importance or sanctity and perhaps intended to mark the shrine

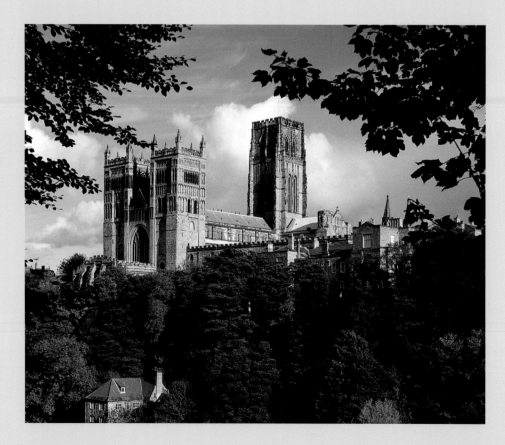

20 Durham Cathedral,
view from the south-west

21 The nave of Durham Cathedral, showing the rib vaults and decorated columns

of St Cuthbert, which stood in the central apse. Further west the columns have diamonds, zig-zag and fluting, and the fine moulding in the arches of the building offsets the raw bulk of the masonry. The stonework is notably regular, indicating a high level of coordination between quarry and building site, in contrast to some earlier essays in the Anglo-Norman style.

The quantity of linear decoration has inspired some scholars to see a conscious attempt to revive an Anglo-Saxon aesthetic in the building (both spiral piers and intersecting arcading had been found in Anglo-Saxon works); others have concentrated on structural innovations. The building is fully rib-vaulted, though perhaps only the vaults of the choir were planned at the outset, and their secure and early date (those in the choir were built before 1104) has led some historians to view them as a forerunner of the Gothic vaults of medieval France. Although

there are other rib vaults with good (if less certain) claims for an earlier date, the linear quality of Durham's ribs, with a roll moulding on the underside, does seem to foreshadow their use in Gothic architecture. Durham, moreover, employs pointed arches in the nave, probably to ensure an even curvature of the vault, some of the first such in England.

The building found immediate echoes at Dunfermline and in Norse Orkney, at Kirkwall Cathedral, as well as elsewhere in England (see p.32). The former two buildings may have used masons directly from the cathedral, and the reason for their employment is as likely to be the popularity of the saint as the quality of the building. The decorated columns and general level of carved enrichment seem to have been more immediately appealing to later architectural patrons than the rib vaults, which have attracted more recent architectural historians.

FURTHER READING

R.W. Billings, *Architectural Illustrations and Description of the Cathedral Church at Durham*, London 1843.
D. Marner, *St Cuthbert: His Life and Cult in Medieval Durham*, London 2000.
J. Raine (ed.), *Rites and Monuments of the Cathedral Church of Durham*, Durham and London 1842.
D. Rollason, M. Harvey and M. Prestwich (eds.), *Anglo-Norman Durham 1093–1193*, Woodbridge 1994.

The Wilton Diptych

DILLIAN GORDON

The Wilton Diptych takes its name from Wilton House, seat of the Earls of Pembroke, who owned it from 1705 (fig.22). It had once belonged to Charles I, and was almost certainly painted for Richard II, who became King of England at the age of ten in 1377 and was deposed in 1399.

Richard is shown kneeling in the left wing, wearing a white enamel brooch of the white hart, which he adopted as his personal emblem from 1390. Around his neck is a collar of double broomcods. Originally the livery of the kings of France, this was used by Richard probably from 1395, when negotiations began for his marriage to his second wife, Isabelle, daughter of Charles VI of France (1380–1422). Richard's rich robe is patterned with broomcods encircling harts. He is being presented by St John the Baptist, dressed in camel skin and holding the Lamb of God; Richard was born on 6 January, which is both the feast of the Baptism of Christ and Epiphany, feast of the Adoration of the Christ Child by the Three Kings. It was not uncommon for European rulers to have themselves depicted as one of the Three Kings, Richard himself here representing the youngest. The two kings who also present him are his saintly predecessors Edward the Confessor, King of England (1042–66), holding a ring that he is supposed to have given to St John the Evangelist (disguised as a pilgrim), and St Edmund, last King of East Anglia (d.869), holding the arrow with which he was killed. Whereas Richard and the three saints are shown in wasteland, presumably the earth, the Virgin and Child in the right wing stand on a meadow strewn with flowers, presumably heaven, surrounded by eleven angels, each wearing Richard's livery, badges of the white hart and single broomcod collars. One of the angels holds a white standard with a red cross and points to the king. The Child is dressed in gold and within his halo are stippled symbols of his Passion, a crown of thorns and three nails. While the two interior wings are religious in content, the exterior is entirely secular. One shows the arms of Edward the Confessor impaled with those of England and France ancient, as used by Richard II from 1395/6, and the other shows a white hart lying amongst flowers and plants. Although the heraldry provides evidence for the approximate date of the Diptych, probably between 1395 and 1399, and for its likely ownership by Richard II himself, the identity of patron and painter, and the purpose and meaning all remain unsolved.

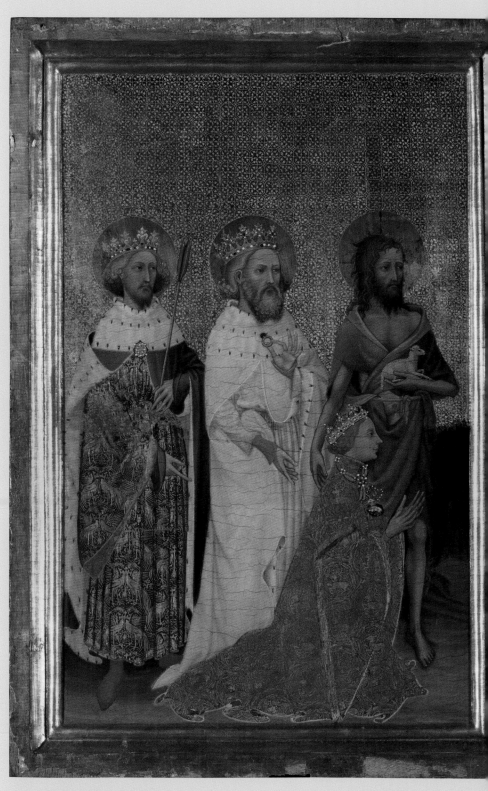

22 The Wilton Diptych, c.1395–9
Egg tempera on oak, each panel 47.5 × 29.2 (18¾ × 11½)
National Gallery, London

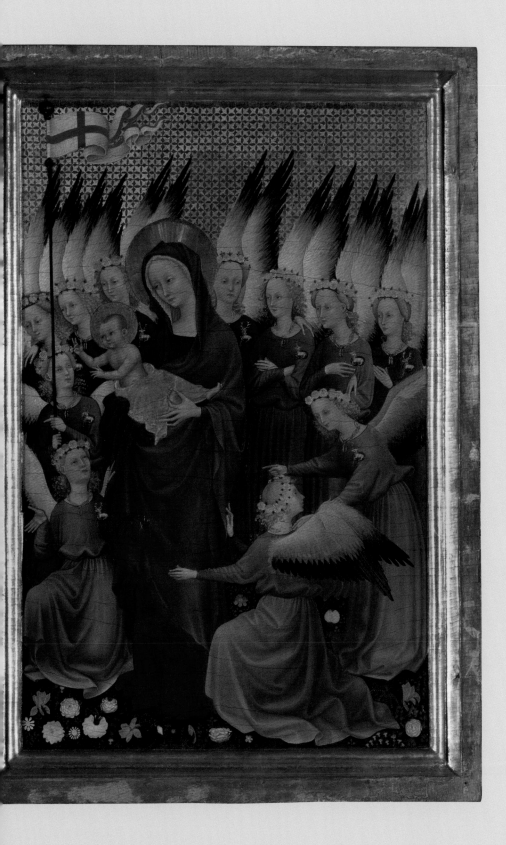

In 1991 it was discovered that painted in the tiny orb (just one centimetre wide) at the top of the standard is a green island with a white castle with two turrets and black windows, and trees on the horizon; below is a silver sea with a boat in full sail, and above is blue sky. By analogy with a lost altarpiece in Rome in which Richard was shown presenting an orb to the Virgin described as her dowry, it has been argued that this island represents England, known then as the dowry of the Virgin Mary. Most critics accept this. At its simplest level the king is receiving the standard of St George from the Virgin and Child, symbol of divine blessing for his kingship; Richard was deeply preoccupied with the sacred nature of his kingship. It has been pointed out that the three saints presenting the king all had chapels in Westminster Abbey – location of Richard's coronation and of his tomb among the tombs of the kings of England around the shrine of Edward the Confessor.

Although the predominant theme is that of kingship, the Diptych would seem to contain several different layers of meaning and symbolism. For example, the white standard with a red cross was also symbol of Christ's Resurrection, and it has been argued that the Diptych should be seen in the context of the crusade to recover the Holy Land, which Charles VI of France attempted to persuade Richard to undertake with him.

No painting comparable to the Diptych survives, so the identity of the painter remains a mystery. The support is oak with a chalk ground, characteristic of Northern painting, which suggests that it was made in England, but the technique is Italian – green earth underpaint for the flesh, and egg tempera as the medium for the pigments.

The Wilton Diptych is one of the most exquisite and one of the most studied paintings in the history of European art. Yet it remains one of the most enigmatic.

FURTHER READING

D. Gordon (with an essay by C. M. Barron and
 contributions by A. Roy and M. Wyld), *Making and
 Meaning: The Wilton Diptych*, exh. cat., London 1993.
D. Gordon, L. Monnas and C. Elam (eds.), *The Regal
 Image of Richard II and the Wilton Diptych*,
 London 1997.
U. Ilg, *Das Wilton Diptychon. Stil und Ikonographie*,
 Berlin 1996.
N. Saul, *Richard II*, New Haven and London 1997,
 esp. pp.304–7.

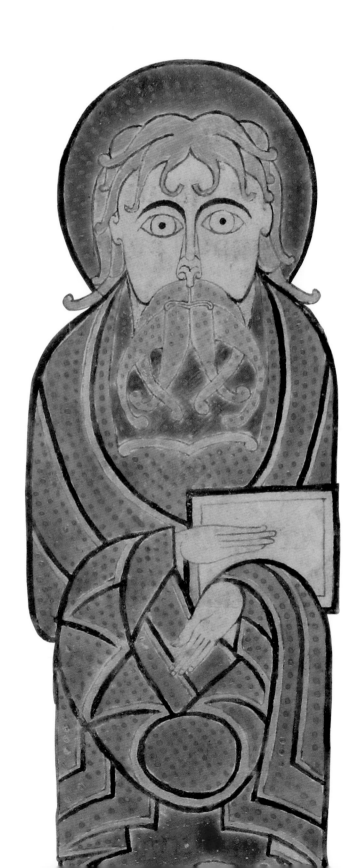

2 British Art and the Continent

UTE ENGEL

23 JEAN DE LIÈGE
Tomb of Philippa of Hainault,
wife of Edward III, d.1369 (detail)
White marble and Tournai marble
Westminster Abbey, London

WHEN QUEEN PHILIPPA of Hainault (d.1369) commissioned her tomb for Westminster Abbey in 1366/7 (fig.23), she chose the sculptor Jean de Liège from Brabant, who was then employed by the French king Charles V (1364–80). Philippa's tomb is different from earlier English royal effigies: like the tombs of the French kings at the abbey church of Saint-Denis, outside Paris, it was made from white marble, shows her fashionably dressed, and rested on a black Tournai marble tomb chest. Originally, no less than thirty-two weeper sculptures surrounded the chest, representing the queen's husband King Edward III (1327–77), flanked by the Holy Roman Emperor, the French king and a large number of Philippa's contemporary relatives from the great European houses, with prominence

given to Edward III's allies in the Hundred Years War against France. Philippa's tomb thus makes a dynastic and political statement in the context of the international affairs of her day, underlining England's claim to be one of the leading European powers, as well as its rivalry with France. The tomb of Edward III, on the other hand, possibly designed during his lifetime but finished only in the late 1380s, reverts to the traditional form of English royal effigy: Edward's figure is of gilt-bronze on a base of local Purbeck marble and depicts the king dressed in a plain gown and mantle, with characteristic long hair and beard. Only twelve weepers surround this chest, and they represent Edward III's children.[1] The king's tomb therefore attaches greater importance to immediate kinship and the continuation of his own dynasty than to international affiliations.

Made within a short time of each other, these English royal tombs demonstrate a range of possible relations with Continental art. On the one hand, there is the taking up of the latest Continental fashions and developments, even the employment of a Continental craftsman. On the other, we find a concentration on established artistic traditions and the use of native techniques and materials.

The Geography of Art and the Englishness of Art

The relationship between British art and architecture and that of the Continent can be treated in two different ways: first, by stressing the differences and searching for the constant, determining factors of supposed national characteristics; or second, by emphasizing the similarities that exist on both sides of the Channel and exploring the many instances of artistic exchange, especially with Britain's closest neighbours in north-western Europe: France, the Low Countries and Germany.

The first method dominated scholarship of the mid-twentieth century, as exemplified by the books of two Continental art historians, who applied the German methodology of the geography of art (*Kunstgeographie*) with comparable results, although each book was produced

under very different circumstances.[2] *Englisches Wesen im Spiegel seiner Kunst* (English Character as Mirrored in its Art) was published in 1942 by the Viennese art historian Dagobert Frey (1883–1962),[3] a professor at the university of Breslau (Wrocław) from 1931 to 1945. The book formed part of the Nazi research project, 'Kriegseinsatz deutscher Geisteswissenschaften' (Military Application of the German Humanities), that attempted to analyse the national character of Germany's enemies during the Second World War.[4] The much more successful *The Englishness of English Art* (1956) was the work of Nikolaus Pevsner (1902–83), a German art historian who settled in England as a refugee from Nazi Germany in 1935, but who had occupied himself with English art since his first visit to England in 1930.[5]

Frey aimed at defining the essence (*Wesen*) of English art as an expression of the mental attitude of the English people, dependent on the geographical and physical conditions of the environment, especially the insular seclusion of Britain, and on the national (*völkisch*), racial and social composition of its population, marked by the tension between the Mediterranean-Celtic and the northern-Germanic races. Pevsner's search for 'national character as it expresses itself in art' deals with language, character, climate and 'the awareness of the sea around the island'. He dismisses 'race' as 'a dangerous tool' and instead addresses in Hegelian manner the interrelation between 'the spirit of an age' and 'national character', structuring his material as a set of polarities arranged 'in pairs of apparently contradictory qualities', that complement each other. These qualities are described in terms of both formal and mental characteristics: angularity, addition, rationalism and reasonableness are set against overall decoration, the undulating line, irrationality and imagination.[6]

Avoiding these systematizing approaches, with their inherent danger of producing distorting generalizations,[7] more recent scholarship has explored the specific and manifold instances and possibilities of artistic exchange between British and Continental art in historical, economic, social or geographical contexts.[8] The interaction between regional traditions of artistic production and international trends has been investigated, as have the means of exchange, whether this be the travels of craftsmen and patrons, the movement of art objects themselves or drawings of them. A complex picture emerges, showing a constant shift between convergence and divergence,[9]

between the factors that unite and those that separate Britain and the Continent.

On the one hand, both shared the heritage of the Roman Empire and belonged to the Universal Church until the Reformation; both had royal courts and aristocratic societies that formed a cosmopolitan world, often adhering to the same values and closely bound together by dynastic relationships; England was part of political realms that extended into both Scandinavia and France in the eleventh and twelfth centuries; people of all social classes moved widely for diplomacy, pilgrimages or crusades; and trade linked British merchants with sea and river ports all over Europe.

On the other hand, Britain is separated from the Continent by its island geography, and England early developed a culture with a defined national and sometimes xenophobic identity that expressed itself in language, law and the arts. Scotland, as a separate kingdom, had its own, independent connections to the Continent, especially France, with whom it was allied against England from the time of the 'Auld Alliance' in 1295. Wales, by contrast, was culturally closely related to south-west England in the later Middle Ages and lost its political independence in the struggle with Edward I (1272–1307) in the late thirteenth century. The aim of this essay, therefore, is to explore some of the modes of artistic exchange between Britain and the Continent in the Middle Ages, dependent upon the historical circumstances of its component regions as well as the whole.

Christianization and the Heritage of Antiquity: The Travels of Monks and Books

The earliest copy of the *Vita* of St Columba – one of the great figures in the early history of Christianity in Britain, founder of the monasteries of Derry and Durrow in Ireland, and of Iona in Scotland in 563 – is not kept in the British Isles but in the Swiss city of Schaffhausen, whence it came from the neighbouring monastery of Reichenau in south Germany (Stadtbibliothek Schaffhausen, MS Gen. 1, c.688–713).[10] This astonishing link is due to the history of Christianization. Irish monks not only spread Christianity to Scotland and Anglo-Saxon Northumbria, but also to Germany and northern Italy.[11] So Gallus established the

monastery of St Gallen in today's Switzerland after 612 and was soon revered as a saint. Numerous monks from the British Isles visited St Gallen and other Continental monasteries with Insular connections, such as Echternach, Luxemburg, on their way to and from Rome. They brought with them manuscripts like the *Vita* of St Columba and the St Gallen Gospels (fig.24), which were left behind at these monasteries and in turn influenced the emerging Continental scriptoria.[12]

Insular manuscript illumination itself had been formed by an effective melding of pagan Celtic and Christian Roman culture. Irish and Anglo-Saxon monks brought books and paintings from Italy back from their travels, which became the models for their own book production.[13] The Codex Amiatinus (Bibl. Medicea Laurenziana, Florence, MS Amiat. 1) and the contemporary Lindisfarne Gospels (BL Cotton MS Nero D.IV), written c.700 at the monasteries of Wearmouth-Jarrow and Lindisfarne respectively, used the same or a similar Mediterranean source (the Codex Grandior of Cassiodorus), which is especially apparent in their author portraits. While the miniature of the scribe Ezra in the Codex Amiatinus copied the Late Antique illusionist manner closely, the image of the Evangelist St Matthew in the Lindisfarne Gospels transformed it into the Insular style (see Hawkes, pp.198–9, fig.113).[14]

At Canterbury (Kent), seat of the first bishop of the Anglo-Saxons, the impact of Late Antique imagery survived even longer. St Augustine (d.604), arriving from Rome in 597, brought an Italian Gospel book with him (p.24, fig.2), which had an important impact on the scriptorium of Canterbury Cathedral.[15] The monastic reform movement in the second half of the tenth century was carried through in close contact with Continental monasteries in the West Frankish realm, especially Ghent, Corbie and Fleury (also called Saint-Benoît-sur-Loire).[16] As English monasteries enlarged their libraries with books from abroad, Canterbury Cathedral acquired the Utrecht Psalter, a key work of the Carolingian Renaissance, produced c.820–35 at Hautvillers, near Reims. It inspired three versions produced in the early eleventh century, and the mid- and late twelfth centuries respectively (Harley Psalter, BL MS Harley 603; Eadwine Psalter, fig.25; Great Canterbury or Paris Psalter, Paris, Bibl. Nat., MS lat. 8846),[17] each interpreting the model in the stylistic manner of its time (see Lindley, pp.146–7). The first, the Harley Psalter, c.1010–20, follows the original style closely, with pen

drawings in a sketchy and expressive hand, clearly reminiscent of the Late Antique style, combined with coloured inks and washes.[18]

By the eleventh century Anglo-Saxon manuscript illuminators were creating highly original and brilliant works in a style very distinct from the Continent, memorable for their lively pictorial narratives in coloured outline drawings or full-page paintings surrounded by imaginative picture-frames with luxuriant foliage.[19] Equally unparalleled on the Continent was the wealth of literature in the vernacular English language.[20] At the same time, the people responsible for this flowering of Anglo-Saxon culture were heavily occupied with defending themselves against foreign invasions, reacting to the threat by creating a distinct identity, as is expressed by their identification with the Israelites of the Old Testament. Anglo-Saxon poems compare the exodus from Egypt and the crossing of the Red Sea to a new homeland, with the Anglo-Saxon settlement in England; and the defence of this home country against foreign threat is paralleled with the struggle between the English and the Vikings and others who raided, invaded and settled between the ninth and eleventh centuries.[21] A culture of separateness had begun to develop.

The Norman Conquest: Imposition of a New Culture

The most successful invasion of England took place in 1066, under the leadership of Duke William of Normandy, and resulted in the almost complete erasure of the Anglo-Saxon upper class – secular and ecclesiastic – and their culture.[22] These new Norman rulers used architecture, in particular, to express their power in a new way. King William I (1066–87) and the new aristocracy marked the conquered regions by the construction of mighty stone castles of the French donjon type (see Goodall, pp.130–2), erected often in close vicinity to the new cathedral churches started by bishops from Normandy, Lotharingia, France and Italy. The Normans brought their monumental style of architecture with them, even shipping their superior stone across the Channel, and produced cathedrals even larger than those in Normandy. In this way they created impressive signposts for the new rule in church and state, and stressed the contrast with the modest architecture of

24 Portrait of St Mark from the
St Gallen Gospels, mid-8th century
On parchment 29.5 × 22.5 (11½ × 9)
Stiftsbibliothek, St Gallen
(MS 51, f.78)

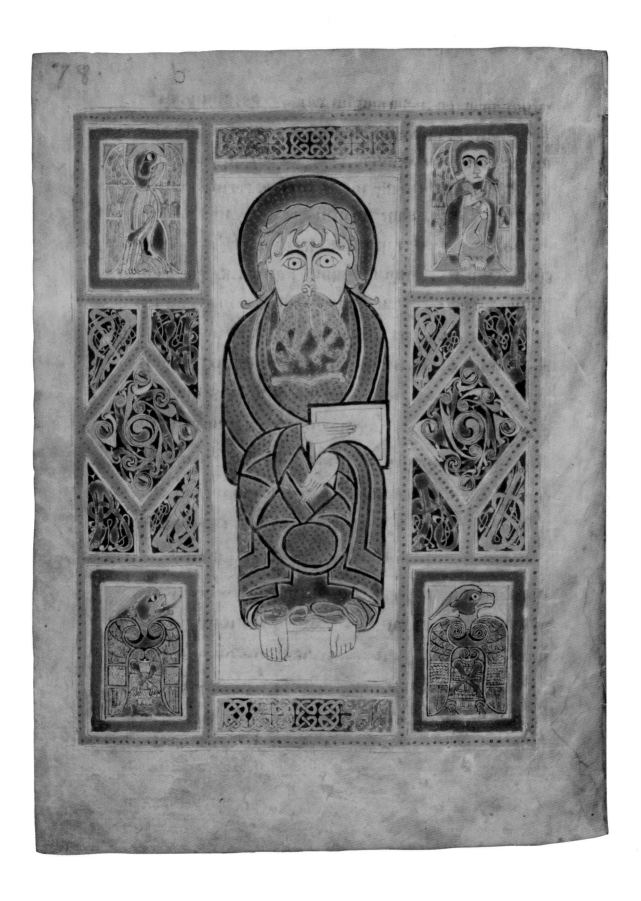

the conquered Anglo-Saxons.[23] The new builders also incorporated elements from other areas of Continental Europe, adopting from the German Empire a variety of forms for the west end of churches such as the western transept, and architectural details like the 'cushion' capital.[24]

At Durham Cathedral (1093–1133; see Plant, pp.48–9), the most significant manifestation of Norman rule in the north of England, close to the Scottish border, they experimented with high rib vaults about the same time as one of the most important monuments of the Holy Roman Empire, Speyer Cathedral, was reshaped with this innovative vault form under the patronage of Emperor Henry IV (1084–1105).[25] In the west of England, at the other end of the conquered regions, Burgundy, the Loire region and the buildings of the French and Italian First Romanesque style provided the models for the use of monumental cylindrical piers in Anglo-Norman churches. Drawing on a variety of Contin-ental sources and, from c.1100 onwards, also incorporating rich decorative elements of the Anglo-Saxon artistic heritage,[26] the Anglo-Normans soon formed a sophisticated architectural style with an astonishing creativity, appropriate for a new kingdom that was aiming to play its part as one of the most powerful realms of medieval Europe, alongside France and the Holy Roman Empire.

The Universal Roman Church and French Gothic

The Church was another promoter of increased exchange between Britain and the Continent in the twelfth century: The Gregorian reform movement, undertaken by the papacy from the late eleventh century, aimed to achieve uniformity within the Western Church, with central direc-tion from Rome. As a result, new monastic orders, such as the Cistercians, with their international networks, rapidly settled in the British Isles. British scholars studied and taught at the universities of Paris or Bologna and took an active part in the flowering of scholarship called the Twelfth-century Renaissance.[27] The status of the English kingdom was also enhanced when it became part of the Angevin Empire in 1154 with the accession of Henry II Plantagenet (d.1189) to the throne. This connection brought England into even closer contact with France, and the king into rivalry with the French monarch, a rivalry

that was to be a decisive factor in English politics for the next 300 years.

Close contact between Anglo-Norman and French ecclesiastical patrons explains why the new Gothic style of building and furnishing a great church with sculptures and stained glass as developed in the Île-de-France, the French crown lands, from the 1140s onwards was received in Britain earlier than anywhere else on the Continent. The commissions of Archbishop Roger de Pont l'Évêque (1154–81) at York Minster and the collegiate church of Ripon were clearly related to contemporary northern French Gothic churches like Noyon or Laon, with the use of slender, clustered piers, pointed arcades and the vertical articulation of rib vaults.[28] French portal sculpture was also reflected at York, Lincoln (c.1145) and Rochester cathedrals (c.1160–70).[29]

The response to French Gothic architecture developed distinctive regional variants, including those of England's immediate neighbours, Scotland and Wales. At St Andrews a new cathedral was begun in 1162 during the struggle of the Scottish Church against the hegemony of the Archbishopric of York, the independence of the Scottish Church from England being finally achieved by 1192.[30] It was built in obvious rivalry with the new choir of York Minster, just started by Archbishop Roger. Like York, St Andrews refers to the Early Gothic architecture of the Île-de-France, an influence supported by intense connec-tions between the Scottish and the French crowns in the 1160s and 1170s. The cliff-like east end of St Andrews, with its protruding eastern chapel at full height, became an important model for the many new choirs built in the late twelfth and early thirteenth centuries in Scotland and northern England. The canons of St Davids Cathedral in Wales were less successful in their fight for metropolitan status and independence from Canterbury in the later twelfth century.[31] They started the nave of their new cathe-dral in 1182, combining the new Gothic idiom created at Wells Cathedral (Somerset) in the 1170s with the highly ornate manner of Late Romanesque architecture in the West Country.

A French master mason, William of Sens, was commissioned to reconstruct the choir of Canterbury Cathedral after a fire in 1174, which was built to enshrine a great new martyr of the Universal Roman Church: Archbishop Thomas Becket, murdered by the knights of Henry II in 1170 and canonized in 1173 (see Coldstream,

pp.70–1).[32] The birthplace of the master mason certainly played a major role in the clergy's decision: Sens was where Archbishop Thomas had spent most of his exile during the conflict with the king, it was the seat of the most important archbishopric of France, and only recently an imposing new cathedral had been finished there. William of Sens and his successor William the Englishman created an ingenious synthesis of new French and traditional Anglo-Norman building practice and set the aesthetic model for great church architecture in twelfth- and thirteenth-century England.

Other characteristic devices of English Gothic architecture may refer to a wider European context, such as the lavish use of Purbeck marble. This, a dark fossil-bearing limestone from the Isle of Purbeck (Dorset), was particularly used for colonnettes and probably carried the implication of antiquity and the Early Christian past for English ecclesiastical patrons. This is made explicit in the case of the first patron known to have used Purbeck marble in England, Henry of Blois (c.1096–1171), Abbot of Glastonbury and Bishop of Winchester, who imported antique Roman statues to England and may have had illuminations in an astonishingly Byzantine style integrated into manuscript commissions that have been associated with him, the Winchester Psalter, c.1145–55 (BL Cotton MS Nero C.IV), and the Winchester Bible, c.1160–75 (Winchester Cathedral Library; see Donovan, pp.68–9).[33] At Canterbury this reference to antiquity had an especially long tradition, as we have seen, and was further underlined by the setting of large-scale double columns of rose and grey marble around the Trinity Chapel, the shrine area of St Thomas Becket, in a manner reminiscent of the Early Christian circular mausoleum of Santa Costanza in Rome.[34] Furthermore, the Trinity Chapel was equipped with a mosaic floor, and the relics of Becket were translated into a marble shrine in 1220.[35]

English National Identity

Contrary to the building boom in France in the twelfth and thirteenth centuries, Canterbury and most English churches were only partly reconstructed, and the architects had thus to face the task of combining a new building designed in the latest Gothic manner with an older part (usually the nave) in the Romanesque style. In this way

certain traits of the Anglo-Norman tradition remained characteristic for English Gothic architecture and separated it from developments on the Continent, key features being the limited height of English ecclesiastical architecture in contrast to the ever increasing scale and lightness of French Gothic cathedrals; the use of full-scale galleries instead of narrow triforium bands; and the thick-wall technique with its passages in front of clerestory windows, which made it possible to support the stone rib vaults by buttresses concealed below the gallery roofs.

By contrast, the delight of English Gothic in decorative details was a product both of an inherited Anglo-Saxon and Anglo-Norman interest in intricate surface patterns and an expression of the great wealth of the English Church in comparison to her Continental counterparts.[36] At Lincoln Cathedral English masons extended this decorative richness onto the vault surface and in this way created the first European figurative rib vaults, starting with the asymmetrical or 'crazy vaults' of Lincoln choir (c.1210/15; see Coldstream, pp.72–3).[37] The patrons of these English cathedrals and abbey churches were of an international upbringing and standing, like Bishop Hugh of Avallon, the patron of Lincoln choir (St Hugh's choir), who came from Burgundy and maintained a cosmopolitan scholarly centre at Lincoln.[38] But the architecture that they commissioned followed premises very different from contemporary Continental developments.

This distinctiveness also expressed itself in the sculpture that adorned these new church buildings. Unlike in France, English sculpture was mainly applied to the church interiors. There it enfolded on a small scale on capitals, bosses or arcade spandrels, but with an exquisite quality. When it was displayed on church facades, English sculpture was not concentrated around the portals as in the Gothic cathedrals of northern France, but was positioned in spandrels, niches or under canopies in horizontal registers in a manner comparable to the twelfth-century facades of south-west France, then part of the Angevin Empire ruled by the English kings. The most complete example, the screen facade of Wells Cathedral (Somerset), is covered by a huge number of figures up to life size, that present a complex pictorial programme of the Church Triumphant from the tympanum of the central portal up to the main gable (c.1220–50, fig.26).[39]

These apparent differences between English and French Gothic have been connected to the development of national

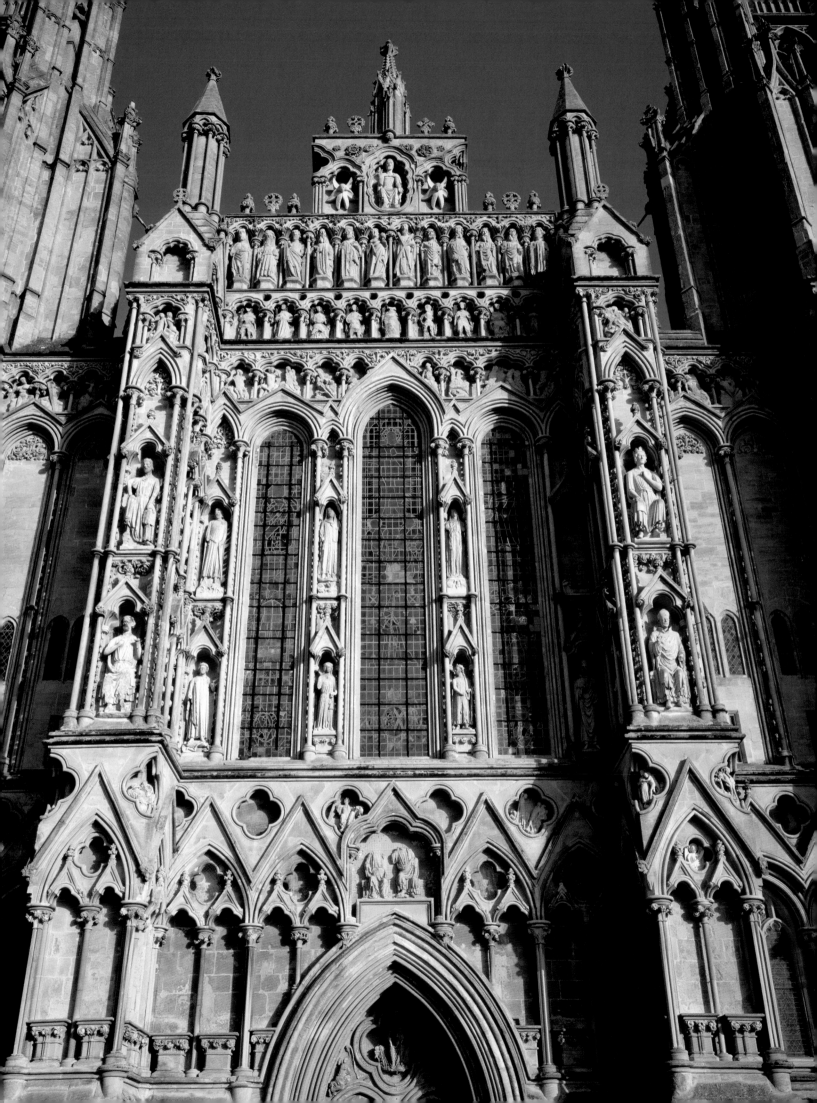

27 Page from Matthew Paris's *Chronica Majora* with illustration of the sea battle off Sandwich, c.1236–59
On parchment 36 × 24.5 (14¼ × 9⅝)
Corpus Christi College, Cambridge
(MS 16, f.56r)

Politically, the Norman and Plantagenet rulers built upon the achievements of the Anglo-Saxon kingdom, established a strong centralized government and administration, a common monetary and taxation system and, in contrast to the Continent, introduced Common instead of Roman law.[43] The loss of Normandy and Anjou in 1204 further separated England from its Continental dominions, and a French army invaded in 1216–17. A strongly xenophobic response is vividly demonstrated by the St Albans chronicler Matthew Paris (d.1259) in his literary and pictorial descriptions of the decisive battles. Working in the Anglo-Saxon technique of coloured outline-drawing, he depicts, for example, the English bishops who, on the shore, await the outcome of a sea battle off Sandwich (Kent), praying 'I absolve those who will die for the liberation of England' (*Absolvo pro liberatione Angliae morituros*) (fig.27).[44] The English Church, too, developed a degree of resistance against foreign, especially Italian and French, clerics appointed to English benefices by papal provision from the 1220s.[45] These anti-foreign feelings escalated during the reign of Henry III (1216–72), who promoted foreign nobles in his household, provoking the opposition of the English barons, and leading to open conflict in the Barons' War of 1258–65.[46] So exterior pressure resulted in the identification of English-born magnates of church and lay aristocracy with England and its heritage. With some reservations, this national consciousness in England can be linked to the preparedness of English patrons to keep to established and obviously revered aesthetic values in art and architecture, which today can be described as a specifically English style of Gothic.[47]

identity in medieval England.[40] During the twelfth century English society had integrated its Anglo-Saxon and Norman cultural heritage, which was certainly the effect of increasing intermarriage.[41] This is also expressed by the trilingual situation peculiar to England in the High Middle Ages: Old English (Anglo-Saxon) was used as the everyday language, especially of the lower social classes; Anglo-Norman French was the language of the court and upper classes; and Latin was the language of administration and the Church. But the three languages also had an equal standing to a certain degree, as is witnessed by the second version of the Utrecht Psalter (see above, p.56): the Eadwine Psalter (fig.25). The drawings, transformed into the more sharply outlined style of the mid-twelfth century, illustrate three Latin versions of the psalter text, the Gallican, the Roman and the Hebrew, with interlinear translations into French and English.[42]

Henry III and Court Culture

In contrast to the increasingly nationalistic attitude of the aristrocatic patrons mentioned above, Henry III maintained a cosmopolitan outlook, which was linked to dynastic connections common to rulers throughout this period. His sister Isabella, for example, was married to Emperor Frederick II (1220–50), and Margaret, his sister-in-law, to Louis IX (1226–70) of France.[48] When efforts to regain French Plantagenet possessions failed, the king turned to the second great force on the Continent, the Holy Roman Empire, in order to strengthen the Plantagenet position.

After the death of Emperor Frederick in 1250 Henry tried to secure Sicily and Apulia, former Norman dominions, for his son Edmund, though in the event this Sicilian adventure failed.[49] Only slightly more successful was the king's brother, Richard of Cornwall, who was elected King of the Romans in 1257 but was not able to secure a stable regency.[50]

It is in the context of this cosmopolitan court and such international ambitions that the main artistic commission of Henry III, the rebuilding and furnishing of Westminster Abbey from 1245 onwards, has to be seen (see Coldstream, pp.106-7). This extraordinary and extravagant building was intended to compete on a national and international level. The most obvious competition was with the great cathedrals of the île-de-France, markedly expressed by Westminster's height of 32 metres, which no English church had achieved up to then. By choosing Reims Cathedral as the main model for Westminster and appointing a master mason, Henry of Reyns, who was probably trained in that city, the status of Westminster Abbey as coronation church of the English kings was underlined. But Westminster Abbey was to fulfil many more royal functions: it was to serve as the burial place of Henry III, and it housed the relics of the canonized King Edward the Confessor.[51] In this respect, Henry III most clearly surpassed his French rival: France had the protection of Saint Denis, but the French monarchy was not able to present a sainted king until the canonization of Louis IX in 1297. So Westminster Abbey was conceived as one of the most ambitious and ornate buildings of Christendom in its time, mixing elements from contemporary architecture in France with traditional English ones. In this way Westminster can be compared to Canterbury; indeed, it was surely conceived to outdo Canterbury and its saint, Thomas Becket (?1120–70), with his anti-royalist associations.[52]

The king envisaged the most luxurious fittings for his new abbey church, which came to a peak in the sanctuary and shrine area. This was especially achieved by the *opus sectile* mosaic work, which covers the floors of the sanctuary and the Confessor's Chapel, the shrine base and the tomb of Henry III. It was executed by a Cosmati workshop from Rome, dated by inscriptions to 1268 and 1279/80.[53] In choosing Cosmati work, Henry opted for the most precious decorative material internationally available, and brought to England the most advanced stylistic mode of Italy and the papal court.[54] Furthermore, this *romanitas* stressed the imperial aspirations of the English monarchy, especially the frequent employment of porphyry, the precious stone material reserved for imperial use in the Roman world, in the Westminster mosaics, which enhance the role played by the sanctuary during the coronation ritual of the English kings.[55] Adorning the high altar, the Westminster Retable was linked to the overall concept of the Cosmati work by the painted imitation of red porphyry on its reverse side, the application of classicizing cameos, and the complex gilded frames with inlaid coloured glass, enamels and gemstones (see Binski, pp.74-5). But the style of its paintings is firmly rooted in the Anglo-French court culture of the second half of the thirteenth century.[56]

This high-level, sophisticated culture connected the princely courts of Western Europe in the High and Late Middle Ages, bound by common aristocratic norms and values of Christianity and chivalry. These courts have recently no longer been defined as dominated by French superiority, but rather as 'cosmopolitan, multilingual places', with a complex social and cultural intercourse, despite the wars of the period.[57] Books, particularly psalters and apocalypses (see Morgan, pp.116-7), gold-smiths' work and other luxury goods were frequently exchanged between the courts of England, France and the Low Countries, especially on the occasion of dynastic marriages. For example, when Richard II married his second wife Isabelle (1389-1409), daughter of the French king Charles VI (1380-1422), in 1396, Flemish tapestries were exchanged against English horses and hunting equipment, while Charles VI commissioned the *Epistre au roi Richart* by Phillipe de Mézières as a gift for the English king (BL Royal MS 20 B.VI). The frontispiece shows the English and French crowns side by side with the Crown of Thorns, possibly alluding to the project of a common Anglo-French crusade.[58]

The Craftsmen's Exchange: Tracery and Vault Designs

Craftsmen seem to have moved frequently between Britain and the Continent in the High and Late Middle Ages. To some extent, this was encouraged by trade and the growth of towns as trading places. English illuminators worked in Paris, and a large number of Low Countries or German

illuminators or goldsmiths are documented in London and York (see Lindley, pp.163–4).[59]

Continental masons were aware of innovations in English tracery and vault design. After the introduction of bar tracery and French Rayonnant micro-architectonic forms at Westminster, English Decorated architecture of the second half of the thirteenth and early fourteenth centuries excelled in an unparalleled creativity, leading to unusual spatial experiments, as in the octagon at Ely (see Lindley, p.157) and the choir at Wells Cathedral, as well as a large variety of tracery designs filled with flowing forms. The figurative vault was developed, ranging from star patterns enriched with tierceron ribs as in the Lincoln nave (see Coldstream, p.72, fig.34) to closely knit rib nets applied to tunnel vaults, which extinguish the bay divisions.[60] These English innovations had an impact on Continental architecture from the early fourteenth century onwards, initially in the areas around the Baltic Sea. English tierceron vaults seem to have triggered the experiments with star vaults composed of triradials in the 1310–20s at Lübeck (St Marien, Briefkapelle, c.1310) or in the dominions of the Teutonic Knights in Prussia (for example, Krone a.d. Brahe Koronowo, 1315; Thorn/Toruń, St James, c.1320).[61] The transmission of these new ideas was probably facilitated by the connections of the Cistercians and the Hanseatic League of merchants. The exchange presumably worked via architectural drawings.[62] The idea of a net vault covering a unified vault surface by a system of parallel and intersecting ribs, as executed in the new choir of Wells Cathedral c.1330–40 (fig.28), presumably induced Peter Parler to design one of the earliest net vaults of this type in Continental architecture in the choir of Prague Cathedral, 1356–85.[63]

The Import and Export of Art Objects

The Hundred Years War between England and France (1337–1453) led to a growing separation of England from the French cultural sphere and to a more acute feeling of difference between English and French identities.[64] Scholars have long debated whether an emerging English national consciousness was expressed in English late medieval architecture.[65] At Gloucester Abbey, the burial place of the recently murdered King Edward II (1307–27),

a new system of unified church interior was created from c.1331 onwards, originating in the French Rayonnant ideas of curtain tracery and glazed triforium design. This system, consisting of the multiplication of flexible and adaptable rectangular tracery panels, soon dominated English church architecture of all building types well into the sixteenth century.[66] The rise of this so-called Perpendicular style can be paralleled to the development of English as the dominating vernacular language from the mid-fourteenth century onwards.

This image of growing English separation from the Continent has to be modified, however, by other kinds of international contacts, especially with the Low Countries, which were of the greatest importance for English and Scottish trade connections.[67] The wool production of the British Isles was closely interlocked with the great cloth-manufacturing towns of Flanders and Brabant. Trade and merchants were the decisive factor for artistic exchange in the later Middle Ages, which resulted in art objects such as illuminated (later printed) books, engravings, tapestries, sculptures or paintings being imported into Britain (see Goodall, p.128). The famous Netherlandish and Flemish painters of their day worked for English, Welsh or Scottish patrons.[68] Hans Memling (c.1430/40–94), for example, born at Seligenstadt near Frankfurt am Main, painted a triptych at Bruges for the widely travelled Welshman Sir John Donne of Kidwelly in 1478 (National Gallery, London), who also commissioned a Book of Hours by Simon Marmion of Valenciennes and other illuminators in the southern Netherlands (Louvain-la-Neuve, Université catholique, MS A.2, c.1480).[69] Hugo van der Goes (d.1482) was commissioned to make an altarpiece for the Collegiate Church of the Holy Trinity at Edinburgh showing portraits of the Scottish king James III (1460–88) and his queen (see Marshall, pp.78–9).[70] English specialist art products, like embroidery in silk and gold thread, the so-called *opus anglicanum*, and sculpted alabaster panels were exported, in turn, across the whole of Europe (see Riches, pp.76–7 and Staniland, pp.168–9).[71]

Trade also produced a connection between England and the Rhineland. From the eleventh century onwards merchants from Cologne settled in London and enjoyed special royal protection.[72] Artistic links between Rhenish or Westfalian and English painting in the fourteenth and early fifteenth centuries have been proposed.[73] The connection with the Rhineland is certainly also the background to the

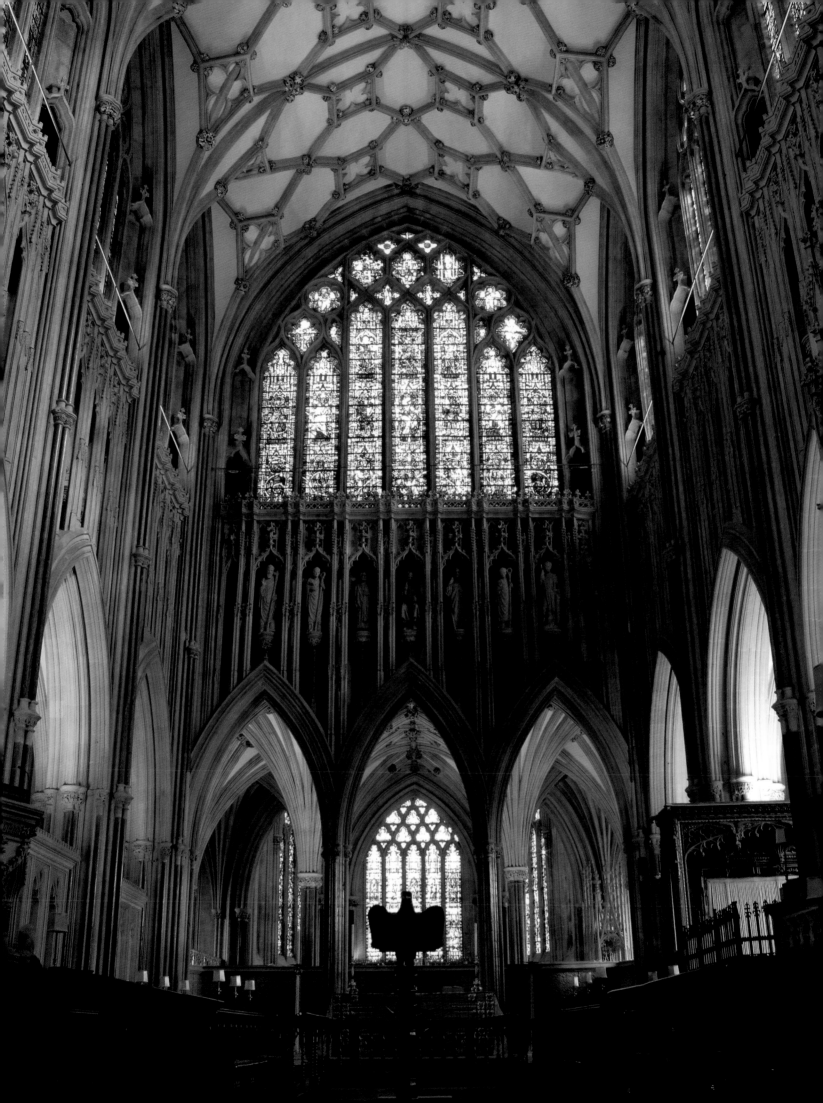

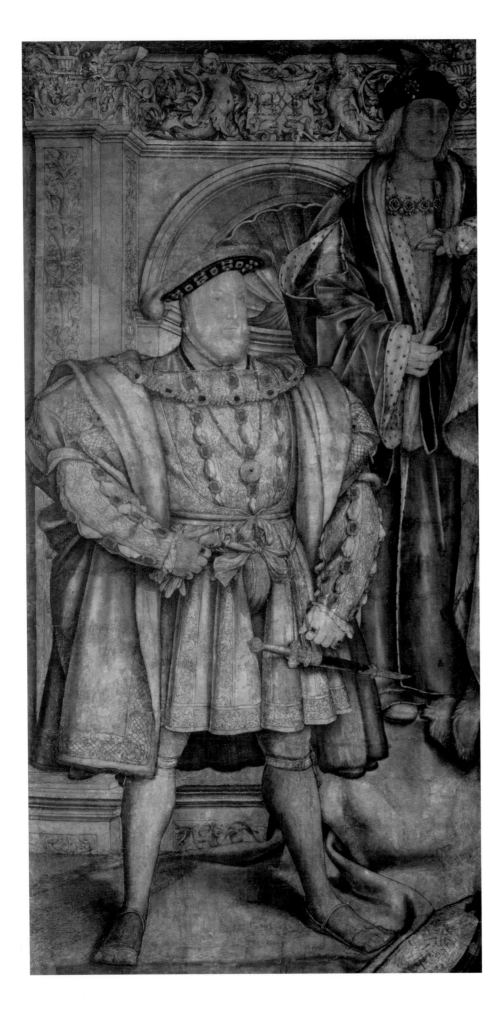

29 HANS HOLBEIN THE YOUNGER
Henry VII and Henry VIII (or
The Whitehall Cartoon), 1536–7
Ink and wash on paper
257.8 × 137.2 (101½ × 54)
National Portrait Gallery, London

episode of a 'crux horribilis', executed by a German sculptor named Thidemann, which the bishop of London ordered to be removed from the parish church of St Mildred, in the city, because it showed 'an erroneous sculpted image of the crucifixion' (*yconia crucifixi erronee sculpta*).[74] Probably this crucifix had the form of a fork-crucifix (*Gabelkruzifix*) or *crucifixus dolorosus*, which displayed the suffering of Christ at the Cross in an extreme way and thus provoked the emotional and spiritual identification of the viewer with the image. This new type of devotional image and practice developed in Germany in the later thirteenth century, especially in nunneries, and, despite the efforts of the Bishop of London, also spread over England, as testified by the visions of the anchorite (recluse) Julian of Norwich in 1373.[75]

Italian Renaissance and Northern Reformation

From the mid-fifteenth century onwards the most avant-garde movement of the Continent, the Italian Renaissance, found its way to England. Duke Humphrey of Gloucester, Henry VII (1485-1509) and Henry VIII (1509-47) promoted humanist scholarship and employed Italian artists at their courts.[76] Pietro Torrigiano (1472-1528) executed the royal tombs in Henry VII's Chapel at Westminster Abbey in 1511-12, and Nicholas Bellin of Modena (c.1490-1569) worked on the sculptural decoration of the royal palaces (see Lindley p.164).[77] The Scottish kings, on the other hand, who were politically, dynastically and economically closely linked with France and the Low Countries, chose French and Flemish masons for their building projects, as can be seen in the commissions by James V for Stirling Castle and Falkland Palace (see Fawcett, pp.137).[78]

Yet the predominant artist at Henry VIII's court was not Italian, but German, and belonged to the Northern European circle of humanists: Hans Holbein the Younger (1497/8-1543).[79] Holbein first came to England in 1526 at the behest of Erasmus of Rotterdam and Thomas More, returned to his home town Basel in 1528 and came back to London in 1531/2. He witnessed the Reformation, which linked England to the Protestant countries of Northern Europe.[80] Taking up the achievements of German and Netherlandish portrait painting, Holbein, king's painter

from c.1535, created the leading models for state and private portraiture in England. He combined a sharply observed realism with the invention of imposing poses in his images of Henry VIII (fig.29), aristocrats, merchants, and the king's possible Continental brides.[81]

As the Church ceased to be the major factor in artistic patronage, portraiture and other new image types (see Howard, pp.232-40) were to dominate British painting for a century. The independence of the Anglican Church furthered the separation of Britain from the Continent, but the artistic exchange did not cease. Royal and aristocratic patrons continued to call Continental artists into England, especially from the Low Countries. One of them was Anthony Van Dyck (1599-1641), who settled in England in 1632 and was to become the founding father of the flowering of British painting in the eighteenth and nineteenth centuries, explored in the next volumes of this series.

The Winchester Bible

CLAIRE DONOVAN

The Winchester Bible is among the most magnificent productions of twelfth-century monastic art in England. Now bound in four huge volumes it remains in the library at Winchester Cathedral, close to the monastic scriptorium where it was made between about 1160 and 1175 as one of the major projects of Henry of Blois, Bishop of Winchester between 1129 and his death in 1171.

The most obvious significance of the Winchester Bible to the history of British art lies in the quality of its illumination, and it is through images of the great initials that the Bible is best known. The detail opposite shows the initial letters 'B' from Psalm 1 with two parallel translations (fig.30). The 'B' for Beatus vir ('blessed is the man'; *left*) depicts the psalmist David rescuing his sheep from the bear and the lion, matched with the parallel imagery (*right*) of Christ delivering one of his human flock from an evil spirit and releasing the souls from torment in the Harrowing of Hell.

However, for the monks of the Cathedral Priory of St Swithun, and to Bishop Henry, this bible carried many layers of significance. The new cathedral of St Swithun in Winchester was consecrated in 1093, but building and decoration continued and Bishop Henry contributed substantially to the cathedral's possessions: vestments, candlesticks, jewels, jewelled book bindings and the Tournai marble font. The fittings of the cathedral included manuscripts for the monastic library and for the performance of the liturgy. Essential to a monastic cathedral in the twelfth century was a large-scale and richly decorated Bible. Surviving Bibles from Lincoln, Rochester, Bury St Edmunds, Lambeth, Durham and Canterbury all share these characteristics. Two magnificent Bibles from Winchester survive: one in Oxford's Bodleian Library (Auct E. inf.1-2), and the Winchester Bible. Both are complete, from Genesis to Apocalypse, including prologues, letters and commentaries of St Jerome (c.340–420), and their corrected texts both display attention to biblical scholarship.

The Winchester Bible is uniquely ambitious in its illustration: biblical scholarship being as evident in the iconography as in the text. The preparation of the massive quantity of parchment – 468 folios, each of approximately 58 by 40 cm – demonstrates a meticulously designed, though ultimately unfinished, project. The layout is complete, including initial-shaped spaces even where no initial is drawn. The writing is complete, the work of a single scribe, apart from corrections. Each new section is marked by a historiated initial, large in scale and sumptuously painted in rich pigments, with laid gold leaf, burnished, tooled and engraved (fig.30). Unfinished initials show the complex preparatory drawing – pictorial imagery and elaborate decoration defined in graphite, sometimes overdrawn in pen.

The design and painting is identifiably the work of six separate artists of the highest calibre, whose stylistic origins include a local Winchester-style illuminator (named the Master of the Leaping Figures), together with artists associated with other stylistic traditions. They worked in a complex collaboration, with each contributing designs and underdrawing, and each also painting and gilding. While sometimes the draughtsman is the same as the painter, in other cases the identifiable design of one artist is overpainted by another, establishing an intricate and intriguing matrix of artistic relationships. The Leaping Figures' Master is evidently the main designer, as he works in all parts of the manuscript: the final volume contains seventeen elaborate but unfinished designs by him for the books of the New Testament – Gospels and Epistles, often found with iconographic instructions in the margin. Elsewhere he completes both design and painting, and elsewhere again his design is overpainted by another. The complexity of the collaboration between scribe, designer and artists is exceptional. The diverse stylistic origins of these artists suggest that they, like other examples of Bishop Henry's eclectic patronage, were brought to Winchester specifically for their artistic prowess, to contribute to this great work.

Evidence of full-page pictorial prefaces at significant openings indicates a change to the original illustrative scheme, but a change only partly achieved: some leaves were subsequently removed, others remain, but as blanks. Only three pages show what was intended: the preface to the Book of Kings (removed, and now at the Pierpont Morgan Library in New York) and drawn iconographic prefaces before both the Books of Judith and Maccabees. In each, three registers of narrative imagery were designed and meticulously drawn by the Apocrypha Master, whose elegant, linear style suggests he was trained at St Albans. Only the Morgan Leaf was overpainted, but in a very different style. The Morgan Master's style shows knowledge of contemporary work in Rome and Sicily, and his overpainting calmed and clarified the draughtsman's crowded, emphatic design.

The identification of the original location of the Morgan Leaf within the Winchester Bible confirms the scale of this enterprise: its iconographic ambition, including the significance of narrative iconography as found in contemporary wall painting; the intimate collaboration between draughtsman and painter, notwithstanding such diverse stylistic traditions; and the connections between text and iconography, and between scribe and designer.

FURTHER READING

C. Donovan, 'The Winchester Bible', in *Winchester Cathedral 900 Years*, ed. J. Crook, Winchester 1993.
C. Donovan, *The Winchester Bible*, Winchester, London and Toronto 1993.
C.M. Kauffmann, *Biblical Imagery in Medieval England, 700–1550*, London and Turnhout 2003, chap.3.
W. Oakeshott, *The Artists of the Winchester Bible*, London 1945.
W. Oakeshott, *The Two Winchester Bibles*, Oxford 1981.

30 Illuminated initial letters for Psalm 1, detail from the Winchester Bible, c.1160-75
On parchment, approx. 58.3 × 39.6 (23 × 15½)
Winchester Cathedral Library (MS 17, f.218)

Sed in lege dñi uolūtas ei · & in lege eius medita

bitur die ac noctt. Tempore suo.

Sed in lege dñi uolūtas eius · & in lege eius medi

tabitur die ac nocte. Tpore suo.

Canterbury Cathedral and the Cult of Thomas Becket

NICOLA COLDSTREAM

The Cathedral of Christ Church Canterbury is an ancient foundation, the seat of the Christian mission that arrived from Rome in 597 (fig.31). Its archbishops were titled Primate of All England, to differentiate the see from the archdiocese of York and the diocese of London, which in the early days was a rival location for the archbishopric. Canterbury played a significant role in the development of art and architecture in the archdiocese, effectively southern England.

Christ Church was a cathedral priory, a Benedictine abbey led by a prior, with the palace of the archbishop (the nominal abbot) adjacent. Monastic churches, as distinct from secular cathedrals, placed great emphasis on relics and shrines, as at Durham (see Plant, pp.48–9) and for centuries the monks of Christ Church revered and preserved the memories of their archbishops, who were entombed in the church. As the building expanded from its Anglo-Saxon form to a monumental Norman church by the early twelfth century, the sacred remains were reburied in carefully recorded locations, with the reforming Archbishops Dunstan (959–88) and Ælfheah (1006–12) accorded important positions on either side of the high altar.

The authority, image and influence of Canterbury were enhanced as a consequence of the murder of Archbishop Thomas Becket in 1170, and his rapid canonization in 1173. Canterbury became famous throughout Catholic Christendom, a symbol of the conflict between the secular and ecclesiastical powers that had provoked the killing. What had been an essentially private, monastic cult of the archbishops was refocused as the public cult of a highly popular saint. Not only King Henry II, whose men had carried out the murder, but other rulers felt obliged to expiate their sins with visits and gifts to the shrine. Pilgrimage to Canterbury was almost as obligatory as pilgrimage to the great Christian sites at Rome, Jerusalem and Santiago de Compostela. Even before the dissolution of the abbey in 1540, when the cult had long been in relative decline, Henry VIII was sufficiently apprehensive of the saint's lingering force for dissent to order all traces of him to be obliterated.

Owing to a fire that half-destroyed the Norman choir in 1174, suspiciously soon after Becket's canonization, the choir and transepts of the cathedral were rebuilt within the shell of its predecessor, but on a grander scale that

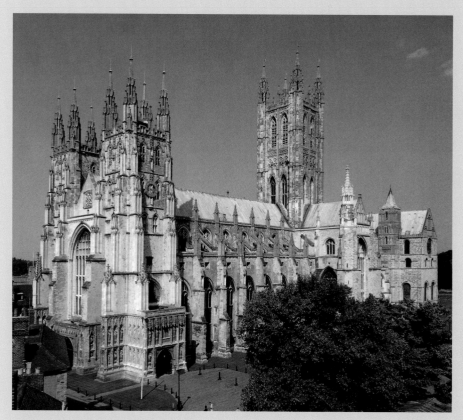

31 Canterbury Cathedral from the south-west

included the apsidal Trinity Chapel projecting east of the high altar, and the rotunda beyond it known as the Corona, where Becket's severed scalp was displayed. The Trinity Chapel lies open to the choir (fig.32). Within it stood Becket's reliquary shrine positioned directly over the site of his tomb in the crypt. This arrangement replicated that at the French royal abbey of Saint-Denis.

Pilgrims circulated in the aisles of the Trinity Chapel, at the climax of a tour that began in the north-west transept at the spot where Becket was murdered, and included the crypt and the Corona. The rising levels from the nave and main transepts, up to the choir and up again to the Trinity Chapel, were carefully designed to ensure the greatest dramatic impact and emotional effect on the pilgrims. The Trinity Chapel brought together a number of features that already existed in settings for shrines, and used them to great effect.

The reliquary was set on a high base to make it visible to the priests at the high altar, and inaccessible to thieves. Its elaborate cover was

raised only at certain feasts, which added to the mystery of the relics themselves. Pilgrims could approach the shrine to pray for intercession or a cure by creeping up steps to the base. The whole was surrounded by colour: the dark Purbeck stone used for contrast in the twin columns of the arcade, the triforium arches and the vaulting shafts; the stained glass windows depicting the miracles of the saint; and the marble mosaic floor in front of the shrine base. This richly coloured, precious setting was complete when the young King Henry III attended the translation of the relics in 1220, and it is likely that the subsequent arrangements for St Edward at Westminster were a response to the great theatrical show at Canterbury (see Coldstream, pp.106–7).

Canterbury, by adopting elements of the contemporary style of Early Gothic in France, helped to transform architecture in Britain. Its eastern rotunda may have influenced the late-twelfth-century eastern termination of Lincoln Cathedral (see Coldstream, pp.72–3). As the cult of Becket spread through Christendom it gave

32 Trinity Chapel, Canterbury Cathedral, looking west, with candle in foreground that marks the site of the destroyed shrine of Thomas Becket

rise to many works of art depicting the saint's life and miracles including enamelled metal reliquaries, ivories, manuscripts, wall paintings and stained glass. Above all, the setting of Becket's shrine set the standard for great shrines throughout Britain, and was the objective of Chaucer's pilgrims in *The Canterbury Tales*.

FURTHER READING

P. Binski, *Becket's Crown: Art and Imagination in Gothic England*, New Haven and London 2004, chap.1.
P. Draper, *The Formation of English Gothic: Architecture and Identity*, New Haven and London 2006, chap.1.
Gervase of Canterbury, 'On the burning and repair of Canterbury Cathedral', in R. Willis, *The Architectural History of Canterbury Cathedral*, London 1845, pp.32–62.

Lincoln Cathedral

NICOLA COLDSTREAM

Lincoln Cathedral (figs.33 and 35) is one of the few medieval buildings in Britain to have persuaded generations of scholars that, rather than reflecting the influence of European Gothic architecture, it inspired buildings on the Continent.

The diocese of Lincoln, which covered a huge area between the River Humber and the River Thames, was established only after the Norman Conquest. The cathedral buildings thus had no Anglo-Saxon forebears. This absence of an older, honoured structure may partly explain the freedom with which successive builders – bishops and master masons – looked southward, to Canterbury Cathedral and, later, Westminster Abbey, for ideas, while supporting innovation in design and form. With no Anglo-Saxon saint to revere, Lincoln sought successively to canonize two of its bishops, Remigius and Hugh of Avallon (1186–1200), each to be enshrined behind the high altars of choir extensions that were architecturally or decoratively adventurous.

Lincoln's architects tried out so many new ideas that the building is in no sense a mere imitator of its models. The west window of the nave, remodelled in the fifteenth century, has early thirteenth-century mouldings that imply the existence of window tracery, which would have been among the first examples in Britain; and the great east window of the Angel Choir, set into a flat, clifflike wall, used tracery forms derived from Westminster to produce the first of the elaborate traceried windows that define the interior views of later medieval great churches. The extensive imagery of angels in

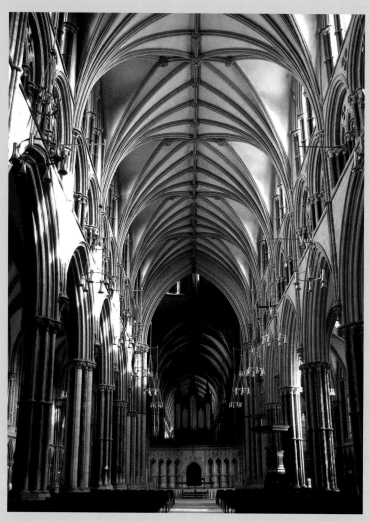

33 The nave of Lincoln Cathedral, c.1220–35, looking east

the eponymous Angel Choir (begun 1256) adopted the notion of monumental relief sculpture that had been developed at Westminster, but the programme was more elaborate and the symbolism more complex.

The influence of Lincoln outside Britain has been found in Norway and the Baltic. East Anglian ports, to which Lincoln had easy access, traded with both Scandinavia (the Norwegian settlement at Grimsby was not far from Lincoln) and the Hanseatic towns of the Baltic, including such leading Hanseatic centres as Lübeck. In addition, there were regular visits between Britain and Scandinavia by churchmen, and a steady supply of both craftsmen and artefacts arrived in Scandinavia from England.

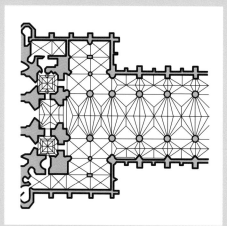
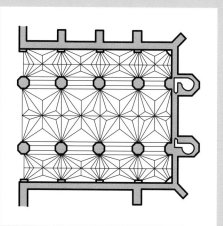

34 Diagrams of rib vaulting in the nave of Lincoln Cathedral (*left*) and in the choir of Pelplin Abbey (*right*)

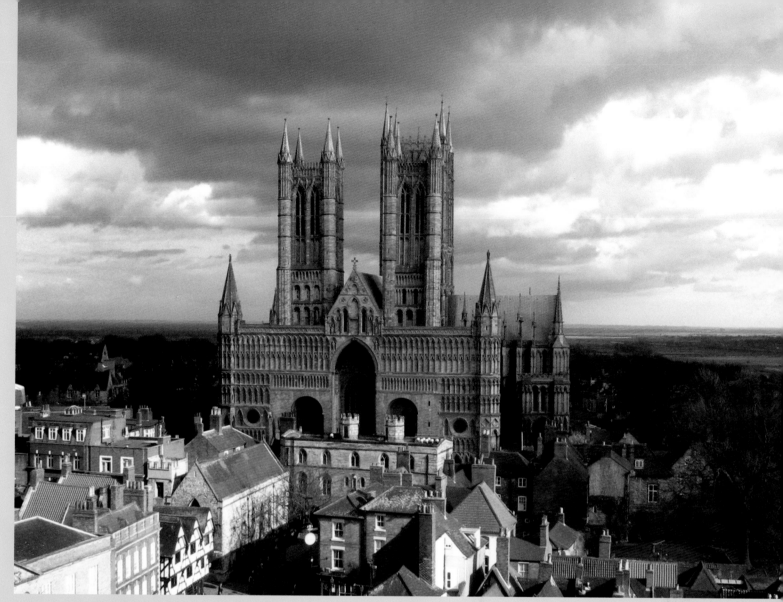

35 West front of Lincoln Cathedral

In Norway Lincoln's strongest relationship was with Nidaros Cathedral in Trondheim. However, the eastern octagon at Trondheim, which housed the shrine of St Olav, may owe less to Lincoln than to the Corona at Canterbury: Archbishop Eystein Erlendssohn, who began the octagon, had seen Canterbury, while the curious octagonal eastern termination of St Hugh's choir at Lincoln was begun only in 1192, after Eystein's death. The structure at Lincoln, perhaps conceived in the unfulfilled hope of receiving the shrine of Remigius, had a similar symbolic resonance, and was probably also based directly on Canterbury. Yet the carved foliage and other details of the early thirteenth-century phases of the Trondheim octagon are evidently the work of sculptors from Lincoln Cathedral and other churches in the region. The chancel, nave and west front of Nidaros Cathedral were all replaced in the course of the thirteenth century, drawing designs from each successive phase of the contemporary works at Lincoln.

Although the extent of Lincoln's influence in the Baltic region is disputed, its existence is accepted. There Lincoln inspired not symbolic forms or decorative sculpture, but plans, vault structures and patterns of vault ribs (fig.34). Two buildings – Pelplin Abbey (Poland; fig.34 *right*) and St Mary's Lübeck (Germany) – show the direct influence of Lincoln in a manner that implies personal knowledge on the part of the master mason, since it is technical as well as aesthetic. The non-structural tierceron ribs introduced in the vault of St Hugh's choir of Lincoln and continued in another design in the nave, released the vault from the governing principle of the arch. Once built, the curvature of a vault web, which supports itself on the same principle as an eggshell, makes it independent of the ribs; the masons' realization of this allowed them to lay ribs in patterns on the underside of a shallower curve.

In the fourteenth-century abbey church of Pelplin the patterns of the choir-aisle vaults imitate those of the Lincoln nave so closely that they even adopt the use of a continuous ridge rib on the north side and an interrupted one on the south. The Briefkapelle, built c.1310 off the west end of the nave at Lübeck, adopts several forms from the nave chapels at Lincoln.

Lincoln did not provide the sole impetus for designs of patterned vaults, but the genius of its master masons supplied the understanding from which designs were to develop in future both in Britain and in Continental Europe.

FURTHER READING

P. Binski, *Becket's Crown: Art and Imagination in Gothic England, 1170–1300*, New Haven and London 2004, chap.3.

P. Draper, *The Formation of English Gothic: Architecture and Identity*, New Haven and London 2006, chap.5.

T.A. Heslop, 'The Iconography of the Angel Choir at Lincoln Cathedral', in *Medieval Architecture and its Intellectual Context: Studies in Honour of Peter Kidson*, ed. E. Fernie and P. Crossley, London 1990, pp.151–8.

The Westminster Retable

PAUL BINSKI

Thirteenth-century Anglo-French court culture is well represented by the survival of outstanding manuscript illumination, such as the Psalter of St Louis commissioned by Louis IX, and the Douce Apocalypse, owned by Eleanor of Castile and Edward I, both c.1270. But with the exception of the Westminster Retable (fig.37), no altar panel paintings survive from this inventive milieu.

The Westminster Retable, though badly damaged, is generally acknowledged to be the most technically astonishing panel painting of its date to survive in Northern Europe. It was probably commissioned for the high altar of Westminster Abbey, rebuilt in a hybrid Anglo-French Gothic style in 1245–72 by King Henry III, and it was quite possibly executed towards the end of his reign. The size of the panel (96 by 334 cm), the central position of Christ and the inclusion of the graceful figure of St Peter pointing to his keys in the position of honour on the viewer's left, are all compatible with a position over the high altar dedicated to Peter (fig.36). Unfortunately, though the panel seems to have come through the Dissolution of the Monasteries and English religious upheavals of the sixteenth and seventeenth centuries relatively unscathed, all the imagery on the right-hand side was struck out in the eighteenth century, when the retable was reused as part of the cupboard containing the abbey's royal funeral effigies; it was not formally recognized as being an important work of art in its own right until the 1830s. But we know from early descriptions of it that the lost

scenes included St Paul, in the position opposite St Peter, and scenes from the Gospels like those surviving in fragments on the left. The reverse consists of simple battening covered in paint in imitation of porphyry.

Artistically the retable is extraordinary. It consists of elaborate oak joinery, dividing the front into a series of five Gothic tabernacles and eight star-shaped medallions. The frame was gilded and set with decorative coloured glass imported from the Paris region; in addition, there are remains of hundreds of small painted enamels, paste cameos and glass gemstones which create the effect of bejewelled metalwork. The artistic taste combines ideas drawn from thirteenth-century French metalwork and stone liturgical objects, such as the glass-inlaid retables that survive at the French royal abbey of Saint-Denis. Similar techniques were used in the interior of the Sainte-Chapelle, in Paris, which Henry III is known to have admired. The paintings were executed in a very refined linseed-oil technique on gesso. The inclusion of imitation gilt Kufic lettering on the hems of the robes of the figures, and the eight-pointed medallions, also shows an interest in Islamic art.

The style of the painting is inconceivable without knowledge of French painting and sculpture, and attests to the huge impact of Paris and Reims especially. It cannot have been made without some French expertise being involved. Yet the surviving painting commissions that most resemble the retable were all English: the Douce Apocalypse and the murals formerly

36 Detail of St Peter

in the Painted Chamber in Westminster Palace. Henry III and Edward I shared the same taste, employed the same artists, and admired a wide range of artistic styles. Small details prove that the retable was made at Westminster, and it uses oak probably felled in the royal forests at some point between the 1240s and 1260s.

The surviving images suggest precise thought about the abbey's high altar. It was dedicated to St Peter in the name of Christ, who stands in the centre panel as Saviour of the World, blessing and holding a tiny globe filled with life. In the tabernacles by him are the Virgin Mary and St John; normally these saints accompany Christ on the Cross, but since here they hold palms of triumph, the idea may be influenced by passages in the Book of Revelation concerning Christ's eternal triumph over worldly tribulation. Christ stands at the centre of a miniature portal composition, the gates of heaven that St Peter has opened to us. To either side, very unusually, were eight miracles of Christ, of which the Raising of Jairus's Daughter, the Healing of the Blind Man and the Feeding of the Five Thousand survive, subtly depicted in a brilliant technique (fig.38). No other European altarpiece gives such prominence to Christ's miracles; but then no other surviving painted altarpiece of this stature was located immediately in front of a great shrine, that of St Edward the Confessor (d.1066), himself a worker of miracles. The altarpiece was conceived to show that Christ was the true source of all miraculous works in the world.

38 Detail of Christ Feeding the Five Thousand

FURTHER READING

P. Binski, 'What was the Westminster Retable?', *Journal of the British Archaeological Association*, 3rd series, vol.140, 1987, pp.152–74.

P. Binski, *Westminster Abbey and the Plantagenets: Kingship and the Representation of Power 1200–1400*, New Haven and London 1995, pp.152–7.

E.W. Tristram, *English Medieval Wall Painting: The Thirteenth Century*, Oxford 1950, I, 127–48.

F. Wormald, 'Paintings in Westminster Abbey and Contemporary Paintings', *Proceedings of the British Academy*, vol.35, 1949, pp.161–76.

37 *left* The Westminster Retable, 1260s
Oil on oak 96 × 334 (37¾ × 131½)
Westminster Abbey, London

An Alabaster Altarpiece of St George

SAMANTHA RICHES

The creation of alabaster sculpture – in the form of relief panels as well as figures such as tomb effigies – was a significant aspect of late medieval artistic production in England. One important format was the arrangement of sculpted panels in a narrative sequence, which was primarily used within altarpieces to create a decorative screen (see Binski, pp.74–5 and Marshall, pp.78–9).

Virtually all alabaster panels now extant in Britain are isolated single pieces, and in nearly every case this is an inaccurate reflection of their original use for the vast majority would have formed part of a sequence. The only surviving multi-panelled alabaster altarpieces within Britain are the Swansea Altarpiece of around 1450–80 at the Victoria and Albert Museum, London (fig.39), which shows scenes of the life of the Virgin Mary, and an altarpiece of the Passion of Christ of around 1450–75 in the Castle Museum, Nottingham. Both are fine works, but their restrained subject matter and decorative detailing mean that they give only a partial insight into the creative abilities of English alabaster workers. It is only by looking abroad, along the trade routes of medieval England, that we are able to gain a fuller sense of the possibilities of the medium (see Lindley, p.162 and Howard, p.233).

St George (d. c.303) is best known today as the patron saint of England, a role that he seems to have been assigned in the Late Middle Ages, but his cult is much wider. Indeed, the two extant alabaster altarpieces that feature a narrative of the saint were probably created for foreign patrons, Norman and Danish. The Borbjerg altarpiece (fig.40), with its complex narrative of St George, is indicative of the popularity of English alabasterwork outside England but it also provides insights into contemporary understandings of this saint. The work was almost certainly created as the result of local patronage: there is a strong cult of St George in the western part of the Jutland peninsula around Borbjerg. Whilst it is possible that the work was sold ready-made by an itinerant trader, it is more likely that it was created for a specific commission. The figures display many of the hallmarks of English alabaster work of the mid- to late fifteenth century, such as elongated fingers, but the panels also indicate that the carver(s) – or designer(s) – were skilled at using the spatial possibilities of relief sculpture.

The altarpiece consists of five panels plus two terminal figures of saints. Comparison with the conventional narrative of St George indicates that at least two further subjects were present originally; the panels were dispersed during the Reformation, and it is probably at this time that the missing elements were lost. All the panels except the central one are topped with a separate canopy piece of alabaster, cut to resemble gothic tracery; it is likely that the central subject was also canopied. The panels would have originally been displayed in a purpose-built wooden frame with a solid back, shaped as an inverted 'T' to accommodate the height of the central panel. The frame doubled as a protective travelling case for the shipment from England; in common with most surviving alabasters the original frame is lost, but it was probably inscribed with explanatory titles for each subject.

The narrative subjects are all drawn from established medieval understandings of St George, especially as an *imitatio Christi* and the champion of the Virgin. They are concerned with the trial, sufferings and miracles of the martyr (scenes 1–3), his resurrection and arming by the Virgin Mary and angels (scene 4), and a battle with a heathen enemy (scene 5). The absence of a scene of dragon slaying and the rescue of the princess may look odd to modern eyes, but St George the dragon slayer does appear, paired with St Michael, in the form of a terminal saint so the sequence could be deemed complete. Terminal figures of saints are a conventional aspect of alabaster altarpieces.

Presumably created to be set upon an altar dedicated to St George, this work was almost certainly intended to encourage discussion of the example of his life as well as devotional contemplation. The detailing of elements such

39 The Swansea Altarpiece, English
(probably Nottinghamshire), c.1450–80
Alabaster with polychromy, in oak case
83 × 216 (32⅞ × 84)
Victoria and Albert Museum, London

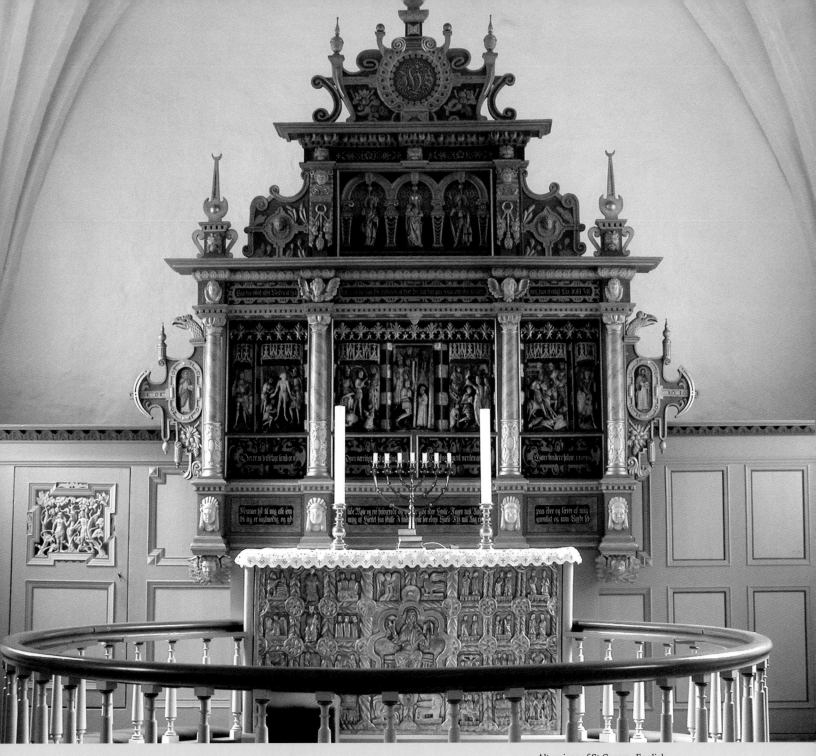

as the drapery, armour and crowns is very fine, with considerable use of undercutting (the saint's helm, for example, is entirely hollow). The carving has been enhanced by polychromy, a technique that was widely used to enhance alabaster sculpture, particularly relief panels, in order to make it more lifelike and easier to interpret when viewed from a distance. The overall effect is such that this altarpiece is harmonious yet legible, and its artistic merits are such that it rises above the 'naïve' quality often associated with English alabaster panels.

FURTHER READING

F. Beckett, 'Engelske Alabasttavler i Danmark', *Tidsskrift for Industri*, 1905, I, pp.19–48.

F. Cheetham, *English Medieval Alabasters, With a Catalogue of the Collection in the Victoria and Albert Museum*, Oxford 1984.

P. Nelson, 'English Alabaster Carvings in Iceland and Denmark', *Archaeological Journal*, vol.77, 1920, pp.192–206.

N. Ramsay, 'Alabaster', in *Medieval Industries, Craftsmen, Techniques, Products*, ed. J. Blair and N. Ramsay, London 1991, pp.29–40.

S. Riches, *St George: Hero, Martyr and Myth*, Stroud 2000 (revised ed. 2005).

40 Altarpiece of St George, English (probably Nottinghamshire), c.1480
Alabaster with polychromy, in 17th-century case
Panels: (including canopies)
approx. 51.8 × 27 (20⅜ × 10½);
terminal saints width 13.5 (5⅜)
Borbjerg Parish Church, Denmark

The Trinity Altarpiece

ROSALIND K. MARSHALL

The Trinity Altarpiece, attributed to the Flemish artist Hugo van der Goes (d.1482), demonstrates the international trade in luxury art for high-status patrons by the end of the Middle Ages (fig.41). It consists of two panels. The left bears the earliest authentic portrait of a Scottish king, James III. In crown and ermine-trimmed mantle, he kneels in prayer in an ecclesiastical interior. Behind him are a young boy, generally taken to be his son, the future James IV (1488–1513), and the imposing figure of St Andrew, Scotland's patron saint. The right panel shows James III's queen, Margaret of Denmark, likewise at prayer in ceremonial dress, accompanied by St George. Two very different paintings decorate the back of the altarpiece. On the reverse of the king's panel is the Holy Trinity. God is seen seated on a golden throne, clasping the broken body of Christ, over whose head hovers a dove, symbolizing the Holy Spirit. This image of intense physical suffering is in dramatic contrast to the scene on the back of the queen's panel, which conveys a great sense of peace and calm. There, Edward Bonkil, Provost of Edinburgh's Collegiate Church of the Holy Trinity, kneels with his hands folded in prayer, while behind him an angel plays a hymn to the Virgin on a golden organ.

How, then, did an artist who worked only in Flanders come to paint an altarpiece famous for its portraits of the King and Queen of Scots already had many connections with the Low Countries, cultural as well as commercial. Tapestries and beautifully illuminated Books of Hours from Bruges, religious paintings and altarpieces from Antwerp and bells from Mechelen were all imported by wealthy Scots, while the choir stalls of Melrose Abbey (Scottish Borders) had been carved by a carpenter in Bruges in the 1440s. Moreover, one of James III's favourite courtiers was a Bruges exile, Anselm Adornes. It was hardly surprising that this cultivated monarch turned to Flanders in a wish to embellish one of the great churches of his capital city.

James III's mother, Mary of Gueldres, had founded the Church of the Holy Trinity in the late 1450s, but she had died when her son was only twelve, leaving the building unfinished. Devoted to her memory, James continued her work and the assumption is that the altarpiece was commissioned for that church, either by him, through the agency of Provost Bonkil, or by Bonkil himself, who had his own Flemish connections. We have no details of the commission, which probably dates from the mid-1470s,

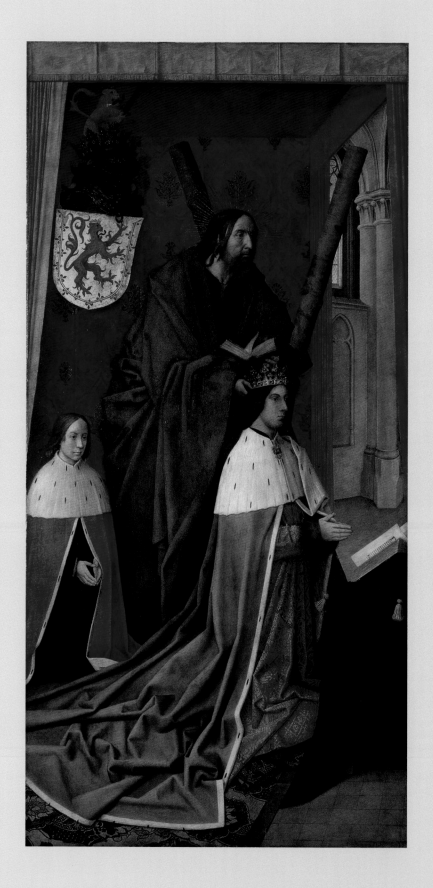

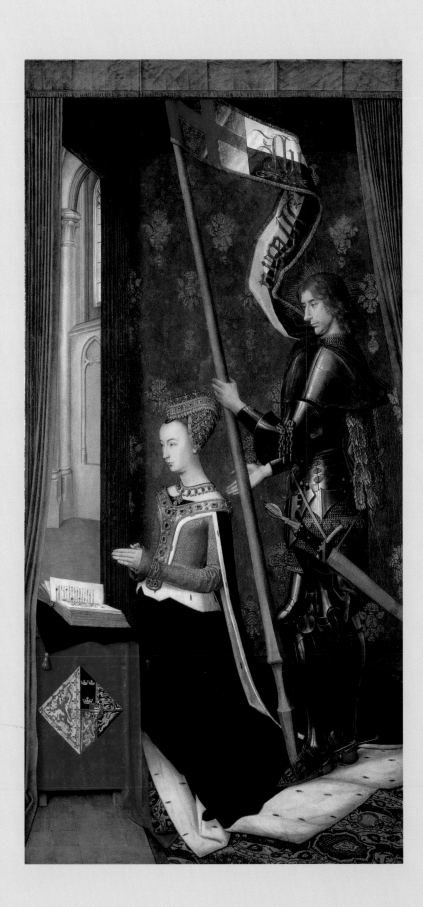

41 ATTRIBUTED TO HUGO VAN DER GOES
The Trinity Altarpiece, c.1478–9
Oil on panel
each panel 202 × 100.5 (79½ × 39½)
National Gallery of Scotland, Edinburgh
(on loan from the Royal Collection)

but it did present an obvious difficulty. Although Hugo van der Goes must have come face to face with Bonkil, who would have visited him in his studio in Ghent, he could never have met the Scottish king and queen. So how was he to achieve acceptable likenesses?

Some art historians, often examining only black and white photographs and observing the rubbed condition of the portrait heads, thought in the past that van der Goes had sent the panels unfinished, so that an artist working in Scotland could supply the features of the monarch and his wife. This theory was discarded when subsequent examination of x-rays and infra-red photographs revealed a rather different profile slightly to the right of the king's head, suggesting that it had been overpainted during his lifetime, presumably in Scotland, to make it look more like him. The queen's face has suffered clumsy modern retouching, spoiling the original sensitive drawing of the features. It would therefore seem that van der Goes did complete the panels, probably basing the royal figures on sketches supplied by Bonkil.

In 1974, when Colin Thompson and Lorne Campbell published a very detailed study of the Trinity Altarpiece, Thompson suggested that it had originally been a triptych, speculating that there had once been a central panel showing the Virgin and Child accompanied by angel musicians. If such a panel did exist, it must have been destroyed at the time of the Reformation, while the surviving panels escaped destruction because of their royal portraits. Whatever the truth of the matter, the altarpiece was taken to London in the early seventeenth century by James VI of Scotland (1567–1625), I of England, who gave it, appropriately, to his Roman Catholic Queen, Anne of Denmark. After more than two centuries in various royal palaces in the south, it was moved to Holyroodhouse in 1857, and since 1931 has been on loan to the National Gallery of Scotland.

FURTHER READING

D. Ditchburn, *Scotland and Europe: The Medieval Kingdom and its Contacts with Christendom c.1215–1545*, 1, *Religion, Culture and Commerce*, East Linton 2001.

N. Macdougall, *James III: A Political Study*, Edinburgh 1982.

R.K. Marshall, *Scottish Queens 1034–1714*, East Linton 2003.

C. Thompson and L. Campbell, *Hugo van der Goes and the Trinity Panels in Edinburgh*, National Galleries of Scotland 1974.

3 The Patronage of the Church and its Purposes

JULIAN LUXFORD

Introduction

In 597 the papal emissary and evangelist Augustine, later St Augustine of Canterbury (d.604), landed in the Isle of Thanet in Kent. Within the week the region's king, Ethelbert (c.560–616), arrived to learn about the new religion that Augustine had brought from Rome. Bede (673/4–735), the historian who describes their meeting, says that the saint and his companions approached the king carrying an image of Jesus Christ depicted on a board. Later, when granted land in Canterbury on which to build a monastery, they bore the same image aloft into the city, parading it before the local inhabitants and praising God aloud as they did so.[1] Roman Catholicism, which was the basis of post-Antique Christianity in Britain for almost a millennium (notwithstanding the somewhat earlier establishment of a Celtic monastery on Iona in the inner Hebrides), thus began with the public display of a panel painting.[2] This painting was no mere accoutrement, and its exhibition was not incidental. Rather, it performed a range of functions vital to the success of Augustine's apostolic mission. Brandished like a protective shield and elevated like a victor's trophy, it was also intended to help convert a pagan king and his subjects, bolster the missionaries' *esprit de corps*, confess and honour God, embellish a basic liturgy and provide a symbolic, material and perhaps aesthetic link with far-off Rome. It expressed a range of aspirations and responded to a variety of experience, simultaneously advertising, codifying, unifying, strengthening, justifying, clarifying, consoling, beautifying, and, it was believed, providing access to salvation. In these respects it constituted the fountainhead of an artistic culture that grew progressively in scale and complexity until the Reformation of the mid-sixteenth century.

While the main purposes of St Augustine's image of Christ, and their mediation through its public display, are stated or implied by Bede, he says nothing of its patronage. Clearly, we can know quite a lot about the painting in ignorance of this. However, our grasp of its age, artistic characteristic and the interests and priorities underlying its manufacture, and by extension the history of art in general,

would be better if this information were ours. The study of art and architectural patronage enjoys increasing popularity for precisely this reason. Detailed analysis of the existing corpus of medieval art and architecture has revealed much of what can be known about the formal, material and iconographic aspects of its constituent works. Art historians have thus turned to patronage to extend and contextualize understanding of their discipline's object domain. In doing so, they have crossed a once distinct subject-divide between formalist art history on the one hand and socio-religious history on the other. The study of patronage has a foot in each camp. Despite some anxiety about disciplinary conflation,[3] most current researchers recognize the value of exploiting any evidence that can improve comprehension of medieval art and architecture, and patronage has thus become a core theme in academic art history. Few scholars, however, have treated it even-handedly. Most attempts at analysis – including a recent one taking a gender-specific tack – focus on the artistic practices of lay or clerical elites (e.g. kings, courts, bishops, aristocratic women), who were involved with large, sumptuous and prestigious projects.[4] This reductive approach invariably overlooks less elevated patrons and consequently disqualifies from consideration the overwhelming majority of known or inferable acts of patronage. Yet, as chronicles, inventories, wills, inscriptions and a host of other evidence demonstrate, medieval churches were products of contributions made by individuals at all levels of society, something that will be reflected in the coming pages.

There are two distinct ways in which medievalists define patronage. Most commonly, historians use the term to denote the patron–client relationship that existed between those in positions of power and their dependants or protégés. For art historians it refers essentially to the commission, financing and gifting of works of art and architecture or the materials (e.g. timber, stone) from which such works were made. It is often implied that patronage also includes general auspices exerted independently of physical or financial input, but this notion is set aside here because it cannot be consistently applied or even demonstrated: it is simply too intractable. Our

definition, though relatively straightforward, adumbrates an extremely complex phenomenon. For the sake of clarity this chapter will focus on some of its broader and more recognizable aspects, but it is worth remembering that at an individual level there were at least as many motives for patronage, as many functions for it to fulfil and as many contexts for display as there were works. Medieval Britain contained many thousands of consecrated buildings, each possessed of a unique art and architectural identity. This identity was, moreover, dynamic. Over time a church's structure and embellishment were replaced, updated and augmented according to the dictates of innovation, function, fashion and decorum. With certain exceptions such as the Lindisfarne Gospel book (c.698), which was made by those who first used it (see Lindley, p.145 and Hawkes, pp.198–9), practically all ecclesiastical art and architecture was the product of patronage, and every instance of commissioning, funding and donating was deeply culturally embedded.[5] While the circumstances surrounding the vast majority of acts of patronage are unknowable, the basic fact of this variety and multiplicity helps us to recognize the richness of the subject we are examining, and cautions against sweeping generalizations based on scanty documentary survivals and the detritus of medieval visual culture that have come down to us.

Historians often speak of 'the Church' in the Middle Ages as though it was a unity, but such reification is difficult to justify. While medieval writers occasionally use the term as a metaphor for Christian unanimity, the concept it encapsulates is never understood literally. Starkly put, the customs, perspectives, habits and even the theology – let alone the art and architectural environment – of a seventh-century monk living at the island monastery of Lindisfarne in Northumbria were very different to those of a fifteenth-century archbishop of Canterbury: although both belonged to 'the medieval Church', the two were worlds apart in all but a fundamental, biblically based devotion to God.[6] Yet, in spite of this, themes in the history of ecclesiastical patronage that run more or less consistently through the thousand years covered by this volume can be identified, and six of these are analysed here. Following a brief outline of the nature of existing evidence for patronage, we will examine the obligatory dimension of church building and embellishment, an aspect of the subject normally ignored but essential in any balanced survey. We then turn to the aesthetic, devotional, salva-

tional, corporate and political purposes of ecclesiastical patronage in that order. Isolating these purposive strands is not meant to imply that patronage was exercised for single reasons. On the contrary, multiple purposes can be identified for most acts of patronage, and the examples used to illustrate given points below could often serve to demonstrate others with equal clarity. Such isolation does, however, permit us to analyse major patronal concerns in a lucid, graspable way. So long as we acknowledge the rich cultural tapestry to which our strands belong we will not deceive ourselves that medieval patronage or its products were in any way simple.

Evidence and Interpretation

Knowledge of patronage comes chiefly from written sources, of which tens of thousands exist, mainly from the Late Middle Ages. Most relevant documents are in Latin, but French, Old English, Welsh and other vernaculars were also employed, and Middle English and Scots are common at the end of the period. Heraldry, too, can be informative, but is often imprecise to the point of deception.[7] Predominantly, the art and architectural patronage mentioned in surviving medieval texts concerns church projects as opposed to secular ones. This is substantially due to the literary prominence of medieval churchmen, who naturally prioritized matters affecting their profession, and also to the fact that the commonest and most informative late medieval sources, wills, were usually composed close to death, when the makers' minds were keenly focused on religion. Between c.600 and c.1250 the richest source is history writing. Thereafter, quotidian documentation – wills, accounts, visitation records, inventories and the like – survive in significant numbers and overtake a declining historiographic tradition in terms of usefulness. While such documentation is easily understood, history writing must be carefully interpreted. If rarely framed to deceive, it was nevertheless informed by priorities foreign to our own. The patronage data supplied by such influential authors as Bede, Orderic Vitalis, Henry of Huntingdon, John of Worcester and William of Malmesbury is endemic to perspectives shaped by personal responsibilities and experiences, contemporary politics, religious convictions, financial and social dependence, and a host of other

factors, of which simple ignorance was not the least influential. For example, the *Historiae ecclesiasticae* of Orderic Vitalis (1075–c.1142) states that Gunter, Abbot of Thorney in Cambridgeshire (1085–1112), 'built from its foundations a very beautiful [abbey] church and monastic buildings', whereas the author of the Crowland Abbey chronicle says that Gunter only began the church, which was finished 'at great expense' by his successor Robert (1113/14–1151).[8] Orderic wrote from Normandy, while Crowland is less than five miles from Thorney; local knowledge is presumably to be trusted here, and Abbot Robert given his due as an architectural patron.

Occasionally, medieval writers acknowledge the principles underlying their accounts of patronage. For instance, the major thirteenth-century Benedictine chronicler Matthew Paris (d.1259) notes that as a matter of respect (*ob reverentiam*) abbots are given credit for monastic art and architectural patronage performed during their administrations, whether or not they had a hand in it.[9] Here and elsewhere, observing decorum was more important than sticking strictly to facts that of themselves may not have been thought worth recording. That this point seems to have been generally accepted in the Middle Ages makes Matthew's explication of it seem surprising. In any case, it advocates cautious interpretation of other accounts of art and architectural benefaction by high-status individuals (bishops, lay aristocrats, princes, kings and queens, as well as abbots), and indicates some of the responsibilities involved in writing sound patronage history.

Just as written sources can be challenging to interpret, so also they incorporate a vocabulary that requires us to come to terms with the sophistication of medieval ideas about ecclesiastical patronage. The language of medieval art is analysed elsewhere in this volume by Jennifer O'Reilly (see pp.173–97), but it is worth pointing out here the most remarkable aspects of the vocabulary of patronage: its emphasis on aesthetics (which is discussed below) and the sheer variety of verbs it employs. In history writing, inventories and other retrospective texts these verbs typically occur in the third person singular or plural of the perfect tense, while in wills, letters and the like the first person (singular or plural, depending on the diplomatic formula in use) of the present tense is used. Between twenty and thirty Latin verbs for patronage occur frequently in existing sources. Among the commonest are 'to give' (*donare*), 'to bequeath' (*legare*), 'to grant'

(*concedere*), 'to make' (*facere*), 'to ornament' (*ornare*), 'to present' (*offere*), 'to endow' (*dotare*) and 'to bestow' *conferre*). 'To found' (*fundare*), 'to build' (*aedificare*), 'to repair' (*reparare*) and 'to improve' (*meliorare*) are used of architectural patronage in particular. Occasionally, a single source will use two, three or even four verbs of the same patron's largesse. For example, Robert Burnell, Bishop of Bath and Wells (1275–92), gave (*dedit*), bequeathed (*legavit*) and procured (*procuravit*) various works of art to and for the monks of Bath Cathedral Priory according to a passage in their general cartulary.[10] On the one hand, this range of verbs, together with the 'aesthetic' adjectives discussed below, demonstrates a simple rhetorical concern with terminological variety. On the other, it suggests sensitivities to different modes of patronage that deserve assessment in the light of medieval ideas about obligation, responsibility, gratitude, humility, pragmatism and a range of other factors relevant to both the donation and reception of art and architecture. While these topics cannot be explored here, it may be noted that they tend to suggest the inadequacy of our current, relatively limited critical construction of ecclesiastical patronage, which acknowledges the pragmatics of gift-giving but rarely engages with its metaphysics. That patronage of art and architecture could, for example, be inspired directly by God (e.g. Abingdon Abbey in Berkshire, late eleventh century), demonstrate moral probity (e.g. tenth-century English royal and episcopal patronage generally), realize biblical prophesy (e.g. Meaux Abbey in Yorkshire, mid-twelfth century) and manifest patriotism, popularism and connoisseurship at once enthusiastically secular and ardently spiritual (Benedict Biscop's seventh-century endeavours at Wearmouth and Jarrow in Northumbria) is hardly recognized today, despite the earnestness with which it is attested by medieval writers.[11]

Patronage and Obligation

The idealism of medieval Christianity ensured that church building and embellishment were conceptualized in high-minded terms as a matter of course. However, this does not disguise the fact that mundane obligation was one of the major agents of patronage. Naturally chroniclers made virtues of necessities, but a fundamental purpose of such

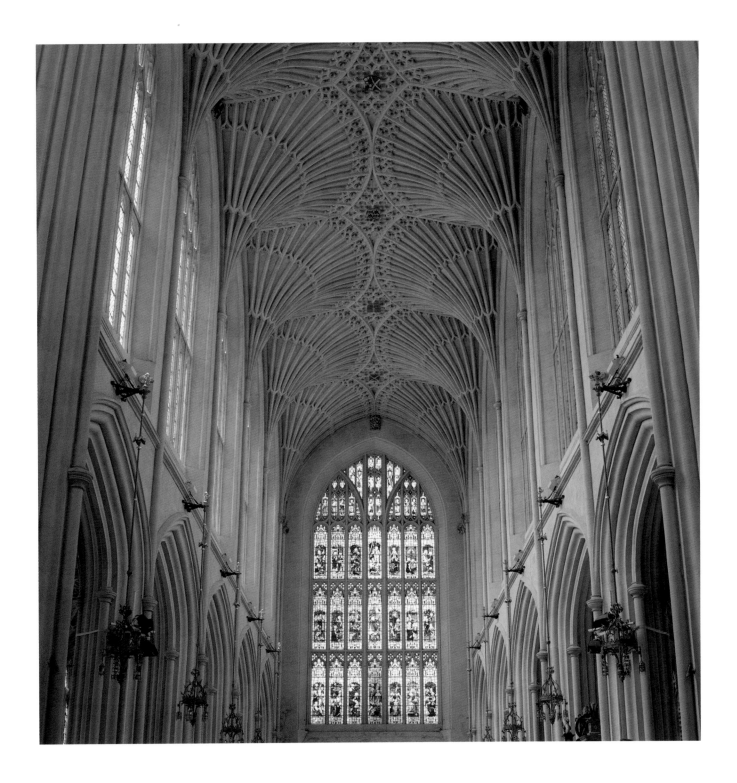

patronage was simply putting things to rights. This is clearly seen in the case of that common enemy of medieval buildings, fire. Most large and medium-sized churches in Britain appear to have been burned, often with their ancillary structures, at one time or another during the Middle Ages. Sometimes lightning struck, as at Barnwell in Cambridgeshire in 1287. At others, human agency was involved: the great East Anglian monasteries of Norwich (1272) and Bury St Edmunds (1327) stand out among victims of arson. Not infrequently, churches were caught up in general urban conflagrations, like that which

destroyed Peterborough and its abbey in 1116. As well as incinerating timber elements, artworks and furnishings, intense fires could destroy masonry, as at Canterbury Cathedral in 1174 (see Coldstream, p.70) and Milton Abbey in Dorset in 1309.[12] Natural disasters also caused major acts of patronage, the phenomena described as 'earth-quakes' prominent among them. The earthquake that 'split' Lincoln Cathedral apart in 1185 was the catalyst for one of the most remarkable of all British medieval campaigns of rebuilding and re-embellishment. Another toppled the campanile of Merton Abbey in Surrey 'and

many [other] buildings in England' in 1222, while a 'very horrible and terrible' quake 'threw down buildings and churches in many parts of England' in 1275.[13] High winds likewise wrought destruction, as did floods: that which swamped the Cistercian Abbey of Waverley in Surrey in 1233 rose almost 8 feet (2.4 metres) in height, while all churches in the lowlands of East Anglia, Lincolnshire and Somerset were constantly vulnerable to inundation by both rivers and the sea. Further to all of this, structural defects proved great wreckers: many so-called earthquakes will actually have been due to defective foundations. In 1207 the crossing-tower of Evesham Abbey fell eastwards, crushing the presbytery and, with the exception of three shrines, 'everything that was precious . . . [including] feretories, the high altar with its altarpiece, and other ornaments around it'. Ely Cathedral suffered a similar fate in 1322.[14] All destruction, regardless of its cause, necessitated intensive restorative patronage. There was no question of walking away from such challenges. These disasters were rationalized in terms of what the chronicler Gervase of Canterbury (c.1145–1210) called 'the occult but just judgement of God', and bore connotations of spiritual inadequacy.[15] In this light, patronage and the privations it occasioned were necessary acts of penance.

Dilapidation, royal decree and legal or moral responsibility also obligated widespread patronage. General wear and tear probably gave rise to more art and architectural expenditure than anything else. Oliver King, Bishop of Bath and Wells (1495–1503), was horrified to discover the cathedral priory church at Bath, as he put it (with characteristic late-medieval hyperbole), 'demolished to its very foundations' when visiting in 1499. He forced its monks to start rebuilding immediately, and used his influence at court to secure the finest architects available. The bishop promised a fan vault of such distinction that 'ther shal be noone so goodely neither in england nor in france', and the vault still distinguishes the boxy Perpendicular Gothic interior beneath it (fig.42). In other cases, as at Tavistock (Devon) in 1338 and 1348, visiting bishops ordered the repair or reconstruction of decaying cloisters and other conventual buildings, no doubt considering that, as symbols of the monastic vocation, these structures reflected the spiritual dispositions of their users.[16] Royal decree could be physically and psychologically devastating for an ecclesiastical institution. Edward I (1272–1307) ordered the total destruction of the Augustinian priory church of Leeds in Kent and

the Cistercian abbey at Aberconwy in Gwynedd for strategic reasons. The latter's rebuilding was paid for by the king, but Leeds's canons, who suffered further at the siege of the adjacent castle in 1341, were still begging for help with reconstruction decades later.[17] Possession of local church revenues often carried a duty to maintain chancels and liturgical ornaments. Indeed, this obligation passed into canon law in some regions during the thirteenth and early fourteenth centuries, clarifying if not straitjacketing what until then had been a murky domain of miscellaneous responsibilities.[18] A great many examples of such patronage are documented, among them the complete reconstruction of the chancel at Oxney in Northamptonshire, including 'an altarpiece with an image of the holy [Virgin] Mary', by Abbot Robert de Lindsey of Peterborough (1214–22).[19] As his surviving psalter suggests, Lindsey was an aesthetically sensitive patron, and the parishioners of Oxney perhaps gained more by his solicitude than other communities in analogous circumstances (fig.43).[20] However, it is clear from both documents and the size and splendour of chancels like that at Heckington in Lincolnshire, famous for its Decorated Gothic sculpture as well as its architecture, that large sums were often involved in fulfilment of parochial building obligations, and that patrons frequently went beyond the bare required minimum.[21]

Other obligations fulfilled through the commission, purchase and donation of art and architecture were contracted by vows and the papal imposition of *amendes honorable* in lieu of physical penance. Alfred, King of Wessex (871–99), vowed to build an abbey at Athelney in the Somerset fens, where he had hidden from the invading Danes and where St Cuthbert had assured him in a dream of eventual victory. The result was a church whose cross-in-square design was sufficiently exotic for William of Malmesbury (d. c.1142) to describe it. Similarly, William the Conqueror (1066–87) is said by post-Conquest tradition to have founded Battle Abbey in Sussex after vowing to do so if successful in his invasion of 1066, supposedly describing the institution as 'that which gave me my crown and by means of which my rule flourishes'. The prosperous abbey of Benedictine nuns at Wherwell in Hampshire was established by Queen Ælfthryth in penance for involvement in the murder of her stepson, King Edward (975–8). According to Gerald of Wales (c.1146–c.1223), King Henry II (1154–89) declined to undertake the three-year crusade imposed on him for precipitating the murder of Thomas Becket, and

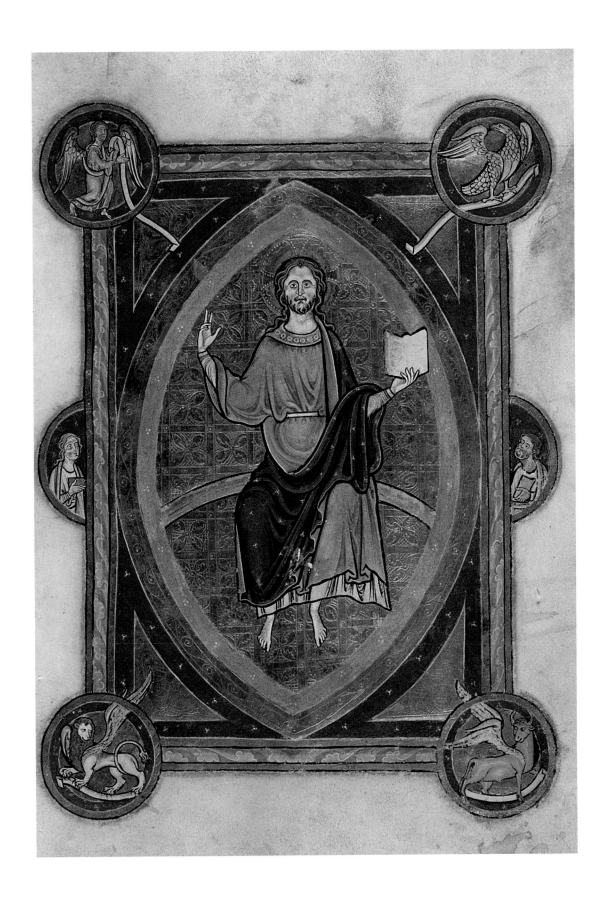

43 Christ in Majesty, Psalter of
Robert de Lindsey, before 1222
On parchment 24 × 15.5 (9½ × 6)
Society of Antiquaries, London
(MS 59, f.36r)

founded three monasteries instead, including the first British house of Carthusian monks at Witham in Somerset.[22] In the early fifteenth century a three-monastery penance was also imposed on Henry IV (1399-1413) for his role in the murder of Archbishop Scrope. This led to the foundation of the Carthusian priory of Sheen and the fashionable Brigittine abbey of Syon in Middlesex by his son Henry V (1413-22): the third monastery, of the Celestine order, was partially built but never completed. While an act of foundation did not necessarily entail actual patronage, and Henry II was in fact notoriously stingy with Witham, the expense to the Crown of setting up Sheen and Syon is well documented, as for that matter is the shipment of Caen stone to Battle by William I.[23] Given the grave catalysts for their institution, most products of such obligation are likely to have involved substantial expenditure by those responsible for them.

A smattering of additional examples will reinforce the vitality of obligation as a motive for patronage. Rulers of religious houses, and even lesser ecclesiastics, were often obliged to gift their institution an embroidered cope or chasuble on investiture or ordination. Anthony Bek, Bishop of Durham (1283-1311) and a notable late medieval patron of art, gave to his cathedral priory two hangings of red samite 'embroidered with the history of the nativity and Passion of Christ' and 'a vestment of the same cloth, embroidered with [images of] many martyrs in roundels' three days after his installation in 1284. Richard of Barking, Abbot of Westminster (1222-46), donated 'in the chapter house, in the presence of the entire convent, two green embroidered copes, and one [displaying] the old arms of England intermixed with bosses [nodis]' on the day of his investiture in 1237.[24] Barking, like other heads of monastic houses, had deeper patronage obligations than this. The Rule of St Benedict states unambiguously that care of subordinates is a duty whose performance superiors will answer for at the Last Judgement. For this reason among others, perhaps, the reconstruction of monastic dormitories and refectories regularly took precedence over renovation of conventual churches. This was the case at Bath, for example, where the refectory was rebuilt during John of Dunster's priorate (1461-81) at a cost of 1,000 marks (£666), while the church languished in the state deplored shortly afterwards by Bishop King.[25] Superiors also felt obliged by precedent to build. William of Malmesbury observed of pre-Conquest Abingdon that 'each abbot added something new, so as not to be thought inferior to his

predecessors', and Matthew Paris was later to lament that 'unfortunately, at almost all monasteries . . . each successive abbot initiates new building works . . . [while] practically ignoring maintenance of the works of his predecessors': patronage here emerges as an unambiguous expression of individuality.[26] Monarchs, too, were obliged by custom to donate gifts to the religious houses they visited. The indignation provoked by King John's present of a simple silk cloth to Bury St Edmunds in 1199 suggests that monks expected more of royal generosity on these occasions. However, such gifts appear to have been conventional, at least during the later Middle Ages. Edward I gave similar on visits to Worcester Cathedral Priory in 1293, 1295, 1300, and 1303, while Edward III (1327-77) donated a piece of cloth of gold on his first trip to Glastonbury Abbey in 1331.[27] Neither king gave anything else classifiable as art on these occasions. Finally, lay men and women as well as royalty and ecclesiastics clearly felt themselves under familial obligation to provide for the spiritual health of their kindred, and patronage of church art and architecture was a traditional way of doing this. Prominent among the reasons that Robert de Vere advanced for 'founding and constructing' the Cluniac priory of Monk's Horton in Kent in 1142 was the health of 'the souls of my ancestors and descendants'.[28] This form of obligation, which subsisted at all levels of society, relates closely to the salvational purpose of patronage discussed below.

The Aesthetic Purpose

Our impression of what constitutes quality in medieval art is historically rooted, but hard to align precisely with descriptions of buildings and their embellishments contained in contemporary writings. In most cases loss precludes comparison of texts and the objects that they mention, but the few survivals that there are, along with what may be called a standardized aesthetic mode of description, tend to show that works of widely differing quality were discussed in similar terms. Prominent adjectives of this mode include 'beautiful', 'glorious' and 'splendid' (*pulcher, praeclarus, decorus, gloriosus*), 'excellent' and 'best' (*nobilis, optimus*), 'wonderful' (*mirus*), 'lavish' and 'expensive' (*sumptuosus, pretiosus*), 'incomparable' (*incomparabilis*), 'fine' and 'delicate' (*subtilis*), 'pure' and

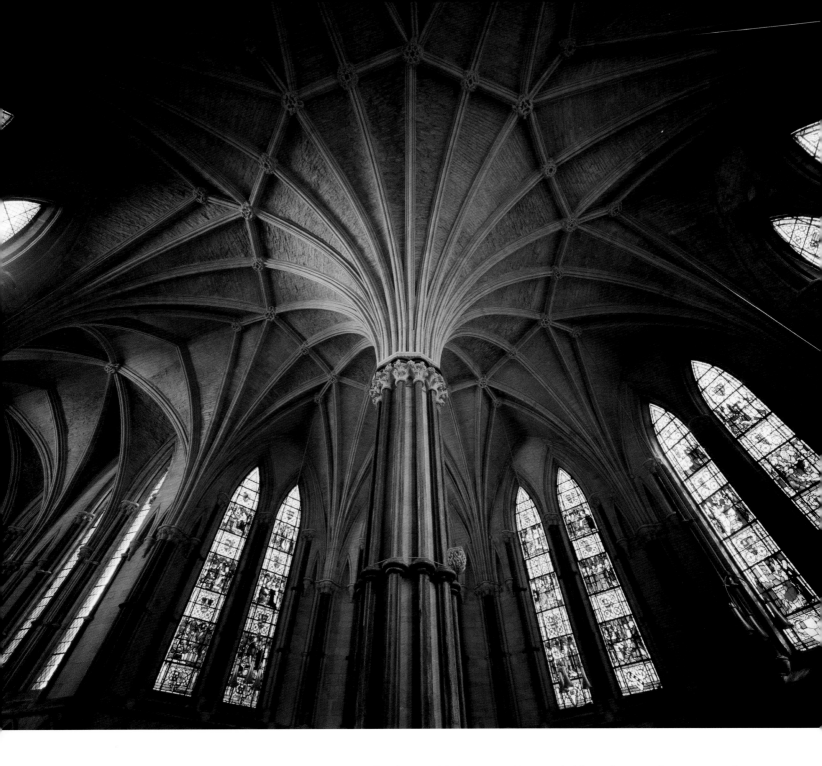

'clear' (*purus*), 'majestic' (*augustus*), 'polished' and 'refined' (*politus*), 'extraordinary' (*incredibilis*), 'choice' and 'exquisite' (*exquisitus*), 'handsome' (*honestus, decentis*), 'praiseworthy' (*laudabilis*), and 'careful' and 'painstaking' (*curiosus*). These are routinely expressed in the superlative degree, and qualified with adverbs such as 'very' (*valde*) and 'tolerably' (*satis*). In Middle English the standard vocabulary, which in any case is grounded in the Latin, is slimmer, but 'busy', 'faire', 'curious', 'costlie', 'goodly' and 'sumptuous' are commonly encountered and demonstrate the same range of visual and intellectual impressions. While most of these adjectives have more than one meaning, and some refer to cost as well as beauty, it is usually safe to assume that all

likely connotations carried by a given word are expressed in it. Expression of diversity and, particularly, ingenuity are also closely related to that of beauty. Medieval writers repeatedly emphasize special aesthetic qualities by saying of a work that its craftsmanship outshines the materials it is made from (*materiam superabat opus*: a borrowing from book two of Ovid's *Metamorphoses*), or that it is either worthy of or would stupefy Daedalus, the pre-eminent artificer of the ancient world.[29]

Such language is a prevailing feature of many medieval descriptions of patronage, particularly those of chroniclers. It is formulaic, but no less sincerely applied for being so. Art and architecture were described in these terms to

emphasize both their intrinsic qualities and those of their patrons and recipients. A crucifix given to Winchester Cathedral by Bishop Henry of Blois (1129–71), portrayed by the chronicler Gerald of Wales as 'wonderfully and exquisitely made . . . incomparable and inestimable', reflects the holiness of its venerable patron and the splendour of the proud and powerful institution to which it was donated. Edward, a citizen of Salisbury living in the late eleventh century, gave to the fledgling Yorkshire abbey of Selby an altar frontal of linen 'wonderfully decorated with Our Lord [in] majesty and the four evangelists'. His charity was stimulated by his 'love of the beauty of God's house' and reflected for the local chronicler 'a man shining with honesty in every habit': an aesthetic description in its own right.[30] Indeed, all objects of patronage, and by extension their patrons, were ultimately considered beautiful by association with their institutional context. As simulacra of heaven, whose peerless beauty is described in Revelation chapter 21, medieval churches were understood in aesthetic terms whether or not their physical constituents were of what would now be considered high quality.[31] There is an intentional suggestion of symbolic continuity between churches and heaven in the repeated citation by medieval writers of the psalmist's declaration 'Lord I have loved the beauty [decorem] of thy house' (Psalm 26:8) to extol the qualities of patrons and their gifts.[32] Such a suggestion is also found in the common equation of ecclesiastical buildings with Jerusalem, and specifically the Temple of Solomon, to which, for example, Lincoln Cathedral's decagonal chapter house is compared in the aesthetically aware Metrical Life of St Hugh of Lincoln by Henry of Avranches (d.1260; fig.44).[33] Monasteries, in their religious self-containment and sufficiency, were all ideally understood as models of heaven.[34] A cope called 'Paradise' given to St Albans by King Henry III (1216–72) and embroidered with the expulsion of Adam from the Garden of Eden was in this light a highly appropriate gift, its iconography representing the dichotomy between the heavenly and mundane spheres mirrored in the juxtaposition of walled monastic precinct and the world outside its gates.[35]

Thus the manifestation of aesthetic qualities was an important purpose of patronage, because, in addition to the fundamental endeavour of honouring God, it underscored the esteem in which patrons held the churches to which they donated, implied the virtues of both parties and emphasized a mutually edifying and scripturally

demonstrable link between ecclesiastical buildings and the heavenly halls of the New Jerusalem. In utilitarian terms any act of church ornamentation also possessed for its patron the basic value of a charitable and thus potentially salvational act, while descriptions of such endeavours and their products functioned as emulative stimuli to future readers.[36] Occasionally, the aesthetic elements normally praised were criticized in the ecclesiastical domain. This is particularly notable where the Cistercians are concerned. In the decades after its foundation in Burgundy in 1098, the order imposed upon itself an artistic austerity to match the rigorous discipline required of its monks. Accordingly, sculptures, multicoloured and iconographic glass, decorated liturgical vestments, manuscript illumination and gold in any artistic context were banned by various twelfth-century decrees, as were towers in church architecture.[37] However, by the thirteenth century, when an elaborate Gothic eastern arm was built onto the Romanesque church of Rievaulx in Yorkshire, these strictures were losing their hold, and by the early sixteenth, when Abbot Marmaduke Huby (1495–1526) built a great bell-tower at Fountains Abbey in the same county, and Abbot Thomas Chard (1521–39), a sumptuous and decorative residence for himself adjacent to the abbey church of Forde in Dorset, they had been effectively forgotten.[38] Outside the early Cistercian milieu criticism of aesthetic splendour in ecclesiastical contexts was unusual and confined either to ideological polemic, like that of Gervase of Chichester (fl. late twelfth century) and, later, those influenced by John Wyclif (c.1330–84), or specific circumstances. Examples of the latter include the abstemious rejection by Henry VI (1422–61, 1470–1) of 'superfluite of too gret curious werkes of entaille [i.e. carving] and besy moldyng' at King's College Chapel, Cambridge, and the censure that followed the ruin of the facade of St Albans Abbey church in the early thirteenth century due to inclusion of 'carved work, unnecessary, trifling, and above all costly' at the expense of finishing the whole before the season turned.[39] In general, and despite scholarly attentiveness to counter-examples – to which, for example, the swelling corpus of published work on early Cistercian art and architecture owes its volume – aesthetic characteristics and the patronage productive of them were immediately equated with virtue.

As indicated here, any product of patronage might be understood in terms of its aesthetic values. Durham Cathedral owns a copy of Bede's Life of St Cuthbert

45 Cnut and Ælfgifu donating a
reliquary cross from the
New Minster *Liber Vitae*, c.1031
On parchment 25.5 × 15 (10 × 6)
British Library, London
(MS Stowe 944, f.6r)

illuminated in the later twelfth century and described in a book-list of the 1390s as 'a special and precious book', while a missal 'incomparably illuminated' was given by Abbot Walter of St Albans (1119–46) to his monks. The stained glass of Lincoln Cathedral is eulogized for its colour, luminosity and symbolic connotations in the *Metrical Life of St Hugh*. John Flete, the fifteenth-century historian of Westminster Abbey, calls the Cosmati-work pavement commissioned by Abbot Richard of Ware (1258–83) 'wondrous'.[40] However, from this broader

artistic sphere, architecture, metalwork and ecclesiastical vestments emerge as especially likely to attract aesthetic description, due to the particular esteem in which they were held. At the heart of this circle the products of the goldsmith stand out for their large and manifest financial value, their material relationship with heaven as described in the Book of Revelation, and the traditional association of bejewelled, precious metal reliquaries with the sacred purity of saints' relics. The aesthetic characteristics of reliquaries were often subjects of fervent praise. A feretory of St Augustine established in his eponymous abbey at Canterbury in the eleventh century was 'of the purest gold, encircled with the most valuable gems', and another made during the same period for St Alban was 'glorious . . . of magnificent workmanship' and 'glitter[ing] wonderfully with gold and gems'. The feretory of St Edward the Confessor (1042–66), rebuilt in 1241 at the orders of Henry III and his queen Eleanor, was 'most excellent . . . of the best and purest, unalloyed gold, and the most lavish gems': it cost over 1,000 marks (£666).[41] These descriptions are entirely typical and unambiguously intended to reflect patronal virtues and institutional dignity as well as the beauty of such gifts and the honour these paid to God's elect. Just such a compound of meanings is epitomized by the illustration on folio 6 of the *Liber vitae* of New Minster, Winchester, illuminated c.1020–30 (fig.45). This records pictorially the donation by King Cnut (1016–35) and his queen, Ælfgifu, of an object described in Thomas Rudbourne's *Historia maior* as 'a most excellent cross, lavishly and handsomely ornamented with gold and precious stones' and filled with relics.[42] Accordingly, the king and queen, who are identified by name, are shown placing the cross upon an altar, while angels set a crown and a veil upon their respective heads. These angels point upwards to a benign Christ in a mandorla, flanked by interceding figures of the Virgin Mary and St Peter. Both donors and altar stand upon an arch containing an arcade inhabited by monks. With Christ's book (an emblem of the *Liber vitae* itself), the cross is the only coloured motif, emphasizing its aesthetic and symbolic qualities. Here the proud and grateful monastic recipients, virtuous and blessed donors, and reverenced, benevolent heavenly hierarchy are brought together in a relationship of mutual benefit around an act and an object of patronage whose aesthetic and symbolic dimensions made them worthy of pictorial as well as textual record.

The Devotional Purpose

Could any medieval patron of ecclesiastical art or architecture be asked the chief purpose of his or her benefaction, the answer would almost certainly be a pious wish to honour God, the Virgin Mary and the other saints. This would be followed, and occasionally preceded, by a desire for *post mortem* salvation, but as the latter was thought to depend on bona-fide devotion, the purposive order is logically devotional followed by salvational. That the two motives were separate, if reciprocal, cannot be overemphasized. If, with many historians, one assumes the devotional impulse to constitute an aspect of salvational instincts, rather than the other way around, then patronage will appear an essentially self-centred exercise rather than one also influenced by properly confessional, philanthropic sentiment. This would acutely misrepresent medieval attitudes. For the Late Middle Ages, scholars such as Clive Burgess, Eamon Duffy and Richard Marks have recently placed strong emphasis on the role of charitable enthusiasm in the provision of ecclesiastical liturgy, art and architecture.[43] While the mirror becomes darker with time, it can be assumed that such enthusiasm motivated gift-giving in the Early and High Middle Ages as well, both in and out of the monasteries. Even patrons who donated art or built with the stated aim of spiritual salvation were not necessarily driven solely by an egocentric urge for self-preservation. A saved soul was one that would not only live but also praise God eternally.

The desire to worship God through embellishment of his temporal estate is very commonly expressed in the written patronage record, from the top down. King Malcolm III of Scotland (1058–93) and his saintly queen Margaret (d.1093) founded and funded construction of Dunfermline Abbey in Fife 'in honour of the Holy Trinity' (fig.46), embellishing it with 'a cross of incomparable value, which had an image of the Saviour of silver and pure gold, clothed by shining gemstones'. That it was to be their burial church, where monks would intercede continually for their souls, does not gainsay the devotional probity of their intentions: the same monks also praised God perpetually. Indeed, Margaret's devotion was so great that she was later canonized. With her tomb at its heart, Dunfermline's abbey church became the royal mausoleum. The greatest of Scottish royal ecclesiastical patrons, King David I (1124–53), was buried there before the high altar in

1154. 'Pious King David', a man 'full of the love of God', founded and helped build, restore and ornament as many as twelve Scottish monasteries, including such major houses as Holyrood at Edinburgh, Jedburgh, Kelso and Melrose.[44] At the other end of the scale stand the churchwardens and parishioners of Eye in Suffolk, whose collective patronage of their magnificent flint-and-stone church tower is described thus in an early source: '[The churchwardens] gatheryd that yere [i.e. 1470] partly with the plough, partly in church ales, partly in legacies given that waye, but chiefly of the frank and devoute hartes of the people the some of xlli [£40] and litell odde money'.[45] This local piety will have been mediated by many complex considerations, both communal and idiosyncratic, but its magnificent result was first and foremost a monumental oblation to God and his Apostles Peter and Paul, in whose names the church was consecrated.

Devotional patronage was not always directed ostensibly towards God. Love of the Virgin Mary is often its stated catalyst, a reflection of the enormous and enduring popularity of a cult that produced such architectural gems as the Lady Chapels at Ely, Glastonbury, St Albans and Westminster, and that was a major element in medieval Britain's robust and diverse pilgrimage culture. In the 1040s Lady Godiva, with her husband Earl Leofric of Mercia, established the major Benedictine monastery of St Mary at Coventry, and to prove her strength of purpose she had a valuable circlet of gems, which she used for counting her prayers 'so that . . . she might not leave any of them out', hung around the neck of a statue of the Virgin – an interesting prefiguration of later medieval devotion to the rosary of the Blessed Virgin Mary.[46] Affection for many other saints, conventional and otherwise, also elicited philanthropic generosity. In his *Life* of the Anglo-Saxon saint Edith (d.984), the hagiographer Goscelin of Saint-Bertin (d. c.1099) describes a chapel dedicated to St Denis at the east end of Wilton Abbey church in Wiltshire commissioned by the holy nun. 'For a long time', he wrote, 'Edith had applied her mind with greatest fervour towards a votive basilica for her most beloved patron, St Denis, which indeed she built . . . in the likeness of an elaborate and beautiful temple.' Further, she decorated the interior, 'the whole basilica indeed . . . with an omnicoloured painting by the hand of the accomplished [artist] Benna': this incorporated images of Christ's passion that she herself had envisaged in her devotions.[47] While one would expect such

motives of a saint's patronage, figures such as Edith were models of pious practice for later generations (a vernacular version of Goscelin's *Life* including the same description appeared in the fifteenth century), both in their general demeanour and in specific actions such as church building and decoration. Aldhelm, Augustine of Canterbury, Benedict Biscop, Cuthbert, Dunstan, Edward the Confessor and Osmund, to name a handful, stand alongside Margaret of Scotland and Edith as saints whose art and/or architectural patronage were invoked as exemplary of sanctity in historical and hagiographical literature.

Medieval piety, while rooted in fundamental objects, was subject to fluctuation in its expression, and this had implications for patronage. Two particularly striking examples of this illustrate the point. During the tenth, eleventh and twelfth centuries, a great number of Benedictine monasteries were founded, but thereafter, as enthusiasm

for the mendicant orders in particular grew, such foundations dried up completely. Between 1220 and 1300 at least 190 mendicant houses were founded in England and Wales, but no independent Benedictine monasteries were established (see Monckton, pp.108–9).[48] The lists of thirteenth-century contributors to the Franciscan church at Cornhill in London suggest great enthusiasm for this new order, with its popular vocation and perceived spiritual integrity. 'The church's nave was built at great expense by sir Henry Galis, mayor of London . . . its chapterhouse was built by Walter the Potter, citizen and alderman . . . the entire dormitory, with desks and toilets, was built by sir Gregory de Rokysley, mayor of London . . . the refectory was built by sir Bartholomew de Castro, citizen . . .' and so on.[49] Over 500 non-Franciscan burials are recorded in this same church and its cloister, a number that, given the medieval habit of bequeathing works of art to the place of one's

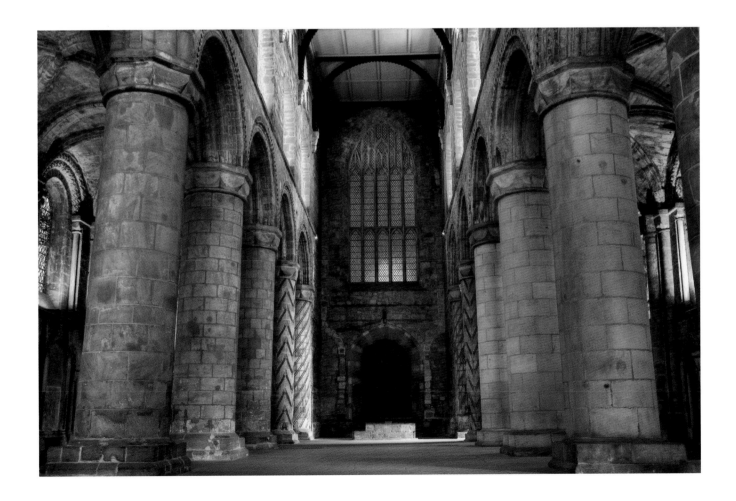

47 Page for Trinity Sunday from the Sherborne Missal, with text and illustration of Abbot Robert Browning kneeling opposite Bishop Richard Mitford of Salisbury beneath the figure of Christ displaying His wounds, c.1395–1405
On parchment 53.6 × 38 (21 × 15)
British Library, London
(MS Add 74236, p.276)

burial, suggests vast quantities of patronage.[50] In the fourteenth and fifteenth centuries it was the Carthusians who rapidly began to benefit from strong, if less pervasive, lay patronage. Of Britain's ten charterhouses (nine English, one Scottish), eight were founded in the century after 1340.[51] Initiated by kings and aristocrats, they were also sponsored by lay people of lower degree. Like the Dominicans and Franciscans in the thirteenth century, Carthusians were considered particularly pure of spirit, and sponsoring their infrastructure thus constituted a pious endorsement of religion itself, as well as a good work of special salvational benefit. The Augustinian chronicler Walter Bower wrote that the holiness of the Carthusians was 'sufficient to make clear the devotion of the king [i.e. James I, 1406–37] who brought this order to Scotland'.[52]

Lastly, the devotional purpose of patronage is often expressed pictorially as well as literarily. Representations of patrons kneeling in prayer abound in monumental and manuscript painting and stained glass, particularly of the later Middle Ages (see fig.41, pp.78–9). Votive prayers were often included as well. In psalter illustration the most usual context for a donor figure was at the beginning of Psalm 101 (modern 102), which opens with the words, 'Hear my prayer, O Lord.'[53] In many cases, of course, such manuscripts were made for private use, and accordingly their patronage was not properly ecclesiastical. In others, however, they were conceived as so-called 'gift psalters', or else donated to a church or ecclesiastic after a period in private hands. Certain books have multiple donor portraits. The Sherborne Missal, made c.1395–1405 and perhaps the greatest surviving late medieval British illuminated manuscript, contains approximately a hundred illustrations of Robert Browning, who was Abbot of Sherborne at the time and undoubtedly a driving force behind its commission and manufacture. In most cases he is accompanied by his votive motto, 'Praise be unto the Trinity' (*Laus sit Trinitati*) (fig.47).[54] Such images, embedded within the object of patronage itself, were immediate and ingenious reminders of patronal piety and generosity. A further dimension of such iconography is seen in the representation of so-called 'votive architecture'.[55] The late-thirteenth-century common seal of Evesham Abbey in Worcestershire has a schematic representation of St Egwin (d.717), the monastery's founder and patron, offering his abbey to the enthroned Virgin and Child in the form of a model church. Every time the monks sealed a document they reminded its recipients and them-

selves of the concrete form their forebear's piety had taken.[56] Such votive models appear in representations of patrons on tombs, in statuary, stained glass, wall paintings and manuscript illustration, and were intended both as mementos of generosity and perpetuations of devotion.

The Salvational Purpose

'He who does not give what he has will not get what he desires.' These words were inscribed on a chessboard belonging to King Henry III, a prolific Church patron who, in line with this motto, spent some £42,000 on the reconstruction of Westminster Abbey between 1245 and his death in 1272.[57] Surviving evidence suggests that along with the state of grace they implied, spiritual salvation and ease of passage to heaven, for self and kindred, were probably the most pervasive of all medieval desires. That this should be apparent in the patronage record in particular is not surprising. Churches were sites of commemoration for both ecclesiastics and lay people, and much patronage was exercised shortly before death, or even after it in the case of bequests. With Seneca, medieval people clearly recognized that while life is short, art endures. Accordingly, many historians consider spiritual salvation the single most important purpose of ecclesiastical patronage.

As with devotion, salvational motives can be reasonably inferred for practically all acts of medieval philanthropy, including patronage. They are often explicit in the written record, and in other cases represent an obvious subtext. A patron's will may or may not stipulate salvation as a motive for the bequest it contains, but concern for the soul is always implied. For a sick or dying person, giving money to enhance the fabric and fittings of a church represented a valuable opportunity not only to please and appease God, but to annex intercession, which it was hoped would further expedite the uncomfortable process of spiritual salvation. Accordingly, benefactors' names and requests for prayers were routinely inscribed on or near the objects of their patronage, leading one current historian to characterize the late medieval parish church and its furnishings as nothing less than an obit roll.[58] Some patrons took the convention for labelling works to extremes. William Wenard, who in 1441 bequeathed 80 marks (£53) to the Benedictine nuns of Polsloe Priory in Exeter for a new

48 Freestone cadaver tomb of John
Fitzalan, 7th Earl of Arundel, c.1435,
in Holy Trinity Church, Arundel, Sussex

campanile and 100 marks (£66) to that city's Franciscans
for a new cloister, also requested that 8s 4d be spent on
writing his name on a glass window or furnishing in every
parish church in Devon and Cornwall, so that 'friends [and]
enemies . . . when they chance to see my name publicly
written . . . perchance will be induced to pray more quickly
for my soul'.[59] In other instances donors' largesse was
specified in a chronicle, benefactors' book (e.g. St Albans,
Rochester) or inventory, with the intention that future
readers would call it to mind and offer prayers. The mid-
thirteenth-century inventories of St Paul's Cathedral in
London are long and materially complex, evoking the ability
of large medieval churches to absorb almost limitless
quantities of patronage. Many of the items recorded have
givers' names attached to them.[60] Another instance in
which the salvational motive is explicit is where episcopal
indulgences were issued for gifts towards church construc-

tion or repairs. These represented one of the commonest
and socially most inclusive opportunities of all for patron-
age. Donors were guaranteed a specified number of days'
remission from purgatory after death – typically forty, but
often twenty or a hundred – as long as they gave for love
of the church. While many such donations will not have
been spent directly on art or architecture, countless others
surely were. Individually, they constituted minuscule
contributions, but taken together they represent one of the
major collective patronage endeavours of the Middle Ages.

Indulgences conferred spiritual benefits on donors
alone, but patronage motivated by salvational concerns
was more often exercised for the benefit of multiple souls.
Unusually, Roger, Baron de Merlay (d.1265), even founded
and equipped a perpetual chantry at Stannington in
Northumberland 'for the souls of all faithful departed'
without any personal reference, although he must have

been individually commemorated in its Masses. His twelfth-century predecessor, Ralph de Merlay, had been more conventional in setting up Newminster, a Cistercian abbey in the same county, 'for the [spiritual] health of myself, my wife, my children, my lords and all my ancestors, and for the souls of my mother and father, my predecessors and friends, and all the faithful dead'. The same duty to kith and kin is reflected in wills and inscriptions recording even the most modest acts of patronage, and kings were no less stimulated by it. Henry I (1100–35) had Reading Abbey (begun 1121) constructed 'for the absolution of his sins, and for the souls of his father, mother and wife, and the health of all his successors'.[61] Like Henry III, he recognized as well as the commonest man that all souls were equal before God.

An object of patronage with strong salvational associations was the sepulchral monument. Such monuments served many purposes – consolatory, propagandistic, aesthetic, genealogical and even historical – but scholars generally identify elicitation of intercessory prayer as the most important. Supporting this is the fact that many carry inscriptions pleading for God's mercy and the prayers of saints and passers-by. As embellishments that were by and large considered church property (there are numerous records of them being sold off or converted to other uses both before and during the upheavals of the sixteenth century), their commission and manufacture constituted significant acts of artistic patronage. Early in the period, when only the most prestigious individuals were buried in churches, monuments were rare. With time, however, intramural church burial became common, as decorum adjusted to accommodate it and ecclesiastics recognized it as both a source of income and a demonstration of allegiances. Monuments, of both two and three dimensions, came in many different forms. During the twelfth century the fashion arose for embellishing the more important ones with sculpted effigies, and copious regal, ecclesiastical, military and civilian examples survive from all parts of Britain. At the end of the thirteenth century the sepulchral brass emerged in England and achieved immense popularity there, although it was never common in Wales or Scotland (see Saul, pp.138–9). And by the fifteenth century the 'double-decker' cadaver tomb had become fashionable with the wealthy, again particularly in England. These have two effigies, one above representing the deceased as in life, and the other in a space beneath it taking the form of a mummified or rotting corpse (fig.48). Such shocking iconography was unequivocally intended to wrench salvational prayer from all who saw it.

For those of means, establishment of a perpetual chantry or better still a secular or academic college was a popular way of accumulating spiritual merit in later medieval Britain. Such foundations, on which vast sums of money were lavished, usually entailed extensive art and architectural patronage: some, like Rosslyn Chapel near Edinburgh (begun 1446), were so materially ambitious that they were never finished. As expressions of piety, chantry chapels and colleges were formidable, but their salvational purpose is no less obvious. By his will Richard Beauchamp, Earl of Warwick (1382–1439), directed construction of a Lady chapel flanking the collegiate church of St Mary at Warwick (see Monckton, pp.108–9). This was to contain a high tomb of Purbeck marble with gilded bronze effigy and 'weepers'. He chose his executors well, and the astonishing result of his largesse survives in relatively good condition. The earl's effigy, its hands raised in perpetual adoration, still stares upwards towards a vault boss sculpted with an image of the Virgin. Beauchamp's will also specifies the priestly intercession to be performed daily for his soul in the chapel, and requests 'that there be in all haste, after my decease, and before all other things, to be said for me five thousand Masses'.[62] Here liturgy, devotion, stone, paint, timber, sculpture, stained glass, fine embroidery and metalwork were yoked together in the service of a patron acutely concerned about the fate of his soul. That the result was particularly glorious reflects a blend of wealth and anxiety, a combination deeply implicated in the character of Britain's medieval art and architectural heritage.

The Corporate Purpose

As we have seen in the case of Eye's church tower, not all patronage was exercised independently. Much of it was collective, and directed towards expression of the corporate, characteristics like piety, dignity, independence, prosperity and antiquity. The latter concept, discussed further in this volume by John Goodall (pp.118–19), was a matter of great importance to many institutions during the Middle Ages. From a certain perspective the great majority of medieval churches (chapels are another matter) can be identified as

49 The west tower of the church of
St Peter and St Paul, Eye, Suffolk,
later 15th century

products of collective patronage, because even those like
Westminster Abbey that are usually considered single-
patron projects in fact benefited from the input of many.[63]
In the unusual cases where one individual took an entire
building in hand, as Sir Ralph Shelton did in 1497 in willing
his executors to 'make up completely the church of Shelton
[in Norfolk] . . . in masonry, tymber, iron and leede, accord-
ing to the form as I have begun it', others contributed to
the many aspects of its embellishment.[64] Such collective
patronage expressed the corporate identity cultivated on
numerous levels of medieval society: monastic, dynastic,
secular ecclesiastical, parish, guild, civic and the like.
Within such groups patronage-active sub-corporations
might exist. Individual stained glass windows in the church

of St Neot, Cornwall, dating to 1528–30, were donated by
single-sex groups within the parish: the wives of the western
part of the parish, the sisters and the young men (i.e.
bachelors). The young men's window depicted episodes
from the life of St Neot, whose tunic and comb were
displayed to pilgrims visiting the church. Rood screens,
important sites of display as well as ritual in medieval
churches, were funded in the same way. At Morebath in
Devon during the 1530s the parish's young men contributed
40s to the screen, while the young women paid for its
carving and gilding.[65] In cases like these the donated
work's iconography often reflected shared interests or
concerns. An example is the St Edward the Confessor
window that the palmers' (i.e. pilgrims') guild installed in

the chapel of St John on the north side of St Lawrence's Church at Ludlow, Shropshire, during the fifteenth century. St Edward was renowned for having given a valuable ring to a beggar – actually St John the Evangelist in disguise – which two pilgrims, locally believed to have come from Ludlow, subsequently returned to him.[66] By having this window made, the palmers both honoured an important protector saint and demonstrated a direct link with St John, who had magnanimously involved pilgrims in his demonstration of St Edward's sanctity.

The great wave of parish church rebuilding experienced in parts of Britain during the fourteenth, fifteenth and early sixteenth centuries generated copious opportunities for expression of communal piety and pride through patronage of architecture (see Eavis, pp.112–13). Eye's tower is one example of this (fig.49). Such opportunities existed earlier in the Middle Ages as well, for the eleventh and twelfth centuries witnessed a great, if indeterminate, amount of parochial reconstruction.[67] However, whereas texts relating to this earlier work are practically non-existent (chroniclers of the age being preoccupied with major churches), the late medieval period is sufficiently documented to expose candidly the attitudes of its patrons. Collective rivalry now emerges as a driving force. It is common in late medieval architectural documentation to find a clause stipulating that a commissioned building should be 'as good as or better than' a pre-existing local structure.[68] This attitude is manifest in lowland Somerset, where the skyline is studded with ornate Perpendicular parish church towers, many clearly inspired by their neighbours. The group including Martock, Ile Abbots, North Petherton, Kingsbury Episcopi, and Huish Episcopi is a case in point.[69] As it happens, the emulative urge is not documented in this instance, but its spirit nevertheless remains palpable after more than five centuries. The similarities in late medieval Somerset tower design are not ascribable simply to groups of masons replicating standard models, for each structure is formally distinct, in conscious reflection of the corporate individuality it symbolized. Elsewhere, contracts for the reconstruction of parish church towers and other elements survive that illustrate parochial rivalry in action. Those for Walberswick (1425) and Helmingham (1487/8) in Suffolk both specify features of neighbouring towers to be imitated, suggesting informed scrutiny and a desire to excel. In 1448 the parishioners of Totnes in Devon shortlisted four particularly fine towers (three in Devon, one in Cornwall) as possible

models for their own, and sent their project supervisors on a tour of inspection to identify the best of them.[70]

Exercise of patronage by parishes is particularly interesting to social historians as evidence of spontaneous community cohesion. Theoretically, each solvent parishioner (the poor could not afford to give in any case) was a free agent who could choose to withhold support, although in practice social pressure must have compelled many would-be abstainers to contribute. Legal pressure was also brought to bear, as when those guilty of local misdemeanours had contribution to projects imposed on them in lieu of fines.[71] Canons of secular cathedral and lesser collegiate chapters usually became patrons when a major project was in progress as a matter of course. Salisbury Cathedral's prebendaries, under the auspices of their bishop, Richard Poore, and their dean, William de Wanda, annexed a quarter of their total income to rebuilding their church in the years after its relocation from Old Sarum in 1219. The result was a resounding acclamation of the chapter *per se* as well as its bishop. A number of canons of Wells Cathedral can be identified as contributors to its early fourteenth-century stained glass, notably that of the chapter house, itself a symbol of community.[72] For monks, nuns and other enclosed religious orders, too, corporate patronage was part and parcel of their vocation. The incomes of most independent religious houses were divided between their superiors (an abbot or abbess) on the one hand and their subordinate members on the other. As the above-mentioned statements of William of Malmesbury and Matthew Paris suggest (p.88), superiors often exercised patronage according to personal inclinations, but subordinates from the prior or prioress down perforce commissioned and spent on art and architecture collectively. Often both incomes were combined in tackling a major project, especially in the wake of disaster. Whatever the circumstances, patronage by members of religious houses was essentially corporate by virtue of symbolic as well as practical communism. A superior, as *pater* or *mater familias* of his or her institution, represented the whole as effectively as did its physical infrastructure. Domestic chroniclers emphasized this by describing superiors' patronage in terms of conventual integrity and prosperity. The patronage achievements of an abbot or abbess, presented sequentially with those of his or her predecessors, were construed as investments in historical tradition as well as the status quo. Abbess Euphemia of Wherwell

50 Head of mace of St Salvator's
College, St Andrews, Paris 1461
Silver-gilt, head approx. 12 × 9
(4⅝ × 3½)
St Andrews University

(d.1257) is eulogized in an extended passage in her abbey's
general cartulary for patronage so heroically prosecuted
that 'she seemed to have the spirit not of a woman but
rather of a man'. This included construction of a new Lady
chapel and provision of crosses, reliquaries, precious
stones, vestments and books for the church. Euphemia's
patronage is presented as a contribution to a spiritual,
material and historical continuum not only through the
writer's praises, but also by virtue of its documentation in
a volume containing the legal, financial and moral bases
of the abbey's existence, including a précis that outlines
Wherwell's royal, pre-Conquest origins.[73]

Corporate unity is brilliantly epitomized in one of the
finest of all surviving works of late medieval metalwork,
the mace of St Salvator's College, St Andrews University,
which was made in Paris in 1461 (fig.50).[74] James Kennedy,
Bishop of St Andrews, founded the college during the years
1450 to 1458 for bachelors of art and theology, thirteen in
all, 'like to the number of apostles'. It was one of thirty-
five later medieval secular colleges established at British
universities for the augmentation of divine service, the
spiritual health of founders and benefactors, and the
education of scholars. St Salvator's Chapel, with its high,
apsidal east end and single western tower on the Franco-
Netherlandish pattern, still stands. Like all medieval
academic chapels it represented the symbolic heart of
collegiate life, the cynosure of generations of scholars
bound by statute and conscience to pray for its founder's
soul. Yet its glass, painting and figure sculpture have all
vanished, and only the mace remains to demonstrate
Kennedy's conception of his institution's relationship to
itself, its spiritual protector and the wider world. The mace
is no less than an idealized model of the college, and its
elaborate head in particular must have reminded onlookers
of the votive architecture discussed above when clasped
by the founder or his proxy. At the centre of an open
aedicule stands a beautifully modelled figure of Christ (the
St Saviour of the dedication) standing on an orb, displaying
the wounds of his crucifixion and attended by three angels
holding instruments of the Passion. This eschatological
and eucharistic iconography makes unambiguous reference
to the college's salvational function as realized through the
Masses celebrated on the altar of its chapel. Externally, the
aedicule is set about by the figures of a king, a bishop and
a layman, evidently representing the three estates of man
for whom the Saviour's blood was shed, who helped to

sustain the college and who benefited by its intercession.
Three miniature crenellated pulpits, now empty, may origi-
nally have contained figures of preaching clerics, while the
college's scholars are represented by figures reading from
books and scrolls on the knops of the staff: the 'apostles'
around their Christ. Functionally, the mace was a conven-
tional, if complex, symbol of collegiate unity and authority,
while iconographically its purpose was to exemplify the
secular and spiritual capital of St Salvator's, thereby
emphasizing its corporate integrity, strength and devotion.
Its visible and symbolic Christocentrism tidily evokes the
elementary fact that all medieval ecclesiastical corporations
were ultimately rooted in the figure of Jesus.

The Political Purpose

The politics of ecclesiastical patronage are amenable to a wide range of definition. According to current critical discourse, the use of a panel painting by Roman missionaries to convert Kentish pagans or the emulation of one parish church tower by another was no less 'political' than Edward I's incorporation of the Stone of Scone, on which Scotland's kings were crowned, into the English Coronation Chair (fig.8, p.33) that he commissioned for use in Westminster Abbey, or his entrustment of the supposed crown of King Arthur, taken from the Welsh in 1277, to the same institution.[75] The examples mentioned below correspond to the traditional association of politics with statecraft and institutional strategy and are intended to underscore the potential agency of medieval art, architecture and patronage in human affairs. Royal projects lend themselves most readily to political definition. As a product of an inherently political institution, any building or publicly displayed work of art commissioned and paid for by the Crown was bound to have political overtones. Sir John Fortescue's mid-fifteenth-century treatise *The Governance of England* advises that royal commission of sumptuous art and architecture was a matter of decorum that in the interests of dignity and reputation should not be overlooked.[76] The principle held good in Scotland as well, and while much of what kings and queens spent on material culture was channelled into ceremonial, domestic and military projects, Church patronage played an enduring role in monarchical self-fashioning. In the Anglo-Saxon period kings like Alfred, Athelstan (924–39) and Edgar (959–75) had poured such prodigious energy and finance into church projects that they were commemorated in subsequent centuries as saints. Insofar as it was political, their aim had been to cement the ecclesiastical and divine power they relied upon for effective rule, and to symbolize royal virtues, influence and solvency. While later medieval monarchs did not patronize church art and architecture so sweepingly, the ecclesiastical buildings they did commission articulated the same core values. Munificence, piety, salvational aspirations and the quasi-sacred nature of kingship were expressed in successive waves of patronage at Westminster Abbey (see Coldstream, pp.106–7). Edgar's sweeping renovation, undertaken in 958 at the insistence of St Dunstan, was followed a century later by Edward the Confessor's church, raised in what William of Malmesbury

recognized as 'a new style of building'.[77] Two hundred years after this, Henry III's reconstruction of the abbey church was well advanced, and its medieval patronage was finally consummated by the addition of the magnificent Lady Chapel commissioned by Henry VII (1485–1509), begun in 1503 and consecrated thirteen years later. Here the tomb of the founder and his queen, embellished with gilded bronze effigies by the Italian sculptor Pietro Torrigiano (1472–1528), occupies the centre of a heavenly hall rippling with light and beset with sculptures of the saints whose company the king, as God's anointed, theoretically shared. The whole is overarched by a fan vault whose complexity of design suggested the mysterious intricacy and beauty of heaven. The historical integrity and magnificence of both the English Church and the English Crown, which were very much before the international eye in cosmopolitan London, were never more intimately associated than in this highly politicized building.[78]

Due to its location in a centre of royal government, Westminster Abbey was bound as a whole to reflect political ideology on a general level. In its individual monuments and furnishings specific political circumstances were also referenced. For example, the Coronation Chair, which has already been mentioned, emphasized Edward I's claim to rule Scotland as well as England. The monument of King Henry V provides a further instance. After his death in 1422 Henry was buried in the abbey beneath a tomb incorporating a wooden effigy plated with silver. Never before had silver been chosen for the effigy of an English king or queen; gilded bronze and stone had been the materials of choice to that point. As the basic constituent of liturgical vessels and reliquaries, silver possessed immediate sacral associations that corresponded both to Henry's much vaunted piety and the special status conferred upon him by ceremonial anointing with consecrated oil at his coronation. In turn, these qualities reflected positively upon the yet young Lancastrian regime, conscious of the whiff of illegitimacy surrounding it and facing in 1422 a prolonged period of regency administration during the juvenescence of Henry VI. The effigy did its job, attracting attention and suggesting to observers the legitimacy that Henry V and, by extension, his Lancastrian successors were regarded by God as possessing. A contemporary account written in the London Charterhouse claims that the King's executors had the silver effigy made in response to eyewitness testimony of Henry's assumption into heaven after only a token period in purgatory.[79] This indicates that the monument was

51 Kings in stained glass at All Souls
College, Oxford (originally in the
college library), including John of
Gaunt as King of Spain (*lower left*),
mid-15th century

known even to strictly enclosed Carthusians. That Edward IV (1461–83) subsequently chose a silver-plated effigy for his own tomb at Windsor may represent Yorkist imitation of successful Lancastrian artistic strategy.

Although unique in its particulars, this case is one of many in which a sepulchral monument was designed to serve a political purpose. The location and commemoration of an eminent corpse – particularly a king's – were inherently political matters during the Middle Ages, by dint of their symbolic and practical connotations. The potential complexity of such politics is seen in the translation of the tomb of King Arthur and Queen Guinevere to a new location before the high altar of Glastonbury Abbey at Easter in 1278. Edward I, at that time occupied with the annexation of Wales, attended the translation and inspected the bones before their reinterment. Royal presence and attention ensured that the event was widely reported, underscoring the English contention that Arthur was indeed dead and would not rematerialize beneath the banner of the red dragon as legend gave the Welsh reason to hope.[80] In short, the tomb was an element in a larger political campaign. It also served the political interests of the monks of Glastonbury, both by involving them in a nexus of common interest with the king and underscoring their claim to be the pre-eminent English ecclesiastical institution.

Only Glastonbury could claim King Arthur, but many other ecclesiastical organizations commissioned works representing kings past and present in both broad and circumstance-specific attempts to advertise allegiance to the Crown. In large part this was a matter of simple expediency. Monarchs exercised a good deal of financial and political control over landowning religious houses, regular and secular. The relationship was reciprocal, for the king provided ultimate protection and a vital avenue of redress in litigious and economically unstable times. Durham's monks mounted images of kings and queens of England and Scotland to whom they were beholden at their choir's entrance 'to incite and provoke theire posteritie' to emulate their forebears' generosity. Evesham Abbey's great gate, the face it presented to the external world, was similarly embellished in the 1330s with statues of the kings who had underwritten conventual prosperity. During the fourteenth century the walls of the Lady Chapel at Peterborough Abbey were set with 'images of kings of England, from the first until the latest', each with the details of his career inscribed beneath. In the mid-fifteenth-century windows

of All Souls College Chapel at Oxford is a series of images of kings in stained glass (fig.51), beginning with such legendary figures as Constantine and Arthur and ending with Henrys IV, V and VI. Richard II is omitted, but John of Gaunt, labelled 'Rex Hispaniae', is included because the Crown's descent via him rather than Richard justified the Lancastrian claim to the throne. York Minster's pulpitum, or screen, still has a complement of fourteen sculpted kings of England, from William I to Henry V, set up c.1440–60 (fig.52): this, too, has Lancastrian overtones.[81] York's display is paralleled in a thought-provoking and rather poignant way in the roughly contemporaneous rood-screen paintings of sixteen rulers at Catfield parish church on the Norfolk Broads, probably installed when the chancel was rebuilt between 1460 and 1471 (fig.53).[82] Catfield cannot often have come to royal notice, but its parishioners nevertheless devoted their screen's panels to honouring the authority and sanctity of the monarchy rather than Christ and the standard helper saints. The aura of kingship clearly exercised a powerful attraction for them, and insofar as it registers deference to and dependence upon the nation's premier institution, it is political in purpose no less than the artistically more ambitious examples mentioned here.

Conclusion

In chapter 8 of this volume Maurice Howard discusses the effects exerted on British art and architecture by the Reformation, which officially, while a long drawn-out process, occurred in 1547 in England and Wales and 1556 in Scotland. Here we will note simply that, notwithstanding the continuities between pre- and post-Reformation Britain stressed by many recent historians, the fall of Catholicism was a watershed in terms of Church patronage. More was probably destroyed during the dissolution of the monasteries, chantries and colleges in these countries than was commissioned and manufactured during the following 250 years. In certain quarters some purposive continuity was achieved, albeit on a vastly reduced scale. For example, obligation, piety and corporate awareness remained important catalysts when parish churches and university colleges were built or restored. On the whole, however, British Calvinism militated against not only the institutional

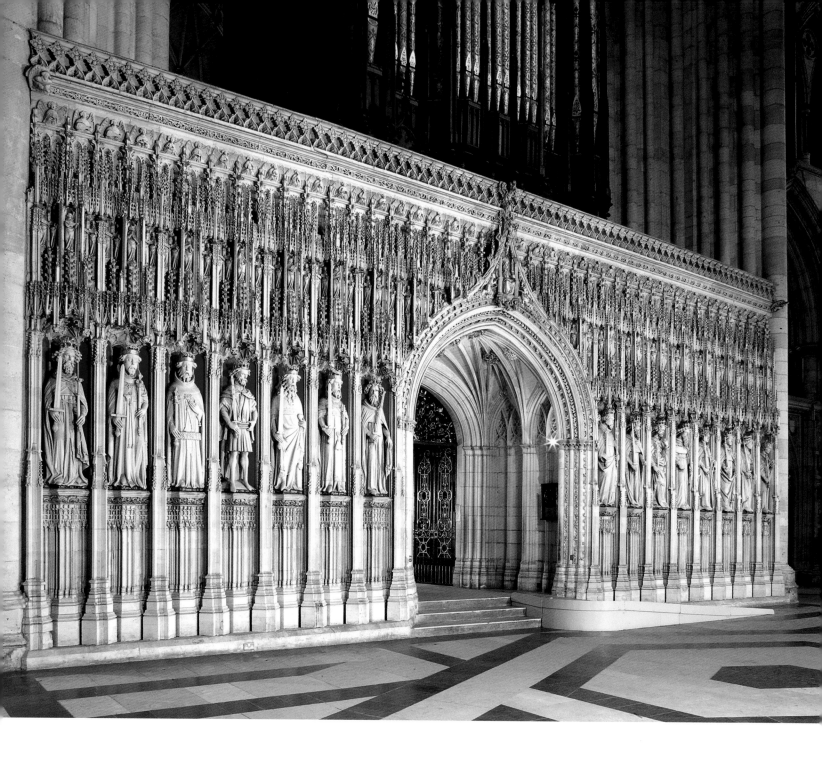

forms, imagery and materials of pre-Reformation art but also the psychological and emotional attitudes that had orientated patrons in their direction.[83] At the level of cathedral and parish, money that would previously have gone into art and architecture was now substantially channelled into social projects (e.g. poor relief, sustenance of public amenities) that, while important during the later Middle Ages, were invested with an even higher profile thereafter. At other levels there was simply nothing left to endow.

Before the sea change of the Reformation variation in patterns of Church patronage was constant but less pronounced. The culture of commissioning and endowing, like any other culture, was dynamic in the Heraclitean sense that no one act or object was the same as another. In a thematic sense, however, change is also detectable, and although our appreciation of this is restricted by the paucity and unevenness of textual survivals, it is obvious that, as Britain became more populous and socially, religiously and artistically diverse, and as opportunities for patronage waxed and waned in particular quarters, the scale and distribution of patronage shifted. An example of this has been given above with reference to the art and architectural patronage of the Benedictines, mendicant

52 Pulpitum with sculpted kings of England, from William I to Henry V, c.1440–60 (Henry VI added later), York Minster

53 Two kings, detail from the rood screen, c.1460–71, Catfield Parish Church, Norfolk

status of patrons changed. On the basis of chroniclers' accounts, kings and queens were more active as patrons of church art and architecture before the thirteenth century than after. This was balanced by the financial mobility of much of society towards the end of our period, which was expressed to a large extent in ecclesiastical patronage.

As noted in the introduction, the themes discussed in this chapter are detectable in the British patronage record throughout the Middle Ages. Notwithstanding local and project-specific variations, the physical infrastructure of Christianity was fundamentally and continuously influenced by obligation, aesthetic factors, devotional, salvational and corporate aspirations, and political exigencies. This was true outside England, Scotland and Wales as well. While patrons in France, the Netherlands, Germany, Italy, Scandinavia, Spain and elsewhere often targeted their activities differently (civic architecture benefited more than ecclesiastical in the later-medieval Netherlands for example, while Italy's cathedrals, vastly greater in number than Britain's, typically attracted less widespread and sumptuous benefaction), they were also motivated by these elemental influences. From an artistic and architectural point of view, what universality the medieval Church did possess is expressed in such correspondences no less than in the pan-European suffusion of stylistic and iconographic phenomena like the Romanesque and Gothic styles, the Crucified Christ, and the Virgin Hodegetria (literally, 'one who shows the way'). While British patronage and its products possessed their own distinctive, insular colour, it is in an international context that they are ultimately to be situated.

orders and Carthusians. One might also point to the patronage of university colleges, which was essentially religious and wholly later medieval in nature, as a change in direction: the predecessors of those who endowed such institutions had often patronized other categories of church art and architecture more fulsomely. This point is adumbrated in an indenture of Bishop Richard Fox of Winchester (1501–28), which makes provision for a programme of renovation at his cathedral only if and when the foundation of the Oxford college of Corpus Christi is complete.[84] Patronage was influenced by fashions, and fashions are fluxive by definition. Similarly, the social

Westminster Abbey

NICOLA COLDSTREAM

Over the two centuries following the Norman Conquest Westminster, a settlement with a Benedictine monastery and adjoining royal palace a few miles west of London, superseded Winchester as the capital of England. By 1300 the abbey church had become the shrine of the last Saxon king, St Edward the Confessor, the coronation church and a royal mausoleum. The architecture, sculpture and coloured decoration of both church and palace promulgated an image of Christian kingship.

Some aspects developed early: Edward had rebuilt the church and was buried there in 1066, an event shortly followed by the coronation of William the Conqueror; Edward was canonized in 1161, while at the same time the palace of Westminster, with its imposing Anglo-Norman great hall, was becoming a centre of administration and justice. Yet it was Henry III (1216–72) who instigated a more focused purpose: he replaced the Confessor's church, established Westminster as the traditional site for corona-tions and royal weddings, and promoted the cult of St Edward, eventually arranging for his own burial in the tomb vacated by the saint, now translated to a new shrine behind the high altar.

Henry's motives, influenced by his brother-in-law, Louis IX of France (1226–70), a man of deep personal piety who exerted strong moral power throughout Catholic Christendom, combined pious devotion and political calculation. Westminster Abbey as reshaped by Henry integrated the functions of three French buildings – the coronation church at Reims, the royal abbey and shrine of the national saint at Saint-Denis, and the Sainte-Chapelle, newly built in Paris to house the relics of the Crown of Thorns and the True Cross, which Louis had recently bought. Henry's answer to the latter was to acquire a relic of the Holy Blood of Christ, which was carried in triumphant procession to Westminster.

The new abbey church, begun in 1245, reflects these influences. The relative height of the building and the plain quadripartite rib vaults in the choir are generically French, but Reims and the Sainte-Chapelle were models for the window tracery, which is among the earliest in Britain. The Sainte-Chapelle also influenced the shrine-like interior ornament, with crisply carved rosette diaper, foliage and mouldings, some painted, others made of dark, polished Purbeck stone, which evoked the metallic qualities of a precious reliquary. The copious use of Roman mosaic work, a traditional symbol of authority, was, however, a riposte to the impressive new and threatening shrine of St Thomas Becket at Canterbury Cathedral (see Coldstream, pp.70–1).

Much of the imagery in the church is focused on the Confessor: monumental sculptures of St Edward, St John the Evangelist and angels high on the wall opposite the main entrance, immediately visible to visitors, enacted one of Edward's miracles: the Ring and the Pilgrim, a story that emphasized the royal virtue of

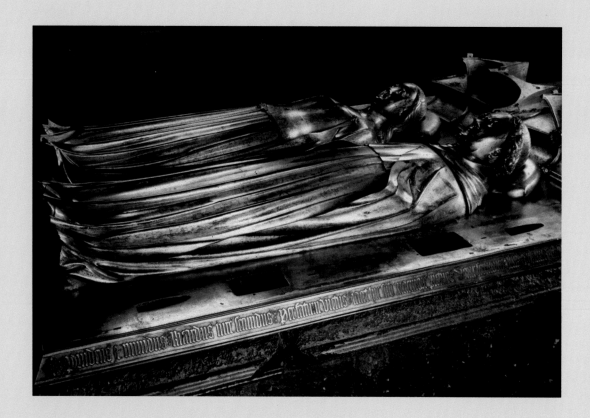

54 Tomb of Richard II (1377–99) and Anne of Bohemia (d.1394) Gilt-bronze and Purbeck marble, Confessor's Chapel, Westminster Abbey, London

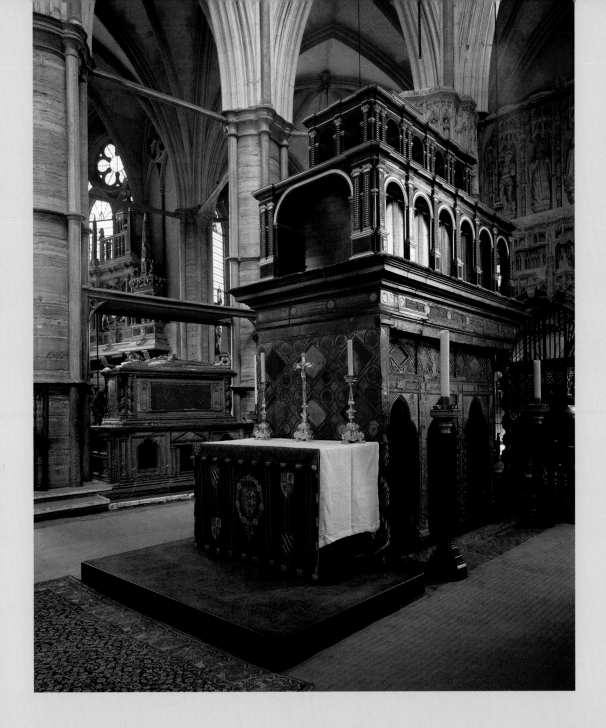

55 Shrine of St Edward the Confessor, the Purbeck marble base dated 1279/80, with the tomb of Henry III in the background, 1291–3, Confessor's Chapel, Westminster Abbey, London

largesse and encouraged meditation on the virtues of a Christian king.

There is little evidence that Henry intended his successors to be buried at Westminster; but his son Edward I (1272–1307), influenced by his French cousins, allowed family burials throughout the eastern arm, and transformed the saint's chapel into a royal mausoleum (fig.55). In the early 1290s he interred both his father and his wife Eleanor of Castile in canopied tombs on the north side of the shrine, commemorating them with gilt-bronze effigies made by the goldsmith, William Torel. His own, plain tomb lies next to them. This glittering display associated monarchy with sanctity, Eleanor's presence perhaps bringing the queenly attribute of intercession. The kings' obligation to dispense largesse, mercy and

justice was seen to descend from God, mediated through their sainted predecessor.

The fourteenth century was the apogee of Westminster as a symbol of sacred kingship, reflected also in the imagery of St Stephen's Chapel in the palace, which Edward III completed to exalt Plantagenet Christian power. Richard II (1377–99) remodelled the great hall. In his pious devotion to the Confessor he placed symbols of the saint on his tomb (fig.54) and rebuilt the surviving eleventh-century nave of the abbey church. The architect, Henry Yevele (c.1320–1400), unusually continued the thirteenth-century design. Yet royal interest was already shifting to Windsor and other residences, and to the cult of St George. Henry V's tomb occupied the last free space in St Edward's Chapel. Some

future royal burials would take place in the eastern chapel built in 1503–9 by Henry VII to house the shrine of Henry VI. In the event Henry VI was not canonized, and the Reformation brought to an end the association of monarchy and the saints.

FURTHER READING

P. Binski, *Westminster Abbey and the Plantagenets: Kingship and the Representation of Power, 1200–1400*, New Haven and London 1995.

P. Draper, *The Formation of English Gothic: Architecture and Identity*, New Haven and London 2006, pp.241–4.

C. Wilson, P. Tudor-Craig, J. Physick and R. Gem, *Westminster Abbey*, New Bell's Cathedral Guides, London 1986.

The Beauchamp Chapel, Warwick

LINDA MONCKTON

The Beauchamp Chapel in the former Collegiate Church of St Mary's, Warwick, has long been accepted as one of the most sumptuous and lavish displays of piety in late medieval England. In 1437 Richard Beauchamp, Earl of Warwick, gained consent to endow the existing college of priests at St Mary's to the sum of £40 per year, to support an additional four priests and two clerks. In the same year the earl wrote his will specifying that 'in such place as I have devised (which is well known) there be made a chappell of Our Lady, well, faire and goodly built, within the middle of which chappell I will, that my tombe be made'. The site was directly to the south of the chancel, which had been built by his grandfather to mark the creation of the college as a family mausoleum.

After the earl's death in August 1439 his executors immediately set about their task, and the chapel was created under their auspices between 1439 and 1462. Whilst the architecture of the chapel was completed by about 1446, the completion of the fittings was more protracted, with work continuing throughout the 1450s and

1460s. The earl's body was finally translated only in 1475. Whilst his will may not set out a detailed agenda, his wishes, and the social context into which those wishes would fit, would have been clearly understood. The resulting chapel was one of the most expensive commissions of its day, an indication of the Beauchamps social status, and his religious and political aspirations (fig.57). It was not just the tomb that stood as a monument to the deceased earl but the chapel in its entirety, which remarkably retains much of its sculpture, glass, painted decoration and liturgical furnishings. This monument, therefore, would abide in perpetuity as the symbol to the visible world of his wealth and status.

Beyond this secular purpose, however, its overriding function was to ensure the salvation of the earl's soul, achieved through the provision of priests to pray daily for the souls of himself and his family. The scale of the enterprise, intended to ease his journey through purgatory, is equally reflected by the provision at the earl's funeral for no less than 5,000 Masses, or services. Whilst the foundation of a chantry was

commonplace with the aristocracy at this date, if not obligatory, the creation, by one man, of a Lady chapel within an existing religious community was not. In this the Beauchamp Chapel can be compared only to the chantry foundations of royalty, namely those of the Black Prince and Henry VII. The chapel's iconography is predominantly on a Marian theme and the effigy itself gazes up at a roof boss of the queen in heaven. His tomb chest, of Purbeck marble, is surmounted by an effigy created out of cast metal (fig.56), which indicates further parallels with royal tombs: by this date this medium was exclusively used by members of the royal house, with the single and notable exception of the Earl of Warwick.

The chapel is separated from the adjacent chancel by a series of three small spaces, acting respectively as vestibule, seating area and small private oratory, all set behind an openwork tracery screen. The chapel proper is likewise conceived as three distinct but related spaces, defined by the presence of the three-bay vaulted structure. The west bay is filled by the now

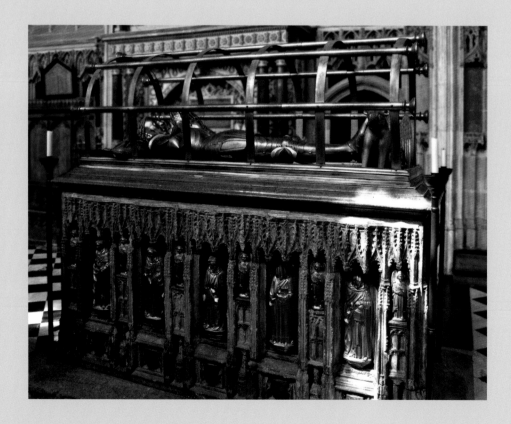

56 Tomb of Richard Beauchamp,
Earl of Warwick (d.1439)
Gilt-bronze and Purbeck marble,
Beauchamp Chapel, Church of St Mary's,
Warwick

57 Beauchamp Chapel, 1439–62,
Church of St Mary's, Warwick

mostly rebuilt Lady Chapel choir stalls, the
central bay houses the recumbent earl and the
east bay the altar. Such tripartite divisions are
common amongst so-called cage chantry
chapels (private chapels within churches that
are completely enclosed by elaborate stone or
wooden traceried screens and house an altar
and often a tomb), albeit on a smaller scale. In
this and other ways the Beauchamp Chapel is a
cage chantry enlarged, maintaining their charac-
teristic richness and profusion of internal and
external decoration on a remarkable scale.

Although the master mason responsible
for the chapel remains anonymous, there is
reason to believe that the designer was Richard
Winchcombe, from Oxford. That leading crafts-
men from London were employed for all the
other artistic elements of the commission is
known from surviving contracts. In common
with much fifteenth-century architecture,
the design of the chapel combines a series of
quotations from significant buildings and monu-
ments, in this case from Oxford, Tewkesbury
and the West Country, mostly of the preceding
twenty years. These are reinterpreted and
combined with the apparent intention of
surpassing them all; every surface is panelled,
every panel was painted, and the jambs of the
east window support sculpted figures. The
building as a whole set a standard for royal
commissions of the Tudor age.

FURTHER READING

W. Dugdale, *The Antiquities of Warwickshire*, I, London
1730, pp.400–46.
R. Marks, 'Entumbid Right Princely: The Beauchamp
Chapel at Warwick and the Politics of Interment',
in *Art and Imagery in the Middle Ages*, London (forth-
coming)
R. Marks and P. Williamson (eds.), *Gothic, Art for
England 1400–1547*, exh. cat., Victoria and Albert
Museum, London 2003, chap.7, 'The Beauchamps
and the Nevilles'.
L. Monckton, 'Fit for a King? The Architecture of the
Beauchamp Chapel', *Architectural History*, no.47,
2004, pp.25–54.

Norwich Blackfriars

LINDA MONCKTON

Founded by St Dominic (1170–1221) in the early thirteenth century, the Dominicans, or Blackfriars, were a scholarly order, in many ways inheriting aspects of traditional monasticism. But their predominant mission was preaching to large lay congregations, and they adopted the Franciscan habit of mendicancy – surviving by bequests and alms, rather than by land. Their rise to popularity was swift: by 1250, twenty-six years after their arrival in Britain, they had twenty houses in England, three in Wales and one in Scotland. Although their mission was aimed at helping the urban poor, challenging heresy and ensuring spiritual teaching, their success was largely based on gifts and requests for burial by the increasingly wealthy mercantile class and the nobility, and on a fast-developing role as confessors to a series of monarchs.

The Dominicans came to dominate the cultural life of the cities in which they resided,

influencing urban ideology and becoming significant patrons of art. The Thornham Parva Retable and the Macclesfield Psalter are just two surviving objects that indicate the quality and cost of their direct artistic patronage, or involvement in the patronage of others (see Panayotova, pp.228–9). Large libraries were established by the Order, a result of their scholarly interests – so much so that in preparing for a new library at Merton College, Oxford, in the 1370s, a visit was made to the London Blackfriars to see their renowned library.

Attracted to the larger urban settlements, their first house in Britain was founded in Oxford in 1221. Five years later, they founded a house in Norwich, the first in the region and the third in the country. As relatively late additions to the medieval religious landscape, the friars commonly established themselves on land at the edge of a city. In Norwich they took

possession initially of a confined site north of the river, in the parish of St Clement, but in 1307 they astutely relocated south of the river, closer to the religious and military heart of the city, taking advantage of the suppression of the friars penitential. A cloister that was probably begun at this date remains extant and is a unique survival in England.

Large naves were favoured for accommodating sizeable congregations, and to this end parcels of land in Norwich were acquired piecemeal to create enough space for the construction of a new large church in the 1330s. This was replaced after a fire in 1413 (figs.58–9). Construction was essentially complete by the 1430s, as a burial is recorded at this time, the first within the church for thirty years. A spate of burials in the newly completed nave and choir in the 1440s and 1450s generated considerable wealth, and illustrates the popularity of the

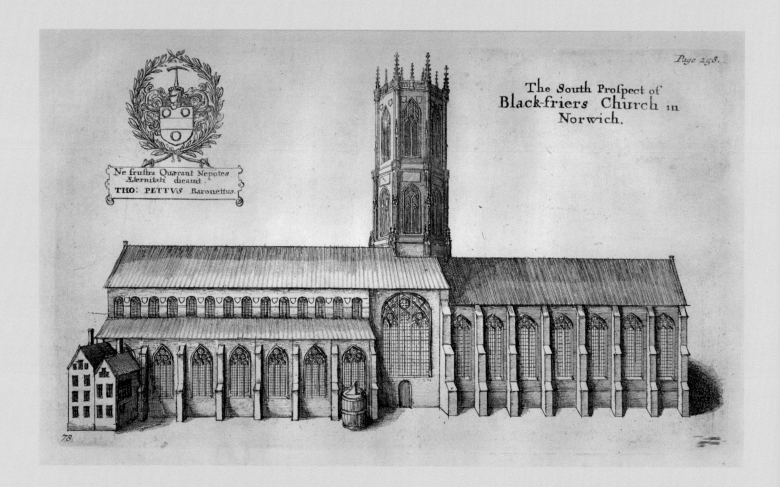

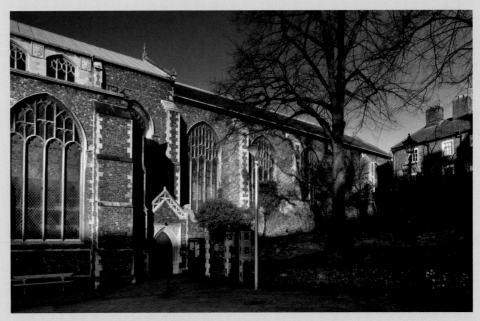

59 Norwich Blackfriars, looking north-east

house. Sums of money were then spent on new fittings, stained glass and altars for the church in the 1460s. Bequests indicate broad mercantile, gentry and noble patronage. The single largest contributor to the new church must have been Sir Thomas Erpingham (c.1355–1428), whose arms are prominently displayed at many points on the exterior of the nave.

Norwich Blackfriars exemplifies many traits known to be common to the form and planning of Dominican buildings. The new church was surmounted by a bell tower in the 1460s, to summon the population to sermons, either held in the large nave or the open-air preaching space to the south. Octagonal towers were a common feature in mendicant architecture, and that at Norwich survived until 1712 (fig.58). Commonly, these towers sit over a passage, which divides the church in two: a long aisleless chancel to the east for the friars, and a large airy and aisled nave to the west for the laity. This large preaching and burial space is most obviously characterized by a tall slender arcade, large aisle windows and small clerestory windows, and covered by a timber roof. The passage, another common feature, formed a barrier between the two distinct ends of the buildings with their different functions, and provided access to the cloister.

The Dominicans made a unique contribution to late medieval urban life, and changed the relationship between the ordained clergy and the laity. The unusual characteristics of their buildings were clearly driven, in part, by their specific functional requirements, but in turn proved a significant influence on the form of the late medieval parish church. The buildings in Norwich owe their remarkable survival to purchase by the town in 1538, at the time of the Dissolution of the Monasteries. Urban locations made such buildings obvious candidates for redevelopment from the sixteenth century onwards, and of the fifty-three houses in England only parts of fifteen remain. The Norwich building comprises by far the most significant and complete remains of a mendicant house in England.

FURTHER READING

F.C. Elliston Erwood, 'The Norwich Blackfriars', *Archaeological Journal*, vol.106, 1949, pp.90–4.
D. Knowles, *The Religious Orders in England*, Cambridge 1948.
C.H. Lawrence, *The Friars: The Impact of the Early Mendicant Movement on Western Society*, London 1994.
H. Sutermeister, *The Norwich Blackfriars: A History and Guide to St Andrew's and Blackfriars' Halls*, Norwich 1977.

58 DANIEL KING
The South Prospect of Black-friers Church in Norwich, engraving from *Monasticon Anglicanum*, London 1718 edition

Holy Trinity, Long Melford, Suffolk

ANNA EAVIS

The Church of Holy Trinity, Long Melford, Suffolk (fig.60), is of interest not only for its fabric but also for the rare survival of an account of its contents at the Reformation, written by one Roger Martin in the late sixteenth century, after many of these had been destroyed (fig.60). The church had been rebuilt and refurbished by its rectors and parishioners between 1467 and 1507. Collaborative patronage was common during this period, investment in ecclesiastical fabric and fittings constituting 'good work' believed to aid the soul's journey through Purgatory, and an act whose benefit was enhanced by commemoration of the donors in parishioners' prayers. A flexible form of spiritual insurance, it allowed participants to contribute according to their means. At Long Melford over thirty families, ranging from innkeepers to clothiers, contributed to the undertaking, some posthumously. The wealthy financed sizeable sections of the building, like Richard Martyn's Chapel. Others gave less: a single arch, a window or an altar cloth. Donors' names were commemorated in the fabric of the building itself, on those parts of the walls they had paid for and in its windows.

The project was co-ordinated by John Clopton executor for many of its donors, which may explain why the architecture of the main body of the church is, despite its numerous benefactors, stylistically coherent. The design is characterized by very plain forms, with simple pier profiles, panelling and grid-like tracery lights. Clopton and Richard Martyn ensured spatial unity and architectural consistency by themselves rebuilding the chancel, technically the responsibility of the Abbey of Bury St Edmunds. By contrast, those parts built exclusively by Clopton – the Lady Chapel and his own chantry chapel – are distinguished by more sophisticated mouldings and sculptural features.

The lavishness of the church's medieval interior, now lost, is recorded in Martin's text, which describes its gilded tabernacles, starry roof, painted altar cloths and the imposing shuttered retable adorning the high altar. The images contained in different parts of the building reflected varying aspects of religious practice. The processional aisles of the Lady Chapel evoke the ceremony associated with its revered cult figure of the Virgin Mary. Clopton's chantry chapel suggests a more intimate richness, with elaborate niches and painted armorials crowned by the words of John Lydgate's appropriately penitential poetry, the Ecce Homo verses above

60 Holy Trinity Church, Long Melford, Suffolk

the east window pointing to a lost image of the crucified Christ below. But the church's most visually dominant element was its glazing. The windows, as numerous and as large as possible, effectively formed walls of glass, while the retention of the fourteenth-century nave piers created a low main arcade allowing for an unusually large clerestory, clearly visible from the ground.

The stained glass of the choir and south nave clerestories displayed over forty of Holy Trinity's benefactors kneeling beside holy figures, each with an inscription inviting a prayer from the onlooker. The scheme thus testified to the good works of these Long Melford citizens, all of whom had contributed to the refurbishment of the church. It provided, in its vision of a town at prayer, a call for the salvation of each soul. By contrast, the north nave clerestory was entirely devoted to those people for whom John Clopton was bound to pray. The lower lights showed members of his family in an elaborate genealogy which ran from west to east, asserting a kinship with the Howard Dukes of Norfolk and placing him at its centre. The upper lights contained images of his most prestigious associates, living

and dead. By commemorating them here, Clopton was helping to fulfil his own spiritual obligations, inviting their inclusion in the prayers of onlookers.

He was also asserting his social position for posterity and to the community in which he lived. Viewed from the town's entrance to the church, Clopton's scheme would have had terrific visual impact. While the donors in the choir and south nave clerestories were small and knelt, often in groups, in humble supplication at the feet of intercessory figures, those in Clopton's scheme were massive, each filling a single light (fig.61). Kneeling on embroidered cushions beneath canopies, each wore official regalia or heraldic arms in a vivid blaze of colour, recalling the heraldic rolls that became fashionable among noble families during the fifteenth century. The contrast is evident in the surviving panels now in the north nave aisle, which include, from the chancel clerestory, a tiny figure of the Abbot of Bury St Edmunds at the feet of King Edmund (fig.62).

The many thousands of medieval parish churches in Britain represent a rich, and still understudied, resource for medieval life and

culture in all its regional diversity. Long Melford church is exceptionally rewarding for understanding the relationships between medieval images, liturgy and devotional practice. A collaborative spiritual endeavour, it also provides an insight into the social hierarchies and individual preoccupations, pious and worldly, of this part of late medieval England.

FURTHER READING

E. Duffy, *The Stripping of the Altars: Traditional Religion in England c.1400–c.1580*, New Haven and London 1992.

D. Dymond and C. Paine, *The Spoil of Melford Church: The Reformation in a Suffolk Parish*, Ipswich 1992.

C. Paine, 'The Building of Long Melford Church', in *A Sermon in Stone*, Lavenham 1983, pp.9–18.

C. Woodforde, *The Norwich School of Glass-Painting in the Fifteenth Century*, London, New York and Toronto 1950.

61 *right* Lady Elizabeth Dinham (1430–c.1485), from John Clopton's stained glass scheme in the north clerestory at Holy Trinity Church, Long Melford

62 *below* Abbot Richard Hengham (1474–9) at the feet of St Edmund, now in the north nave aisle, once in the chancel at Holy Trinity Church, Long Melford

4 Patronage, Function and Display: The Secular World

JOHN A.A. GOODALL

Introduction

On 24 July 1649, the year of Charles I's execution, the Council of State that governed Commonwealth England directed that the defences of the great castle of Kenilworth in Warwickshire be demolished. The parliamentary commander of the castle, a certain Colonel Hawkesworth, used the instruction as an opportunity for what seems in retrospect like a spectacular act of vandalism. His men and officers were owed substantial arrears of pay and it was arranged between them to exploit the fabric of the castle for their own advantage. Besides destroying the defences and blasting open with gunpowder the massively constructed twelfth-century great tower, Hawkesworth also stripped all the fittings of the principal buildings. Of the magnificent suite of royal apartments, residential towers and service buildings, only the stables and gate-house were preserved. The castle estates and the great lake or mere that enclosed it were similarly treated. In the words of William Best, Vicar of Kenilworth, writing in 1717:

> These new lords of the manor . . . pulled down and demolished the castle, cut down the king's woods, destroyed his parks and chase, and divided the lands into farms, amongst themselves, and built them houses to dwell in. Hawkesworth seated himself in the gatehouse of the castle and drained the famous pool, consisting of several hundred acres of ground.[1]

Time has now made the ruins of Kenilworth and its despoiled estates both familiar and pleasing (fig.63). To those that witnessed the destruction, however, the pillage of the castle must have savoured of the same shocking, violent and revolutionary tide that carried Charles I to the executioner's scaffold. Since its foundation more than five hundred years previously in 1121, Kenilworth had consistently been one of the most important noble residences in the Midlands, and its history was intimately bound up with many figures and events that had shaped England. It was here in 1264 that Henry III (1216–72) and his forces had been famously resisted in an epic eight-month siege; here, from 1372, John of Gaunt (1340–99) had created

apartments befitting his status as King of Castile and León; here Henry V (1413–22) had sought retirement from the cares of state, residing in a pleasance on the banks of the great mere enclosing the castle; here Henry VIII (1509–47) had made his base for hunting in the surrounding park; and here – perhaps most famously of all – Elizabeth I (1558–1603) had four times visited her favourite, Robert Dudley (1532/3–88), Earl of Leicester, amidst sumptuous and profligate display.[2]

The demolition, or so-called 'slighting', of Kenilworth was not an isolated incident. Across the kingdom (and in Wales, Scotland and Ireland as well) the hostilities of the Civil War and the licensed destruction of property in its aftermath brought about a scale of architectural and artistic loss probably unrivalled between the Reformation in the sixteenth century and the Second World War. Accompanying this destruction and underlining its significance was another profound change. Although there was much that survived the upheavals of the Civil War, the last important social and institutional continuities that tied Britain to its medieval past were effectively severed. This is most obviously true in the case of the monarchy: Charles I had ascended the throne in 1625 as the notional descendant through St Edward the Confessor (1042–66) of the Anglo-Saxon royal line of Wessex. Through his descent he also claimed the right to rule Scotland, Wales and Ireland. When his son was 'restored' to power in 1660, the continuity and trappings – including the royal regalia – that lent this claim conviction had been destroyed and needed to be recreated (see Geddes, p.33).

But the ruin of Kenilworth expressed an attendant change that was no less significant. For nearly a thousand years one of the cornerstones of English (and British) society was a fighting order that received the riches of the land in return for its military service. The terms by which this group defined itself and operated varied enormously over this huge period of time. It was first constituted by those professional warriors of the Anglo-Saxon kingdoms – variously termed *comites* or *thegns*, who enjoyed the fellowship of the king's hall and table. The Norman Conquest of England in 1066 reformulated the identity of this group to

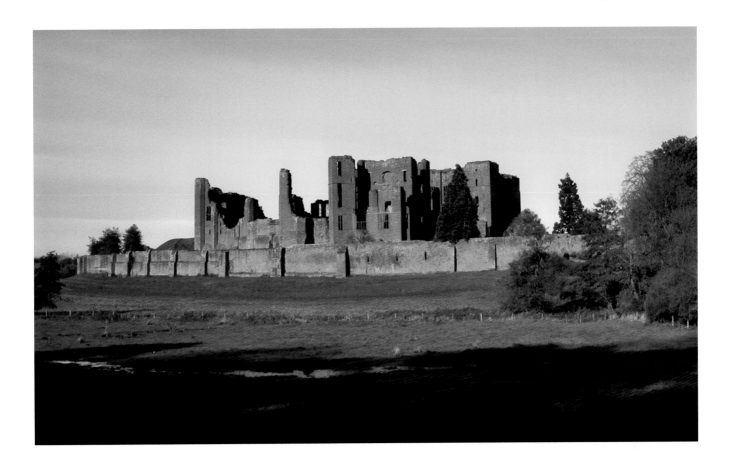

radical effect. Under the feudal settlement it imposed, England was broken down into parcels of land to support the king's following of nobles or barons and their knights.[3] By stages the feudal settlement was introduced to the entirety of Britain, penetrating Wales, Scotland and Ireland, where it was distinctively reinvented.[4] During the High Middle Ages this social group and its sense of noble identity was enriched by the ideals of chivalry. These survived not only the massive social and religious changes brought about by the Reformation in the mid-sixteenth century but also the evolving character of European warfare.

Castles like Kenilworth were perhaps the pre-eminent architectural expressions of this fighting order as it had evolved since the mid-eleventh century. Through the architectural trappings of fortification – such as battlements and towers – castles expressed the military vocation of their owners and, by their longevity, the legitimacy of the political and social order they represented. Within their interiors were displayed many of the works of art that are the objects of this essay. The mass destruction of castles in the aftermath of the Civil War brought with it the demise of this social order and the break-up of the artistic collections that it had created and the patterns of secular patronage that it had sustained for more than a millennium. This was the end of a period that is never usually studied coherently

by reason of its sheer length. For convenience it is here termed the 'Long Middle Ages'.

It would be impossible here to treat the art of the secular world over the enormous period of time between around 600 and 1650 within a conventional, chronological account. Nor is it possible to explore the urban world in depth or certain spheres of life dominated by the institutions of the church, notably education and provision for the poor and sick.[5] What follows, therefore, is an exploration of some central themes and patterns of patronage that ran as continuities throughout the millennium.

At the heart of the analysis presented here is a treatment of the decorative arts in the context of the grand domestic interior, the environment in which most surviving art of the period was used or displayed. By this means it is generally possible to contextualize works of art in a physical, social and functional sense. In addition, this approach helps overcome important constraints in the evidence available. Time has sufficiently reduced the available evidence, so that for much of the Long Middle Ages we have information only about the very wealthiest in society. Moreover, in terms of survival, architecture has fared relatively well. Indeed, in Britain today we can get no closer to the artistic experience of men, women and children for much of the Long Middle Ages than by walking through the remains of the buildings they created.

Rome and Britain

In both social and artistic terms, medieval Britain was fundamentally shaped by the experience of Roman rule that followed the invasion of the Emperor Claudius (AD41–54) in AD43. In the areas that subsequently enjoyed effective Roman government, a social, economic and cultural revolution took place with the establishment of cities, many of them developing in relationship with forts and military outposts. By its very achievement the Roman Empire created fault lines of language and culture across Europe. The subsequent importance of these cannot be overstated. Roman rule not only bestowed upon the empire a sense of common identity but provoked those beyond its limits to articulate their own in return. In this way Rome crystallized the cultural identity of Europe, defining what belonged to its mainstream and the barbarian world beyond.

Through the long process of imperial decline these divisions were blurred and changed but they lived on. And when the Roman Empire collapsed, it was within its former boundaries, reared on the ruins of its achievements, that the medieval European miracle happened. Through the offices of the church the barbarian tribes assumed the mantle of Rome and revived its institutions. What they created was a completely new order, but one dependent on the memory of the Roman past for its identity and legitimacy. This process is strikingly illustrated within the British Isles, where the extent of the Roman province of Britannia determined in geographic terms the cultural heartlands of Britain and the areas subsequently central to the narrative of this essay.

When Roman rule in Britain failed, the cities and institutions associated with it collapsed but they were not forgotten. In part this is because the vestiges of imperial dominion remained so visible in the landscape, even as ruins: it was not until perhaps the eleventh century that buildings were erected in Britain that matched their Roman forebears in quantity, scale or sophistication. But even more important than this, the influence and memory of Rome was established through the agency of the Roman Church. From the seventh century onwards the power of the papacy and its distinctive practices grew in Britain at the expense of the Celtic Church. With it came the revival of the Latin language and the forms of the Roman liturgy, including music and dress as well as stone architecture in what the historian St Bede (672/3–735) described as the *mos Romanorum*, or 'the Romans' style'.[6] In the secular sphere kings also portrayed themselves on coins after the fashion of Roman emperors.

The evocation of the Roman past remains a central and recurrent theme of English art throughout the Long Middle Ages. What complicates an appreciation of this ever fresh interest is the variety of ways in which it might be understood. In the seventh century, for example, in a world of

65 Interior of the Globe Theatre in Southwark, London (completed in 1997), which attempts to reproduce accurately the kind of theatre known to William Shakespeare

understood today to be Roman. This is not in fact the case. For example, it is only in the last century or so that any clear consensus of opinion has emerged about what comprises the canon of Roman buildings in Britain. Prior to this, structures of many dates might be identified as Roman. One striking example is the White Tower at the Tower of London. This is now known to have been begun by William the Conqueror (1066–87) in around 1070 (fig.64). But between the fourteenth and the eighteenth centuries it was often viewed as a Roman building and specifically attributed to Julius Caesar.[9] Such confusions add much to the richness and interest of revivals of the Roman past.

Nevertheless, for all the complications in understanding what Rome meant to different generations, there is no gainsaying its consistent importance. The relationships it can create between otherwise unrelated ages can be breathtaking. For example, the purpose-built theatres familiar to Shakespeare around 1600 evoked in form, decoration and nomenclature their classical predecessors (see fig.65).[10] Exactly the same Roman theatre forms would also seem to be the source for an auditorium built a millennium earlier around 620 at the Anglo-Saxon palace complex at Yeavering in Northumberland, of whose function we know nothing.[11]

The Secular and Ecclesiastical Spheres

Over the Long Middle Ages it would be broadly true to say that there were three groups active in the patronage of art. Pre-eminent for nearly the whole period was the Church, whose concerns in this respect defy all comparison in their quality, variety and scale (see Luxford, pp.81–105). Following the Reformation in the mid-sixteenth century, however, the artistic initiative passed (along with the property of the church) to its two secular counterparts. The most important was the fighting order – the nobility and gentry – and the kings and queens who ruled them. Their new wealth served to amplify well-established patterns of patronage right up to the catastrophe of the Civil War. But the Reformation also benefited the urban merchant classes and contributed to their emergence by the late seventeenth century as the newly dominant force in English society, with distinctive artistic interests of their own.

It is the artistic patronage of the last two groups – the fighters and merchants – that can be broadly understood

timber building, the use of stone alone might be deemed sufficient to make a structure seem 'Roman'. By the seventeenth century, however, the spirit of Rome had to be evoked through classical detailing and form, much of it imported from Continental sources. Trying to understand how such perceptions changed is complicated by the fact that every period presents surprising instances of sensitivity to – and ignorance of – the Roman past. For example, the eleventh-century builders of the great tower at Chepstow Castle (Monmouthshire) chose to finish parts of the building with a distinctive pink mortar created using ground brick, a technique minutely observed from Late Roman fort buildings.[7] In this sense it is a remarkably faithful rendition of Roman architecture. By contrast, the accomplished classical architect Inigo Jones (1573–1652) and his associate John Webb could mistake Stonehenge as the ruin of a regularly planned Roman temple.[8]

Such misunderstandings highlight an additional and confusing problem in historic attitudes to the Roman past. It is very easy for a modern reader to assume that Rome was revived with reference to objects and buildings that are

as the subject of this essay. Nevertheless, throughout the period the secular and the ecclesiastical worlds must be understood as inextricably related on many levels. In a fundamental sense this was true because all powers ultimately understood their authority to be derived from God. This is perhaps most famously illustrated in the case of royal power and the ancient ceremony of coronation. By this act of anointment with holy oil, or chrism, most recently enacted for Elizabeth II in 1953, kings and queens became simultaneously secular and religious figures. What it means to be at once a priest and a king or queen has long remained a matter of contention, but the notion strengthened a bond between secular and religious power that cascaded down into every level of society and government. In theory, at least, a well-governed, Christian kingdom embraced and furthered the needs of both church and people. One natural result of this was that secular spaces were full of what we would regard as religious art: palaces, for example, contained chapels and had domestic chambers decorated with religious imagery.

As government and society looked to God, so did the arts themselves. All artistic endeavours – from architecture to music – were conceived of as man-made essays in the proportions and order of God's creation. Prior to the Reformation it was natural, therefore, for daring artistic experimentation usually to take place in the context of designing, decorating or serving religious buildings. And where the church led, the secular world eagerly followed, adopting forms and ideas for its own purposes. Encouraging this exchange was the practical circumstance that the castle and cathedral were built, decorated and furnished by the same craftsmen.

The Reformation in the mid-sixteenth century arrested the long established relationship between the religious and secular arts that had driven the medieval artistic tradition. For the next hundred years patrons and masons continued to create essentially conservative buildings, but ones aware, through published books and the work of foreign craftsmen, of wider European architectural fashions (see Howard, p.234). At the same time the church connections that had helped maintain some link between the architectural traditions of Scotland and England broke down and the two kingdoms began to move in decisively different artistic directions. Only with the genesis of more academic essays in classical architecture during the early seventeenth century did important new and common avenues

of design develop, a story beyond the scope of this volume.

It should be added that drawing a distinction between secular and ecclesiastical art is further complicated by the practical circumstance that throughout the Long Middle Ages clerics wielded enormous power within the state. Moreover, the institutions of the church were sustained on vast endowments of land that they governed as secular overlords. As a result many great churchmen were also effectively patrons in a secular capacity, building and furnishing castles and manor houses. Particularly notable in this regard are figures such as the Bishops Roger of Sarum (1118–39), Anthony Bek of Durham (1283–1311) and Henry Gower of St David's (1328–47), as well as Cardinal Wolsey (c.1470/1–1530)[12] and Cardinal Beaton (d.1546). By the same token, many secular figures commissioned what we would regard as ecclesiastical art, such as devotional manuscripts, and endowed Church institutions. Female patrons, it would seem, were outstandingly active in this respect.[13] In Scotland there is the additional complication that in the sixteenth century many monasteries were exploited as sources of income by the nobility.

Such ambiguities make it impossible to draw a firm distinction between the secular and ecclesiastical worlds in the Long Middle Ages. Yet, if the bonds that inextricably linked these spheres are properly understood, it is meaningful to study the artistic production of both separately: in all their activities the nobility, gentry, merchants and the Church were aware of their individual character and commissioned art within a common culture that answered their distinct concerns.

Grand Domestic Living

Throughout the Long Middle Ages power was associated with profligate consumption. As a result, although works of art were clearly valued for their beauty, they were chiefly important as a means of displaying wealth to advantage. This circumstance ensured that architecture and precious metalwork remained amongst the most valued of the arts, while some of those most prized today – notably painting and sculpture – were relatively inexpensive. It also encouraged the creation of art for specific occasions of celebration, such as funerals, weddings and triumphal entries, much of it ephemeral (fig.72). The disappearance of such things can change our perception of artists. Hans Holbein

(1497/8–1543), for example, is today famous as a painter of portraits in the court of Henry VIII (see p.66, fig.29). Yet his portraits represent only a fraction of his artistic output and were undertaken along with a great variety of other work, virtually none of which survives. This included the design of precious metalwork (fig.66), jewellery, and the creation of huge and temporary decorations for court occasions.[14]

In addition merely to celebrating wealth and power, artistic display of all kinds in the Long Middle Ages was concerned to reflect hierarchy and social order or estate. Particularly for kings and the aristocracy, but for merchants, too, it was essential to show rank and dignity. Crowns, arms, heraldry and different kinds of clothing were all in this sense formal trappings of estate. On a day-to-day basis estate was also conveyed by domestic lifestyle, which for this purpose was made deliberately public. In this context architecture and art in all its forms were props for the enactment of social identity. To study this daily existence, therefore, is to explore the function and the purpose of artistic patronage in the secular world in this period.

The social unit of the rich and powerful throughout the Long Middle Ages was not the family, crucially important though that was, but the household. A household was a following that reflected by its size and complexity of organization the importance of the figure at its head. The origins of this institution lay in the Anglo-Saxon world and the war band, or *comitatus* (or the British *teulu*), that congregated around powerful leaders.[15] From these beginnings highly sophisticated social units developed, observing complex protocol and governed by elaborate sets of rules. Indeed, for much of the millennium covered by this essay, anyone with power or money could support a household, be they child or adult, male or female, single or married, lay or clerical, noble or common. Moreover, because the household served an individual it was also possible for different members of the same family – such as a king and queen – to have their own. Households were also overwhelmingly composed of men, regardless of the sex of the person at their head.[16]

Broadly speaking the grandest households comprised three groups of followers, of which the largest numerically was concerned with the production of food and its service to the table (fig.67). The second was intended to give the household credibility and magnificence in the eyes of the world. In origin this group was made up of the warriors who attended their lord on the battlefield. It was composed of figures who agreed to serve the head of the household in return for patronage. When a woman was the head of a household this body contained female companions of high social standing. Service in this context was not a menial affair and the greater the household the more important the ranks of this second element might be. Indeed, many followers of a king or a great nobleman or noblewoman

would have maintained households of their own. Finally, there was a clerical arm to the household. This was greatly diminished in numbers and importance after the Reformation.

The constitution of the household shaped the evolution of domestic architecture. In the Anglo-Saxon period each group within the household can be understood as possessing its own building: a kitchen, a hall, a chapel and a chamber, the latter for the head of the household. These structures usually stood separate from one another as a cluster of buildings. In some English cases this cluster was regularized by aligning two or more buildings end to end, as at Cheddar (Somerset) in the ninth to tenth centuries.[17] This particular idea was probably drawn from the habit of aligning churches in Anglo-Saxon monastic plans. Over time the different buildings within a residence began to coalesce physically into a more coherent plan, though it remained conventional to articulate their difference through contrasting styles of fenestration well into the sixteenth century. At the same time all the elements of the household – with the single exception of the hall – began to grow more complex physically and to sprout additional chambers. The speed at which these changes took place, the forms adopted and the terminology used varied from region to region across Britain.[18]

Because the wealthy usually owned many residences across their landed possessions, the lifestyle they led was itinerant. As a result, the household was necessarily a mobile

institution, capable of decanting from residence to residence with its lord or lady. All the objects it possessed, therefore, had to be portable. In this sense houses and their architecture were only the shell of a living, domestic interior. When a household arrived, it not only populated the rooms but dressed them with everything from furniture and sumptuous fabrics to kitchen utensils (fig.67). And when the household moved on, the interiors were stripped down once more.

THE GATEHOUSE

It was perhaps the rambling character of domestic architecture that first encouraged the development of a distinctive tradition of gatehouse architecture: if the residence as a whole might lack architectural impact, the authority of its owner could be made apparent in a single, magnificent entrance structure. The specifically English interest in gatehouses can be traced back to the late Anglo-Saxon period and the residences of its knightly class called *thegns*. These entrances were dominated by high gate towers and were consequently known as *burhgeats*, a name that literally means 'the entrance to the enclosure'.[19]

Most, if not all, Anglo-Saxon gate towers were built in timber and something of their form and ornament can probably be inferred from contemporary church towers, such as Earls Barton (Northamptonshire). Given the importance of these lost structures it can be no coincidence, that following the Norman Conquest in 1066, several major gate towers were erected in England at sites such as Ludlow (Shropshire), Exeter (Devon) and Bramber (Sussex). These were almost certainly evocations in stone of Anglo-Saxon *burgheats* and implied that their Norman builders laid claim to the same lordly rights as the men they supplanted.

For the remainder of the Long Middle Ages in both urban and rural settings, gatehouses appear to have enjoyed a very special status in secular and ecclesiastical design. It was one reflection of this conceived importance that the facades and vaults of gatehouses often displayed sculpture and heraldry, as at Herstmonceux Castle (Sussex), begun in 1441.[20] Through the gatehouse the outer court of a residence was typically found, a space filled with ancillary ranges such as storehouses, stables, breweries and laundries. By 1600, at sites such as Burton Agnes (Yorkshire), these ranges were sometimes moved away from the approach to the house. In such cases, the main gatehouse became isolated as a grand entrance. The residential buildings

beyond could be arranged around an inner court with its own smaller gatehouse. Whether or not this was the case, the entrance to the house itself was enclosed by a porch. Before the late sixteenth-century fashion for entrance arcades, termed loggias, such porches were often treated in architectural terms as a miniature gatehouse and occasionally possessed their own displays of sculpture and heraldry (for heraldry, see below). The great hall porch of Chepstow Castle (Monmouthshire) of the 1270s, for example, appears to have possessed its own drawbridge and is internally decorated with painted coats of arms.

THE GREAT HALL

As far back as it is possible to trace the history of secular architecture in post-Roman Britain, the hall or great hall had been one of the fundamental elements of domestic life. The origin of the form seems to lie in Northern Europe and was probably introduced during the Germanic invasions of the fourth and fifth centuries.[21] It was in such a space that Edwin, King of Northumbria (616–33), was converted to Christianity by St Aidan in 627 and that the monster Grendel made his nightly predations on the followers of Hrothgar in the celebrated Anglo-Saxon epic *Beowulf*. And – contrary to what is sometimes argued – this type of building remained a recognizable feature of great house architecture into the seventeenth century and beyond. Indeed, it is in deference to the importance of this ancient space that the front door of a modern house opens into what is generally termed 'the hall'.

Our knowledge of Anglo-Saxon halls is exclusively derived from a very limited body of excavated evidence and literary description. From these sources we know that halls were typically built of timber (though the walls were sometimes plastered) and had centrally placed hearths for fires. They were also the largest buildings in any residential complex, a scale befitting their role as the communal space for the entire household to eat and sleep. This outstanding scale remained a defining feature of the hall throughout the Long Middle Ages and served as an index of the owner's power. For kings, therefore, halls were of particular symbolic importance. The hall of William II (1087–1100) at Westminster, built 1097–9, for example, was deliberately the largest in Britain. Its unrivalled size not only made it appropriate for the huge state occasions that took place there but also served to mark out the palace as principal

seat of the English kings.[22] In Scotland, too, the much later fifteenth- and sixteenth-century royal halls at Linlithgow (West Lothian), Edinburgh and Stirling (Aberdeenshire) were the largest in the kingdom (see Fawcett, p.137).[23] The hall of Llywelyn ap Gruffudd, the last native Prince of Wales (1246–82), was apparently treated as a trophy of war by Edward I (1272–1307) and re-erected within the walls of the new town of Conwy (North Wales) in 1283.[24]

Besides its size, the great hall of the later Middle Ages preserved a prominent architectural feature that spoke of its Anglo-Saxon roots. Although there are exceptions from around 1500 onwards, it remained consistently popular to cover great halls across Britain with huge open-timber roofs. Again, the largest structure of this kind was at Westminster Hall. The form of the original eleventh-century structure is lost, but its successor in the form of the angel roof built by Richard II (1377–99) in the 1390s is justly celebrated as one of the masterpieces of medieval carpentry (fig.68). Amongst Scottish examples, too, the royal halls of Edinburgh and Stirling (the latter recently re-created) are pre-eminent. But there are a legion of magnificent – if less enormous – designs surviving from the twelfth century onwards in merchant and knightly houses, for example Stokesay (Shropshire) of the 1280s; Darnaway (Moray), possibly of the 1380s; Gainsborough Old Hall (Lincolnshire) of the 1440s; and Middle Temple (London) of 1562–70. Because halls were built in houses of every scale, there also survive hundreds of much more modest medieval halls in town and village houses across Britain.

Up to the Reformation the architectural evolution of the hall was closely allied to that of church architecture. In pursuit of permanence and prestige, stone – previously an ecclesiastical preserve – began to be used in hall construction in the eleventh century. Nevertheless, timber remained the most common material for all but the greatest halls for another two hundred years and in some areas, such as Cheshire, it remained pre-eminent in domestic design throughout the Long Middle Ages. Not only was it much cheaper, but it could be detailed to look like stone. Similarly, the fenestration of halls consistently reflects the forms found in contemporary church architecture, as do the moulding and decoration of internal arcades supporting the roof. It may also be in emulation of some monastic refectory design that great halls are found raised up onto first-floor level, as for example with Scolland's Hall of the 1080s at Richmond Castle (Yorkshire).

The internal arrangements of halls were varied in both time and region across Britain, but by 1400 there had clearly emerged what might be termed a conventional plan. At one end of the hall there was an area reserved for the head of the household and his table (fig.67), which was defined by a low dais. By this date it was also becoming typical to light the space with either a large or a projecting window termed an oriel. In front of the dais stood a central hearth, the smoke from which escaped through a louver in the roof. Along the long sides of the hall there extended trestle tables for the household to sit at in descending order of seniority. Mirroring the position of the dais at the opposite end of the hall was a space called the screen's passage, an internal corridor created by a timber screen set with two doorways. Into the screen's passage there opened the doors to the kitchens and services and – at one end of it – the main entrance to the hall and the house. This layout of a hall is still to be found in Inns of Court and most university colleges established during the Long Middle Ages such as Queens' College, Cambridge, begun in 1448.

Such law and university institutions still today perpetuate essentially medieval traditions of dress and protocol on formal occasions. The different styles of robe worn reflect the varying status of the individuals present. In the Long Middle Ages these robes would have been made from the distributions of cloth that constituted one of the benefits of belonging to a household. The more important received longer lengths of fabric in richer colours and made grander clothes with them. Similarly, today those present sit in broad hierarchy beneath a high table on the dais and they often receive different qualities of food, again a reflection of membership and status within this body.[25] Exotic and splendidly presented food has long been associated with opulent living. Indeed, that food presentation graduated into art is illustrated by the fashion for 'subtleties', a type of confectionery. In October 1527, for example, the French ambassadors were entertained at Hampton Court Palace with an astonishing array of subtleties including a model of St Paul's Cathedral, a castle, beasts, birds and dancing couples. All this was brought to the table to the 'pleasant noise of diverse instruments of music'. As a special treat they took home a sugar chess board, carefully packed so that it would not spoil.[26]

The high tables of colleges and Inns today still display objects that reflect their past: large-scale coats of arms; the portraits of founders; rich table pieces in silver or gold; and

68 Westminster Hall, London, built
by William II between 1097 and 1099;
the great angel roof was added in
the 1390s

side cupboards dressed with plate. The intention of these displays was to present the wealth of an owner in material form to those present in his house. Such displays are documented across Britain from the fifteenth century, but are known from much earlier. For example, Henry III ornamented the dais of his halls with heraldry, the figures of saints and even a map of the world.[27] By the sixteenth century decorative cycles in great halls commonly extended into glazing schemes and wall hangings.

A particular feature of major royal halls that accompanied such dais displays was the throne. This piece of furniture was understood to symbolize the individual that occupied it. In only one hall was this a permanent fixture: at Westminster from at least 1245 the king had a marble seat on the dais. The Courts of Chancery and King's Bench took place beside the dais and their hearings were consequently described as taking place in the presence of the king. Henry III took particular pains to reorganize this

69 The Great Hall at Hampton Court
Palace, Surrey. Its tapestries, owned by
Henry VIII, show scenes from the life of
Abraham and were woven in Brussels,
c.1541–3

throne, setting sculpted leopards before it.[28] Elsewhere thrones or 'chairs of estate' were moveable items. They often took the form of Roman-inspired x-framed chairs, a type familiar from many royal portraits from the sixteenth century but in fact current throughout the Middle Ages.[29]

The architectural form of the great hall and its decoration remained so consistent over the Long Middle Ages because it developed into a symbolic rather than a strictly functional space. It celebrated the household in architecture, looking back to a golden age in which men of every degree cohabited under the government of their lord and subsisted on his generosity. It is not really clear when the great hall ceased to be the place where the whole household ate and slept on a regular basis, although by the twelfth century the practice was undoubtedly over in large households. Yet, with its passing, the ideal became even more important, so important that a great hall remained an essential feature of any major house into the seventeenth century. Something of the power exercised by this ideal is apparent in the fact that the Stuart kings continued to feed their household until 1663.[30]

THE CHAMBER AND WITHDRAWING APARTMENTS

On 29 December 1170 a group of knights arrived at Canterbury intent on the murder of the estranged friend of Henry II (1154–89), Archbishop Thomas Becket. Their actions on that day were to be reported across a scandalized Europe and are minutely documented.[31] The men entered the archbishop's hall in the early afternoon and demanded an audience with Becket. At the time Thomas was in his chamber, on the upper floor of a neighbouring building, sitting on his bed surrounded by advisers, monks and clerks. It appears that this chamber was the innermost of two rooms connected to the hall by a stair. The knights were permitted up to see him and came through into the chamber. A quarrel ensued, which was heard through the open door by those waiting in the outer room. The knights then left, only to break into the building again later that night to kill the archbishop, whom they finally found and butchered in the cathedral church.

The image of Thomas sitting on a bed is one of the first we receive of a chamber and its use in Britain. Such interiors, set on the first floor of a building adjacent to the hall, had

existed since the Anglo-Saxon period (Hrothgar in *Beowulf* gives audience in one) but almost nothing is known about their appearance or use. As the presence of companions and the detail of the open door illustrate, the archbishop's chamber was not private as we would understand the term. In fact modern ideas of privacy do not apply well to the Long Middle Ages as a whole.[32] Solitude for the wealthy was certainly possible from at least the thirteenth century, but in the context of closets or chambers overlooking chapels. Thomas Becket would therefore have been retiring or withdrawing from the hall for more intimate company rather than seclusion. That his chamber was one in a pair of withdrawing rooms accords well with such late twelfth-century buildings as Boothby Pagnell (Lincolnshire). This is a two-storey building with two chambers set over a vaulted undercroft, possibly a space for the wardrobe and the storage of valuable items. It formerly stood beside a hall and is thought to comprise a set of withdrawing apartments.

As the Long Middle Ages progressed the number of withdrawing apartments in a great residence grew steadily. By this process a series of interiors were created, each space more removed than the last, and each occupied by a designated household group. Throughout this evolution the first and last rooms in the sequence were generally named the great chamber and the bed chamber, but the terms used in documents vary. Great chambers were typically display rooms and splendidly finished. By 1400 new types of specialist interiors also began to emerge, such as the parlour, a space for informal audiences. The latter room was commonly found at the head of the hall immediately beneath the great chamber. A counterpart also generally existed at the low end of the hall over the kitchen or services.

The growing complexity of the withdrawing chambers encouraged the development of new systems of communication between parts of a residence. To give visitors access to the first-floor great chamber, for example, it was necessary to create an imposing entrance stair. Depending on the level of the hall this could either stand at the entrance to the house or before the great chamber. The earliest grand stairs in English domestic architecture are to be found from around 1100 onwards in the so-called forebuilding structures that gave access to the great towers of castles, the largest of which was built at Dover (Kent) from 1182–9. In the sixteenth century, however, a new tradition of grand stairs developed. These were often virtuoso works of timber

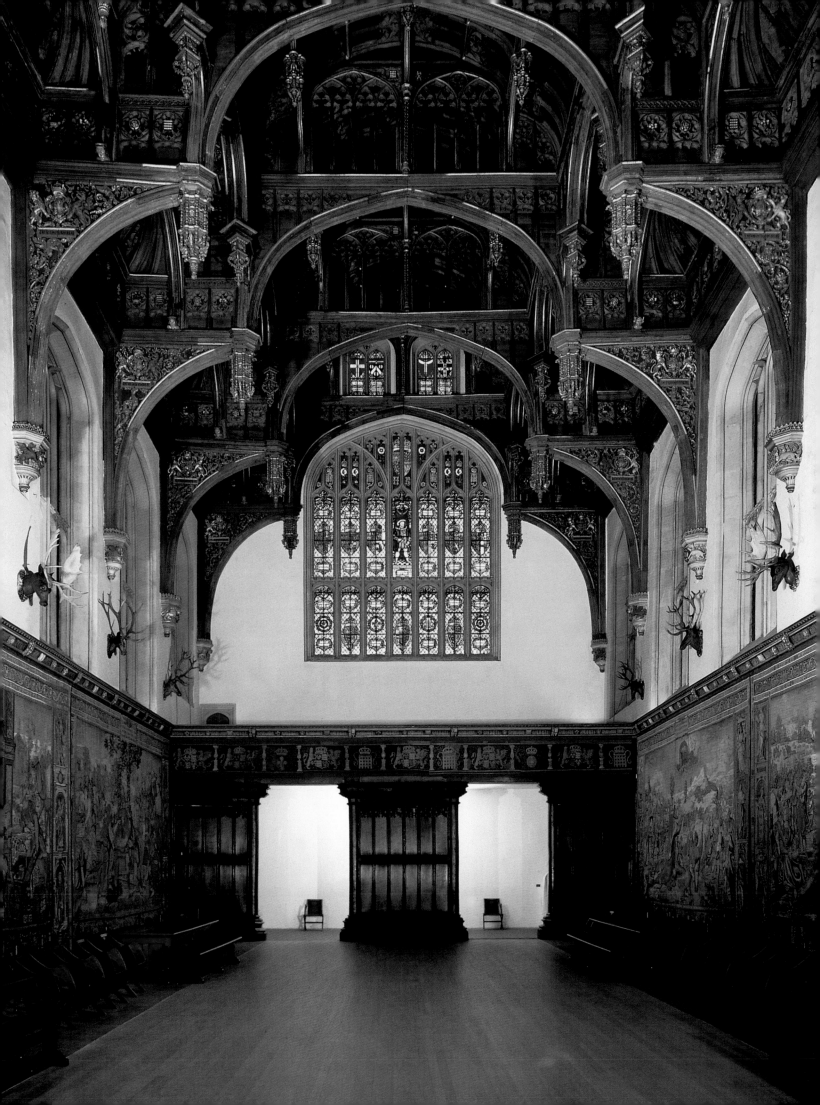

framing intended to impress guests as they walked from the hall to the great chamber. Over the same period in Scotland stair turrets directly leading to the withdrawing apartments became popular, an idea derived from French design.[33]

From the mid-fourteenth century onwards corridor systems begin to appear in English designs for the first time. It is probably ultimately from these structures that the first long galleries developed, long and well-lit chambers intended for recreation and the display of paintings (see Cooper, pp.244–5). A mid-fifteenth-century example of such a gallery may survive within the ruins of the great gate at Raglan Castle (Monmouthshire), but this form of interior became common from the sixteenth century.[34]

FURNITURE AND DECORATION

The withdrawing chambers were the spaces in which the wealthy lived from around 1200, emerging only on special occasions into the hall. In Thomas Becket's chamber at Canterbury the most important object of furniture was evidently the bed, which he was using as a seat. This is entirely in accordance with later medieval practice. Beds and their hangings were very valuable items and are known to have doubled as chairs or thrones. Moreover, they continued to be found in great chambers as status symbols long after the head of the household retired elsewhere to sleep. It was from the example of beds that thrones developed the 'canopy of estate', a rich cloth that overhung the seat.

Because personal items had to be carried from residence to residence, most were permanently stored in chests with drawers or tills. The contents of Henry VIII's twenty-one travelling trunks are famously itemized in the inventory taken immediately after his death in 1547. Each was labelled with a letter of the alphabet, presumably to avoid confusion during moves. They carried everything from maps and plans to buttons and jewellery, including – appropriately – three wedding rings.[35] Where tables appeared in important spaces they were covered in fabrics or carpets. In this period carpets were too valuable to place on the floor except beneath a throne. The commonest form of floor covering comprised loose rushes or woven matting, the latter in use from at least the late fourteenth century.

Of the wider decoration of withdrawing chambers little is known prior to the twelfth century. Much use was made of hangings and wall paintings depicting scenes with figures, such as those that can be seen at Longthorpe

Tower (Northamptonshire), which date to the fourteenth century.[36] From the details and decorative treatment of such surviving paintings (and also from documentary evidence), it would seem that many types of material were used as hangings, including wool and silk. These could be painted, embroidered or hung in alternate loom widths of colour, an effect called paling. The distances that some fabrics are known to have travelled (even from China and the Middle East) by the thirteenth century are eloquent testimony to the reach of Northern European trade. Typically, hangings were pinned up below a cornice to cover only the lower two-thirds of the wall.

From the late fourteenth century a particularly rich form of fabric hanging from the Continent, called tapestry, also became available. This was vastly expensive to produce and remained a specialist export of the Low Countries. Well into the fifteenth century its importation into Britain relied on direct royal favour. One set of tapestries commissioned by Henry VIII in 1528 cost just over £1,500, the price of a large warship then.[37] Some pieces from his great tapestry collections still survive at Hampton Court (fig.69). So prestigious was tapestry that it had a direct architectural impact: those individuals who could afford it created interiors with windows set high in the room above blank walls.

With such a variety of hangings available, it became the practice from at least the mid-fifteenth century to hang the withdrawing chambers with different qualities of material to indicate their relative importance. Moreover, because of their value, tapestries might only be displayed on special occasions and could be arranged in pointed ways to deliver a message to visitors. In 1466, for example, the dowager Duchess of Suffolk hung her withdrawing chambers at the manor of Ewelme in Oxfordshire with a carefully graded display of hangings. The arrangement was probably intended to celebrate a christening and is recorded in an inventory. As was appropriate, the most magnificently furnished interior was her great chamber, which contained a rich bed as its centrepiece. Hung around the chamber were tapestries showing the defeat of the classical heroes Hercules and Achilles by Amazonian warriors, a story doubtless intended to underline the duchess's formidable reputation and feminine virtues. It was probably known to her, moreover, from a book she kept in a nearby room, Christine de Pizan's *The Book of the City of Ladies*.[38] Narratives of this kind were popular in figurative tapestry, but so, too, were heraldry and the representation of flowers and foliage in a design

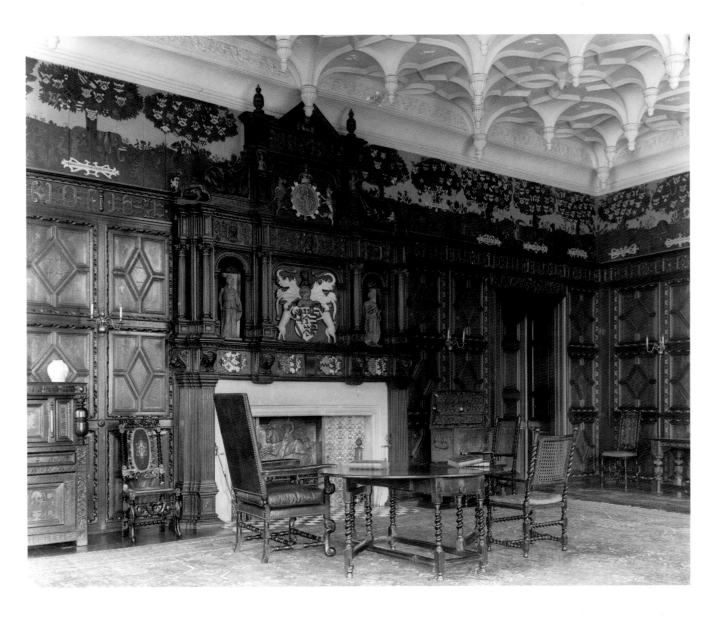

known as a 'thousand flowers' or *millefleurs*.

The principal decorative alternative to hangings was panelling or wainscoting in wood. Henry III is the earliest monarch known to have decorated his chambers in this way. Such panelling was often painted and the king's favourite combination of colours appears to have been green with golden stars. Sadly, nothing remains of such schemes and perhaps the earliest wainscot to survive in Britain of a type probably found in domestic interiors is fixed within a fourteenth-century closet for the Earl of Warwick in St Mary's Church, Warwick. During the sixteenth century wainscoting grew more popular than before and became proportionately elaborate with richly carved, inlaid or painted detail. Amongst other finishes in this period it became common to colour the wood in imitation of marble or decorate it with inlaid patterns.

In contrast to the great hall with its high timber roof, the withdrawing chambers typically came to be covered in flat ceilings for warmth. In Scotland the tradition of painting such ceilings remained strong into the seventeenth

century.[39] From at least the fifteenth century the complex vault patterns associated with the Perpendicular style of Gothic architecture also began to be reproduced on ceilings, as at Gilling Castle (Yorkshire; fig.70). This was particularly true in the context of great chambers, where pendant vault motifs became popular. These could be produced in plaster or wood.

Glass was possibly used in withdrawing chambers from the Anglo-Saxon period onwards and has been found, for example, at the tenth-century royal palace at Cheddar (Somerset). By the fourteenth century stained glass had become widespread in a domestic context. This could bear devotional imagery but it also employed heraldry, a consistently popular feature of domestic decoration. At Eltham (Greater London) around 1400, for example, Henry IV glazed a new chamber, parlour and study with a scheme that included royal badges, arms, mottoes, the figures of saints and absurd images of animals and birds termed 'baboueney' (see Mills, p.206). The study, which evidently served as a retiring room, had a painted ceiling studded

71 JAN SIBERECHTS
Wollaton Hall, Nottinghamshire, 1697
Oil on canvas
191.8 × 138.4 (75½ × 54½)
Yale Center for British Art,
New Haven

with figures of angels, and contained two desks, one with a shelf for the king's books.[40]

Fireplaces were a natural focus for any living interior and came to be positioned and ornamented in distinctive ways throughout Europe. The French, for example, tended to place fireplaces on the axis of public chambers such as the *grande salle* (or great hall) to form the backdrop to the dais. Such arrangements were occasionally copied in British royal building works, as for example by the Scottish kings in the great hall at Linlithgow and the late fourteenth-century great halls of Kenilworth and Kennington (Greater London). Normally, however, fireplaces in Britain were set in the long walls of interiors. Moreover, they were often placed asymmetrically so as to create a warmer, favoured end to the room.

In formal chambers it was the universal practice to ornament the surfaces above fireplaces. Such ornamentation could take a wide variety of forms including painted decoration, special tapestries and miniaturized architectural displays of stone or timber. Moreover, just as with hangings, it became the practice to signal the relative importance of withdrawing chambers by the splendour of their fireplaces, the richest being reserved for the great chamber. The most common subject of fireplace decoration throughout the Long Middle Ages was heraldry. Indeed, in houses where the owner was not of sufficient status to possess a canopy of estate, the fireplace came to stand in its place as a statement of identity. It is worth noting that prior to the seventeenth century there developed no tradition in Britain of decorative overmantles above doors, a practice known in France from 1400 onwards.

As fireplaces received internal emphasis, so, too, did their external adjuncts: chimneys. From the early twelfth century in the works of Bishop Roger of Salisbury at Old Sarum (Wiltshire) a fascination with complex carved ornament, that was to become a hallmark of English chimneys in particular was becoming apparent. Besides being richly carved, chimneys also came to be massed in extraordinary numbers on the parapets of great residences for deliberate architectural effect. In some cases they could take on the forms of full-scale buildings: at Maxstoke Castle (Warwickshire), for example, built in the 1340s, the chimneys echo the massive Caesar's Tower at nearby Warwick. During the mid-fifteenth century it further became common to build chimneys in red brick and also to set additional dummy chimneys on gables. The interest in chimneys may have

been encouraged by the increasing use of flat lead roofs as a space for recreation in grand residences from the fourteenth century onwards. At buildings such as Longleat (Wiltshire), completed in the 1570s, it is still possible to appreciate the extraordinary effect of massed chimneys set between banqueting houses as ornamental features in the roofscape of a house.[41]

The Castle and the Great Tower

Throughout the Long Middle Ages the elements of a residence could be distinctively organized to create a type of building that implicitly celebrated the military vocation of a nobleman or knight. The castle was a type of fortified building that developed in the area of the former Carolingian Empire during the chronic political instability of the ninth and tenth centuries.[42] It was effectively introduced to England at the Norman Conquest in 1066 and over the next century penetrated every corner of Britain. The nobility both in mainland Britain and Ireland had previously lived in fortified residences, but the castle differed from these buildings in both institutional and architectural senses. Institutionally, castles were buildings of military and administrative purpose, erected, maintained and garrisoned with the resources of a designated group of estates. In this sense they were bound to the land and served as a physical expression of lordship and military service. Architecturally, castles were not only more ambitious than their predecessors, but in some cases they made use of a kind of building without Roman or native precedent: the 'donjon'.

Where they were constructed, donjons were the visual centrepieces of castles, dominating the fortified enclosures or baileys that lay adjacent to them. Significantly, the word derives from *dominatio*, which literally means 'lordship'. Donjons might take various forms depending on the resources and needs of the builder. The most common type across Britain prior to about 1150 was a tower embanked within or raised up on an artificial mound of earth termed a motte. Such towers set on mottes were usually of wood but could incorporate stone elements as well. Mottes are found widely distributed across the whole of Britain and – contrary to what is conventionally argued – in certain major castles continued to be adapted and occupied into the seventeenth century, as at Windsor (Berkshire) and

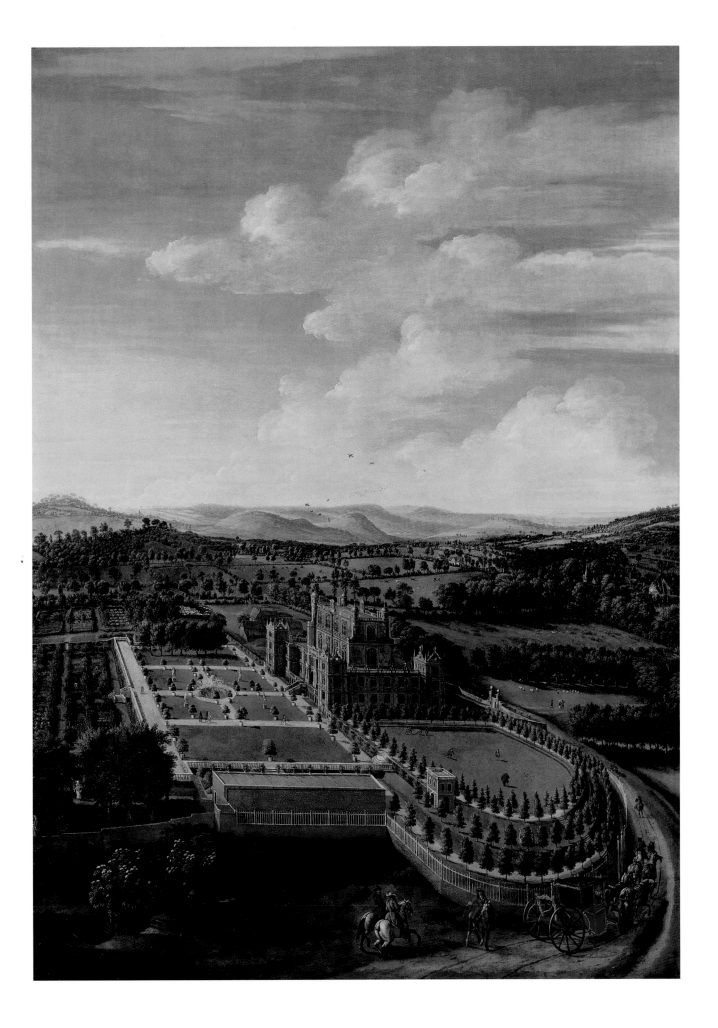

Tamworth (Staffordshire). The alternative type of donjon was a massively constructed tower of stone, usually on a rectangular plan. Simply by virtue of their cost, until the mid-twelfth century such buildings were the exclusive preserve of the English king and his immediate circle. None at all were built in Scotland in the same period, though King David I (1124–53) probably completed one begun by Henry I (1100–35) at Carlisle (Cumbria).[43]

The defining building in the tradition of English great tower building was the White Tower at the Tower of London (fig.64, p.118). Begun by William the Conqueror in around 1070, it was almost certainly a copy of the tower built by the dukes of Normandy in their capital at Rouen. Various regional traditions of great-tower architecture subsequently developed in twelfth-century England, all of which looked ultimately to the Tower of London for their inspiration. Great towers quickly became an essential feature of all major castles and a steady stream of such buildings was erected throughout the Long Middle Ages. Their construction was often linked to the accession of an owner to noble title. Notable surviving examples include Clun (Shropshire), of the late thirteenth century; Tattershall (Lincolnshire), begun in 1440; Ashby-de-la-Zouch (Leicestershire), begun

in 1473; and the 'Little Castle' at Bolsover (Nottinghamshire), begun in 1612. To the number of new great towers should be added those ancient ones which were repeatedly refurnished, such as Kenilworth or Corfe (Dorset).

Part of the appeal of these massive towers lay in the prestige of the architectural form they imitated, which in the case of the White Tower was thought to be of Roman origin. This link with Rome may suggest that the continued popularity of the form in buildings such as Wollaton (Nottinghamshire) was bound up in part with an interest in home-grown classical design (fig.71). Great towers were also consistently admired because they organized residential apartments within a regular and imposing volume. Yet the classic rectangular plan limited the ways in which residential chambers could be contrived and some patrons chose to reject it altogether. The late fourteenth-century great towers at Warkworth (Northumberland) and Old Wardour (Wiltshire), for example, are respectively laid out on the plan of a Greek cross and a hexagon. In such designs – and the Perpendicular style from which they sprung – are to be found the origins for the fascination with complex, high-rise and compact planning during the late sixteenth and early seventeenth centuries (see Cooper on Hardwick Hall, pp.244–5).

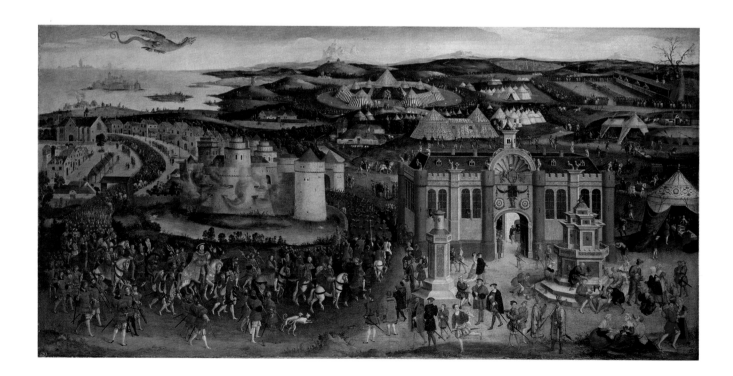

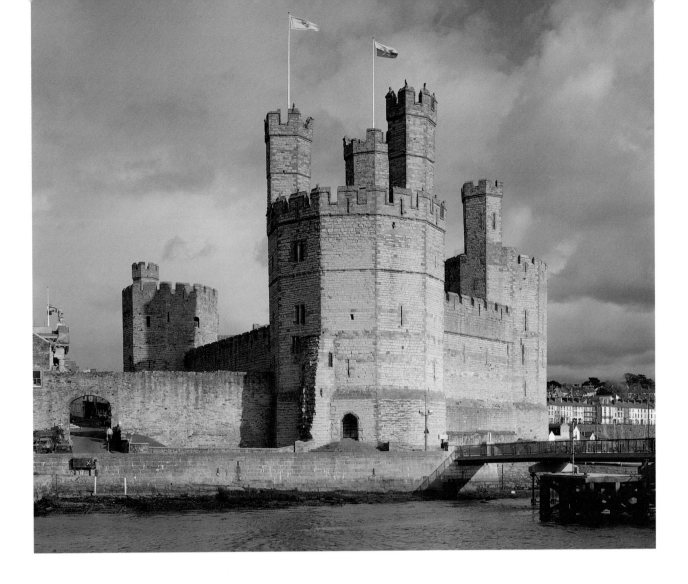

Great towers always remained the preserve of the wealthiest noblemen, but they were emulated as far down the social scale as money allowed, and houses and castles in both rural and urban settings commonly incorporated a dominating tower. In different parts of Britain such towers tended to be informed by regional traditions of design. Amongst the most celebrated are the tower-house traditions of Scotland, northern England and Ireland, which properly developed from the late fourteenth century onwards.[44]

Another architectural form that became inextricably bound up with the castle was the battlement or crenellation. This was in origin teeth of stone or timber intended to protect men fighting from a parapet. Battlements were probably first introduced by the Romans and surviving manuscript illustrations demonstrate that they continued in use through the Anglo-Saxon period.[45] By virtue of their defensive purpose they became the outstanding symbol of the castle after the Norman Conquest in 1066. Rich with martial and chivalric symbolism, the battlement also became universally popular from the thirteenth century onwards as architectural ornament in all types of building, from churches to town houses, with their stepped gables.[46]

In all these contexts battlements might be used as much for defence as decoration. They begin to appear from the late thirteenth century on buildings in both full-scale and miniature form. Scholars have been much concerned to distinguish between the defensive and decorative application of battlements that such varied use implies. But the reality is that the two blend seamlessly into one another. Something of their deliberately theatrical quality is suggested by the practice of populating battlements with sculptures of animals or men, the latter often depicted hurling stones and brandishing weapons. A famous example occurs on the so-called Eagle Tower at Caernarfon, a building symbolic of Edward I's conquest of Wales and rich with architectural detailing (such as banded masonry) evocative of Roman building (fig.73). Populated battlements also appeared on Henry VIII's palace for the field of Cloth of Gold in 1520 (see fig.72) and the new royal apartments of Stirling Palace, begun 1538 (see Fawcett, p.137). In both cases it was combined with heraldic displays. So familiar did the battlement become that it was eventually possible to alter without compromising its message. In the sixteenth century it might become smothered in

74 Pendant case showing a knight
armed by his lady, c.1325–40
Silver-gilt with translucent enamel,
height 5.1 (2)
Victoria and Albert Museum, London

Renaissance detailing, as at Layer Marney (Essex), or pierced through with inscriptions, as at Hardwick New Hall in Derbyshire (see Cooper, pp.244–5).

Knighthood and Chivalry

As battlements glorified buildings, so did armour aggrandize men. Throughout this period fine arms and armour were the exclusive preserve of the wealthy and became more than merely functional objects: they became symbols of knightly vocation, social status and power.[47] The weapons and armour of the Anglo-Saxon world were literally inherited from the late Roman period. Not only was Roman armour probably still in circulation, but it also influenced the design of new pieces such as the eighth-century Coppergate Helmet found at York.[48] Direct Roman influence is also apparent in the insignia of battle. King Edwin of Northumbria, for example, rode about his kingdom with the banner 'called *Tufa* by the Romans and *Thuf* by the English' carried before him.[49]

Following the Norman Conquest in 1066, a new style of fighting was introduced to England. Henceforth the Anglo-Norman knight fought on horseback, as opposed to fighting on foot, and wielded the lance and sword. The expense of his equipment and the technical training necessary for this feat effectively set him apart from other soldiers. Quite how exclusive this mode of fighting was is reflected in the emergence of concepts of chivalry, a word that literally means 'the behaviour of those with horses'.[50] This came to embrace ideals of behaviour in war, love and religion. As a mark of knighthood there also developed a system of heraldry, a form of visual identification devised for the battlefield with rules of application and use that grew steadily more complex as time progressed (see Geddes, p.35).[51] By the thirteenth century heraldry was being applied to every type of object from floor tiles to window shutters and from women's dresses to jewellery (for later examples see Saul, pp.138–9, fig.78, and p.205, fig.115).

In order for knights to practise their trade it also became common from the twelfth century to stage mock battles called tournaments. At first these were pitched battles in all but name, but they evolved a complex protocol and a completely separate set of equipment. They also became extravagant chivalric spectacles (fig.75). Men not only jousted under tournament heraldry (termed the 'arms of

peace') but dressed as fictional characters or heroes of chivalric legend. They also bore weapons and armour deliberately fashioned for the tourney field. It is a mark of their appeal that, despite the attendant dangers, tournaments continued to be fought by the British nobility into the seventeenth century.[52]

One side-product of this chivalric culture was a huge and vastly popular genre of literature, the chivalric romance, in which heroic figures like King Arthur and Guy of Warwick struggled to fulfil their vocations as lovers, Christians and knights (see Bovey, p.136). These heroes in turn inspired works of art and architecture: for example, in 1397 Thomas Beauchamp, Earl of Warwick, possessed a set of tapestries depicting the deeds of Guy of Warwick, having also completed Guy's Tower at Warwick Castle in 1393–4. And in 1423 one of his successors established a chapel that enclosed a large effigy of the hero cut in the living rock at nearby Guy's Cliffe.[53] At Winchester a round table for Arthurian jousts was created in the thirteenth century and still survives on the wall of the great hall (p.43, fig.15). The cult of chivalry also encouraged scenes of parody-warfare in festivities and emerged as a subject in art, prominent motifs including the castle of love and the image shown here of a knight armed by his lady from a tower (fig.74).[54]

75 Richard Beauchamp, Earl of
Warwick (d.1439), jousts for the queen
at her coronation, page from the
Beauchamp Pageant, after 1483
On parchment 27.8 × 24 (11 × 9½)
British Library, London
(Cotton MS Julius E.IV, f.3)

Conclusion

The end of the Long Middle Ages in the mid-seventeenth
century is most readily apparent in the breakdown of the
chivalric culture that defined the aristocracy. Prior to the
Civil War and from the date of the earliest monuments
with effigies (around 1150), it remained consistently popular
to depict men who owned land – regardless of their
military record – in armour (see Monckton, pp.110–11).
From at least the thirteenth century it was also the practice
to suspend over tombs the weapons, armour and shield of
the deceased as 'achievements', as survive over the Black

Prince's tomb built after 1376 at Canterbury Cathedral
(Kent).[55] In some cases the armour portrayed on effigies or
presented as achievements is outdated in style
or fabricated for effect. Nevertheless, these symbols made
a point about the conceived importance of the fighting
vocation within society. It is notable that within two
generations of the Civil War such funeral effigies of men in
armour were becoming unusual; soldiering was no longer
a mark of social distinction. The knight's arms and his
castles were things of the past. There could be no more
powerful witness to the passing of the Long Middle Ages.

Picturing Romance

ALIXE BOVEY

It is one of the ironies of medieval British art that, while Arthur was revered as King of Britain with growing intensity across Europe from the twelfth century, comparatively little art celebrating his exploits survives in the British Isles. This contrasts sharply with the situation on the Continent, where illuminated manuscripts and artefacts depicting Arthurian scenes are in much greater supply. A range of factors, including patterns of survival, different Insular reading tastes and practices, and a preference for imported illuminated literary manuscripts and luxury objects, could partially account for the paucity of British visual Arthuriana.

One exceptional survival is the Arthurian tale of *Sir Gawain and the Green Knight*, a masterwork of Middle English alliterative verse, which survives in a single, scruffy manuscript dated to c.1400. *Gawain* and the three other poems in this manuscript are accompanied by twelve illustrations, executed in a rough and ready style that was derided by Loomis and Loomis as '[t]he nadir of English illustrative art'. The three images accompanying *Gawain* illustrate key moments in the narrative. The first shows King Arthur and his court, seated at a table, looking on in astonishment as the Green Knight's decapitated head, held aloft by the Green Knight's body, addresses Gawain, who has just chopped it off with an axe as part of a mysterious beheading game (fig.76); the second shows Gawain's attempted seduction by his hostess; and the third depicts Gawain's return to court. While acknowledging the artist's shortcomings as a draughtsman, a growing number of scholars have argued that these images offer a careful and revealing critique of the poem.

Much secular art has been lost, and objects made for the domestic sphere have been particularly vulnerable; however, documents and a few artefacts indicate that Arthurian romance caught the imagination of England's rulers. Henry III's palaces were decorated with now-lost scenes from romances. The tiles of c.1250–70 that were discovered at Chertsey Abbey, containing depictions of episodes from the romance of Tristram, may have been designed originally for a royal palace. A monumental round table measuring 18 feet (5.5 metres) in diameter, arguably made in the second half of the thirteenth century and repainted during the reign of Henry VIII (1509–47) with an image of King Arthur and his knights' names, survives in the great hall of Winchester Castle (fig.15, p.43).

76 King Arthur and his court watch as the Green Night's decapitated head addresses Gawain, from *Gawain and the Green Knight*, c.1400
On parchment 17.1 × 12.3 (6¾ × 4⅞)
British Library, London
(MS Cotton Nero AX, f.94v)

Arthur's iconic Round Table, first mentioned by Wace, an Anglo-Norman poet, in 1155, was not only a chivalric brotherhood and a piece of furniture, but evidently also a type of building: recent excavations at Windsor Castle have unearthed the foundations of an enigmatic 'Round Table' building erected in 1344 by Edward III (1327–77) to house the knights of the Order of the Garter.

The low survival rate for Arthurian art is indicative of the scarcity of images of romance more generally. The Auchinleck Manuscript is a remarkable, if mutilated, exception (National Library of Scotland, Edinburgh, Advocates' MS 19.2.1): a stout compendium of Middle English literature, it was made in London in c.1340 and once included miniatures situated at the beginning of most of its texts, though at some point all bar five of these were cut from the book. The Auchinleck Manuscript includes the earliest Middle English version of several romances, including *Beves of Hamptoun*, *Guy of Warwick* and its sequel *Reinbroun*, the story of Guy's son; today only five miniatures survive, including those for the romances *Beves of Hamptoun*, *Reinbroun*, *King Richard* and the *King of Tars*.

Seemingly, *Guy of Warwick* had a more secure place in English visual culture than his Arthurian rivals and other romantic heroes. Composed in the thirteenth century in Anglo-Norman French, it recounts the exploits of its eponymous hero as a courageous adventurer, dragon slayer, rescuer of distressed ladies and saviour of England. Images of Guy appear in chronicles and also in narrative cycles recounting some of Guy's adventures, including in the margins of two manuscripts made in London c.1330–40, the *Taymouth Hours* (BL, Yates Thompson MS 13) and the *Smithfield Decretals* (BL, Royal MS 10.E.IV). On a silver and wood dish (c.1300–50) depicting Guy's most iconic deed, the slaying of a dragon, Guy carries the arms of the Earls of Warwick, the Beauchamps. Keen to cultivate identification between Guy of Warwick and themselves, the Earls of Warwick nurtured Guy's cult at Guy's Cliffe near Warwick Castle, the cave to which Guy allegedly retreated as a hermit at the end of his life. There, in a chapel near his cave, a monumental statue of Guy remains as a reminder that romance once featured more prominently in the arts of medieval Britain than is obvious from surviving artefacts.

FURTHER READING

M. Andrew and R. Waldron (eds.), *The Poems of the 'Pearl' Manuscript*, London, 1979.

M. Biddle (ed.), *King Arthur's Round Table*, Woodbridge 2000.

M. Borroff (trans.), *Sir Gawain and the Green Knight*, London 1968.

R. S. Loomis and L. Loomis, *Arthurian Legends in Medieval Art*, Oxford 1938.

V. B. Richmond, *The Legend of Guy of Warwick*, New York and London 1996.

Stirling Castle and the Architecture of Scottish Kingship in the Late Middle Ages

RICHARD FAWCETT

On the basis of the little that is known of how Scotland's kings were housed before the fifteenth century, it seems that the differences between their own residences and those of their leading magnates were of scale rather than of essential character. A turning point in the design of the royal residences may have been the return of James I (1406–37) from English captivity in 1424, following which works were undertaken at Linlithgow Palace (West Lothian). But these were as nothing to the scale of the works carried out for James IV (1488–1513) and James V (1513–42), who were clearly determined to express their royal and chivalric credentials through palace building operations of unprecedented magnitude. Since the former married a daughter of Henry VII of England in 1503, and the latter was briefly a son-in-law of Francis I of France in 1537, the need for these two kings to proclaim their role as monarchs on the European stage by all available means may have assumed greater urgency.

An extraordinary series of new buildings was erected at the castles of Stirling (Stirlingshire) and Edinburgh, and at the palaces of Linlithgow, Holyrood in Edinburgh and Falkland (Fife), as well as at some of the lesser residences. In most cases enhanced dignity was achieved by grouping the main buildings around the four sides of a courtyard. At Linlithgow and Holyrood tightly regular quadrangular arrangements were eventually achieved: in the former case the influence of the great northern English houses of Lumley (County Durham) and Bolton (Yorkshire) is probably discernible, while at Holyrood the growth out from the cloister of the host Augustinian abbey was a factor. At Stirling, Edinburgh and Falkland, however, the process was more accretive, with only limited striving after architectural uniformity. Since it would not be possible to consider all of the later medieval Stewart residences here, attention will be concentrated on Stirling, where work over recent years has clarified our understanding of the constituent buildings (fig.77 and illustration on p.12).

The first recorded significant construction carried out for James IV at Stirling was a suite of lodgings for himself on the west side of a new courtyard – the inner close – formed at the heart of the castle and on the very edge of the castle rock where it could command fine views across to the distant hills around Loch Lomond. This was the 'king's house' designed by Walter Merlioun in 1496, and within it were a hall, chamber, inner chamber and kitchen, all raised

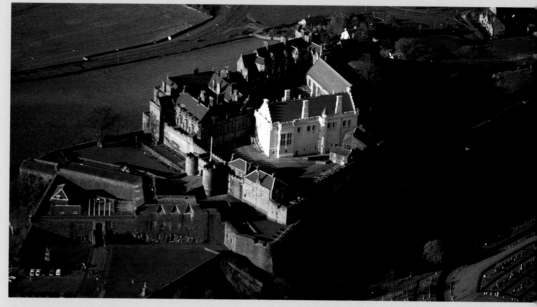

77 Aerial view of Stirling Castle

to first-floor level above vaults. A vast new great hall on the opposite side of the close was probably started at the same time, since its walls were ready for plastering in 1503, around the time of the king's marriage to Margaret Tudor. With its symmetrical pair of bay windows flanking the dais, a band of clerestory windows to the main space, and a hammer-beam roof, this was perhaps intended to outrival his father-in-law's hall at Eltham Palace, which still survives outside London. The architectural idiom, however, was resolutely Scottish, and it is possible that, like the king's house, it was designed by Merlioun.

On the south side of the close an older lodging may have been modified to accommodate the new queen, while along the north side was an obliquely set chapel. In 1501 James handsomely endowed the latter as the Chapel Royal of Scotland, and presumably hoped eventually to rebuild it; his death at the Battle of Flodden (1513) prevented this, however, and it was only in 1594 that it was rebuilt to its present form for James VI. One other structure that James IV did build, however, was the forework, a great many-towered wall across the main approach to the castle, which was nearing completion by 1504 at the hands of the masons John Yorkston and John Lockhart. With its soaring gatehouse and towers, all capped by *chemins-de-ronde* and conical roofs, this was plainly intended to mark

the approach to the court of a king whose pursuit of the chivalric ideals was paramount.

The south side of the courtyard was eventually closed by a massive new quadrangular palace built for James V and his second French queen, Mary of Guise Lorraine, on which work was started in 1538. Ranged around four sides of a small courtyard, its three main facades were richly articulated by arches decorated with dropped cusping and by statues carried on baluster shafts; all of this, although much Scoticized in execution, was presumably designed by one the king's French masons, perhaps Mogin Martin, Nicholas Roy or John Roytell. Nevertheless, the progression of pilaster-like salients and the deep crenellated parapet may also have been intended to make reference to the donjons of the twelfth century that were still regarded as an important expression of ancestry. Inside the palace was a precociously arranged pair of lodgings, each consisting of a hall, outer and inner chambers and closets.

FURTHER READING

J.G. Dunbar, *Scottish Royal Palaces*, East Linton 1999.
R. Fawcett, *Scottish Architecture from the Accession of the Stewarts to the Reformation, 1371–1560*, Edinburgh University Press 1994.
R. Fawcett, *Stirling Castle*, London 1995.
R. Fawcett (ed.), *Stirling Castle: The Restoration of the Great Hall*, Council for British Archaeology, 2001.

Death, Art and Memory at Cobham, Kent

NIGEL SAUL

Tombs and brasses survive in greater number in England than anywhere else in Europe. The market for funerary sculpture in England was large, reaching into the lesser gentry, though it was smaller in Scotland and Wales. A rough hierarchy of decorum determined choice of commemorative form. Gilt metal was reserved for the tombs of royalty (see Coldstream, pp.106–7, and Monckton, pp.110–11), while high chests were used by the nobility and incised slabs by clients of lesser status. Figure brasses costing no more than a few pounds were commissioned by patrons of all ranks.

From as early as the mid-Saxon period monuments played an integral role in strategies for salvation of the soul. Their primary task was to elicit intercessory prayer for the commemorated. At the same time, however, through the use of effigies, they were ensigns of status; they answered the question, what sort of person is buried here? An armoured figure commemorated a member of the male gentry, a civilian figure a member of the burgess or professional class. Substituting for the deceased, the monument preserved his or her memory in the community.

The grandest series of brasses to have come down to us is that at Cobham (Kent). Here, in the chancel, are two impressive rows of memorials, all to members of the Cobham family, lords of the manor (fig.79). As in so many other parish churches, the spur to commemoration was a chantry foundation. In 1362 John, Lord Cobham, established a chantry of five chaplains to pray for the soul of the founder on his death and others named by him. Shortly afterwards he commissioned four brasses to some of those for whom the priests were to pray – his father, cousin, aunt and of course himself. On all the memorials intercessory discourse is dominant in the Latin or French inscriptions. On his own epitaph John stressed the transience of earthly existence.

Over the next fifty years nearly a dozen brasses were to be laid alongside these four. The growth was partly a reflection of the natural development of Cobham as the Cobham clan's burial place. In part, too, however, it was a reflection of a family in crisis, a family facing extinction in the male line. John's heiress was his daughter Joan, whom he married to Sir John de la Pole of Chrishall (Essex). They bore just one

78 Rubbing of the brass of Joan, Lady Cobham (d.1434), the Cobham family heiress

79 The chancel of Cobham Church, Kent,
mid-13th century with late 14th-century additions

daughter, another Joan, who was brought up in Kent by her grandfather after the deaths of her parents and was invested with a Cobham identity (fig.78). This Joan, the eventual family heiress, was five times married. By her first and her two later marriages she had no issue. By her second and third marriages, however, she bore three sons, not one of whom survived to manhood. The brasses at Cobham attest the family's bitter disappointment. The brasses to Reginald Braybrooke and Nicholas Hawberk, the second and third husbands, which Joan commissioned in about 1409, are among the earliest to show children, the figures of the little boys nestling by their fathers' feet.

When Joan herself died in 1434, she was shown on her memorial as the fecund mother, the bearer of a healthy brood. At her feet are two little groups of children, boys as well as girls, all looking up to their mother. In reality, however, only one daughter survived, a child by Braybrooke: hence the description of Joan in the epitaph as Braybrooke's wife. At one level,

the brass can be seen as a celebration of the Cobham lineage, its dazzling heraldry offering an epitome of the Cobhams' history (see fig.78). At a deeper level, however, it is a study in hopes disappointed. After six generations the Cobham line had ended. The emphasis, however, is on continuity between past, present and future. The memorials were instrumental in negotiating the transition to the new family succeeding to the Cobham title. The impression was given of preservation of the old identity through the issue of the second husband, Braybrooke.

The Cobhams' brasses provide one of the clearest instances of memorials being commissioned in response to family crisis. Not every set of monuments, however, should be interpreted in these terms. There are many fine monuments commissioned by families whose fortunes were stable. The splendid series to the Vernons at Tong (Shropshire) fall into this category. The fact is that by the fourteenth century commemoration by monuments was part and parcel of gentry culture. Assemblages of brasses and

tombs hardly less impressive than the Cobhams' can be seen at Spilsby (Lincolnshire), Chinnor (Oxfordshire) and Harewood (Yorkshire). It is likely that further insights into motivation may be yielded by close study of this type of monument in the context of the dynastic and religious strategies of the family.

FURTHER READING

P. Coss and M.H. Keen (eds.), *Heraldry, Pageantry and Social Display in Medieval England*, Woodbridge 2002.

N.E. Saul, *Death, Art and Memory in Medieval England: The Cobham Family and their Monuments 1300–1500*, Oxford 2001.

Pictura et scriptura huius pagine subtus
uisa est de propria manu sci dunstani.

Abbat. Alley. 1579.

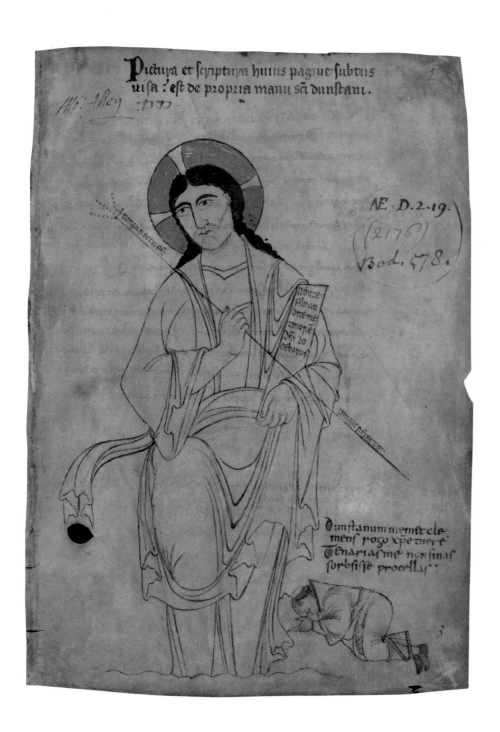

ÆED.2.19.
(2176)
V.Bod.578.

Dunstanum memet clemens rogo xpe tuere
Tenarias me non sinas sorbsisse procellas.

5 The 'Artist': Institutions, Training and Status

PHILLIP LINDLEY

Introduction

The first question to address here is whether the medieval 'craftsman' can actually be identified as an 'artist' at all. The use of the word 'artist', its meaning (or range of meanings), status and reception by readers today – are all culturally determined.[1] It cannot simply be employed as if its current meaning were the same as the various different terms used in the 'Middle Ages' when the status of the makers of what we now call 'works of art' was very different:[2] as a consequence, the terms 'artisan' and 'craftsman' or 'craftswoman' will sometimes be preferred here.[3] In fact, our modern desire to identify individual artists' originality and innovation would have seemed strange in medieval Britain, when collaborative production was normal, though some craftsmen and craftswomen achieved considerable fame, individual work was often subsumed within 'workshop' output, and tradition was looked upon as positive and authoritative, not as something to be despised and rejected.[4] The model of art history that lays so much emphasis on the individual creators' contribution to artistic progress was not actually encountered in Britain until the sixteenth century when there was a reappraisal of the status of the artist and the first steps towards modern definitions of art were brought to England by Italian artists. A second question is what should be included within the definition of 'art'. The Renaissance trilogy – architecture, painting and sculpture – is inappropriate to Britain c.600–1600 when goldsmiths' work and textiles were of equal or greater contemporary importance.[5] Accordingly, a variety of different types of media will be considered, even though some of them would now generally be classified as 'minor' or 'decorative' arts. Finally, there is the definition of British. Mass immigration and the 1998 establishments of elected Northern Irish, Scottish and Welsh assemblies have undermined the whole notion of 'Britishness' today, but 'British' is also a problematic word to employ in the period covered by this volume.[6] Scotland was an entirely separate nation from England throughout most of it – whatever the claims of Edward I (1272–1307) to overlordship – and Wales can only really be subsumed within a political notion of 'Britain' towards the end of our period, under the Tudor monarchs. Earlier attempts at conquest, culminating in Edward I's decisive invasions, mean that the major castles of Wales can be best understood as significant examples of *English* architecture. As well as conquerors of Wales, English monarchs were also dukes of Normandy and Aquitaine, counts of Anjou, Maine and Touraine and lords of Ireland during some of this period. Defining Britain in a nineteenth- or twentieth-century sense seems inaccurate and inappropriate here. Accordingly, 'Britain' in this essay will generally designate only 'England' and sometimes 'England and Wales'. The currents of art and artisans from mainland Europe, and the flow in the other direction, will, however, be a constant theme.

I have subdivided the millennium covered here into three separate periods. The first, focused on Anglo-Saxon England, stretches from c.600 to 1066. The other two parts, covering the period from the Norman Conquest to the Black Death (1066–c.1350), and from the Plague to the Reformation (c.1350–c.1550), are similarly defined by major ruptures.[7] It is inevitable that such a wide chronological sweep must sacrifice depth in favour of breadth and preclude all but the most fleeting considerations of some important issues.[8] Here I shall concentrate on the place of monastic craftsmen, the king's works, workshops and later medieval guilds; other major issues, such as the status and training of 'artists', workshop processes, the use of models and the relationship between tradition and innovation, will also be discussed.

Anglo-Saxon England: An Aesthetics of Effulgence

SOURCES AND SURVIVALS

'The men of England are outstandingly skilled in all the arts', claimed the Norman historian William of Poitiers (c.1020–90) after the Conquest. He went on to describe the superlative qualities of Anglo-Saxon goldsmiths' work.[9] Today it is hard to appreciate the international reputation

that the sumptuous arts of Anglo-Saxon England once enjoyed. Viking invasions; the looting by the Normans after the Conquest; the anarchy of Stephen's reign (1135–54); the vulnerability of all precious metalwork to liquidation to realize the materials' intrinsic value or for reuse; fires, thefts and accidents; the massive depredations caused by the sixteenth-century Dissolution of the Monasteries; and the looting of parish churches in Edward VI's reign (1547–53), have deprived us of virtually all the most important pieces of Anglo-Saxon goldsmiths' work.[10] None of the few extant pieces would have been considered of major significance at the time, save for those from the Sutton Hoo burial.

As a consequence, we have to rely on archaeological discoveries and on scanty documentary references, generally chronicles, charters, saints' lives or wills. Bishop Asser (d.909), for example, testifies to the revival of metalwork craftsmanship at the court of King Alfred (871–99), and monastic chronicles are a major source of information.[11] An Abingdon chronicler documents – apparently from earlier records – that Bishop Aethelwold's gifts to the monastery included a gold and silver retable, a weighty gold chalice, three crucifixes of silver and gold, Gospel books covered with silver and gold, censers and cruets, cast basins and silver repoussé candelabra and many other objects.[12] Such references are almost always incidental in these sources, which did not share our interest in the work of art for its own sake. The chronicles, too, are ambiguous, and it is frequently unclear whether a patron had something made or made it him- or herself.[13]

NAMES AND STATUS: MONASTIC AND LAY CRAFTSMEN AND CRAFTSWOMEN

What do we know about the identity or status of the craftsmen? Their names can be found on some surviving metalwork, in terms that make it clear that the maker is indicated. Thus, the Brussels Cross of the early eleventh century has 'Drahmal made me' on the arms, flanking the Agnus Dei (p.182, fig.100), whilst another inscription includes the patrons.[14] The Pershore censer (British Museum, London) bears the Old English inscription, 'Godric made me', in rather badly spaced letters, suggesting the artist may not have been used to writing.[15] Anglo-Saxon moneyers had to be able to strike the letters of inscriptions on the piles and trussels of their dies, and their own names were struck on the reverse of coins. Moneyers

were specialized goldsmiths, whose high social status is demonstrated by the fact that they were often of the 'thegnly' class, the landed nobility.[16] That weaponsmiths were also highly esteemed is shown by the will of Aetheling Aethelstan (d.1014), in which the craftsman is named: 'the sword with the silver hilt which Wulfric made and the gold belt and armlet which Wulfric made'.[17] Swords not infrequently bore their makers' names. Signatures can also be found on stonework: a font at Little Billing (Northamptonshire) bears the statement that it was made by Wigberhtus 'craftsman and mason' and the name of Toki the stonemason is inscribed on a memorial slab at Stratfield Mortimer (Berkshire).[18] Such inscriptions show the craftsman's awareness of his worth (and also demonstrate a level of literacy).[19]

In the Insular period some goldsmiths may have been monks. Aethelwulf's ninth-century *De abbatibus* includes the names of an earlier scribe and a metal-worker, both monks in a daughter-cell (or offshoot) of Lindisfarne.[20] The Lindisfarne Gospels (BL Cotton MS Nero D.iv; see Hawkes, pp.198–9) itself has a tenth-century colophon (f.259r) telling us that the book's cover was embellished with gems, gold and silver-gilt by Billfrith the anchorite and inviting the reader's intercession for his salvation.[21] Three more monastic goldsmiths are listed in the records of the New Minster, Winchester.[22] However, by the end of the Anglo-Saxon period, most goldsmiths were probably laymen. For the 971 translation of St Swithun at Winchester, King Edgar (959–75) gathered secular goldsmiths at his own residence, and at Wilton King Cnut (1016–35) brought three goldsmiths together to make a shrine for relics of St Edith.[23] An exception to the general rule was Abbot Spearhafoc of Abingdon: the hagiographer Goscelin (d. c.1099) tells us that Spearhafoc was an outstanding artist in painting, gold-engraving and goldsmithing.[24] Before 1047 he was fashioning large figures in metal at St Augustine's Abbey, Canterbury, demonstrating that monastic craftsmen, too, could be peripatetic.[25] However, after Edward the Confessor (1042–66) nominated him to the Bishopric of London in 1050, and provided him with a store of gold and jewels for a new crown, Spearhafoc absconded and was never seen again.[26]

Goscelin praised the needlework of Anglo-Saxon craftswomen.[27] Such needlework, incorporating gold, gems and pearls, was the product of a long and distinguished tradition, today represented by the tenth-century stole and

maniple from the tomb of St Cuthbert (c.635–87; fig.80).[28]
Bede (672/3–735) complains that the nuns of Coldingham
misused their talents, devoting their attentions to 'weaving
fine clothes, either to adorn themselves like brides, to the
peril of their calling, or to procure the friendship of strange
men'.[29] In 745 St Boniface also criticized the vainglorious
ornamentation of habits in nunneries, although he encour-
aged such skills when put to their 'proper use', and sent
thanks to Abbess Bugga for the vestments she had sent
him.[30] Thomas of Ely recorded that Aethelswitha, Cnut's
daughter, 'devoted herself, with her maids, to gold embroi-
dery . . . [W]ith her own hands, being extremely skilled in
the craft, she made a white chasuble.'[31] Craftswomen also
worked on secular hangings. After the death of Ealdorman
Byrhtnoth at the Battle of Maldon in 991, his widow Aelfflaed
gave the monastery of Ely a hanging, woven and embroi-
dered with the deeds of her husband, as a memorial.[32]
The Bayeux Tapestry must have been embroidered by
a whole team of expert craftswomen, but is generally
thought to have been designed by a male artist and the
patron is usually identified as Bishop Odo of Bayeux, half-
brother of the Conqueror (d.1097; see Gameson, pp.46–7).[33]
Some embroiderers were lay professionals: Domesday
Book records land held by one Aelfgyth 'on condition of her
teaching [the sheriff's] daughter embroidery work', whilst
Leofgyth held an estate because 'she used to make, and
still makes, the embroidery of the King and Queen'.[34]

The craft of the book, the means by which so much of
the learning of the past was transmitted to the future, was
fostered within and protected by Insular monastic commu-
nities. Both Celtic monasticism, which had arrived in
England with St Aidan's foundation in 635 of a monastery
at Lindisfarne in Northumbria, and Benedictine-style
monasticism from Rome, which increasingly supplanted
it after the 664 Synod of Whitby, emphasized the impor-
tance of studying and copying the foundational texts of
Christianity, the Old and New Testaments. Abbot Ceolfrith
had a Bible, the Codex Grandior of Cassiodorus (d.598),
brought from Rome to the monastery of Wearmouth-
Jarrow. The Late Antique illumination of this manuscript
was – most unusually – copied by the Insular artist of
the Codex Amiatinus (Biblioteca Medicea Laurenziana,
Florence, MS Amiatinus 1), one of three bibles made under
Ceolfrith, who died taking the Codex Amiatinus to Rome.[35]
In the medieval period, such historicizing imitations of
earlier styles are very rare and are generally a feature of

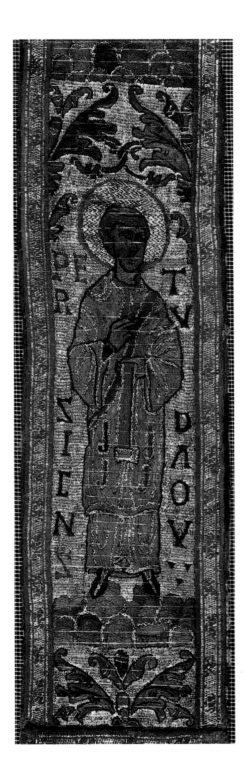

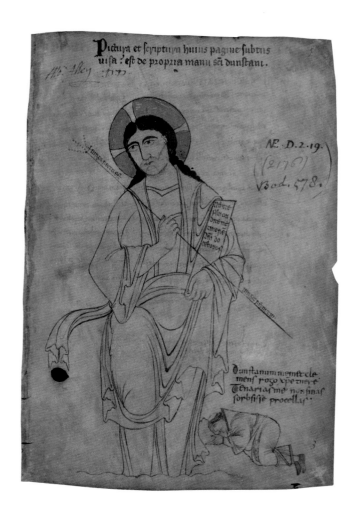

81 Christ adored by St Dunstan, page from St Dunstan's classbook, c.950
On parchment 24.5 × 17.9 (9⅝ × 7)
Bodleian Library, Oxford
(Auct F.4.32, f.1)

classical revivals.[36] They contrast with the transmutation of the illusionistic and painterly style of a similar model into an abstract linear style in the Lindisfarne Gospels. In fact, by transforming their sources, Insular craftsmen created the carpet pages and initial pages that are their greatest contribution to the history of manuscript illumination.[37]

An inscription in the Lindisfarne Gospels added by the priest Aldred (who translated the Latin text into Old English in the tenth century) lists three earlier monks involved in the manuscript's production.[38] The monks he named include Eadfrith, Bishop of Lindisfarne (698–721), who was responsible for the manuscript's illuminations as well as for its script; here, then, 'patron', scribe and artist were one and the same man, and this may also have been the case later in the period.[39] One of the three great ecclesiastics responsible for the tenth-century revival of the Church, St Dunstan, Archbishop of Canterbury (959–88), seems to have been both scribe and painter. His classbook, which appears to have been at Glastonbury when he was abbot there (c.940–56), has a drawing of Christ adored by a kneeling monk (fig.81). The later inscription testifies that it is the work of Dunstan.[40]

Although there were both specialist painters and separate specialist scribes, there is considerable evidence that sometimes they were one and the same man. The Eadui Gospels, now in Hanover (Kestner Museum WM xxiᵃ 36), include a colophon recording that the scribe was a monk named Eadui Basan.[41] He was at Christ Church Cathedral Priory, Canterbury, in c.1012–23 and was the artist of illuminations that include elaborate canon tables, a decorative initial for each Gospel and portraits of the Evangelists.[42] The Eadui Psalter (BL MS Arundel 155) includes a magnificent full-page miniature with an arched structure subdivided into two arches. The left-hand side, which is fully painted, shows St Benedict resting his feet on a kneeling monk wearing a girdle inscribed 'zona humilitatis': this must represent Eadui himself. On the right, in a line drawing touched with wash, is a group of monks, one of whom holds a book inscribed with the opening words of St Benedict's Rule.[43] There are isolated examples of monastic manuscripts being written by laymen at this time, but most scribes and illuminators continued to be monks or nuns.[44]

CONTINENTAL CONNECTIONS

Pilgrimage and monastic peregrination, the acquisition of relics, books and materials, as well as many other ecclesiastical contacts, led to the exchange of ideas and objects. The record of a magnificent manuscript sent to Abbot Gauzelin of Fleury-sur-Loire (1005–30) proves that Anglo-Saxon manuscripts were being transmitted to France.[45] St Oswald, Bishop of Worcester (961) and Archbishop of York (972–92), may have owned the large and opulent Ramsey Psalter (BL MS Harley 2904);[46] its line drawing of the Crucifixion (p.185, fig.102) was painted by an Anglo-Saxon artist who had worked at Fleury, where Oswald himself had been trained in strict observance of the Benedictine rule between 955 and 958.[47] Fleury, which housed St Benedict's shrine, was visited by monks from across Europe for two reasons. First, because a saint's physical remains were directly linked to his active *praesentia* (presence) in the Middle Ages. Second, the reform of Fleury's monastic discipline under Odo of Cluny (d.942) in the late 930s endowed the abbey with status as the centre of authority, scholarship and expertise on Benedictine

monasticism. Abbo, who headed the school there, was sent by his abbot to Ramsey (Cambridgeshire) at Oswald's request; when Abbo returned after two years (985-7), he took with him a gold Anglo-Saxon chalice and vestments, as well as a beer belly from too much English ale.[48]

Benedict Biscop (d.690), Wilfrid (d.709), Ceolfrith and many other prominent churchmen paid visits to Rome: Benedict Biscop journeyed there several times. It was from there that the archbishops of Canterbury collected their pallia (insignia of office) from 927 at the latest.[49] One such journey, made in 990 by Archbishop Sigeric (990-4), is recorded in a collection of scientific treatises, illustrated at Christ Church, Canterbury (BL Cotton MS Tiberius B.V part 1).[50] Sigeric visited many churches in the Holy City before returning to England and compiling a brief diary of his journey.[51] Manuscripts were also exchanged as diplomatic gifts: while Ealdred (d.1069) was Bishop of Worcester, he led a legation to Cologne in 1054 and, according to William of Malmesbury's *Vita Wulfstani*, brought back to Worcester a much travelled sacramentary and psalter that had been produced at Peterborough, given to King Cnut and Queen Emma, and presented by the king to Cologne.[52] Part of the reason for the upsurge in production of de luxe illuminated Gospel books in the first half of the eleventh century may have been that royal patrons commissioned them specifically for use as gifts.[53] Ealdred went on pilgrimage to Jerusalem in 1058 and after his return had the 'upper part of the church [of Beverley, Yorkshire], from the choir to the tower . . . covered with painter's work, which is called ceiling-painting, which is intermingled with gold in various ways and in a wonderful fashion'.[54] While mural paintings generally received little attention from contemporaries, those at Beverley (East Yorkshire) attracted comment because of their gold content. Today only fragments of Anglo-Saxon figurative wall painting survive *in situ*: for example, those at Nether Wallop (Hampshire), and at Deerhurst (Gloucestershire).[55]

A precious survivor of King Alfred's patronage, the Alfred Jewel, with its rock-crystal and cloisonné enamel and engraved gold rear panels, may have been inspired by imperial goldsmiths' work, and this serves to remind us that throughout the Anglo-Saxon period there were also close connections between England and Continental Europe for secular, political reasons. Alfred had spent a short time at the Carolingian court when his father Aethelwulf, King of Wessex (839-58), married his second

wife Judith, daughter of Charles the Bald, King of the Franks. At the end of the Anglo-Saxon period, in the first half of the eleventh century, England was ruled by a Dane and then by a half-Norman king, Edward the Confessor.

THE FERTILITY OF TRADITION: EXEMPLARS AND COPIES

Patrons might bring back manuscripts or other objects from their travels, or require craftsmen to emulate works of art they had seen. Stone sculpture bears witness to the influence of many different kinds of model. Crosses and grave covers reflected Roman and even Middle Eastern material – images and themes probably transmitted through textiles and other artefacts such as the illustrated bible Ceolfrith brought from Rome, mentioned previously.[56] Carolingian manuscripts such as the Coronation Gospels (BL Cotton MS Tiberius A.ii), presented by King Athelstan (924-39) to Christ Church, Canterbury, were made available to Anglo-Saxon artists by such donations. Indeed, one of the Coronation Gospels' four Evangelist miniatures was copied by a mid-tenth-century Anglo-Saxon artist into a still-extant manuscript (St John's College, Oxford, MS 194).[57] When Athelstan visited the community at Chester-le-Street in 934, he gave them a fine Gospels manuscript, unfortunately burned in the Cotton Library fire of 1731 (BL Cotton MS Otho B.ix); it was another Carolingian import, to which was added an illustration of the king kneeling to St Cuthbert and offering the Gospels to him.[58] In 934 the king gave St Cuthbert's shrine both this manuscript and a copy of Bede's *Life of St Cuthbert* as well as the embroideries still preserved at Durham. The manuscript is doubtless that in Cambridge (Corpus Christi College MS 183), which also contains a representation of Athelstan presenting the manuscript to St Cuthbert, now the earliest surviving Anglo-Saxon presentation miniature.[59]

One of the most famous examples of the employment of a Carolingian exemplar occurred towards the end of the Anglo-Saxon period and, indeed, continued after it. The Utrecht Psalter (Rijksuniversiteit Bibliotheek, Utrecht, MS 32), written and illustrated in c.830 at Reims, was brought to England and used as an exemplar for the Harley Psalter (fig.82).[60] The fact that both the Harley Psalter and its exemplar survive permits a detailed exploration of the concept of 'copying', an idea critical to understanding the nature of authority and creativity in early medieval art. The

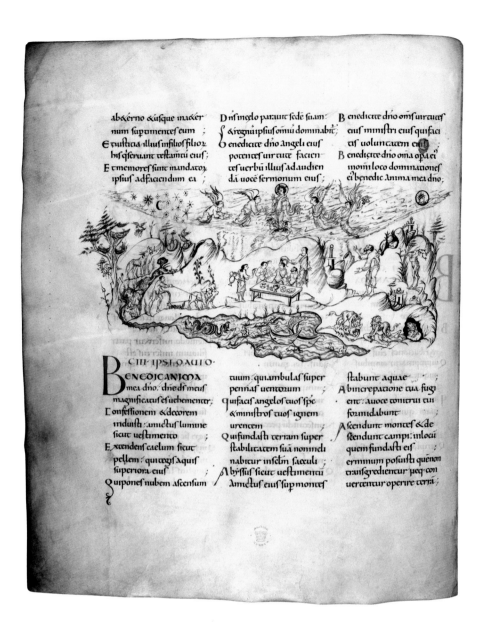

82 Psalm 103 with illustration,
from the Harley Psalter,
c.1010–20 and later
On parchment 37.6 × 31.2 (14¾ × 12¼)
British Library, London
(BL MS Harley 603, f.51v)

Harley Psalter was the work of twelve different hands – two scribes, eight artists, and two scribes who were also artists – including Eadui Basan, the 'scriptorum princeps' (master scribe), whom we have already met at Christ Church, Canterbury. Work started in c.1010 but was left incomplete in the first half of the twelfth century. The potent attraction of the Utrecht Psalter was its superb cycle of illustrations, visually realizing selected verses of the Psalms in a particularly concrete form: the pen drawings head each Psalm, canticle and prayer and are situated in a space that runs across (and between) the three columns of script. Evidence for the priority accorded to these illustrations is provided by the ruling patterns (which determined where text was to be placed) early in the manuscript's production: the artist's requirements for space for illustrations were considered first, before the scribe's, so that work on the illustrations *preceded* the writing of the text.[61] The contention that artists always followed the scribes, and that illustrations

were only added after the writing of texts, is incorrect. Part of the reason that such a view is inadequate is that it neglects the fact that artists were also sometimes scribes and vice versa.[62] Detailed analysis of the manuscript has uncovered the variety of different artistic and scribal responses evoked by the Utrecht Psalter, and suggested how and why Harley, in its later phases of production, deviated dramatically from its exemplar.[63] A strikingly complex and lengthy production process contributed to significant departures both from the exemplar and indeed from the intentions of the Harley manuscript's original patron and artists, in the hands of later artists and scribes.

Patrons of the time might also influence English art by sending for, or bringing back, Continental artists. When Benedict Biscop founded the monastery of Wearmouth in 674, he brought masons and glaziers from Gaul; books, relics and paintings (of the Gospel and incidents from the

Apocalypse) from Rome; and even John the archcantor from St Peter's to ensure that the northern monastery *sounded* Roman.[64] St Wilfrid (c.634–709/10) apparently used masons from Rome to build his church at Hexham, Northumbria, in around 700;[65] in 764 Cuthbert, Archbishop of Canterbury, wrote to Mainz seeking makers of glass; and in the late ninth century, according to Asser, King Alfred gathered large numbers of craftsmen from all nations round him.[66] Just before 984 a priest from Trier called Benna decorated the church at Wilton (Wiltshire) with wall paintings;[67] Athelstan's court was notably cosmopolitan and some of his moneyers had German names; in the next century one of Edward the Confessor's goldsmiths, Theodoric, also seems to have been German. The Confessor's taste for Continental art and architecture was also manifested by his rebuilding from c.1050 of the abbey church of Westminster in the new Romanesque style (see Coldstream, pp.106–7).

CONCLUSION: PATRONS, ARTISTS AND MODELS IN THE ANGLO-SAXON PERIOD

Four chief conclusions are suggested by this brief survey. First, in the Anglo-Saxon period, some churchmen and women, were themselves 'artists'. Secondly, the patron's role in generating artistic activity is of key significance throughout the period. Early on, the writing and decorating of some major books such as the Lindisfarne Gospels were the solitary labours of individual monks working for the glory of God and propagation of the Word; later, even the greatest monastic scriptoria rarely saw more than a generation's continuous artistic productivity. The monks' veneration of splendid books and their inspirational effects on later generations are exemplified by the subsequent history of the Lindisfarne Gospels, with its interlinear translation added 250 years after it had been produced, and by the use of a Carolingian manuscript as the Harley Psalter's exemplar. Thirdly, individual artists were celebrated for their skill not for a contribution to artistic progress. Finally, the employment of exemplars, whether contemporary or earlier, indigenous or foreign, was important throughout the period.[68] The modern belief that tradition and innovation necessarily conflict would have seemed astonishing in the Middle Ages, when admired models were modified and manipulated, combined and

recontextualized. The fascinatingly complex nature of the various creative relationships between works of art and their exemplars is a subject to which we shall return.

Conquest to Black Death

ARCHITECTURE AND INVASION: THE STATUS OF THE MASTER MASON

Edward the Confessor's architectural patronage anticipated a period of massive change following the defeat and death at Hastings of the last Anglo-Saxon king, Harold, by William the Conqueror. The Norman victory in 1066 led to the replacement of every major Anglo-Saxon church. The new buildings were much bigger, some of the largest and most ambitious churches Europe had ever seen. The chronicler William of Malmesbury (d. c.1143) wrote: 'with their arrival, the Normans breathed new life into religious standards, which had everywhere been declining, so that now you may see, in every village, town and city, churches and monasteries rising in a new style of architecture'.[69] The claim that religious standards had been declining may be disingenuous but no one can harbour doubts about the scale of the new churches, or about the novelty of the style, Romanesque, the first pan-European style since the fall of Rome.

Who were the master masons? Documentary evidence only furnishes a few names: for example, Blithere at Canterbury, Robert at St Albans, and Hugh at Winchester. Blithere (fl.1070–91), described in 1091 as 'the very distinguished master of the craftsmen and director of the beautiful church' of St Augustine's, Canterbury, will – to judge by his name – have been an Anglo-Saxon.[70] Robert (fl. c.1077–1119), like Hugh (fl. c.1086), came from the Continent (though most of their workmen will have been indigenous). Such masons had reached the top of their trade and acquired the geometrical skills to design the plans of the new buildings and to draw out details for the masons to cut.[71] They were laymen: only a handful of clerics can be numbered amongst the roughly 1,700 masters whose names are known from the English Middle Ages.[72] The massive scale of Norman building programmes led to a standardization of elements, and the entire process of construction was expanded and rationalized by comparison with Anglo-

Saxon practices. The emphasis on huge dimensions was also seen in domestic architecture, the most impressive example being William Rufus's aisled Great Hall (1097–9) at Westminster, perhaps designed by Wimund de Leveland, the largest hall north of the Alps for a century and a half (see Goodall, p.124, fig.68).[73]

The invaders also imported the techniques of castle building. Some master masons were specialists in military structures: for example, Ralph of Grosmont (fl.1177–91) appears to have been responsible for work at Hereford castle, and at Grosmont, Skenfrith and White castles (Monmouthshire). Another master, Ailnoth (fl.1157–90), worked on Westminster Palace and Orford Castle (Suffolk), and on the Fleet prison and the Infirmary Chapel of St Katherine at Westminster Abbey.[74] Richard de Wolveston (fl.1170–c.1182) undertook both military and ecclesiastical projects for Bishop Hugh du Puiset of Durham. In connection with a miracle ascribed to St Cuthbert, we learn that Richard kept in his wallet 'painted letters which he possessed of very great beauty' – perhaps illuminated initials for use as two-dimensional models for his sculptors.[75]

The most celebrated architectural enterprise of the later twelfth century was the rebuilding of the east end of Canterbury Cathedral after the conflagration of 1174 (see Coldstream, pp.70–1). The monk Gervase (c.1145–1210) records the care taken by the Christ Church monks in their selection of a master mason: they chose a Frenchman, William of Sens, 'a man active and ready and as a craftsman most skilful in both wood and stone'; after he was severely injured in a fall from scaffolding, he was succeeded by an English mason, 'William by name . . . in workmanship of many kinds acute and honest'.[76] At St Albans, by contrast, Master Hugh de Goldclif was 'a workman of great reputation, but a deceitful and unreliable man', whose lavish employment of 'carved work unnecessary, trifling, and beyond measure costly', led to the exhaustion of funds.[77]

THE SEPARATION OF SCRIBE AND ILLUMINATOR AND THE RISE OF THE LAY PROFESSIONAL

Although the Conquest generated huge architectural activity, it had a deleterious effect on the production of illuminated manuscripts.[78] Initially, this may have been the result of conflict between indigenous and Norman monks and superiors, as at St Augustine's, Canterbury, where the whole community was dispersed in 1089;[79] but it may also have been the result of a Norman predilection for illuminated initials rather than full-page paintings. A book of Gospels now at Wadham College, Oxford (MS A.18.3), is symbolic of this change of emphasis: the script is evidently post-Conquest in style but the manuscript's full-page illuminations, copying earlier Anglo-Saxon models, were never completed.[80] Norman scriptoria quickly expanded book production and demand grew. At Christ Church, Canterbury (where the numbers of monks more than doubled between c.1080 and 1125), there was intense scribal activity, and a 'perceptible evolution in terms of preparation, script and decoration' has been identified: just as in architecture, 'intense activity fostered refinement of procedures'.[81] Although monks, secular clergy and lay professionals can all be found working as scribes and illuminators in the twelfth century, there was a developing separation of scribes from illuminators, with the latter increasingly identifiable as lay professionals.[82] This seems true of the masters responsible for illuminations in the St Albans Psalter, the first manuscript with an extensive cycle of miniatures in a fully developed Romanesque style; it was produced in c.1120–30 at St Albans for Christina of Markyate, a female hermit who was also a skilled embroideress.[83] After its calendar the Psalter is prefaced by forty pictures by the main artist (known as the Alexis Master) illustrating scenes of the Life, Passion and Resurrection of Christ introduced by two Old Testament scenes. The images thus underscored how the Old Testament foreshadowed the New and how man's redemption was achieved through the incarnation of Christ.[84]

The design of scenes in a manuscript of *The Life and Miracles of St Edmund*, produced for Bury St Edmunds Abbey in c.1130, was probably by the St Albans artist, who must have travelled to Suffolk for the commission.[85] Although this artist does not depict himself, the anonymous illuminator of the Dover Bible in the mid-twelfth century does, revealing himself to be a layman, with a fine moustache and showing rather too much of a bony leg as he paints an initial 'N'. He also depicts his assistant grinding colours, the type of practical task entrusted to an apprentice.[86] The one well-known artist whose documentary persona can be matched with surviving manuscripts, Master Hugo, was employed for a considerable period at the monastery of Bury St Edmunds, where he illustrated the Bury Bible (c.1135), one of the masterpieces of Romanesque

manuscript illumination.[87] Master Hugo was also a sculptor – he prepared a bell for casting and the bronze doors of the abbey church, and subsequently carved a wooden crucifix in the time of Abbot Ording (1148–56) – and this expertise influenced his pictorial style.[88]

The so-called Eadwine Psalter (Trinity College, Cambridge, MS R.17.1) contains more illuminations than any other twelfth-century English book.[89] Written and illuminated at Christ Church Canterbury, mid-twelfth century, the Psalter is named after the scribe, the monk Eadwine, whose portrait is bombastically inscribed: 'Scribe: the prince of scribes am I: neither my praises nor my fame shall ever die.' The luxurious manuscript featured the best of everything: three versions of the Latin psalter text, more than 500 lavishly illuminated initials, and a comprehensive redaction of the Utrecht Psalter illustrations in 166 coloured outline drawings. The Eadwine Psalter's textual apparatus is much more comprehensive than that of the Utrecht Psalter and it was once preceded by a cycle of at least eight pages of biblical narratives.[90] The ancient exemplar had not inspired a slavish 'copy', but a psalter in which its authoritative precedent was employed for a lavish new manuscript. The artist responsible for most of the illustration seems to have been a lay professional, not linked to previous work in the scriptorium.[91] The Utrecht Psalter was again to be transformed in the Canterbury Psalter of c.1170–90 (Bibliothèque nationale de France, Paris, MS lat 8846) where the illustrations were painted in full colour and the textual apparatus employed was that of the Eadwine Psalter.

PATRON AND CRAFTSMAN: ADVICE AND OVERSIGHT

During the thirteenth century we have, for the first time, detailed records of working relationships between patrons and craftsmen. Financial accounts were increasingly written down, enabling clerks to check them more efficiently than with the old system of verbal testimony.[92] As a consequence, the accounts of Henry III (1216–72) provide an insight into his discussions with his craftsmen, both in his great projects at Westminster (see Coldstream, pp.106–7) and elsewhere.[93] Edward of Westminster (d.1265), trained as a goldsmith, was Henry III's factotum for twenty-five years and there are indications that his tastes directly influenced Henry. The king states in a letter of 1245: 'since we recall that you told us that it would be rather more splen-

did to make the two leopards which are to be on either side of our throne at Westminster of bronze instead of cutting them out of marble, we command you to have them made of metal as you said, and to have the steps before the throne made of cut stone.'[94] Similarly, Elias of Dereham, at work at the cathedrals of Wells, Winchester and Salisbury, was a favoured project manager, perhaps capable of design but a conduit for advice rather than a master mason himself.[95] Henry III was not just a passive recipient of such advice; indeed, his exacting requirements may have stimulated his artists' drive towards expressive naturalism. In 1240, for example, Henry ordered 'the figure of Winter, which as well by its sad countenance as by other miserable distortions of the body may be deservedly likened to Winter itself' to be portrayed on a fireplace at Westminster.[96]

Until the middle of the thirteenth century the master masons worked for the king intermittently or continuously as required.[97] However, in 1256 Henry III appointed two experienced craftsmen, 'chief masters of all works of castles, manors and houses on this side of the Trent and Humber'. This was to ensure technical oversight by trusted craftsmen. One of their functions was to stipulate contract prices for carpentry and masonry on the king's behalf: the system of 'taskwork', as contemporaries called it.[98] It presupposed both the contractors' ability to manage or sub-contract each stage of construction and their access to considerable capital.

PROFESSIONALIZATION AND URBAN PRODUCTION

Increasingly, lay professionals were predominant in other crafts. Royal accounts show that professional embroideresses were working for the king, during this first phase of a new European dominance by English artisans of the craft that became known as *opus anglicanum* (see Staniland, pp.168–9). Mabel of Bury St Edmunds, for example, is frequently named.[99] Specialist imagers – figure-sculptors – begin to appear in the records;[100] a Thomas 'imaginarius' is referred to in 1226.[101] Through the proliferation of documentary evidence, we learn more about artists working in London and towns such as Kings Lynn and York. Foreign mercantile communities facilitated the importation of works of art and access to foreign artists: in 1258, for example, Henry III purchased two panels, at the enormous

83 Page with self-portrait of William de Brailes, from the William de Brailes Hours, c.1240
On parchment 15 × 12.3 (6 × 4¾)
British Library, London
(MS Add 49999, f.43)

price of £80, from Master Peter the Spaniard.[102] On the other hand it is through the monastic chronicler of Westminster that we learn that Abbot Richard of Ware (1259–83), travelling to Rome for confirmation of his appointment, brought back Roman Cosmati workmen, whose glittering lapidary work in Westminster Abbey for Henry and for Edward I lent both kings, as well as St Edward and the Abbey, a veneer of *romanitas*.[103]

The growth of Oxford University in the thirteenth century stimulated the production of manuscripts there, the first time that a university had a major impact on English book production.[104] The scholars needed a whole range of texts, and the book trade grew rapidly to supply them, generating a living for illuminators at the luxury end of the book market. Scribes and illuminators are recorded as living in or near Catte Street, now the site of the

Radcliffe Camera.[105] William de Brailes (fl.1230–60) is documented there between 1238 and 1252 and can plausibly be credited with a number of manuscript illuminations.[106] He painted 'W de Brailes me fecit' (W. de Brailes made me) on a scroll grasped by an angel rescuing a suppliant tonsured man in the Last Judgement, a scene found on a leaf from a psalter now in the Fitzwilliam Museum, Cambridge (MS 330, leaf 3; p.195, fig.110). The tonsure indicates that he was at least in minor orders (but cannot have been a priest since documents show William was married). A 'W. de Brailes' (we have to be cautious about definitively identifying this as William because a Walter de Brailes is documented in c.1288–91) also signed the earliest fully illustrated English Book of Hours with the phrase 'qui me depeint' (who painted me) beside a self-portrait, proving that he was the illuminator (fig.83).[107]

ILLUMINATION BY MONKS: A FINAL PHASE?

Although luxury manuscript illuminations may have been increasingly the preserve of laymen, some were still produced by monks. A St Albans chronicler relates that the monk Matthew Paris (d.1259) had written and 'most elegantly illustrated the lives of Saints Alban and Amphibalus, and of the archbishops of Canterbury Thomas and Edmund'.[108] The *Life of St Alban* survives in Trinity College, Dublin (MS 177 [E.I.40]), with fifty-four of its original tinted drawings and a mutilated drawing of the Virgin and Child. At the front of the book is a series of notes by Matthew indicating three things: that the book was loaned to aristocratic ladies; that he had himself translated and illustrated lives of St Thomas and St Edward; and that he was planning a series of illustrations of saints, doubtless to preface a psalter.[109] Working for God, for himself and for the glory of his abbey, Matthew Paris shows in his output that artist and patron might still be identical in the mid-thirteenth century.[110]

Matthew took a lively interest in works of art and their makers, compiling a detailed description of the St Albans altarpieces at the time of Abbot John de Cella (c.1200), including the names of some artists, notably Walter the Painter of Colchester, his brother Simon and Simon's son Richard.[111] All had been laymen, who joined the monastery. Matthew himself travelled to Norway and may have been instrumental in spreading an awareness of contemporary English art there; a panel painting of St Peter, formerly at Faaberg, seems to have been his work.[112] Matthew is reported to have possessed considerable 'skills in working [*sculpendo*] gold and silver and other metal' but nothing of this aspect of his oeuvre now remains.[113] A few other craftsmen were ecclesiastics. Royal accounts refer to a Cistercian monk from Pipewell in Northamptonshire who made windows for Rockingham Castle, but he may have been a lay craftsman who subsequently joined a monastery.[114] One apparently clerical sculptor was the versatile John of Flanders who worked for Henry III; he was a contemporary of William Yxewerth whose Annunciation images in the Chapter House at Westminster Abbey are the first significant pieces of English Gothic sculpture for which we know the artist's name (and his payment, 53s 4d).[115]

THE DOMINANCE OF LONDON

By the end of the thirteenth century London had become a major centre for art production. The letter-books of the City contain large numbers of artists' names, and it is evident that religious houses were increasingly buying from London suppliers.[116] The Chapter of Beverley Minster, for example, contracted in 1292 with a London goldsmith, Roger of Faringdon, to make a gold and silver shrine.[117] Edward I had himself turned to city artists for the supply of images for a programme commemorating his late wife Eleanor of Castile (fig.84).[118] The centripetal effect of London-based demand explains why specialist marble-workers originating in Corfe also ran London workshops, supplying Purbeck 'marble' and monumental brasses (which were set into Purbeck matrices).[119] The occupational name 'marbler' becomes common in London from the 1280s, just at the time that the trade in brasses also became centred in the capital.[120] Adam of Corfe was the main marble supplier in the capital from c.1305 and was probably responsible for the bulk of brass production in London until his death in 1331.[121] When he died, Adam left property in Paternoster Row, where his workshop was located, but also tenements in Corfe, suggesting that he maintained a connection between the quarries and his workshop and retail premises.[122]

The demand for Apocalypse manuscripts in the later thirteenth century was probably satisfied by London workshops, with their iconography being carefully replicated (see Morgan, pp.166–7).[123] The unfinished Douce Apocalypse (Bodleian Library, Oxford, MS Douce 180), probably commissioned by the future Edward I, exhibits a taste for French art and architecture also seen in the Westminster Retable (see Binski, pp.74–5).[124] By the early thirteenth century, the area round St Bride's, Fleet Street, seems already to have been a centre for book production.[125] A group of illuminators working in Bermondsey is recorded in c.1250–96, and by the end of the century a thriving centre of manuscript production existed in or near the City of London. The size of the market in the capital, a city of 80,000 people by 1300 and close to the royal palace at Westminster, encouraged the establishment of fixed workshops.[126] In 1331 Queen Philippa paid Richard of Oxford for illuminating two books for her and it has been suggested that he came from Oxford to supply demand from the court.[127]

84 ALEXANDER OF ABINGDON
Sculpture of Eleanor of Castile removed
from the Waltham Eleanor Cross, 1291–2
Stone, height approx 180 (71)
Victoria and Albert Museum, London

London did not completely eclipse all other centres, of course. Oxford must have continued to be a centre of book production and several of the larger provincial cities – such as York, Lincoln, Bristol and Bury St Edmunds as well as Norwich – may also have supported groups of manuscript illuminators as well as scribes.[128] By the 1340s, if not before, Cambridge may have become a centre of production, too, with artists moving there from other regions (see Panayotova, pp.228–9). Some illuminators must have been peripatetic, perhaps following patronage networks: the superb Psalter (Brussels Royal Library MS 9961–62) given in 1318 by Abbot Geoffrey to the papal nuncio may have been illustrated at Peterborough Abbey by a lay illuminator. Monastic (and mendicant) manuscript patronage still continued to be important.[129]

Huge regional building programmes such as those at Exeter Cathedral or York Minster in the first half of the fourteenth century, or at Ely (Cambridgeshire) in c.1320–50, will also have drawn large workforces together for substantial periods, ensuring continuity of employment for masons, as well as years of work for painters, glaziers and other craftsmen. Bishop John de Grandisson of Exeter (1327–69), during whose episcopate the nave and west end of the cathedral were brought to structural completion, also commissioned a series of superb ivories from a carver who must have had direct access to near-contemporary Italian models, perhaps paintings brought back by Grandisson from Avignon where the bishop was consecrated (fig.85).[130]

THE FAMILY WORKSHOP

Documentary evidence indicates that the production of art often took place in small family-based groupings and that this continued to be the case throughout the Middle Ages. As some of the following examples show, there were probably many husband and wife teams, with craft skills frequently transmitted through the family, as also documented in contemporary Paris.

Hugh le Luminor is recorded in Oxford in c.1248–67, and Reginald and his wife Agnes la Lumenore appear in c.1257–79; John le Luminor de Chastleton and Alice his wife are probably another husband and wife team.[131] After a great fire in 1272 Norwich Cathedral seems to have drawn on local groups of professional painters such as John of Acle, Aldreda his wife and Robert Peyntor her son, and Roger son of Thomas Beston and his wife Helwyse, rather

85 A triptych made for John de Grandisson, Bishop of Exeter, c.1330–40
Elephant ivory 23.8 × 20.2 (9½ × 8)
British Museum, London

86 The Swinburne Pyx
(inside of lid), c.1325
Silver, engraved, formerly enamelled
diameter 5.7 (2¼)
Victoria and Albert Museum, London

than on monastic artists.[132] Female illuminators are recorded working alongside their male counterparts in Bermondsey in c.1250–96.[133] Agnes, daughter of the great master mason William Ramsey (d.1349), may have carried on her father's shop: she was paid in 1358–9 for the tomb of Queen Isabella of France set up in the London Greyfriars.[134]

The Settere family (a name derived from the Middle-English word for embroidery) shows the importance of familial relationships in embroidery production.[135] Alexander Settere is mentioned in 1307, in 1314 William le Setter was called on to value a silk-embroidered cope and in 1327–8 Matilda le Settere worked in the royal embroidery workshop of the young Edward III (1327–77; see Staniland, pp.168–9).[136] Later documents relating to this workshop provide evidence that specialist designers were employed.[137] The transference of designs across

media is well demonstrated by the Nativity engraved on the Swinburne Pyx of c.1325 (fig.86), which appears to be based on that painted in the Alice de Reydon Book of Hours (University Library, Cambridge, MS Dd.4.17).[138] A documented instance of the employment of a model by sculptors occurred at Norwich Cathedral in 1346-7 where an Apocalypse manuscript was provided as a model for carving the cloister vault bosses.[139]

IMPRESSMENT

Perhaps the greatest architectural undertakings of the late thirteenth century were Edward I's programmes of castle building in Wales (see Goodall, fig.73, p.133). The surviving records provide considerable information about the master masons such as James of St George.[140] Originating in the Savoy region, Master James came from the court of Edward I's cousin, Count Philip. In 1278 he went to Wales 'to ordain [design] the works of the castles there': Flint, Rhuddlan, Builth and Aberystwyth. By 1282 he was 'master of the king's works in Wales', working at three times the normal day rate of a master mason.[141] Although Master James was a specialist, some contemporaries, such as Master Walter of Hereford, worked on both military and ecclesiastical architecture: Walter was responsible for the design of the Franciscan church in London, the largest church for the Friars ever built in England.[142] Because the workforces were obtained through impressment – the royal right to commandeer workmen, the king's requirements taking precedence over anyone else's – the documentation of the Edwardian castles also provides glimpses of the origins of the huge numbers of anonymous craftsmen employed. Amongst the nearly 3,000 workmen assembled between June and September 1277, before building began, were 320 masons from Leicestershire, Lincolnshire, Nottinghamshire, Wiltshire, Dorset and Somerset.[143] It was inevitable that architectural ideas and techniques spread amongst the working masons, as well as the masters.

CONCLUSION: LAY PROFESSIONALS AND THEIR PATRONS

The period inaugurated by the Conquest witnessed the rise of the lay professional craftsman in architecture and the arts, and in embroidery the skill of English craftswomen won pan-European recognition. Monastic patronage continued to be important in this period but other patrons – mendicant, episcopal, lay and royal – were increasingly significant. The survival of royal accounts permits us, for the first time, a detailed understanding of the mechanisms of this category of patronage. Craftsmen and craftswomen were increasingly likely to be lay professionals, often working in cities, though some were peripatetic, moving from commission to commission. Technical details, especially in architecture, were increasingly complicated, and the predilections of specialists might inform and influence their patrons' tastes. The growth of major urban centres such as London ensured continuity of production, often in workshops based on family networks, and aided the development of craft organizations. The massive scale of royal works under Edward I placed new demands on the royal bureaucracy and on the king's workforce, but also aided the rapid dissemination of ideas. The importation of works of art and artists had considerable significance at a time when most indigenous artists did not travel abroad: Matthew Paris is a rare exception, both as a monastic artist and in his travel overseas.

Plague to Reformation

THE PLAGUE'S EFFECTS

There is no parallel in recorded history for the loss of between a third and a half of the population in two years, such as occurred in the mid-fourteenth century. Although there is copious evidence of the plague's effects in England, Scotland and Wales, distinguishing them from longer-term change is sometimes difficult, both in general and in terms of artistic production.[144] Before the Black Death Edward III was already using impressment for civil buildings, but from 1349 the huge works at Windsor were reliant on it.[145] Wages rose in spite of legislation to control them: workmen employed at Westminster Palace deserted the site and, although a 1360 Statute of Labourers complained about 'alliances and covines' of craftsmen unlawfully pushing up wages, the king himself was forced to pay at non-statutory rates.[146]

Impressment was also employed to obtain the workforce for glazing and painting St Stephen's Chapel in the Palace of Westminster. The vicissitudes of the chapel's construction over half a century and three reigns ensured it acted as a clearing house for architectural ideas, as

workmen were assembled and dispersed, when funding was diverted.[147] Now, as it was brought to completion, the country was scoured for painters, glaziers and materials. John of Brampton was sent to buy glass in London, Shropshire and Staffordshire in July 1349, and in March 1350 another master glazier, John of Lincoln, was given a commission to select glaziers and other workmen. In 1351–2 between twenty and thirty glaziers were at work under half a dozen masters. One of the masters, John Athelard, was also involved in impressing painters, a point that serves to stress the interconnections between crafts. Whether or not there was an increased separation of design from execution, the exchange of ideas must have been facilitated by the simultaneous gathering of many different workmen at Westminster.[148] Work on the painting scheme seems to have lasted until 1363. From 1354 the master was John Barneby, whose son, John Barneby junior, was one of the three main designers under him.[149] John senior has been identified as the John Bernetby paid £15 for painting the table and tabernacle of the high altar of Thornton Abbey in 1341 and Lincolnshire may have been his county of origin. For St Stephen's, commissions to impress painters had been sent to Kent, Middlesex, Essex, Surrey, Sussex, the midland counties and East Anglia.[150] Stylistic evidence indicates that some of the mural painters had just worked at Ely.[151]

East Anglia had been an important regional centre for art production in many media, as we have seen; indeed, the Peterborough Psalter mentioned above may have been produced there, rather than in London. At least one major painter's working career was terminated by the plague.[152] It also probably cut short the career of the artist responsible for Sir Hugh Hastings' brass (d.1347) at Elsing (Norfolk).[153] Perhaps as a result, the second half of the fourteenth century saw an increasing penetration of the English market by Flemish products, and a standardization of English brass design in the hands of London workshops. The plague also impacted on embroidery production, tending to suppress standards and to concentrate embroidered elements on orphreys and cope hoods, and on decorating vestments of imported Italian silks and velvets.[154]

NEW DOCUMENTARY SOURCES

The documentary information on St Stephen's highlights the substantial expansion of written sources in this period.

Large numbers of building contracts, churchwardens' accounts and virtually all the extant contracts for medieval tomb-monuments and furnishings originate in this period. However, the relatively copious survival of royal accounts can misrepresent the nature of other relationships between patrons and artists, and skew our evidence. Subtle changes in the nature of the royal accounts render them less informative regarding the king's own tastes, from Edward I's reign. Fewer instructions – such as were so revealing of Henry III's aesthetic and iconographic predilections – are recorded.[155] Nevertheless, glimpses of the actual process of aesthetic evaluation are sometimes disclosed, as for instance, in the 1350s accounts for St Stephen's. Work on stalls and a screen had been started under William of Hurley in 1351, but in the summer six carpenters removed the stalls and raised 'various panels for the reredos of the said stalls in order to show and exhibit the form and design of the said stalls to the treasurer and other members of the king's council'. The result was dramatic: Hurley's wood-work was sold to the nuns of Barking and a completely new scheme adopted. A new master carver was brought from Nottinghamshire, an Augustinian canon from Newstead Abbey named Master Edmund of St Andrew (fl.1355–60), who now worked on site with his assistants. He was the last major clerical sculptor of the English Middle Ages.[156]

THE KING'S WORKS: DIVISIONS OF RESPONSIBILITY AND STATUS

There was no office of 'king's sculptor' in this period. Neither Edward I nor Edward II (1307–27) followed Henry III's innovation in establishing permanent offices to be held by chief craftsmen. Edward III issued letters patent establishing the posts of royal master mason, carpenter and smith in 1336, but it was not until later in the century that there was a regular succession of office holders. The king's master craftsmen were men who possessed a significant reputation. John of Brampton, for example, appointed king's glazier in 1378, had become Master of the London Glaziers' Company in 1373.[157] Edward III's master mason, William Ramsey, who died of the plague in 1349, possessed his own seal, bearing on a shield the canting arms of a pair of masons' compasses between two rams' heads.[158] At Windsor Castle from 1350 to 1377 the chief mason was John Sponle (c.1350–c.1386), whose high status is clear from his place in the funeral procession of Queen

Philippa, where he ranked alongside 'esquires of great estate', as did William Herland (c.1332–75), the king's chief carpenter; in the same procession two other master masons, Henry Yevele (c.1320–1400) and William Wynford (fl.1360–1405), are ranked as esquires of lesser degree.[159]

What distinguished the late-medieval master mason (as also his earlier medieval predecessors) from other masons was his knowledge of practical geometry.[160] In the absence of blueprints, the master had to be capable of designing every masonry component of a whole building and drawing out details (for example of window tracery) at full scale on whitened plaster floors – of which examples still survive at York Minster and Wells Cathedral – or on drawing-tables.[161] Templates were provided from these designs to guide the working masons. It is this personal involvement of the master in the design of architectural details that renders moulding analysis so valuable a tool in discriminating the work of individuals.[162] Thus, when Westminster Hall was rebuilt under Richard II (1377–99), the design of the masonry was due to Henry Yevele (c.1353–1400), who supplied the design and template to the working masons.[163] Unlike the modern architect, the late medieval master mason only exercised control over a building's masonry: he deferred to the master carpenter when it came to the roof, and in buildings such as the Octagon of Ely Cathedral (Cambridgeshire), a complex masonry and timber construction, one must envisage a detailed interaction between patron, mason and carpenter before and during construction. At Westminster Hall the carpentry of the massive hammerbeam roof was the responsibility of Hugh Herland (c.1330–c.1411), who collaborated with Yevele on many occasions. The roof was pre-fabricated at 'the Frame' near Farnham and brought by carts to be erected on site at Westminster.[164] A detailed set of drawings by the master carpenter must have been agreed with the patron and discussed with the mason. In the fifteenth century such drawings were increasingly specified, even in much less grand constructions.[165]

The status of senior craftsmen is also shown by the depiction in the east window (now a copy of 1822–8) of Winchester College, including kneeling figures of the master carpenter (Herland), mason (Wynford) and the glazier himself with a label, 'Thomas operator istius vitri'. In other words Thomas the Glazier of Oxford was responsible for the glass and in 1393 payments are recorded for two wagons carrying the glass from Oxford on a nine-day journey.[166] Artists' self-portraits are, though, rare in all media in this period. Just two others of English glaziers are known, both from the sixteenth century: John Petty in York Minster and Ralph Harries at St Neot (Cornwall). In both cases the craftsmen were also the donors, evidence of their economic status as well as of their piety.[167] Artists' signatures are also extremely rare: one example is that of the Dominican illuminator John Siferwas, who seems to depict himself presenting a lectionary (BL MS Harley 7026) to the patron John, Lord Lovell (d.1408); he includes other self-portraits, identifying himself by inscriptions on scrolls and the Siferwas coat of arms, in the magnificent Sherborne Missal (BL MS Add. 74236).[168]

The fact that the master mason and master carpenter was each supreme in his own sphere was reflected in the workshop arrangements at Westminster Palace. The Clerk of the King's Works had a chamber in which was a 'long oak chest made to keep the patrons [patterns] and instruments' belonging to the chief mason; nearby was the 'Tracerhouse' in which were the designers' drawing desks, the 'portraying-tables of wainscot'.[169] The carpenters worked in their own separate tracing-house. The king's glazier, too, had his own 'shedde,' called the 'glasiers logge'.[170] It was here, doubtless, that John Prudde executed his work for Henry VI (1422–61, 1470–1) from 1440 and also for Richard Beauchamp's chapel in Warwick in 1447.[171] Coloured glass was, at this time, imported from the Continent as the contract (known from later transcriptions) for Beauchamp's Chapel reveals (see Monckton, pp.108–9). John Prudde had to glaze the windows 'with Glasse beyond the Seas, and with no Glasse of England; and that in the finest wise, with the best, cleanest, and strongest glasse of beyond the Sea that may be had in England, and of the finest colours'.[172] Henry VI, however, took steps to establish an indigenous glass manufacturing base by summoning John Utynam from Flanders to make glass for Eton and King's College.[173]

Some master masons also acted as entrepreneurs, selling materials, and supplying labour, the most prominent example in the fourteenth century being Henry Yevele.[174] Yevele was also intimately involved in monumental design, working with the sculptor Thomas Wrek on the tomb of John of Gaunt and Duchess Blanche of Lancaster between 1375 and 1378.[175] Yevele contracted for the masonry work of the tomb of Richard II and Anne of Bohemia and can be convincingly linked to other monuments of the period; in his will of 1400 he referred to a tenement with 'all my

marble and latten goods [for brasses] and my tools therein' and played a significant role in the creation of London series 'B' brasses.[176] When he died, Yevele was buried in a tomb he had made for himself.[177]

THE PATRON'S REQUIREMENTS: TOMB-SCULPTURE, HERALDRY, MATERIALS AND AESTHETIC ISSUES

The contract for Richard II and Anne of Bohemia's tomb (p.106, fig.54) is the first to survive for any English royal monument. Yevele and his associate contracted for the Purbeck marble tomb-chest on the basis of a pattern they had provided; the gilt-bronze effigies and other metal details on the other hand were produced by two London coppersmiths, to a pattern probably supplied by a painter. The monument was, then, a collaboration between different specialists, with realistic portraits required for the effigies.[178] What may seem surprising, however, is that this desire for portraiture was rarely specified in other tomb commissions.[179] The contract for Sir Nicholas Loveyne's monument of 1376, for example, required an effigy of a knight of good quality freestone, shown in his arms with his helm beneath his head and a lion at his feet.[180] A draft contract for Richard and Anne Willoughby's brass at Wollaton (Nottinghamshire) in 1466 specified that the knight's image should be 'hoole armyd except the hed of the best harnes and godelyest wyse'; and the brass effigies of Richard and his wife were to be set into 'a gravestoon of the finest marbl[e]'.[181] The representation of the deceased's status and the quality of materials mattered here, not accurate portraiture. The details of the heraldry, on the other hand, were very important.[182] On a list of instructions dating between c.1494 and 1498, Thomas Froxmere carefully (if inexpertly) drew himself and his wife in their appropriate heraldry, to ensure the glazier made no error.[183] At Wollaton the London marbler and brass engraver James Reames had to follow a pattern of the Willoughby coat of arms impaled with those of Leek (his wife's family) shown on a drawing delivered to Reames by Willoughby's agent.[184]

Leaving the craftsman to determine detail could cause expense and delay. In 1439 the authorities at Oxford blamed the slow progress of the Divinity School on the elaborate detail introduced by the master mason; his successor was urged to eliminate all 'supervacuous curiosity', which caused excessive expense and delay and 'had been reproved by magnates of the realm and others'.[185] A similar reaction to expensive complexity seems to have occurred at Eton College in 1448, when Henry VI required the new chapel to avoid 'superfluite of to grete curiouse werkes of entaille [carving] and besy moldyng'.[186] Most unusually, the king particularized, in a way which makes it clear he was listening to expert advice, which stone and other materials should be avoided for the foundations.[187]

Insistence on the quality of materials and of workmanship is a constant refrain in medieval contracts (and litigation) and this is shown by the agreements recorded for Richard Beauchamp's tomb in the 1440s and 1450s, as well as for the chapel's glass. The tomb was the work of a team of collaborating artists. The marbler John Essex (d.1465) and founder William Austen (fl.1449–54) contracted to make the base plate 'in most finest wise and of the finest Latten . . . of the finest and thickest Cullen [Cologne] plate'. The Purbeck marble tomb-chest, 'to be made well, cleane and sufficiently, of a good and fine Marble, as well coloured as may be had in England', was supplied by a Corfe-based marbler, John Bourde, to whom the 'portraiture' or pattern was delivered.[188] The gilt-bronze figures on the tomb-chest were cast by Austen following timber patterns, probably by John Massingham (fl.1409–50), who also carved the wooden model of the duke's effigy. Massingham himself, however, carved the effigy's model on the basis of a full-sized, painted, two-dimensional design.[189] All but Bourde were London-based craftsmen, whose work was delivered from the capital and set up in Warwick. John Prudde (d.1460/1) was to supply the glass, working from 'patterns in paper', which Prudde was to have 'newly traced and pictured by another Painter in rich colour', presumably as full-scale cartoons: Prudde, though he was the king's master glazier, was working to the designs of a specialist draughtsman. By contrast, when John Thornton of Coventry had contracted for the east window of York Minster (see Gilderdale Scott, pp.170–1), he had been required to draw out 'w[i]th his own hands . . . the s[ai]d window w[i]th Historicall Images & other painted work'.[190]

EXEMPLARS, CREATIVITY AND 'COPYING'

The London series 'D' brass produced by James Reames for the Willoughbys was integrated into a large wall monument, designed by a mason.[191] This architectural design was replicated, in a slightly modernized form, in

88 Samson removing the Gates of Gaza, detail of carved wood misericord in Ripon Minster, c.1489–94

the monument of John Strelley (d.1502) and his wife, some thirty years later.[192] This type of 'copying' was frequently specified by patrons.[193] An example is provided in a 1486 contract between the warden of Merton College Oxford and the London joiner John Fisher for a new rood loft.[194] Two different models, one local, one in London, were to be combined and the doors were to be 'ferre better'.

If the patron ascribed particular importance to the iconography or subject matter of imagery he was commissioning, he might furnish a visual exemplar. One patron's particular veneration for St Cuthbert explains why fifteenth-century cycles of the saint's life appear after more than two centuries during which no extensive series had been produced.[195] The donor of the c.1440 St Cuthbert window in York Minster was Thomas Langley, Bishop of Durham (1406–37), who also funded Cuthbertine cycles in glazing at Durham and painted on linen.[196] Another cycle comprises seventeen, still surviving, painted panels on the backs of the choir stalls of Carlisle Cathedral, probably dating between 1484 and 1507; these images were directly copied from a c.1200 manuscript *Life of St Cuthbert*.[197]

What of 'marginal' areas, which might escape patronal supervision? Do we find here the creative inventiveness praised by modern scholars?[198] For fourteenth-century misericords the sculptors seem frequently to have relied directly on two-dimensional models, as at Ely Cathedral in c.1339–41.[199] Later misericords suggest the same reliance on exemplars: those of c.1489–94 from Ripon Minster (Yorkshire) – produced by craftsmen headed by William Brownfleet – show a repetition of subjects and designs found in 150-year old manuscripts.[200] It is possible that the patrons supplied a manuscript, but it is more likely, in this case, that the sculptors had model books recording the designs. Four other misericords at Ripon are directly based on prints in a fifteenth-century book, the so-called *Biblia Pauperum*, or 'Bible of the Poor' (fig.87–8). Such woodcut models, which printing made widely available for the first time, swiftly became very popular iconographic sources: at Tattershall, for example, the extensive programme in the church's choir windows was based on a forty-leaf example that must have been provided to the glaziers.[201] An obscure Old Testament image seen at Ripon – the spies returning from Canaan – appears again at Manchester and Beverley, demonstrating that the carvers repeated their subjects (and that the two schemes are by the same workforce).[202] The eclectic mixtures of sources

and the repeated employment of the same models tends to undermine the claim that 'marginal' imagery was inherently innovative.

Patterns and tools were important enough for them sometimes to be mentioned in wills, bequeathed to sons, apprentices or other successors. In 1349, for example, Maud, widow of John de Mymmes, a London 'ymaginour' who had just died in the plague, left to her apprentice William 'the best third part of her stock of copies or patterns, and tools appertaining to the making of pictures, with a chest to keep them in'.[203] Again, in 1503 a York glazier left a colleague 'all my scrowles' and an apprentice 'all my bookes that is fitte for one prentesse of his craffte to lerne by'.[204] Similarly, the master mason John Smyth in 1517 bequeathed 'all my Bokis of purtiturys'.[205] Such 'portraitures' may have been his own designs, like William Orchard's 'portraiture' for the west window of the chapel of Magdalen College, Oxford.[206]

Drawings were increasingly used to report the existing or projected state of works of art or architecture. Thus, the master mason Christopher Dickinson and his colleague, the carpenter William Clement, took Henry VIII (1509–47) 'platts' in 1538.[207] During Henry VIII's French wars numerous 'plats' (the spelling varies) of fortifications were made for his scrutiny, and in 1549 a carpenter was paid for visiting some of the king's palaces 'not only to vew and see the state of the same but also in drawinge platts for everye house and making mencion in the platts of everye decaye thereof'.[208] The king himself drew one for a fort at Cowes.[209] As yet, though, no three-dimensional wooden models of projected buildings were constructed. The first is recorded in 1567, when Adrian Gaunt, a French joiner, was paid £4 15s for making 'ye model for ye house of Longleate'.[210]

The actual process of consultation between patron and artist can be glimpsed in the case of some vidimuses (the approved drawing for a stained glass design was termed a vidimus: literally 'we have seen') in Brussels, which are connected with a lost glazing scheme for Cardinal Wolsey (1470/1–1530). In the centre of the upper register of an east window was to be a crucifixion and two alternative designs were provided: one with angels collecting the blood of Christ in chalices and one without. The artist probably did not know, in a period when transubstantiation was the subject of bitter controversy, where the patron stood on the issue.[211] These vidimuses have been attributed to the Netherlandish glazier James Nicholson.[212] Another design

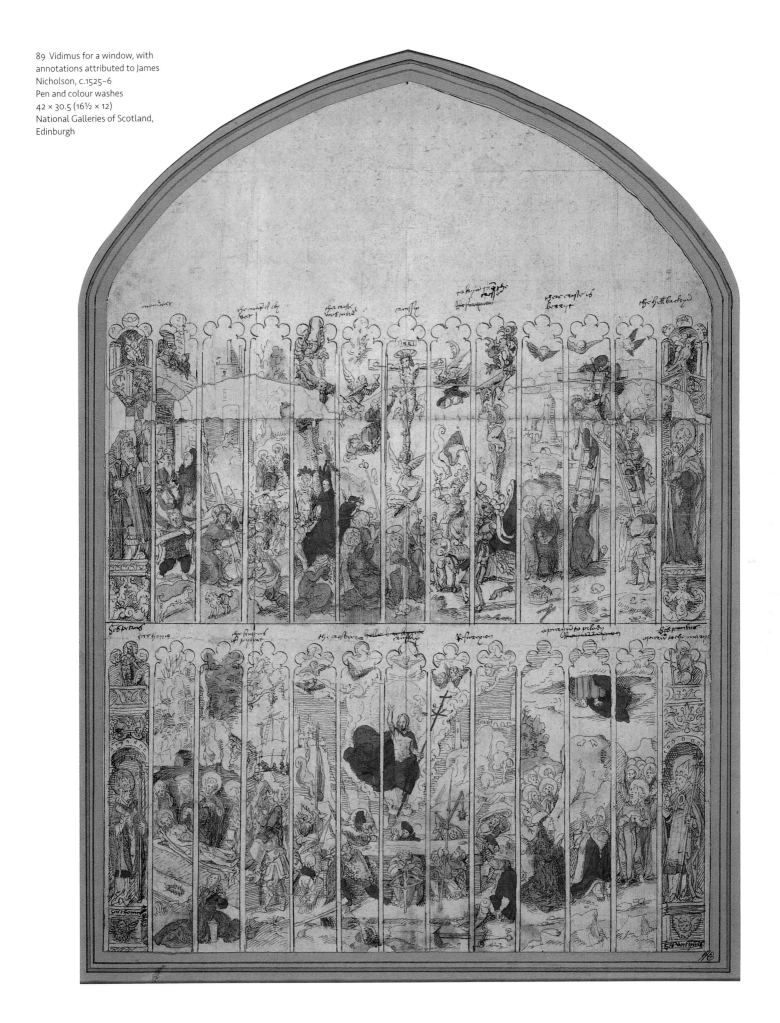

89 Vidimus for a window, with annotations attributed to James Nicholson, c.1525–6
Pen and colour washes
42 × 30.5 (16½ × 12)
National Galleries of Scotland, Edinburgh

has the glazier's scribbled alternative subjects in pen above the scenes, evidently a written record of oral consultations with Wolsey (fig.89).

URBAN WORKSHOPS AND LATE-MEDIEVAL GUILDS

The longevity of models was assisted by their transmission through father/son and master/apprentice networks. Thus a marbler named Henry Lakenham (fl.1355–87), probably the main supplier of London series 'B' brasses in the third quarter of the fourteenth century, worked close to where Adam of Corfe's workshops had earlier flourished (for some of its finest products, see Saul, pp.138–9).[213] Lakenham's father Richard was also a marbler: he may have been one of the originators of this long-lived series, which continued under William West, named as Henry Lakenham's apprentice in the latter's 1387 will; West was sworn in as a master in the Mistery of Masons in 1416, but was still alive in 1453 and appears to have worked with John Essex, who inherited his business.[214] Here, then, documentary evidence supports stylistic analysis for the flourishing of a traceable style in brass production close to St Paul's, in the hands of three or four men linked by familial relations or apprenticeship for over a century.[215] Family-based networks of craftsmen, reinforced by inter-marriage and apprenticeship, well-documented in the sixteenth century, certainly operated much earlier.[216]

Artists generally tended to congregate together. London painters, for example, gathered in the parish of St Giles's, Cripplegate. Hugh of St Albans (d.1368), buried in the churchyard at St Giles's, bequeathed a 'table' (probably an altarpiece) of six panels of Italian workmanship, which had cost him the huge sum of £20 originally.[217] This evidence both for Hugh's wealth and for his personal interest in Italian art, sheds a fascinating light on the Italianate painting in St Stephen's Chapel on which he worked. The later king's painter, Gilbert Prince (d.1396), had a dwelling house and tenements in the same parish.[218] In York, a centre for stained glass production for much of the later Middle Ages, glaziers concentrated in the Stonegate area, particularly round St Helen's Church.[219] At least ten glaziers' burials are recorded in St Helen's, and another three were buried in St Michael-le-Belfrey at the other end of the street.[220]

Nottingham seems to have been the centre of an important alabaster industry from the fourteenth century, although carving also took place in London and elsewhere (see Riches, pp.76–7). It has, indeed, been suggested that the survival of documentation from Nottingham has perhaps overemphasized its importance.[221] Nottingham's alabastermen turned out large numbers of standardized panels, which were widely exported. In 1491 Nicholas Hill sued his travelling salesman for the value of no fewer than fifty-eight images of the head of St John the Baptist on a platter.[222] Some alabaster tomb-monuments, on the other hand, were produced near the quarries at Chellaston (Derbyshire), in small shops with one or two craftsmen working together. Where different materials were specified, specialists might be co-ordinated by the patrons, although some artists may themselves have taken on the task of sub-contracting.

The rapid development and increasing power of guilds was one of the major features of the later Middle Ages.[223] From the early thirteenth century artists were operating within a developing guild system: an 'Alexander pictor' was accepted into the merchants' guild at Shrewsbury in 1209/10, for example, and another entered the Leicester merchants' guild in 1225. Later it became virtually impossible for any craftsman to pursue his calling unless he first enrolled in a craft guild.[224] Guilds of glass-painters, for example, existed in London, Chester, Norwich and York, the London regulations dating to 1364/5 and the York Ordinances from c.1380 and 1463/4. Whereas glaziers were numerous enough in London and York to form guilds of their own, the Norwich glaziers were part of a larger guild of bell founders, braziers, painters, pewterers and plumbers, and in Chester the guild included painters, embroiderers and stationers.[225] Guilds were formed for mutual support, to control professional standards, conciliate disputes, inspect quality and regulate competition.[226] Thus, in 1327 a royal charter granted to the London Goldsmiths ensured that all goldsmiths should keep shop in Cheap, that they should assay all work for sale and that they should have national control of their craft (see Campbell, pp.172–3).[227] Masters of the craft fraternities were increasingly recognized by the authorities as the officials to whom control of the craft should be entrusted. Many crafts gave preferential treatment to the sons of existing masters.[228] Training generally seems to have started at the age of ten and usually lasted for five, seven or ten years.[229] Stiff fines

were imposed for breaches of regulations, and in the later Middle Ages women were increasingly excluded from official associations.[230] One benefit of membership was that participants were endowed with the 'cachet of respectability', something that then, as now, greatly assisted one's business.[231] Craft guilds were also, in part, religious organizations, offering *post mortem* intercessory prayer, and this must have also made membership attractive. By the end of the fourteenth century they were increasingly acquiring premises and administering chantries and assistance.

Some late-medieval craftsmen attained considerable status in the towns and cities. This is most obviously true of the goldsmiths, whose work required considerable capital: between 1478 and 1506 alone no fewer than five goldsmiths became mayors of London.[232] Some other artisans also attained high civic office. Simon of Lynn was an alderman in fourteenth-century Lynn (now King's Lynn); John of Brampton was elected warden of the London Mistery of Glaziers in 1375, and much of his prosperity must have been due to his work for private clients as well as for the king.[233] William Brownfleet became a freeman of York in 1482–3 and was mayor of Ripon in 1511. Thomas Drawsword, a sculptor, took up the freedom of York in 1495–6 and was Lord Mayor there in 1515 and 1523. The glazier John Petty held in succession posts of Chamberlain, Sheriff, Alderman and Lord Mayor of York. John Godwyn of Wells and Henry Smart of Winchester, also glaziers, both sat in Parliament in the fifteenth century.[234]

ALIEN INVASIONS

English craftsmen were often concerned that their prosperity might be undermined by immigrant craftsmen. As early as 1474 the London Glaziers complained that more than twenty-eight alien (from outside England) craftsmen were exercising their craft.[235] Shortly afterwards Netherlandish artists painted the kneeling figures of Edward IV (1461–83) and Elizabeth Woodville with their sons and daughters in the 'Royal' window at Canterbury.[236] In the early sixteenth century their numbers dramatically increased and all three king's glaziers were immigrants: Barnard Flower (d.1517), Galyon Hone (d. c.1551/2), and Peter Nicholson who was naturalized in 1552. They all carried on private practice – Flower, for instance, glazed the Lady chapel at Walsingham in 1512 – and with many other Netherlandish artists lived in Southwark, outside the control of the City

Glaziers company.[237] The Netherlandish glaziers' new pictorial style, introducing scenes running right across the stone mullions of the window tracery, can still be seen in the great scheme of King's College Chapel, Cambridge, the 'masterpiece of foreign glass-painting in England and . . . the end of the medieval tradition'.[238]

The dominance of foreign artists in stained glass was paralleled in many other arts, and not just in London.[239] The Donne altarpiece by Hans Memling (d.1494) and the altarpiece by Hugo van der Goes (d.1482; see Marshall, pp.78–9, fig.41) for Edward Bonkil, provost of the Collegiate Church of the Holy Trinity in Edinburgh, were both imports, but manuscripts such as the Beauchamp Pageant, and wall paintings, such as those in Eton College Chapel, were executed by immigrant artists working in Britain.[240] From the time of Edward IV, if not before, king and court led the way in patronizing alien artists. For example, in 1500 Henry VII (1485–1509) commissioned vestments not from London but from the weavers of Florence and Lucca. After Andrew Wright's appointment as the king's Sergeant Painter (1532–43) the post was held by an Italian, Antony Toto (1544–54), and then a Frenchman, Nicholas Lizard (1554–71).[241] Incomparably the most important painter of the period was another foreign artist, Hans Holbein (1497/8–1543), who had made his way to England introduced by a letter from Erasmus to Thomas More.[242] Holbein's employment by Henry VIII and courtiers for portraits, murals and miniatures is well known (see Engel, p.67, fig.29), but he also furnished numerous designs for Low Countries' goldsmiths who supplied Henry VIII and the court.[243] Royal commissions enabled immigrant artists to flout the authority of the London guilds, and foreign mercantile communities may have provided easy routes for artists and imported art-works into England.

There was hostility from the city guilds to the large numbers of foreign craftsmen. Already in 1469 there were 113 alien goldsmiths in London, 98 of whom were in Southwark and Westminster.[244] Between 1479 and 1510 another 319 arrived, almost all working with other aliens.[245] The city glaziers complained regularly but unavailingly about these competitors.[246] A statute passed in 1523 stated that all apprentices in future were to be English, and no more than two were permitted, but allowed the Flemings to retain their current journeymen and apprentices. Hone was obtaining so much work that in 1533 he was permitted to employ four extra journeymen.[247]

Even 'divers of the aldermen and citizens of the City of London' were buying glass made by the immigrants.[248] Foreign artists were technically superior, using up-to-date pictorial models and working in more modern styles than their English counterparts, whose guilds now functioned like 1970s trade unions, retarding innovation and restricting trade. The passing down of patterns through the generations contributed to an old-fashioned approach to their crafts. The patrons' artistic ideals, by contrast, were increasingly international in outlook, and they wanted art that was the equal of that produced abroad. Whereas William of Poitiers had once praised English skill in the arts, Sir Thomas Elyot now wrote, in 1531, that 'englisshmen be inferiors to all other people, and be constrayned, if we wyll have any thinge well paynted, kerved, or embrawdred, to abandone our owne countraymen and resorte unto straungers'.[249] The situation resembles that today in Premier League football, increasingly dominated by foreigners.

THE ITALIAN CONNECTION AND NEW CONCEPTIONS OF ART

Arguably, it was in sculpture that the greatest changes occurred, because Italian artists such as Pietro Torrigiano (1472–1528), Giovanni da Maiano (c.1487–c.1542) and Nicholas Bellin of Modena (c.1490–1569) dominated royal commissions. Even architecture, of all crafts the most resistant to foreign innovation, was affected: Nicholas Bellin was commissioned to design the timber banqueting house in the Privy Garden at Whitehall and John of Padoa was given an annual fee of £36 10s in 1552. The latter is a rather enigmatic figure: his description as 'deviser of buildings' argues that he was a designer, even if he is elsewhere called a musician, artificer and engineer. He may have designed banqueting houses and temporary works in a modern, Renaissance, Italianate style.

Torrigiano was the first to bring with him a sense of his status as a great artist and an idea of artistic progress as propelled by the contributions of individuals, views he had formed in humanist-influenced late Quattrocento Florence. This strongly contrasts with the view of the artist as a master craftsman, which obtained in early sixteenth-century England.[250] At first Torrigiano was obliged to accept traditional procedures, at least in part. From the 1511 contract for the tomb of the queen mother Margaret Beaufort (fig.90), it appears that her tomb-effigy and flanking niche had been

designed by a Netherlandish craftsman, Maynard Vewick (fl.1502–25). After three alternative designs had been shown to the patrons, one had been selected and Vewick then produced two full-size copies, one for Torrigiano and one for Beaufort's executors.[251] The sculptor had been obliged to translate the painter's designs into gilt-bronze. Although this division of responsibility was traditional in England, it must have seemed demeaning to a major Florentine artist. Torrigiano himself, however, designed the touchstone tomb-chest, providing a three-dimensional model in timber, on the basis of which he carved the final product. Previously, the tomb-chest had always been a separate area of responsibility from the gilt-bronze effigy, and was normally carved by a marbler working to a mason's design. The fact that Torrigiano was himself responsible for the design and execution of the tomb-chest suggests that the Florentine's expertise was recognized by his patrons.[252] In the next contract, for the tomb of Henry VII and Queen Elizabeth, Torrigiano was no longer constrained to work as part of a team assembled by the patrons. Traditional medieval divisions of responsibility were abandoned because Torrigiano could design, carve and mould to a higher standard than any English sculptor or mason. Moreover, he employed the latest classical Renaissance idiom, giving his work the international gloss that the patrons desired.

Torrigiano's work, and that of his Italian contemporaries, promised a rethinking of the distinctions between crafts and arts, and between artists and patrons. In 1531 Sir Thomas Elyot even devoted a chapter of *The Governour* to the proposition that 'it is commendable in a gentilman to paynte or karve exactly, if nature do therto induce hym'.[253] But the revolution was stillborn: the break with Rome and the assault on Roman Catholic religion that we call the Reformation fundamentally changed English attitudes to the visual arts (see Howard, p.232). It is ironic that the religious imagery whose use in the service of the Church had been promoted throughout the Middle Ages was stigmatized by reformers as idolatrous, whilst the classical images earlier feared as pagan idols were now viewed as 'Art'.

90 PIETRO TORRIGIANO and
MAYNARD VEWICK
Tomb for Margaret Beaufort, 1511
(date of contract)
Gilt-bronze (latten), polychromy
and touchstone
Henry VII's Chapel, Westminster
Abbey, London

Conclusion

From the middle of the fourteenth century, recurrent outbreaks of plague had an enormous impact. Some effects such as the loss of a generation of top craftsmen in the first outbreaks – were immediate; others, such as increased import penetration and subtle changes in artistic subject matter, were longer term. The quality of materials and of workmanship remained key concerns of the patron. With an increased volume of documentation, we can sometimes follow the design process from inception through to completion. Particularly revealing are occasions when the taste and objectives of the patron and his artisans diverged.

Collaborative production remained typical throughout this period, which saw mass production of works such as alabaster panels, England's most significant artistic export. Some craftsmen became wealthy, holding civic office and dominating the guilds that increasingly regulated urban crafts. Printing made possible mass production of books on a huge scale for the first time and the rapid dissemination of woodcut models (see Hamling, pp.242–3). Under

Henry VIII printed imagery was deployed as propaganda to support royal supremacy.[254] There is evidence of increased separation of design from execution during the period, and a reliance on established models may have retarded artistic innovation, which increasingly rested in the hands of Continental artists, in spite of the guilds' attempts to restrict competition. As yet, the Renaissance conception of 'artistic progress' as generated by the contributions of individual artists was unfamiliar in Britain. It was brought to England by a handful of Italian artists in the early sixteenth century, but the break from Rome under Henry VIII and the Reformation under Edward VI retarded change until the end of the century, restricted artistic activity and generated a widespread and long-lasting hostility to religious imagery. It has been argued that the emancipation of art as an autonomous activity may have been hastened by the effective separation of art from religion.[255] What is certain is that it would take until the seventeenth century, when British art reconnected itself with the Continental mainstream, for the artist to be perceived as an individual possessing distinctive intellectual and spiritual qualities, and not just as a superior type of craftsman.

The Lambeth Apocalypse

NIGEL MORGAN

A large proportion of the English thirteenth-century painting that has survived the ravages of the centuries appears on the pages of illuminated manuscripts. Certainly, some stained glass and wall painting also remain, but these do not possess the same range of difference in style and imagery as the paintings in the manuscripts.

From the middle years of the century up to c.1275 there was a great interest in illustrated Apocalypses, of which this manuscript in Lambeth Palace Library (fig.91) is one. The text of the Book of Revelation, also called the Revelation of John, is accompanied by a theological commentary explicating the complex allegory of its text, as well as seventy-eight pictures. This page has the Latin text of Revelation 13:14–15 in the section with the gold 'P', which is then interpreted by the theological commentary in the section beginning with the blue 'P'. The Apocalypse is a vision of this man named John, written in the closing years of the first century AD, who in the Middle Ages was thought unquestionably to be the same John as the author of the fourth Gospel. The vision, as recounted in Revelation, narrates events leading to the final judgement of God and the establishment of the New Jerusalem, and is mainly concerned with a struggle between the forces of good and evil, culminating in the eventual triumph of good and destruction of the wicked.

This scene illustrates the passage in which the false prophet, 'with horns like a Lamb', who is described as rising up from the earth in Revelation 13:11, erects a statue of the seven-headed and ten-horned beast who had come up from the sea in 13:1, and orders the people to worship the image. The text in verse fifteen explains that the false prophet has miraculously given life to the image of the beast, so that it could speak. Those who refuse to worship the image he orders to be killed. The false prophet sits on a mound in the centre of the picture, with people adoring the statue of the beast on the right, and turns *contrapposto* to observe the slaying of those who refuse to worship. The theological commentary explains the significance of this. The beast is described as the Antichrist and the commentary opens with the words: 'There is nothing that leads simple

people astray as much as the showing of signs.' The false prophet has led people astray by the sign of this 'miracle' of bringing the image of the beast to life. The commentary continues to explicate the deception of this sign: 'It can be imagined by devilish art that Antichrist dies and rises again, and that by this act he may deceive men more easily.' The picture can thus be understood in its fullness by reading both the Apocalypse text and its commentary.

The men and beasts in the picture are set against a background with a burnished gold rectangle framed by a wide orange-red border and ornamental outer frame. Linear devices of verticals, horizontals and frames are used by the artist to accentuate the main protagonists and actions of the composition. Dramatic figure poses and gestures give a dynamism to the opposing groups of the worshippers of the dragon and those being killed, with the false prophet dividing them by his authoritative gestures.

In the first half of the thirteenth century English painters developed an Early Gothic style, moving away from the Byzantine-influenced painting of the late twelfth century (see Donovan, pp.68–9) to a style in which figure forms, head types and costume more closely resembled those of their contemporary culture. Artists observed aspects of the surrounding world and did not rely so much on formal and eclectic visual traditions from the past. In the 1250s and 1260s, when the artist of the Lambeth Apocalypse was working, English painters came under the influence of contemporary painting in the French 'court style'. In the picture shown here the artist shows relatively little of this influence, but in his final work in the book he has taken up the new style. A centre of French influence in the period was Westminster Abbey (see Binski, pp.74–5 and Coldstream, pp.106–7), and it is possible that the Lambeth Apocalypse was made in London.

At the end of the book is a picture of Eleanor de Quincy, Countess of Winchester, kneeling before the Virgin and Child. She was therefore the owner of this book, probably made for her after the death of her husband, Roger de Quincy, Earl of Winchester, in 1264, and before she married Roger de Leybourne in 1267.

FURTHER READING

G. Henderson, 'Studies in English Manuscript Illumination I, II, III', *Journal of the Warburg and Courtauld Institutes*, vol.30, 1967, pp.71–137; vol.31, 1968, pp.103–47.

S. Lewis, *Reading Images: Narrative Discourse and Reception in the Thirteenth-Century Illuminated Apocalypse*, Cambridge 1995.

N. Morgan, *Early Gothic Manuscripts [I] 1190–1250, [II] 1250–1285*, from *Survey of Manuscripts Illuminated in the British Isles*, vol.4, 2 parts, London 1982, 1988.

N. Morgan, *The Douce Apocalypse: Picturing the End of the World in the Middle Ages*, Oxford 2006.

N. Morgan and M. Brown, *The Lambeth Apocalypse, Manuscript 209 in Lambeth Palace Library*, London 1990.

91 Page from the Lambeth Apocalypse with illustration of the 'false prophet ordering the killing of those who refuse to worship the image of the beast' (Rev. 13:14–15), c.1264–7
On parchment 27.2 × 20 (10⅝ × 8)
Lambeth Palace Library, London
(MS 209, f.20r)

20

Propter signa que data sunt
illi facere in conspectu bestie
dicens habitantibz in terra ut faci
ant ymaginē bestie que habz plagā
gladii ⁊ uixit. ⁊ datum est illi ut daret
spiritu ymagini bestie ⁊ ut loquať
ymago bestie. Et facit. Quicūcz hō
ad orauerint ymaginē bestie · occidať
propt signa ⁊ ꝛ̄ . Nichil est q̄ sedu
cat simplices quosꞇz qꝫ admodū
signoꝛ demonstratione . Ideo qꝫ minis⸗
antxpisti propt signoꝛ opatōne dicē⸗
tes habitantibz in terra · ut faciant yma
ginē bestie que habz plagā gladii ⁊ uixit ·
ut hō impius aliquid deitatis ī se habeat ·

udelicet in ymaginibz antxpistus aꝺ
adoretur. Qui autē bestiam plagam gla
dii habuisse dixit ⁊ uixisse pꝫ fieri ut
arte diabolica fingat se antxpistus
mori ⁊ resurgere · ut hoc facto faciliuˢ
homines decipiat. unꝺe symon maguˢ
fecisse dicitur · ⁊ datum est illi dare spi̅
tū ymagini bestie · sꝫ ⁊ hoc quosdam
magos fecisse audiuimus. Faciebant
quippe per nigromanciā arte ut sta
tue uiderentur moueri ⁊ loqui · possi
mus hoc aliter intelligere · ymago
spem hz hominis sꝫ non ē homo · sic
⁊ antxpꝫ xpi operacioūe uirtutū
atꞇz a signoꝛ putabit̄ deus · sꝫ hoc
fallissimū erit non eum pꝫ fieri
ymaginē ergo antxpi facient · qꝫ
eū deum existimabt̄

167

English Medieval Embroidery

KAY STANILAND

English embroidery was highly regarded across Europe both before and after the Norman Conquest. Surviving examples of the tenth century already demonstrate accomplishment in design and execution (see Lindley, pp.143–4, fig.80). Although its origins continue to be contested, the eleventh-century Bayeux Tapestry represents a sizeable group of lost but recorded embroidered wall hangings that were probably worked on cloth and silk as well as linen, using various stitching techniques (see Gameson, pp.46–7).

Liturgical vestments now form the bulk of English embroideries surviving from the later Middle Ages. Justly famous for beauty of design and fineness of execution (fig.93), they were costly and impressive possessions coveted by princes of the Church. The Vatican's 1295 inventory recorded over eighty examples of English work (*opus anglicanum*), some of which were sent as royal diplomatic gifts. The Bologna Cope (fig.92), now ascribed to the late thirteenth or early fourteenth centuries, is believed to have belonged to Pope Benedict XI (1303–4) and to

have been given by him to the church of San Domenico in Bologna. It is worked in split stitch in silk with underside and surface couching in silver and silver-gilt threads on a linen ground, and is ornamented with deep concentric zones containing scenes of the Life of Christ, headed by narrow zones containing the heads of Christ, Peter and Paul, and twenty-nine other saints; the hood and orphreys are missing.

Vestments of this quality are assumed to be the work of professional embroiderers in small London workshops, probably financed by wealthy merchants able to bear the high cost of materials and remunerate the embroiderers while the work was under way. Capable professional artists were clearly responsible for designing these embroideries but, apart from a few tentative suggestions – the figure style of the Bologna Cope has been paralleled with paintings in Westminster Abbey, for example – their identity continues to tantalize. Ink under-drawing, visible through worn areas, reveals that the embroiderers did not always carry through an artist's intentions.

There are now few examples of embroidery destined for secular use before 1300 and limited documentary evidence, but a proliferation of detail is to be found in the fourteenth-century accounts of the royal household, in entries recording payments for silken and gold and silver threads, and for wages to teams of craftsmen and craftswomen with mixed skills employed in the workshops of the king's armourers. Draughtsmen and painters, the most highly remunerated, headed teams working on clothing for the king, his family and friends standards and flags; domestic furnishings such as bed and wall hangings, bench covers, bed covers and mattresses; and martial equipment like saddles, horse covers and tunics. Much ornament was heraldic, but other motifs (personal badges and mottoes, flowers and animals) were required by the king; some designs were clearly influenced by imported textiles.

Limitations on production time frequently dictated the techniques used and the form of design, such as repeating motifs that could be worked separately and then assembled. Many

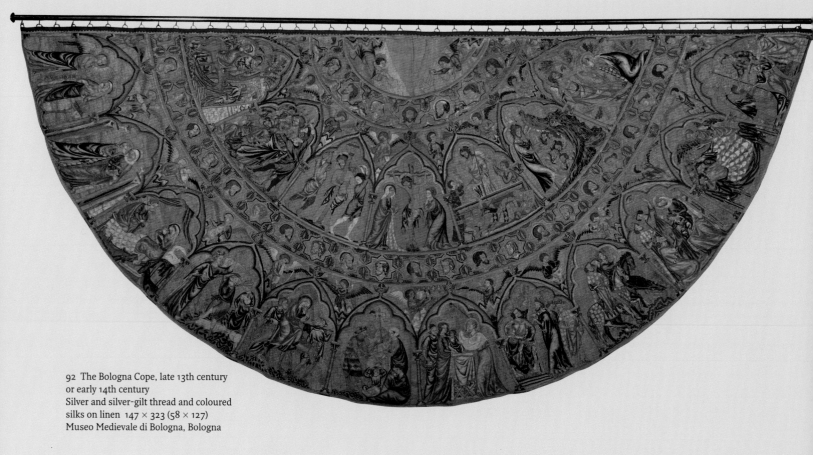

92 The Bologna Cope, late 13th century
or early 14th century
Silver and silver-gilt thread and coloured
silks on linen 147 × 323 (58 × 127)
Museo Medievale di Bologna, Bologna

pieces, like their liturgical counterparts, were enriched with pearls and gemstones, small gold motifs or enamelled plaques. A surviving heraldic embroidery of c.1330, thought originally to have been a horse covering, was probably created for Edward III in such a workshop (Musée nationale du Moyen Âge, Paris; p.35, fig.9). A decline in the quality of liturgical embroidery from about 1350 has been attributed to the Black Death, but the extensive employment of embroid- erers in armourers' workshops, together with the grow- ing quantities of richly patterned silks and cloths of gold, must also have been determining factors. From about 1350 liturgical vestments for the king's use were made in these workshops. Little is known regarding the existence of a guild of embroiderers in London; there was possibly one in the fourteenth century, but ordinances are not known until the following century and chartered status was achieved only in 1561.

A.G.I. Christie's 1938 survey of English medieval embroideries still remains the definitive study, after some seven decades. Naturally there have been a number of changed attributions, reconsidered dates and additions to the group, whilst inclusion in exhibitions has focused both scholarly and conservation attention on a number of pieces, allowing more thorough investigation of comparable material and of practical evidence. A complete reassessment of these outstanding and vulnerable examples of medieval craftsmanship is long overdue. Such a study, or studies, could provide a more satisfactory and coherent explanation of their commissioning, selection of iconography and design, as well as their links with contemporary decorative arts. Research into the royal work- shops is already under way, as is research into the destruction of liturgical vestments during the Reformation.

FURTHER READING

A.G.I. Christie, *English Medieval Embroidery*, Oxford 1938.

D. King, 'Embroidery and Textiles', in J.J.G. Alexander and P. Binski (eds.), *Age of Chivalry*, exh. cat., Royal Academy, London 1987, pp.157–61.

K. Staniland, *Medieval Craftsmen: The Embroiderers*, London 1991.

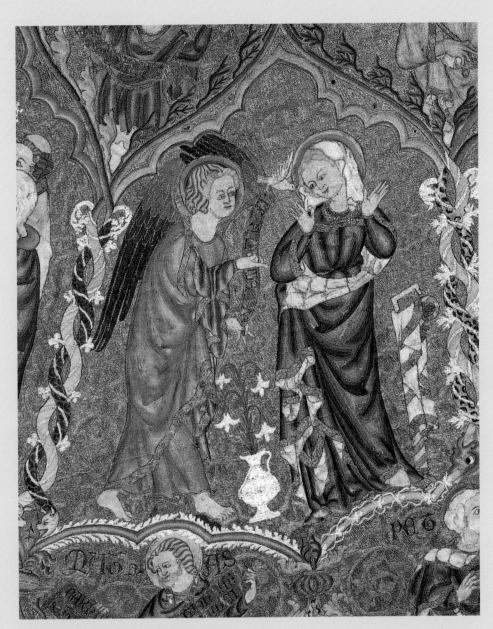

93 The Annunciation, detail from the Pienza Cope, presented to Pienza Cathedral by Pope Pius II (1458–64), 1315–30
Silver and silver-gilt thread and coloured silks on linen 163.9 × 350.5 (64½ × 138)
Pienza Cathedral, Pienza

John Thornton of Coventry

HEATHER GILDERDALE SCOTT

John Thornton, glazier, ranks among the best-known craftsmen of late medieval England, responsible for one of the major artistic achievements of the period: the great east window of York Minster (figs.94). He was contracted by the dean and chapter in 1405, and their agreement summarizes the mechanics of the stained-glass commissioning process, stipulating, on the one hand, Thornton's responsibilities, including the provision of appropriate men and materials and the timely completion of the project, and, on the other, the financial rewards he could expect to receive if the terms were successfully met.

The vast wall of painted glass, today one of the largest surviving expanses of medieval glazing in Europe, throws light on the process by which such monuments were produced, and in particular the roles of patron and craftsmen. Comprising a complex and unusual mix of figures illustrating the Minster's history, Old Testament episodes, an extensive Apocalypse cycle and images of the celestial hierarchy, the window's iconography reflects location-specific choices and a profound theological knowledge suggestive of the close involvement of either the clerical community at York or the donor of the funds for the window, Bishop Skirlaw of Durham (1388–1406), represented in a panel at the window's foot. If patronal institutions and donors were responsible for iconographical choices, the successful translation of these into glass required the glazier's skills in design (fig.95). At York the cartoons produced to guide the work recognized the need to prioritize clarity in scenes of relatively small scale and intricate subject matter, particularly when placed far from the viewer's eye. It is likely that, as the contracted glazier, Thornton took the lead in establishing his patron's requirements and producing viable designs, but the obvious variations in the quality of the figures in the York window indicate that the window was the product of a much larger team of craftsmen, emphasizing the highly collaborative nature of medieval glass painting, and much late medieval art in general (see Lindley, p.158).

The 1405 contract describes Thornton as 'of Coventry'. His employment on a project as grand as the York window demonstrates that in the early fifteenth century the best and most sought-after glass painters did not necessarily originate in London and were willing to travel considerable distances. The decision to bring Thornton to York may be explained by the fact

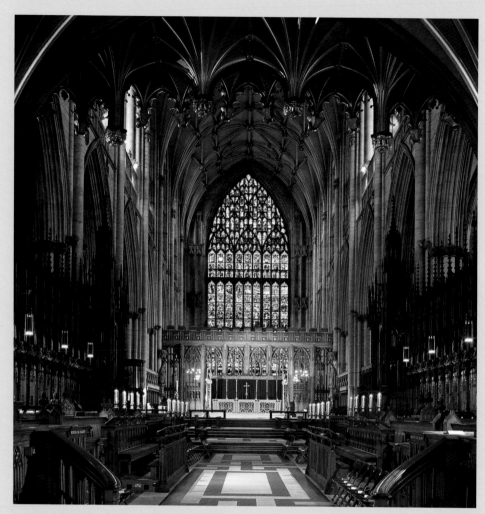

94 The choir of York Minster, looking towards the east window

that Archbishop Scrope of York (executed 1405) and Walter Skirlaw, the window's donor, had served as Bishops of Coventry and Lichfield between 1385 and 1398, emphasizing the importance of patronal will in shaping the stained glass industry. Thornton's painting style has traditionally been termed the 'York school' of glass painting. Whilst the city's glaziers did adopt Thornton's style and traits, more recent research has highlighted evidence for Thornton's ongoing association with Coventry and the Midlands, suggesting that he operated workshops out of both cities.

The obligation that Thornton 'wth his own hands . . . portrature the sd Window . . . where need required according to the Ordination of the Dean & Chapter' suggests that the exceptional

quality of his design work and painting determined his employment at York. Generally, it belongs to the so-called International Gothic style that dominated English monumental painting and illumination in the first third of the fifteenth century, a particularly fine example of which is the Wilton Diptych (see Gordon, pp.50–1). The style of the York glass may indicate that high-status patrons in late medieval England were also attracted by a glazier's ability to innovate. The narrative form of the window enjoyed enormous popularity in subsequent decades, but in 1405 it appears to have differed dramatically from other top-quality commissions, such as those made in the 1380s and 1390s for William of Wykeham, Bishop of Winchester (1366–1404), at Oxford and Winchester, which are characterized by series of standing figures within fictive niches. Despite such formal novelty, Thornton's glazing technique was common to glaziers of all ranks throughout the Middle Ages: the creation of figures and scenes through the leading together of thousands of pieces of painted and coloured glass.

As such, John Thornton of Coventry exemplifies the potential in late medieval England for glass painters with artistic talent, innovative ideas and, no doubt, an ability to manage effectively those who worked for them, to rise to the top of their profession, winning key commissions such as York on the one hand, and meeting more widespread parochial demands through their workshops on the other.

FURTHER READING

T. French, *York Minster: The Great East Window*, Corpus Vitrearum Medii Aevi: Great Britain, Summary Catalogue 2, Oxford 2003.

J.A. Knowles, *Essays in the History of the York School of Glass Painting*, London 1936.

R. Marks, *Stained Glass in England during the Middle Ages*, London 1993.

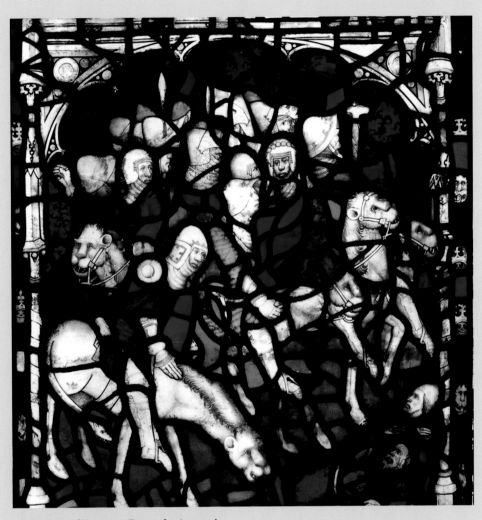

95 The Army of Horsemen (Rev. 9:16–19), a panel of stained glass in the east window of York Minster, begun 1405
91 × 86 (36 × 34)

English Precious Metalwork in the Late Middle Ages

MARIAN CAMPBELL

Throughout the Middle Ages and beyond, gold and silver were, in relative terms, far more valuable than they are today. England's wealth in precious metals had attracted the Vikings and before them the Romans. At the time of the Norman Conquest England was still rich enough to be compared to the gold treasury of Arabia by William the Conqueror's biographer, William of Poitiers. At the very end of the Middle Ages in around 1500, it is interesting to find a comparable reaction. This time it is that of an Italian, who marvelled at the fifty-two goldsmiths' shops, all located in the City of London's chief shopping street, Cheapside. Here the shops were filled with silver salts, cups and basins: 'In all the shops in Milan, Rome, Venice and Florence put together, I do not think there would be found so many of the magnificence ... to be seen in London.'

To the wealthy 'magnificence' was essential as a statement of power and prestige, and it was largely defined as the ownership of gold and silver. This might be in the form of gemencrusted jewellery, garments embroidered in gold and silver and, above all, splendid dishes and cups, both used at the table for dining and as display pieces on tiered sideboards nearby. The medieval Church regarded gold and silver as the materials essential for the making of church vessels, needed for the ceremony of the Mass and for the reliquaries and shrines made to contain the most precious and prized relics of saints. One of the most visited shrines in medieval Europe was that of St Thomas Becket in Canterbury Cathedral, the site of his martyrdom in 1170. When the shrine was destroyed in 1538, on the orders of King Henry VIII, the gold and silver from it filled twenty-six cartloads, along with the contents of the cathedral treasury. All were taken to the Mint in London, there to be melted down, either into new coins or new plate for the king.

Gold and silver have been recycled throughout the centuries, so that little medieval English goldsmiths' work has survived, and we rarely know anything about its original owners or makers. It is thus quite exceptional to find a group of plate at Corpus Christi College, Oxford, all owned or commissioned by the college founder, Richard Fox (d.1528). As Bishop of Winchester from 1501, Fox presided over the wealthiest bishopric in England, and enjoyed an income rivalling that of the king and the richest magnates. His status and power extended well

beyond the Church; earlier in his career he had been Lord Privy Seal and Secretary of State.

His plate reflects both secular and religious roles. The intricate hourglass-shaped salt cellar, set with pearls and a crystal, made of silver gilt once enamelled, is one of the grandest ceremonial salts (fig.97). It was undoubtedly a special commission of c.1494–1500, since it is decorated with Fox's initials as Bishop of Durham, and his pelican badge. The large silver-gilt basins for washing are enamelled with his arms as Bishop of Winchester but span both his bishoprics, since one is hallmarked for 1493–4, the other 1514–15. Each was made in London by different but unknown goldsmiths. No goldsmiths' marks can be identified before 1697, because of the loss of the mark plates in a fire at Goldsmiths Hall, London. The gold ring of c.1500, enamelled and set with a large faceted sapphire, is thought possibly to have been a gift to Fox.

The pieces associated with Fox in his role as churchman are still more remarkable. His chalice with paten, of gold, enamelled, bears the London hallmark for 1507–8 and is the earliest of all English gold vessels to survive. Most splendid of all is the enormous and intricate crozier (fig.96), the symbolic staff of office of a bishop, which was carried before him in processions. At nearly 6 feet (1.8 metres) long, the crozier is of silver gilt, enamelled and decorated with finely modelled silver figures of the twelve Apostles, set in two rows around the staff under an elaborate arcade of Gothic niches. The knop is decorated with enamelled roundels of saints. Enamelled roses and pelicans – Fox's badge – decorate the sides of the crozier. In the crook, set within an ornate Gothic niche, sits a large figure of St Peter, holding a book and the keys of heaven. The crozier is unmarked, but was clearly commissioned especially, probably by Fox when Bishop of Winchester, since its cathedral is dedicated to St Peter.

FURTHER READING

M. Campbell, 'Gold, Silver and Precious Stones', in J. Blair and N. Ramsay (eds.), *English Medieval Industries, Craftsmen, Techniques, Products*, London 1991, pp.107–66.

C. Ellory, H. Clifford and F. Rogers (eds.), *Corpus Silver: Patronage and Plate at Corpus Christi College, Oxford*, Barton-under-Needwood 1999.

96 Bishop Fox's Crozier, c.1501–10
Silver-gilt, length 181 (71¼)
Corpus Christi College, Oxford

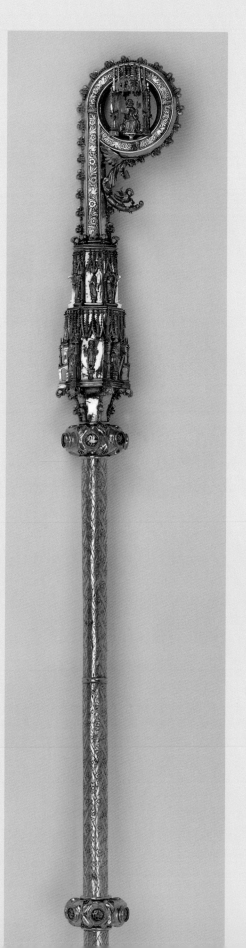

97 Bishop Fox's Salt, c.1494–1501
Silver-gilt, with a crystal, pearls and
enamel, height 30.8 (12⅛)
Corpus Christi College, Oxford

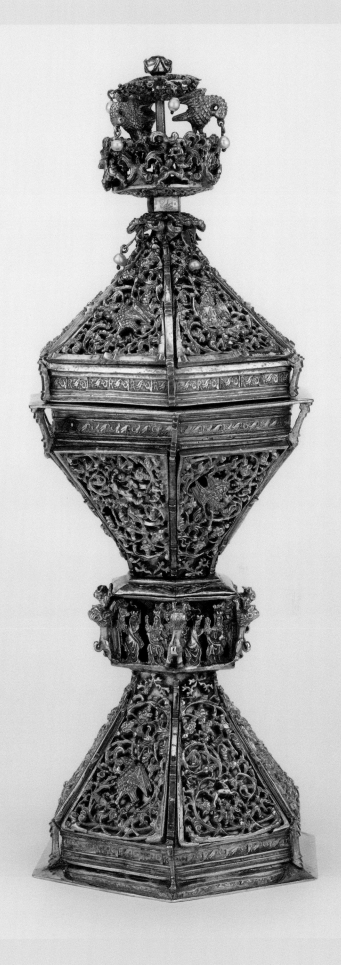

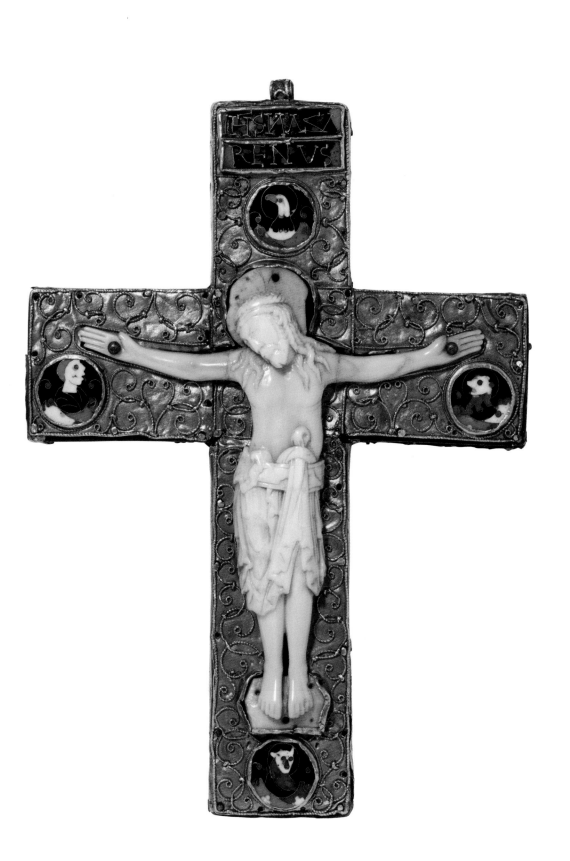

6 Signs of the Cross: Medieval Religious Images and the Interpretation of Scripture

JENNIFER O'REILLY

THE INTERPRETATION OF visual images involves considering not only the materiality of individual art objects and their immediate contexts of patronage, location and function but also the complex social and cultural elements of the imaginative world in which they were formed. For the medievalist faced with the scale and importance of religious art from the seventh to the fifteenth centuries, an essential part of the task is to understand the nature and variety of the connection between religious images and texts. The connection with the written word is most obviously apparent in the illumination of biblical, liturgical and devotional texts, which was a major art form throughout the period, but images in other media, including liturgical metalwork and carved ivory, often have allusive or contrapuntal inscriptions as an integral part of their design.[1] Even large-scale works such as wall paintings and stained glass, displayed in places of public worship, generally pre-suppose that the viewer, whether technically literate or not, has some familiarity with Scripture and with particular ways of seeing it. The identification of biblical subject matter alone is rarely enough to enable the modern viewer to understand the original function and possible meaning of images that do not simply illustrate biblical narratives but also offer an interpretation of their significance, drawing on ancient traditions of reading the text. The present chapter first briefly outlines some of those interpretative traditions and then considers their diverse and changing influences on the visual arts in the Middle Ages by examining the central Christian image of the Cross in examples taken from various times, media and contexts.

The Spiritual Interpretation of Scripture

The interpretative techniques of the early fathers of the Church were inherited, along with the Latin Bible, by the barbarian or non-Roman peoples of the West when they received Christianity from the Mediterranean world of Late Antiquity. The Anglo-Saxons who settled in Britain had been converted during the seventh century by papal Rome and also by the Irish, who had received Latin Christianity two centuries earlier. In the Northumbrian monastery of Wearmouth-Jarrow the inherited traditions of biblical commentary or 'exegesis' found a highly creative exponent in Bede (672/3–735), whose work did much to promote a Latin Bible culture in the early medieval West.[2]

Though pre-supposing a learned understanding of the literal text of Scripture, the discernment of its inner meaning was regarded as a spiritual act requiring grace. The large body of expository literature produced by early holy fathers of the Church, and cited in its councils, therefore had great authority. Patristic interpretation derived models from the meditation on the sacred Hebrew scriptures in the light of the Incarnation, to be found in the New Testament itself. Read in this way, the Old Testament was seen to disclose prophecies and prefigurings of Christ, and to offer spiritual guidance for the Christian faithful. The fathers read a passage from the Old or New Testament in the context of the whole of Scripture, seeking its allegorical or mystical allusions to Christ, its underlying significance for the moral conduct and spiritual growth of the Church and the individual believer on earth, or its implications for the future heavenly life. These compatible ways of understanding the hidden meaning of the literal text of Scripture can all be described as spiritual interpretation.[3] It was not a closed system of fixed meanings, but was alert to context and the possibilities of metaphor. The biblical text was believed to be divinely inspired and both its great paradoxes, like the Cross, and some apparently unimportant details, like lists of names and numbers, were regarded as *sacramenta*, or 'signs of salvation' which, if spiritually interpreted, could yield insight. The fathers' interpretation of such signs often showed the influence of classical rhetorical techniques, and might take the form of further paradox and wordplay, etymologies and numerology, or the linking together of scriptural passages that share a key word or image.

A core of patristic texts was well known throughout the Middle Ages. Extracts and summaries of the fathers were included in standard annotated copies of the Latin Bible circulating from the twelfth century, and there were impor-

tant later medieval renewals of patristic study, culminating in published editions by Erasmus (c.1467–1536) and others. The spiritual interpretation of Scripture, however, expressed a world view by no means confined to those who wrote or read works of biblical commentary. It was central to the seasonal arrangement of scriptural texts in the public liturgy of the Church's year, to the use of the Psalms in the daily monastic office, and to the practice of meditative reading known as *lectio divina*.[4] Monastic practices were to inspire traditions of private prayer and the development of Books of Hours, widely used by the later medieval laity.[5] The patristic tradition was further mediated through medieval re-tellings of Scripture in popular devotional works in the thirteenth and fourteenth centuries, such as Jacobus de Voragine's *Golden Legend*, the pseudo-Bonaventure's *Meditations on the Life of Christ*, and Ludolph of Saxony's *Life of Christ*. The spiritual interpretation of Scripture is evident in hymns, homilies, hagiography, typological manuals and in many of the teaching and confessional works produced, particularly by Franciscans and Dominicans, in response to the pastoral requirements of the Fourth Lateran Council in 1215, reiterated by later synods and bishops. Though expressed and understood with widely differing degrees of sophistication, the world view so variously disseminated from its biblical and patristic origins permeated medieval Latin Christian culture, underpinned the writing of post-biblical history and was influential in the formation of vernacular literature and visual art.

The task of trying to understand the relationship between visual images and the written word concerns not only the transmission of this interpretative tradition in the different times, places and contexts in which individual works of medieval art were produced but also the nature of visual images and the function of religious art.[6] Bede repeated patristic explanations of the divine sanctioning of non-idolatrous religious art and stressed the spiritual value, for example, of depicting events already known, especially the exaltation of the Lord on the Cross, recalling to the minds of the faithful how Christ had conquered death. Like Gregory the Great (540–604), Bede explained that 'the sight of these things often tends to elicit greater compunction in the beholders' and offers 'a living writing', even for the unlearned.[7] The process of looking at medieval religious images has often been usefully compared with the activity of meditative reading, but images do not offer

direct translations of the written word: they present a visual experience.

Medieval artists used pictorial conventions and motifs, many derived from the art of the Mediterranean world of Late Antiquity, in which classical traditions of realism were in the process of transformation. Christian art had first developed in this culture, assimilating the pictorial conventions of late Roman art to represent or subvert normal temporal and spatial relationships, or to denote authority by scale, centrality and attributes, for example. The conventions were adapted to new purposes and contexts, however, including the genre of non-narrative, iconic devotional images, so important to Western medieval and Renaissance art.[8] An enormous range of biblical subject matter had by the sixth century already acquired characteristic modes of representation, or iconography, formed by the two diverse traditions of Greco-Roman art and Judeo-Christian biblical interpretation. In a very different culture artists and patrons in Britain and Ireland in the early Middle Ages selectively received and adapted such models and developed new means of visual eloquence. Art did not passively reflect the changing spirituality and sensibility of later centuries, but often creatively articulated or re-formulated contemporary concerns: some medieval images took on the authority of a text.

The following examples of the iconography of the Cross illustrate just some of the ways in which visual images, the written word and the spiritual interpretation of Scripture were closely related in early medieval monastic art. As art attracted increasingly diverse patronage and was produced for places of public worship and for the private devotional use of the laity, there were remarkable continuities as well as important changes in the nature of that relationship in the later Middle Ages.

The Sign of the Cross

The representation of the Crucifixion was slow to develop its dominant role in Christian art; examples survive from the early fifth century, but there are remarkably few from before the seventh century.[9] Far more typically in the world of Late Antiquity, the Cross was depicted as an abstract symbol: the intersection of vertical and horizontal lines, with four equilateral arms or with the four terminals

embellished, sometimes combined with abbreviated inscriptions of Christ's titles.[10] Such images offer a visual counterpart to the work of the early fathers of the Church, who expounded the mystery of the Cross hidden beneath the outward 'sign' of its physical appearance. They rhetorically described the four projections of the Cross as penetrating all creation and converging on the centre from east and west, north and south; they pictured its horizontal beam as extending from the rising to the setting sun, the vertical shaft spanning earth and heaven.[11] It formed the very structure of divine creation and encompassed one universal faith. Such expositions reflect the influence of Neoplatonic concepts of number and cosmology that were familiar in the late Roman world, particularly the idea that the divine creator is evident in the cosmic harmony underlying the fourfold ordering of time, space and matter (such as the four seasons, the four cardinal directions and the four elements). St Paul's image of 'the breadth and length, and height and depth' of the love of Christ came to be associated with the four dimensions of the Cross.[12] Paul was describing how God, the hidden creator of all things, had been made manifest in Christ (Ephesians 3:8–10, 18). For early Christian commentators the cosmological Cross was a figure of Christ himself, the divine Creator. By taking on human flesh and nature at a particular time and place in history, and stretching out his hands on the Cross, he had reversed the fall of Adam and Eve, renewed creation and restored humanity, which had originally been made in the divine image. The concept of the cosmological Cross, represented through various pictorial conventions, survives in many medieval depictions of the Crucifixion, as will later be seen.

Insular gospel books are famous for their adaptation of motifs from the native repertoires of Irish and Germanic Anglo-Saxon metalwork, but their abstract designs of spirals, interlace and rectilinear ornament often convey these patristic themes. Drawing on the concept of a fourfold universe and the importance of the number four in biblical symbolism, the fathers, readily followed by Irish commentators, had developed the idea of the harmonious fourfold nature of the Gospel, in which the incarnate Christ is revealed. The concept is expressed visually in numerous Insular gospel books that depict symbols of the four Evangelists in the four angles of a cosmological Cross.[13]

In the Lindisfarne Gospels aniconic carpet pages present the sign of the Cross as a focus for meditation at the beginning of the book's prefatory material and also at the threshold of each of the four constituent gospels (see Hawkes, pp.198–9).[14] The prefaces include copies of patristic texts that affirm the divine authority and harmony of the fourfold Gospel taken to the four corners of the earth. Jerome (c.347–420), for example, here cites biblical instances of quaternities, particularly the Old and New Testament visions of four winged creatures with the features of a man, lion, ox and eagle (Ezekiel 1:5–10; Revelation 4:6–8), which the fathers had interpreted as symbolic of the four Evangelists, Matthew, Mark, Luke and John. All four harmoniously testify to the same Christ, but each reveals an aspect of his identity – his humanity, kingship, priesthood or divinity – in a particular way, which is epitomized in the opening words of each gospel. Individual author portraits of the Evangelists, each with his symbolic creature, precede the four constituent gospels in the Lindisfarne Gospels. Each portrait is followed by a carpet page facing the beginning of one of the four gospels, whose opening words are transformed by their layout and ornamentation into an abstract visual image.[15]

The sign of the Cross dominates every carpet page yet is unique in each because of the multiplicity of forms with which it is depicted. It appears as an imposing Latin cross on folio 26v facing Matthew's gospel (fig.113 centre, p.198), but as a Greek cross or a stepped cross, with variously shaped terminals that themselves form four Latin crosses or T-shaped (*tau*) crosses, in the carpet pages prefacing Mark, Luke and John. Signs of the omnipresence of Christ are also hidden from the casual eye in the tiny crosses concealed within each design and its interstices.[16] The frame of each cross-carpet page is embellished at the four corners and at the four projecting cardinal points. The effect is enhanced in the examples facing the openings of Mark, Luke and John, where the crosses are equal-armed and centred, so that both the transverse and upright beams are aligned with the cardinal points and divide the page into four quarters, filled with quadripartite ornament. The cruciform abstract design of the four carpet pages evokes, as no figural composition could, the fourfold nature of divine creation, the diversity and unity of the fourfold Gospel and the mystery of the Cross, in all of which Christ is revealed to those accustomed to searching for the spiritual meaning lying beneath the literal text of Scripture.

Such designs might inspire or deepen awe and devotion; they do not offer narrative illustration or didactic visual

98 Inscribed image of the Crucifixion
in the Durham Gospels, late 7th or
early 8th century
On parchment 34.4 × 26.5 (13½ × 10⅜)
Durham Cathedral Library
(MS A.II.7, f.38(3)v)

aids for the illiterate. The illuminated Insular Gospel book, written in stately script, and sumptuously decorated and bound, enshrined a sacred text. It was also a ceremonial liturgical object, used in the Eucharist and enthroned on the altar. The production of such a book, whether by a single monk or several, was a contemplative work representing the faith and worship of the monastic community. The book was a potent symbol of the Word of God whose Incarnation is described in its pages; it contains arcane images in which his identity might be discerned and further pondered by the initiated who saw the book at close quarters.

God and Man: Early Iconography of the Crucifixion

The Christological debates of the early Church councils, whose reverberations continued into the seventh and eighth centuries, had profound implications for the representation of the Crucifixion. The Council of Chalcedon in 451 presented its definition of belief concerning the identity of Christ as that revealed in the Scriptures, handed down by the Apostles and fathers of the Church, and confessed by all in the creed. It incorporated Pope Leo the Great's exposition of orthodox belief, frequently affirmed in the West, which explained the divine and human natures of Christ as distinct and unconfused, but united in one person at the Incarnation; Christ became the mediator between God and man (1 Timothy 2:5). Taking on all the weaknesses of the human condition, except sin, he redeemed fallen humanity from the penality of its sin by overcoming death. Leo further explained that Christ suffered on the Cross in his human nature; in his divinity he could not suffer but, because his two natures were inseparably combined in one person, it could be said that the Son of God was crucified.[17]

The difficulties of portraying this paradox visually are evident. The representations of the Crucifixion to be considered here show some of the ways in which medieval artists attempted to depict the invisible God made visible in the incarnate Christ. The iconographic conventions they used to suggest the identity of the Crucified as God and man commonly depart from the literal text of the Gospel accounts of the Crucifixion, but adapt other scriptural texts cited by the Evangelists or patristic commentators to explain the underlying and continuing significance of the event. Artists were similarly concerned to show the Crucifixion as the turning point in history, which transformed humanity and offered the possibility of eternal life for all. Visual representations often indicate how the viewer should respond in order to share fully in the grace of redemption. Some Crucifixion images, for example, allude to the Eucharist in which Christ's sacrifice on the Cross is made present and the faithful become sacramentally one with him; many later medieval representations stress the suffering of Christ as the focus of affective meditation arousing compassion and penitence. Repeatedly, the viewer is invited to look at the Crucified with the inner eye: the act of seeing is itself presented as a potentially transforming experience. The theological implications of picturing the Crucifixion are demonstrated in its earliest extant representation in Insular manuscripts, whose iconography provides an important comparison with subsequent developments.

The Durham Gospels was produced in the late seventh or possibly the early eighth century, probably in Northumbria, though it preserves some Irish traditions more

fully than the Lindisfarne Gospels.[18] Its Crucifixion iconography became an enduring type in Irish art, but the Durham Gospels image alone is framed by expository inscriptions that give valuable insights into how this particular example may have been understood in a literate monastic culture (fig.98). It is adapted from a Crucifixion type found in the Mediterranean world from the late sixth century.[19] The long-robed Christ is pictured as if simultaneously receiving the sponge of vinegar to his lips and the spear to his side, though the Gospel specifically reports them as consecutive events (John 19:28–34). Other details seen in the more naturalistic art of Byzantine and Roman examples, such as the setting, the two thieves, Mary and John, are stripped away. The Insular composition is reduced to a stylized two-dimensional image, with the dominant figure of Christ forming the central axis. He is symmetrically flanked by the spear-bearer and sponge-bearer beneath the cross arms, and by two angelic beings above. The vertical shaft of the Cross and the body of Christ thus span heaven and earth, and the horizontal beam on which his hands are outstretched in priestly oblation is so low and wide that all four terminals of the Cross reach the frame, suggesting the cardinal points. These are pictorial conventions, whose origins in the concept of the cosmological Cross have already been discussed, whereby the Crucified is identified with the divine Creator.

St John's Gospel uniquely describes the wounding of Christ's side and specifies that it happened after he died (John 19:28–34). In the Durham Gospels the wounded Christ is pictured erect and with eyes wide open, indicating his victory over death. This is a radical departure from the literal text of Scripture, yet the image reveals the significance of the event in a way that is compatible with St John's own exposition. St John presents the Crucifixion as a triumph by showing that the wounding was part of the divine plan of salvation and fulfilled Old Testament prophecy, which he quotes: 'They shall look on him whom they pierced' (John 19:37; Zechariah 12:10). This mysterious prophetic text is also recalled in the opening vision of the last book of the Bible, the Apocalypse or Book of Revelation, believed to have been written by the same St John. The Durham picture puts into visual terms the common patristic linking of the Crucifixion and the vision of Christ's Second Coming in glory at the end of time, when he is at last recognized by all the peoples of the earth: 'every eye shall see him, even those who pierced him.' In the

apocalyptic vision his true identity is further revealed in the solemn opening and closing incantations, 'I am *Alpha* and *Omega*, the beginning and the ending [*initium et finis*], which is, and was, and is to come, the Almighty'; 'I am . . . the first and the last.' (Revelation 1:8, 17; 22:13.) The first and last letters of the Greek alphabet here serve as a sign of perfection and eternal divinity, which is customarily expressed in the oracular self-proclamations of God Almighty in the Old Testament, such as: 'I am the first and the last' (Isaiah 41:4; 44:6). The display of the two Greek letters on images of the exalted Cross was commonplace and they later appear in medieval representations of Christ enthroned in majesty; here, however, their connotations of divinity and majesty are transferred to an image of the crucified Christ.

The Durham Gospels picture shows the mocking inscription written over Christ's head at the Crucifixion: 'This is Jesus the king of the Jews' (Matthew 27:37). Patristic and Insular commentators interpreted the literal words to reveal Christ's divine sovereignty. In the Crucifixion picture this spiritual interpretation is expressed through the texts from Revelation 1:8, namely the Greek letters *alpha* and *omega* and the words *initium* and *et finis*, which are written either side of the cross-head and immeasurably expand a reading of the title-board. Christ's divinity was veiled from most eyes at the Crucifixion by his suffering humanity, but he is here shown as a hieratic figure robed in purple and gold, and attended by cherubim so that, for those with eyes to see, the Crucifixion itself reveals the exaltation of his humanity to share in the glory of his timeless divinity. With commanding gaze he draws the present viewer to 'look on him whom they pierced' and to recognize now, before the Second Coming, that the crucified 'king of the Jews' is God Almighty.

The context of the picture in the book further extends the range of allusion. The image is not located in St John's account of the Crucifixion at all, but on the reverse of the last page of Matthew's Gospel, where an ornamented border frames and highlights Christ's last words to his disciples before he disappeared from their physical sight. He commanded them to teach and baptize all peoples and promised that he would be with his followers until the end of the world (Matthew 28:17–20). This text and the Crucifixion image are thematically related. The wound in Christ's side, from which water and blood issued (John 19:34), was universally interpreted as the source of baptism

99 The Ruthwell Cross, decorated with figural scenes with Latin inscriptions on the two broad sides and vinescrolls with runic inscriptions in Old English on the two narrow sides, probably early 8th century Red sandstone, approx. 549 × 50 × 34 (216 × 19⅝ × 13½) Now located in Ruthwell Parish Church, Dumfriesshire

and the Eucharist in which Christ remains invisibly present to the faithful.[20] The liturgy presents each Eucharist as a participation in the body of Christ and a commemoration of his death until he comes again (1 Corinthians 10:16–17; 11:24–6). St Paul had also spoken of baptism as a sacramental sharing in the death of Christ (Romans 6:3–4). Numerous commentaries and monastic texts urged the necessity of actively entering into the life-long process of what baptism symbolizes, by daily dying to sin, imitating Christ and taking up the Cross. Similarly, the Latin inscription running outside the lateral and lower frame of the Durham Crucifixion refers to Christ as overcoming death, 'renewing our life if we suffer along with him' that 'he might make us also to reign with him': by sharing Christ's suffering, restored humanity will share in his divinity.

But the Durham Gospels image of Christ flanked by sponge and spear does not realistically picture his suffering. Rather, it symbolically presents the unity in one person of his human nature, in which he experienced thirst and suffering, and his divine nature, by which he triumphed over death and his wound became the sacramental source of eternal life for believers. The opening of the inscription placed above the Crucified in the upper margin enjoins the viewer: 'Know who and what he is.' In a cryptic definition of Christ's divine and human natures combined in one person, and in marked contrast to the visual image, this inscription refers to him as one 'who suffered for us'. It is a notable example of the Insular use of the rhetorical technique of *ekphrasis*: the inscription does not redundantly describe what is depicted in the devotional icon, but brings other remembered images and texts before the informed viewer's inner eye, expanding and deepening what is already known.

THE TREE OF LIFE

The technique is used on a monumental scale in the different medium and context of the Ruthwell Cross, whose red sandstone shaft with equilateral cross-head stands over 5 metres high (fig.99). It is sited on the Solway Firth, at the far edge of what the Roman imperial world had regarded as the ends of the earth, yet shows remarkable skill in relief sculpture and familiarity with themes from contemporary Roman Christian culture.[21] Latin inscriptions, or *tituli*, are inscribed around deeply cut figural panels on the two broad sides of the shaft, depicting scenes of the

100 The Brussels Cross reliquary,
early 11th century
Oak core with silver sheeting on
back and sides, partly gilded
54.9 × 27.7 (21½ × 11)
Treasury of Cathedral of St Michel
and St Gudule, Brussels

recognition of Christ's identity by John the Baptist, the Evangelists, the man born blind who was healed and spiritually saw that Christ was the Son of God (John 9), other figures from the Gospels, post-biblical desert monks and all creation. They are implicitly joined in their witness by the Anglo-Saxons themselves, at the ends of the earth, who had more recently become part of the people of God, for the Ruthwell Cross also speaks in the language of Old English heroic verse, inscribed in runes in the borders of a sculpted vinescroll on the two narrow sides of the monument.

The classical vinescroll had been used in Late Antiquity as a Eucharistic image of the incorporation of all the diverse members of the universal Church into the body of Christ, and as an eschatological image of their union with

him in heaven. Alluding to the Old Testament metaphor of the vine and vineyard, Christ had described himself as 'the true vine' and his followers as the branches (John 15:1–5). The Old Testament also draws on the ancient Middle Eastern concept of the Tree of Life, the axis at the centre of the world, which joins earth and heaven, supports the constellations and provides food, healing and immortality for all. Patristic commentators had interpreted the Tree of Life (*lignum vitae*) in the middle of the earthly paradise of Eden in Genesis 2:9 as a mystical prefiguring of the redeeming Cross at the centre of the world, identified with Jerusalem (Ezekiel 5:5). The final apocalyptic vision pictures the *lignum vitae* in the heavenly paradise of the new Jerusalem (Revelation 22:1–2).

A rooted vine tree, inhabited by birds and beasts feeding on its fruit, rises the full height of the tapering cross-shaft at Ruthwell on both of its narrow sides.[22] It reveals the Cross to be the cosmological Tree of Life, a figure of the sacramental and glorified body of Christ. An apparently incompatible concept, however, is contained in the riddling runes of the Old English poem incised in the borders of the vine. This inscription voices the testimony of the Cross, on which 'the lord of heaven' was lifted up: 'I was drenched with blood poured from the man's side.'[23] Vinescroll and runes characterize the Cross as both Tree of Life and gallows, compelling the onlooker to ponder the paradox of the divine and human natures of the Crucified.

In the same rhetorical tradition whereby inanimate objects tell their story, the early eleventh-century Brussels Cross speaks of itself as an artefact through a prominently displayed vernacular inscription: 'Drahmal made me' (fig.100). But it speaks again with the voice of the Cross of the Crucifixion through a verse *titulus* in Old English, inscribed in Roman letters along its narrow edges and visible only to those who look closely: 'Rood [Cross] is my name; once, trembling and drenched with blood, I bore the mighty king.'[24] The words are in stark contrast to the material and decorative splendour of the object, raised up and carried in liturgical procession. The jewelled front is missing but the wooden core, which held a relic of the True Cross, is covered in engraved silver on the surviving reverse side, the nodes which project from its borders perhaps suggesting the knots of wood beneath. At the centre Christ is depicted as the Lamb of God, surrounded at the four terminals of the cross by gilded medallions of the four winged creatures who, in the apocalyptic vision of

101 Anglo-Saxon reliquary crucifix,
c.1000
Wooden core with gold sheeting,
cloisonné enamels, walrus ivory figure
18.5 × 13.7 × 1.4 (7⅜ × 5½ × ⅝)
Victoria and Albert Museum,
London

Christ's divine majesty at the Second Coming, surround his throne and chant his unending praise: 'Holy, Holy, Holy, Lord God Almighty, who was and who is and who is to come' (Revelation 4:7–8). This heavenly liturgy recalls the hymn of the seraphim in Isaiah's vision of the divine majesty (Isaiah 6:3), echoed in the Sanctus in the Eucharistic prayer of the earthly liturgy.

Allusions to the Tree of Life and the jewelled Cross are also combined in an Anglo-Saxon reliquary crucifix, c.1000 (fig.101).[25] Gold sheeting decorated with foliate filigree scrolls covers the wooden core of the Cross, and the four bright enamels at its terminals depict the four winged creatures who attend the enthroned Christ in the Apocalyptic vision. The cross acts as a foil to the carved ivory figure of

the crucified Christ whom it bears: he is shown stripped to the waist, his arms and body slightly sagging, his head sunk on his shoulder and his eyes closed. The poignant depiction of his humanity is a striking departure from the early Insular iconography of the Crucifixion seen in the Durham Gospels. This crucifix and the Brussels Cross are from among the liturgical objects and illuminated manuscripts produced during the Benedictine monastic reform in southern England, under the patronage of the Old English monarchy, from the mid-tenth century until the Norman Conquest. The work shows the influence of Carolingian and Ottonian art, which had assimilated a larger range of figural subject matter and a greater degree of naturalism from the Mediterranean world of Late

102 Frontispiece with Crucifixion,
Ramsey Psalter, late 10th century
On parchment 28.5 × 24.2 (11¼ × 9½)
British Library, London
(MS Harley 2904, f.3v)

103 Frontispiece with Crucifixion,
Gospels of Judith of Flanders,
mid-11th century
On parchment 29 × 19 (11½ × 7½)
Pierpont Morgan Library, New York
(MS 709, f.1v)

Antiquity than was characteristic of the early Insular period. But late Anglo-Saxon art also developed its own distinctive character and innovative iconography.[26]

The Virgin and St John: Witnesses of the Crucifixion

The early Insular Crucifixion image of the robed Christ, flanked by cherubim and the spear-bearer and sponge-bearer, was largely replaced in post-Carolingian Anglo-Saxon art by the more intimate devotional tableau of Mary and John at the foot of the Cross, and by the depiction of Christ with a loincloth and naked torso, as in Continental and earlier Roman art.[27] The fourth Gospel alone describes the Virgin at the foot of the Cross with the beloved disciple (John 19:26-7), who was identified with John the Evangelist. A fine tinted line drawing of this Crucifixion type serves as a frontispiece to the late tenth-century Ramsey Psalter (fig.102).[28] Christ's head is bowed, the blood from his wounds is visible, and the viewer's initial response to his suffering and death is cued by the downcast head and mourning gesture of the Virgin. But the Cross, like that in the Durham Gospels, spans earth and heaven; the body of Christ remains on a dominant scale and unrealistically posed, with arms extended horizontally and hands opened to suggest oblation. Moreover, the upward gaze of John towards the title-board directs the viewer to look again and follow his animated gesture and pointing pen, to read what he has written on his scroll.

In the Gospel the Evangelist testifies that he witnessed the opening of Christ's side (John 19:35). In the Ramsey Psalter picture, however, the abbreviated text on John's scroll is from his similar but later attestation as the witness of the Resurrection: 'This is the disciple who gives testimony of these things and has written these things' (John 21:24; John 20:8). Seeing the Crucifixion from the perspective of the Resurrection transforms a reading of the title - board of the Cross and the understanding of who Christ is. There are other examples in late Anglo-Saxon monastic art where the unusual image of John writing his gospel testimony beside the Cross does not show the actual words he writes but is combined with more pictorial ways of suggesting Christ's identity, most notably in the

frontispiece of the eleventh-century Gospel book of Judith of Flanders, wife of Earl Tostig of Northumbria (fig.103).[29]

The book opens with the startling image of Christ hanging from a hewn timber cross that looks like a roughly lopped tree. His head slumps on his shoulder, his eyes are closed, the arms sag below the horizontal beam. The whiteness of the body, its serpentine pose and delineated rib cage, seem to anticipate the selective realism with which some later medieval works depict his humanity and the fulfilment of Old Testament prophecies of his suffering, particularly Psalm 21, which is quoted in the Gospel accounts of the Crucifixion and used in the liturgy of Holy Week. But the frontispiece has important differences from those later medieval pictures that elicit the compassionate participation of the viewer in the sufferings of Christ.

The cross is in the T-shaped form of the Hebrew letter *tau*, interpreted in exegesis as the sign of deliverance with which the ancient Israelites had been marked and as prefiguring the sign of the redeeming Cross (Exodus 12:7; Ezekiel 9:4; Revelation 7:3). The term *lignum* (literally meaning 'wood', but often understood as 'tree') is used in numerous Old Testament passages that were regarded as prophetic of the Cross and in several New Testament references to the Crucifixion, such as 'he bore our sins in his own body on the tree' (1 Peter 2:24).[30] The evocation of the Cross as both wood and tree was particularly familiar from the sixth-century hymns of Venantius Fortunatus used on Good Friday. *Crux fidelis* also refers to the antithetical relationship between the Tree of the Knowledge of Good and Evil, by which humankind fell, and the Tree of the Cross, the means of redemption. The hymn *Vexilla Regis* incorporates the words, '*Regnavit a ligno Deus*: the Lord our God reigns from a tree', from the Old Latin text of Psalm 95 (96):10.[31] Judith of Flanders's Gospel-book frontispiece presents a visual conceit or riddle, exploiting the ambiguity of the term *lignum*. What to the outward eye is a man-made object of dead wood on which Christ is suspended, is to the inner eye of the faithful the Tree of Life on which he is exalted. The paradox is symbolically enacted in the ceremony of the Adoration of the Cross (*Adoratio Crucis*) on Good Friday, when a cross is unveiled and raised up by deacons with the acclamation: '*Ecce lignum crucis*: Behold the wood of the Cross on which has hung the world's salvation'.[32] The personifications of sun and moon in the Gospel book picture are classical cosmological symbols whose presence helps to reveal that the rough-hewn Cross

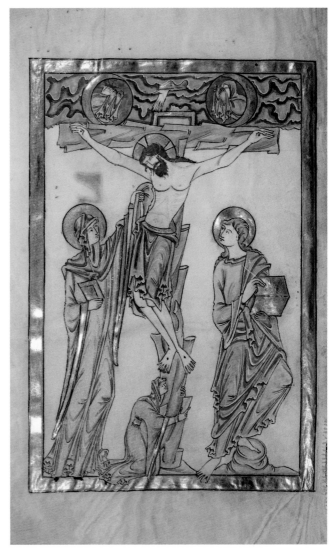

is in fact the *lignum vitae*, joining earth and heaven. Sun and moon recognize their Creator in the Crucified, and veil their faces from the sight of his holiness.

The small kneeling figure of a female supplicant, probably the patron, embraces the Cross and clings to it as the means of her salvation and heavenward ascent. In this there is some resemblance to the dreamer awaiting Christ's return in judgment at the end of the Old English poem known as *The Dream of the Rood*. The Cross is revealed to the dreamer through shape-shifting visions as a cosmic tree of glory, a sign of salvation towering beneath the heavens, and a gallows made of timber derived from a tree hewn down by men. The Rood is both the means of exaltation and an instrument of suffering; through this paradox, it is identified with Christ. As in the vernacular Crucifixion poem on the Ruthwell Cross and the verse distich engraved on the Brussels Cross, the Rood speaks. It bears witness that at the Crucifixion 'All creation wept; they lamented the king's death: Christ was on the Cross'.[33] The poem's series of changing images opens up for the reader the possibility of

a variety of insights into the identity of Christ and the nature of Redemption. In Judith of Flanders's Gospels frontispiece, however, illumination has to be conveyed through a single enigmatic image.

The picture recalls a long tradition of private devotion associated with the practice of prayerful reading in the monastic office, from which the *Prayers and Meditations* of St Anselm (Archbishop of Canterbury, 1093–1109) were to develop in the 1070s.[34] Over the previous two centuries ardent prayers on the Holy Cross, to Christ, and to Mary and John, were among those added to Psalters or compiled in separate *libelli*, owned by laity as well as monks.[35] An early eleventh-century example demonstrates the close relationship between such devotional texts and visual art. The tiny prayer book of Aelfwine, deacon of the New Minster, Winchester, has a line drawing of the Crucifixion with Mary and John shown writing (fig.104). It is set between St John's Gospel account of the Crucifixion and the readings, offices and prayers of the Cross, which according to a rubric, are to be said before an image of the

Cross.[36] The drawing is inscribed with a prayer seeking the powerful protection of the Cross: 'May Aelfwine be signed in body and mind by this Cross, hanging on which God draws all things to himself.' The inscription plays on John's account of Christ's words concerning his death, 'I, if I be lifted up [*exaltatus*] from the earth, will draw all things to myself' (John 12:32), but replaces *exaltatus* with *suspendens*, to create the paradoxical image of God hanging on the Cross. The text of John 12:32 appears in feasts of the Cross in the prayer book, where it is paired with a liturgically important text describing Christ's descent at his Incarnation: 'He humbled himself and became obedient unto death, even the death of the cross. Wherefore God has exalted him . . . that at the name of Jesus, every knee should bow' (Philippians 2:8–11).

In the Gospels of Judith of Flanders there is no inscription, but Mary and John guide the kneeling figure, and the

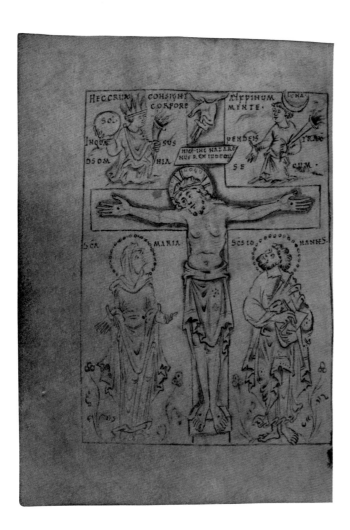

viewer, to see the Crucifixion as an exaltation. Mary and John are depicted on the same scale as Christ; their swaying forms, with knees bending to the right, accentuate his contrary pose, and their serene gestures and gaze direct attention up at him, countering the downward pull of his slumped body. They are not presented in attitudes of mourning but as witnesses; they suggest the role of the Church and the faithful disciple. In the tradition of seated Evangelist portraits, St John was pictured writing or meditating on the opening verse of his Gospel which, by alluding to the account of divine creation at the opening of Genesis, identifies Christ as the divine Creator-Logos. St Augustine said that John in writing his Gospel rose, like a mountain, in mystical ascent to contemplate the divinity of the Word, providing a model for the faithful to lift up their eyes and rise above the carnal to the spiritual interpretation of the scriptures.[37] In Judith's frontispiece this well-known metaphor of John's spiritual ascent and insight is transposed to the Crucifixion. The kneeling woman clasps the Cross, but points to St John and looks at him as he rises up and gazes up at the Crucified. Similarly, in a fervent prayer to John the Evangelist, Anselm pleaded: 'Let your gaze become my prayer.'[38]

During the period of the Anglo-Saxon monastic reform the image of Mary and John at the foot of the Cross was depicted with iconographic inventiveness, drawing on a rich tradition of scriptural interpretation and liturgically derived texts. There were new developments in depicting the Passion in English art in the period following the Norman Conquest, such as showing the Deposition from the Cross, a sequence of incidents in the Passion narrative or, from the 1260s onwards, a fuller representation of the scene at Calvary. There was also the later proliferation in various media of affective devotional images of the Instruments of the Passion, and the body of the Crucified shown separately from the Crucifixion, as in the Image of Pity, the Wounds of Christ, and the Pietà.[39] The tableau of the Virgin and St John flanking the Cross, however, remained a favoured means of picturing the Crucifixion throughout the Middle Ages, especially in English manuscripts and notably in thirteenth- and fourteenth-century Psalters. Two examples will be discussed, the Amesbury and De Lisle Psalters, demonstrating elements of continuity and change in later medieval iconography.

The Incarnation and the Crucifixion

The Hebrew psalms were traditionally read as the voice of Christ speaking to the Church, and the response of the faithful in praise and penitence, intercession and petition. This Christological interpretation had long been reflected in illuminated copies of the Psalter, where the Crucifixion could appear as the frontispiece, as in the Ramsey Psalter, or in prefatory pictorial cycles of the life of Christ, which from the twelfth century took increasingly varied forms; they were combined with Old Testament scenes, emphasizing the Fall and Redemption, and with other material, including devotional images of the Virgin and visualizations of the Last Judgement, as will be seen.[40]

The Amesbury Psalter, c.1250–60, shows the dead Christ on a roughly hewn Cross (fig.106).[41] Blood issues from his five wounds, his head is bowed, the rib-cage emphasized, and both feet are fixed with a single nail. Mary and John are shown with downcast heads and classical gestures of grief and mourning. Yet the Cross may be read as the Tree of Life, for it spans the universe depicted by the frame and is flanked by the sun and moon. There are also new means of alluding to its redemptive power. In four corner medallions angels with censers kneel in adoration, as though disposed around a throne or altar. Scenes at the four cardinal points of the frame introduce further material as visual expositions of the main image, though thereby reducing the element of puzzling ambiguity seen in earlier examples of the iconography of the hewn Cross. In the upper frame a symbol of the Godhead shows the Crucifixion to be the work of the Trinity. From the foot of the Cross blood streams down on the dead who, restored to life, rise from their tombs. In the border to Christ's right a personification of *Ecclesia* is aligned with the Virgin and raises a chalice to indicate the sacramental nature of the life-giving blood received from Christ's wound by the faithful. In the corresponding position in the opposite border is the personification of *Synagoga*, which in this context denotes the passing of the first stage of God's covenant with humanity in the Old Testament, and the extension of divine revelation to the new chosen people, the universal Church. The depictions of *Synagoga* and *Ecclesia* on either side of the Cross reveal it to be the turning point in providential history.

The Crucifixion scene on folio 5 is part of the Psalter's prefatory sequence of four full-page illuminations, which expands its range of allusion: the final image on folio 6 shows Christ triumphantly enthroned in heavenly majesty with the world as his footstool, inscribed with the *alpha* and *omega*. The page that precedes the Crucifixion scene is closely linked to it by a similar frame and colouring, and by the figure of the Virgin, dressed just as she is at the foot of the Cross and with the same tender inclination of her head, but here enthroned with the Child and enshrined in architectural splendour, suggesting the new Temple of the Heavenly Jerusalem (fig.105).[42] She is offering her breast to the cross-nimbed infant on her lap, and her feet rest on the vanquished lion and dragon, rather as Christ in majesty is shown in some earlier thirteenth-century Psalters with the two beasts beneath his feet, in abbreviated allusion to his fulfilment of the prophecy that the Messiah would trample underfoot the asp and basilisk, the lion and dragon (Psalm 90 [91]:13).

At first sight the Amesbury Psalter's use of the motif in an image of the Virgin seems arbitrary. The fathers, however, had linked the Psalm prophecy to the Incarnation, which alone made possible the Crucifixion and the overcoming of the power of the devil. Early visual interpretations of the Psalm verse paired the Annunciation or Nativity with an image of Christ holding the triumphal standard of the Cross and trampling the beasts underfoot.[43] Patristic tradition had also connected the psalmist's prophecy with the prophecy of Genesis 3:15, explaining that, after the expulsion of Adam and Eve from Eden, God put enmity between the serpent and the woman and her seed until the coming of the seed born of Mary, Christ, who was appointed to tread down the serpent's head. The Virgin Annunciate, obedient to God's will, was sometimes depicted treading underfoot the serpent who had tempted Eve to disobedience. In the thirteenth century such theological and iconographic traditions were cross-fertilized with the immensely popular devotional image of the Virgin and Child. Amongst the relief sculptures of the Angel Choir in Lincoln Cathedral, c.1260–75, in the bays that depict the Fall and the Passion, an angel censes the seated Virgin and Child. Mary has her foot on the serpent and, as in the Amesbury Psalter, offers her breast to the Child.[44] The vanquished beasts of Psalm 90 beneath her feet in the Amesbury Psalter attest her exalted part in the Incarnation and therefore in the divine work of redemption. Christ drew his sinless humanity from his virgin mother and her gesture of nursing him (*virgo lactans*) further emphasizes

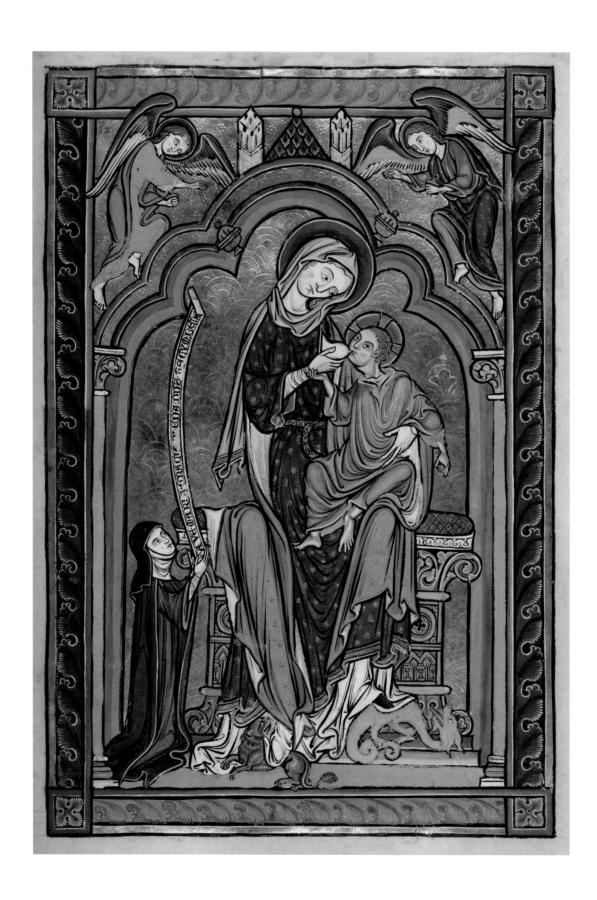

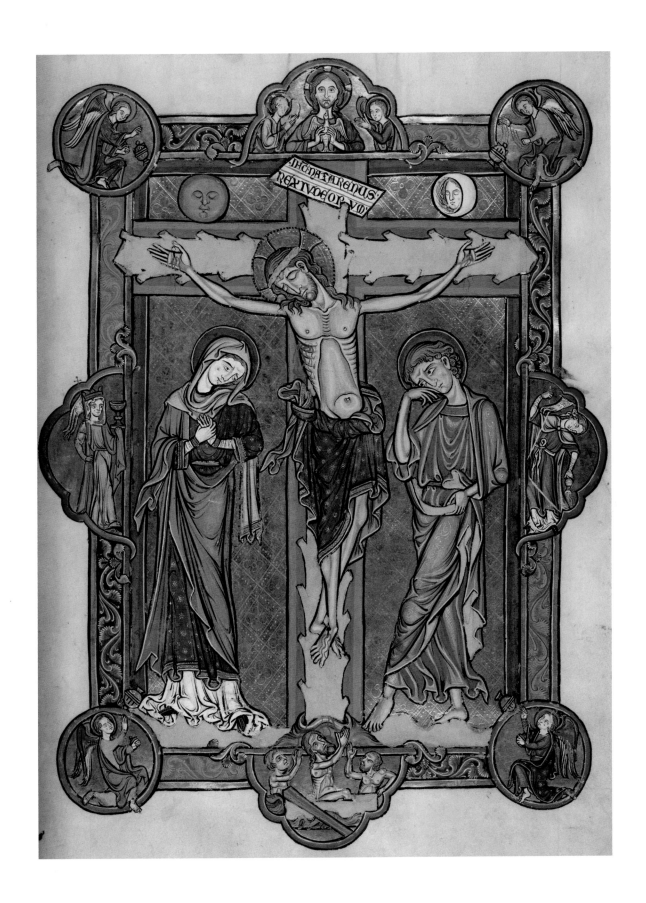

his human nature, which was crucial to his redemptive role as the mediator between God and humankind.[45]

Mother and child are shown censed by angels and this heavenly yet intimate image is venerated by the small earthly figure of a woman. She holds a scroll inscribed with the opening words of her own prayer, which floats upwards to the Virgin and prompts the response of the reader: 'Hail, Mary full of grace, the Lord is with you, blessed . . . '

The inscription recalls Gabriel's salutation of the Virgin at the Annunciation (Luke 1:28) but additionally includes the name of Mary. Gabriel's next words, 'blessed art thou among women', also open Elizabeth's salutation of Mary at the Visitation (Luke 1:42). The combined texts form the Ave Maria, a universally popular devotion in the cult of the Virgin, often recited before her image.[46] The angelic salutation appears as the daily invitatory at Matins in the Little Office or Hours of the Virgin, which had developed from the monastic office and formed the main text in Books of Hours; it was customarily illustrated by the Annunciation.[47] The Amesbury Psalter image of the Virgin and Child, preceded by the opening picture of the Annunciation on folio 3, can therefore be seen as providing a particular devotional context in which to view the Virgin and St John standing at the foot of the Cross.

Mary and John are also prominent in Crucifixion scenes that do not use the iconography of the hewn Cross. In the unusually encyclopaedic cycle of pictures surviving from the Psalter of Robert de Lisle, c.1310, they are set against architectural panels of burnished ornament and flank an improbably slender Cross on which the dead Christ is suspended (fig.109).[48] His arms hang well below the crossbeam and his feet are nailed together high on the Cross, so that his knees are now drawn up and his body sharply contorted, an iconographic type that had appeared in the later thirteenth century. The moving but mannered depiction of his human vulnerability and the grief of Mary and John do not attempt to make the historical Crucifixion present in all its physical horror but to persuade the viewer of its continuing spiritual reality; the image's sorrowful beauty and restraint are an intrinsic part of its rhetorical power to arrest attention and provide a focus for meditation.

The Cross is green, of cosmological proportions, and the foliage and fruit beyond the terminals reveal it to be the Tree of Life. At its top a pelican on a nest of chicks pierces her own breast. This offers another instance of the adapta-

tion of motifs from other contexts and their insertion into later medieval depictions of the *lignum vitae*. Augustine's commentary on Psalm 101 (102):7 notes that the pelican is said to slay its young and bring them to life after three days, feeding them on its own blood; in this it resembles Christ, 'by whose blood we have been called to life'. The image draws on the *Physiologus* tradition of moralized animal lore popularized in illustrated medieval bestiaries, which related the action of the pelican to the Crucifixion and the sacraments.[49] In the Psalter picture the self-wounding pelican is emblematic of Christ's sacrifice and the relationship between his wound and the Eucharist, whose redemptive power is visualized in a further motif. The Tree of Life stems from the open grave of Adam who, like a figure of Everyman, rises to receive the blood of the Redeemer in a raised chalice. This in turn is expanded by other Tree diagrams in the prefatory cycle.[50]

The Crucifixion scene is part of a diptych. The facing page, like a miniature altar panel, depicts a vision of the Virgin and Child enthroned over the vanquished lion and dragon of Psalm 90, and censed by angels within a foliated architectural shrine (fig.108).[51] In the earlier example of the iconography in the Amesbury Psalter (fig.105), the Christ Child holds a fruit, an abbreviated allusion to the fruit of the Tree of the Knowledge of Good and Evil by which Adam fell, and to the salvation of his descendants through the second Adam and the fruit of the Tree of Life. In the De Lisle Psalter the Child clutches a goldfinch, whose thorny habitat was seen as an allusion to the Passion. Mary is here shown crowned, the royal bride as well as the virgin mother of Christ. Some of the complex strands in this concept, which was of particular importance in later medieval devotion and art, can only be briefly indicated. New Testament references to Christ's union with his Church use the image of the Church as his bride.[52] From the Cross, Christ had said of Mary to his beloved disciple, 'Behold thy mother' (John 19:27); the fathers saw Mary as a figure of the Church, the mother of all the faithful. Patristic commentaries on the Song of Songs in the Old Testament interpreted the exchanges of the royal bridegroom and bride as a dialogue between Christ and his Church or the individual soul. A number of the text's images were early applied to Mary and were echoed in the Little Office of the Virgin; from the twelfth century the Song of Songs was often read as a dialogue between Christ and Mary, his bride and the exemplar of all the faithful.[53]

107 Inscribed carved panel depicting
the wounded and enthroned Christ,
probably late 10th century
Whalebone ivory 10.2 × 6.4 (4 × 2½)
Museum of Archaeology and
Anthropology, Cambridge University

In the De Lisle Psalter picture the Virgin holds a green shoot. It is leafier than the sprouting sceptre held like royal regalia by the crowned and enthroned Virgin with Child in twelfth-century examples.[54] In some representations of the popular Jesse Tree the Virgin holds the Christ Child and a burgeoning shoot; this detail may in the context of the Psalter picture similarly allude to the well-known patristic identification of the Virgin (*virgo*) as the *virga*, or shoot from the root of Jesse, in Isaiah's prophecy of the Incarnation and Christ's human descent from David's royal line (Isaiah 11:1–3).[55] In the picture Mary is also presented as the *virgo inter virgines*, flanked by two popular virgin martyrs, St Catherine of Alexandria, a notable 'bride of Christ', and St Margaret, patron of women in childbirth; they are shown as small statues in the niches of the Virgin's shrine.

The elaborate layering of details in the complementary scenes of the Crucifixion and the Virgin and Child in both the Amesbury and De Lisle Psalters provides visual delights that slow down the process of looking. It is a means of picturing epithets of the Virgin, like the listing of her attributes in the *Obsecro te*, a popular prayer to the Virgin in Books of Hours, and of visualizing images contained in familiar scriptural texts, which here act as wordless glosses on the main subject.[56] Such representations, however, taken from a variety of contexts and media, give a curiously literal, circumscribed form to biblical sacred metaphors that had been so allusively expounded in patristic tradition.

The Cross, The Five Wounds and the Last Judgement

The final group of examples illustrating the changing relationships between medieval visual images, texts and the spiritual interpretation of Scripture highlights other aspects of the iconography of the Cross, not in scenes of the Crucifixion, but at the Second Coming and the Last Judgment. The paradox of the Cross presented in the Insular and late Anglo-Saxon Crucifixion scenes already discussed is differently expressed in a small, late tenth-century Anglo-Saxon carved ivory (fig.107).[57] The Virgin and St Peter, the heavenly patrons of the New Minster, Winchester, attend the enthroned Christ, who raises his

hands, palms outwards. Through the words inscribed on his oval mandorla, he commands onlookers to behold his hands and feet: *O vos om(ne)s vi(det)e manus meas et p(edes)*. The inscription is made up of two separate texts. The first three words are from the Lamentation of Jeremiah, used in the night office in Holy Week as though spoken by Christ, emotively appealing to 'all you who pass by' to behold his grief, including the wounds of his Passion. In contrast, the second part of the inscription is taken from Luke 24:39, where the risen Christ shows the disciples his wounds as a proof of the Resurrection: 'Behold my hands and feet, it is I myself'. There is a discrepancy, therefore, between the ivory's inscription, which refers only to the wounded hands and feet, and the image, which depicts Christ with his upper-right torso bared to reveal the wound in his side as well.

The five wounds are not mentioned together in any single Gospel text. They are a harmonization of scriptural passages in which verbs of seeing are again important. As already noted, only John describes the wounding of Christ's side, which was both the fulfilment of prophecy, 'They shall look on him whom they pierced', and a prefiguring of his Second Coming, 'when every eye shall see [recognize] him' (John 19:37, Zachariah 12:10, Revelation 1:7). John

109 The Crucifixion, Psalter
of Robert de Lisle, c.1310
On parchment 35 × 23 (13¾ × 9)
British Library, London
(MS Arundel 83 II, f.132)

110 The Last Judgement, detached leaf from the Psalter of William de Brailes, c.1240
Parchment 25 × 17 (9⅞ × 6¾)
Fitzwilliam Museum, Cambridge (MS 330, leaf 3)

describes the risen Christ's invitation to doubting Thomas to see the nail prints in his hands and touch his wounded side. This elicited from Thomas the belated recognition of Christ's identity, 'My Lord and my God'. Christ reproved him, 'Blessed are they who have not seen and yet have believed' (John 20:25-9). The Cambridge ivory plaque invites the beholder to see with the inner eye what cannot now be seen physically.

In the Good Friday ceremonies, after the unveiled cross is raised by two deacons and adored by the congregation, the chanting of Christ's solemn reproaches to his people, who had failed to recognize him at the Crucifixion, alternates with acclamations of his divinity. In the lower register of the ivory a cross is exalted by two angels. The small figures of the faithful community below are now damaged, but presumably once looked up at the Cross; what it signifies is visualized above in the wounded yet enthroned figure of Christ. The viewer sees with them the vision of Christ's humanity, raised up to share in the glory of his eternal divinity.[58]

Already in contemporary Old English poetry, notably *Christ III*, preserved in the tenth-century Exeter Book, Christ exhorts sinners to behold his five wounds in the rather different context of the Last Judgement. The work draws on the gospel prophecy that at the end of time 'the sign of the Son of Man' (understood to be the Cross) will appear in the heavens, announcing Christ's Second Coming in judgment and that, seeing him, 'all the tribes of the earth shall mourn' (Matthew 24:29-30), conscious of their sins. This passage in turn evokes the chain of texts concerning Christ's side wound, especially Revelation 1:7 ('and every eye shall see him, and they also that pierced him. All the tribes of the earth shall mourn'). This chain was important, with Acts 1:11, in forming the belief that Christ would return at the end of time as he had left this earth, bearing the marks of his suffering humanity in his glorified body.

The scene of Christ exhibiting his wounds and the angels displaying the Cross was probably not represented in English art in the full context of the Last Judgement until after the Norman Conquest, when it appeared in wall paintings at Clayton, Sussex.[59] At the end of the prefatory cycle of Old and New Testament scenes in the Winchester Psalter, c.1150, Christ is shown enthroned, his hands raised and side exposed; the Anglo-Norman French inscription describes him as God in majesty showing the

wound in his side.[60] As in the Anglo-Saxon ivory, he is placed immediately above the image of two angels with the Cross, though here, like two deacons at the *Adoratio Crucis*, they exalt the Cross before an altar. But the image now forms the centrepiece of a nine-page sequence showing the dead rising from their graves, angels with the instruments of the Passion, the Apostles, scenes of the Blessed and torments of the Damned, and the locking of the mouth of hell. The components of this extended Last Judgment sequence had already been assembled in a single image concluding a cycle of drawings of Gospel scenes, possibly from Bury St Edmunds, c.1130.[61] Christ, enthroned within a mandorla, shows his wounds and an enormous Cross is held upright before him by two angels, but with the important difference that it also forms the central feature of the display of the Instruments of the Passion – the nails, spear and crown of thorns.

The Last Judgement depicted on one small page of the detached leaves from the Psalter of William de Brailes, c.1240, has a number of significant changes and additions to this iconography, some of which were to be popularized in later public and monumental representations of Doomsday (fig.110).[62] The exaltation of the Cross has now disappeared; the Cross is one of the Instruments of the Passion displayed by angels in the two upper medallions. Christ with bared side raises his hands and exhibits his five wounds. The lion and dragon of Psalm 90 lie defeated beneath his feet. The book on his knee displays the *alpha* and *omega*, as in contemporary scenes of his divine majesty, but he is here unambiguously enthroned as Judge. Two inscribed scrolls pronounce his words to the separated groups on his right and left: 'Come, ye blessed of my Father' and 'Depart from me you cursed' (Matthew 25:34, 41). In Matthew's Gospel these are the words of judgment that will be said to the blessed and the damned respectively, that is, to those who during their lifetime saw Christ in the needy and practised the works of mercy, and those who failed to do so.[63] The artist himself is shown narrowly saved from the fate of the damned. The Matthean texts had already been used in the context of Judgement in Old English poetry, and by much earlier homilists and exegetes. St Peter and St Paul are clearly identified among the Apostles who sit in judgement, but the Virgin is shown on Christ's right as an intercessor for humanity.

By the end of the thirteenth century the motif of Mary offering her breast, seen in images of her with the Christ

Child, as in the Amesbury Psalter, was to appear in some Psalters and in the frame of the Hereford world map (see Ayers, pp.226-7, fig,133), in the quite different context of the Last Judgement, where she kneels to intercede for her spiritual sons and daughters.[64] In the recently recovered wall-painting of Doomsday in the large parish church of Holy Trinity, Coventry, c.1430-40 (see Gill, pp.200-1 and fig.114) the Virgin as the mother of the whole Church pleads forgiveness on their behalf; she proffers her naked breast before the wounded Judge, reminding him of the humanity he received from her and shares with them. She is joined by another powerful intercessor, John the Baptist. He had been the first to recognize Christ's divinity, from his mother's womb (Luke 1:44), and acclaimed him as the one 'who takes away the sins of the world' (John 1:29).[65] The central image is the gigantic figure of Christ enthroned in a heavenly paradisal landscape, the sphere of the earth as his footstool. With raised hands he displays his bared torso and the five bleeding wounds of his Passion, as testimony of his Incarnation and Crucifixion, and as a solemn reproach to those who have continued to wound him by their sins and now stand before 'him whom they pierced'. The Instruments of the Passion were once visible above him. Christ's body is so pitted with the many smaller wounds of his scourging that he looks leprous, as in some late medieval representations of the Crucifixion and Pietà, which depict,

not the Gospel Passion narrative, but the literal fulfilment of Old Testament prophecies of the suffering Messiah, festering with sores 'from the sole of the foot to the top of the head' and 'as it were a leper . . . wounded for our iniquities and bruised for our sins' (Isaiah 1:6; 53:4-5).[66]

The heavenly gates, tormenting devils and the jaws of hell's mouth set the scene like the staging of a mystery play. As the last trump sounds, figures of the dead, men and women, laity and tonsured clerics, rise from their tombs and come before the judgment seat. They are naked, except for those whose status is indicated by their head-gear – cardinals' hats, the occasional crown or papal tiara, the fashionable headdresses of alewives. The destinations of the blessed and the damned, in the kingdom of God or in everlasting fire, are pronounced through two scrolls inscribed with the usual texts of Matthew 25:34, 41, which issue like speech balloons either side of Christ's head.[67] He is flanked by the martyred princes of the Apostles, Peter and Paul, and the rest of the twelve Apostles destined to help judge 'the twelve tribes of Israel', that is, the whole Church (Matthew 19:28). The Coventry Doom painting, one of a great number that once existed throughout Britain, is in the traditional position, high on the east wall of the nave, above the arch of the crossing leading to the chancel, so that its warning of the need for amendment of life is directed towards the lay congregation in the nave.

They are exhorted to look on Christ's wounds and the
instruments of his Passion, and to recognize who the
Crucified is, now, before his divine power is made un-
mistakably evident at the Last Judgement. The diverse
exegetical and iconographic origins of some features of
the scene have been indicated, but this circumstantial
depiction of the Last Judgement, which is nowhere
described as such in Scripture, has itself taken on the
quality of an authoritative prophetic narrative.

In the Late Middle Ages the image of Christ crucified
was frequently viewed in dramatic conjunction with the
image of Christ enthroned, because the Last Judgment
was customarily painted above or behind the rood screen,
which supported monumental and even life-sized statues
of the Crucifixion, flanked by Mary and John the Evangelist,
and sometimes by cherubim or seraphim. The rood figures,
and the supporting screens of wood or stone that separated
the chancel from the nave, once existed in very large
numbers, probably many hundreds, but were particularly
vulnerable to iconoclasm (fig.111 and p.260). Fifteenth-
century accounts of the celebrated Brecon Rood; figural
fragments from other Welsh examples, notably the late
thirteenth-century wooden sculpture of Christ from Kemeys
Inferior, Monmouthshire; and the fourteenth-century
figures of Christ and the Virgin from the rood formerly at
Mochdre, Montgomeryshire (fig.112), as well as remnants
of painted screens and their depiction of universal and local
saints that survive especially in East Anglia and Devon, can
only hint at what has been lost.[68] Where a rood screen
closed off the high altar from the view of the laity, it might
serve as a reredos to the nave altar, but the liturgy in the
chancel of a parish church would have been viewed from
the nave through the pierced arches of the rood screen
supporting the Crucifix. Christ's universal redemptive
sacrifice, made at the centre of the earth, was thereby made
vividly present in the liturgical life of the local church.[69]

In grand liturgical spaces the theme could be further
orchestrated, as in York Minster. Behind the high altar in
the centre of the eastern arm, a rood screen probably once
spanned the width of the presbytery, before the magnifi-
cent backdrop of John Thornton of Coventry's surviving
east window, 1405–8 (Gilderdale Scott, pp.170–1, figs.94–5).
Christopher Norton has memorably pictured the effect for
those in the choir stalls of seeing the sacrifice of the Mass
offered at the high altar beneath the rood screen: its
Crucifixion tableau would be outlined against the great

expanse of the Trinitarian east window, the shape of the
Cross overlaying the complex numerology of the window's
depiction of the history of the world and human salvation,
the apocalyptic vision, the Last Judgment and the hosts of
the blessed.[70] In the Heavenly Jerusalem Christ is shown
holding a book inscribed with the letters '*alpha*' and
'*omega*', the same sign by which God Almighty proclaims
his eternal divinity at the opening of the Apocalypse and in
the east window's top-most light: *Ego sum alpha et omega*
(Revelation 1:8). The immense vision of Christ as both the
crucified Redeemer and the beginning and end of all things
is that evoked in miniature by different iconographic
means in the context of the Durham Gospels, over seven
centuries earlier.

The Lindisfarne Gospels

JANE HAWKES

The Lindisfarne Gospels (British Library, London' fig.113) is unusual among early medieval manuscripts in that its provenance can be identified: as Lindisfarne on Holy Island (Northumberland). Its maker, Eadfrith – the earliest named 'English' artist – can be identified as an abbot of the monastery there and, as the occasion of its production was probably the translation of St Cuthbert's remains in 698, it can also be dated. These associations ensured that the manuscript was preserved among Cuthbert's relics when the monks left Holy Island in the ninth century, and that its history was recorded on the end page shortly before the community settled at Durham in the tenth century. It is thus of major historical and palaeographic interest, but the artwork of this codex has also earned it a reputation as one of the great masterpieces of manuscript painting.

The art of the Lindisfarne Gospels shows how the various artistic traditions circulating in seventh-century Anglo-Saxon England were combined to form a new art, known since 1901 as Insular, being common to Britain and Ireland at the time (see Geddes, pp.27–8). This was generally, but not always, used to serve Christian purposes, here in a medium, the painted page, that was new to the Anglo-Saxons. Thus the manuscript's decoration mingles the interlacing zoomorphs of Germanic Anglo-Saxon art (familiar from Sutton Hoo, Suffolk; see Hawkes, pp.44–5), with the curvilinear patterns traditional to the Celtic art of Ireland and the British west, and the art of the classical tradition, re-introduced to the region through the Church, with its associated language of Christian symbolism. While depicting forms familiar in Late Antique works, the resultant art retains a strong sense of colour, pattern, stylization and deliberate visual ambiguity that was exploited to explore the complexities of the Christian message set out in the accompanying Gospel text.

As they recount Christ's salvation, such manuscripts were more commonly produced by the early Church than other biblical texts. They consisted of the four Gospels accompanied by an extensive prefatory section that emphasized the harmony of their varying narratives. The decoration of Insular gospels also tended to draw attention to this harmony. In the Lindisfarne Gospels it was expressed in the innovative organization of text and image. Each Gospel opens with a set of the same three decorated pages: an Evangelist portrait page, featuring the

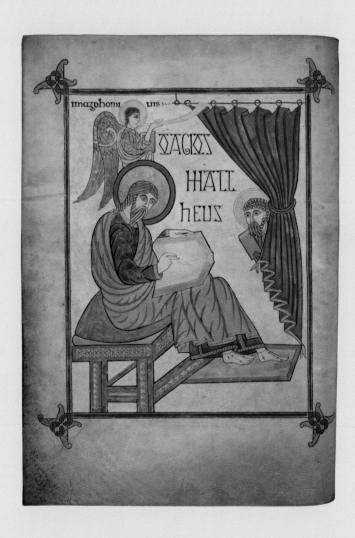

Evangelist writing his Gospel and a creature symbolizing him; a cross-carpet page, given over to ornament organized as a series of crosses; and an initial page, in which the first letters of the Gospel are transformed into iconic designs. Together these pages present complex visual commentaries on the succeeding text.

The details of the decorated pages complement such concerns. The Evangelists, for example, depicted as blocks of bright colour and linear patterns, are transformed into abstract forms that downplay their humanity and emphasize their symbolic function – like the creatures that accompany them. The way that these creatures are portrayed as full-length figures with wings, haloes and Gospel books for the first time in Gospel art presents them both as Evangelist symbols (often illustrated as full-length creatures without wings or books) and as the winged beasts of the Apocalypse that encircle the heavenly throne (usually depicted as half-length winged creatures emerging from clouds). They thus link the Gospel to the end of time. Here a vernacular artistic language combines with other visual traditions to serve a symbolic function that draws out the relevance of its setting.

The initial pages serve a similar purpose, demonstrating that the Word is sacred. Thus, the 'chi-rho' page – where Christ's name is separated from the rest of the text while being disguised in the Greek letters *X*, *P* and *I* (the initial letters of 'Chri[st]') – functions as an icon of Christ. The *X* figures Christ and the means of his salvation, a device repeated in the cross formed by the juncture of the *P* and *I*, where the bow of the *P* forms a halo. Here, by hiding shapes in linear patterns, a common characteristic of the vernacular arts, the artist presents Christ and the Gospel narrative in an abstract and highly symbolic manner. Furthermore, by replicating the way that Germanic and Celtic metalwork presents paradoxical patterns, forcing the viewer to contemplate the forms to understand them, the artist has articulated the value of the Word in a traditional manner, transforming the painted page into something that both represents and is the subject of the Gospel.

Overall, the Lindisfarne Gospels demonstrates the vibrant and sophisticated nature of Insular manuscript art and the innovative manner in which it was employed by artists in Anglo-Saxon England to highlight the central paradoxes of Christian doctrine, serving a complex matrix of religious and theological functions.

FURTHER READING

J. Backhouse, *The Lindisfarne Gospels*, Oxford 1981.
M. Brown, *The Lindisfarne Gospels: Society, Spirituality and the Scribe*, London 2003.
T.D. Kendrick (ed.), *Evangeliorum Quattuor Codex Lindisfarnensis*, 2 vols., Oltun and Lausanna 1956 and 1960.

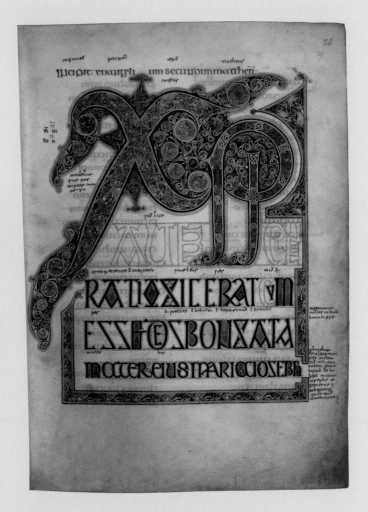

113 Portrait of St Matthew (*far left*), cross-carpet page (*centre left*) and chi-rho initial (*left*), from the Lindisfarne Gospels, c.698
On parchment 34 × 24.5 (13³⁄₈ × 9⁵⁄₈)
British Library, London
(Cotton MS Nero D.iv, ff.25v, 26v, 29)

Medieval Wall Painting of The Doom, Holy Trinity Church, Coventry

MIRIAM GILL

An impressive Last Judgement or 'Doom' painting fills the east wall of the nave of Holy Trinity parish church in central Coventry (fig.114). Recently cleaned, it offers a very powerful indication of the original impact of medieval wall painting. Its content and context provide an insight into the fate of this once ubiquitous art form.

The Doom is now the only major painting in Holy Trinity, but it seems likely that in the medieval period the walls were covered with decorative motifs and figurative subjects, such as the lives of Christ, Mary and the saints, and the teachings of the Church. In the Middle Ages murals were a normal and perhaps even essential element of internal decoration in sacred and secular buildings (see Goodall, p.128). The earliest murals *in situ*, in the church of Nether Wallop (Hampshire), date from c.1000, but the Coventry Doom dates from the late medieval period as do the majority of the surviving or recorded painted schemes. The consistent reference to the Coventry Doom as a 'wall painting' or 'mural' is deliberate. The term 'fresco', sometimes applied indiscriminately to paintings on walls, in fact refers to a technique of painting directly on 'wet' or 'fresh' plaster that was used in only a few murals from twelfth-century England. Nearly all surviving paintings are 'secco' – executed on dry plaster. This enabled artists to apply a wide range of pigments and techniques, from simple drawings in a limited range of earth colours to complex works built up from layers of paint and subtle glazes. Technical analysis, an area of research that has developed significantly from the 1980s, reveals that the Coventry paintings use a sophisticated combination of pigments, glazes and gold leaf.

As with most murals, no contemporary documentation for the Coventry Doom has survived, and therefore there are no named artists or patrons, nor a precise date. It is presumed that wall paintings were executed by itinerant artists and it is sometimes possible to identify stylistically churches painted by the same workshop. Even when records preserve the names of painters, it is hard to construct their careers or sometimes even their nationality. The presence of a Guild of Painters in late medieval Coventry and a resemblance to the style of local stained glass may suggest that the painters came from the city (see Gilderdale Scott, pp.170–1). Some wall paintings contain 'donor portraits' or inscriptions identifying patrons, but in most schemes the contribution of the patron is unknown. The mural may have been financed by individual donations, corporate contributions (for example from the trade guilds who had chapels in Holy Trinity) or by collective fund-raising. The date of the Coventry wall painting, as with most murals, is based on a combination of architectural, stylistic and costume evidence, which point here to the 1430s or 1440s.

The Doom is one of the most easily identified and enduring themes in English wall painting; the earliest surviving examples date to the period around 1100. The subject includes elements from biblical and didactic sources; the combination of motifs may display the influence of painter, patron or period. The iconography and possibly the theological interpretation of the Doom also changed over the course of the Middle Ages. Like most of the subjects depicted in wall painting, the Doom is not unique to the medium. The large number of elements in the Holy Trinity Doom is typical of late medieval examples. The composition focuses on the large, central image of the wounded Christ raising his hands in judgement. He is flanked by the Apostles (St Peter on his right, St Paul on his left), while St John the Baptist kneels to his left and the Virgin to his right. Heaven is shown as a walled city to the upper left, while in the bottom right flame-licked souls are framed by the sharp teeth of the monstrous mouth of hell. Angels blow the last trump and naked figures, their status indicated by their headgear, emerge from their graves to learn their fate. Alewives with mugs are prominent among those dragged towards hell in chains. Civic legislation of 1434 and 1439 suggests concern about alewives in contemporary Coventry.

The lively and uncompromising approach of the painting is typical of parochial murals. It was clearly intended to stir the emotions, as well as convey religious knowledge, but it is less clear whether details such as the fraudulent alewives would have evoked horror or humour. Some elements of the painting, such as the Virgin's intercession would be recognizable as symbols of mercy, while the demons might inspire dread. This combination of a variety of symbols and emotional 'registers' is particularly common in the mural depiction of didactic subjects. Something of the sophistication of 'readings' available to a medieval viewer is suggested by a sermon in the *Festial* of John Mirk (c.1382–90), in which he interprets an image of Christ in

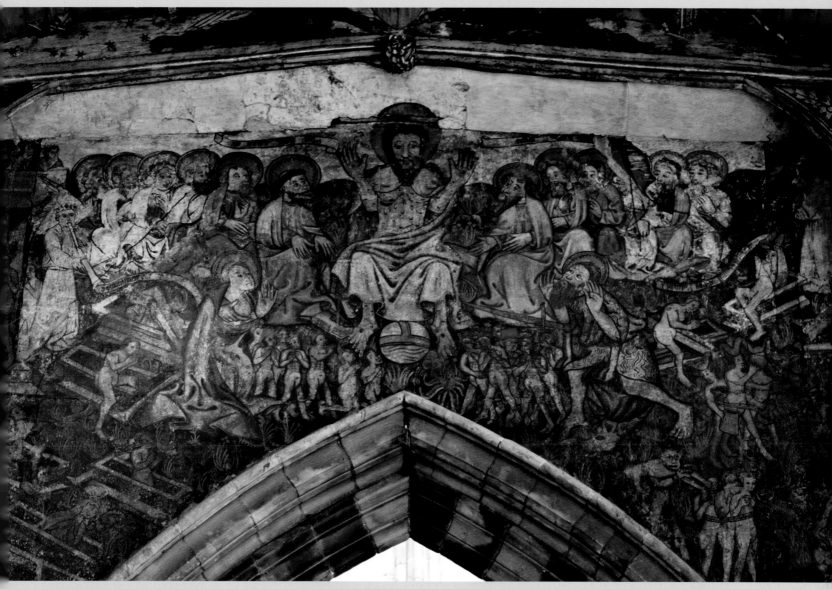

114 Wall painting depicting the Doom,
Holy Trinity Church, Coventry

judgement between St Peter and St Paul as an allegory of penitence and salvation. The Coventry Doom painting includes Latin inscriptions from the *Parable of the Sheep and the Goats*, the source of many elements of the iconography; these would have reinforced the message for literate viewers.

Although there was no 'official' template for the placement of murals in a church, the Doom was often on the nave east wall above the chancel arch. This and the scale of many Doom paintings ensured that, as medieval worshippers faced east, their vision was dominated by an image of Christ's return in Judgement. In many churches the theological and emotional impact was heightened by its juxtaposition with the image of Christ on the Cross (or Rood) displayed on the rood beam, at the transition from the nave to the chancel (see O'Reilly, p.197). At Coventry the rood stood to the east of the crossing, but in churches where the two were combined, they set up a contrast between the mercy implicit in the cross and the implacable image of judgement. This is one of the clearest examples of the way in which wall paintings might work with other images, as well as with the liturgy and preaching, a combination that challenges the distinctions between media often made in the study of medieval art.

Although hundreds of medieval wall paintings survive, they have often been neglected in the history of medieval art because they are hard to see, appreciate and interpret. The Holy Trinity Doom enables us to understand their sophistication and power.

FURTHER READING

A. Caiger-Smith, *English Medieval Mural Painting*, Oxford 1963.

M. Gill, 'Medieval Wall Painting in Coventry', in R.K. Morris and L. Monckton (eds.), *Coventry: Medieval Art, Architecture and Archaeology*, British Archaeological Association Conference Transactions, forthcoming.

E.C. Rouse, *Medieval Wall Paintings*, Princes Risborough 1991.

P. Tudor-Craig, 'Painting in medieval England: The Wall to Wall Message', in N. Saul (ed.), *Age of Chivalry: Art and Society in Late Medieval England*, London/ New York/Sydney/Toronto 1992, pp.106–19.

E.W. Tristram, *English Medieval Wall Painting of the Fourteenth Century*, London 1955.

7 Monsters and Margins: Representing Difference

ROBERT MILLS

115 Sir Geoffrey Luttrell armed as a knight, detail from the Luttrell Psalter, c.1325–45
On parchment 35.5 × 24.5 (14 × 10)
British Library, London
(MS Add 42130, f.202v)

HOW WAS HUMAN difference visualized in pre-modern Britain? To pose this question is to articulate a paradox. After all, the very terms modern scholars use to categorize medieval visual culture are themselves occasionally repositories of difference. 'Gothic', for example, is a word first deployed by early Renaissance art historians in Italy to describe what they viewed as the 'barbaric' architecture erected between the decline of classical civilization and its rebirth in their own age. Implicitly the word carries with it connotations of geopolitical as well as aesthetic distinction. Giorgio Vasari (1511–74), in his *Lives of the Artists* (1550), famously characterized the pinnacles and pointed arches of medieval buildings as a style of architecture *mostruosi e barbari* – 'monstrous and barbarous' – one that dispenses with 'every familiar idea of order'.[1] The use of the terms 'Goth' and 'Gothic' to establish, by way of opposition, classical virtue and to confirm, in so doing, the superiority of the present offers an instructive vantage point from which to view the themes of this chapter. Vasari's outburst, which ends with a plea that God defend every land from the 'invasion' of such styles, is invested in a rhetoric that differentiates self from other and that imagines the other as a locus of multiple disjunctions – ethnic, geographic, temporal, stylistic.[2] Likewise, 'medieval' itself, another Renaissance construct, continues to operate in contemporary popular culture as a byword for barbarism and strangeness. So in the course of investigating difference in the Middle Ages we also need to keep in view the perceived difference *of* the Middle Ages, from the present and from ourselves. Indeed, to explore visualizations of human difference before 1600 is potentially to confront perceptions of the period as itself monstrously other, modernity's dark and undesirable shadow.

One manifestation of this image of the Middle Ages as a historiographic other is the identification of the period as a foundational chapter in the formation of a 'persecuting society'. This view holds that the twelfth and thirteenth centuries, promoted by twentieth-century historians as a point of origin for such prized emblems of modernity as individuality and the nation-state, were also instrumental in the development of technologies of oppression – a process associated with the need to demonstrate power visibly, as a symptom of increased centralization. Consequently, we are asked to confront the fact that the so-called 'High' Middle Ages not only fostered new modes of individuality, rationality and love, but also religious hatred, racism and intolerance.[3] A mentality of conquest asserted itself in such events as the colonization of Ireland and the Crusades; a need to define Christendom's conceptual and geographic limits through the demonization of heretics, Jews and Muslims; and an effort to police desire itself in the disparagement of female sexuality and sodomy. One problem with such arguments is that they sometimes assume a period of early medieval tolerance, against which late medieval persecution nastily emerges. When we confront difference across as diverse a period as the Middle Ages, we need to be wary of sweeping chronologies or approaches that assume a one-size-fits-all pattern of differentiation and oppression. Attempts simply to catalogue 'signs of otherness' in medieval art risk lumping all 'minority groups' together as an undifferentiated mass of outcasts, rendered monstrous by an easily identifiable and fully coherent centre.[4] It may also help to acknowledge different degrees of otherness among marginal groups, alternative timelines in the development of negative typologies, moments when the rhetoric of rejection is applied inconsistently or fails to work as it should. If the Middle Ages is the other of modernity, it is not differentiated in any singular or uniform manner.[5]

To acknowledge the heterogeneity of the period's confrontations with otherness is also to recognize that monsters function as 'intimate others', analogous to Freud's concept of the uncanny in their combination of familiarity and strangeness.[6] This chapter investigates the strategies medieval artists deployed to visualize distinctions of social class, gender, sexuality, religion, nation and ethnicity. One of the aims will be to outline what might be termed, after Debra Higgs Strickland, the 'pictorial code of rejection' deployed by artists to represent outsiders in Anglo-Saxon, medieval and Renaissance iconography – a code that shifts according to particular media, historical circumstances and ideological remits.[7] But in narrowing

the focus to the ways in which these categories map onto
the bodies of monsters, it is important to keep in view the
role of the other in producing various modes of selfhood
and those spaces where difference and sameness turn out
to be mutually constitutive. I work with the assumption
that art produced in Britain in this period is a site for the
projection of otherness, but it is a site that produces
identification as well as alienation. After all, the other is
not simply that which is not-us. What we define as 'self'
is usually more than just body, and our experiences even
of our own bodies can be permeated with feelings of
estrangement or separation, so that as embodied beings
we are also, in a sense, 'other to ourselves'.[8]

After outlining the ideal human type as it was
constructed in medieval and Renaissance theories of the
body, the opening section examines a variety of ways in
which representations of bodies deviated from that ideal,
focusing especially on the peasant and the woman, and on
depictions of sexual outsiders. The next section considers
the demonization of non-Christians and the construction
of geographic and ethnic distinctions. But the chapter is
also framed by a consideration of margins, both with respect
to the locations of the artworks under consideration –

many of which inhabit the borders and threshold spaces
of medieval Britain – and with respect to the social status
of the groups being represented. Notions of boundaries
and limits play a key role in our investigations, but it will
not be assumed that margin and centre are discrete or
readily defined entities: the brief concluding section
proposes that we may need to move beyond straightforward
conceptions of marginality in order to comprehend the
degree to which images of difference can resist as well as
reinforce dominant ideologies.

Intimate Others

Towards the end of the Luttrell Psalter (c.1325–45), a work
that has become a focal point for a number of influential
discussions of difference in medieval art, a scene appears
that depicts the patron Sir Geoffrey Luttrell (1276–1345), of
Irnham in Lincolnshire, as a knight on horseback (fig.115),
beneath the inscription, 'Dominus Galfridus louterell me
fieri fecit' (Lord Geoffrey Luttrell caused me to be made).
This is the largest single miniature in Geoffrey's psalter;

116 Babewyn, detail from the
Luttrell Psalter, c.1325–45
On parchment 35.5 × 24.5 (14 × 10)
British Library, London
(MS Add 42130, f.202v)

117 'Muscle Man' in Claudius (Pseudo)
Galen's *Anathomia*, mid-15th century
On parchment 18 × 13.5 (7 × 5¼)
Wellcome Library, London
(MS 290, f.49v)

unlike other marginal imagery in the manuscript, it has been cordoned off from text by the inclusion of a blue, rectangular frame. Thrusting upwards into the textual centre of folio 202v, Geoffrey's sumptuous 'portrait' totally dominates the page. Michael Camille suggests that the image can be read in the light of the more modest miniature that immediately follows it on the facing folio, in the initial 'D' that opens Psalm 109. The initial depicts a haloed God the Father, the heavenly lord, holding the orb of the world and conversing with King David, who as God's earthly representative carries a sceptre and wears a crown. In a daring juxtaposition that connects Geoffrey, by association, with the lordship of the biblical king and in turn with the lordship of God himself, the image idealizes its subject as a beacon of chivalry, functioning as a monument to the patron's knightly identity and a symbol against which all other images in the psalter can be measured.[9]

A significant proportion of these other images can be classified as monsters and grotesques. One such hybrid is depicted on the very folio that features Geoffrey Luttrell's equestrian image: a fishy, yellow 'babewyn' (fig.116) emerges from the right of the page, with a spiky blue fin and the head of a balding, bearded man looking upwards and grimacing; the monster's expression and colouring possibly signify choleric temperament. Sin, disease and repulsive appearance were seen as interrelated, whence the saying 'as ugly as sin'. The medieval symbolic pairing of beauty with virtue and deformity with sin was an inheritance from ancient Greece and Rome. Classical astrology, medicine, natural philosophy and ideas of physiognomy generated the belief that one's environment, bodily form and moral well-being were intimately related; these theories, in turn, provided the basic template for later Christian beliefs about the links between outer appearance and inner character.[10] One consequence of such beliefs was

the development of an ideal human 'type'. A rather crude representation of this prototype manifests itself in a mid-fifteenth-century anatomical diagram showing the arrangement of muscles on the human body (fig.117). 'Muscle Man', who is included in an English version of an anatomical treatise by Claudius (Pseudo) Galen (AD129–200/216), presents a marked contrast to Geoffrey Luttrell's portrayal as a mounted knight in his psalter. More than a century separates the two images, and the texts they illustrate are utterly dissimilar; Muscle Man's body is naked and full frontal, whereas Geoffrey sits on his horse in profile, almost totally covered up by his luxurious carapace. Ready to accept the trappings of his knightly identity – the shield, the helmet, the lance – Geoffrey's selfhood is an effect of signification and artifice, rather than a manifestation of the body beneath; if anything, it is the body of the patron's enormous warhorse, itself almost entirely cloaked in an elaborate blue trapper, that grounds his identity as a knight. But these depictions can be compared to the extent that they represent facets of a Western European ideal. To be fully 'human' in the Middle Ages in Western Europe was, implicitly, to be well-proportioned, light-skinned and male; such attributes were also frequently combined with youth, aristocratic status and wealth. The jaundiced, balding babewyn that penetrates the text of the psalter, with its misshapen and incongruous body, represents the obverse to such ideals, but also potentially their 'fleshly' underside: when Geoffrey appears a few folios later in the manuscript, in a scene depicting him feasting with his family, he displays the same upward-looking scowl as the fishy hybrid. Thus it is possible to speculate that the 'other' on folio 202v also bodies forth a version of 'self', albeit a self visually differentiated from the disembodied ideals with which Geoffrey's identity is explicitly aligned. The babewyn's body is permeated with difference but also strangely resonant with the patron's presumable failure to live up fully to this perfect image of himself – an intimate other indeed.

Long admired for its idyllic scenes of English village life, the Luttrell Psalter has more recently been at the centre of a debate about whether images in this and other manuscripts present peasants sympathetically or critically. Camille has argued that scenes of 'everyday life' in the psalter, such as a famous miniature on folio 170r depicting ploughing, can only be understood in relation to the lord who reaped the benefits of such labour. So rather than comprehending images of this sort as realistic depictions

118 An ape ploughman, detail from
the Gorleston Psalter, c.1320
On parchment 37.4 × 23.5 (14¾ × 9¼)
British Library, London
(MS Add 49622, f.15v)

of the harassed and downtrodden peasant, we should view them as ideologically motivated portrayals - representations that render economic necessity an effect of natural order. Everyone in this order has a place, the iconography implies, labouring for his or her lord.[11] Nonetheless, it is clear that in other manuscripts of the fourteenth and fifteenth centuries depictions of peasant labour do not simply camouflage social antagonism with reference to an idealized vision of feudal order but actively embody it, in the context of images depicting peasants as objects of outright mockery or contempt.[12] The Psalter of Robert de Lisle, partly illuminated around 1310 in London (BL MS Arundel 83 II), contains a blunt evocation of peasant laziness: labelled a *pauper superbus* or 'proud pauper', he sits cross-legged, in the authoritative pose of a king, while under the guidance of a devil he allows his crops to wither.[13] Whereas here agency for the vice is displaced onto the poor man's demonic counsel, an illuminator in the East Anglian Gorleston Psalter (c.1320) dehumanizes the ploughman himself, by depicting him as an ape who works the soil with an implausible-looking contraption, the wheels of which don't even touch the ground (fig.118). Apes were more frequently shown in manuscript margins parodying aristocratic or clerical activities - they appear elsewhere in this guise in the Gorleston Psalter - but here the motif of 'apeing' has been deployed to underline the futility of

peasant labour.[14]

One aspect the Luttrell Psalter ploughman shares with his simian cousin in the Gorleston Psalter is his stooped pose. Indeed, peasants throughout the manuscript are depicted with bent or crooked postures, a characteristic especially highlighted in the scene of reaping on folio 172v, which unusually depicts three female harvesters at work (fig.119). Armed with sickles, two of the women bend over sharply to cut the barley, thrusting their posteriors outwards; a third takes a break, resting her sickle on her shoulder and her hands on her hips while she sways as if stretching her back. The man gathering the cut stems to the left also adopts a hunched stance, which contrasts markedly with the patron's upright bearing on folio 202v. The equestrian portrait miniature also shows Geoffrey attended by his wife, who hands him his helmet and lance, and his daughter-in-law, who carries his shield. Their elegant postures likewise diverge from the buckled bodies of the female reapers in the harvest scene. Depictions of peasant bodies as crooked or misshapen may simply suggest that the tasks they perform are hard work. If they represent a more contemptuous attitude to the lower classes, it was an attitude probably taken for granted - and in some senses held unconsciously - by a patron of aristocratic status like Geoffrey.[15] In truth elite society did not push peasants to the margins of humanity consistently

119 A reaping scene, detail from
the Luttrell Psalter, c.1325–45
On parchment 35.5 × 24.5 (14 × 10)
British Library, London
(MS Add 42130, f.172v)

120 Detail of carved wood misericord,
15th century, from the Church of St
Lawrence, Ludlow, Shropshire

or systematically, and notions of poor people as coarse and uncultivated coexisted with the recognition that they could be exemplary, closer to God by virtue of their humility and hardship. Ploughmen in particular could be exalted as emblems of pious labour, figures for Christ himself, as in the great poem *Piers Plowman* by William Langland (c.1325–c.1390). This more positive evaluation of agricultural work manifests itself in an English fifteenth-century alabaster, now in the Victoria and Albert Museum, representing Christ with a spade – a rendition of John 20:15, in which Mary Magdalen mistakes the resurrected Christ for a gardener.[16]

One way in which Geoffrey Luttrell's peasants are possibly subjected to a disparaging gaze, albeit indirectly, is their dress. After all, the ploughmen on folio 170r are shown wearing plush, brightly coloured garments – fashions that later in the century would be forbidden to people of lower orders as a result of strict sumptuary regulations.[17] Ostentatious attire was stereotypically a taste to which women were especially prone. The Wife of Bath in *The Canterbury Tales* by Geoffrey Chaucer (c.1343–1400) is described as wearing elaborate 'coverchiefs' on her head on a Sunday, weighing 'ten pound', as well as a hat as big as a shield; women's headdresses were frequently objects of ridicule in satirical works, being interpreted as signs of vanity and pride.[18] One of the misericords in the choir of

St Mary's, Minster-in-Thanet (Kent), includes the bust of a woman wearing an outsized headdress shaped like two horns, between which a devil has made a nest, while an early fifteenth-century analogue at St Lawrence's in Ludlow (Shropshire) transforms the figure herself into a truly monstrous hag (fig.120).[19] Marked as a scold by her bridle, she stares out with wild, fiery eyes, while the two men on the supporters fight it out to win her affections. This image, which represents the frightful demeanour of its subject as well as the subject's restraint, can be compared with scenes depicting women in a variety of situations as undisciplined viragos, exerting power over men. A popular theme on English misericords was a woman beating a man with a household implement, such as a distaff, ladle or washing beetle; other scenes represent a man and a

121 Scenes showing beast of pride, rape and domestic violence, on carved wood misericord, c.1480–1520, Church of Holy Trinity, Stratford-upon-Avon, Warwickshire

woman fighting tooth and nail, or battling it out in a mock tournament, as in an example from Bristol Cathedral, where a woman riding a goose wields a broomstick against a man hurtling towards her on a sow. Comparable scenes, such as the 'Battle for the Breeches', are also found in Continental woodcuts from the late Middle Ages.[20]

These images of sexual inversion conform to the topos of *mundus inversus*, or the world upside-down, which is also a theme in manuscript marginalia. A legal compendium called the Smithfield Decretals, copied in Italy but illuminated in England c.1340 (BL MS Royal 10 E.IV), contains various illustrations depicting a husband performing a series of domestic chores, such as washing the dishes and baking bread, and being beaten by his wife after completing each task.[21] Anthropologists have traditionally interpreted such role reversals as a sanctioned form of 'letting off steam', one that clarifies the social hierarchy in the course of reversing it. Conversely, some critics have speculated that depictions of disorderly women, which were also common in the early modern period, may have worked to widen the behavioural options available to real women, sanctioning unruliness by rendering it visible.[22]

There are instances in medieval literary culture where women-on-top are depicted in a positive light. For example, a thirteenth-century Middle English *Life of St Margaret* designed as reading matter for a group of female recluses describes how, while in prison between bouts of torture, Margaret is confronted with a demon whom she proceeds to grasp firmly by the hair, swing upwards and throw down to the ground, before setting her foot on his neck.[23] Here the monstrous figure, who represents sexual temptation, is gendered male by the narrative, the demonic counterpart to the pagan tormentor Olibrius, who earlier in the text attempts to win Margaret's affections and, when she refuses, orders her gruesome tortures. Margaret is depicted as a virgin martyr battling heroically against masculine temptation, a role model for readers devoted to a life of chastity; the demon himself is described as 'blacker than any black man, so grisly, so loathsome, that no one could easily find words to describe it, with both his hands tightly bound to his gnarled knees'.[24] Here monstrous deformity is compared explicitly with a *blamon*, or 'black man', and contrasted both with the beauty of Christ and the saint's 'fair flesh'; the threats that Olibrius poses to Margaret's chastity are mirrored in the activities of his demonic evil twin, who prides himself on causing virgins to defile themselves. Another text often included in the same manuscript as this particular *Life of Saint Margaret*, an 'Epistel of meidenhad' or 'Letter on Virginity', presents a very different view. In a polemical account designed to turn readers from thoughts of marriage, the narrator evokes a scene in which the husband 'rails at you and scolds you and abuses you shamefully, treats you disgracefully as a lecher does his whore, beats you and thrashes you like his bought slave and his born serf . . . especially in bed she must put up with all his indecencies and his improper games, however obscenely devised, whether she wants to or not'.[25]

One striking misericord from the Church of Holy Trinity in Stratford-upon-Avon (Warwickshire) bears witness to this other dimension of female experience – a world of domestic violence and sexual assault (fig.121). The left supporter depicts a woman pulling at the beard and mouth of a man in military dress, while he clutches her wrist and tugs at her long hair. A beard was a sign of a man's virility, and its pulling a mark of humiliation. But in medieval visual culture the gestures of the male figure towards the female – the seizing of the wrist and pulling of hair – commonly occur in scenes depicting rape. Indeed, the motif of a man pulling a woman's hair as a sign of sexual violation was especially prominent in images of war from the fifteenth to the seventeenth centuries, which may have a bearing on the portrayal of the male violator on the

122 The Temptation of Adam and Eve,
prefatory miniature in a Psalter,
c.1270–80
On parchment 28 × 18 (11 × 7)
St John's College, Cambridge
(MS K.26, f.4r)

Stratford misericord as a soldier.[26] This suggests that the scene represents male violence and female resistance, rather than a woman-on-top – a portrayal of the deadly sin of lust, here identified with a man. The right supporter contains a horrifying scene in which a male in peasant attire birches a naked woman, who is depicted bottom up with a dog sinking its teeth into her legs. This may represent wrath, while the central scene, showing a headless figure riding a crowned, plump-looking beast, presumably signifies pride. Pride itself was often personified as female in medieval culture. Its depiction here, as an elaborately coiffured monster, may be designed to convey parallels with the other two vices represented on the misericord. Although lechery is presented as a vice of which men are guilty, its 'cause' is nonetheless feminized within this overarching didactic framework – a warning to men who keep the company of women. Sin is gendered female either at base or by association, women being caught in a double bind in which their very presence provokes men into committing misdeeds.

Attitudes to women in the Middle Ages and the Renaissance were frequently polarized between two extremes: the Virgin Mary, representative of humanity's highest spiritual goals, was set in opposition to Eve, figured as the embodiment of sexual depravity. Genesis describes how the Fall, which led to the expulsion of Adam and Eve from the Garden of Eden and the bringing of death and suffering into the world, was precipitated by a serpent, who tempted Eve to taste the fruit of the Tree of Knowledge. Although the serpent's gender is not specified in the biblical account, literary texts from the later Middle Ages were explicit on the matter: in Langland's *Piers Plowman* Satan is described as carrying away humankind by treachery and deceit, 'ylik a lusard with a lady visage'.[27] Moreover, art from the thirteenth to the sixteenth centuries often presented the creature as a monstrous hybrid, in the form of a snake with a woman's head, hair and even torso. A composite manuscript from St John's College, Cambridge, consisting of a set of full-page Bible pictures from around 1270–80 and a later fourteenth-century psalter, includes a scene among the biblical images in which the serpent is endowed with a female face and woman's headdress, as well as a pair of sinuous arms (fig.122). The creature's countenance is almost the spitting image of Eve's, except that the serpent's hair is bunched up in a net. The contrast with Eve, who wears her hair long and loose, encapsulates

the serpent's associations with sexual experience: like the depictions of outrageous headgear worn by women on certain English misericords, the Fall miniature genders wantonness and vanity as specifically feminine traits.

Animals in general were synonymous with fallen humanity in medieval and Renaissance thought, with terms such as 'beastly' or 'brutish' being strongly associated with excessive lust. Although early Christian writers made confident assertions about the differences between humans and animals, based on the notion that humans, unlike animals, possessed reason, in the later Middle Ages these distinctions were less easily maintained.[28] Bartholomew Batty, a late sixteenth-century moralist, decried the capacity for lust to make men like 'swine, goats,

dogs and the most savage and brutish beasts in the world',[29] while the margins of medieval manuscripts were replete with images of animals, or animalistic hybrids, interacting with each other and with human associates. The recently discovered Macclesfield Psalter (c.1330), related in style and provenance to the Gorleston Psalter discussed earlier, is embellished with a stunning set of marginalia depicting animals engaged in a range of activities. Rabbits joust with one another, or ride on the hounds normally used to hunt them; a man bends over while an ape peers intently at his naked rump, or brandishes a sword against an oversized snail. One eye-catching scene, which appears at the base of a folio containing the text of Psalm 38, shows a lady making a choice between the man on horseback to her right and the hairy wild man in the forest to her left (see Panayotova, pp.228–9). Wild men were creatures poised on

a threshold between human and animal, who represented the obverse of Christian civilized norms. Especially common in fourteenth-century literature and art, they were interpreted as symbols of immoderate passion, a negative ideal to the high-minded principles of courtly love.[30] But the Macclesfield Psalter depiction, which shows the lady and horseman pointing towards the mythical beast, also highlights the wild man's magnetic appeal: the wild man himself gestures in the direction of the trees, as if making a petition on behalf of rampant sensuality. Other and self are intertwined in this scene, the wild man embodying a world of erotic satisfaction that is the logical corollary of courtly sublimation.

The wild man's sinful side and his animalistic disposition may also be signalled by a depiction in the Helmingham Herbal and Bestiary (c.1500), itself probably East Anglian in provenance, which features him among an alphabetical sequence of creatures, both real and fantastical (fig.123). The book, which also contains alphabetically arranged images of plants, may originally have been intended as a book of diversion and instruction for children.[31] However, the depiction of the wild man ultimately appears to draw on an iconographic model with a more overt moralizing tone. The bearded figure, whose body is covered in hair, wields a stick in one hand and a serpent in the other, and he also appears to wear a serpent around his waist as a belt. This may signal a connection with the Fall and the slipperiness of his desires.

In fifteenth- and sixteenth-century depictions wild men were regularly joined by wild women and even children: a misericord in Henry VII's Chapel in Westminster Abbey (c.1512) depicts a harmonious 'wild family', naked but no longer covered in fur, residing in a forest of grape vines. Whereas the wild man was identified strongly with sexual prowess, the wild woman was more often idealized in the later Middle Ages as his devoted helpmate, a symbol of faithfulness and fertility as much as bestial impulse.[32] It is possible that such depictions testify to a decline in the moralizing impulse that characterized art produced in earlier centuries.[33] The Church appropriated monstrous rhetoric in the High Middle Ages, as part of an effort to codify belief and demarcate Christian identity. Representations of female temptresses and unruly wives fitted into this scheme by displacing the traits of which all humanity is potentially guilty onto women specifically – a scapegoating mechanism that conveniently let male

monks, priests and confessors off the hook. But these representations need to be balanced by iconography that presents savagery positively, as a space of freedom from the strictures of 'civilization'. The Renaissance wild woman represents otherness at the very borders of selfhood, a figure to be imitated, idealized and desired.

Another motif that treats female sensuality ambivalently is the Sheela-na-gig, a type of carving found on the corbel-tables of a number of rural churches, which depicts naked females displaying enlarged genitalia. The most famous female exhibitionist in British art appears on a twelfth-century corbel at the Church of St Mary and St David in Kilpeck, a few miles south-west of Hereford: a bald figure, head disproportionately large compared to the torso, stares out from the eaves of the church exterior and inserts her hands into her gaping vulva (fig.124). Nineteenth-century antiquarians and folklorists were the first to take these carvings seriously, attributing them with apotropaic functions or seeing in them vestiges of a pre-Christian fertility religion unique to the British Isles. More recently research has shown that Sheela-na-gigs, far from being a purely Insular phenomenon, are in fact derived from Continental models and associated with pilgrim routes into northern Spain; of a piece with other Romanesque carvings depicting human sexuality in Britain, Ireland, France and Spain, they have been interpreted as didactic warnings against lust, providing visual support to the moral teachings of the Church.[34] This hypothesis rests on the fact that Sheelas of the sort found at Kilpeck are normally ugly and associated with religious architecture, so presumably not designed to be erotically stimulating. A carving on a lintel above a Norman window in the tower of St Mary and St Andrew in Whittlesford (Cambridgeshire) appears to support this view: it depicts a bearded, ithyphallic male crawling over to a fat, splay-legged female fingering her genitals, in a scene seemingly designed to make the sexual act appear unpleasant.[35] Current critical opinion thus favours Sheelas as products of twelfth-century clerical misogyny rather than folkloric traditions, but the matter may never be fully resolved: recent scholarship has also turned up evidence that the facial expressions, poses and genitalia of Sheelas may connote women in childbirth, rather than monstrous hags engaged in sexual display.[36] This signals the importance of opening up representations of difference to multiple interpretations, rather than assuming that they were inevitably pejorative.

Sheela-na-gigs are often divorced from the sorts of narrative context that would aid interpretation. When we turn to representations of difference in hell, the connections with Church doctrine are more clear-cut. For much of the Middle Ages, artists presented hell as a disorderly space, the inhabitants of which were distinguished primarily by their social estate. The twelfth-century Winchester Psalter (BL Cotton MS Nero C.IV), which shows hell as an all-devouring mouth, depicts sinners in this mode. Locked with a key by an angel, the mouth's central chasm sprawls with demonic hybrids, who attack crowned kings and queens and men with tonsures, or pull at the long tresses of naked females.[37] By the thirteenth century it became more common for artists to identify particular sins, using a system of differentiated punishments. This judicial system produced its own exclusionary logic: hell was compartmentalized, its spatial divisions mapped onto the seven deadly sins.[38] The particularizing emphasis allowed ample opportunities for the construction of otherness. One early instance of this phenomenon in England appears on a depiction roughly

contemporary with the Winchester Psalter. The carved
frieze of Lincoln Cathedral includes, in addition to scenes
representing the elect in heaven and the harrowing of hell,
reliefs exemplifying the vices of avarice and lust (fig.125).
Avarice is depicted to the right as a naked male with a
purse hanging from his neck, being attacked by devils and
serpents; the scene on the left shows a male and female
being separated from one another by demons, two of which
chomp on their genitals; the relief in the middle, badly
weathered like the others, portrays two naked figures in
an almost identical pose, encircled by a horned devil who
pulls at their hair. George Zarnecki has identified the pair
in the latter scene as two males, who 'presumably thus
suffer punishment for sodomy'.[39]

Thomas Aquinas defined 'sodomitic vice' as a subspecies
of the sin 'against nature', a vice carried out with a 'person
of the same sex, male with male and female with female'.[40]
But the biblical narrative of Sodom arguably confounds
attempts to pin the vice down so precisely. Genesis 19 tells
how the inhabitants of Sodom besieged Lot's house and
called on him to deliver his guests – the angels sent by God
to investigate sins in the city – 'that we may know them';

Lot and his family are escorted out of the city by the angels,
after which God destroys Sodom and Gomorrah with
brimstone and fire. Some medieval sources condemn the
city for *luxuria*, the deadly sin under which all sexual sins
were grouped, rather than sexual activity specifically
between males. Yet, despite the episode's ambiguities,
Anglo-Saxon representations do occasionally highlight
the homoeroticism of Sodom's misconduct. For example,
the Old English illustrated Hexateuch, whose numerous
narrative images can be ascribed to the second quarter of the
eleventh century, contains a drawing depicting Lot seated
within a building, while the men of Sodom huddle outside,
gazing attentively into one another's eyes (fig.126).

Frequently characterized by Christian moralists as the
'unmentionable vice' or the sin 'against nature', sodomy
was not subjected to any secular legal proscription in
Britain before 1534. But it features regularly in penitentials
and confession manuals, from the tenth century to the
fifteenth; visual images like those in the Old English
Hexateuch suggest that medieval artists were not always
circumspect in their condemnations. Indeed, the relief on
the Lincoln frieze, which presents the sin's chastisement

125 A male and female sinner being punished for lust (*left*), and two males, encircled by a horned devil, being punished for sodomy (*right*), detail from carved stone frieze, west front, Lincoln Cathedral, mid-12th century

126 Lot and inhabitants of Sodom, detail from an Old English illustrated Hexateuch, c.1025–50
On parchment 32.8 × 21.7 (13 × 8½)
British Library, London
(Cotton MS Claudius B.IV, f.23v)

as a mode of violent sexual assault, is unusually explicit about the nature of the vice. The rarity of the Lincoln scene needs to be emphasized: no analogues survive in British sculpture, and the Doom paintings of medieval parish churches, such as that at Holy Trinity Church, Coventry, offer no parallels (see Gill, pp.200–1). (However, sodomy was sometimes presented explicitly as a subspecies of *luxuria* in fourteenth- and fifteenth-century Italian Last Judgement frescoes.[41]) As has been stressed throughout this chapter, depictions of otherness should not be viewed simply as projections of that which was despised, feared or misunderstood but also, potentially, as a means of working through and constructing aspects of selfhood. The reason why sodomy was rendered visible so infrequently may have been to do with the concern that its visualization would corrupt the faithful, by disclosing illicit, previously unheard of practices. It is for this reason that the Lincoln frieze makes efforts to present the vice in an unreservedly negative light: the scene's significance is clarified by comparing it with the penalty described in a vision of purgatory and paradise experienced at the Benedictine monastery of

Eynsham (Oxfordshire) in Easter 1196. The *Revelation of the Monk of Eynsham*, which was translated from Latin into English for a fifteenth-century printed edition, contains a chapter on the 'unclean and foul vice and sin of sodomites' that affords a clear glimpse of the activities involved. The visionary describes how certain 'unnaturally shapen' monsters violently 'came upon' the sodomites and, 'in a foul damnable abusion', compelled them to 'meddle' with them.[42] The Lincoln scene likewise imprints in the minds of viewers an image of sodomy as violent 'abusion': the devil, who forces the sinners together in a manner that brings to mind anal or inter-femoral penetration, holds his victims by the hair, which, as we have seen on the Stratford misericord (fig.121), was a coded means of signifying rape. What's more, the relief simultaneously makes monsters of its subjects, by presenting sodomitic activity as a fusion of demonic assault and fallen fleshliness. This strikes a chord with Aquinas's characterization of all forms of 'unnatural' intercourse as activities that make use of 'monstrous and bestial techniques'.[43]

127 Two pages, with illustration of 'good' and 'bad' Jews (*left*) and hyena (*bottom right*), from Guillaume le Clerc's *Bestiaire*, c.1265–70
On parchment 22 × 14.8 (8⅝ × 5⅞)
Bibliothèque Nationale, Paris
(MS fr. 14969, ff.29v–30r)

Others on the Edge

So far we have confronted representations of difference within the Christian community – distinctions of class, gender and sexuality. Such images render the 'other' inhuman, monstrous in appearance and behaviour. Often they seem motivated by prejudice and hate, but they may also be haunted by a powerful ambivalence – the recognition that otherness is a site of identification and desire. We have yet to explore how artists visualized groups already external to the body of Christian faithful in Britain, by virtue of religious identity, geographical location or ethnicity. Did these 'others on the edge' likewise have the capacity to generate desire?

It is worth beginning with the acknowledgement that it was demons, above all, who functioned in medieval visual culture as ciphers for all that was evil, abhorrent and threatening in the world. We have already encountered these fantastical creatures in the course of our investigations – in the depths of hell, as wicked tormentors, and in the legends attached to saints. The sheer variety of forms bestowed on demons by medieval artists testifies to their ability to resist categorization: they combine the markings of several kinds of difference in one body, mingling body parts, species, even genders. To medieval audiences, demons were ubiquitous and 'real' but they were also ambiguous and elusive figures. Two points follow from the recognition of the demon's special status. Because demons

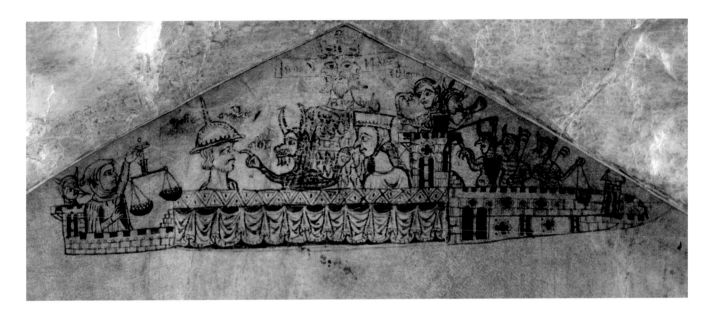

were in some senses everywhere, they offered a resource and conceptual framework for the depiction of other types of enemies. As we shall see, demonology produced an especially rich aesthetic storehouse for the depiction of Jews and Muslims, who were often cast similarly, in the role of torturers or terrifying savages. But they were also nowhere, to the extent that their provenance was ultimately otherworldly. This made them ideal models for the construction of imaginary kinds of difference.[44]

The people denigrated most regularly by a process of imaginary distinction were Jews. One of the ironies of the Middle Ages is that Judaism, a religion represented in the Old Testament as rejecting a multiplicity of gods, was slurred as idolatrous by image-loving Christians. Idols themselves were often represented in art as demonic creatures, 'anti-images' that were devilishly motivated: the occasional practise of smudging or rubbing out depictions of pagan idols in manuscript illuminations testifies to this belief in idolatry as a vehicle for evil spirits.[45] Moreover, Christian art often identified Jews as idolaters, devil worshippers in a literal sense. Jews were represented in this fashion in medieval bestiaries, books offering edifying commentary on the natural world to Christian readers. Numerous bestiaries survive from thirteenth-century England, among them the *Bestiaire* of Guillaume le Clerc, written in Anglo-Norman French around 1210. An illustrated copy of Guillaume's *Bestiaire*, produced in London

or Oxford around 1265–70, contains a number of anti-Jewish scenes, including a two-tier miniature contrasting 'good' Old Testament patriarchs such as Moses in the upper scene, who behold the burning bush and the face of the true God as described in Exodus 3:1–3, with the 'bad' Jews below, who worship the Golden Calf of Exodus 32 and get slaughtered by a man with a sword (fig.127). The virtuous Jews face right, while the idolaters face left, in keeping with the typical medieval association of right with moral rectitude and left with 'sinister', diabolical evil. The miniature illustrates the section of the bestiary devoted to the hyena, an animal thought by medieval naturalists to be capable of changing sex. The beast's sex change was viewed allegorically, as a symbol of the Jews who initially venerated the true God but subsequently turned idolatrous. Reinforcing this belief in Jewish perfidy, the page opposite contains a pendant image depicting a malevolent hyena stepping over a disembodied head to devour a naked human corpse in a sepulchre. The hyena faces left, in the same direction as the idolatrous Jews in the previous folio, and the eyes of the cadavers are closed – a grisly evocation of Jewish 'bestiality', feeding on the corruption of 'dead' pagan doctrine.[46]

Both patriarchs and idolatrous Jews in the bestiary miniature are distinguished by their appearance: they all wear beards, long robes and pointed hats. Following the Fourth Lateran Council in 1215, instructions were issued

129 Christ before Caiaphas, from the
Salvin Book of Hours, c.1270
On parchment 32.2 × 21.7 (12¾ × 8½)
British Library, London
(MS Add 48985, f.29r)

that Jews be visibly differentiated from Christians by their
dress. This prescription was motivated by the belief that
Christians were unknowingly engaging in sexual relations
with Jews. After 1217 in England, in keeping with these
regulations, Jews were expected to wear a badge modelled
on the twin tablets of the Law.[47] The long robes and conical
cap known as the *pileum cornutum* were originally worn in
accordance with Jewish religious mandates, but Christian
artists combined these motifs with deformed facial features,
such as the crooked nose, in order literally to 'demonize'
Jewish communities. One extremely striking manifestation
of this phenomenon appears at the head of a 1233 tallage
roll, in a cartoon depicting members of the Norwich Jewry
(fig.128). At the top of the scene, as the written caption
makes clear, is Isaac of Norwich, the wealthiest Jew in
England at that time. Represented as a monstrous, three-
headed hybrid, in a bizarre parody of the Holy Trinity, Isaac

is shown crowned and bearded, with two hooked noses
in profile. Below Isaac several other Jewish townspeople
with similar physiognomy line the city walls, including a
wimpled woman called Abigail, a man weighing money in
a pair of scales and a man called Moses Molke, who wears
the characteristic spiked hat. A devil sits between Moses
and Abigail, tickling their noses, while a trio of fellow
demons, whose pointy, down-turned snouts mirror those
of the Jews, march in from the right like an army of
infernal policemen.[48]

Not all medieval depictions of Jews are demeaning. It
should be recalled that the bestiary miniature juxtaposes
idolatrous Jews with virtuous, monotheistic Jews in the
scene above. Pointed hats and beards sometimes function
simply as identifiers of Old Testament Israelites, rather
than as attributes carrying explicitly negative connotations.
So it is important to consider an image's immediate contexts,

and the shifting social and political circumstances that impinge on its reception, rather than assuming that signs of difference are inevitably depreciatory. It is in their guise as the enemies of Christ in the New Testament that Jews emerge most consistently in Christian art as demonic figures. Since the time of the early Church fathers Jews had been typecast as 'Christ-killers': Augustine of Hippo (d.430), making the allegation that 'in your ancestors, you killed Christ', characterizes contemporary Jews as witnesses to Christ's kingdom on earth, albeit ignorant witnesses who are blind to the true significance of the evidence they supply. Although patristic accounts describing Jews as God's chosen people and witnesses paved the way for a certain amount of ambivalence regarding their role in medieval culture, depictions of Jews by Christian artists in late medieval Britain were overwhelmingly pejorative, reaching their apogee in Passion iconography.[49] A striking example occurs in the Salvin Hours, illuminated in England around 1270, in a historiated initial depicting Christ being brought before Caiaphas (fig.129). Christ, with his graceful, upright demeanour, pale skin and serene expression, represents the aristocratic ideal, whereas the Jews who arrest him turn their faces in profile to reveal sharply exaggerated hooked noses, stooped postures and grimacing mouths. The seated Caiaphas and the Jew to the left are distinguished by flamboyant headgear, while the two Jews in the background are set apart by their dark skin. Like the tormentors of sinners in hell, the ugly appearance of the Jews is designed to mirror their moral ineptitude.

Jewish communities were established in England following the Norman Conquest in 1066, from which point, though often restricted to professions such as pawn broking and money lending, they had fallen under royal protection. The Salvin Hours miniature dates to just a couple of decades before the expulsion of those communities in 1290, the culmination of a century of increasing tension between Christians and Jews. Nonetheless, Jews continued to be disparaged in Passion iconography produced in Britain long after the expulsion, testifying to the enduring power of the 'virtual Jew' in the Christian imagination. A marginal scene in the early fifteenth-century Lovell Lectionary from Glastonbury (BL MS Harley 7026) shows two Jews in contemporary dress stabbing at a consecrated host – the bread that was believed by medieval Christians to be transformed into the actual body of Christ

through the ritual of Mass – in a powerful evocation of the myth that Jews not only murdered Christ at the time of the New Testament but continue to do so in the present, by desecrating the Eucharist.[50] A banner of around 1520, embroidered in Scotland and probably belonging to the Confraternity of the Holy Blood in St Giles' Cathedral, Edinburgh, is no less explicit in its characterization of Jews as abusers of Christ: it incorporates, above a scene portraying Christ before his cross as the Man of Sorrows, representation of the instruments of the Passion, including the busts of two Jews in profile with bulbous noses and gloomy expressions. The head on the right, with a moneybag round his neck, clearly represents Judas, while the face on the left, puckering his lips, stands in for the Jews who, according to certain late medieval polemicists, befouled Christ's face with their spit. The prominence of the 'spitting Jew', in an image produced in a region where there was no significant Jewish community during the Middle Ages, draws attention to the significance of imaginary, as well as actual, distinctions for the production of Christian identity.[51]

Imaginatively venturing outwards beyond Britain's geographical limits, medieval artists distinguished Christians from other non-Christian groups using comparable visual codes. Qualities such as clothing and skin colour, which have the ability to signify in a relatively neutral fashion, were combined with physical deformity and brutish gestures to produce unequivocally negative interpretations. Two groups that came in for particular attention were Muslims and Mongols, referred to respectively as 'Saracens' and 'Tartars' in pejorative contexts. The Crusades – expeditions undertaken between the late eleventh and the fifteenth centuries, to liberate the Holy Land from Muslim invaders – coincided with this increased interest in representing non-Christian others as demonic figures. A folio from the Luttrell Psalter includes in its margins two jousting figures, often taken to be Richard the Lionheart (Richard I, 1189–99) and Saladin, which aligns the Muslim warrior explicitly with demonic, anti-Christian traits. Represented in the process of being knocked off his mount, the knight's helmet falls from his head to reveal dark, bluish skin, a hooked nose, red lips and exposed teeth; his grimace is echoed in the toothy scowl both of the horse he rides and of the dark face – presumably Mohammed – on his shield.[52] Matthew Paris's *Chronica Majora* (1236–59), which exists in a manuscript in which

Cephandi tartari ul' tartari humanis carnibus uescente.

Equi tartaror qui sunt ua[...]

130 Page with illustration of 'Mongol
depravities', from Matthew Paris's
Chronica Majora, c.1236–59
On parchment 36 × 24.5 (14¼ × 9⅝)
Corpus Christi College, Cambridge
(MS 16, f.166r)

the author was both artist and scribe, contains a famous
marginal scene showing the depravities allegedly committed
by Mongols during their incursion into Poland in 1241
(fig.130). The image shows towards the left a young, naked
male being barbecued on a spit, with his hands in a gesture
of prayer, framed by depictions of a Mongol eating human
limbs and another engaged in an act of decapitation; to the
right is a naked female victim tied by her hair to a tree, the
branches of which are being consumed by an enormous
horse. The scene identifies the Mongols as cannibals, as
well as murderers and rapists: an inscription appears above
the spit-roasted boy, stating that it depicts 'abominable
Tartars eating human flesh'. That the interaction between
the horse and the restrained female has sexual undertones
is made clear by comparing the drawing with the accom-
panying text, a letter written by Ivo of Narbonne about
the Mongol atrocities, which describes how 'virgins were
deflowered until they died of exhaustion'. Ivo also goes
into depth about Tartar physiognomy: they have 'short
distorted noses', he splutters, 'their eyes are black and
restless, their countenances long and grim, their extremities
bony and nervous'.[53]

Horrific though they are, these portraits of others on
the borders of Christendom, differentiated by eating habits
and sexual morality as well as by physical appearance, ulti-
mately bear a resemblance to depictions of the 'monstrous
races'. Medieval accounts of these legendary peoples
located at the edges of the known world were derived from
the descriptions of classical authors such as the Roman
historian Pliny the Elder (AD23–79), as well as from legends
about Alexander the Great. Monstrous races were charac-
terized by gross physical deformities – some were giants
or midgets, or possessed a single, umbrella-like leg; some
had eyes in their shoulders, or faces on their chests, or
sported the heads of dogs. But they were also differentiated
by barbarous customs – strange eating habits, habitats
and methods of communication.[54] It is not surprising that
Paris's *Chronica Majora* makes direct allusions to the
monstrous races in the description of Mongols: Ivo of
Narbonne's letter describes how the Tartar chiefs, 'with
the houndish cannibals their followers', feed upon the flesh
of human carcases and how 'the old and ugly women were
given to their dog-headed cannibals – Anthropophagi, as
they are called – to be their daily food'.[55] Anthropophagi were
monstrous man-eaters, very much the cannibalistic counter-
parts to medieval wild folk, but here Ivo seems to have

elided them with dog-headed Cynocephali, a race said to
communicate by barking. Unlike Paris's portrait of
Mongols, however, depictions of the monstrous races
possessed dual significance – conveying a sense of wonder
as well as terrifying depravity. Augustine for example,
wondered whether monstrous races were human, and if
so whether they were capable of receiving God's salvation.
Comparing the races with the deformed beings 'born
among us of human parents', he makes the point that,
if these beings are the work of God, it ought not to seem
odd that 'just as there are some monstrosities within the
various races of mankind, so within the whole human race
there should be certain monstrous peoples'.[56]

So monstrous races are not only 'others on the edge',
they are also intimate strangers of a sort. This comes
across especially clearly in manuscripts of the Anglo-Saxon
Marvels of the East, a text describing the incredible creatures
that inhabit distant corners of the earth. An illuminated
copy from the second quarter of the eleventh century
depicts two different monsters on one page: the Panotii,
giants with enormous ears described by Pliny, are repre-
sented alongside the Donestre, a creature derived from the
Alexander tradition. The latter were believed to consume
their victims' bodies, but afterwards 'seize the head of
the same man which they have eaten and weep over it'
(fig.131).[57] Legend has it that the Donestre had the ability
to 'coax' strangers with familiar speech, by using the
names of their parents and relatives: this is conveyed in
the upper register of the drawing by the creature's hand
gestures, which mimic those of the traveller he confronts.
Below right, the monster bends over to devour the man's
arm, while to the left we see him gesticulating wildly at
the traveller's disembodied head. If Paris's Mongol is an
embodiment of absolute evil, the Anglo-Saxon Donestre
encapsulates a different kind of monstrosity, caught
between positive and negative meanings. This monster
is both like and unlike human beings. He stands upright,
engaging our sympathy with his weeping; a symbol of
hypermasculine excess, he is endowed with prominent,
humanoid genitals; his mimicry of human language
precedes his desire to consume us literally – to *become* us –
but through the process of mourning he also realizes his
estrangement from himself. The scene draws attention
to the lines customarily erected between self and other,
familiar and strange, but it can also be read as a metaphor of
the ways in which, through the simultaneous appropriation

131 Donestre with traveller (*left*) and sausage-eared Panotius (*right*), from *Marvels of the East*, Winchester, c.1025–50
On parchment 26 × 21.8 (10¼ × 8½)
London, British Library
(Cotton MS Tiberius B.V., f.83v)

132 Woman with a goat from Gerald of Wales' *Topographia Hibernica*, Bury St Edmunds, c.1250–75
On parchment 29.5 × 20 (11½ × 7⅞)
University Library. Cambridge
(MS Ff.1.27, f.28v)

and disavowal of otherness, those lines move in and out of focus.[58]

The *Topography of Ireland* by Gerald of Wales (c.1146–c.1223), several manuscripts of which are illustrated with pen-and-ink drawings, provides a powerful witness of the ways in which these negotiations of sameness and difference play out in actual colonial situations. Gerald, who travelled to Ireland twice in 1183 and 1185, on the second occasion with Prince John on behalf of King Henry II with the purpose of claiming English overlordship, explicitly connects his account of these journeys with the *Marvels of the East* tradition. The preface to the second section of the *Topography*, titled 'The Wonders and Miracles of Ireland', announces that just as the marvels of the East have come to light through the work of certain authors, 'so the marvels of the West which, so far, have remained hidden away and almost unknown, may eventually find in me one to make them known even in these later days'.[59] Gerald begins by cataloguing Ireland's topographical quirks, such

as an island where no one dies and a well that turns those who wash in it grey, before considering the country's monstrous inhabitants. Gerald is especially struck by what he sees as an Irish penchant for bestiality. Sex with animals, he says, is a 'particular vice of that people', an idea that bolsters the overall impression of Irish barbarism that he wishes to construct. Although acknowledging that the Irish are Christians – the *Topography* includes a touching account of a male werewolf from Meath who persuades a priest to give his dying companion Holy Communion – Gerald also makes efforts to align the Irish with practices 'against nature', by using a rhetoric that partially chimes with medieval discourses of sodomy. He tells, for instance, the story of a woman from Connacht who had 'bestial intercourse' with a goat, and declares the deed 'unworthy and unspeakable', which parallels sodomy's identification as the *crimen nefandum,* or unmentionable vice.[60] A drawing in a thirteenth-century manuscript of the *Topography* nonetheless renders the transgression visible and coherent,

abuſum ſubponebat. O in
dignum facinus z nefandū.
O qm enormit ſenſualita
ti ſuccumbit raco. qm degene
rante nature puilegio ·i beſ
tiam bruteſcit beſtiaz dña
tor cū bruto animali tam
turpi comercio rōnale ſe ſub
mittit. Quibus enim utiq3
deteſtabile nimis ſit ab homi
nabile: longe tñ minus;
brutū rōnabilib3 ēē ſubiecta.
z quia bruta: z qm natura
liter ſeruire para. Licet tñ
no abuſum: ſz ad uſum cre
ata. In metrū q natura
forte negare puipit id iġ
cio. Omnia tam nouitate iu
uant· noua grata uolupta?
Et naturalis inueterata
venus· arte minus natura
placet· conſumit uſus: in re
bz raco· iam rōne carens.
Vis genitiua gemit uiolata
cupidinis arte. Et uiolans
iunder publicat ira ſcelus·
Pandit enim natura po̅tz
pudorem: criminis infandi·
prodigioſa creans.
Partius erem adamante

Pleonem uidimus quem
Cardinalis quidam philippo
Ledouici regis filio tūc pue
ro catulū tranſmiſerat. Hic
fatuam qñdam johannam
noie beſtiali amore amplec
ti ſolebat. qui cū e carcere
aliquocies erupiſſet: z in
tantam comotus iram ut au

ſus acce̅de nemo fuiſſz· tūc atti
ta iohanna iuxta eū z maliaā z
continentem mitigabat. z mulieb3
illum demulce̅s illecebris z quo
uoluerat ducebat: z omnem ſtati
furorem in amore conuertebat.
Outinq3 beſtiam turpi morte
digniſſimam· nec tā mod? uis
cū temporib3 ſcelera huiuſmodi
ſuit attemptata. Verū z antiq
tempora maiori innocentia z ſi
plicitate laudabilia nephandis
huiuſmodi criminib3 maculam q
traxerant. Vnde z in leuitico ſep
tum eſt. Mulier q acceſſerit ad
omne pecus aſcendenda ab eo.
muliere interficietis· z pecus mor
te moriat? rei enim ſunt. Pecus
interfici iubet no qp culpam a qua
beſtialitas excuſat. Sz qp memo
rie refricaco̅nem que ad mente
facinus reuocare ſolet. De pa
ſiphe quoz z̄ thaurū adamaute
multoz opione no fabula q̄e.
ſz res geſta fuit. De gaƚƚ alie
in hybnia qm alibi uociferantib3.

Galli gallinacii no hic ut a
libi itam z extremam noc
tis ptem aduab3 pmis tpl̄ra i
teriuallo uociferando diſtingut.
Priq eni̅ an diem hic audiūt·
z qñtū alibi a tña· tūc hic aſt
galli uoce dies diſtare dinoſci
tur· Nec arbitrādū tam eſt
aliam hic qm alibi gallos hue
naturam. Haur alir eni̅ uociſe
rant huc aliunde aduecti. Sed
ſi̅t breui contenta britanniā noctē
c̄· ſic z hybnia z tanto briuiore.

typically characterizing it as a reversal of gender roles (fig.132). The Irish, goat-loving woman isn't differentiated ethnically from other Europeans: an image on the same folio depicts an almost identical woman kissing and embracing a lion sporting an erect penis, which illustrates the anecdote in Gerald's text about a woman in Paris who was in love with a lion. Instead the Irishwoman is depicted usurping male privilege in the sexual act, by stooping over the goat and taking the upper hand. (The ancients themselves, Gerald tells us, were stained with such 'unspeakable deeds'.) Irishmen in *Topography* manuscripts are differentiated visibly by appearance: they are often hairy, with long beards, and wear distinctive clothing. The colonized Irish, however, are distinguished by behaviour as well as ethnic variation – monsters of the soul as well as of the body.[61]

Ideas of similitude and difference were also charted spatially on maps, which were themselves sometimes included in manuscripts of Gerald's *Topography*.[62] *Mappae mundi*, maps offering world images, were especially popular in medieval England. These maps were often inscribed with depictions of monstrous races at their margins. Drawing boundaries between the known or imaginable world and the unknown or unimaginable other, they can be seen as manifestations of a colonizing impulse. But despite their recognizable ethnocentrism, world maps also disrupt modern expectations. The form known as the 'T-O' map, so-called by virtue of the T-shaped boundary that divides the East at the top from Europe and Africa below, depicts the Orient as a space of strangeness but also places it in the uppermost region, closest to paradise and to God.[63] This is the case in the Hereford Mappa Mundi, drawn around 1290, which is the only extant large-scale world map from the thirteenth century. This shows at the apex Christ in Majesty, sitting in judgement, and immediately below, a scene depicting the Fall and the location of terrestrial paradise (see Ayers, pp.226–7). Spread below this is India, which contains among its inhabitants the one-legged Monocoli or Sciapods, one of whom is depicted sheltering himself from the heat of the sun with an overgrown foot; the seas to the north-east are dotted with islands inhabited by a variety of other strange peoples, with huge ears or the hooves of horses.[64] The East of the Hereford map is unfamiliar, but it is not simply an Orient of out-and-out otherness. It is also a space united conceptually with the Christianized West, a site of wonder and

divinity. Britain itself is located on the bottom left, at the extreme margins of the world, while Jerusalem occupies the centre in the T-O scheme.

Margins, Carnival and the Power of the Centre

The Hereford map draws attention to the need to challenge ideas about the relationship between 'margin' and 'centre' in the visual arts. Britain is comparable, in its marginal location, to the outer reaches of Africa and Asia. Whereas in later centuries the Orient often functions as a kind of negative image of the West, a repository for cultural differences of many kinds, the medieval *mappa mundi* looks East, not West, from the point of view of cosmology and eschatology. Thus, even as the divide between margin and centre constitutes one of our most powerful metaphors for thinking through questions of difference, such maps hint at the possibility that its contours are not always completely transparent or self-assured. What is socially or spatially peripheral may turn out to be symbolically central, and vice versa; monsters, which inhabit the physical edges of medieval visual culture, inscribed in the margins of manuscripts, at the edges of maps or beneath the seats of church choirs, may also be mainstream to the extent that they function as cognitive devices for thinking through complex theological problems, or as the mirrors in which viewers discover selves.

In conclusion, it is worth exploring these issues in a more theoretical vein, by briefly considering the methodologies deployed by modern scholars. The most influential (and controversial) arguments about marginalia in medieval art have been put forward by Michael Camille, in his book *Image on the Edge* (1992), in his study of the Luttrell Psalter and in a number of book chapters and articles.[65] Camille argues that it is possible to map ideas of social marginality onto the physical spaces of medieval art. The topsy-turvy world of marginalia functions as a space in which the discourse of the centre – which Camille associates for the most part with 'high religion' and the Church – gives voice to the cultural 'other', only to mock it and ultimately recoil from it. In a powerful conflation of aesthetic and political concerns Camille thus brings into focus the capacity of the visual arts to demarcate, offend,

categorize and control. He takes his cue here from the Russian literary critic Mikhail Bakhtin, whose concept of carnival has, over the last few decades, given rise to a number of lively debates about issues of power, representation and social restraint in pre-modern literature and art. At the heart of these debates is the question of whether the carnivalesque can be seen as genuinely subversive. For Bakhtin carnival is a period of freedom and challenge to hierarchy and order, a transformative space in which acceptable official forms become inverted; it represents a point in the calendar when the univocal truths of the centre are forced to confront, on the margins, a world of debate, multiplicity and flux. Such an analysis could be seen as being especially relevant to some of the images discussed in this chapter, where inversions of power relations and social roles are clearly at issue. Camille, however, foregrounds the limited nature of carnival's revolutionary potential, arguing that medieval marginalia ultimately 'work to reinstate the very models they oppose'; for him the visual rebellions in medieval margins frequently sustain efforts to 'give birth to meaning at the centre'.[66]

Although Camille has subsequently refined these arguments, it is worth engaging with them to the extent that they draw attention to the conflicted nature of medieval art.[67] The margins of medieval art clearly did play host to representations that marginalized social outsiders, differentiating them, sometimes violently, with reference to a rhetoric of monstrosity. The images assembled in this chapter make it clear that depictions of monsters are often complicit with the status quo, so that – with Camille – we can say that it is difficult to discover in medieval art depictions of otherness with truly utopian or revolutionary potential. At the same time, the idea that the Middle Ages produced the conditions for a system of 'absolute hegemony', where monsters and margins function simply to fix the meanings of the centre, risks shoring up ideas of the period as a cultural monolith, other to modernity in its ability to foster a system of fixed and stable truths. As well as potentially reinforcing a neat dichotomy between sacred and profane, by associating the centre with official religion and the margins with secular culture, this viewpoint ignores the role of hybridity and contradiction in cultural expression.[68] In truth the monsters of medieval culture speak with many voices, meaning different things to different viewers in different time frames. They are figures that can be appropriated by the centre, helping to define it through negation; equally, they can function positively, as images to think with. But there are also situations when monsters may operate more ambiguously, encoding a desire – sometimes not fully conscious – for ambivalence, uncertainty, even transgression. Representations of human difference certainly draw attention to the role of visual images in controlling people's lives, dividing bodies that matter visually from bodies that ostensibly do not. Yet these depictions also remind us that societies, like bodies, are essentially polymorphous entities – open, contradictory, antagonistic and incomplete. If visualizations of difference function pejoratively, as witnesses to the power of the centre, they can also serve as reminders of just how shaky these ideals of social and religious unity really are.

The Hereford World Map

TIM AYERS

The Hereford Mappa Mundi, as such objects were known in Latin, is the largest surviving medieval world map. Several are recorded in England (including one commissioned by King Henry III [1216–72] for the Palace of Westminster), fragments of a similar English map survive and there are smaller examples in manuscripts, from the late Anglo-Saxon period onwards. All follow the so-called 'T-O' form, deriving from antiquity, in which a circular image of the world (O) is subdivided into three (in a T shape), with Asia at the top, Europe at lower left and Africa at lower right. In spite of appearances, the world was not understood to be flat; the depicted part was conceived as a schematic representation of the northern hemisphere.

The Hereford example is painted on a very large piece of parchment, the skin of a single animal, and stands 1.58 metres high (fig.133). It carries an inscription in Anglo-Norman, the language of the ruling elite in England at the time, identifying the maker as Richard of Holdingham or Sleaford (Lincolnshire), who may have been a member of the Lincoln Cathedral clergy. The map can be dated to after 1283, because it shows Caernarfon Castle, begun in that year (see Goodall, p.133, fig.73); on palaeographical and stylistic grounds, it probably dates to c.1290–1310. It was evidently adapted for its Hereford setting, as it includes an added or adjusted representation of the city and the River Wye on which it stands, with an additional text (still by the scribe of the rest of the map). The map was presumably made for the cathedral, where it was first recorded in the seventeenth century. It was once set within a Gothic wood frame with doors, like a triptych, which protected it and allowed control of its display.

The map is revealing of a world view very different from our own. It is painted in colour (now faded) with land masses, seas and rivers, and a wide variety of places, identified by explanatory inscriptions in Latin. These are sometimes quite long and reveal a variety of sources in writers on geography and travel, and their interpretation, from the classical and medieval periods, such as Gaius Julius Solinus, third-century author of *De mirabilibus mundi*, and Paulus Orosius (c.385–420). At bottom left the Emperor Augustus (27BC–AD14) is shown sending out surveyors, and itineraries were probably used in the map's compilation. In Europe the rough shape of Sicily can just be made out, but this map does not convey geo- graphical forms or distance accurately, or facilitate navigation in the way that contemporary portolan charts did. Rather, it invites journeys of the imagination, not only through space but also through time and sacred history.

The following is clear from its context: the circle of the world is surmounted by an image of Christ in Judgement at the end of time (see O'Reilly, pp.195–6). The wings of the case, when open, showed the Angel of the Annunciation on the left and the Virgin Annunciate on the right, so that the map appeared between them, in a poetic analogy between Christ (promised by the Annunciation) and the created world. Within the map, the Garden of Eden is at the top and Jerusalem at the centre with an image of the Crucifixion. On one reading, then, there is a chronological progression from the top to the bottom of the map, from the site of the Creation in the Old Testament to Jerusalem in the New, and to actual sites of the medieval world in Europe at lower left: Hereford, London, Paris, Cologne, Constantinople and Rome. But the subject matter is not predominantly biblical. The map is packed with over 500 pictures and texts, demonstrating a fascination with the wider world and its multiple possibilities, as they had been explored in works both learned and fantastic. Monsters are shown in the Asian and African sectors of the map (see Mills, p.224). These were popular in texts of the *Marvels of the East*, dating back to the Anglo-Saxon period, and in the widely read *Mandeville's Travels*, of the mid-fourteenth century. Here they are presented as part of a monumental visual encyclopaedia.

Although it is not known exactly where the map was originally displayed, it reveals in passing something about how it was intended to be received. The Anglo-Norman inscription addresses 'All those who possess this work – or who hear, or read or see it'. This implies reception in a variety of ways, evoking the reading aloud, discussion and exposition that may once have surrounded the interpretation of this extraordinary object. World maps were among the furnishings that privileged both royal palaces and the great cathedrals as sites of spectacle and wonder.

FURTHER READING

E. Edson, *Mapping Time and Space: How Medieval Mapmakers Viewed their World*, London 1997.

P.D.A. Harvey, *Mappa Mundi, The Hereford World Map*, London 1996/2002.

P.D.A. Harvey (ed.), *The Hereford World Map: Medieval World Maps and their Context*, London 2006.

N.R. Kline, *Maps of Medieval Thought: The Hereford Paradigm*, Woodbridge 2001.

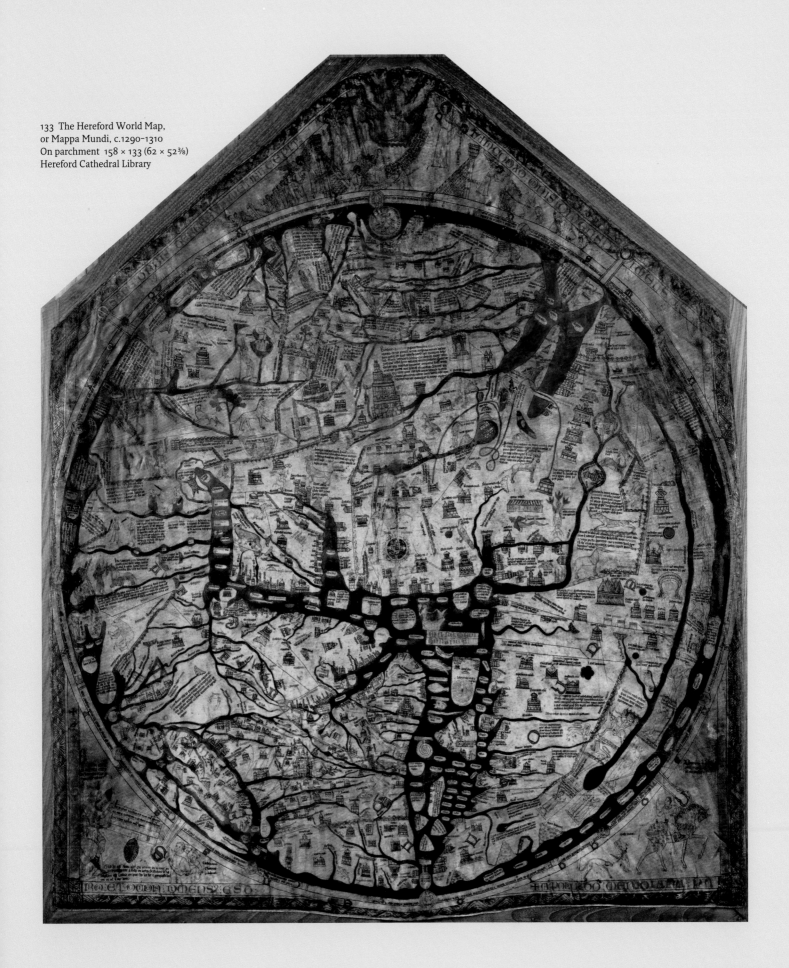

133 The Hereford World Map,
or Mappa Mundi, c.1290–1310
On parchment 158 × 133 (62 × 52⅜)
Hereford Cathedral Library

The Macclesfield Psalter

STELLA PANAYOTOVA

Discovered in the library of the Earl of Macclesfield at Shirburn Castle (Oxfordshire), the Macclesfield Psalter was acquired by the Fitzwilliam Museum, Cambridge, in 2005 (MS 1-2005; fig.134). It is an important addition to the corpus of English medieval art. It clarifies the relationship between celebrated and less well-known manuscripts; demonstrates the close links between illumination and monumental painting in East Anglia; highlights the porous boundaries between lay and religious patronage; and exemplifies the vigorous exchange between local traditions, metropolitan trends and Continental fashions in fourteenth-century England.

Among the manuscripts closely related to the Macclesfield Psalter in iconography, style and textual and liturgical features are the Gorleston Psalter of c.1310–20 (BL Add MS 49622); the Howard Psalter of the 1320s (BL Arundel MS 83 1); the contemporary, second campaign of the Ormesby Psalter (Bodleian Library, Oxford, MS Douce 366; the second attempt to complete the illustrative programme); and the Stowe Breviary of c.1325 (BL Stowe MS 12), which was copied by the scribe of the Macclesfield Psalter. Work by the Macclesfield Master features in three manuscripts of the 1330s: a *Summa Confessorum* by the Dominican John of Fribourg (BL Royal MS 8.G.XI), a copy of Bede's *Ecclesiastical History* (Trinity College, Cambridge, MS R.7.3) and the Douai Psalter (Bibliothèque municipale, Douai, MS 171). Close stylistic and compositional analogues also occur in East Anglian panel painting, namely the Kingston Lacy screenwork fragment of c.1330 and the Thornham Parva Retable, made in the 1330s for the Dominican Priory at Thetford or Norwich. The Retable shows particularly strong affinity with the work of the second Macclesfield artist, named the Anointing Master after his illustration of Psalm 26 (f.39r).

The Macclesfield Psalter was produced with a Dominican input, too. In addition to the portrait of its intended recipient, the man shown beneath the Confession prayer (f250r) whose identity remains a matter of speculation, the artist has depicted a Dominican, presumably the owner's confessor, at Psalm 107 (f.158r). Surprisingly, St Dominic is absent from the Calendar and Litany of the Macclesfield Psalter. The prominence of St Andrew in the full-page miniature on folio 1v is matched in the Calendar

and Litany, but the dedication of his church at Gorleston on the Suffolk–Norfolk border, which was entered in gold in the Gorleston and Douai Psalters, is absent from the Macclesfield Psalter. It is possible that St Andrew was the patron of the Macclesfield Psalter's commissioner or owner, or of one of the numerous churches dedicated to this popular saint. Two of them were in Norwich and Cambridge, and their parishes included the Dominican priories in both cities.

The marginal images of the Macclesfield Psalter hint at the socio-economic climate of a city, with its professionals and outcasts. They draw on, or parody, a wide range of Latin and vernacular texts, from exempla and saints' lives to romances and fabliaux. They also comment on recent events and filter the economic, political and social landscape of England in the 1330s through the eyes of those involved in the production of the manuscript. The pictorial allusions to contemporary events and the livery colours of the Fitzalan family suggest an association with Richard Fitzalan (c.1313–76), 3rd Earl of Arundel, nephew and heir of John, 7th Earl of Warenne (1286–1347), who commissioned the Gorleston Psalter. The place of honour reserved for St Edmund of Bury in the Macclesfield Psalter's opening miniature (f.1r) may have referred to two Edmunds in the Fitzalan family, Richard's father and his first-born son.

This Psalter is an important example of the 'Italianate' tendencies in fourteenth-century English painting: the three-dimensional illusion of volume and texture, the anatomically precise rendering of the human body, and the virtuoso depiction of emotions. Traditionally explained through successive waves of Italian influence, this phenomenon may be seen as the product of receptive creativity at a major centre of international artistic and intellectual exchange.

The Macclesfield imagery reveals knowledge of classical texts and realia, suggesting that the manuscript was produced at a place of learning with a strong interest in antiquity. There were two such centres in England in the second quarter of the fourteenth century, Oxford and Cambridge. Both considered the friars, or Dominicans, to be at the head of their classicizing movement. The Cambridge priory headed the East Anglian visitation, one of the four visitations of the Dominican Order in England. It was at the heart of a growing university, accommodated a mobile international community and provided regular recruits for the Norwich

Blackfriars (see Monckton, pp.110–11). Combined with the Dominican presence and the urban flavour of the marginalia, the classical motifs may suggest that a Cambridge or Norwich friar was involved in the manuscript's production.

The Macclesfield Psalter advances the current state of research, since it invites detailed examination of manuscripts both as fascinating items in their own right and as products of wide networks of patronage and artistic exchange – exceedingly mobile and transgressing the boundaries of media and geography.

FURTHER READING

M.A. Michael, 'Seeing-in: the Macclesfield Psalter', in *The Cambridge Illuminations: Conference Volume*, ed. S. Panayotova, London and Turnhout 2007, pp.115–28.

S. Panayotova, *The Macclesfield Psalter*, facsimile with commentary, London 2008.

L.F. Sandler, *Gothic Manuscripts 1285–1385*, A Survey of Manuscripts Illuminated in the British Isles, vol.5, Oxford 1986.

L.F. Sandler, 'In and Around the Text: The Question of Marginality in the Macclesfield Psalter', in *The Cambridge Illuminations: Conference Volume*, ed. S. Panayotova, London and Turnhout 2007, pp.105–14.

134 Page from the Macclesfield Psalter, with initial for Psalm 38, 1330s (evidence of ownership removed from the top right-hand corner)
On parchment 17 × 10.8 (6¾ × 4¼)
Fitzwilliam Museum, Cambridge
(MS 1-2005, f.58r)

8 Art and the Reformation

MAURICE HOWARD

THE REFORMATION CHANGED the systems of religious belief and practice in Britain, a process beginning in the 1530s and resolved only in the civil wars and political settlements of the seventeenth century. Those visual arts that had served older forms of religious practice were deemed inappropriate and new forms took their place. It has become usual in discussions of post-Reformation art to claim that the visual arts 'suffered' thereby, becoming more limited in both their range of functions and their widespread use. To some extent this is true, but the visual arts remained of crucial significance at all times. At every stage of religious reform, whether radical or reactionary, issues concerning the appearance of things were at the very centre of religious debate. Protestantism may have held the visual arts in great suspicion, but that very nervousness expressed itself in some of the most searching questions about the power of imagery that have ever been raised.[1]

In England and Wales (the latter being fully absorbed into the English governmental system by Acts of Union in 1536 and 1543) the Reformation was initially a series of political actions that separated the religious life of the country from the control of the papacy and exploited the wealth of the established Church. It was driven by King Henry VIII (1509-47), frustrated in his wish to secure a divorce with papal consent. Around this issue gathered many long-standing grievances with the Church of Rome: over taxation, over the subservience to Rome of a body of clergy ultimately not beholden to the rule of secular government, and over the perceived corruption of the monasteries. Because in England the Reformation happened in stages, no one sequence of government decrees created a structure of religious devotion that in turn determined how the visual arts would be used. The acts of the Reformation Parliament of the 1530s stopped the recourse of English clergy to the external authority of the pope in Rome, suppressed the monasteries and declared the sovereign as head of the Church, this last giving the monarch the opportunity to be represented for the first time in ways that underlined that new ecclesiastical authority. Under Henry VIII, however, the celebration of the Mass, whereby it was believed that the body of Christ

was present in the Eucharist, remained central to religious worship, and altars, images and church furnishings remained in place.

It was in the brief reign of Edward VI (1547-53) that the government denied the central mystery of the Mass and actively encouraged the removal of images, declaring them idolatrous. The brief Catholic reaction of the reign of Mary I (1553-8) was able to restore ritual, but not the renewal of the old visual culture. Whilst never supporting the re-instatement of images, the government of Elizabeth I (1558-1603) sought to control the over-zealous destruction of works of art. The social order seemed to be threatened by undisciplined incursions into churches by zealots unable to distinguish between images of saints and representations of the dead in their defacing of monuments.[2] During Elizabeth's reign radical puritan forces sought continually to push the boundaries further in the establishment of a truly Protestant Church. Puritans initiated heated parliamentary debate, but never had a dominant voice in the royal council. However, the re-adoption of certain High Church practices of devotion and image-making by members of the establishment under Charles I (1625-49) and their spiritual intercourse with known Catholics, reaching as high as the Queen Consort Henrietta Maria herself, which demarcated an emphatic division between king and country that led to the civil wars of the 1640s.

In Scotland the initial political achievement of Reformation was a far more concentrated and orchestrated event, brought about by a nationalistic, aristocratic rebellion in 1559-60, that challenged the stalled Catholic reform policies of the government of the French Mary of Guise, mother of the young Mary, Queen of Scots (1542-67). The Scottish Parliament then created a wholly new Protestant Church, the Kirk. In subsequent years local civic and religious leaders of both radical and conservative persuasion had a considerably greater influence on the establishment of the new Church than their counterparts in England, such that in some places Catholic and Protestant churches survived alongside each other. There was no sudden dissolution of the monasteries (though some urban houses were sacked during the rebellion), but over a period of time the buildings

were allowed to decay and their wealth was siphoned away as many of their clergy joined the newly established Church.[3]

Both north and south of the border governments were not able to enforce absolute conformity in every aspect of religious change. The very need to repeat laws laying down codes of conduct towards images was, like the sumptuary laws controlling aspects of clothing across classes and occupations, a sign of how patchy adherence to the law actually was. The regions of England were different, so that, whilst it seems that the westernmost counties of England largely complied with the government, there emerged something of a Catholic power base in a swathe of territory stretching from the West Midlands (the nurturing ground and 'safe house' of the Gunpowder Plot traitors in 1605) up into Cheshire and Lancashire. There was always a tussle in Catholic minds between religious beliefs and their often genuine loyalty to the Crown and the national interest. Equally, scaremongering about Catholic conspiracies served the government's purpose. For Catholics the legitimacy of removing the head of government was first prompted by the papal excommunication of Elizabeth I in 1570. Conspiracies both real and imagined caused much government anxiety thereafter, culminating in the Spanish Armada of 1588.

It has become an accepted fact in the history of the Reformation that in late medieval times these islands were among the most faithful adherents of European Catholicism. Evidence suggests that there was indeed as strong and diversified a corpus of devotional images and other aids to devotional practice as anywhere in Continental Europe. In the early sixteenth century people seemed to be as keen as ever to endow religious foundations, most notably chantry chapels in cathedrals and larger parish churches.[4] Moreover, it has recently been claimed that this richness of patronage, this abundance of aids to devotion, was not a sign of an established religion in doctrinal crisis but of one in the process of renewal, stopped by the events of the 1530s.[5] Physical remains of the late medieval Church in Britain are found extensively on the Continent. One of the most dramatic effects of the Dissolution of the Monasteries and of the rapid dispersal of monastic goods, followed by the iconoclasm of the regime of Edward VI some years later, was the selling of a significant amount of the wealth of English visual culture to Continental Europe, so that great churches and libraries

across Europe today still retain manuscripts, altar furniture and vestments sent abroad at that time. The greater number of these objects had been purchased from Europe in the first place, but England had in return long contributed to the market in religious goods. England had excelled in the making of expensive liturgical textiles (known throughout Europe as *opus anglicanum*) and figures of saints and small narrative altarpieces in Nottinghamshire alabaster (see Staniland, pp.168–9, and Riches, pp.76–7).

If the acts of Henry VIII's government stopped short of challenging the centrality of the Mass, with its need for ritual vessels, church ornaments and the expensive clothing of the higher clergy, the Dissolution of the Monasteries did undermine the efficacy of images. In order to damage the reputation of the religious houses, royal commissioners emphasized, alongside claims about the indulgent private lives of monks and nuns, the decay of proper religious observance and the authority given to the dubious and superstitious manifestations of faith.[6] Much criticism was directed at images of saints that were popularly believed to respond to worshippers by shedding blood or tears. However, it was the government of Edward VI that first spelled out the danger of belief in images that were somehow offered as 'effective' in aiding devotion and began a phase of deliberate iconoclasm. The Protestantism of this government also denied the existence of Purgatory, where souls awaiting final judgement could benefit from the intercession of the living, through prayers and commissioning of devotional objects. Since in the Protestant view it was the balance sheet of the individual's life on earth that now truly mattered, no amount of intercessionary activity could change the fate of those deceased. This shifted the emphasis of belief away from one of forgiveness and promise of redemption to an urge to keep to rules of behaviour and propriety during the earthly life. Texts were believed to convey these rules more directly than potentially ambiguous images. No area of visual production exemplifies this more profoundly than the shift in design and message of funeral monuments. Denial of the efficacy of images to affect the outcome of one's bid for heavenly reward, or indeed to influence the fate of an ancestor in this regard, was one of the chief developments that fuelled a wider suspicion of visual representation.

If the challenge to the imagery of the past was principally in the area of castigating the fooling of the faithful by images that replicated reality, then potentially all things

that looked 'too real' were suspect. This introduces us to a central post-Reformation concern, not just with images in churches, or even principally there, but in all places both public and private. It raises the notion that new forms of 'reality' which elsewhere in Catholic Europe might be influencing and pushing forward the visual arts, might under a Protestant ethos prove dangerous and delusional. The portrait of a sitter that looked too lifelike might be mistaken for something idolatrous. To take one obvious example, the adoption of perspective in a two-dimensional painting, or in inlaid furniture or panelling, might suggest a reality that was not to be believed, not to be trusted. It opens up a different view from the conventional one that contemporaries simply did not understand the clever tricks of some of the greatest artists of Continental Europe and needed some trained, well-travelled master to explain it to them. It suggests rather that the British knew the tricks of perspective but chose to ignore them, or use them very sparingly and thoughtfully as occasion demanded. In the famous image of *Lord Henry Darnley and his Brother Charles* 1562 (Royal Collection), for example, the sitters do not stand 'within' a prescribed perspectival space but in front of it. This implies that the vista (copied, it has recently been established, from a Flemish print) is a backdrop that may be serving to stress the sitters' aristocracy, their pretension to learning, or their familiarity with the latest print culture, but not primarily to place them in a believable spatial setting.[7] The flat, anti-spatial appearance of much portraiture, therefore, not only conveyed messages of heraldry and status through clothing, but also avoided a dangerous realism.

It has also often been argued that the Reformation cut Britain adrift from Continental Europe in such a way as to stifle a growing engagement with Renaissance style and ornament. Looked at differently, however, the Reformation may be said to have enabled a move forward. Certainly, in England there had been a recognition of the decorative potential of *all'antica* (classicizing ornament), for example, in the background of certain paintings such as the celebrated mural at Whitehall Palace by Hans Holbein (1497/8–1543) (now lost), where it proclaimed the power of the dynasty in a way reminiscent of structures devised for the triumphal entry of heroes in ancient Rome.[8] The vocabulary of classical ornament (arabesques, dolphins, candelabra and the like) also appears both in the terracotta ornament around the doors and windows of brick buildings

of the period 1515–35 and in ecclesiastical settings, such as some early sixteenth-century funeral monuments and on stone and wooden screens around chancel areas or chantry chapels.[9] If the foreign journeymen previously responsible for such work were no longer welcome after the Reformation, the ability to take ideas from abroad did not cease. The mid-century Protestant regime seems in fact to have encouraged a dialogue with a more severe, correct, form of the classical orders; simple mouldings and symmetrical facades, stripped of the earlier decorative ornament, are found in the buildings of the circle of patrons around the Duke of Somerset, Protector to Edward VI.[10] Applying the rules of classical ornament correctly also provided a straightforward and proportional means of using classicism as a framing device, as with the simple tabernacle design used for the title pages of books.

What new forms of art production did the Reformation generate? There remain a few works that were the propagandistic tools of the new, anti-papal sovereign states of England and Scotland. Then there were works that shared an identity with contemporary European developments but have a particular, customized message that varied from nation to nation. There was, for example, greater emphasis than before on the commissioning of what have come to be called full-length 'state' portraits of monarchs on both sides of the religious divide (see Geddes, p.40). Witnessed by a far greater cross-section of social classes, however, were the discoveries of new subject matter in biblical and classical texts for painting, sculpture and the applied arts. The example of the life story of a virtuous figure could demonstrate heroic principles coeval with the Protestant creed. This category of production shares a range and potential with a final category, manifest in the most powerful medium of all to proclaim the principles of the new religion, the print. Each of these categories will now be explored in turn.

Only a handful of truly propagandistic painted images of the period survive and it is not always clear how and where they were shown. Recorded in the inventory of the royal palaces taken at Henry VIII's death in 1547, *The Four Evangelists Stoning the Pope* (still in the Royal Collection) by Girolamo da Treviso (1508–44), a small panel in grisaille (fig.135), remains shocking by its violence, though later images in the various editions from 1563 of *Actes and Monuments* by John Foxe (popularly known as *The Book of Martyrs*) extended the notion of physical violence as a

means of expressing the strength of opposing religious opinion and emphasizing the ultimate sacrifice of martyrdom. The painting dramatically illustrates the way that the Evangelists, known to the faithful through their texts on the life of Christ, were used as a weapon to counter the perceived superstition and worldly pomp associated with the Roman Catholic establishment.[11] Other pictures document the new Protestant state recognizing its own history, as yet all too brief and therefore needing constant reiteration. It has recently been established that the famous allegory of *Edward VI and the Pope* by an unknown artist (National Portrait Gallery, London) dates not from the reign of Edward himself but from about 1570–1, at the time of Elizabeth's excommunication. It was a way of reminding the faithful that cutting adrift from Rome had been hard won and needed constant reaffirmation, showing how 'alive' this issue was.[12]

Royal portraiture had always existed in both public and private spaces. We have lost the full-length, full-size representations of kings that Henry VII commissioned for the vanished Richmond Palace, the most recent in a long tradition of such works in medieval royal spaces, including Westminster Hall.[13] The Reformation was crucial, however, in lending the might of majesty a new significance, and one that usurped the position and authority reserved hitherto for the central figures of the Christian faith. Two famous images of Henry VIII and his family may not overtly put the king in the place of God, but visually they certainly rely on a familiarity with older religious art to make their point. The already mentioned Holbein wall painting showed the first two Tudor kings and their wives flanking an 'altar' with an inscription trumpeting the achievements of the dynasty, in the same way that saints might previously support a central image of the Madonna and Child in an altarpiece (see Engel p.66, fig.29). In the painting of *Henry VIII and his Children* (English School, c.1545; Royal Collection) the king is centralized and his daughters Mary and Elizabeth play those supportive, saintly roles. It is undeniable that an image like this depended on the familiar recognition of central image and supportive figures as

'commentators' or intercessors for the viewer, just as in a devotional panel.[14] By the time this was painted, the king also graced the title page of the Great Bible of 1539, enthroned at the top, dispensing the wisdom of the law to those each side of him through texts emblazoned on scrolls. The presence of the sovereign in the daily religious lives of people came also to be made clear in the placing of the royal arms in churches up and down the country, usually in the place over the chancel arch where religious imagery had once been painted. The power of the royal arms to suggest the ultimate authority of the king became as much a prompt to deference as Christian symbols had once been to the authority of God and the suffering of Christ.[15]

But it was in the act of finding new heroes and heroines that the post-Reformation world sought new images most actively to convince its public and bolster a belief structure that dealt in unambiguous messages. The living presence of saints in the earlier church had served as mediators between man/woman and God, but now the lives and examples of those figures were there not to intercede but to give a template for behaviour and one that had to serve in the here and now of a brief earthly existence. The lives of saints and prophets were re-scrutinized. Heroic and bloody deaths, the stuff of medieval altarpieces, were less important than admirable deeds; in any case, following the persecutions of Mary I, Protestants now had their own martyrs to look up to and admire. The post-Reformation

world delved deep into the Bible for stories hitherto rarely depicted, especially where they showed figures facing moments of personal choice between self and country, between different kinds of moral argument or keeping faith with promises to God. In the biblical Book of Judges Jephthah saves his country in war but has promised God in return to sacrifice whoever first greets him at his homecoming. Can he keep that promise when it proves to be his own daughter? This story was the subject of six hangings in the Great Chamber at Lacock Abbey in 1575.[16] Idol-breakers in the Bible were especially welcome to the Protestant creed. At his house of Hill Hall, in Essex, Sir Thomas Smith, courtier, diplomat and scholar, commissioned several series of wall paintings – now fragmentary and partly dispersed – of a remarkable complexity and extent. For his innermost room on the upper floor, he chose a story from the second Book of Kings about Hezekiah, who rid the temple of idols (fig.136).[17]

For every wall painting or overmantel in stone or plaster that was made, contemporaries had many more such narratives in wall hangings; in tapestry at the top end of the market (in costly materials and various grades of splendour) and painted or stained cloths at the lowest end, ubiquitous at the time but now rare survivals and recorded for us largely in inventories. The important factor about the continued representation of holy stories was context; something appropriate in a public room of a house might

be inappropriate in the privacy of a bedroom or study.
There is a convincing argument, in fact, that far from
being expelled from the daily lives of believers, imagery
was just as present, but now it proliferated through a range
of domestic settings. A religious story over a fireplace was
no longer the object of active worship but one to invite
contemplation, to live a daily life beneath a biblical exemplar
(fig.137). This may have been especially true for female
Protestants, active in the making of embroidery; cushion
covers, wall hangings and items of dress in daily use could
be replete with messages from both the Bible and emblem
books. Once created, these served as daily reminders of
moral examples to follow.[18]

Certainly, in the world of the graphic medium the easily
produced and cheaply sold woodcuts of the Late Middle
Ages, with their representations of the central mystery of
Christ's death, the weapons of torment used against him,
the symbolism of the Cross, all disappeared and survive
today only in versions that are often defaced. No great
corpus of figurative, symbolic, Protestant equivalents took
their place. However, inspired by Continental examples,
an open market arose for prints that paraded the religious
politics of the time through figures and narrative (see
Hamling, pp.242–3).[19] Like the paintings of historical
events referred to above, these images were always
customized in nationalist terms and drew their immediate
market through perceived threats to the country at the

time. Some images made popular through prints, and
more especially lines of text, entered the domestic setting
as often simple but effective wall decoration. By 1600
established printsellers were offering a range of engraved
images that widened the market further.

Funeral monuments conclude this section on the new
art of the Reformation, because no other category presents
so rich a mix of all the major aspects of new attitudes to
the visual arts (fig.138). They continued, as before the
Reformation, to be set up in churches, but their presence
was no longer part of the daily rituals of prayer and inter-
cession. Saints and angels no longer accompanied the
effigy; if figures were included they were now of virtues
representing the best qualities of the deceased, such as
fortitude, temperance, or charity. In the late medieval
Church the chantry chapel had been the boldest statement
of the wealth and power of the deceased (see Monckton,
pp.108–9); prayers in perpetuity were paid for and spoken
with particular ceremony on the anniversaries of death
and foundation, in the presence of the deceased's heirs, to
make it clear that family power resided in the adherence
to the Catholic faith. In the post-Reformation church great
monuments were tokens of local families' secular concerns
and achievements, the result of a life well spent in expecta-
tion of heavenly reward, and these attainments were
expressed in long inscriptions more frequently in English
than in Latin. In great wall tombs the inscriptions were

placed within classical tabernacles, showing us just how the order and proportion of the classical opening or 'doorway' proved a frame to the message of the monument. Service to the Crown or to the locality, military prowess, charity and beneficence in the community, the deceased's role as father or mother, the good marriages achieved for children, all were inscribed on monuments according to gender and worldly success. The monument was no longer part of an ongoing negotiation for reward in heaven, but a statement of account, now negotiating the loss of the individual not with God but with the status and Christian virtues of the remaining family, and as an inspiration to all who read the inscription. There are impressive 'portraits' among the funeral monuments of the age, but more often we are struck by the generalized features of the dead, the choice of their dress not in fashions prevalent at the time of death but often in the mode of the deceased's prime of life, as if summarizing the life as a whole, rather than specifying the moment of death. To emphasize this, successive generations often repeated the styles of the monuments of their forebears, continuing a medieval tradition that stressed family continuity, the 'likeness' not in facial resemblance but in similarity of achievement, of keeping faith with duty and service.[20]

The new arts of the Reformation spoke most eloquently of new meanings of faith among the Protestant congregation. Alongside newly made things, however, a wealth of pre-Reformation religious art was refashioned into something new, since not all was destroyed or so defaced as to be unusable. Much of this effort attended to practical adaptation, but this does not mean that refashioned art was meaningless or purely served as the means to an end. In reshaping the past, new and often unforeseen meanings arose out of the transformation of old things.[21]

The most important body of buildings made redundant by the impact of the Reformation was the 800 or so monasteries and nunneries dissolved in the Acts of 1536 and 1539 in England and Wales, and by a slower but eventually just as ruthless appropriation in Scotland, beginning in the 1560s. These buildings were as much at the mercy of political processes as other parts of the fabric of the old church. The monasteries of Lincolnshire were targeted for deliberate dismemberment because of the role their dissolution had played in the grievances expressed in the 1536 rebellion known as the Pilgrimage of Grace. A great monastic establishment was not necessarily spared for its beauty or its key place in the development of English or Scottish architecture, though some regrets may have been voiced when old nationalistic associations were attached to a site. Good building stone was often robbed. The slow decay of many of these great buildings is witnessed today by some of the most evocative ruins in the British landscape, whether commanding wide-sweeping valleys like Tintern, Rievaulx and Fountains, dominating the edge of a town like Jedburgh, or marking the junction between land and sea as at Whitby.

Yet, in many instances other factors resulted in their survival; they were more likely to be spared if they were recently rebuilt or, in the case of monasteries in urban areas, if they were key to the town's infrastructure of water supply or provided enclosed spaces for public gatherings or local government. It has been estimated that at least one half of suppressed monasteries took on new life as another form of building, whether in whole or part. Some monastic churches became new cathedrals like Chester and Gloucester, some served as a new parish church like Malmesbury, yet others were adapted for secular use as town halls or divided up into tenements.[22] Their contribution to new directions in domestic architecture came at the point where new owners were moved to pay attention to the potential of monastic layout or orientation. The cloister garth was the feature that most resembled the layout of a familiar courtyard house and often was so transformed, but some owners learned more: cloister walks became internal corridors, as at Lacock (fig.140). Upstairs, the monastic frater and dormitory suggested the making of grand, upper-floor rooms that had never before been contemplated in grand houses.[23] The wealth of information afforded by these buildings, particularly through recent archaeology of some key sites, has shown how each former monastery has a complex and individualized history.[24] Slowly, a sense of the past and of responsibility for it came upon the owners, so that from the seventeenth century onwards former monasteries played a crucial role in a slow-burning, post-Reformation sense of the past, which would be crucial in nation building.

The recasting of old objects to serve the new world happened in many ways, especially, when it came to the moveable, material goods of the pre-Reformation church. Many objects of the highest value, gold church plate for example, were melted down, yet we still find a number of surviving Catholic chalices transformed into larger

139 Stained glass panel illustrating
the Deposition, 1629, originally from
Hampton Court, Herefordshire
Height 81.3 (32)
Victoria and Albert Museum, London

140 The cloister of Lacock Abbey,
Wiltshire; the cloister walks are 15th
century, but the upper floors were
rebuilt c.1550

The truth here of is historicall deuine and
not superstiffious : .: Anno Domini · 1629 ·

Protestant communion cups. Inventories indicate that
ecclesiastical textiles were recut, unpicked and restitched
to serve secular uses and that people appear to have juxta-
posed newly made goods with older objects that predated
the Reformation. Detailed inventories of people of the
highest class, alongside our knowledge of their religious
convictions, give the fullest evidence of possessions old
and knew. In Elizabeth's reign no one was a greater
champion of the Protestant cause than Robert Dudley,
Earl of Leicester. Yet the inventory of his goods taken at
his death in 1588 includes references to imagery across a
wide range of objects, a miscellany of new and old subject
matter. At Leicester House in London were pictures of
classical subjects ('a picture of Venus and Cupid manecing
her wth his darte' and 'a picture of Diana'), along with
'iiii peeces of old hanginges of the storye of Moyses founde
in a baskett', and in the Great Gallery at Wanstead were
portraits of Henry VIII, Mary I and Elizabeth, 'A Picture
of Christ taken from the Crosse'. Leicester would not have
worshipped using this image but the retention of what
is likely to have been an old picture was not uncommon
in post-Reformation Britain.[25] By the early seventeenth
century some once proscribed imagery was again permis-
sible as long as it was made clear that it was for instruction
and not itself for worship. Along the base of a stained glass
panel of the Deposition of Christ (fig.139) is written: 'The
truth here is of historicall devine and not superstissious.
Anno Domini 1629.'

The striking ruins of monasteries in the British country-
side, defaced or decapitated images of saints on medieval
church screens, and displays of fragments of the medieval
past in both national museums and those at or near sites
where the Dissolution wrought havoc, all testify to the loss
of a wealth of visual objects at this period. Certain skills
were disrupted and damaged to such an extent that the
ways of making some items, like stained glass, were lost or
only partially recovered. But it would be wrong to assume
that the Reformation totally undermined the power of
imagery or the appreciation of the persuasive character of
sight as a conduit for understanding key religious concepts.
The way that medieval religious art spoke to the believer,
its visual language, was not forgotten or eradicated over-
night. Rather, it was the starting-point for discussion as
to what art could and should do both to encapsulate the
core beliefs of the newly reformed faith and to portray its
main protagonists.

The Printed Image

TARA HAMLING

In Reformation Europe prints reached a wide audience and provided a forum for comment on religious and political change. Much of the printed imagery circulating in Britain at this time was produced on the Continent or by émigré engravers working for presses in England. Printing presses were established somewhat later in Scotland and had a limited output in the sixteenth century, but imported printed wares were readily available.

Printed images were encountered in books housed in churches and domestic libraries, in specialist shops, and on the walls of ale-houses and domestic households. Illustrated books and high-quality copper engravings were expensive and therefore restricted to a privileged few. Cruder woodcuts within relatively cheap single-sheet broadsides circulated widely.

The Henrician Reformation curbed the trade in woodcuts of 'cultic' images for devotional use, although surviving examples with defaced inscriptions offering pardons for prayer suggest that such images were still looked at, if not prayed to. Other traditional iconographies survived and were gradually adapted to accommodate the nascent Protestant faith.

It took time for official reform to affect the nature and content of religious images in books. For example, the layout of *Christian Prayers and Meditations* (1569) by the Protestant printer John Daye (c.1522–84) is virtually identical to fifteenth-century printed primers (prayerbooks),

141 The Deposition and Lamentation, from *Christian Prayers and Meditations*, 1569
Henry E. Huntington Library

with Old Testament precursors depicted along-side scenes from the life of Christ, including the Deposition and Lamentation (fig.141). But these controversial 'images of pity' are absent in Daye's revised version of 1578. A similar process of censorship was in operation for illustrations in English Bibles. The 'Bishops' Bible' of 1568 includes narrative scenes interspersed through-out the text, including the figure of God in human form. In the 1572 edition the figure of God has been excised, along with the bulk of the illustrations. Nevertheless, in the context of title pages in books certain religious imagery was acceptable. A series of Bibles printed by Robert Barker from 1601 reproduces a title page depicting the Apostles, Evangelists, Moses, the dove of the Holy Spirit and the Agnus Dei.

Outside the confines of the book printed pictures of a religious nature were treated with caution by printing presses because of their traditional and popular use as aids to devotion. In the Elizabethan period the histories of St Paul, Joseph and the Prodigal Son were depicted in large engravings, while stories involving sacred characters were avoided. Nevertheless, subjects from the Gospels did appear in smaller wood-cuts in ballads. For stricter Protestants diagram-matic charts or 'tables' communicated religious doctrine or moral values without recourse to figurative imagery. Yet these tables were still essentially visual in nature, operating through the spatial arrangement of text in patterns and shapes.

Meanwhile, new iconographies developed that gave Protestantism a popular visual iden-tity, which included propagandistic prints of Protestant leaders, as well as anti-Catholic allegories. These trends are combined in a wood-cut of c.1550 showing Luther fighting the Pope with a pen (fig.142). Anti-papal satire circulated alongside prints celebrating 'deliverances' from Catholic plots. The persecutions and martyr-doms of Protestant heroes are illustrated in horrifying detail in Foxe's *Book of Martyrs* printed in numerous editions from 1563. While this influential book created a new cult of Protestant martyrology, the iconography and emotive force of the illustrations depended on the visual tradition of medieval hagiography.

A new iconography of Protestant kingship was articulated in illustrated title pages to English Bibles. In the *Coverdale Bible* (1535) Henry VIII shares the same pictorial space as holy characters, reflecting his new spiritual

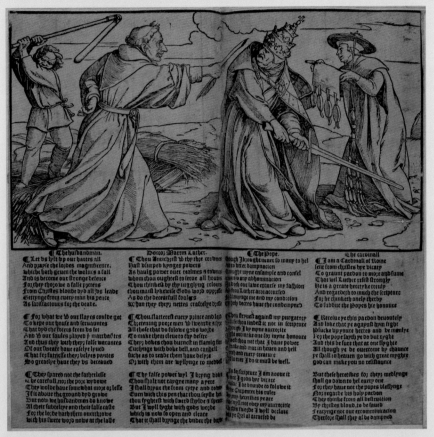

142 Luther fighting with the Pope, from *The Ballad of Luther, the Pope, a Cardinal and a Husbandman*, c.1550
The Pepys Library, Magdalene College, Cambridge

authority. In the Bishops' Bible (1569 edition) the sole authority illustrated on the title page is Elizabeth I, crowned by the cardinal virtues. The image of the queen as icon of Protestant nation-hood was elaborated further after her death by commemorative engravings after her later portraits, and of her newly erected tomb. Prints also extended the death ritual of fallen Protestant heroes such as Philip Sidney (d.1586) and Henry, Prince of Wales (d.1612).

In a domestic context prints were displayed above chimney pieces or on the wall. Images in print also adorned the home at one remove, serving as a source of design and iconography for the applied and decorative arts. Narrative scenes, figures and texts in print were copied for images in wall painting, plaster, carved wood and stone, and painted cloths and embroidery. The range of prints employed encompassed crude woodcuts and fine Continental engravings.

One extensively plundered source was the *Thesaurus Sacrarum Historiarum Veteris Testamenti*, a set of engravings of Old Testament scenes published in Antwerp in 1585. The extensive borrowings from this and other printed material indicates the extent to which the visual culture of post-Reformation Britain depended on the printed image.

FURTHER READING

E. Duffy, *The Stripping of the Altars: Traditional Religion in England c.1400–c.1580*, New Haven and London 1992.

T. Watt, *Cheap Print and Popular Piety, 1550–1640*, Cambridge 1991.

T. Watt, 'Piety in the Pedlar's Pack: Continuity and Change, 1578–1630', in P. Marshall (ed.), *The Impact of the English Reformation 1500–1640*, London 1997, pp.308–42.

A. Wells-Cole, *Art and Decoration in Elizabethan and Jacobean England: The Influence of Continental Prints 1558–1625*, New Haven and London 1997.

Hardwick Hall

NICHOLAS COOPER

Hardwick Hall, in Derbyshire, comprises two separate buildings, the Old Hall and the New, both built by Elizabeth, Countess of Shrewsbury, or 'Bess of Hardwick' (1527–1608). The two were intended to function together. The Old, greatly enlarged by her between 1587 and 1596, provides accommodation for a large, aristocratic house-hold. The separate New Hall, designed by Robert Smythson (1535–1614) and built between 1590 and 1598, essentially comprises two large suites of high-status lodgings on separate floors (fig.144).

Both the form and the function of the New Hall have earlier precedents. Self-contained residential towers for owners or guests occurred at the castles of Tattershall (Lincolnshire; c.1440), Raglan (Monmouthshire; c.1460) and elsewhere, and in the late fifteenth century at the royal palace of Richmond (Surrey). The silhouette of the New Hall, with six projecting towers rising above the roof line, shares with several late sixteenth-century houses a romantic evocation of older chivalric models. However, the model of the lodging tower also allowed the external appearance of the New Hall, symmetrical on two axes, to reject traditional 'high'/'low',

front/back hierarchies. Such bi-axial symmetry had been prefigured at Longleat (Wiltshire; c.1580) and already partially adopted by Smythson at Wollaton (Nottinghamshire), but it is perfected at Hardwick. The accommodation of the bulk of the household in the Old Hall also enabled the plan of the New Hall to reject hierarchical practice in that the hall runs through the house from front to back (rather than laterally between 'low' and 'high' ends), an arrangement without precedent save in hunting lodges where, similarly, there was less need to respect conventional arrangements for the accommodation of a large household graded by rank. In other details also, notably in the expanse of glass in its famous windows, the New Hall is wholly modern.

The ground floor of the New Hall is mainly given over to service functions. The first floor contains Bess's own suite of rooms, comprising great chamber, withdrawing room, bedchamber and closet, with a further room for attendants or for informal dining. The second floor, reached by a ceremonial, straight flight of stairs – itself virtually unprecedented – contains great chamber, withdrawing room, state bedchamber, closet, inner bed chamber and long gallery

(fig.143). The completeness of the provision, its scale and magnificence strongly suggest that these rooms were meant for use by royalty.

The intention of Bess of Hardwick in building so remarkable a house has been much debated, and remains speculative. It is unlikely that she expected a visit by Queen Elizabeth, who was already fifty-seven when the house was begun. However, it is clear that Bess had strong dynastic ambitions, in which she typified contemporary concern with ancestry and family honour in an age of social flux. Four times married, by her second husband, William Cavendish, Bess had six children, and her second daughter was married to Charles Stuart, Earl of Lennox, grandson of Henry VIII's sister, Margaret Tudor. When the New Hall was begun, circumstances could be foreseen in which Lennox's daughter, Arabella, might succeed to the English throne, having inherited a claim through her father. Although Hardwick was destined for Bess's second son, also William Cavendish, it could be expected that Arabella, as queen, might visit the house on progress and make use of the royal apartments. In the event Arabella's star waned during the last ten years of Queen Elizabeth's

143 The long gallery, retaining original tapesteries and portraits on the walls

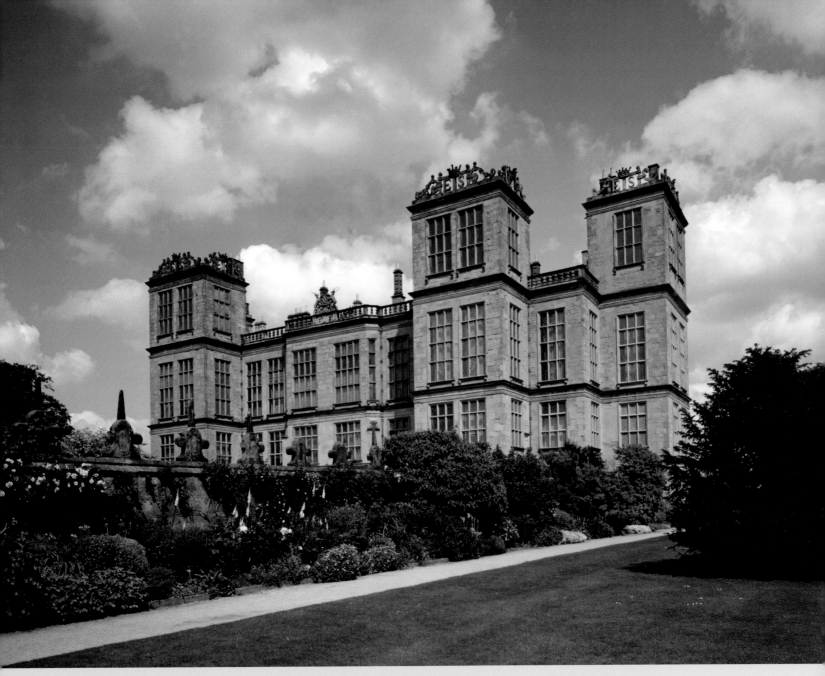

144 The New Hall, begun 1590

life, as that of James VI of Scotland (1567–1625) correspondingly rose. Earlier, as Countess of Shrewsbury (by her fourth marriage), Bess had housed James's mother Mary Queen of Scots, and Bess may not have abandoned hopes that the house would be honoured with a royal visit through family connections. Portraits of Scottish royalty are prominent among the pictures listed in an inventory of 1601.

Dynastic concern is also evident in the heraldic decoration of the house, in which the stag supporters of the Hardwick coat of arms and the stags' heads on the Cavendish shield are prominent. The frieze in the High Great Chamber, perhaps the finest surviving example of contemporary, naturalistic, relief plaster-work, appears to show the goddess Diana with stags and other beasts in a forest and can be similarly interpreted as an allegory, drawing

a parallel between the virgin Queen Elizabeth and the virgin goddess by whom the stags are protected and ruled.

The furnishings of both New and Old Halls are described in considerable detail in the 1601 inventory. The use of textiles is particularly notable, and the house still contains a number of large and important tapestries and embroi-deries listed at that date, together with other items of contemporary state furniture.

FURTHER READING

D.N. Durant and P. Riden, 'The Building of Hardwick Hall', *Derbyshire Record Society*, IV, 1980 ('The Old Hall, 1587–91'); IX, 1984 ('The New Hall, 1591–98').

M. Girouard, *Robert Smythson and the Elizabethan Country House*, New Haven and London 1983.

M. Girouard, *Guide to Hardwick Hall*, London 1989.

The National Trust, *Of Household Stuff: The 1601 Inventories of Bess of Hardwick*, London 2001.

No.

Cambridge Camden Society.

The Society trusts that its Members, while pursuing their Antiquarian researches, will never forget the respect due to the sacred character of the edifices which they visit.

Date. *Name of Visitor.*

Dedication. Diocese.
Parish. Archdeaconry.
County. Deanery.

I. Ground Plan.

1. Length ⎱ of Chancel ⎰ ⎰ Nave ⎰ ⎰ Aisles ⎰ ⎰
2. Breadth ⎰ ⎱ ⎱ ⎱ ⎰ ⎰

 Transepts ⎰ ⎰ Tower ⎰ ⎰ Chapel ⎰ ⎰

3. Orientation.

II. Interior.

I. Chancel.
 1. East Window.
 2. Window Arch.
 3. Altar.
 α. Altar Stone, fixed or removed.
 β. Reredos.
 γ. Piscina.
 (1) Orifice.
 (2) Shelf.
 δ. Sedilia.
 ε. Aumbrye.
 ζ. Niches.
 η. Brackets.
 θ. Easter Sepulchre.
 ι. Altar Candlesticks.
 κ. Altar Rails.
 λ. Table.
 μ. Steps—number and arrangement.
 4. Apse.
 5. Windows, N.
 S.
 6. Window Arches, N.
 S.
 7. Piers, N.
 S.
 8. Pier Arches, N.
 S.
 9. Chancel Arch.
 10. Stalls and Misereres.
 11. Chancel Seats, exterior or interior.
 12. Elevation of Chancel.
 13. Corbels.
 14. Roof and Groining.
II. North Chancel Aisle.
 1. Windows, E.
 N.
 W.
 2. Roof and Groining.
III. South Chancel Aisle.
 1. Windows, E.
 S.
 W.
 2. Roof and Groining.
IV. North Transept.
 1. Windows, E.
 N.
 W.
 2. Transept Arch.
 3. Roof and Groining.
V. South Transept.
 1. Windows, E.
 S.
 W.
 2. Transept Arch.
 3. Roof and Groining.
VI. Lantern.
 1. Windows.
 2. Groining.
VII. Nave.
 1. Nave Arch.
 2. Panelling above Nave Arch.

9 Perceptions of British Medieval Art

ALEXANDRINA BUCHANAN

ON 16 OCTOBER 1834 the medieval Palace of Westminster, the customary seat of the Houses of Parliament, was destroyed by an enormous fire. According to legend, the heating system had burned out of control when wooden tally sticks, the medieval system of Exchequer receipts which had only fallen from use in 1826, were used as fuel. The disaster dominated the headlines; alternately claimed as divine retribution for recent parliamentary reforms or the sweeping away of the physical remnants of the corrupt old order. When the time came to rebuild, however, the Royal Commission appointed to make decisions shrank from a radical solution. The new building was required to be on the historic site and in a Gothic (or Elizabethan) style. It was to evoke a royal palace, reproducing a symbolic system that gave primacy to the Crown and historic associations. The Perpendicular style of medieval architecture adopted by Charles Barry (1795–1860), the winning designer, recalled the surviving Westminster Hall and the adjacent chapel of Henry VII at the east end of Westminster Abbey (fig.145). Yet behind Barry's carved portcullises and bristling pinnacles was hidden a modern building, with state-of-the-art heating and ventilation systems and a fireproof iron roof. There could be no more potent symbol of the Janus nature of nineteenth-century Britain, its forward-looking face hidden behind a medieval mask.

The decision to rebuild in a Gothic style was an intensely political one, rejecting modernity for tradition and classical references for a style believed by many to have originated in England. It also aroused deep controversy, akin to today's debates over modernist architecture. Throughout the past four centuries, responses to British medieval art have been as polarized as today's views on Brutalism, ranging from ridicule to fascination, from emulation to scholarly study. It is thus virtually impossible for modern viewers to see the art of the period c.600– c.1600 afresh, stripped of the interpretative overlay of subsequent centuries. 'Medieval' remains a journalistic byword for barbarous, and the history of the Middle Ages seems foreign, yet at the same time it encompasses the foundation of the institutions that define Britain as a nation: Parliament, the monarchy, systems of local government, judicial procedure and

constitutional freedoms. For this reason the study of the medieval past, including its art, has often gone hand in hand with debates over present politics. This chapter aims to provide an outline of the interpretations of medieval art offered by past scholarship, in order to provide a context for the contributions of the other authors in this volume.

Taste and Scholarship

In the Middle Ages people were not blind to history and contemporary observers were certainly aware of differences between their own period and earlier ages, differences that extended to artistic products. This essay will nevertheless begin at the end of our period, when the Middle Ages were both identified and characterized. From the fourteenth century, in Italy, scholars and their patrons increasingly began to view their own age as a rebirth of classical antiquity and the years after the Fall of Rome (AD476) as an interruption. Rome had fallen to tribes of barbarians from north of the Alps, including the Goths, whose name became associated with post-classical art and literature. 'Gothic' became a term of abuse for all works that did not obey the rules that the Greeks and Romans were believed to have followed.[1] In Britain the break with the medieval past was not a single event but a series of ruptures occurring over a period of at least a century (see Howard on the Reformation, pp.232–40). It was not until the early seventeenth century that artists and patrons in England began to disparage the art and architecture of the Middle Ages for its style, as well as its iconography. The disfavour shown towards Gothic art was never absolute, however, especially because its products were associated with 'great men' of history. England, and still less the rest of Britain, had comparatively little to show for its Roman antiquity and so those interested in constructing a heroic past had to look to the Anglo-Saxon and medieval periods for physical remains.

Until the nineteenth century medieval art was rarely defined in aesthetic terms, except to draw a contrast with

145 View of the Palace of
Westminster (designed by Charles
Barry and A.W.N. Pugin, built 1837–67)
from the buttresses of Henry VII's
Chapel, Westminster Abbey, London

the works of classical antiquity or those modern works that
aimed to revive antique styles. Instead, those interested in
medieval art and architecture viewed artefacts and build-
ings as the tangible relics of history, sources for a mode of
scholarship usually described as antiquarianism.[2] At a time
when only the Greek and Roman past as told by classical
authors formed the subject of 'history', the antiquarians
of the seventeenth and eighteenth centuries studied the
British past and the evidence provided by material objects
rather than texts. Antiquarians were usually derided by
aesthetes, but during the eighteenth century the arbiters
of taste became increasingly aware of the diversity of
aesthetic values. Philosophers suggested that works could
be valued according to their sublime or picturesque quali-
ties and the nobility of the sentiments they evoked in the
mind of the beholder, as well as by the norms of classical
beauty.[3] This aesthetic pluralism made it possible for
medieval artefacts and buildings to be accepted as art,
and brought a wider audience for antiquarian scholarship,
as modern artists such as Henry Fuseli (1741–1825) and

William Blake (1757–1827) began to seek inspiration in
medieval, particularly Gothic, forms (see fig.146).[4] Writers,
too, began to explore medieval themes and the 'Gothic
novel' was born.[5]

Nineteenth-century scholars served the revival of Gothic
architecture (a style now considered to date from the mid-
twelfth to the mid-sixteenth centuries) through a search
for its original principles, in the hope that these could be
resuscitated. Authors and audiences were as concerned
with the present state of artistic production (and society)
as with the medieval world. The Gothic style, in particular,
came to represent a counterpoint to the perceived prob-
lems of modernity, although, ironically, medievalizing
architecture became very popular for new building types,
such as railway stations, municipal buildings and indus-
trial structures. In line with the contemporary passion for
categorization, medieval architecture was classified into
periods, and its forms justified by a-priori systems such as
symbolism or structural logic, that often had moral over-
tones. Meanwhile, traditional antiquarian interpretations

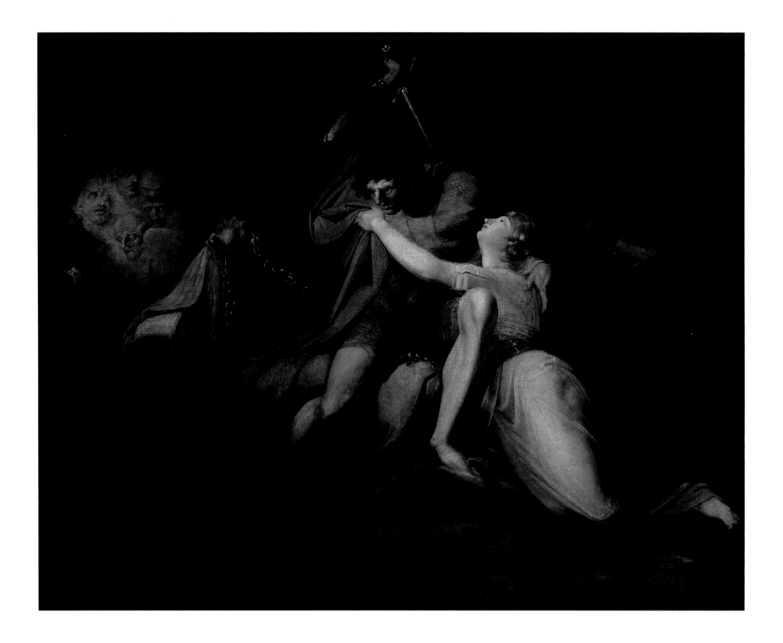

were joined by the new academic discipline of art history, which originated in nineteenth-century Germany,[6] although the *École des Chartes* in Paris (founded 1821) also became an important centre for the study of medieval art and architecture. Despite the advanced state of medieval scholarship in Britain, the discipline was slower to acquire an academic footing, the first professor of art history being the early medievalist Gerard Baldwin Brown (1849–1932), appointed to the Watson-Gordon Chair of Fine Art at the University of Edinburgh in 1880.[7]

The foundation of the Courtauld Institute of Art in 1932 and the 1934 transfer of the Warburg Institute from Hamburg to London represented a new beginning in the academic study of art history in Britain. Both institutions included prominent scholars specializing in medieval art and architecture. Although the Courtauld was wholly English in origin, in Germany art history had been institutionalized as an academic discipline sooner and more thoroughly than in other countries, and its methods thus came to be seen as more advanced and rigorous. The Germanic

notion of style spread to other countries in the early twentieth century, a process given additional impetus when many Continental art historians (like those of the Warburg) escaped from the Nazis to England and America.[8] Through the preoccupations of émigré scholars like Nikolaus Pevsner (1902–83) post-war scholarship in English thus acquired an interest in 'space' as an architectural category and an elevated sense of the importance of art as a means of recognizing historical change in action, a diagnostic tool for interpreting the characteristics of an age, or a people, in every aspect. Academic art history was more interested in the explanation of artistic change than previous models of scholarship – specifically antiquarianism – had been, meaning that the study of medieval art in the twentieth century has been characterized primarily by a search for influences. In addition, and surely related to the interest shown by modern artists in 'primitive' art, art historians became increasingly interested in the pre-Gothic styles, which their nineteenth-century forebears had tended to shun. As art history became established as a discipline, so, too, did archaeology, whose discoveries could be of great importance. For medievalists the 1939 discovery of the ship burial at Sutton Hoo in particular completely transformed the picture of Anglo-Saxon art (see Hawkes, pp.44–5).[9]

The 1960s and 1970s saw the establishment of art history and archaeology departments in the new universities and polytechnics, providing jobs for a number of medievalists. This expansion coincided with the development of the 'New Art History', a radical mode situating itself in opposition to the formalistic connoisseurship associated with older departments.[10] American medieval studies, with its interdisciplinary ideal and focus on literary scholarship, was quicker to adopt the new approach, which thus affected transatlantic art and architectural historians sooner than medievalists in British departments.[11] There in particular, feminist scholarship and queer theory have inflected readings of medieval imagery, and some medievalists have found inspiration in the critiques of the Western (predominantly post-medieval) canon typified by Edward Said's *Orientalism* (1978). Nevertheless, more traditional scholars have not been unaffected by changing methods, arguing (though rarely on record) that their customary stress on historical context had made the 'antiquarianism' of British medieval art and architectural historians interdisciplinary (if not radical) already. Controversies aroused by social readings of art have been particularly heated in

the more public arena of museums, which, along with manuscript collections in libraries, had long been important *loci* of medieval research and continue to exert an influence. A succession of major exhibitions of British medieval art has done much to stimulate research.[12] Nostalgics may wallow in the chivalric and pious image peddled by the heritage industry, whilst the more adventurous relish the 'dungeons and dragons' mystery of a vision owing more to Gothic novels and horror films than the Middle Ages conjured up by historians, but these exhibitions prove that the public appetite for the period remains as strong as ever.

Chronologies and Geographies

Antiquarian studies of medieval art and architecture were and are particularly concerned with classification by appearance and historical period. John Aubrey (1626–97), a member of the scholarly Royal Society, which promoted empirical research into all areas of knowledge, recognized that buildings erected in the same era tended to resemble each other.[13] From this observation arose an awareness of period style, which could be used for dating purposes. Such knowledge was important because many buildings were inadequately documented, and Anglican scholars were unsympathetic towards medieval chronicles, written by monks and filled with 'popish' miracles. The first distinction to be made was that between the 'Ancient' or 'Saxon' style, characterized by the round arch, and the 'Modern' or 'Gothic' style, distinguished by the pointed form.[14] The round arch was known in Ancient Rome (hence the early nineteenth-century label 'Romanesque'), but the typical eighteenth-century search for origins gave birth to a wide variety of suggestions for the source of Gothic.[15]

By 1817 awareness of style as a diagnostic tool was sufficiently developed for Thomas Rickman (1776–1841) to write a handbook that popularized the names of the styles of architecture still familiar today: Norman, Early English, Decorated and Perpendicular.[16] As an aspiring architect, he aimed less to establish an art-historical methodology than to educate potential patrons, at a time when church building was being heavily supported by both state and private funds. Rickman also attempted to differentiate between Saxon and Norman architecture,

147 Installation view of the exhibition
Gothic: Art for England, held at the
Victoria and Albert Museum, London
in 2003–4

both of which were associated with round arches and had often been confused. Rickman's method of classification by the close visual analysis of different elements was enormously influential and came to shape the study of virtually every other medieval art form. Even today, the medievalist art historian is expected to have a keen awareness of the typical characteristics of an art form at a given period, in order to ascertain its date in the absence of external evidence.[17]

The study of style is often associated with art-historical methods developed in Germany, usually known as formalism, and in particular with the philosophical concept of the *Zeitgeist*, or 'spirit of the age', which was believed to affect every aspect of the period in question. In Britain an awareness of style had developed independently, for more practical purposes, but British scholars were not unaware of their German counterparts: William Whewell (1794–1866), the first to define an area of research as 'architectural history', was deeply influenced by German Idealist philosophy, as was his younger friend, John Ruskin (1819–1900), whose books probably brought an appreciation of medieval art before a wider audience than any other writer before or since. Nevertheless, it may have been a discomfort with the Continental notion of style that led many twentieth-century writers on British art to prefer the term 'period'. This resulted in some rather strange usages, such as the 'East Anglian Period' for early fourteenth-century painting, whose characteristic products have been identified as a group of manuscripts associated with East Anglia (see Panayotova, pp.228–9).[18] Manuscript illumination (and, to a lesser extent, seals) inevitably provided the key to period styles in the figurative arts, as most larger paintings and sculpture in Britain have been lost to iconoclasm.

The predominant focus on period style throughout the nineteenth century, and well into the twentieth, meant that awareness of regional style was slower to develop. When scholarly research on medieval architecture began, it was widely, though wrongly, believed that the Gothic style originated in England, or that its native development was independent of Continental influence.[19] As nineteenth-century scholars came to see that the various medieval styles shared commonalities throughout Europe, the focus on dating and universal principles made local variations appear as signs of infant or decadent art forms, rather than the product of deliberate aesthetic choices. Twentieth-century scholars, with their focus on 'influences', were more ready to admit international transfer of artistic ideas and the conscious use of particular motifs. A standard feature of many mid-century textbooks was a diagram depicting influences as arrows across a map. Nevertheless, interest in what was most 'advanced', later characterized as 'Court Art', tended to discourage research into local styles, except as part of the study of 'schools' (see below, p.258). Local researches tended to be channelled into topographical guides to architecture and sculpture, of which *The Buildings of England* series, initiated by Nikolaus Pevsner in 1951, was the most rigorous.[20]

During the late nineteenth and early twentieth centuries nationalism pervaded scholarship, and art of all periods was often viewed as the product of unchanging racial characteristics. A series of international exhibitions held in the 1920s and 1930s displayed art of all periods from a single country as a demonstration of diachronic stylistic tendencies.[21] The English love of line, visible in art from Anglo-Saxon manuscripts to William Hogarth (1697–1764), was deemed one such national proclivity. The devastating effects of nationalist ideologies in the Second World War have made later twentieth-century scholarship less open to racial explanations and isolationist categorizations, although the regionalist tendencies of recent politics have encouraged the study of the arts of Wales, Scotland and Ireland separately from those of England (see Geddes, p.20). In contrast to the exhibition of 'Native Primitives' held at the Royal Academy in 1923, whose stated aim was to identify works by English artists, the 2003–4 show *Gothic: Art for England* was specifically English in focus but admitted art known to have been made abroad, or works made in England by foreign artists, in order to explore a society that we now interpret as pluralist in its artistic consumption (fig.147).

Iconography and Function

Earlier in this volume we saw how the religious changes of the sixteenth century resulted in the destruction of vast quantities of art objects. Those sacred artefacts and buildings that survived did so because their original meanings could be suppressed or transformed to fit with the requirements of a reformed faith (see Howard, p.239). Within little more than a generation the richly symbolic language of

148 The Bridge at Crowland, Lincolnshire, with carved figure dating from the late 14th century, once believed by locals to be Oliver Cromwell

medieval religious art, discussed by Jennifer O'Reilly in chapter 6 (pp.175–97), had been rendered meaningless to all but the few who retained a sympathy for the old faith. Secular items had a better survival rate but later fell foul of changing lifestyles and fashions, whilst medieval buildings with a military function were either abandoned gradually or despoiled during the civil wars of the seventeenth century (see Goodall, p.116).

Some of the more prominent survivals acquired new meanings that rang true to the popular imagination. For example, a statue on the famous triangular bridge at Crowland in Lincolnshire was believed by villagers to represent Oliver Cromwell (1599–1658), a local benefactor (fig.148).[22] John Carter (1748–1817), an antiquary writing in the decades around 1800 and a convert to Roman Catholicism, was impatient with such explanations.[23] In their quest for origins he and his contemporaries had begun to search for the initial meanings of medieval imagery. However, their Enlightenment sympathies had little taste for medieval legends, whilst the sensibility of a predominantly Protestant culture was more accustomed to secular portraiture than sacred art. The medieval practice of depicting sacred events within contemporary settings encouraged the interpretation of these images as documents of medieval society, almost as windows on the past. Horace Walpole (1717–97), an early collector and apologist for medieval art, concentrated his researches on images of historical personalities, even identifying figures of saints as characters from medieval English history.[24]

The scholars most attuned to the predominantly religious subject matter of medieval art were Catholic in creed or sympathy. Most famous of these was Augustus Welby Northmore Pugin (1812–52), an architect perhaps best known for his manifestos, which represented a clarion call to Gothic. Possibly his most famous work, *The True Principles of Pointed or Christian Architecture* (1841), by its very title represents in almost parodic form the tendencies of the nineteenth century to search for laws and to justify them in moral terms. Nor was his voice heard predominantly by Roman Catholics. In the mid-nineteenth century the religious campaign known as the Oxford Movement sought to restore to Anglicanism aspects of its Catholic heritage.[25] An offshoot of this movement became particularly interested in the liturgy of the pre-Reformation Church and in its buildings and artefacts.[26] The study of such subjects was termed 'ecclesiology' and its proponents

were immensely influential, both on the design of new churches and on the restoration and refurnishing of old ones. Thus for many in the nineteenth century, both supporters and opponents, the Gothic Revival was equally a Catholic Revival.[27] However, Gothic alone was seen as fully embodying the principles of Christianity and there was less sympathy for earlier styles such as the Anglo-Saxon or Romanesque. Nor, despite general approval for Gothic architecture and a new interest in medieval art forms such as illumination, metalwork and stained glass, was there much enthusiasm for reviving the styles of medieval figurative art.[28] The nineteenth century, with its progressive temper, could see little charm in what were viewed as the crude and clumsy forms of medieval draughtsmanship, preferring instead to reinterpret its more acceptable aspects (such as coloration and ornamentalism) in the light of post-Renaissance naturalism. That the group of artists most influenced by medieval art was known as the Pre-Raphaelite Brotherhood gives some idea of the period's comparatively late, and Italianate, bias.

Although the ecclesiologists expressed preferences for certain styles and periods, they were less interested in dating than in function and symbolism. It is to their

149 Report of the Cambridge Camden
Society for 1841, with a checklist of
features of interest to be noted in
churches
British Library, London

'Christian archaeology', a discourse with Continental counterparts, that we owe the identification of the different functional elements within a church: the *sedilia* and *piscina*, the stoups and banner stave lockers. The Cambridge Camden (later the Ecclesiological) Society, founded in 1839, issued checklists of features to be noted, veritable 'I-Spy' lists for churches (fig.149), which turned visiting churches into the popular leisure-time pursuit it remains today. They also viewed buildings in terms of their liturgical functions, noting the location of altars, screens and processional routes. Christian archaeology throughout Europe was equally fascinated by iconography and the first dictionary of Christian iconography was written by a French Catholic Revivalist, Adolphe-Napoléon Didron (1806–67).[29]

Nor was Protestantism a bar to iconographical interpretation. Chapter four of Ruskin's treatise, *The Bible of Amiens* (1885), viewed the great French cathedral as the expression of the essential tenets of Christianity.[30] Increasingly, however, the study of iconography became analogous to the study of any other language, meanings and etymology taking precedence over expression and context. For Émile Mâle (1862–1954), whose book on French Gothic, later published as *The Gothic Image*, was first translated into English in 1913 and remains a standard text, medieval imagery was the direct visual counterpart of medieval theology.[31] He was a staunch Roman Catholic, seeking to counter his compatriot Viollet-le-Duc's secular vision of the Gothic age (see below). For Mâle the correspondence between text and image was exact; there was no possibility that the visual could, through its particular medium, perform a different function or carry an alternative message. The only possibility he allowed was that it could speak to different audiences, following the famous defence of art by Pope Gregory the Great (c.540–604), who justified art as the book of the illiterate. In Britain Mâle's method found its counterpart in the works of Montague Rhodes James (1862–1936), for whom the immensely scholarly task of identifying the subject matter of a work of art and providing its textual source was deemed sufficient as an interpretation.[32] This may perhaps be explained by his role in relation to the works of art he studied: he concentrated on cataloguing individual collections of illuminated manuscripts. Content was therefore paramount and each item was valued for its status as a unique work of art, rather than for its position in a wider context, either

within the development of art or in relation to history. Moreover, Germanic art history, which was becoming known in England during James's lifetime, aestheticized its objects of study, thereby stripping them of alternative meanings. The metaphysical 'will to form', which propelled the development of style, took little account of functional requirements, whether practical or symbolic. Those modern art historians who continue to see their subject as the study of the history of forms argue that forms may change independently of functions, or vice versa, but the strength of the antiquarian tradition in Britain has meant that within medieval art history, formalism has never wholly prevailed.[33]

An alternative Germanic tradition which was of greater significance to native medievalism, was that associated with the Warburg Institute. Its members were welcomed in particular by Francis Wormald (1904–72), then a manuscript curator at the British Museum.[34] Wormald's introduction to medieval art had come from late-Victorian ecclesiology and he was therefore very open to an approach that linked iconographical motifs with intellectual history, a method termed by his friend Erwin Panofsky (1892–1968) 'iconology'.[35] Panofsky's famous *Gothic Architecture and Scholasticism* (given as a lecture in 1948 and published in 1951) referred primarily to French Gothic, but a similar method was used by Paul Frankl (1878–1962), another German émigré, in his interpretation of the vaults of Lincoln Cathedral (see Coldstream, pp.72–3) as the expression of the scholastic philosophy of its thirteenth-century bishop, Robert Grosseteste (c.1170–1253).[36] Iconological interpretations rarely sought evidence for the transmission of ideas between theologians and artisans, nor was iconography linked directly with function. It is doubtless relevant that many of the great mid-twentieth-century scholars were secular in outlook and reacted against their predecessors' overwhelmingly religious interests. In the late twentieth century, however, scholars have returned to spiritual readings, seeking to understand medieval sacred artefacts and buildings not primarily as expressions of pure aesthetic forms but as items whose purpose was fundamentally devotional.[37] The influences they therefore pursue are less stylistic than functional and iconography is thereby related to purpose. Similar approaches have also been applied to secular art and architecture.

Patronage

In medieval texts, particularly chronicles, works of art were usually mentioned only as examples of the pious works of the 'great men' (they were, almost invariably, male) who commissioned them (see Luxford, p.92). Antiquarian writers often followed this model, both as an echo of their sources and a spur to similar acts of generosity amongst their readers. In a society in which a distinguished ancestry brought status, medieval art, with its use of heraldry and commemoration of donors, could provide a valuable genealogical record. This interest directed research towards tombs and stained glass well into the nineteenth century, especially as an edict by Elizabeth I forbidding attacks on tombs meant that these provided the best-surviving examples of medieval sculpture.

Until the nineteenth century the relationship between patron and artwork was seen in primarily moral terms: the character of the commissioner was not seen as directing the detailed appearance of the work, nor was the work interrogated as a representation of the identity of the patron. The notion of a paradigmatic progression of style, according to which all works of a given period should use a shared vocabulary of forms, was resistant to the possibility of style as a conscious expression of non-artistic values. It was axiomatic that, whilst the nineteenth century used a variety of styles for their associative meanings (Gothic for churches, classicism for civic buildings, Italianate for commercial buildings and so forth), the medieval designer could only work in the style of his own age. The character of the age could have a bearing on its style: the nineteenth-century French apologist for Gothic, Eugène Viollet-le-Duc (1814–79), for example, saw the Romanesque as the product of the age of monasteries, whilst the Gothic cathedral was a product of a more secular age, dominated by towns and commerce. Yet, as the study of stylistic variation became more subtle, there came the recognition that, within a single period, some works were 'advanced' and others 'retrograde', and also that stylistic variations could be associated with patronage. Late nineteenth-century German manuscript scholars in particular, with a nationalistic interest in art of the period of Charlemagne, the first Holy Roman Emperor (800–14), sought to identify works associated with his court and also with the scriptoria of the great monasteries of the day.[38] They derived their attributions from textual evidence, but extended these to identify shared visual tropes.

'Advanced' art forms were often associated with the court, often on little external evidence, but on the assumption that only royalty was able to pay for the best artists and/or had the international connections necessary for importing foreign practitioners.[39] According to this argument, stylistic variation had a primarily economic basis. In terms of the order of Cistercian monks, however, their undoubted wealth was accompanied by a peculiarly austere form of Gothic, deliberately chosen to advertise the reformed character of their order. Here, style was apparently being used as a 'branding' device, expressing group identity in the same way in which architectural style was used in the Board Schools or Peabody housing estates of nineteenth-century London. Cistercian architecture became a topic of international interest in the years around 1900, as the observation seemed to hold true of the Order's foundations throughout Europe. Scholarship breeds scholarship and the fascination with Cistercian patronage has remained strong to the present, doubtless helped by the appeal of the minimalist buildings to modernist sensibilities.[40] Despite ongoing debates over the extent to which medieval patrons would have been able to convey their requirements to their artificers, the notion of art as expressing the group or individual identity of the commissioning agent came to be of great interest.[41] Concepts such as Cluniac art (associated with the lushness of Late Romanesque) and the Episcopal style (connecting thirteenth-century reformist bishops with a form of the Early English style) were invoked to explain artistic variety and stylistic development.[42]

For scholars in the 1980s, schooled by the New Art History to be wary of grand narratives and alert to more historically inflected readings, relationships between patrons and art provided a particularly fertile subject.[4] For the first time, audiences were invoked as an important element in the construction of a work's meanings. More than most periods, the Middle Ages had tended to be romanticized as an era of harmonious social relations, when each stratum of the hierarchy knew its place. Inspired by radical research in other disciplines, even medievalists came to accept the possibility of art being an agent within social conflicts. The field most amenable to politicized readings seemed to be the grotesque and comic imagery common in secondary locations, and often called marginalia from its position in the margins of illuminated manuscripts. In the eighteenth and nineteenth centuries researchers had concentrated on the scenes that could be interpreted as illustrations of contemporary life, dismissing the monsters as evidence of the barbarity of the medieval mind.[44] The frequent occurrence of sexual imagery merely confirmed Protestant polemics against the pre-Reformation Church. Twentieth-century iconographers began to search for sources in secular texts and influences from other art forms, notably prints, as a source for misericords (see Lindley, p.160, figs.87–8) in order that previously hidden meanings could be read.[45] The discipline of semiotics (the study of signs), developed in the 1950s and 1960s, was compatible with traditional iconographical interests and it is notable that the well-known semiotician and novelist Umberto Eco started his scholarly career as a medieval art historian.[46] With the New Art History's introduction of anthropology as a methodological influence, scholars such as Michael Camille (1958–2002) began to read such imagery not literally, but as a continuous carnival of legitimized dissent (see Mills, pp.224–5).

Production

The earliest texts that may be read as art historical, such as *Lives of the Artists* (first published in Italian in 1550) by Giorgio Vasari (1511–74), identified the artist as the key to interpreting the artwork. This represented a problem to those interested in medieval art, whose makers were usually unknown to posterity because biographical information was of less interest to the Middle Ages than it became in the Renaissance. In the eighteenth century Walpole and his contemporaries made some efforts to try to discover names of artists, and when they were known, they were celebrated in the same terms as any post-medieval designer.[47] For example, in his paean to Strasbourg Cathedral, *Von Deutsche Baukunst* (On German Architecture) (1773), the German writer Johann Wolfgang von Goethe (1749–1832) praised as a genius Erwin von Steinbach, whom he had identified as the architect.[48] Some nineteenth-century moralists, however, believed that the silence of the majority of sources on the subject of artistic identity was the deliberate choice of the modest medieval craftsmen. Condemning the post-Renaissance cult of the artist, who overshadowed the importance of his subject matter, these writers saw in the medieval system a pious

anonymity in which the personality of the craftsman was not allowed to detract from his sacred subject matter.

The character of the makers was nevertheless the topic of much speculation. Thomas Hope (1769–1831) wrote of bands of freemasons, directed by the pope, which accounted for the similarity of medieval architecture throughout Europe.[49] William of Wykeham, Bishop of Winchester (1366–1404), known from documents to have overseen building works, became the archetype of the clerical architect, a role guaranteed to appeal to ecclesiologically minded clergymen.[50] He thus appears on the Albert Memorial and the fronts of the Royal Academy and the Victoria and Albert Museum (fig.150). Likewise, illuminators were usually believed to be monks, evidenced by the portraits of Eadwine (Prince of Scribes), Matthew Paris and Siferwas, all monastic artists whose names and books were known from the early nineteenth century (see Lindley, pp.143–5, 152). Although little was known of the circumstances of medieval production, this did not prevent speculation on the subject, indeed it rather encouraged it. In one of the most celebrated chapters in *The Stones of Venice* (3 vols., 1851–3) Ruskin wrote of 'The Nature of Gothic', arguing that the style derived from the unfettered imagination of the workman. Rarely has a text had such influence on architects disillusioned, as Ruskin was, by the deskilled workforce of industrial Britain.[51] The perceived failure of the revival of Gothic in the nineteenth century was attributed to the contemporary system of production, with the professionalized architect removed to a drawing office and the builder mindlessly following his directions, paid to do so with efficiency rather than artistry.

Meanwhile, in academic art history on the Continent, instead of celebrating artistic anonymity, researchers sought to tackle it as a problem. The Italian scholar Giovanni Morelli (1816–91) argued that by the examination of apparently insignificant details, the authorship of a work could be identified.[52] As a Renaissance specialist, Morelli normally attributed work to named artists. However, the method could also be used by medievalists to identify hands, who thus took on an artistic personality despite remaining unnamed. The technique of connoisseurial attribution was known in England from the late nineteenth century and was used by Sydney Cockerell (1867–1962) to identify the oeuvre of W[illiam] de Brailes, an Oxford illuminator (see Lindley, p.151, fig.83).[53] A later generation of manuscript scholars, including Francis Wormald, Charles Reginald Dodwell (1922–94) and Walter Fraser Oakeshott (1903–87), heavily influenced by Germanic manuscript studies, used the method to distinguish the hands of artists within individual manuscripts or manuscript groups, which were thus connected to particular 'Schools' (a term derived from the study of Old Master paintings). These artists were given names, such as 'The Master of the Leaping Figures' or 'The Master of the Apocrypha Drawings', responsible for different parts of the magnificent twelfth-century Winchester Bible (see Donovan, pp.68–9).[54] By analysing

150 William of Wykeham (*centre*),
detail of sculpted frieze on George
Gilbert Scott's Albert Memorial,
1854–76, Hyde Park, London

the stylistic tropes used by these artists, suggestions could be made about their careers: where they might have trained, what other works they might have known and where else they might have worked. Scholars were thus able to construct convincing theories about production methods, entirely without directly recorded evidence.

A contemporary of Sydney Cockerell, the architect William Richard Lethaby (1857–1931) was also interested in artistic identity. Although heavily influenced by Ruskin's socialism, he rejected the theory of the anonymous artisan, and instead used building accounts to discover the names of a number of masons, particularly those working on Westminster Abbey.[55] England's public records, originally the royal administrative papers, are second to none but were not very accessible until after the establishment of the Public Record Office in 1838 (now the National Archives). Lethaby's biographical interests were shared by John Hooper Harvey (1911–97), who combined documentary research with the connoisseurial methods of Morelli both to catalogue medieval architects and to construct their careers, using details such as moulding profiles and tracery designs (formerly used for dating) to distinguish their individual *oeuvres*, as well as their sources and influence.[56] Like Ruskin, although from an entirely different political standpoint, Harvey wished to hold up the Middle Ages as an ideal to which the present should aspire, with its buildings representing its highest and most symptomatic achievement. This approach, as well, no doubt, as his extreme nationalism, brought Harvey into direct conflict with Nikolaus Pevsner.[57] As a German-trained scholar, Pevsner identified with the formalist approach in its attempt to construct a 'history of art without names' – an ideal based on the approach of Heinrich Wölfflin (1864–1945) – and had a disdain for the 'individualism' of much Victorian architecture, which he related to the cult of the individual architect. Wanting to create for the modern world an anonymous architecture that would be attuned to the spirit of the age, he saw and idealized such a relationship in the Middle Ages. Although there is unease regarding Harvey's political interpretations, modern scholarship tends to admit that his equally idealized Middle Ages were, at least in terms of the architectural system he described, closer to what is known from the documentary evidence than Pevsner's (see Lindley, p.156–7).

Conclusion

The changing theoretical perspectives on medieval art are not merely the subject of academic curiosity. They have affected not only how the art of the Middle Ages has been viewed but also the material existence of the objects themselves. No English medieval art objects survive entirely in their original state, location and function: all have been subject to real physical changes, either in an attempt to defuse their potency (iconoclasm) or to perpetuate it to future generations (restoration). In an attempt to protect them, many pieces have been removed from their original location, divorcing them from the architectural or spatial context that was often essential to the work's original impact. Portable items are removed into museums, where they become the opening chapter in a narrative of which their makers would have been wholly unaware.[58] Medieval artists (unlike those of the Renaissance and later ages) had no concept of a gallery, where art objects would be gathered together for aesthetic enjoyment, nor did they prioritize painting over other art forms. Even in publications the illustrated art object tends to be isolated from its context, which is left out of the photographer's frame, destroying ensembles that are perceptually, if not conceptually, a unity. Yet it is the belief of the authors of this book that, however dark is the glass through which we see the Middle Ages, the view is nevertheless worth the effort. The glass is not a mirror, reflecting back only what we bring to it. Throughout its existence the medieval art of Britain has had the means to delight, surprise and even shock its viewers and interpreters. Despite the temporal distance of the age from our own, its surviving products retain their potency.

Notes

1 IDEAS AND IMAGES OF BRITAIN 600–1600 (pp.19–43)

1 McRoberts 1981.
2 Hay 1956–7, pp.55–66; MacColl 2006, pp.248–69; Pocock 1975, p.603.
3 MacCulloch 2003, p.xxvi.
4 Davies, N. 1999, pp.xxi–xlii, 151–531.
5 Ireland is excluded from *The History of the King's Works*, even though the Edwardian castles there were built by the same designers and paid for by the same Exchequer as those in Wales: Colvin 1963. In *The Age of Chivalry* catalogue, whereas Welsh castles are included, Ireland is not even shown on the map: Alexander and Binski 1987.
6 Davies, N. 1999, pp.342–4. William Marshall, Earl of Pembroke, founded Tintern Abbey (County Wexford), Ireland, named after Tintern Abbey, Wales; Henry III asked for Dublin Castle hall to be built 'with glazed windows after the hall of Canterbury': Stalley 1971, p.14. Buildings like Christchurch Cathedral, Dublin, produced innovative developments in the so-called Early English style: Stalley 1984, p.72.
7 'The Ruin', in Alexander, M. 1966, pp.30–1.
8 Kermode 1994.
9 Fernie 2000, pp.93–8, 208–19.
10 Henry and Zarnecki 1957–8, pp.1–34. Thurlby 1999, p.26. For instance, Oliver de Merlimond went on a pilgrimage to Compostela between about 1125 and 1130, bringing back ideas from western France to the churches of Herefordshire.
11 Holmes 1937, pp.78, 80.
12 Foister 2006.
13 Wilson, C. 1990; Karlsson 1988, I, pp.156–224; Zarnecki 1953, pp.34–8; Thurlby 1999.
14 Caldwell 2001, pp.267–82.
15 Hourihane 2003, pp.117–22.
16 Battiscombe 1956, p.68; Fordun 1993, pp.214–15.
17 Stalley 1971, pp.68–71.
18 Hourihane 2003, pp.79–81, 132. An image of St Patrick is identified by an inscription on the north portal of Clonmacnoise Cathedral; Harbison 1992, I, p.309.
19 British Library, London, Add. MS 54782. Lord 2003, 256–7.
20 Yeoman 1999, p.68, pl.12.
21 Pierpont Morgan Library, New York, MS 736. Abou-el-Haj 1983, pp.1–29.
22 Riches 2000, pp.17, 21, 22, 101–8.
23 Riches 2000, pp.110–16.
24 Corpus Christi College, Cambridge, MS 286. Binski and Panayotova 2005, p.47, no.1.
25 Archibald, Brown and Webster 1997, pp.208–48.
26 Filmer-Sankey 1996, pp.1–9; Bruce-Mitford 1975–83, II, pp.361, 368, 384.
27 Webster and Backhouse 1991, pp.105–6, nos.75a and b.
28 Backhouse, Turner and Webster 1984, pp.170–88, 174, no.188.
29 Nash-Williams 1950, pp.123–5.
30 Henderson and Henderson 2004, pp.189–94.
31 Foster, S.M. 1998.
32 Wilcock 1818/1973, p.10; Colgrave and Mynors 1969, p.533.
33 Colgrave and Mynors 1969, p.17.
34 Higgitt and Spearman 1993, pp.1–2.
35 Henderson 1987, pp.94, 96–7.
36 Dublin, Trinity College, MS A.4.5.
37 Henderson 1987, pp.18–55.
38 Brown 2003.
39 Dublin, Trinity College, MS 50. Lord 2003, pp.59–60.
40 Dublin, Royal Irish Academy, MS 23. Hourihane 2003, pp.141, 142.
41 Cruickshank 1999; Henderson and Henderson 2004, pp.37, 134.
42 Allen and Anderson 1903, I, pt. II, pp.8–9.
43 Cassidy 1992.
44 In 1901: Spearman and Higgitt 1993, pp.1–2.
45 Henderson 1987, p.179.
46 Harbison 1992, I, pp.1, 302–9.
47 Lang 1991.
48 Berg 1958, p.35.
49 Bailey 1988.
50 Whitelock 1961.
51 Webster and Backhouse 1991, pp.258, no.233; pp.282–3, nos.259, 260.
52 British Library, Stowe MS 944, f.6. Backhouse, Turner and Webster 1984, pp.77–8
53 Dodwell 1982, pp.9, 216–22.
54 Backhouse, Turner and Webster 1984, p.195.
55 Davies 1999, p.339.
56 Draper 2000, pp.26–7.
57 Fernie 2000, pp.55–67; Wheatley 2004.
58 Cruden 1960, pp.10, 27.
59 Stalley 1971, pp.30–6.
60 Fernie 2000, pp.89–194.
61 Ryan 1983, no.77, p.165 and no.79b, p.167; Henry 1970; Thurlby 1999, p.24.
62 Stalley 1971, p.2.
63 Thurlby 1988, p.285.
64 Stalley 1971, pp.15, 91, 100–8.
65 Holmes 1959, pp.220, 216, 218; Holmes 1937, pp.73–90.
66 Broun 2003, pp.183–97.
67 Barrow 2003, p.199; Vale, J. 1999, pp.187–8.
68 Barrow 2003, pp.199–205.
69 Binski 2003, pp.207–24.
70 Welander 2003, pp.235–59.
71 Taylor 1950, pp.433–57.
72 Brown, R.A. 1976.
73 Tabraham 1997, p.62; other Edwardian Irish castles were at Mackynegan (County Wicklow), Randown and Athlone (County Athlone): Stalley 1971, pp.52–7.
74 Stalley 1984, pp.65–86.
75 Fawcett 1990; Wilson 1998, pp.55–76.
76 Thorpe 1978, pp.238–44, 251–2.
77 Lord 2003, pp.79–87.
78 Free Library of Philadelphia, Rare Book Department, MS Lewis E201, in Lord 2003, p.250–1.
79 Heslop 1984, pp.298–319.
80 Barrow 2003, p.199.
81 Harvey, P.D.A. and McGuiness 1996, pp.27–9.
82 Alexander, J.J.G. and Binski 1987, p.202, cat. no.12.
83 Payne 1987, pp.55–9, 488, cat. no.659.
84 Davies 1999, p.378.
85 Evans, S. 1963, pp.4, 26, 29; Alexander, J.J.G. and Binski 1987, p.200, no.10.
86 Webster, B. 1997, pp.85–6, 99.
87 Campbell, I. 1995, pp.302–25.
88 Steer and Bannerman 1977, pl.38.
89 Steer and Bannerman 1977, p.144, no.75, pl.23c; p.186, pl.26c.
90 The sculptors are Ó Brolchán and Ó Cuinn: Steer and Bannerman 1977, pp.39, 35, 121, pls 23, 38. Earlier examples: Ardchattan Priory (Lorn), Kildonnan (Eigg) (Fisher 2001, pp.120, 94).
91 Champneys 1910, p.178.
92 Stalley 1984, pp.65–86.
93 Hourihane 2003, pp.139–52.
94 Burnett and Tabraham 1993.
95 Campbell, I. 2001, pp.25–34.
96 Wilson, C. 2003a, p.99; Draper 2000, p.27.
97 Anderson, C. 2000, pp.148–61; Crossley and Clarke 2000, pp.1–21; Draper 2000, pp.21–35.
98 Vale, M. 1995, pp.115–31.
99 Howard, D. 2000, p.163.
100 Howard, D. 2000, p.163.
101 Marks and Williamson 2003, p.168, no.29.
102 Reynolds 2003, pp.76–85; Ditchburn 2001, pp.113–35. Foister 2006.
103 Marks and Williamson 2003, p.293, no.156; p.196, no.55.
104 Thurley 1993; Airs 1989, vol.3, pp.46–90.
105 Knowles, D. 1976; MacCulloch 2003, pp.502–33.
106 Baker-Smith 1989, p.38; Airs 1989, pp.46–99; Howard, M. and Llewellyn 1989, p.233.
107 Camden 1607, p.65; Britannia had first appeared on coins under the Emperor Hadrian in AD119. Toynbee 1924, pp.14, 142–57.
108 Peacham 1612, p.108.
109 Yates 1975, pl.42c; Dresser 1989, pp.27–31.
110 Lord 2003, p.251.
111 Marks and Williamson 2003, cat. no.174, p.306.
112 Evans, S. 1963, pp.193–204; *De principis instructione* in Thorpe 1978, pp.280–8.
113 Simms 1989.
114 Loomis 1956–7, pp.1–22.
115 Biddle 2000.
116 Munby, Barber and Brown 2007.
117 http://news.bbc.co.uk/1/hi/scotland/463221.stm; http://www.timesonline.co.uk/tol/comment/debate/letters/article1318965.ece. David Cameron, 28 Jan 2007: http://www.timesonline.co.uk/tol/news/uk/article1267592.ece.; http://www.lifeintheuktest.gov.uk/

2 BRITISH ART AND THE CONTINENT (pp.53–67)

1 Binski 1995, pp.107–12, 195–9; Sekules 2000; Morganstern 2000, pp.94–102, 117–26.
2 Kaufmann 2004, pp.80, 86, 91–2.
3 Frey 1942; Betthausen, Feist and Fork 1999, pp.100–1.
4 Hausmann 1998, p.204–5; Hausmann 2003, pp.109–12, 297–337.
5 Pevsner 1993 (1956), reprint of the 1964 edition. The original was published in 1956; Betthausen, Feist and Fork 1999, pp.306–8. On the books of Frey and Pevsner, see also Vaughan, W. 2002.
6 Pevsner 1993, pp.15, 18, 21, 24, 197. In his use of pairs of principles, of geography of art and *Zeitgeist*, Pevsner echoes the methods of his

teachers Heinrich Wölfflin and Wilhelm Pinder -
see Vaughan, W. 2002, pp.348-352; the essays
by Engel and Muthesius in Draper 2004;
Crossley 2007.

7 See the critique by Alexander, J.J.G. 1998, pp.207-
8, 217.

8 Haussherr 1970, pp.164, 170-1; Alexander, J.J.G.
1998, p.207; Kaufmann 2004, pp.93-104, 341-51;
the essays in Mitchell and Moran 2000.

9 Black 1994. See also the new series *Britain and
Europe*: James, E. 2001; Matthew 2005.

10 Flury, Schmuki and Tremp 2002, pp.70-1.

11 Stiegemann and Wemhoff 1999, II, pp.419-91;
Wamers 1999; Bierbrauer 1999.

12 Alexander, J.J.G. 1978, no.44, pp.66f.; Dodwell
1993, pp.82f.; Flury, Schmuki and Tremp 2002,
pp.32f., 70-84; Kauffmann 2003, pp.2f., 16f., 21-
3.

13 Kauffmann 2003, pp.2-3, 10.

14 Alexander, J.J.G. 1978, nos.7, 9, pp.32-40; Nees
2002, pp.157-9, 164-6; Kauffmann 2003, pp.1, 10-
17, 30-1.

15 Nees 2002, pp.153-5.

16 Dodwell 1993, pp.96-8; Black 1994, pp.39-40;
Kauffmann 2003, pp.33-4.

17 Van der Horst, Noel and Wüstefeld 1996; Nees
2002, pp.200-2; Kauffmann 2003, pp.107-12. On
the three copies respectively: Noel 1995; Gibson,
Heslop and Pfaff 1992; Dodwell 1996a.

18 Temple 1976, no.64, p.813; Dodwell 1993, p.100.

19 Dodwell 1993, pp.100-18.

20 Kauffmann 2003, pp.33-5.

21 Dodwell 1993, pp.49, 119-20; Kauffmann 2003,
pp.36-7.

22 Dodwell 1993, pp.120-2; Black 1994, pp.44-53;
Thomas, H.M. 2003; Matthew 2005.

23 Fernie 1983; Fernie 2000; Gem 2001.

24 Plant 2002.

25 Kidson 1996; Hoey and Thurlby 2004.

26 Fernie 2000, pp.208-11; Thurlby 2003.

27 Clanchy 1983, pp.88-109, 162-79; Black 1994,
pp.61-3.

28 Thurlby 2000.

29 Kowa 1990, p.73; Williamson 1995, pp.102-5;
Thurlby 2000, pp.45f.; Zarnecki 2000, pp.28-9.

30 Thurlby 1994; Mentel 2002, pp.190-241.

31 Draper 1999; Stalley 2002.

32 Wilson, C. 1990, pp.84-90; and recent studies by
Peter Kidson and Millard Fil Hearn as evaluated
in Draper 1997.

33 Kauffmann 1975, nos.78, 83, pp.105-6, 108-11;
Clanchy 1983, pp.175-6; Zarnecki 1984b; Kowa
1990, pp.73-4; Dodwell 1993, pp.359-63, 365-73.

34 Draper 2001; Binski 2004, esp.pp.3-6, 23-4.

35 Binski 1995, pp.94-5; Norton 2002; Binski 2002,
esp. p.128; Binski 2004, pp.6, 24; Blick 2005.

36 Wilson, C. 1987, p.74.

37 Frankl 1953; Kowa 1990, pp.86-95; Howard, R.E.,
Laxton and Litton 2001.

38 Heslop 2000.

39 Williamson 1995, pp.105-11; Sampson 1998;
Malone 2004; Binski 2004, pp.103-21.

40 See for example Clanchy 1983, pp.241-62;
Wilson, C. 1987, p.75.

41 Dodwell 1993, pp.321-8; Black 1994, pp.51-3.

42 Kauffmann 1975, no.68, pp.96-7; Draper 2000,

pp.27-34; Kauffmann 2003, pp.112-16.

43 Clanchy 1983, pp.244-7; Black 1994, pp.26-30,
39, 57-60, 67, 70.

44 Lewis, S. 1997, esp. pp.59-60, 202-4; Engel
2002, p.82.

45 Black 1994, pp.64-5.

46 Clanchy 1983, pp.210-11, 216-21, 241-4, 262-83.

47 Draper 2006.

48 Clanchy 1983, pp.213-14, 232, 296-7; Weiler 2002.

49 Clanchy 1983, pp.229-35; Black 1994, p.74.

50 Clanchy 1983, pp.235-40.

51 Binski 1995, pp.52-89.

52 Binski 1995, esp. pp.33-43.

53 Binski 1995, pp.93-107 and the essays in Grant
and Mortimer 2002.

54 The Cosmati work at Westminster can be linked
to and possibly even predates the works of the
Cosmati and related workshops in Italy, like the
tomb of Pope Clement IV (d.1268) in Viterbo:
Binski 2002, pp.127-30; Foster, R. 2002.

55 Binski 1995, pp.126-40; Binski 2002, pp.122, 126.

56 Binski 1995, p.164; Binski 2002, pp.121, 123; see
Corley 2000, pp.195-8, for a different dating to
between 1310-40.

57 Vale, M. 2000; Vale, M. 2001, p.298.

58 Stratford 2000.

59 Alexander, J.J.G. 1992, p.23; Dobson 2000.

60 Coldstream 1994.

61 Lepsky and Nussbaum 1999, pp.216-23; Becker-
Hounslow and Crossley 2000, pp.122-8. On the
trade connections between Lübeck, the Baltic
cities and London, see Huffman 1998, pp.23-40.

62 Crossley 2004b, pp.157-8.

63 Wilson, C. 1990, pp.224-32, and Crossley 2004b
plead for a connection between Parler and
England of some kind. More sceptical are Lepsky
and Nussbaum 1999, p.229; Jansen 2004.

64 Black 1994, pp.63-5, 68-9, 86-92; Wood, D.
2000; Reynolds 2003, p.78.

65 Frey 1942, pp.148-74; Pevsner 1993, pp.90-127;
also the works of John Harvey; see Crossley 2007.

66 Wilson, C. 1987, pp.79-82; Wilson, C. 2003a.

67 See the essays in Barron and Saul 1995; Fawcett
1996.

68 Barron and Saul 1995, pp.16-17, 19, and further
essays in this volume; Mitchell 2000; Reynolds
2003; Woods 2003.

69 Marks and Williamson 2003, cat. nos.213, 215,
pp.337-9.

70 Tolley 1994.

71 King, D. 1987, pp.159-61; Corley 2000, p.195;
Cheetham 2003; Kauffmann 2003, pp.268-70;
Reynolds 2003, p.82.

72 Huffman 1995.

73 Clemen 1930, I, pp.19-58; Corley 2000.

74 Binski 2004, pp.201-5.

75 Dinzelbacher 2002, pp.128-9; Marks 2004, esp.
pp.123-47.

76 Porter and Teich 1992, pp.146-63; Clough 2000.

77 Thurley 1993, pp.85-111; Lindley 1995, pp.36-72;
Reynolds 2003, p.83.

78 Fawcett 1996, p.173; Howard, D. 2000.

79 Buck 1997; Reynolds 2003, p.82; Foister 2004.

80 Black 1994, pp.101-6; Kauffmann 2003, pp.271-84.

81 Foister 2006.

**3 THE PATRONAGE OF THE CHURCH
AND ITS PURPOSES (pp.81-105)**

1 Colgrave and Mynors 1969, pp.74-5.

2 St Columba arrived on Iona in 565. On Roman
and Celtic Christianity in Britain, see Brown, M.
2006b.

3 See Sauerländer 1988; Sauerländer 2004.

4 See further Caskey 2006, p.194; Gee 2002
(women and patronage).

5 On the Lindisfarne Gospels' manufacture,
see Alexander, J.J.G. 1978, pp.39-40.

6 On medieval theological multiplicity,
see Hamburger 2006, p.4.

7 Luxford 2005, pp.14-15. Surviving works of art
and architecture are useful only as inferential
bases, themselves built on textually founded
understanding.

8 Lehmann-Brockhaus 1955-60, II, p.567,
nos.4399, 4400.

9 Riley 1867-9, I, p.280.

10 Lehmann-Brockhaus 1955-60, I, pp.63-4.

11 Lehmann-Brockhaus 1955-60, I, p.11 no.31
(Abingdon); II, p.255 no.3087 (Meaux); Preest
2002, pp.19-20, cf. no.90 (moral rectitude);
Thomson and Winterbottom 1998-9, I, pp.82-5
(Benedict Biscop, d.690).

12 Lehmann-Brockhaus 1955-60, I, pp.50-2
nos.185-8 (Barnwell), p.218 no.800 (Canterbury);
II, pp.299-302 nos.3304-9 (Norwich), p.332
no.3468 (Peterborough); James 1895, pp.122-3,
158 (Bury); Flower and Dawes 1934, I, p.272
(Milton).

13 Lehmann-Brockhaus 1955-60, II, p.25 nos.2363-4
(Lincoln), p.267 no.3142 (quake of 1222); III, p.176
no.5085 (quake of 1275).

14 Lehmann-Brockhaus 1955-60, I, p.443 no.1633
(Evesham); II, p.604 no.4530 (Waverley);
Wharton 1691, I, pp.642-3 (Ely).

15 Lehmann-Brockhaus 1955-60, I, p.218, no.801.

16 Luxford 2005, pp.58-60 (Bath), pp.115-16
(Tavistock).

17 Hays 1963, pp.68-9 (Aberconway); Goodman
1927, p.59 no.119 (Leeds).

18 Mason 1976, pp.23-6.

19 Lehmann-Brockhaus 1955-60, II, p.323 no.3425.

20 For the psalter, now belonging to the Society
of Antiquaries of London, see Morgan 1982,
pp.94-5 and nos.151, 156-9.

21 On Heckington, see Sekules 1990.

22 Preest 2002, p.116, 126 (Wherwell), p.133
(Athelney); Searle 1980, pp.17-21 (quote at p.17),
148-51 (Battle); Knowles, D. and Hadcock 1996,
p.135 (Witham).

23 Hogg and Schlegel 2005, p.369 (Witham); Colvin
1963, I, pp.265-7 (Sheen and Syon); Lehmann-
Brockhaus 1955-60, I, no.249, p.67 (Battle).

24 Lehmann-Brockhaus 1955-60, I, pp.400-1,
no.1487 (Bek); II, p.116 no.2696 (Barking).

25 Fry, T. 1981, chap.2; cf. Collett 2002, p.90;
Luxford 2005, p.133 (Bath).

26 Preest 2002, p.128; Riley 1867-9, II, p.283.

27 Greenway and Sayers 1989, p.102 (Bury);
Lehmann-Brockhaus 1955-60, II, pp.705-6
nos.4925, 4928, 4934-5 (Worcester); Watkin
1945-50, I, pp.194-5 (Glastonbury).

28 Lehmann-Brockhaus 1955–60, II, p.270 no.3158.
29 For example, Lehmann-Brockhaus 1955–60, II, p.120 no.2714, p.431 no.3867; cf. Campbell 2001, pp.191–3; Panofsky 1979, pp.62–3 (Ovid) and Lehmann-Brockhaus 1955–60, II, p.595 no.4486, p.652 no.4694, p.685 no.4841 (Daedalus).
30 Lehmann-Brockhaus 1955–60, II, p.522 no.4181 (Selby), p.665 no.4745 (Winchester).
31 In fact, by modern standards most works of medieval Church art and architecture were not of particularly distinguished quality.
32 For example, Lehmann-Brockhaus 1955–60, I, p.4 no.14 (Abingdon), p.412 no.1524 (Ely), p.548 no.2054 (Hereford); II, p.480 no.4054 (Salisbury), p.522 no.4181 (Selby) (Psalm 26:8). For churches as simulacra of heaven, see generally Coldstream 1987 and Meyer 2003.
33 Garton 1986, pp.60–1.
34 Southern 1990, p.230.
35 Lehmann-Brockhaus 1955–60, II, p.447 no.4923.
36 Heslop 1987, p.31.
37 Fergusson 1984, pp.9–10.
38 Fergusson and Harrison 1999, pp.151–74 (Rievaulx); Platt 1984, pp.213–16 (Forde and Fountains).
39 Binski 2004, pp.31–3, 44; Aston 1988, pp.96–159 (orthodox and Lollard criticisms of sumptuous church building and embellishment); Salzman 1952/1992, p.522 (Henry VI, 1448); Riley 1867–9, I, p.219 (St Albans).
40 Norton 2001, p.213 (Durham); Lehmann-Brockhaus 1955–60, II, pp.174 no.2854 (Westminster), p.424 no.3840 (St Albans); Garton 1986, p.56–7 (Lincoln).
41 Lehmann-Brockhaus 1955–60, I, p.172 no.639 (Canterbury); II, p.119 no.2713 (Westminster), pp.419–20, nos.3827, 3833 (St Albans).
42 Dodwell 1993, pp.119–20; cf. Lehmann-Brockhaus 1955–60, II, p.656 no.4071.
43 For example, Burgess 1985; Duffy 1992/2005; Marks 2004.
44 Lehmann-Brockhaus 1955–60, I, p.343 no.1284 (Dunfermline), p.581 no.2196; III, pp.145–7 nos. 5658, 5666–8 (David I).
45 Salzman 1952/1992, p.409.
46 On Coventry, see Knowles, D. and Hadcock 1996, p.63; Preest 2002, pp.209–10.
47 Gem 2001, I, p.214.
48 Compare the figures in Knowles, D. and Hadcock 1996. Trends in monastic and mendicant endowment differed substantially in Scotland: see Easson 1957.
49 Lehmann-Brockhaus 1955–60, II, pp.110–11 (nos.2678–80).
50 Shepherd 1902, pp.266–87.
51 Hogg and Schlegel 2005, pp.361–567.
52 Watt, D.E.R. et al. 1987–98, IX, pp.274–5.
53 Morgan 2005, p.311.
54 Backhouse 1999, p.48.
55 On this phenomenon generally, see Coldstream 2002, p.193.
56 Luxford 2005, pl.25.
57 Colvin 1963, I, pp.156–7 (Westminster), p.497 (chessboard).
58 Richmond 1996, p.186.
59 Weaver 1901, p.148.

60 Lehmann-Brockhaus 1955–60, II, pp.123–43 nos.2732–49.
61 Lehmann-Brockhaus 1955–60, II, pp.280–1 no.3203 (Newminster), pp.370–1 no.3628 (Reading), p.547 no.4294 (Stannington).
62 Hearne 1729, pp.240–9 (Beauchamp's will; quote at p.241). On the chapel generally, see Marks and Williamson 2003, pp.223–6.
63 See, for example, Lewis 1995b, arguing for abbatial as well as royal patronage of the abbey church.
64 Heslop 2005, pp.246–7.
65 Mattingly 2000, pp.21–2 (St Neot's); Duffy 1994, p.140 (Morebath).
66 Marks 1993, p.6; Tanner, L.E. 1952, p.7.
67 Gem 2001, II, p.744.
68 Harvey, J.H. 1978, p.161.
69 For these towers, see Wright 1981, especially pp.134–43.
70 Salzman 1952/1992, p.24 (Totnes), pp.499–500 (Walberswick), p.547 (Helmingham).
71 See, for example, Heslop 2005, p.260 (social pressure); Platt 1981, pp.90–1 (legal pressure).
72 Binski 2004, p.72 (Salisbury); Ayers 2004, II, pp.421–3, 485–7, 627–35 (Wells).
73 Doubleday 1903, pp.132–3.
74 On the mace generally, see Evans, G. 1994.
75 Binski 1995, pp.135–6, and Binski 2003 (coronation chair); Vale, M. 1999, pp.187–8 (Arthur's crown).
76 As discussed in Wilson, C. 2003b, p.142.
77 Lehmann-Brockhaus 1955–60, II, pp.58–9 nos.2487–8 (Edgar); Preest 2002, p.92.
78 See in general Tatton-Brown and Mortimer 2003.
79 Hope 1925, pp.62–3, 84.
80 The politics of Arthur's exhumation were more complex than this: see Parsons 2001.
81 Fowler 1903, pp.20–2 (Durham); Cox 1964, p.53 (Evesham); Lehmann-Brockhaus 1955–60, II, p.339 no.3500 (Peterborough); Marks 1993, pp.88–9 (All Souls); Brown 2003, pp.232–5 (York).
82 Nichols 2002, p.167.
83 There were exceptions: see, for example, Woodger 1984.
84 The indenture appears in Smith 1988, pp.378–413.

4 PATRONAGE, FUNCTION AND DISPLAY: THE SECULAR WORLD (pp.115–35)

1 Carey-Hill 1929–30, pp.21–37.
2 Morris, R.K. 2006, pp.37–48.
3 Barlow 1961, pp.1–26.
4 Foster, S. 1996, pp.33–52 and Frame 1990, pp.7–71.
5 See Marks and Williamson 2003, pp.254–61 (urban world). See Orme 1973 and Rawcliffe 1995, and Orme and Webster 1995 (institutions of the church).
6 Plummer 1896, p. 368.
7 Turner et al. 2006, p.26.
8 Chippindale 1994, pp.48–62.
9 Wheatley 2004, p.142.
10 Gurr 1992, pp.115–54, and Ronayne 1997, pp.121–40.
11 Hope-Taylor 1977, pp.119–22.

12 Gunn and Lindley 1991, *passim*.
13 Gee 2002, pp.1–6.
14 Foister 2004, pp.10–23.
15 Davies, S. 2004.
16 Woolgar 1999, pp.1–29.
17 Blair 1993, p.5.
18 Wood 1965, pp.67–116, and Emery 1996–2006, *passim*.
19 Williams 1992, pp.221–6.
20 Goodall, forthcoming, chap.2.
21 Fernie 1983, pp.11–22.
22 Fernie 2000, pp.84–7, and Wilson, C. 1997, pp.33–7.
23 Fawcett 1994, pp.317–19.
24 Colvin 1963, I, pp.353–4.
25 Percy 1905, pp.73–98.
26 Brears 1999, pp.76–8.
27 Dixon-Smith 1999, pp.79–96.
28 Colvin 1963, I, p.545.
29 Thurley 1993, pp.238–40.
30 Bryant 1935, p.146.
31 Barlow 1986, pp.240–7.
32 Girouard 1978, pp.14–118.
33 McKean 2001, p 74.
34 Cooper 1999, pp.301–5.
35 Starkey 1998, p.74.
36 Alexander, J.J.G. and Binski 1987, pp.249–50.
37 Campbell, T. 2002, p.4.
38 Goodall 2001, pp.18–19.
39 Howard, D. 1995, pp.86–90, and Bath 2003, *passim*.
40 Colvin 1963, I, p.935.
41 Girouard 1983, p.46.
42 Brown, R.A. 1976, pp.14–39.
43 Goodall 2004, pp.39–62.
44 McNeill 1997, pp.201–23.
45 Battlements appear, for example, on the classically inspired depiction of a burgh on Bodleian Library, Oxford MS Junius II, f.81.
46 Coulson 1979, pp.73–90.
47 Crouch 1992, pp.177–251.
48 Webster and Backhouse 1991, pp.60–2.
49 Colgrave and Mynors 1969, pp.192–3.
50 Keen 1984 and Coss 1993.
51 Crouch 2002, pp.17–38; Alexander, J.J.G. and Binski 1987, pp.55–9, and Wagner 1956.
52 Barber and Barker 1989, pp.29–37.
53 Dugdale 1730, pp.273–6, 401–2 and 427.
54 Wheatley 2004, pp.102–8.
55 Wilson, C. 1995, p.497.

5 THE 'ARTIST': INSTITUTIONS, TRAINING AND STATUS (pp.141–65)

1 Foucault 1977.
2 Henderson 1967; Martindale 1972; Heslop 1988; Sekules 2001.
3 See, too, cautions as to the concept of 'artisan' in Rosser 1997.
4 Alexander, J.J.G. 1989.
5 Hamburger 1993.
6 See the essay by Geddes, pp.19–43.
7 Horrox 1994; Ormrod and Lindley 1996. For the Reformation, see Howard, pp.231–41.

8 For ecclesiastical patronage, see in this volume Luxford, pp.81–105; and, for secular patronage, Goodall, pp.115–35.

9 Dodwell 1982 and 1996b; Webster, L. and Backhouse 1991; Backhouse, Turner and Webster 1984.

10 Dodwell 1982, chap.7.

11 Backhouse, Turner and Webster 1984, p.18.

12 Bishop Aethelwold, together with Dunstan and Oswald, was one of the great monastic reformers of King Edgar's reign: before appointment as Bishop of Winchester in 963, he had been Abbot of Abingdon. He wrote the *Regularis Concordia*, the common rule for all monastic communities in England. See ODNB, s.n.

13 See, for example, Hare 2004, pp.109–44.

14 Okasha 1971, pp.57–8; Backhouse, Turner and Webster 1984, p.92. See Gameson 1995, chap.2, for inscriptions in general.

15 Okasha 1971, p.106.

16 Dodwell 1982, pp.76–8.

17 Backhouse, Turner and Webster 1984, p.149. See also Holder 1988, pp.81–98.

18 Okasha 1971, pp.97–8, 114–15; Dodwell 1982, p.47.

19 Dodwell 1982, p.47.

20 Dodwell 1982, p.50.

21 Brown 2003, pp.90–104. L. Nees, 'Reading Aldred's colophon for the Lindisfarne Gospels', *Speculum*, vol.78, no.2, April 2003, pp.333–77.

22 Dodwell 1982, p.52. Three monastic painters are also listed.

23 Dodwell 1982, p.67.

24 Dodwell 1982, p.55.

25 Lehmann-Brockhaus 1955–60, I, no.642, p.173; Dodwell 1982, p.58.

26 Lehmann-Brockhaus 1955–60, III, no.6301, pp.320–1; Dodwell 1982, pp.46–7.

27 Dodwell 1982, p.45.

28 Christie 1938.

29 Dodwell 1982, p.57.

30 Dodwell 1982, p.57.

31 Staniland 1991, p.8.

32 Lehmann-Brockhaus 1955–60, I, no.1534, p.415.

33 Wilson, D. 1985, p.212, sees the tapestry as made 'probably by women, but not necessarily by nuns'.

34 Staniland 1991, p.8.

35 Alexander, J.J.G. 1978, cat. no.7, p.33. For Ceolfrith, see also ODNB, s.n.

36 Alexander, J.J.G. 1989, p.66. S.J. Coates, in the ODNB, points out that the Codex Amiatinus 'places the books of the Bible in the order of the old translation as listed by Cassiodorus, yet uses the Vulgate translation of Jerome and was conceived as a papally organized text, further drawing Wearmouth-Jarrow into the orbit of Rome'. This desire to associate Wearmouth-Jarrow with Rome may explain the deliberate imitation of Late Antique art.

37 Alexander, J.J.G. 1978, p.10.

38 The colophon is on f.259r. See Nees 2003 for sceptical scrutiny of this evidence. The Gospels, together with the relics of St Cuthbert, were taken by the community during the Viking invasions to Chester-le-Street from 883 to 995 and thence to Durham in 995.

39 Dodwell 1982, pp.51, 55; Alexander, J.J.G. 1978, p.15.

40 Temple 1976, no.11 and p.17; Backhouse, Turner and Webster 1984, no.31; Dodwell 1982, p.53.

41 Temple 1976, no.67; Backhouse, Turner and Webster 1984, no.56.

42 The Eadui Psalter (BL Arundel MS 155) has a Christ Church calendar originally including the death of St Aelfheah, who was martyred by the Danes in 1012, but not his translation from London to Canterbury in 1023 (added by a later hand).

43 Temple 1976, no.66; Backhouse, Turner and Webster 1984, no.57.

44 R. Gameson, 'Book production and decoration at Worcester in the tenth and eleventh centuries', in Brooks and Cubitt 1996, p.235.

45 Backhouse, Turner and Webster 1984, no.39; Brooks and Cubitt 1996, p.205. Many books were made in Anglo-Saxon style on the Continent in the later eighth century.

46 Brooks and Cubitt 1996, pp.200ff.

47 Backhouse, Turner and Webster 1984, no.41. J. Nightingale, 'Oswald, Fleury and continental reform', in Brooks and Cubitt 1996, p.24.

48 Brooks and Cubitt 1996, p.44; D. Bullough, 'St Oswald: monk, bishop and archbishop', in Brooks and Cubitt 1996, pp.1–22. Oswald had founded Ramsey, probably in the 960s.

49 Brooks and Cubitt 1996, p.16, n.58.

50 Backhouse, Turner and Webster 1984, no.164.

51 Ortenberg 1990, pp.197–246.

52 Darlington 1928, pp.5, 15–16; Backhouse, Turner and Webster 1984, p.132.

53 Heslop 1990, pp.151–95.

54 Lehmann-Brockhaus 1955–60, I, no.326, p.86; Dodwell 1982, p.93.

55 Tudor-Craig 1990; Bagshaw, Bryant and Hare 2006, pp.66–109.

56 Alexander, J.J.G. 1978, p.33; Backhouse, Turner and Webster 1984, p.143.

57 Backhouse, Turner and Webster 1984, no.3.

58 Backhouse, Turner and Webster 1984, pp.24–6. See also the ODNB entry on Athelstan by Sarah Foot.

59 Temple 1976, p.11; Backhouse, Turner and Webster 1984, no.6, p.27.

60 Noel 1995.

61 Noel 1995, p.74.

62 J.J.G. Alexander, 'Scribes as Artists: The Arabesque initial in Twelfth-Century English Manuscripts', in M.B. Parkes and A.G. Watson (eds.) *Medieval Scribes, Manuscripts and Libraries*, London 1978, pp.87–116.

63 Noel 1995, p.204.

64 Dodwell 1982, pp.63–4 and 84–5; Salzman 1952, p.160. ODNB, s.n. (entry by S.J. Coates).

65 Salzman 1952, p.356.

66 For archaeological discoveries of Anglo-Saxon stained glass, Marks 1993, pp.105–9.

67 Dodwell 1982, p.65.

68 Alexander, J.J.G. 1989, p.64.

69 Fernie 2000.

70 Harvey 1984, s.n.

71 R. Gem, 'English Romanesque Architecture', in Zarnecki 1984a, p.31. J. H. Harvey, 'The education of the medieval architect', *Journal of the Royal Institute of British Architects*, 52 (1945), pp.230–4.

72 Harvey, J.H. 1984, s.n. Peter of Colechurch is a significant exception.

73 Harvey 1972, p.61.

74 Harvey 1984, s.n.

75 Salzman 1952, p.11; Harvey 1984, s.n.

76 Salzman 1952, pp.369–76; Davidson Cragoe 2001, pp.40–53.

77 Salzman 1952, p.376.

78 Kauffmann 1975. A possible exception is a prototype *Life of St Cuthbert* produced between c.1083 and 1090: Baker 1978.

79 Over sixty foreign abbots were appointed between 1066 and 1135, and by 1075 Wulfstan of Worcester was the only remaining bishop of English birth.

80 Backhouse, Turner and Webster 1984, no.263.

81 R. Gameson, 'Book production', in Brooks and Cubitt 1996, p.227.

82 Alexander, J.J.G. 1992, p.16.

83 Pächt, Dodwell and Wormald 1960; Geddes 2005.

84 Geddes 2005, pp.81–6, for the other artists of the manuscript.

85 Geddes 2005, p.65.

86 Alexander, J.J.G. 1992, p.18.

87 Kauffmann 1975, p.15 and no.56.

88 Parker 1981.

89 Gibson, Heslop and Pfaff 1992.

90 Incisively analysed by G. Henderson, 'The Textual Basis of the Picture Leaves', in Gibson, Heslop and Pfaff 1992, pp.35–42.

91 M. Gibson, 'Conclusions: The Eadwine Psalter in Context', in Gibson, Heslop and Pfaff 1992, chap.14.

92 Colvin 1963, I, p.96.

93 Binski 1995.

94 Colvin 1963, I, p.102.

95 See N. Vincent's entry in ODNB and Reeve 2007.

96 Calendar of Liberate Rolls 1226–40, p.444.

97 Colvin 1963, I, p.175.

98 Colvin 1963, I, p.107.

99 Staniland 1991, p.10. See also Christie 1938, Appendix I.

100 The term 'sculptor' was not used in the same way as today, because of the associations of sculpture with pagan idolatry: see Dodwell 1987.

101 Riley 1861, p.74.

102 Salzman 1952, p.164.

103 Binski 1995, pp.93–107. See, in this volume, Coldstream, pp.106–7.

104 Morgan 1982, I, cat.23, p.71.

105 No fewer than seventy-two references to illuminators in Oxford from 1190–c.1340 are listed in Michael 1993.

106 Morgan 1982, I, cats.69–74.

107 Morgan 1982, I, cat.73, p.121. Donovan 1991.

108 Riley 1871, p.303.

109 Morgan 1982, I, cat.85, p.132. Vaughan 1958, p.170.

110 See also his self-portrait, praying to the Virgin and Child: Alexander, J.J.G. 1992, fig.36.

111 Vaughan 1958, p.186.

112 Vaughan 1958, pp.6–7, 228–9.

113 Vaughan 1958, p.20.

114 Brown, S. and O'Connor 1991, p.21.

115 Lindley 1994.

116 For example, Sharpe 1899, pp.124 (Friars, for clothing), 172 (the Abbot and Convent of Ramsey contract for a new *lavatorium*).
117 Sharpe 1899, pp.180-1.
118 Lindley 1991, pp.68-92.
119 J. Blair, 'Purbeck marble', in Blair and Ramsay 1991, pp.41-56.
120 Blair 1987, p.140.
121 Blair 1987, pp.166-9. See also Badham and Norris 1999, p.84.
122 Blair 1987, p.168.
123 Morgan 1988, II, p.103. Alexander 1989, p.68.
124 Morgan 1988, II, cat.153; Binski 1986.
125 Michael 1993, p.68.
126 Sandler 1983.
127 Ramsay 1987, pp.49-54.
128 One rare survival is a 1346 contract from York; see Alexander, J.J.G. 1992, p.179.
129 Sandler 1974.
130 N. Stratford, in Alexander, J.J.G. and Binski 1987, cat. nos.593-6.
131 Michael 1993, pp.64-5.
132 Michael 1993, p.73. The painters here named were not necessarily illuminators, of course.
133 Michael 1993, p.69.
134 Harvey, J.H. 1984, p.244.
135 Fitch 1976.
136 Staniland 1991, p.12.
137 Staniland 1986, pp.238-9.
138 Ramsay 1987, pp.52-3.
139 Fernie and Whittingham 1972, p.38
140 Edwards, J. 1946; Taylor 1986.
141 Colvin 1963, I, p.204; see also II, pp.1036-40.
142 Harvey, J.H. 1984, s.n.
143 Taylor 1961.
144 Ziegler 1969.
145 Wilson, C. 2002.
146 Salzman 1952, p.73.
147 Wilson, C. 1990, chaps.2-3.
148 Colvin 1963, I, pp.518-19; Salzman 1952, p.167. For the separation of design from execution, see Ramsay 1987, pp.51-2.
149 Salzman 1952, p.167.
150 Alexander, J.J.G. and Binski 1987, p.50. Marks 1993, p.41.
151 Lindley 1995, pp.113-46. Howe 2001, pp.259-303.
152 Dennison 1986.
153 Dennison and Rogers 2000.
154 Staniland 1991, p.65; Monnas 1997, pp.165-77.
155 Colvin 1963, I, pp.162-3. But cf. the July 1358 order for works at Newcastle, 'which lie near to the king's heart'.
156 For this whole episode, see Colvin 1963, I, pp.520-1.
157 Brown, S. and O'Connor 1991, p.26. Colvin 1963, I, p.226.
158 Harvey, J.H. 1984, s.n.
159 Colvin 1963, I, pp.212, 220.
160 Harvey, J.H. 1972.
161 Coldstream 1991, pp.24-39.
162 Roberts 1977; Morris, R.K. 1978/1979; Morris R.K. 1990.
163 Harvey, J.H. 1984, s.n.; Salzman 1952, pp.472-3.
164 Salzman 1952, p.218.
165 E.g. Salzman 1952, p.584.
166 Woodforde 1951, p.5.

167 Marks 1993, chap.2.
168 Alexander, J.J.G. 1992, p.30. See also Scott 1996, II, no.10, who throws doubt on this identification in the Lovell Lectionary; Backhouse 1999.
169 Colvin 1963, I, p.201.
170 Colvin 1963, I, p.226; C[*alendar of*] P[*atent*] R[*olls*], *Henry VI, 1436-41*, London 1907, p.469; *CPR, Henry VI, 1441-6*, London 1908, p.280, and *CPR, Edward IV, 1461-7*, London 1897, p.10.
171 Brown, S. and O'Connor 1991, p.26.
172 Marks 1993, p.23.
173 *CPR, Henry VI, 1446-52*, London 1909, p.255.
174 Harvey, J.H. 1984, s.n.
175 Armitage-Smith 1911, pp.212-13, 296, and Lodge and Somerville 1937, p.40.
176 Badham 2004.
177 Harvey, J.H. 1984, s.n.
178 P.Lindley, 'Absolutism and Regal Image in Ricardian Sculpture', in Gordon, Monnas and Elam 1997, p.65.
179 For wills, see, for example, d'Elboux 1949.
180 Blair 1980, pp.66-74.
181 Saul 2006, p.167.
182 See the manipulations of heraldry, designed to enhance their status, in the Catesby brasses: Bertram 2006.
183 Marks 1993, p.24, fig.20.
184 Saul 2006, p.169.
185 Myres 1967, pp.151-68.
186 Colvin 1963, I, pp.287-8.
187 Colvin 1963, I, p.288.
188 Oakley Park manuscript, 'A Booke of Sundry Matters of Antiquityes', ff.14-16.
189 Lindley 1995, pp.64-6
190 French 1995, pp.153-4.
191 For the classification of London brasses, see Kent 1949; Emmerson 1978, p.68.
192 Saul 2006, fig.7.
193 Lindley 2006, p.156 (John de Hastings, d.1375).
194 E. Hobhouse, 'Original Document', *Archaeological Journal*, II (1846), pp.181-2.
195 Brown, S. 2003, pp.231-2.
196 Baker 1978, Appendix B.
197 B. Colgrave, 'The St Cuthbert Paintings on the Carlisle Cathedral Stalls', *Burlington Magazine*, vol.73, no.424, July 1938, pp.17-21. D. Park and S. Cather, 'Late Medieval Paintings at Carlisle', in *Carlisle and Cumbria, Roman and Medieval Architecture, Art and Archaeology*, M. McCarthy and D. Weston (eds.), British Archaeological Association Conference Transactions, vol.27, Leeds 2004, pp.214-31.
198 Camille 1992, p.97.
199 Grössinger 1975.
200 Purvis 1936, p.117. Alternative views are offered by Stone 1955, pp.221-2, and Tracy 1990, chap.3.
201 Marks 1984, pp.191ff.
202 Jones 2002, p.160.
203 Sharpe 1890, I, p.576.
204 J. Raine (ed.), *Testamenta Eboracensia*, vol.4, in Surtees Society, vol.53, 1868, pp.216-17.
205 Harvey, J.H. 1984, s.n.
206 Harvey, J.H. 1984, pp.221, 333.
207 Colvin 1975, III/1, p.31.
208 Colvin 1975, III/1, p.42, n.13.

209 Salzman 1952, p.5.
210 Girouard 1983, p.46.
211 Wayment 1991, p.119.
212 Wayment 1991, p.118; Marks 1993, p.25.
213 Blair 1987, p.168; Kent 1949, pp.70-97.
214 R. Emmerson, 'Monumental Brasses: London Design c.1420-1485', *Journal of the British Archaeological Association*, vol.131, 1979, pp.50-77.
215 Badham 2004.
216 D. R. Ransome, 'Artisan Dynasties in London and Westminster in the Sixteenth Century', *Guildhall Miscellany*, no.2, 1964, pp.236-47.
217 Sharpe 1890, pp.106-7.
218 Sharpe 1890, pp.319-20.
219 Marks 1993, p.41.
220 Brown, S. and O'Connor 1991, p.25.
221 N. Ramsay, 'Alabaster', in Blair and Ramsay 1991, pp.29-40.
222 Stevenson, W.H. 1885, p.19.
223 Eighteen unrecognized London guilds were fined in 1179-80, proving the early origins of these bodies. Reddaway 1975, pp.106-7, for guilds' relative wealth in the fifteenth century.
224 Unwin 1963, pp.70-1, 74-6.
225 Marks 1993, p.42.
226 Unwin 1963, pp.79-81.
227 Unwin 1963, pp.79-81.
228 Rosser 1997, p.17.
229 Unwin 1963, p.91. For a deceitful early fifteenth-century apprentice, see Reddaway 1975, pp.83-4.
230 Brown, S. and O'Connor 1991, pp.23-4.
231 Rosser 1997, p.10.
232 Reddaway 1975, p.175.
233 E.A. Veale, 'Craftsmen and the economy of London in the Fourteenth Century', in A.E.J. Hollaender and W. Kellaway (eds.), *Studies in London History Presented to P.E. Jones*, London 1969, pp.148-9.
234 Marks 1993, p.42.
235 Marks 1993, p.206. For alien goldsmiths in the fourteenth century, Reddaway 1975, pp.47-8; for Italian officers of the king's mint, p.49.
236 Marks 1993, p.206.
237 Knowles, J.A. 1925, pp.148-9. Oswald 1951-5, pp.8-21.
238 Marks 1993, p.217.
239 Cf the goldsmiths John Colan in York (*Testamenta Eboracensia*, IV, pp.56-60) and Martin Soza, probably from Zafra in Spain, who became a freeman of the city of York in 1530-31 and city sheriff in 1545-46: see Dobson 2000.
240 Campbell, L 1984; Gill 2003. Sinclair 2003.
241 Colvin 1975, III/1, p.38.
242 Foister 2004.
243 Foister 2004.
244 Reddaway 1975, p.120; Campbell 1987, p.44.
245 Reddaway 1975, pp.171-2.
246 Ransome 1960, pp.12-14.
247 Knowles, J.A. 1925, p.150.
248 Knowles, J.A. 1925, p.151.
249 Croft 1890, I, p.140.
250 Thomas, K. 2006, pp.16-40.
251 Lindley 1995, pp.50-1.
252 The designs for the heraldry were separately supplied to Torrigiano.

253 Croft 1890, I, chap.8.
254 Lloyd and Thurley 1990.
255 As suggested in Thomas, K. 2006.

6 SIGNS OF THE CROSS: MEDIEVAL
RELIGIOUS IMAGES AND THE
INTERPRETATION OF SCRIPTURE
(pp.175-97)

1 Heslop 2001 and Lewis, S. 1995a, pp.309-36, for the relationship between inscriptions and images in a series of twelfth-century English typological works.
2 Bede particularly used Ambrose, Augustine, Jerome and Gregory the Great, who became acknowledged as the major Latin fathers; their work preserved traditions of earlier Greek commentators, especially Origen.
3 Young 1997, for the shaping of a 'totalizing discourse'; de Lubac 2000.
4 Leclerq 1978, pp.87-109; Daniélou 1956.
5 Duffy 2007, p.3, notes nearly 800 surviving manuscript examples and even more printed copies produced for the English market.
6 For some recent approaches, see Lewis, S. 1995a, pp.1-16, 337-9; Sears and Thomas 2002, pp.1-7; Kessler 2000 and Kessler 2004, pp.19-42 for the materiality of medieval art. For a sympathetic study of the relationship between visual images and the imaginative universe in which they were created, see Binski 2004.
7 De templo 2, Corpus Christianorum, Series Latina, 119A (Turnhout 1969), 212-13; Connolly 1995, p.91; Chazelle 1990.
8 Belting 1994, pp.21-143, 377-457.
9 Schiller 1972, 2, pp.88-161, surveys medieval Crucifixion iconography.
10 For example, the Greek letters chi and rho (Christus, meaning Messiah), the alpha and omega, or the names of the dead, united with Christ. For later inscribed stone crosses from Hartlepool, Wearmouth-Jarrow and Lindisfarne, see Okasha 1971, figs.45-50, 75-82, 92.
11 Rahner 1963, pp.46-68; Ladner 1995, pp.99-106.
12 Green 1999, pp.128-9.
13 O'Reilly 1998.
14 British Library, London, Cotton MS Nero D.IV, ff.2v, 26v, 94v, 138v, 210v.
15 Krasnodebska-D'Aughton 2002.
16 Stevenson, R.B.K. 1981, for examples in other media.
17 Tome of Leo the Great: Tanner, N.P. 1990, 1, pp.77-82.
18 Durham Cathedral Library, MS A.II.17, f.38a verso. Verey, Brown and Coatsworth 1980; Henderson 1987, pp.57-68, 80-8.
19 Nees 2005.
20 See Augustine's influential commentary on John's Gospel, In Iohannis Evangelium, Tractatus 120, 2, Corpus Christianorum, Series Latina, 36 (Turnhout 1954), 661, translated in Nicene and Post-Nicene Fathers, 7, 434.
21 Ó Carragáin 2005 discusses the Ruthwell Cross in the context of the Roman cult of the Cross and

the Lenten and Easter liturgy.
22 Bailey 1996, pp.52-4, pls.19-22, on vinescroll.
23 Ó Carragáin 2005, pp.280-303, figs.1-4, for the tituli.
24 Backhouse, Turner and Webster 1984, no.75, pl.XXIII; Ó Carragáin 2005, fig.55, for the inscriptions.
25 Victoria and Albert Museum, London, inv. 7943.1862. Backhouse, Turner and Webster 1984, no.118, pl.XXVI.
26 For the liturgical and exegetical influences in the formation of one great illuminated manuscript, the Benedictional of Aethelwold, produced for a leader of the monastic reform, see Deshman 1995.
27 Raw 1990, pls.I-XI, XIV-XVI.
28 British Library, London, MS Harley 2904, f.3v. Temple 1976, no.41, ill.142. The Crucifixion faces the opening words of Ps.1, beatus vir, inscribed in gold. The blessed man, likened to a fruitful tree planted by running waters, was interpreted by patristic commentators as referring to Christ, and the Psalm was early illustrated with a Crucifixion scene, as in the Carolingian Stuttgart Psalter, c.820.
29 Pierpont Morgan Library, New York, MS 709, f.1v. Temple 1976, no.93, ill.289.
30 Gen. 2:9; 22:6-9; 1 Kgs. 17:10; Acts 5:30, 10:39; Gal. 3:13, citing Deut. 21:23.
31 Szoverffy 1966.
32 Symons 1953, p.42. The exegetical and liturgical traditions sketched here long pre-date the twelfth-century combination of early apocryphal and legendary material on the Cross and its material origins, later summarized in the Golden Legend's history of Adam and the Invention of the Holy Cross, which shows that the Cross by which humanity is saved came of the tree by which humanity had been damned. O'Reilly 1987 and O'Reilly 1992a.
33 Hamer 1970, pp.160-71 (quote at 164-5, line 56).
34 Fulton 2002, pp.141-92, on 'Praying to the crucified Christ'. For the importance of the inscribed word on early medieval images of the Cross, see Henderson 1972, pp.201-38.
35 Wilmart 1932; Gjerlow 1961, pp.13-28.
36 British Library, London, Cotton MS D.XXVII, f.65v. Temple 1976, no.77, ill.246.
37 O'Reilly 1992b, pp.170-5.
38 Ward 1973, p.169, lines 196-8 and also 215-16.
39 Binski and Panayotova 2005, pp.163-233, on illustrated books of private devotion; Duffy 2007, figs.15, 17, 20, 27-8, 32, 48-50; Marks 2004, pp.123-43, for the Pietà; Moss 2007.
40 Haney 2002, pp.229-305, for an introduction to Psalm exegesis; Noel 1996, pp.120-65; Haney 1986; Gibson, Heslop and Pfaff 1992, pp.25-42, for the associated cycle of biblical illustrations.
41 All Souls College, Oxford, MS 6, f.5. Morgan 1988, no.101, fig.29. Binski 2004, pp.209-30, figs.165, 169, 170, for the Tree of Life in the Evesham, Amesbury and Robert de Lindsey Psalters.
42 Morgan 1988, no.101, fig.23; Martindale 1967, col.fig.53.
43 For example, the Genoels-Elderen ivory diptych, of possible Insular influence, Webster, L. and

Backhouse 1991, no.141. There was an early tradition that the Crucifixion had occurred at the Spring equinox (25 March in the Julian calendar), the same date on which the feast of the Annunciation was celebrated from the seventh century.
44 Binski 2004, p.277, fig.227.
45 Binski 2004, fig.93, for the virgo lactans revered by Jocelin, Bishop of Wells, on his seal, c.1206; she is flanked by lay patrons at prayer in the Cuerden Psalter, c.1270, Alexander, J.J.G. and Binski 1987, no.355.
46 Van Dijk 1999, pp.420, 425. Morgan 1982, no.175, fig.370, for a psalter and hymnal, c.1280-90, associating the crowned virgo lactans with Marian prayers, including the Ave Maria; Smyth 2003, pl.6, figs.119, 120, for the patron with the virgo lactans in the Neville of Thornby Hours, and the Virgin teaching the Ave Maria in the Taymouth Hours.
47 Duffy 2007, p.37.
48 Sandler 1983, p.66, pl.17.
49 Ladner 1995, pp.121-5; Hoogvliet 2006, pp.158-61, fig.5.
50 The pelican appears again in the De Lisle Psalter, f.125v, in the inscribed lignum vitae diagram of Franciscan influence. The traditional contrasted Tree of Vices and Tree of Virtues, ff.128v-129, are visually assimilated to the dry Tree of the Knowledge of Good and Evil, flanked by Adam and Eve at the Fall, and the green Tree of Life with the Annunciation of Mary, the second Eve, at its foot. Sandler 1983, p.60, pls.8, 9, 14; O'Reilly 1992a, pp.188-90, pls.12, 13.
51 Sandler 1983, pl.16.
52 2 Cor. 11:2, Eph. 5:23-28; Rev. 21:9.
53 Fulton 2002, pp.244-88, 249; Astell 1990, pp.42-72, 43.
54 Kauffmann 2001, pp.264-5, fig.7 and n.16.
55 For example, Bibliothèque municipale, Dijon, MS 129, f.4v. See Watson 1934, pls.5, 8, and the entry for Bodleian Library, Oxford, MS Bodley 269 (S.C.1935), f.iii, c.1130-40, in Kauffmann 1975, p.86, no.52, ill.135.
56 Wieck 1988, pp.157-67, for the texts of the Hours of the Virgin and the Marian prayers, Obsecro te and O intemerata.
57 Cambridge, Museum of Archaeology and Anthropology, inv. Z15154.
58 O'Reilly 1987-88, pp.72-118, pl.1; pp.103-11, on seeing the five wounds. Leo the Great in his Tome regarded Christ's invitation to behold his wounds (Luke 24:39) as offering spiritual insight into the continued union of his divine and human natures in one person after the Resurrection.
59 Dodwell 1993, pp.324-46, n.19, fig.332.
60 British Library, London, Cotton MS, Nero c.IV, f.35. Wormald 1973, p.35.
61 Pembroke College, Cambridge, MS 120, f.6. Kauffmann 1975, no.35, ill.102.
62 Binski and Panayotova 2005, no.70.
63 The Matthean texts are used in a rare example of a Last Judgement scene prefacing Ps. 1 in a psalter combined with the Hours of the Virgin, c.1170, Kauffmann 1975, no.89, fig.254.
64 The Huth Psalter, British Library, London, MS

Add 38116, f.13v, after 1280, and Queen Mary Psalter, British Library, London, MS Royal 2B.vii, c.1290-1300: Kline 2001, pp.65, 67, figs.2.5,6. Fulton 2002, pp.205-43, for 'Praying to the Mother of the crucified Judge'.

65 John the Baptist's intercessory power and status as the 'revealer of God' had long been revered, Ward 1973, pp.127-34, lines 175-6, 196-200. The poet implores John, who showed to the world him who takes away the sin of the world (John 1:29): 'by the grace given to you, gain for me that mercy to take away my sins'.

66 Examples of the 'leprous' body of Christ in other contexts: the Crucifixion in the Holkham Bible Picture Book, 1330s, Binski 1984, fig.182; Pietà in fifteenth-century stained glass at Long Melford church, Suffolk, Marks 2004, fig.92.

67 The seven works of corporal mercy deriving from Matt. 25:34-46, along with other 'sevens', such as the seven sacraments, featured in catechetical programmes from the thirteenth century. Remnants survive from a scheme in stained glass in the parochial part of Holy Trinity Church, Tattershall, Lincs., c.1480-88: Marks and Williamson 2003, no.292.

68 Lord 2003, pp.168-72, pls.264-7; Duffy 1992, pp.157-60, figs.5, 44, 55; Marks and Williamson 2003, nos.326, 435.

69 The identification of Christ's sacramental body on the altar with his crucified and glorified body could also be suggested by the celebrant's vestments. Alexander and Binski 1987, no.578, for the Marnhull orphrey, c.1315-35, a cross-shaped panel in *opus anglicanum* on the back of the chasuble, visible to the congregation as the priest celebrated before the altar. It depicts the Crucifixion on a hewn timber cross, flanked by the Virgin and St John, directly below the enthroned Christ exhibiting his wounds, flanked by angels with the instruments of the Passion, and attended by St Peter and St Paul.

70 Norton 2005, pp.177-9, figs.9, 11, 12. I am grateful to Dr Tim Ayers for this reference.

7 MONSTERS AND MARGINS: REPRESENTING DIFFERENCE (pp.203-25)

1 Sansone 1906, I, pp.137-8.
2 The racial connotations of Gothic in Vasari's statements are discussed in de Beer 1948.
3 For the High Middle Ages as a period of innovation and rationality, see Strayer 1970 and Morris 1973; for the persecutorial mentality, see Moore 1987; for the mentality of conquest, see Bartlett 1993.
4 See, for example, Mellinkoff 1993.
5 Freedman 2002 discusses the identification of the Middle Ages as an era of persecution and irrationality.
6 Cohen 1999, pp.xi-xvii; Cohen 1996a, pp.16-20.
7 Strickland 2003.
8 For a more detailed discussion of these issues, see Bynum 1990 and Bynum 1991, pp.239-98.
9 Camille 1998, pp.49-57; Camille 1987, pp.442-4.

The manuscript is reproduced in full in Brown, M. 2006a.

10 Strickland 2003, pp.29-38; Mellinkoff 1993, I, pp.115-17.
11 Camille's argument is that this idealized vision of feudal hierarchy appears at a time of actual crisis and change in the social and agricultural systems of England in the 1320s. At least five different illuminators contributed to the psalter's decoration, in more than one artistic 'campaign', and these interpretations rest on the assumption that this labour was carried out in the 1330s. In fact, as Gibbs 2000 points out, the gatherings in which the ploughing scenes and Geoffrey's 'portrait' miniature appear, which are the work of the most skilled and imaginative hand, probably date from the early 1340s.
12 Alexander, J.J.G. 1990; Freedman 1999, pp.133-73.
13 Folio 128v, reproduced in Sandler 1999, pl.8. See also Alexander 1990, p.447.
14 Janson 1952.
15 For comparable scenes showing peasants with bent and sometimes sexualized postures, see Alexander, J.J.G. 1990, pp.439-44; Mellinkoff 1993, I, pp.137-8.
16 Freedman 1999, pp.204-35 and fig.11; Mollat 1986.
17 Camille 1998, pp.184-5.
18 General Prologue to the *Canterbury Tales*, ll.453-5, 470-1, in Benson 1987, pp.30-31. On women's headdresses in satire, see Mann 1973, pp.124-5.
19 For the Minster-in-Thanet misericord, see Grössinger 1997a, pl.126.
20 Grössinger 1997a, pp.89-93; the Bristol Cathedral misericord is reproduced as pl.133. See also Grössinger 1997b, pp.112-26.
21 Folios 137-48. Discussion of these and similar marginal scenes in Verdier 1975.
22 Davis 1978.
23 *Seinte Margarete*, in Millett and Wogan-Browne 1990, p.62, ll.34-6.
24 Millett and Wogan-Browne 1990, p.60, ll.27-9.
25 *Hali Meiðhad*, in Millett and Wogan-Browne 1990, p.28, ll.3-6, 13-15.
26 Wolfthal 1999, pp.39-42, 62-5, 70-1.
27 Schmidt 1995, p.320 (passus 18, l.338).
28 Salisbury 1994, pp.77-101; Thomas 1983, p.38.
29 B. Batty, *The Christian Mans Closet*, trans. W. Lowth (London, 1581), f.95v, quoted in Thomas, K. 1983, p.38.
30 Bernheimer 1952.
31 For a guess at the Helmingham Herbal and Bestiary's original functions, and for information about its analogues and provenance, see Barker 1988.
32 Grössinger 1997a, pp.144-8 and pl.43; Grössinger 1997b, pp.80-7.
33 Friedman 1981, pp.131, 197.
34 Andersen 1977; Weir and Jerman 1986; Kelly 1996.
35 Weir and Jerman 1986, p.23 and pl.1.
36 Freitag 2004.
37 Folio 39r, reproduced in Binski 1996, pl. IX.
38 Baschet 1993; Binski 1996, pp.166-81.
39 Zarnecki 1988, p.68.
40 Aquinas 1964-81, XLIII, pp.244-5.
41 For Italian Last Judgement paintings representing

sodomy, see Mills 2005, pp.83-105.
42 Easting 2002, p.79.
43 Aquinas 1964-81, XLIII, pp.244-5.
44 Strickland 2003, pp.61-93.
45 Camille 1989, pp.57-72.
46 Hassig 1995, pp.145-55; Camille 1989, p.166.
47 Mellinkoff 1970, pp.131-2.
48 For comparable scenes drawn by scribes in the margins of official documents, see Roth 1962, pp.22-5. The overall significance of the scene depicting the Norwich Jewry is unclear, but explanations are offered in Lipman 1967, p.107, and Felsenstein 1995, pp.27-9. For anti-Semitic iconography in medieval Christian art, see Mellinkoff 1993; Strickland 2003, pp.95-155; Schreckenberg 1996.
49 Strickland 2003, pp.97-107.
50 Lovell Lectionary, c.1408, f.13, reproduced in Strickland 2003, fig. 47. On the host desecration myth, see Rubin 1999.
51 Fetternear Banner, in National Museum of Scotland, Edinburgh, discussed in McRoberts 1956; Strickland 2003, p.108 and pl.10.
52 Luttrell Psalter, f.82r, reproduced in Strickland 2003, p.14.
53 Giles 1852-54, I, pp.470-1.
54 Friedman 1981; Strickland 2003, pp.41-59.
55 Giles 1852-54, I, pp.469-70.
56 Bettenson 1984, pp.663-4 (book 16, chap.8).
57 *Marvels of the East*, in Orchard 1995, p.196.
58 This interpretation follows Cohen 1999, pp.1-4. Mittman 2006, pp.66-114, provides a general survey of the iconographic traditions of *Marvels of the East* manuscripts.
59 O'Meara 1982, p.57.
60 Gerald's text uses the word *nefandum* twice. For the original Latin, see Brewer, Dimock and Warner 1861-91, V, p.110.
61 For discussions of illustrated *Topography* manuscripts, see Brown 2002, Knight 2001 and Mittman 2003.
62 Mittman 2003, pp.106-7.
63 Friedman 1981, pp.37-58; Friedman 1994, pp.64-95; Mittman 2006, pp.27-44.
64 For detailed accounts of the Hereford map, see Kline 2001; Harvey, P.D.A. 1996.
65 For a complete list of Camille's contributions to this debate, see Boeye 2002.
66 Camille 1992, pp.30, 48.
67 Camille 1998, pp.232-75, for instance, claims that the monstrous marginalia of the Luttrell Psalter encode 'peasant voices', by making reference to the popular practice of mummers wearing animal masks.
68 For an analysis of the contradictions in Camille's argument see Hamburger 1993, and Camille's reframing of these views in Camille 1998, p.308.

8 ART AND THE REFORMATION (pp.231-41)

1 On England, Haigh 1993, *passim*. On Scotland, Cowan 1982, *passim*. On destruction of art, Phillips 1973, *passim*. For England and Scotland in the context of Europe, see MacCulloch 2003,

passim.

2 Aston 1988, pp.314–19. On Scotland, Todd 2002, *passim*.
3 On the Scottish settlement, MacCulloch 2003, pp.378–82.
4 For late medieval patronage, Marks and Williamson 2003, pp.219–54.
5 Duffy 1992, *passim*.
6 Youngs, J. 1971, chaps.1 and 2.
7 Wells-Cole 1997, pp.78–81.
8 Foister 2004, pp.175–84.
9 On architectural terracotta, Morris 2000, pp.179–210. On Renaissance ornament in a major ecclesiastical setting, Biddle 1993.
10 Howard, M. 1990.
11 Shearman 1983, no.115.
12 Aston 1993, *passim*.
13 Kipling 1977, pp.58–62.
14 Millar 1963, no.43.
15 Aston 1988, pp.247, 363, 365.
16 For the Lacock inventory, see Vernon 1968.
17 For a short mention of the Hill Hall paintings in context, see Howard, M. 1995, pp.12–14.
18 Hamling 2007.
19 Watt, T. 1991, chap.4.
20 Llewellyn 2000, chap.5.
21 On the re-use of materials, see the essays in Gaimster and Gilchrist 2003.
22 Gaimster and Gilchrist 2003, see esp. pp.221–324.
23 Howard, M. 1987, chap.7.
24 Gaimster and Gilchrist 2003, bibliographies on pp.233–4, 250–1, 278–9, 288–9, 298.
25 *Archaeologia*, LXXIII (1923), pp.28–48.

9 PERCEPTIONS OF BRITISH MEDIEVAL ART (pp.247–59)

1 De Beer 1948.
2 Momigliano 1966; Levine 1986; Woolf 1992; Arnold and Bending 2003; Sweet 2004.
3 Hipple 1957; Andrews 1989; Copley and Garside 1994.
4 Bindman 1973; Myrone 2006.
5 Hogle 2002.
6 Podro 1982.
7 ODNB. See also entries for Tancred Borenius (University College London from 1922) and Roger Fry (University of Cambridge from 1894, Professor 1933), for whom see also Fry 1933.
8 For the Warburg tradition, see Gombrich 1986.

Scholars associated with the Warburg who made significant contributions to medieval scholarship included Fritz Saxl (1890–1948), Erwin Panofsky (1892–1968) and Rudolf Wittkower (1901–71). Other medievalists who escaped the Nazis to positions in Britain or the United States included Paul Frankl (1889–1963), Ernst Kitzinger (1912–2003), Nikolaus Pevsner (1902–83), Otto Pächt (Austrian, 1902–88), Meyer Schapiro (1904–96), Kurt Weitzman (1904–93) and George Zarnecki (Polish, b.1915).
9 Bruce-Mitford 1975–83.
10 Rees and Borzello 1986; Preziosi 1989. See also early editions of the *Oxford Art Journal*.
11 Gentry and Kleinhenz 1982.
12 Backhouse, Turner and Webster 1984; Zarnecki 1984a; Alexander, J.J.G. and Binski 1987; Webster, L. and Backhouse 1991; Marks and Williamson 2003.
13 Colvin 1968.
14 Cocke 1984; Bizzarro 1992; for an earlier identification of the first use of the concept of Romanesque, see Brownlee 1991.
15 Four of the main theories were republished in a single volume: Warton et al. 1800.
16 Rickman 1817; see ODNB entry.
17 For the origins of concepts of style, see Germann 1972, part I. For changing notions of style (written by specialists in medieval art), see Schapiro 1953; Sauerländer 1983 and Elsner 2003. For periodization, see Elkins 1997, pp.178–96
18 For 'East Anglian Period', see Rickert 1954, chap.6.
19 Bradley, S. 2002.
20 Clifton-Taylor 1968; Bradley, S. and Cherry 2001; Crossley 2004a, p.20.
21 Buchanan 2007.
22 Carter 1780–94, vol.1, p.3.
23 For Carter, see Crook 1995.
24 For example W.S. Lewis et al. 1937–83, vol.2, pp.31–2, 219–21, vol.16, p.184, and vol.42, pp.246–8 (describing the wings of the altarpiece now in All Hallows by the Tower, London). For Walpole, see Brownell 2001.
25 Nockles 1994.
26 White 1962; Webster and Elliott 2000.
27 Close 1844.
28 Anson 1960; London 1971; Harrison 1980; Atterbury and Wainwright 1994; Hindman et al. 2001.
29 Didron 1843.
30 Ruskin 1880.

31 For Mâle, see Luxford 2003.
32 For James, see Pfaff 1980; Cox, M. 1983; Dennison 2001.
33 Besides the writings of Bernard Berenson (1865–1959) on Italian art, the key texts in English for the methodology of formal connoisseurship are perhaps Constable 1938 and Friedländer 1941. Formalist works by medievalists translated into English include Worringer 1927, originally published in English in America in 1918 and Focillon 1942. See also Falkenheim 1980.
34 For Wormald, see Brown, J. 1975 and Alexander, J.J.G. 1984.
35 For Panofsky, see Holly 1984.
36 Frankl 1953. For Frankl, see Fernie 1995, pp.152–3, and Crossley 2000.
37 For British art, key examples are Duffy 1992 and 2001, and Marks 2004.
38 Brush 1996.
39 The term 'Court Style' seems to have been popularized in English by Hastings 1949.
40 Fergusson 2006.
41 For the recent historiography of concepts of identity, see Meyer, R. 2003. Rose-Troup 1929 is a very early work treating individual patronage.
42 For Cluniac Art, see Saunders 1932, pp.47–8, and Evans, J. 1950. For the Episcopal style, see Brieger 1957.
43 Research into patronage was first popularized in art-historical studies by Haskell 1963.
44 Strutt 1796–9 and 1801; Camille 1998, preface.
45 Grössinger 1997a.
46 Eco 1986.
47 Evelyn 1707; Walpole 1762–71.
48 Saint 1983, pp.19–23.
49 Hope 1835, vol.1, pp.229–49.
50 Saint 1983, pp.23–31.
51 Swenarton 1989.
52 Wollheim 1974 , pp.177–201; Maginnis 1990; Anderson 1992; Agosti et el. 1993.
53 Cockerell 1930. For Cockerell, see Blunt 1964.
54 Oakeshott 1945.
55 Lethaby 1906 and 1925. For Lethaby, see Rubens 1986 and Swenarton 1989, chap.4.
56 Harvey, J.H. 1944 and 1954. See Saint 1983, pp.43–7.
57 Pevsner 1942.
58 Bann 1998.

A dragoñ A romoñd A griffon A grihond

A dog A d A hors A hare

Bibliography

This is not intended as a definitive list of books on the art of this period, but has been compiled from references in the long essays in this volume.

ABOU-EL-HAJ 1983
B. Abou-el-Haj, 'Bury St Edmund's Abbey 1070-1124: A History of Property, Privilege and Monastic Overproduction', *Art History*, vol.6, 1983, pp.1-29.

AGOSTI ET AL. 1993
G. Agosti, M.E. Manca, M. Panzeri and M.D. Emiliani (eds.), *Giovanni Morelli e la cultura dei conoscitori*, Atti del Convegno Internazionale, Bergamo, 4-7 June 1987, 3 vols., Bergamo 1993.

AIRS 1989
M. Airs, 'Architecture', in B. Ford (ed.), *The Cambridge Guide to the Arts in Britain*, Cambridge 1989, vol.3, pp.46-99.

ALEXANDER, J.J.G. 1978
J.J.G. Alexander (ed.), *A Survey of Manuscripts Illuminated in the British Isles: Insular Manuscripts: 6th to 9th Century*, vol.1, London 1978.

ALEXANDER, J.J.G. 1984
J.J.G. Alexander, 'Preface', in J.J.G. Alexander, T.J. Brown and J.E. Gibbs (eds.), *Francis Wormald: Collected Writings*, vol.1 (of 2), London and New York 1984, pp.7-9.

ALEXANDER, J.J.G. 1989
J.J.G. Alexander, 'Facsimiles, Copies, and Variations: the Relationship to the Model in Medieval and Renaissance European Illuminated Manuscripts', in K. Preciado (ed.), *Retaining the Original: Multiple Originals, Copies, and Reproductions*, Center for Advanced Study in the Visual Arts, Symposium Papers VII, Washington 1989, pp.61-72.

ALEXANDER, J.J.G. 1990
J.J.G. Alexander, '*Labeur* and *Paresse*: Ideological Representations of Medieval Peasant Labour', *Art Bulletin*, vol.72, Sept. 1990, pp.436-52.

ALEXANDER, J.J.G. 1992
J.J.G. Alexander, *Medieval Illuminators and their Methods of Work*, London and New Haven 1992.

ALEXANDER, J.J.G. 1998
J. J. G. Alexander, 'Medieval Art and Modern Nationalism', in T. Graham and G.R. Owen-Crocker (eds.), *Medieval Art. Recent Perspectives. A Memorial Tribute to C.R. Dodwell*, Manchester 1998, pp.206-23.

ALEXANDER, J.J.G. AND BINSKI 1987
J.J.G. Alexander and P. Binski (eds.), *Age of Chivalry: Art in Plantagenet England 1200-1400*, exh. cat., Royal Academy of Arts, London 1987.

ALEXANDER, M. 1966
Michael Alexander (trans.), *The Earliest English Poems*, Harmondsworth 1966.

ALLEN AND ANDERSON 1903
J.R. Allen and J. Anderson, *The Early Christian Monuments of Scotland*, 2 vols., Edinburgh 1903.

ANDERSEN, J. 1997
J. Andersen, *The Witch on the Wall: Medieval Erotic Sculpture in the British Isles*, Copenhagen 1997.

ANDERSON, C. 2000
C. Anderson, 'Monstrous Babels: Language and Architectural Style in the English Renaissance', in Crossley and Clarke 2000, pp.148-61.

ANDERSON, J. 1992
J. Anderson, 'Giovanni Morelli's Scientific Method of Attribution - Origins and Interpretations', in *L'Art et ses révolutions. Section 5: Révolution et évolution de l'histoire de l'art de Warburg à nos jours*, Actes du XXVIIe Congrès International d'Histoire de l'Art, Strasbourg, 1-7 Septembre 1989, Strasbourg 1992, pp.135-41.

ANDREWS 1989
M. Andrews, *The Search for the Picturesque*, Stanford CA 1989.

ANSON 1960
P.F. Anson, *Fashions in Church Furnishings 1840-1940*, London 1960.

AQUINAS 1964-81
T. Aquinas, *Summa Theologiæ*, 61 vols., ed. and trans. Dominican Blackfriars, London 1964-81.

ARCHIBALD, BROWN AND WEBSTER 1997
M. Archibald, M. Brown and L. Webster, 'Heirs of Rome: The Shaping of Britain, AD 400-900', in L. Webster and M. Brown (eds.), *Transformation of the Roman World*, exh. cat., British Museum, London 1997, pp.208-48.

ARMITAGE SMITH 1911
S. Armitage-Smith (ed.), *John of Gaunt's Register*, London 1911.

ARNOLD AND BENDING 2003
D. Arnold and S. Bending (eds.), *Tracing Architecture. The Aesthetics of Antiquarianism*, Maldon, Oxford, Melbourne and Berlin 2003. First published as *Art History*, vol.25, no.4, 2002.

ASTELL 1990
A. Astell, *The Song of Songs in the Middle Ages*, Cornell 1990.

ASTON 1988
M. Aston, *England's Iconoclasts: Laws Against Images*, London 1988.

ASTON 1993
M. Aston, *The King's Bedpost. Reformation and Iconography in a Tudor Group Portrait*, Cambridge 1993.

ATTERBURY AND WAINWRIGHT 1994
P. Atterbury and C. Wainwright (eds.), *Pugin: A Gothic Passion*, exh. cat., Victoria and Albert Museum, London 1994.

AYERS 2004
T. Ayers, *The Medieval Stained Glass of Wells Cathedral*, Corpus Vitrearum Medii Aevi Great Britain, 4, 2 vols., Oxford 2004.

BABCOCK 1978
B.A. Babcock (ed.), *The Reversible World: Symbolic Inversion in Art and Society*, Ithaca NY 1978.

BACKHOUSE 1999
J. Backhouse, *The Sherborne Missal*, London 1999.

BACKHOUSE, TURNER AND WEBSTER 1984
J. Backhouse, D.H. Turner and L. Webster (eds.), *The Golden Age of Anglo-Saxon Art 966-1066*, exh. cat., British Museum, London 1984.

BADHAM 2004
S. Badham, 'Cast Copper-alloy Tombs and London Series B Brass Production in the Late Fourteenth Century', *Transactions of the Monumental Brass Society*, vol.17, no.2, 2004, pp.105-27.

BADHAM AND NORRIS 1999
S. Badham and M. Norris, *Early Incised Slabs and Brasses from the London Marblers*, London 1999.

BAGSHAW, BRYANT AND HARE 2006
S. Bagshaw, R. Bryant and M. Hare, 'The Discovery of an Anglo-Saxon Painted Figure at St Mary's Church, Deerhurst, Gloucestershire', *Antiquaries Journal*, vol.86, 2006, pp.66-109.

BAILEY 1988
R.N. Bailey, *Cumberland, Westmorland and Lancashire North-of-the-Sands*, Corpus of Anglo-Saxon Stone Sculpture, II, Oxford 1988.

BAILEY 1996
R.N. Bailey, *England's First Sculptors*, Toronto 1996.

BAKER 1978
M. Baker, 'Medieval Illustrations of Bede's Life of St Cuthbert', *Journal of the Warburg and Courtauld Institutes*, vol.41, 1978, pp.16-49.

BAKER-SMITH 1989
D. Baker-Smith, 'Renaissance and Reformation', in B. Ford (ed.), *The Cambridge Guide to the Arts in Britain*, Cambridge 1989, vol.3, pp.2-45.

BANN 1998
S. Bann, 'Art History and Museums', in M.A. Cheetham, M.A. Holly and K. Moxey (eds.), *The Subjects of Art History: Historical Objects in Contemporary Perspectives*, Cambridge 1998, pp.230-49.

BARBER AND BARKER 1989
R. Barber and J. Barker, *Tournaments*, Woodbridge 1989.

BARKER 1988
N. Barker (ed.), *Two East Anglian Picture Books: A Facsimile of the Helmingham Herbal and Bestiary and Bodleian MS Ashmole 1504*, London 1988.

BARLOW 1961
F. Barlow, *The Feudal Kingdom of England*, London 1961.

BARLOW 1986
F. Barlow, *Thomas Becket*, London 1986.

BARRON AND SAUL 1995
C. Barron and N. Saul (eds.), *England and the Low Countries in the Late Middle Ages*, New York 1995.

BARROW 2003
W.S. Barrow, 'The Removal of the Stone and Attempts at Recovery', in R. Welander, D. J. Breeze and T.O. Clancy (eds.), *The Stone of Destiny, Artefact and Icon*, Society of Antiquaries of Scotland, monograph series, no.22, Edinburgh 2003, pp.199-206.

BARTLETT 1993
R. Bartlett, *The Making of Europe: Conquest, Colonization and Cultural Change, 950-1350*, Princeton 1993.

BASCHET 1993
J. Baschet, *Les Représentations de l'enfer en France et en Italie (XIIᵉ-XVᵉ siècle)*, Rome 1993.

BATH 2003
M. Bath, *Renaissance Decorative Painting in Scotland*, Edinburgh 2003.

BATTISCOMBE 2003
C.F.Battiscombe, 'The "Banner of Saint Cuthbert"', in C.F. Battiscombe (ed.), *The Relics of Saint Cuthbert*, Oxford 1956, pp.68–72.

BECKER-HOUNSLOW AND CROSSLEY 2000
S. Becker-Hounslow and P. Crossley, 'England and the Baltic: New Thoughts on Old Problems', in Mitchell and Moran 2000, pp.113–28.

BELTING 1994
H. Belting, *Likeness and Presence. A History of the Image before the Era of Art*, Chicago 1994.

BENSON 1987
G. Chaucer, *The Riverside Chaucer*, ed. L. Benson, 3rd ed., Boston MA 1987.

BERG 1958
K. Berg, 'The Gosforth Cross', *Journal of the Warburg and Courtauld Institutes*, vol.21, 1958, pp.27–43.

BERNHEIMER 1952
R. Bernheimer, *Wild Men in the Middle Ages: A Study in Art, Sentiment, and Demonology*, Cambridge MA 1952.

BERTRAM 2006
J. Bertram (ed.), *The Catesby Family and their Brasses at Ashby St Ledgers*, London 2006.

BETTENSON 1984
Augustine, *Concerning the City of God Against the Pagans*, trans. H. Bettenson, London 1984.

BETTHAUSEN, FEIST AND FORK 1999
P. Betthausen, P.H. Feist and C. Fork, *Metzler Kunsthistoriker Lexikon*, Stuttgart and Weimar 1999.

BIDDLE 1993
M. Biddle, 'Early Renaissance at Winchester', in J. Crook (ed.), *Winchester Cathedral. Nine Hundred Years 1093–1993*, Chichester 1993, pp.257–304.

BIDDLE 2000
M. Biddle, *King Arthur's Round Table*, Woodbridge 2000.

BIERBRAUER 1999
K. Bierbrauer, 'Der Einfluß insularer Handschriften auf die kontinentale Buchmalerei', in Stiegemann and Wemhoff 1999, vol.3, pp.465–82.

BILDHAUER AND MILLS 2003
B. Bildhauer and R. Mills (eds.), *The Monstrous Middle Ages*, Cardiff 2003.

BINDING 1989
G. Binding, *Masswerk*, Darmstadt 1989.

BINDMAN 1973
D. Bindman, 'Blake's "Gothicised Imagination" and the History of England', in M.D. Paley and M. Phillips (eds.), *William Blake: Essays in Honour of Sir Geoffrey Keynes*, Oxford 1973, pp.29–39.

BINSKI 1986
P. Binski, *The Painted Chamber at Westminster*, occasional paper (new series) IX, The Society of Antiquaries of London, London 1986.

BINSKI 1995
P. Binski, *Westminster Abbey and the Plantagenets: Kingship and the Representation of Power 1200–1400*, New Haven and London 1995.

BINSKI 1996
P. Binski, *Medieval Death: Ritual and Representation*, London 1996.

BINSKI 2002
P. Binski, 'The Cosmati and *romanitas* in England: An Overview', in Grant and Mortimer 2002, pp.116–34.

BINSKI 2003
P. Binski, 'A "Sign of Victory": The Coronation Chair, its Manufacture and Symbolism', in R. Welander, D.J. Breeze and T.O. Clancy (eds.), *The Stone of Destiny, Artefact and Icon*, Society of Antiquaries of Scotland, monograph series, no.22, Edinburgh 2003, pp.207–24.

BINSKI 2004
P. Binski, *Becket's Crown: Art and Imagination in Gothic England 1170–1300*, New Haven and London 2004.

BINSKI AND NOEL 2001
P. Binski and W. Noel (eds.), *New Offerings, Ancient Treasures: Studies in Medieval Art for George Henderson*, Stroud 2001.

BINSKI AND PANAYOTOVA 2005
P. Binski and S. Panayotova (eds.), *The Cambridge Illuminations*, exh. cat., Fitzwilliam Museum, Cambridge, London and Turnout 2005.

BIZZARRO 1992
T.W. Bizzarro, *Romanesque Architectural Criticism: A Pre-History*, Cambridge 1992.

BLACK 1994
J. Black, *Convergence or Divergence? Britain and the Continent*, Basingstoke 1994.

BLAIR 1980
J. Blair, 'Henry Lakenham, Marbler of London, and a Tomb Contract of 1376', *Antiquaries Journal*, vol.60, 1980, pp.66–74.

BLAIR 1987
J. Blair, 'English Monumental Brasses before 1350: Types, Patterns and Workshops', in Coales 1987, pp.133–74.

BLAIR 1993
J. Blair, 'Hall and Chamber: English Domestic Planning 1000–1250', in *Manorial Domestic Building in England and Northern France*, G. Meirion-Jones and M. Jones (eds.), Occasional Papers from the Society of Antiquaries of London, vol.15, 1993, pp.1–21.

BLAIR AND RAMSAY 1991
J. Blair and N. Ramsay (eds.), *English Medieval Industries: Craftsmen, Techniques, Products*, London 1991.

BLICK 2005
S. Blick, 'Reconstructing the Shrine of St Thomas Becket, Canterbury Cathedral', in S. Blick and R. Tekippe (eds.), *Art and Architecture of Late Medieval Pilgrimage in Northern Europe and the British Isles*, Boston and Leiden 2005, pp.405–41.

BLUNT 1964
W.J.W. Blunt, *Cockerell: Sydney Carlyle Cockerell, Friend of Ruskin and William Morris and Director of the Fitzwilliam Museum*, Cambridge and London 1964.

BOEYE 2002
K. Boeye, 'A Bibliography of the Writings of Michael Camille', *Gesta*, vol.41, Spring 2002, pp.141–4.

BRADLEY, S. 2002
S. Bradley, 'The Englishness of English Gothic: Theories and Interpretations from William Gilpin to J.H. Parker', *Architectural History*, vol.45, 2002, pp.325–46.

BRADLEY, S. AND CHERRY 2001
S. Bradley and B. Cherry (eds.), *The Buildings of England. A Celebration*, Penguin Collectors' Society, London 2001.

BREARS 1999
P. Brears, *All the King's Cooks*, London 1999.

BREWER, DIMOCK AND WARNER 1861–91
J.S. Brewer, J.F. Dimock and G.F. Warner (eds.), *Giraldi Cambrensis Opera*, Rolls Series no.21, 8 vols., London 1861–91.

BRIEGER 1957
P. Brieger, *English Art, 1216–1307*, Oxford 1957.

BROOKS AND CUBITT 1996
N. Brooks and C. Cubitt (eds.), *St Oswald of Worcester: Life and Influence*, Leicester 1996.

BROUN 2003
D. Broun, 'The Origin of the Stone of Scone as a National Icon', in R. Welander, D.J. Breeze and T.O. Clancy (eds.), *The Stone of Destiny, Artefact and Icon*, Society of Antiquaries of Scotland, monograph series, no.22, Edinburgh 2003, pp.183–97.

BROWN, J. 1975
J. Brown, 'Francis Wormald', *Proceedings of the British Academy*, vol.61, 1975, pp.523–60.

BROWN, M. 2002
M.P Brown, 'Marvels of the West: Giraldus Cambrensis and the Role of the Author in the Development of Marginal Illustration', in Edwards, A. 2002, pp.34–59.

BROWN, M. 2003
M.P. Brown, *The Lindisfarne Gospels: Society, Spirituality and the Scribe*, London 2003.

BROWN, M. 2006a
M.P. Brown (ed.), *The Luttrell Psalter: A Facsimile*, London 2006.

BROWN, M. 2006b
M.P. Brown, *How Christianity Came to Britain and Ireland*, Oxford 2006.

BROWN, R.A. 1976
R.A. Brown, *English Castles*, London 1976.

BROWN, S. 2003
S. Brown, *'Our Magnificent Fabrick'. York Minster: An Architectural History c.1220–1500*, London 2003.

BROWN, S. AND O'CONNOR 1991
S. Brown and D. O'Connor, *Glass-Painters*, London 1991.

BROWNELL 2001
M.R. Brownell, *The Prime Minister of Taste: A Portrait of Horace Walpole*, New Haven and London 2001.

BROWNLEE 1991
D.B. Brownlee, '*Neugriechisch/Néo-Grec*: The German Vocabulary of French Romantic Architecture', *Journal of the Society of Architectural Historians*, vol.50, no.1, 1991, pp.18–21.

BRUCE-MITFORD 1975–83
R.L.S. Bruce-Mitford, *The Sutton Hoo Ship-Burial*, London 1975–83.

BRUSH 1996
K. Brush, *The Shaping of Art History: Wilhelm Vöge, Adolph Goldschmidt, and the Study of Medieval Art*, Cambridge 1996.

BRYANT 1935
A. Bryant (ed.), *Letters, Speeches and Declarations of King Charles II*, London 1935.

BUCHANAN 2007
A.C. Buchanan, 'Show and Tell: Late Medieval Art and the Cultures of Display', in *Late Gothic England: Art and Display*, in R. Marks (ed.), Donington 2007, pp.124-37.

BUCK 1997
S. Buck, *Holbein am Hofe Heinrichs VIII*, Berlin 1997.

BURGESS 1985
C. Burgess, 'For the Increase of Divine Service: Chantries in the Parish in Late Medieval Bristol', *Journal of Ecclesiastical History*, vol.36, 1985, pp.46-65.

BURNETT AND TABRAHAM 1993
C.J. Burnett and C.J. Tabraham, *The Honours of Scotland*, Edinburgh 1993.

BYNUM 1990
C.W. Bynum, review of Camille 1989, *Art Bulletin*, vol.72, no.2, June 1990, pp.331-2.

BYNUM 1991
C.W. Bynum, *Fragmentation and Redemption: Essays on Gender and the Human Body in Medieval Religion*, New York 1991.

CALDWELL 1982
D.H. Caldwell (ed.), *Angels, Nobles and Unicorns: Art and Patronage in Medieval Scotland*, exh. cat., National Museum of Scotland, Edinburgh 1982.

CALDWELL 2001
D.H. Caldwell, 'The Monymusk Reliquary: The Brecc-bennach of St Columba?', *Proceedings of the Society of Antiquaries of Scotland*, vol.131, 2001, pp.267-82.

CAMDEN 1607
W. Camden, *Britannia*, London 1607.

CAMILLE 1987
M. Camille, 'Labouring for the Lord: The Ploughman and the Social Order in the Luttrell Psalter', *Art History*, vol.10, Sept. 1987, pp.423-54.

CAMILLE 1989
M. Camille, *The Gothic Idol: Ideology and Image-making in Medieval Art*, Cambridge 1989.

CAMILLE 1992
M. Camille, *Image on the Edge: The Margins of Medieval Art*, London 1992.

CAMILLE 1998
M. Camille, *Mirror in Parchment: The Luttrell Psalter and the Making of Medieval England*, London and Chicago 1998.

CAMPBELL, I. 1995
I. Campbell, 'A Romanesque Revival and the early Renaissance in Scotland', *Journal of the Society of Architectural Historians*, vol.54, 1995, pp.302-25.

CAMPBELL, I. 2001
I. Campbell, 'Crown Steeples and Crowns Imperial', in *Raising the Eyebrow: John Onians and World Art Studies*, L. Golden (ed.), BAR International Series, vol.996, 2001, pp.25-34.

CAMPBELL, L. 1984
L. Campbell, 'Edward Bonkil: A Scottish Patron of Hugo van der Goes', *Burlington Magazine*, vol.126, 1984, pp.265-74.

CAMPBELL, M. 1987
M. Campbell, 'English Goldsmiths in the Fifteenth Century', in D. Williams (ed.), *England in the Fifteenth Century*, Woodbridge 1987, pp.43-52.

CAMPBELL, M. 2001
M. Campbell, 'An Enamelled Plaque Showing Bishop Henry of Blois', *Journal of the British Archaeological Association*, vol.154, 2001, pp.191-3.

CAMPBELL, T. 2002
T.P. Campbell, *Tapestry in the Renaissance: Art and Magnificence*, New York and London 2002.

CAREY-HILL 1929-30
E. Carey-Hill, 'The Hawkesworth Papers, 1601-60', *Birmingham Archaeological Proceedings and Transactions*, vol.54, 1929-30, pp.18-52.

CARTER 1780-94
J. Carter, *Specimens of the Ancient Sculpture and Painting, now Remaining in this Kingdom, from the Earliest Period to the Reign of Henry ye VIII ...*, 2 vols., London 1780-94.

CASKEY 2006
J. Caskey, 'Whodunnit? Patronage, the Canon, and the Problematics of Agency in Romanesque and Gothic Art', in Rudolph 2006, pp.193-212.

CASSIDY 1992
B. Cassidy (ed.), *The Ruthwell Cross*, Princeton 1992.

CHAMPNEYS 1910
A. Champneys, *Irish Ecclesiastical Architecture*, London 1910.

CHAZELLE 1990
C. Chazelle, 'Pictures, Books and the Illiterate: Pope Gregory I's letters to Serenus of Marseilles', *Word and Image*, vol.6, 1990, pp.138-53.

CHEETHAM 2003
F. Cheetham, *Alabaster Images of Medieval England*, Woodbridge 2003.

CHIPPINDALE 1994
C. Chippindale, *Stonehenge Complete*, London 1994.

CHRISTIE 1938
A.G.I. Christie, *English Medieval Embroidery*, Oxford 1938.

CLANCHY 1983
M.T. Clanchy, *England and its Rulers 1066-1272: Foreign Lordship and National Identity*, London 1983.

CLEMEN 1930
P. Clemen, *Die gotische Monumentalmalerei der Rheinlande*, 2 vols., Dusseldorf 1930.

CLIFTON-TAYLOR 1968
A. Clifton-Taylor, 'Architectural Touring with the Little Guides', in J. Summerson (ed.), *Concerning Architecture: Essays on Architectural Writers and Writing Presented to Nikolaus Pevsner*, London 1968, pp.238-51.

CLOSE 1844
F. Close, *The Restoration of Churches is the Restoration of Popery: Proved and Illustrated from the Authenticated Publications of the 'Cambridge Camden Society.' A Sermon ...* 2nd ed., London 1844.

CLOUGH 2000
C.H. Clough, 'Late Fifteenth-Century English Monarchs Subject to Italian Renaissance Influence', in Mitchell and Moran 2000, pp.298-317.

COALES 1987
J. Coales (ed.), *The Earliest English Brasses: Patronage, Style and Workshops 1270-1350*, London 1987.

COCKE 1984
T. Cocke, 'Rediscovery of the Romanesque', in Zarnecki 1984a, pp.360-91.

COCKERELL 1930
S.C. Cockerell, *The Work of W. de Brailes, an English Illuminator of the Thirteenth Century*, Roxburghe Club, Cambridge 1930.

COHEN 1996a
J.J. Cohen (ed.), *Monster Theory: Reading Culture*, Minneapolis 1996.

COHEN 1996b
J.J. Cohen, 'Monster Culture (Seven Theses)', in Cohen 1996a, pp.3-25.

COHEN 1999
J.J. Cohen, *Of Giants: Sex, Monsters, and the Middle Ages*, Minneapolis 1999.

COLDSTREAM 1987
N. Coldstream, 'The Kingdom of Heaven: Its Architectural Setting', in Alexander and Binski 1987, pp.92-7.

COLDSTREAM 1991
N. Coldstream, *Masons and Sculptors*, London 1991.

COLDSTREAM 1994
N. Coldstream, *The Decorated Style: Architecture and Ornament 1240-1360*, London 1994.

COLDSTREAM 2002
N. Coldstream, *Medieval Architecture*, Oxford 2002.

COLGRAVE 1938
B. Colgrave, 'The St Cuthbert Paintings on the Carlisle Cathedral Stalls', *Burlington Magazine*, vol.73, 1938, pp.17-21.

COLGRAVE AND MYNORS 1969
Bede, *Bede's Ecclesiastical History of the English People*, ed. and trans. B. Colgrave and R.A.B. Mynors, Oxford 1969.

COLLETT 2002
B. Collett (ed.), *Female Monastic Life in Early Tudor England: With an Edition of Richard Fox's Translation of the Benedictine Rule for Women, 1517*, Aldershot 2002.

COLVIN 1963/1975/1982
H. Colvin (ed.), *The History of the King's Works*, I and II: London 1963; III: London 1975; IV: London 1982.

COLVIN 1968
H.M. Colvin, 'Aubrey's Chronologia Architectonica', in J. Summerson (ed.), *Concerning Architecture: Essays on Architectural Writers and Writing Presented to Nikolaus Pevsner*, London 1968, pp.1-12.

CONNOLLY 1995
S. Connolly (trans.), *Bede: On the Temple*, Liverpool 1995.

CONSTABLE 1938
W.G. Constable, *Art History and Connoisseurship: Their Scope and Method*, Cambridge 1938.

COOPER 1999
N. Cooper, *Houses of the Gentry*, New Haven and London 1999.

COPLEY AND GARSIDE 1994
S. Copley and P. Garside, *The Politics of the Picturesque: Literature, Landscape and Aesthetics since 1770*, Cambridge 1994.

CORLEY 2000
B. Corley, 'Historical Links and Artistic Reflections: England and Northern Germany in the Late Middle Ages', in Mitchell and Moran 2000, pp.175–89.

COSS 1993
P. Coss, *The Knight in Medieval England*, Woodbridge 1993.

COULSON 1979
C. Coulson, 'Structural Symbolism in Medieval Castle Architecture', *Journal of the British Archaeological Association*, 3rd Series, vol.132, 1979, pp.73–90.

COWAN 1982
I.B. Cowan, *The Scottish Reformation. Church and Society in early 16th century Scotland*, London 1982.

COX, D. 1964
D.C. Cox (trans.), *The Chronicle of Evesham Abbey*, Evesham 1964.

COX, M. 1983
M. Cox, *M.R. James: An Informal Portrait*, Oxford 1983.

CROFT 1883
H.H.S. Croft (ed.), *Sir Thomas Elyot, The Boke named the Governour*, I, London 1883.

CROOK 1995
J.M. Crook, *John Carter and the Mind of the Gothic Revival*, Society of Antiquaries of London, Occasional Papers, vol.17, London 1995.

CROSSLEY 2000
P. Crossley, 'Introduction', in P. Frankl, *Gothic Architecture*, revised by P. Crossley, New Haven and London 2000, pp.7–31.

CROSSLEY 2004a
P. Crossley, 'Introduction', in P. Draper (ed.), *Reassessing Nikolaus Pevsner*, Aldershot 2004, pp.1–25.

CROSSLEY 2004b
P. Crossley, 'Peter Parler and England – A Problem Revisited', in *Parlerbauten. Architektur, Skulptur, Restaurierung. Internationales Parlersymposium Schwäbisch Gmünd, 17–19 Juni 2001*, Stuttgart 2004, pp.155–81.

CROSSLEY 2007
P. Crossley, '*Anglia Perdita*: English Medieval Architecture and Neo-Romanticism', in S. L'Engle and G.B. Guest (eds.), *Tributes to Jonathan Alexander, The Making and Meaning of Illuminated Medieval and Renaissance Manuscripts, Art and Architecture*, London 2007, pp.471–85.

CROSSLEY AND CLARKE 2000
P. Crossley and G. Clarke (eds.), *Architecture and Language: Constructing Identity in European Architecture c.1000–c.1650*, Cambridge 2000.

CROUCH 1992
D. Crouch, *The Image of Aristocracy in Britain, 1000–1300*, New York and London 1992.

CROUCH 2002
D. Crouch, 'The Historian, Lineage and Heraldry, 1050–1250', in P. Coss and M. Keene (eds.), *Heraldry, Pageantry and Social Display in Medieval England*, Woodbridge 2002, pp.17–38.

CRUDEN 1960
S. Cruden, *The Scottish Castle*, London 1960.

CRUICKSHANK 1999
G. Cruickshank, *The Battle of Dunnichen*, Balgavies 1999.

D'ELBOUX 1949
R.H. d'Elboux, 'Testamentary brasses', *Antiquaries Journal*, vol.29, 1949, pp.183–91.

DANIÉLOU 1956
J. Daniélou, *The Bible and the Liturgy*, Notre Dame 1956.

DARLINGTON 1928
R.R. Darlington (ed.), *The Vita Wulfstani of William of Malmesbury*, London 1928.

DAVIDSON CRAGOE 2001
C. Davidson Cragoe, 'Reading and Rereading Gervase of Canterbury', *Journal of the British Archaeological Association*, vol.154, 2001, pp.40–53.

DAVIES, N. 1999
N. Davies, *The Isles: A History*, London 1999.

DAVIES, S. 2004
S. Davis, 'The Teulu, c.633–1283', *Welsh History Review*, vol.21, pt.3, 2004, pp.413–54.

DAVIS 1978
N.Z. Davis, 'Women on Top: Symbolic Sexual Inversion and Political Disorder in Early Modern Europe', in Babcock 1978, pp.147–90.

DE BEER 1948
E.S. de Beer, 'Gothic: Origin and Diffusion of the Term: The Idea of Style in Architecture', *Journal of the Warburg and Courtauld Institutes*, vol.11, 1948, pp.143–62.

DE LUBAC 2000
H. de Lubac, *Medieval Exegesis, The Four Senses of Scripture*, II, trans. E.M. Macierowski, Grand Rapids and Edinburgh 2000.

DENNISON 1986
L. Dennison, '"The Fitzwarin Psalter and its Allies": A Reappraisal', in *England in the Fourteenth Century*, ed. W.M. Ormrod, Woodbridge 1986, pp.42–66.

DENNISON 2001
L. Dennison (ed.), *The Legacy of M.R. James: Papers from the 1995 Cambridge Symposium*, Donington 2001.

DENNISON AND ROGERS 2000
L. Dennison and N. Rogers, 'The Elsing Brass and its East Anglian connections', in N. Saul (ed.), *Fourteenth-Century Studies*, Woodbridge 2000, pp.167–93.

DESHMAN 1995
R. Deshman, *The Benedictional of Aethelwold*, Princeton 1995.

DIDRON 1843
A.-N. Didron, *Iconographie chrétienne: histoire de Dieu*, Paris 1843.

DINZELBACHER 2002
P. Dinzelbacher, *Himmel, Hölle, Heilige. Visionen und Kunst im Mittelalter*, Darmstadt 2002.

DITCHBURN 2001
D. Ditchburn, *Scotland and Europe: The Medieval Kingdom and its Contacts with Christendom, c.1214–1545*, East Linton 2001.

DIXON-SMITH 1999
S. Dixon-Smith, 'The Image and Reality of Almsgiving in the Great Halls of Henry III', *Journal of the British Archaeological Association*, series 3, vol.152, 1999, pp.79–96.

DOBSON 2000
R.B. Dobson, 'Aliens in the City of York during the Fifteenth Century', in Mitchell and Moran 2000, pp.249–66.

DODWELL 1982
C.R. Dodwell, *Anglo-Saxon Art: a New Perspective*, Manchester 1982.

DODWELL 1987
C.R. Dodwell, 'The meaning of "Sculptor" in the Romanesque Period', in N. Stratford (ed.), *Romanesque and Gothic*, Woodbridge 1987, pp.49–61.

DODWELL 1993
C. R. Dodwell, *The Pictorial Arts of the West 800–1200*, New Haven and London 1993.

DODWELL 1996a
C.R. Dodwell, 'The Final Copy of the Utrecht Psalter and its Relationship with the Harley and Eadwine Psalters', in C.R. Dodwell, *Aspects of Art of the Eleventh and Twelfth Centuries*, London 1996, pp.79–124.

DODWELL 1996b
C.R. Dodwell, 'Medieval Attitudes to the Artist', in C.R Dodwell, *Aspects of Art of the Eleventh and Twelfth Centuries*, London 1996, pp.153–71.

DONOVAN 1991
C. Donovan, *The De Brailes Hours: Shaping the Book of Hours in Thirteenth-Century Oxford*, London 1991.

DOUBLEDAY 1903
H.A. Doubleday (ed.), *The Victoria History of the County of Hampshire and the Isle of Wight*, II, London 1903.

DRAPER 1997
P. Draper, 'Interpretations of the Rebuilding of Canterbury Cathedral 1174–1186. Archaeological and Historical Evidence', *Journal of the Society of Architectural Historians*, vol.56, 1997, pp.184–203.

DRAPER 1999
P. Draper, 'St Davids Cathedral: Provincial or Metropolitan?', in F. Joubert, F. and D. Sandron (eds.), *Pierre, lumière, couleur. Études d'histoire de l'art du Moyen Âge en l'honneur d'Anne Prache*, Paris 1999, pp.103–16.

DRAPER 2000
P. Draper, 'English with a French Accent: Architectural *Franglais* in Late Twelfth-Century England?', in Crossley and Clarke 2000, pp.21–36.

DRAPER 2001
P. Draper, 'Canterbury Cathedral: Classical Columns in the Trinity Chapel?', *Architectural History*, vol.44, 2001, pp.172–78.

DRAPER 2004
P. Draper (ed.), *Reassessing Nikolaus Pevsner*, Aldershot 2004.

DRAPER 2006
P. Draper, *The Formation of English Gothic: Art and Identity, 1150–1250*, New Haven and London 2006.

DRESSER 1989
M. Dresser, 'Britannia', in R. Samuel (ed.), *Patriotism: The Making and Unmaking of British National Identity*, vol.3, National Fictions, London 1989, pp.26–49.

DUFFY 1992/2005
E. Duffy, *The Stripping of the Altars. Traditional Religion in England c.1400–c.1580*, New Haven and London 1992; 2nd ed., 2005.

DUFFY 1994
E. Duffy, 'The Parish, Piety, and Patronage in Late Medieval East Anglia: The Evidence of Roodscreens', in K.L. French, G.G. Gibbs and B.A. Kümin (eds.), *The Parish in English Life 1400–1600*, Manchester 1994, pp.133–62.

DUFFY 2001
E. Duffy, *The Voices of Morebath: Reformation and Rebellion in an English Village*, New Haven and London 2001.

DUFFY 2007
E. Duffy, *Marking the Hours. English People and their Prayers, 1240–1570*, New Haven and London 2007.

DUGDALE 1730
W. Dugdale, *The Antiquities of Warwickshire*, London 1730.

EASSON 1957
D.E. Easson, *Medieval Religious Houses: Scotland*, London 1957.

EASTING 2002
R. Easting (ed.), *The Revelation of the Monk of Eynsham*, Early English Text Society, original series, vol.318, Oxford 2002.

ECO 1986
U. Eco, *Art and Beauty in the Middle Ages*, trans. H. Bredin, New Haven and London 1986.

EDWARDS, A. 2002
A.S.G. Edwards (ed.), *Decoration and Illustration in Medieval English Manuscripts*, English Manuscript Studies, vol.10, London 2002.

EDWARDS, J. 1946
J.G. Edwards, 'Edward I's Castle-Building in Wales', *Proceedings of the British Academy*, vol.32, 1946, pp.15–81.

ELKINS 1997
J. Elkins, *Our Beautiful, Dry, and Distant Texts: Art History as Writing*, University Park PA 1997.

ELSNER 2003
J. Elsner, 'Style', in R.S. Nelson and R. Shiff (eds.), *Critical Terms for Art History*, 2nd ed., Chicago and London 2003, pp.98–109.

EMERY 1996–2006
A. Emery, *Greater Medieval Houses of England and Wales*, 3 vols., Cambridge 1996–2006.

EMMERSON 1978
R. Emmerson, 'Monumental Brasses: London Design, c.1420–85', *Journal of the British Archaeological Association*, vol.131, 1978, pp.70–97.

ENGEL 2002
U. Engel, 'The Bayeux Tapestry and All That: Images of War and Combat in the Arts of Medieval England', in B. Korte and R. Schneider (eds.), *War and the Cultural Construction of Identities in Britain*, Amsterdam and New York 2002, pp.61–92.

EVANS, G. 1994
G. Evans, 'The Mace of St Salvator's College', in J. Higgitt (ed.), *Medieval Art and Architecture in the Diocese of St Andrews*, British Archaeological Association Conference Transactions, vol.14, Leeds 1994, pp.197–212.

EVANS, J. 1950
J. Evans, *Cluniac Art of the Romanesque Period*, Cambridge 1950.

EVANS, S. 1963
Geoffrey of Monmouth, *History of the Kings of Britain*, trans. S. Evans, London 1963.

EVELYN 1707
J. Evelyn, *A Parallel of the Ancient Architecture with the Modern … Made English for the Benefit of Builders. To which is added, an Account of Architects and Architecture …*, 2nd ed, London 1707.

FALKENHEIM 1980
J.V. Falkenheim, *Roger Fry and the Beginnings of Formalist Art Criticism*, Studies in the Fine Arts: Criticism, 8, Ann Arbor MI 1980.

FAWCETT 1990
R. Fawcett, 'Glasgow Cathedral', in *Buildings of Scotland: Glasgow*, E. Williamson, A. Riches and M. Higgs (eds.), London 1990.

FAWCETT 1994
R. Fawcett, *The Architectural History of Scotland. Scottish Architecture from the accession of the Stewarts to the Reformation 1371–1560*, Edinburgh 1994.

FAWCETT 1996
R. Fawcett, 'Architectural Links between Scotland and the Low Countries in the Later Middle Ages', in *Utrecht: Britain and the Continent. Archaeology, Art and Architecture*, E. de Bièvre (ed.), British Archaeological Association Conference Transactions, vol.18, Leeds 1996, pp.172–82.

FELSENSTEIN 1995
F. Felsenstein, *Antisemitic Stereotypes: A Paradigm of Otherness in English Popular Culture, 1660–1830*, Baltimore 1995.

FERGUSSON 1984
P. Fergusson, *Architecture of Solitude: Cistercian Abbeys in Twelfth-Century England*, Princeton NJ 1984.

FERGUSSON 2006
P. Fergusson, 'Cistercian Architecture', in Rudolph 2006, pp.577–98.

FERGUSSON AND HARRISON 1999
P. Fergusson and S. Harrison, *Rievaulx Abbey, Community, Architecture, Memory*, New Haven CT and London 1999.

FERNIE 1983
E. Fernie, *The Architecture of the Anglo-Saxons*, London 1983.

FERNIE 1995
E. Fernie, *Art History and its Methods: A Critical Anthology*, London 1995.

FERNIE 2000
E. Fernie, *The Architecture of Norman England*, Oxford 2000.

FERNIE AND WHITTINGHAM 1972
E.C. Fernie and A.B. Whittingham, *The Early Communar and Pittancer Rolls of Norwich Cathedral Priory, with an Account of the Building of the Cloister*, Norfolk Record Society, vol.41, 1972.

FILMER-SANKEY 1996
W. Filmer-Sankey, 'The "Roman Emperor" in the Sutton Hoo Burial', *Journal of the British Archaeological Association*, vol.149, 1996, pp.1–9.

FISHER 2001
I. Fisher, *Early Medieval Sculpture in the West Highlands and Islands*, Edinburgh 2001.

FITCH 1976
M. Fitch, 'The London makers of Opus Anglicanum', *Transactions of the London and Middlesex Archaeological Society*, vol.27, 1976, pp.288–96.

FLOWER AND DAWES 1934
C.T. Flower and M.C.B. Dawes (eds.), *Registrum Simonis de Gandavo Diocesis Saresbiriensis A.D. 1297–1315*, Canterbury and York Society, vols.40, 41, Oxford 1934.

FLURY, SCHMUKI AND TREMP 2002
T. Flury, K. Schmuki and E. Tremp, *Eremus und Insula. St. Gallen und die Reichenau im Mittelalter*, exh. cat., Stiftsbibliothek, St Gallen 2002.

FOCILLON 1942
H. Focillon, *The Life of Forms in Art*, trans. C.B. Hogan and G. Kugler, New Haven 1942.

FOISTER 2004
S. Foister, *Holbein and England*, New Haven and London 2004.

FOISTER 2006
S. Foister, *Holbein in England*, exh. cat., Tate Britain, London 2006.

FORDUN 1993
W.F. Skene (ed.), *John of Fordun's Chronicle of the Scottish Nation*, 1872; reprinted Llanerch 1993.

FOSTER, R. 2002
R. Foster, 'The Context and Fabric of the Westminster Abbey Sanctuary Pavement', in Grant and Mortimer 2002, pp.49–53.

FOSTER, S. 1996
S. Foster, *Picts, Gaels and Scots*, London 1996.

FOSTER, S.M. 1998
S.M. Foster (ed.), *The St Andrews Sarcophagus*, Dublin 1998.

FOUCAULT 1977
M. Foucault, 'What is an Author?', in D. Bouchard (ed.), *Language, Counter-Memory, Practice*, Oxford 1977, pp.113-38.

FOWLER 1903
J.T. Fowler (ed.), *Rites and Monuments of the Cathedral Church of Durham*, Surtees Society, vol.107, Durham 1903.

FRAME 1990
R. Frame, *The Political Development of the British Isles, 1000-1400*, London and New York 1990.

FRANKL 1953
P. Frankl, 'The "Crazy" Vaults of Lincoln Cathedral', *Art Bulletin*, vol.35, no.2, June 1953, pp.95-107.

FRANKL 1960
P. Frankl, *The Gothic: Literary Sources and Interpretations through Eight Centuries*, trans. P. Silz, Princeton 1960.

FREEDMAN 1999
P. Freedman, *Images of the Medieval Peasant*, Stanford CA 1999.

FREEDMAN 2002
P. Freedman, 'The Medieval Other: The Middle Ages as Other', in Jones and Sprunger 2002, pp.1-24.

FREITAG 2004
B. Freitag, *Sheela-na-gigs: Unravelling an Enigma*, London and New York 2004.

FRENCH 1995
T. French, *York Minster, The Great East Window*, Oxford 1995.

FREY 1942
D. Frey, *Englisches Wesen im Spiegel seiner Kunst*, Berlin and Stuttgart 1942.

FRIEDLÄNDER 1941
M.J. Friedländer, *On Art and Connoisseurship*, trans. T. Borenius, London 1941.

FRIEDMAN 1981
J.B. Friedman, *The Monstrous Races in Medieval Art and Thought*, Cambridge MA 1981.

FRIEDMAN 1994
J.B. Friedman, 'Cultural Conflicts in Medieval World Maps', in Schwartz 1994, pp.64-95.

FRY, R. 1933
R.E. Fry, *Art-History as an Academic Study. An Inaugural Lecture Delivered in the Senate House, 18 October 1933*, Cambridge 1933.

FRY, T. 1981
T. Fry (ed. and trans.), *The Rule of St Benedict in Latin and English with Notes*, Collegeville MN 1981.

FULTON 2002
R. Fulton, *From Judgment to Passion. Devotion to Christ and the Virgin Mary, 800-1200*, New York 2002.

GAIMSTER AND GILCHRIST 2003
D. Gaimster and R. Gilchrist (eds.), *The Archaeology of Reformation 1480-1580*, Leeds 2003.

GAMESON 1995
R. Gameson, *The Role of Art in the Late Anglo-Saxon Church*, Oxford 1995.

GARTON 1986
Henry of Avranches, *The Metrical Life of St Hugh of Lincoln*, ed. and trans. C. Garton, Lincoln 1986.

GEDDES 2005
J. Geddes, *The St Albans Psalter, A Book for Christina of Markyate*, London 2005.

GEE 2002
L.L. Gee, *Women, Art and Patronage. From Henry III to Edward III: 1216-1377*, Woodbridge and Rochester NY 2002.

GEM 2001
R. Gem, *Studies in English Pre-Romanesque and Romanesque Architecture*, 2 vols., London 2001.

GENTRY AND KLEINHENZ 1982
F.G. Gentry and C. Kleinhenz, *Medieval Studies in North America: Past, Present, and Future*, Kalamazoo MI 1982.

GERMANN 1972
G.A. Germann, *Gothic Revival in Europe and Britain: Sources, Influences and Ideas*, London 1972.

GIBBS 2000
R. Gibbs, 'Michael Camille's *Braveheart* Psalter', review of Camille 1998, *Apollo*, vol.151, March 2000, pp.61-2.

GIBSON, HESLOP AND PFAFF 1992
M.T. Gibson, T.A. Heslop and R.W. Pfaff (eds.), *The Eadwine Psalter: Text, Image, and Monastic Culture in Twelfth Century Canterbury*, London 1992.

GILES 1852-4
M. Paris, *Matthew Paris's English History*, ed. J.A. Giles, 3 vols., London 1852-4.

GILL 2003
M. Gill, 'The Wall Paintings in Eton College Chapel: The Making of a Late-Medieval Marian Cycle', in Lindley 2003, pp.173-201.

GIROUARD 1978
M. Girouard, *Life in the English Country House*, New Haven and London 1978.

GIROUARD 1983
M. Girouard, *Robert Smythson and the Elizabethan Country House*, New Haven and London 1983.

GJERLOW 1961
L. Gjerlow, *Adoratio Crucis: The Regularis Concordia and the Decreta Lanfranci*, Oslo 1961.

GOMBRICH 1986
E.H. Gombrich, *Aby Warburg: an Intellectual Biography*, revised ed., Chicago 1986.

GOODALL 2001
J. Goodall, *God's House at Ewelme*, Aldershot 2001.

GOODALL 2004
J. Goodall, 'The Great Tower of Carlisle Castle', in *Medieval Art and Architecture at Carlisle*, D. Weston and M. McCarthy (eds.), British Archaeological Association Conference Transactions, vol.27, Leeds 2004, pp.39-62.

GOODALL FORTHCOMING
J. Goodall, *The English Castle*, New Haven and London (forthcoming).

GOODMAN 1927
A.W. Goodman (ed.), *Cartulary of Winchester Cathedral*, Winchester 1927.

GORDON, MONNAS AND ELAM 1997
D. Gordon, L. Monnas and C. Elam (eds.), *The Regal Image of Richard II and the Wilton Diptych*, London 1997.

GRANT AND MORTIMER 2002
L. Grant and R. Mortimer (eds.), *Westminster Abbey: The Cosmati Pavements*, Courtauld Research Papers, vol.3, Aldershot 2002.

GREEN 1999
R.P.H. Green (ed. and trans.), *Augustine: De Doctrina Christiana*, Oxford 1999.

GREENWAY AND SAYERS 1989
Jocelin of Brakelond, *Chronicle of the Abbey of Bury St Edmunds*, trans. D. Greenway and J. Sayers, Oxford 1989.

GRÖSSINGER 1975
C. Grössinger, 'English Misericords of the Thirteenth and Fourteenth Centuries and their relationship to Manuscript Illumination', *Journal of the Warburg and Courtauld Institutes*, vol.38, 1975, pp.97-108.

GRÖSSINGER 1997a
C. Grössinger, *The World Upside-Down: English Misericords*, London 1997.

GRÖSSINGER 1997b
C. Grössinger, *Picturing Women in Late Medieval and Renaissance Art*, Manchester 1997.

GUNN AND LINDLEY 1991
S. Gunn and P. Lindley (eds.), *Cardinal Wolsey. Church, State and Art*, Cambridge 1991.

GURR 1992
A. Gurr, *The Shakespearean Stage 1574-1642*, 3rd ed., Cambridge 1992.

HAIGH 1993
C. Haigh, *English Reformations: Religion, Politics and Society under the Tudors*, Oxford 1993.

HAMBURGER 1993
J. Hamburger, review of Camille 1992, *Art Bulletin*, vol.75, Sept. 1993, pp.319-27.

HAMBURGER 1997
J. Hamburger, 'Medieval Studies and Medieval Art History', in J. Van Engen (ed.). *The Past and Future of Medieval Studies*, Notre Dame 1994, pp.383-400.

HAMBURGER 2006
J. Hamburger, 'Introduction', in J. Hamburger and A.M. Bouché (eds.), *The Mind's Eye: Art and Theological Argument in the Middle Ages*, Princeton 2006, pp.3-10.

HAMER 1970
R. Hamer, *A Choice of Anglo-Saxon Verse*, London 1970.

HAMLING 2007
T. Hamling, 'To See or not to See? The Presence of Religious Imagery in the Protestant Household', *Art History*, vol.30, no.2, April 2007, pp.170-97.

HAMLING AND WILLIAMS 2007
T. Hamling and R. Williams (eds.), *Art Re-formed: Re-assessing the Impact of the Reformation on the Visual Arts*, Cambridge 2007.

HANEY 1986
K. Haney, *The Winchester Psalter: An Iconographic Study*, Leicester 1986.

HANEY 2002
K. Haney, *The St Albans Psalter. An Anglo-Norman Song of Faith*, New York 2002.

HARBISON 1992
P. Harbison, *The High Crosses of Ireland*, 3 vols.,
Bonn 1992.

HARBISON 1999
P. Harbison, *The Golden Age of Irish Art: The Medieval
Achievement, 600-1200*, London 1999.

HARE 2004
M. Hare, 'Abbot Leofsige of Mettlach: an English
monk in Flanders and Upper Lotharingia in the Late
Tenth Century', *Anglo-Saxon England*, vol.33, 2004,
pp.109-44.

HARRISON 1980
M. Harrison, *Victorian Stained Glass*, London 1980.

HARVEY, J.H. 1944
J.H. Harvey, *Henry Yevele c.1320 to 1400: the Life of
an English Architect*, London 1944.

HARVEY, J.H. 1945
J.H. Harvey, 'The Education of the Medieval
Architect', *Journal of the Royal Institute of British
Architects*, vol.52, 1945, pp.230-4.

HARVEY, J.H. 1954/1984/1987
J.H. Harvey, *English Mediaeval Architects: A
Biographical Dictionary Down to 1550: Including
Master Masons, Carpenters, Carvers, Building
Contractors and Others Responsible for Design*,
London 1954; revised eds., 1984 and 1987.

HARVEY, J.H. 1972
J.H. Harvey, *The Mediaeval Architect*, London 1972.

HARVEY, J.H. 1978
J.H. Harvey, *The Perpendicular Style*, London 1978.

HARVEY, P.D.A. 1996
P.D.A. Harvey, *Mappa Mundi: The Hereford World
Map*, Toronto 1996.

HARVEY, P.D.A. AND MCGUINESS 1996
P.D.A. Harvey and A. McGuiness, *A Guide to British
Medieval Seals*, London 1996.

HASKELL 1963
F. Haskell, *Patrons and Painters: A Study in the
Relations between Italian Art and Society in the Age of
the Baroque*, London 1963.

HASSIG 1995
D. Hassig, *Medieval Bestiaries: Text, Image, Ideology*,
Cambridge 1995.

HASTINGS 1949
J.M. Hastings, 'The Court Style' (with editorial
introduction by N. Pevsner), *Architectural Review*,
vol.105, 1949, pp.3-9.

HAUSMANN 1998
F.-R. Hausmann, *'Deutsche Geisteswissenschaft' im
Zweiten Weltkrieg: Die 'Aktion Ritterbusch' (1940-
1945)*, Dresden and Munich 1998; 2nd ed., 2002.

HAUSMANN 2003
F.-R. Hausmann, *Anglistik und Amerikanistik im
'Dritten Reich'*, Frankfurt am Main 2003.

HAUSSHERR 1970
R. Haussherr, 'Kunstgeographie - Aufgaben,
Grenzen, Möglichkeiten', *Rheinische
Vierteljahresblätter*, vol.34, 1970, pp.58-171.

HAY 1956-7
D. Hay, 'The Use of the Term "Great Britain" in the
Middle Ages', *Proceedings of the Society of Antiquaries
of Scotland*, 89 (1956-7), pp.55-66.

HAYS 1963
R. W. Hays, *The History of the Abbey of Aberconway
1186-1537*, Cardiff 1963.

HEARNE 1729
T. Hearne (ed.), *Historia vitæ et Regni Richardi II.
Angliæ Regis*, Oxford 1729.

HENDERSON 1967
G. Henderson, *Gothic*, Harmondsworth 1967.

HENDERSON 1972
G. Henderson, *Early Medieval*, Harmondsworth 1972.

HENDERSON 1987
G. Henderson, *From Durrow to Kells*, London 1987.

HENDERSON AND HENDERSON 2004
G. Henderson and I. Henderson, *The Art of the Picts*,
London 2004.

HENRY 1970
F. Henry, *Irish Art during the Romanesque Period,
1020-1170*, London 1970.

HENRY AND ZARNECKI 1957-8
F. Henry and G. Zarnecki, 'Romanesque Arches
Decorated with Human and Animal Heads', *Journal
of the British Archaeological Association*, 3rd series,
vols.20-1, 1957-8, pp.1-34.

HESLOP 1984
T.A. Heslop, 'Seals', in Zarnecki 1984a, pp.298-319.

HESLOP 1987
T.A. Heslop, 'Attitudes to the Visual Arts: The
Evidence from Written Sources', in Alexander, J.J.G.
and Binski 1987, pp.26-32.

HESLOP 1988
T.A. Heslop, 'The Visual Arts and Crafts', in *The
Cambridge Guide to the Arts in Britain*, II, *The Middle
Ages*, ed. B. Ford., Cambridge 1988, pp.154-99.

HESLOP 1990
T.A. Heslop, 'The Production of De Luxe Manuscripts
and the Patronage of King Cnut and Queen Emma',
Anglo-Saxon England, vol.19, 1990, pp.151-95.

HESLOP 2000
T.A. Heslop, 'Art, Nature and St Hugh's Choir at
Lincoln', in Mitchell and Moran 2000, pp.60-74.

HESLOP 2001
T.A. Heslop, 'Worcester Cathedral Chapterhouse
and the Harmony of the Testaments', in Binski and
Noel 2001, pp.280-311.

HESLOP 2005
T.A. Heslop, 'Swaffham Parish Church: Community
Building in Fifteenth-Century Norfolk', in C. Harper-
Bill (ed.), *Medieval East Anglia*, Woodbridge and
Rochester NY 2005, pp.246-71.

HIGGITT AND SPEARMAN 1993
J. Higgitt and R.M. Spearman, 'Introduction', in R.M.
Spearman and J. Higgitt (eds.), *The Age of Migrating
Ideas*, Proceedings of the Second International
Conference on Insular Art 1991, Edinburgh 1993,
pp.1-2.

HINDMAN ET AL. 2001
S. Hindman, M. Camille, N. Rowe and R. Watson
(eds.), *Manuscript Illumination in the Modern Age*,
exh. cat., Mary and Leigh Block Museum of Art,
North Western University, Evanston IL 2001.

HIPPLE 1957
W. Hipple, *The Beautiful, the Sublime, and the
Picturesque*, Carbondale IL 1957.

HOEY AND THURLBY 2004
L. Hoey and M. Thurlby, 'A Survey of Romanesque
Vaulting in Great Britain and Ireland', *Antiquaries
Journal*, vol.84, 2004, pp.117-84.

HOGG AND SCHLEGEL 2005
J. Hogg and G. Schlegel (eds.), *Monasticon Cartusiense
Volume III*, Salzburg 2005.

HOGLE 2002
J.E. Hogle, *The Cambridge Companion to Gothic
Fiction*, Cambridge 2002.

HOLDER 1988
N. Holder, 'Inscriptions, Writing and Literacy in
Saxon London', *Transactions of the London and
Middlesex Archaeological Society*, vol.49, 1988,
pp.81-98.

HOLLY 1984
M.A. Holly, *Panofsky and the Foundations of Art
History*, Ithaca NY and London 1984.

HOLMES 1937
M.R. Holmes, 'The Crowns of England', *Archaeologia*,
vol.86, 1937, pp.73-90.

HOLMES 1959
M.R. Holmes, 'New Light on St Edward's Crown',
Archaeologia, vol.97, 1959, pp.215-23.

HOOGVLIET 2006
M. Hoogvliet, 'Animals in Context: Beasts on the
Hereford Map and Medieval Natural History',
in P.D.A.Harvey (ed.), *The Hereford World Map.
Medieval World Maps and their Context*, London 2006,
pp.153-65.

HOPE 1835
T. Hope, *An Historical Essay on Architecture*, 2 vols.,
London 1835.

HOPE 1925
W.H. St John Hope, *The History of the London
Charterhouse from Its Foundation until the Suppression
of the Monastery*, London 1925.

HOPE-TAYLOR 1977
B. Hope-Taylor, *Yeavering: An Anglo-British Centre
of Early Northumbria*, London 1977.

HORROX 1994
R. Horrox, *The Black Death*, Manchester 1994.

HOURIHANE 2003
C. Hourihane, *Gothic Art in Ireland, 1169-1550*,
New Haven 2003.

HOWARD, D. 1995
D. Howard, *The Architectural History of Scotland:
Scottish Architecture from the Reformation to the
Restoration, 1560-1660*, Edinburgh 1995.

HOWARD, D. 2000
D. Howard, 'Languages and Architecture in Scotland',
in Crossley and Clark 2000, pp.162-72.

HOWARD, M. 1987
M. Howard, *The Early Tudor Country House:
Architecture and Politics 1490-1550*, London 1987.

HOWARD, M. 1990
M. Howard, 'Self-Fashioning and the Classical Moment in Mid-Sixteenth Century Architecture', in L. Gent and N. Llewellyn (eds.), *Renaissance Bodies: The Human Figure in English Culture 1540–1660*, London 1990, pp.198–217.

HOWARD, M. 1995
M. Howard, *The Tudor Image*, London 1995.

HOWARD, M. AND LLEWELLYN 1989
M. Howard and N. Llewellyn, 'Painting and Imagery', in B. Ford (ed.), *The Cambridge Guide to the Arts in Britain*, Cambridge 1989, pp.222–59.

HOWARD, R.E., LAXTON AND LITTON 2001
R.E. Howard, R.R. Laxton and C.D. Litton, *Timber: Dendrochronology of Roof Timbers at Lincoln Cathedral*, English Heritage Research Transactions, vol.7, 2001.

HOWE 2001
E. Howe, 'Divine Kingship and Dynastic Display: The Altar Wall Murals of St Stephen's Chapel, Westminster', *Antiquaries Journal*, vol.81, 2001, pp.259–303.

HUFFMAN 1998
J.P. Huffman, *Family, Commerce, and Religion in London and Cologne: Anglo-German Emigrants, c.1000–1300*, Cambridge 1998.

JAMES, E. 2001
E. James, *Britain in the First Millennium*, Britain and Europe series, London 2001.

JAMES, M.R. 1895
M.R. James, *On the Abbey of Bury S. Edmunds*, Cambridge 1895.

JANSEN 2004
V. Jansen, 'Deutsche und englische Architektur der Parlerzeit im Vergleich', *Parlerbauten. Architektur, Skulptur, Restaurierung. Internationales Parler-symposium Schwäbisch Gmünd, 17.–19. Juni 2001*, Stuttgart 2004, pp.181–9.

JANSON 1952
H.W. Janson, *Apes and Ape Lore in the Middle Ages and the Renaissance*, London 1952.

JONES 2000
M. Jones, 'The Misericords', in R. Horrox (ed.), *Beverley Minster: An Illustrated History*, Cambridge 2000.

JONES AND SPRUNGER 2002
T.S. Jones and D. Sprunger (eds.), *Monsters and Miracles: Studies in the Medieval and Early Modern Imaginations*, Kalamazoo MI 2002.

KARLSSON 1988
L. Karlsson, *Medieval Decorative Ironwork in Sweden*, I, Stockholm 1988.

KAUFFMANN 1975
C.M. Kauffmann, *Romanesque Manuscripts 1066–1190*, A Survey of Manuscripts Illuminated in the British Isles, III, London 1975.

KAUFFMANN 2001
C.M. Kauffmann, 'British Library, Lansdowne MS383: The Shaftesbury Psalter?', in Binski and Noel 2001, pp.256–79.

KAUFFMANN 2003
C.M. Kauffmann, *Biblical Imagery in Medieval England*, London 2003.

KAUFMANN 2004
T. DaCosta Kaufmann, *Toward a Geography of Art*, Chicago and London 2004.

KEEN 1984
M. Keen, *Chivalry*, New Haven and London 1984.

KELLY 1996
E.P. Kelly, *Sheela-na-Gigs: Origins and Functions*, Dublin 1996.

KEMPERS 1992
B. Kempers, *Painting, Power and Patronage: The Rise of the Professional Artist in Renaissance Italy*, trans. B. Jackson, Frome and London 1992.

KENDRICK 1938
T.D. Kendrick, *Anglo-Saxon Art to A.D. 900*, London 1938.

KENT 1949
J.P.C. Kent, 'Monumental Brasses – A New Classification of Military Effigies c.1360–1485', *Journal of the British Archaeological Association*, vol.12, 1949, pp.70–97.

KERMODE 1994
P.M.C. Kermode, *Manx Crosses*, introd. D.M. Wilson, Balgavies 1994.

KESSLER 2000
H.L. Kessler, *Spiritual Seeing. Picturing God's Invisibility in Medieval Art*, Philadelphia 2000.

KESSLER 2004
H.L. Kessler, *Seeing Medieval Art*, Toronto 2004.

KIDSON 1996
P. Kidson, 'The Mariakerk at Utrecht, Speyer, and Italy', in E. de Bièvre (ed.), *Utrecht: Britain and the Continent. Archaeology, Art and Architecture*, British Archaeological Association Conference Transactions, vol.18, Leeds 1996, pp.123–36.

KING, D. 1987
D. King, 'Embroidery and Textiles', in Alexander and Binski 1987, pp.157–61.

KING, J. 1989
J.N. King, *Tudor Royal Iconography*, Princeton 1989.

KIPLING 1977
G. Kipling, *The Triumph of Honour. Burgundian Origins of the Elizabethan Renaissance*, Leiden 1977.

KLINE 2001
N.R. Kline, *Maps of Medieval Thought: The Hereford Paradigm*, Woodbridge 2001.

KNIGHT 2001
R. Knight, 'Werewolves, Monsters, and Miracles: Representing Colonial Fantasies in Gerald of Wales's *Topographia Hibernica*', *Studies in Iconography*, vol.22, 2001, pp.5–86.

KNOWLES, D. 1976
D. Knowles, *Bare Ruined Choirs, The Dissolution of the English Monasteries*, Cambridge 1976.

KNOWLES, D. AND HADCOCK 1996
D. Knowles and R.N. Hadcock, *Medieval Religious Houses: England and Wales*, Harlow 1996.

KNOWLES, J.A. 1925
J.A. Knowles, 'Disputes between English and Foreign Glass-Painters in the Sixteenth Century', *Antiquaries Journal*, vol.5, 1925, pp.148–57.

KOWA 1990
G. Kowa, *Architektur der englischen Gotik*, Cologne 1990.

KRASNODEBSKA-D'AUGHTON 2002
M. Krasnodebska-D'Aughton, 'Decoration of the *In Principio* Initials in Early Insular Manuscripts: Christ as a Visible Image of the Invisible God', *Word and Image*, vol.18, no.2, April–June 2002, pp.105–22.

LADNER 1995
G.B. Ladner, *God, Cosmos, and Humankind: The World of Early Christian Symbolism*, Berkeley 1995.

LANG 1991
J.T. Lang, *York and Eastern Yorkshire*, Corpus of Anglo-Saxon Stone Sculpture, vol.3, Oxford 1991.

LECLERQ 1978
J. Leclerq, *The Love of Learning and the Desire for God: A Study of Monastic Culture*, London 1978.

LEHMANN-BROCKHAUS 1955–60
O. Lehmann-Brockhaus (ed.), *Lateinische Schriftquellen zur Kunst in England, Wales und Schottland vom Jahre 901 bis zum Jahre 1307*, 5 vols., Munich 1955–60.

LENIAUD 1994
J.-M. Leniaud, *Viollet-le-Duc, ou, les délires du système*, Paris 1994.

LEPSKY AND NUSSBAUM 1999
S. Lepsky and N. Nussbaum, *Das gotische Gewölbe. Eine Geschichte seiner Form und Konstruktion*, Darmstadt 1999.

LETHABY 1906
W.R. Lethaby, *Westminster Abbey & The King's Craftsmen: A Study of Mediaeval Building*, London 1906.

LETHABY 1925
W.R. Lethaby, *Westminster Abbey Re-examined*, London 1925.

LEVINE 1986
P. Levine, *The Amateur and the Professional. Antiquarians, Historians and Archaeologists in Victorian England 1838–1886*, Cambridge 1986.

LEWIS, S. 1995a
S. Lewis, *Reading Images. Narrative discourse and reception in the thirteenth-century illuminated Apocalypse*, Cambridge 1995.

LEWIS, S. 1995b
S. Lewis, 'Henry III and the Gothic Rebuilding of Westminster Abbey: The Problematics of Context', *Traditio*, 50, 1995, pp.129–72.

LEWIS, S. 1997
S. Lewis, *The Art of Matthew Paris in the "Chronica Majora"*, Berkeley 1997.

LEWIS, W.S. ET AL. 1937–83
Lewis, W.S. et al. (eds.), *The Yale Edition of Horace Walpole's Correspondence*, 48 vols., Oxford and New Haven 1937–83.

LINDLEY 1991
P. Lindley, 'Romanticising Reality: The Sculptural Memorials of Queen Eleanor and their Context', in D. Parsons, ed., *Eleanor of Castile*, Stamford 1991, pp.68–92.

LINDLEY 1994
P. Lindley, 'Westminster and London: Sculptural
Centres in the Thirteenth Century', in H. Beck and
K. Hengevoss-Dürkop (eds.), *Studien zur Geschichte
der Europäischen Skulptur im 12/13 Jahrhundert*,
Frankfurt 1994, pp.231-50.

LINDLEY 1995
P. Lindley, *Gothic to Renaissance: Essays on Sculpture
in England*, Stamford 1995.

LINDLEY 2006
P. Lindley, 'Two Fourteenth-Century Tomb
Monuments at Abergavenny and the Mournful End
of the Hastings Earls of Pembroke', in J.R. Kenyon
and D.M. Williams (eds.), *Cardiff: Architecture and
Archaeology in the Medieval Diocese of Llandaff*,
British Archaeological Association Conference
Transactions, vol.29, Leeds 2006, pp.136-60.

LIPMAN 1967
V.D. Lipman, *The Jews of Medieval Norwich*,
London 1967.

LLEWELLYN 2000
N. Llewellyn, *Funeral Monuments in Post-Reformation
England*, Cambridge 2000.

LLOYD AND THURLEY 1990
C. Lloyd and S. Thurley, *Henry VIII: Images of a
Tudor King*, Oxford 1990.

LODGE AND SOMERVILLE 1937
E.C. Lodge and R. Somerville (eds.), *John of Gaunt's
Register 1379-83*, London 1937.

LONDON 1971
Victorian Church Art, exh. cat., Victoria and Albert
Museum, London 1971.

LOOMIS 1956-57
R.S. Loomis, 'Scotland and the Arthurian Legend',
Proceedings of the Society of Antiquaries of Scotland,
vol.89, 1956-7, pp.1-2.

LORD 2003
P. Lord, *Medieval Vision: The Visual Culture of
Wales*, Cardiff 2003.

LUXFORD 2003
J.M. Luxford, 'Emile Mâle (1862-1954)', in
C. Murray (ed.), *Key Writers on Art: The Twentieth
Century*, London and New York 2003, pp.204-11.

LUXFORD 2005
J.M. Luxford, *The Art and Architecture of
Benedictine Monasteries, 1300-1540:
A Patronage History*, Woodbridge and Rochester NY
2005.

MACCOLL 2006
A. MacColl, 'The Meaning of "Britain" in Medieval
and Early Modern Europe', *Journal of British Studies*,
vol.45, no.2, April 2006, pp.248-69.

MACCULLOCH 2003
D. MacCulloch, *Reformation. Europe's House Divided
1490-1700*, London 2003.

MCKEAN 2001
C. McKean, *The Scottish Chateau. The Country House
of Renaissance Scotland*, Stroud 2001.

MCNEILL 1997
T. McNeill, *Castles in Ireland*, London and
New York 1997.

MCROBERTS 1956
D. McRoberts, 'The Fetternear Banner', *The Innes
Review*, vol.7, no.2, Autumn 1956, pp.69-86.

MCROBERTS 1981
D. McRoberts, *The Heraldic Ceiling of St Machar's
Cathedral, Aberdeen*, Friends of St Machar's Cathedral,
Occasional Papers, no.2, Aberdeen 1981.

MAGINNIS 1990
H.B.J. Maginnis, 'The Role of Perceptual Learning
in Connoisseurship: Morelli, Berenson and Beyond',
Art History, vol.13, no.1, 1990, pp.104-17.

MALONE 2004
C.M. Malone, *Façade as Spectacle. Ritual and Ideology
at Wells Cathedral*, Boston and Leiden 2004.

MANN 1973
J. Mann, *Chaucer and Medieval Estates Satire: The
Literature of Social Classes and the General Prologue to
The Canterbury Tales*, Cambridge 1973.

MARKS 1984
R. Marks, *The Stained Glass of the Collegiate Church
of the Holy Trinity, Tattershall (Lincs.)*, New York and
London 1984.

MARKS 1993
R. Marks, *Stained Glass in England during the
Middle Ages*, London 1993.

MARKS 2004
R. Marks, *Image and Devotion in Late Medieval
England*, Stroud 2004.

MARKS AND WILLIAMSON 2003
R. Marks and P. Williamson (eds.), *Gothic: Art for
England 1400-1547*, exh. cat., Victoria and Albert
Museum, London 2003.

MARTINDALE 1967
A. Martindale, *Gothic Art*, London 1967.

MARTINDALE 1972
A. Martindale, *The Rise of the Artist in the Middle Ages
and Early Renaissance*, London 1972.

MASON 1976
E. Mason, 'The Role of the English Parishioner,
1100-1500', *Journal of Ecclesiastical History*, vol.27,
1976, pp.17-29.

MATTHEW 2005
D. Matthew, *Britain and the Continent 1000-1300:
The Impact of the Norman Conquest*, Britain and
Europe series, London 2005.

MATTINGLY 2000
J. Mattingly, 'Stories in the Glass - Reconstructing
the St Neot Pre-Reformation Glazing Scheme',
Journal of the Royal Institution of Cornwall, n.s.,
vol.3, 2000, pp.9-55.

MELLINKOFF 1970
R. Mellinkoff, *The Horned Moses in Medieval Art
and Thought*, Berkeley 1970.

MELLINKOFF 1993
R. Mellinkoff, *Outcasts: Signs of Otherness in
Northern European Art of the Late Middle Ages*,
2 vols., Berkeley 1993.

MENTEL 2002
R. Mentel, *Building Scotland's Church: Das erste
Jahrhundert schottischer Kirchenbaukunst (1125-1200)*,
Weimar 2002.

MEYER, A.R. 2003
A.R. Meyer, *Architectural Allegory and the Building
of the New Jerusalem*, Cambridge 2003.

MEYER, R. 2003
R. Meyer, 'Identity', in R.S. Nelson and R. Shiff (eds.),
Critical Terms for Art History, 2nd ed., Chicago and
London 2003, pp.345-57.

MICHAEL 1993
M.A. Michael, 'English Illuminators c.1190-1450:
A Survey from Documentary Sources', *English
Manuscript Studies*, vol.4, 1993, pp.62-113.

MILLAR 1963
O. Millar, *The Tudor, Stuart and Early Georgian
Pictures in the Collection of Her Majesty The Queen*,
London 1963.

MILLETT AND WOGAN-BROWNE 1990
B. Millett and J. Wogan-Browne (eds.), *Medieval
English Prose for Women: Selections from the
Katherine Group and Ancrene Wisse*, Oxford 1990.

MILLS 2005
R. Mills, *Suspended Animation: Pain, Pleasure and
Punishment in Medieval Culture*, London 2005.

MITCHELL 2000
J. Mitchell, 'Painting in East Anglia around 1500:
The Continental Connection', in Mitchell and Moran
2000, pp.349-64.

MITCHELL AND MORAN 2000
J. Mitchell and M. Moran (eds.), *England and the
Continent in the Middle Ages: Studies in Memory of
Andrew Martindale*, Proceedings of the 1996
Harlaxton Symposium, Stamford 2000.

MITTMAN 2003
A.S. Mittman, 'The Other Close at Hand: Gerald of
Wales and the "Marvels of the West"', in Bildhauer
and Mills 2003, pp.97-112.

MITTMAN 2006
A.S. Mittman, *Maps and Monsters in Medieval England*,
New York 2006.

MOLLAT 1986
M. Mollat, *The Poor in the Middle Ages: An Essay
in Social History*, trans. Arthur Goldhammer,
New Haven 1986.

MOMIGLIANO 1966
A. Momigliano, *Studies in Historiography*, London
1966.

MONNAS 1997
L. Monnas, 'Fit for a King: Figured Silks shown in
the Wilton Diptych', in Gordon, Monnas and Elam
1997, pp.165-77.

MOORE 1987
R.I. Moore, *The Formation of a Persecuting Society:
Power and Deviance in Western Europe, 950-1250*,
Oxford 1987.

MOREWEDGE 1975
R.T. Morewedge (ed.), *The Role of Woman in the
Middle Ages*, London 1975.

MORGAN 1982/1988
N.J. Morgan, *Early Gothic Manuscripts (I), 1190-1250
and (II) 1250-85*, A Survey of Manuscripts
Illuminated in the British Isles, 4, 2 vols., London
1982 and 1988.

MORGAN 2005
N.J. Morgan, 'Patrons and Their Devotions in the Historiated Initials and Full-Page Miniatures of 13th-Century English Psalters', in F.O. Büttner (ed.), *The Illuminated Psalter: Studies in the Content, Purpose and Placement of its Images*, Turnhout 2005, pp.309-22.

MORGANSTERN 2000
A.M. Morganstern, *Gothic Tombs of Kinship in France, the Low Countries, and England*, University Park PA 2000.

MORRIS, C. 1973
C. Morris, *The Discovery of the Individual, 1050-1200*, New York 1973.

MORRIS, R.K. 1978/1979
R.K. Morris, 'The Development of Later Gothic Mouldings in England c.1250-1400, pts I and II', *Architectural History*, vol.21, 1978, pp.18-57; vol.22, 1979, pp.1-48.

MORRIS, R.K. 1990
R.K. Morris, 'Mouldings and the Analysis of Medieval Style', in E. Fernie and P. Crossley (eds.), *Medieval Architecture and its Intellectual Context*, London 1990, pp.239-47.

MORRIS, R.K. 2000
R.K. Morris, 'Architectural Terracotta Decoration in Tudor England', in P. Lindley and T. Frankenberg (eds.), *Secular Sculpture c.1350-1550*, Stamford 2000, pp.179-210.

MORRIS, R.K. 2006
R.K. Morris, *Kenilworth Castle*, English Heritage Guidebooks, London 2006.

MOSS 2007
R. Moss, 'Permanent Expressions of Piety: The Secular and the Sacred in Later Medieval Stone Sculpture', in R. Moss, C. ÓClabaigh and S. Ryan (eds.), *Art and Devotion in Late Medieval Ireland*, Dublin 2007, pp.72-97.

MUNBY, BARBER AND BROWN 2007
J. Munby, R. Barber, R. Brown, *Edward III's Round Table at Windsor: The House of the Round Table and the Windsor Festival of 1344*, Woodbridge 2007.

MYRES 1967
J.N.L. Myres, 'Recent Discoveries in the Bodleian Library', *Archaeologia*, vol.101, 1967, pp.151-68.

MYRONE 2006
M. Myrone, *Gothic Nightmares: Fuseli, Blake and the Romantic Imagination*, exh. cat., Tate Britain, London 2006.

NASH-WILLIAMS 1950
V.E. Nash-Williams, *The Early Christian Monuments of Wales*, Cardiff 1950.

NEES 2002
L. Nees, *Early Medieval Art*, Oxford 2002.

NEES 2003
L. Nees, 'Reading Aldred's colophon for the Lindisfarne Gospels', *Speculum*, vol.78, no.2, 2003, pp.333-77.

NEES 2005
L. Nees, 'On the Image of Christ Crucified in Early Medieval Art', in M.C. Ferrari and A. Meyer (eds.),

Il Volto Santo in Europa. Culto e immagini del Crocifisso nel Medioevo, Lucca 2005, pp.244-85.

NICHOLS 2002
A.E. Nichols, *The Early Art of Norfolk*, Kalamazoo MI 2002.

NOCKLES 1994
P.B. Nockles, *The Oxford Movement in Context: Anglican High Churchmanship 1760-1857*, Cambridge 1994.

NOEL 1995
W. Noel, *The Harley Psalter*, Cambridge 1995.

NORTH 1937
F.J. North, 'Humphrey Lhuyd's Maps of England and of Wales', *Archaeologia Cambrensis*, vol.92, 1937, pp.11-63.

NORTON 2001
C. Norton, '*Liber specialis et preciosus*: An Illuminated Life of St Cuthbert from Durham', in P. Binski and W. Noel (eds.), *New Offerings, Ancient Treasures: Studies in Medieval Art for George Henderson*, Stroud 2001, pp.210-34.

NORTON 2002
C. Norton, 'The Luxury Pavement in England before Westminster', in Grant and Mortimer 2002, pp.11-16.

NORTON 2005
C. Norton, 'Sacred Space and Sacred History: The Glazing of the Eastern Arm of York Minster', in *Glasmalerei im Kontext Bildprogramme und Raumfunktionen*, Akten des XXII. Internationalen Colloquiums des Corpus Vitrearum, Nuremberg 2005, pp.167-81.

Ó CARRAGÁIN 2005
É. Ó Carragáin, *Ritual and the Rood: Liturgical Images and the Old English Poems of the 'Dream of the Rood' Tradition*, London 2005.

O'MEARA 1982
Gerald of Wales, *The History and Topography of Ireland*, trans. J.J. O'Meara, Mountrath 1982.

O'REILLY 1987
J. O'Reilly, 'The Rough-Hewn Cross in Anglo-Saxon Art', in M. Ryan (ed.), *Ireland and Insular Art A.D. 500-1200*, Dublin 1987, pp.153-8.

O'REILLY 1987-8
J. O'Reilly, 'Early Medieval Text and Image: The Wounded and Exalted Christ', *Peritia*, vols.6-7, 1987-8, pp.72-18.

O'REILLY 1992a
J. O'Reilly, 'The Trees of Eden in Medieval Iconography', in P. Morris and D. Sawyer (eds.), *A Walk in the Garden. Biblical, Iconographical and Literary Images of Eden*, Sheffield 1992, pp.167-204.

O'REILLY 1992b
J. O'Reilly, 'St John as a Figure of the Contemplative Life: Text and Image in the Art of the Anglo-Saxon Benedictine Reform', in N.L. Ramsay, M.J. Sparks and T. Tatton-Brown (ed.), *St Dunstan: His Life, Times and Cult*, Woodbridge 1992, pp.165-85.

O'REILLY 1998
J. O'Reilly, 'Patristic and Insular traditions of the Evangelists: Exegesis and Iconography', in A.M. Luiselli Fadda and É.Ó. Carragáin (ed.), *Le Isole Britanniche e Roma in Età Romanobarbarica*, Rome 1998, pp.49-94.

OAKESHOTT 1945
W.F. Oakeshott, *The Artists of the Winchester Bible*, London 1945.

ODNB
H.C.G. Matthew and B. Harrison (eds.), *Oxford Dictionary of National Biography*, Oxford 2004.

OKASHA 1971
E. Okasha, *Hand-List of Anglo-Saxon Non-runic Inscriptions*, Cambridge 1971.

ORCHARD 1995
A. Orchard, *Pride and Prodigies: Studies in the Monsters of the Beowulf-Manuscript*, Cambridge 1995.

ORME 1973
N. Orme, *English Schools in the Middle Ages*, London 1973.

ORME AND WEBSTER 1995
N. Orme and M. Webster, *The English Hospital 1070-1570*, New Haven and London 1995.

ORMROD AND LINDLEY 1996
W.M. Ormrod and P.G. Lindley (eds.), *The Black Death in England*, Stamford 1996.

ORTENBERG 1990
V. Ortenberg, 'Archbishop Sigeric's Journey to Rome in 990', *Anglo-Saxon England*, vol.19, 1990, pp.197-246.

OSWALD 1951-5
A. Oswald, 'Barnard Flower, the King's Glazier', *Journal of the British Society of Master Glass Painters*, vol.11 (1951-5), pp.8-21.

PÄCHT, DODWELL AND WORMALD 1960
O. Pächt, C.R. Dodwell and F. Wormald, *The St Albans Psalter (Albani Psalter)*, London 1960.

PANOFSKY 1979
E. Panofsky (ed. and trans.), *Abbot Suger on the Abbey Church of St.-Denis and Its Art Treasures*, 2nd ed., Princeton 1979.

PARKER 1981
E.C. Parker, 'Master Hugo as Sculptor: A Source for the Style of the Bury Bible', *Gesta*, vol.20, no.1, 1981, pp.99-109.

PARSONS 2001
J.C. Parsons, 'The Second Exhumation of King Arthur's Remains at Glastonbury, 19 April 1278', in J.P. Carley (ed.), *Glastonbury Abbey and the Arthurian Tradition*, Woodbridge and Rochester NY 2001, pp.179-83.

PAYNE 1987
A. Payne, 'Medieval Heraldry', in Alexander and Binski 1987, pp.55-9.

PEACHAM 1612
H. Peacham, *Minerva Britannia*, London 1612.

PERCY 1905
B. Percy (ed.), *The Northumberland Household Book, The Regulations and Establishment of the Household of Henry Algernon Percy, 5th Earl of Northumberland begun 1512*, London 1905.

PEVSNER 1942
N. Pevsner, 'The Term "Architect" in the Middle Ages', *Speculum*, vol.17, 1942, pp.549-62.

PEVSNER 1993
N. Pevsner, *The Englishness of English Art*,
London 1956; reprint of the 1964 ed.,
Harmondsworth 1993.

PFAFF 1980
R.W. Pfaff, *Montague Rhodes James*, London 1980.

PHILLIPS 1973
J. Phillips, *The Reformation of Images. Destruction
of Art in England 1530-1660*, Berkeley and
Los Angeles 1973.

PLANT 2002
R. Plant, 'English Romanesque and the Empire',
in J. Gillingham (ed.), *Anglo-Norman Studies*,
vol.24, Proceedings of the Battle Conference 2001,
Woodbridge 2002, pp.177-203.

PLATT 1981
C. Platt, *The Parish Churches of Medieval England*,
London 1981.

PLATT 1984
C. Platt, *The Abbeys and Priories of England*,
London 1984.

PLUMMER 1896
Bede, *Historia Abbatum*, in *Venerabilis Bedae Opera
Historica*, ed. C. Plummer, I, Oxford 1896.

POCOCK 1975
J.G.A. Pocock, 'British History: A Plea for a New
Subject', *Journal of Modern History*, vol.47, no.4,
1975, pp.601-21.

PODRO 1982
M. Podro, *The Critical Historians of Art*, New Haven
and London 1982.

PORTER AND TEICH 1992
R. Porter and M. Teich (eds.), *The Renaissance in
National Context*, Cambridge 1992.

PREEST 2002
William of Malmesbury, *The Deeds of the Bishops
of England*, trans. D. Preest, Woodbridge and
Rochester NY 2002.

PREZIOSI 1989
D. Preziosi, *Rethinking Art History: Meditations on
a Coy Science*, New Haven 1989.

PURVIS 1936
J.S. Purvis, 'The Use of Continental Woodcuts and
Prints by the "Ripon School" of Woodcarvers in
the Early Sixteenth Century', *Archaeologia*, vol.85,
1936, pp.107-28.

RAHNER 1963
H. Rahner, *Greek Myths and Christian Mystery*,
London 1963.

RAMSAY 1987
N. Ramsay, 'Artists, Craftsmen and Design in
England, 1200-1400' in Alexander, J.J.G. and Binski
1987, pp.49-54.

RANSOME 1960
D.R. Ransome, 'The Struggle of the Glaziers'
Company with the Foreign Glaziers, 1500-1550',
Guildhall Miscellany, vol.2, 1960, pp.12-20.

RAW 1990
B. Raw, *Anglo-Saxon Crucifixion Iconography*,
Cambridge 1990.

RAWCLIFFE 1995
C. Rawcliffe, *Medicine and Society in Late Medieval
England*, Stroud 1995.

REDDAWAY 1975
T.F. Reddaway, *The Early History of the Goldsmiths'
Company*, London 1975.

REES AND BORZELLO 1986
A.L. Rees and F. Borzello, *The New Art History*,
London 1986.

REEVE 2007
M. Reeve, *The Thirteenth Century Wall Painting of
Salisbury Cathedral: Art, Liturgy, and Reform*,
Woodbridge 2007.

REYNOLDS 2003
C. Reynolds, 'England and the Continent: Artistic
Relations', in Marks and Williamson 2003, pp.76-86.

RICHES 2000
S. Riches, *St George: Hero, Martyr and Myth*, Stroud
2000.

RICHMOND 1996
C. Richmond, 'Religion', in R. Horrox (ed.), *Fifteenth
Century Attitudes*, Cambridge 1996, pp.183-201.

RICKERT 1954
M. Rickert, *Painting in Britain: The Middle Ages*,
Harmondsworth 1954.

RICKMAN 1817
T. Rickman, *An Attempt to Discriminate the Styles
of English Architecture from the Conquest to the
Reformation; preceded by a Sketch of the Grecian and
Roman Orders ...*, London n.d. but 1817.

RILEY 1861
H.T. Riley (ed.), *Liber Albus: The White Book of
the City of London*, London 1861.

RILEY 1867-69
H.T. Riley (ed.), *Gesta abbatum monasterii Sancti
Albani*, Rolls Series, 28, 3 vols., London 1867-9.

RILEY 1871
H.T. Riley (ed.), *Annales monasterii S. Albani, a
Johanne Amundesham*, Rolls Series 28, vol.5, part 2,
London 1871.

ROBERTS 1977
E. Roberts, 'Moulding Analysis and Architectural
Research', *Architectural History*, vol.20, 1977, pp.5-13.

RONAYNE 1997
J. Ronayne, 'Totus mundus agit histrionem', in J.
Mulryne and M. Shewring (eds.), *Shakespeare's Globe
Rebuilt*, Cambridge 1997, pp.121-46.

ROSE-TROUP 1929
F. Rose-Troup, *Bishop Grandisson, Student and
Art-Lover*, Plymouth 1929.

ROSSER 1997
G. Rosser, 'Crafts, Guilds and the Negotiations of
Work in the Medieval Town,' *Past and Present*,
vol.154, 1997, pp.3-31.

ROTH 1962
C. Roth, *Essays and Portraits in Anglo-Jewish History*,
Philadelphia 1962.

RUBENS 1986
G. Rubens, *William Richard Lethaby: His Life and
Work 1857-1931*, London 1986.

RUBIN 1999
M. Rubin, *Gentile Tales: The Narrative Assault on
Late Medieval Jews*, New Haven and London 1994.

RUDOLPH 2006
C. Rudolph (ed.), *A Companion to Medieval Art:
Romanesque and Gothic in Northern Europe*, Malden
MA, Oxford and Carlton VIC 2006.

RUSKIN 1880
J. Ruskin, 'Our fathers have told us': Sketches of the
History of Christendom for Boys and Girls who have
been Held at its Fonts. Part 1, The Bible of Amiens*,
Orpington 1880.

RYAN 1983
M. Ryan (ed.), *Treasures of Ireland*, Dublin 1983.

SAINT 1983
A. Saint, *The Image of the Architect*, New Haven and
London 1983.

SALISBURY 1994
J.E. Salisbury, *The Beast Within: Animals in the
Middle Ages*, London and New York 1994.

SALZMAN 1952/1992
L.F. Salzman, *Building in England Down to 1540*,
Oxford 1952; reprinted 1992.

SAMPSON 1998
J. Sampson, *Wells Cathedral West Front. Construction,
Sculpture and Conservation*, Stroud 1998.

SANDLER 1974
L.F. Sandler, *The Peterborough Psalter in Brussels &
Other Fenland Manuscripts*, London 1974.

SANDLER 1983
L.F. Sandler, *The Psalter of Robert de Lisle*, London 1983.

SANDLER 1986
L. Freeman Sandler, *Gothic Manuscripts 1285-1385*,
A Survey of Manuscripts Illuminated in the British
Isles, 5, 2 vols., London 1986.

SANDLER 1999
L.F. Sandler, *The Psalter of Robert de Lisle in the
British Library*, London 1999.

SANSONE 1906
G. Vasari, *Le opere*, ed. G.C. Sansone, 9 vols.,
Florence 1906.

SAUERLÄNDER 1983
W. Sauerländer, 'From Stilus to Style: Reflections
on the Fate of a Notion', *Art History*, vol.6, no.3, 1983,
pp.253-70.

SAUERLÄNDER 1988
W. Sauerländer, 'Age of Chivalry: Art in Plantagenet
England, 1200-1400' (exhibition review), *Burlington
Magazine*, vol.130, Feb. 1988, pp.149-51.

SAUERLÄNDER 2004
W. Sauerländer, 'Gothic: Art for England 1400-1540'
(exhibition review), *Apollo*, vol.159, Feb. 2004,
pp.59-60.

SAUL 2006
N. Saul, 'The Contract for the Brass of Richard
Willoughby (d.1471) at Wollaton (Notts.)', *Nottingham
Medieval Studies*, vol.50, 2006, pp.166-93.

SAUNDERS 1932
O.E. Saunders, *A History of English Art in the
Middle Ages*, Oxford 1932.

SCHAPIRO 1953
M. Schapiro, 'Style', in A.L. Kroeber (ed.),
Anthropology Today: an Encyclopaedic Inventory,
Chicago 1953, pp.287-312.

SCHILLER 1972
G. Schiller, *The Iconography of Christian Art*, trans.
Janet Seligman, 2 vols., London 1972.

SCHMIDT 1995
W. Langland, *The Vision of Piers Plowman: A Critical
Edition of the B-Text Based on Trinity College Cambridge
MS B.15.17*, ed. A.V.C. Schmidt, London 1995.

SCHRECKENBERG 1996
H. Schreckenberg, *The Jews in Christian Art: An
Illustrated History*, London 1996.

SCHWARTZ 1994
S. Schwartz (ed.), *Implicit Understandings: Observing,
Reporting, and Reflecting on the Encounters Between
Europeans and Other Peoples in the Early Modern Era*,
Cambridge 1994.

SCOTT 1996
K.L. Scott, *Later Gothic Manuscripts 1390-1490*,
A Survery of Manuscripts Illuminated in the British
Isles, 6, 2 vols., London 1996.

SEARLE 1980
E. Searle (ed. and trans.), *The Chronicle of
Battle Abbey*, Oxford 1980.

SEARS AND THOMAS 2002
E. Sears and T.K.Thomas (eds.), *Reading Medieval
Images. The Art Historian and the Object*, Michigan 2002.

SEKULES 1990
V. Sekules, 'The Sculpture and Liturgical Furnishings
of Heckington Church and Related Monuments:
Masons and Benefactors in Early Fourteenth-Century
Lincolnshire', unpublished PhD thesis, University of
London 1990.

SEKULES 2000
V. Sekules, 'Dynasty and Patrimony in the Self-
Construction of an English Queen: Philippa of
Hainault and her Images', in Mitchell and Moran 2000,
pp.157-74.

SEKULES 2001
V. Sekules, *The Oxford History of Art: Medieval Art*,
Oxford 2001.

SHARPE 1890
R.R. Sharpe (ed.), *Calendar of Wills, Proved and
Enrolled in the Court of Hustings, London, AD 1258 –
AD 1688*, 2 vols., London 1890.

SHARPE 1899
R.R. Sharpe (ed.), *Calendar of Letter-Books … of the City
of London: Letter-Book A c.1275-1298*, London 1899.

SHEARMAN 1983
J. Shearman, *The Early Italian Pictures in the Collection
of Her Majesty The Queen*, Cambridge 1983.

SHEPHERD 1902
E.B.S. Shepherd, 'The Church of the Friars Minor in
London', *Archaeological Journal*, vol.59, 1902, pp.238-87.

SIMMS 1989
K. Simms, 'Bards and Barons: The Anglo-Irish
Aristocracy and the Native Culture', in R. Bartlett and
A. McKay (eds.), *Medieval Frontier Societies*, Oxford
1989, pp.177-98.

SINCLAIR 2003
A. Sinclair, *The Beauchamp Pageant*, Donington 2003.

SMITH 1988
A. Smith, 'The Life and Building Activity of Bishop
Richard Fox, c.1488-1528', unpublished PhD thesis,
University of London 1988.

SMYTH 2003
K.A. Smith, *Art, Identity and Devotion in Fourteenth
Century England: Three Women and their Books of
Hours*, London 2003.

SOUTHERN 1990
R.W. Southern, *Western Society and the Church in
the Middle Ages*, Harmondsworth 1990.

STALLEY 1971
R.A. Stalley, *Architecture and Sculpture in Ireland,
1150-1350*, Dublin 1971.

STALLEY 1984
R. Stalley, 'Irish Gothic and English Fashion', in
J. Lydon (ed.), *The English in Medieval Ireland*, Royal
Irish Academy 1984, pp.65-86.

STALLEY 2002
R. Stalley, 'The Architecture of St Davids Cathedral:
Chronology, Catastrophe and Design', *Antiquaries
Journal*, vol.82, 2002, pp.13-45.

STANILAND 1986
K. Staniland, 'Court Style, Painters and the Great
Wardrobe', in W.M. Ormrod (ed.), *England in the
Fourteenth Century*, Proceedings of the 1985
Harlaxton Symposium, Woodbridge 1986, pp.236-46.

STANILAND 1991
K. Staniland, *Embroiderers*, London 1991.

STARKEY 1998
D. Starkey (ed.), *The Inventory of King Henry VIII*,
London 1998.

STEER AND BANNERMAN 1977
K.A. Steer and J.W.M. Bannerman, *Late Medieval
Monumental Sculpture in the West Highlands*,
Edinburgh 1977.

STEVENSON, R.B.K. 1981
R.B.K. Stevenson, 'Aspects of Ambiguity in Crosses
and Interlace', *Ulster Journal of Archaeology*, vol.44,
1981, pp.1-27.

STEVENSON, W.H. 1885
W.H. Stevenson (ed.), *Records of the Borough of
Nottingham*, III, London 1885.

STIEGEMANN AND WEMHOFF 1999
C. Stiegemann and M. Wemhoff (eds.), *799 – Kunst
und Kultur der Karolingerzeit. Karl der Große und Papst
Leo III. in Paderborn*, exh. cat., Paderborn, 3 vols.,
Mainz 1999.

STONE 1955
L. Stone, *Sculpture in Britain, The Middle Ages*,
Harmondsworth 1955.

STRATFORD 2000
J. Stratford, 'Gold and Diplomacy: England and France
in the Reign of Richard II', in Mitchell and Moran
2000, pp.218-38.

STRAYER 1970
J. Strayer, *On the Medieval Origins of the Modern State*,
Princeton 1970.

STRICKLAND 2003
D.H. Strickland, *Saracens, Demons, and Jews: Making
Monsters in Medieval Art*, Princeton 2003.

STRUTT 1796-9
J. Strutt, *A Complete View of the Dress and Habits of
the People of England, From the Establishment of the
Saxons in Britain to the Present Time, Illustrated by
Engravings Taken From the Most Authentic Remains
of Antiquity…*, 2 vols., London 1796-9.

STRUTT 1801
J. Strutt, *Glic Camena Angel Deod. Or, The Sports and
Pastimes of the People of England: Including the Rural
and Domestic Recreations, May-games, Mummeries,
Pageants, Processions and Pompous Spectacles, from
the Earliest Period to the Present Time…*, London 1801.

SWEET 2004
R. Sweet, *Antiquaries: The Discovery of the Past in
Eighteenth-Century Britain*, Hambledon and
London 2004.

SWENARTON 1989
M. Swenarton, *Artisans and Architects. The Ruskinian
Tradition in Architectural Thought*, Basingstoke 1989.

SYMONS 1953
T. Symons (ed.), *Regularis Concordia*, London 1953.

SZOVERFFY 1966
J. Szoverffy, '*Crux fidelis*: Prolegomena to a History
of the Holy Cross Hymns', *Traditio*, vol.22, 1966,
pp.1-41.

TABRAHAM 1997
C. Tabraham, *Scotland's Castles*, London 1997.

TANNER, L.E. 1952
L.E. Tanner, 'Some Representations of Edward the
Confessor in Westminster Abbey and Elsewhere',
Journal of the British Archaeological Association,
3rd series, 15, 1952, pp.1-12.

TANNER, N.P. 1990
N.P. Tanner (ed. and trans.), *Decrees of the
Ecumenical Councils*, 2 vols., London and
Georgetown 1990.

TATTON-BROWN AND MORTIMER 2003
T. Tatton-Brown and R. Mortimer (eds.), *Westminster
Abbey: The Lady Chapel of Henry VII*, Woodbridge and
Rochester NY 2003.

TAYLOR 1950
A.J. Taylor, 'Master James of St George', *English
Historical Review*, vol.65, 1950, pp.433-57.

TAYLOR 1961
A.J. Taylor, 'Castle-building in Wales in the Later
Thirteenth Century: The Prelude to Construction', in
E.M. Jope (ed.), *Studies in Building History*, London
1961, pp.104-133.

TAYLOR 1986
A.J. Taylor, *The Welsh Castles of Edward I*, London 1986.

TEMPLE 1976
E. Temple, *Anglo-Saxon Manuscripts 900-1066*,
A Survey of Manuscripts Illuminated in the British
Isles, 2, London 1976.

THOMAS, H.M. 2003
H.M. Thomas, *The English and the Normans: Ethnic
Hostility, Assimilation, and Identity, 1066-c.1220*,
Oxford 2003.

THOMAS, K. 1983
K. Thomas, *Man and the Natural World: Changing Attitudes in England 1500-1800*, London 1983.

THOMAS, K. 2006
K. Thomas, 'Art and Iconoclasm in Early Modern England', in K. Fincham and P. Lake (eds.), *Religious Politics in Post-Reformation England*, Woodbridge 2006, pp.16-40.

THOMSON AND WINTERBOTTOM 1998-9
William of Malmesbury, *Gesta regum Anglorum*, ed. and trans. R. Thomson and M. Winterbottom, 2 vols., Oxford 1998-9.

THORPE 1978
Gerald of Wales, *The Journey through Wales/The Description of Wales*, trans. L. Thorpe, London 1978.

THURLBY 1988
M. Thurlby, 'The Romanesque Priory Church of St Michael at Ewenny', *Journal of the Society of Architectural Historians*, vol.47, 1988, pp.281-94.

THURLBY 1994
M. Thurlby, 'St Andrews Cathedral-Priory and the Beginnings of Gothic Architecture in Northern Britain', in J. Higgitt (ed.), *Medieval Art and Architecture in the Diocese of St Andrews*, British Archaeological Association Conference Transactions, vol.14, Leeds 1994, pp.47-60.

THURLBY 1999
M. Thurlby, *The Herefordshire School of Romanesque Sculpture*, Logaston 1999.

THURLBY 2000
M. Thurlby, 'Roger of Pont-Evêque, Archbishop of York (1154-81) and French Sources for the Beginning of Gothic in Northern Britain', in Mitchell and Moran 2000, pp.28-35.

THURLBY 2003
M. Thurlby, 'Anglo-Saxon Architecture Beyond the Millennium: Its Continuity in Norman Building', in N. Hiscock (ed.), *The White Mantle of Churches: Architecture, Literature, and Art Around the Millennium*, Turnhout 2003, pp.119-38.

THURLEY 1993
S. Thurley, *The Royal Palaces of Tudor England: Architecture and Court Life 1460-1547*, New Haven and London 1993.

TODD 2002
M. Todd, *The Culture of Protestantism in Early Modern Scotland*, New Haven and London 2002.

TOLLEY 1994
Toynbee. T. Tolley, 'Hugo van der Goes' Altarpiece for Trinity College Church, Edinburgh and Mary of Guelders, Queen of Scotland', in J. Higgit (ed.), *Medieval Art and Architecture in the Diocese of St Andrews*, British Archaeological Association Conference Transactions, vol.14, Leeds 1994, pp.213-31.

TOYNBEE 1924
J. Toynbee, 'Britannia on Roman Coins of the Second Century A.D.', *The Journal of Roman Studies*, vol.14, 1924, pp.142-57.

TRACY 1990
C. Tracy, *English Gothic Choir-Stalls 1400-1540*, Woodbridge 1990.

TUDOR-CRAIG 1990
P. Tudor-Craig, 'Nether Wallop Reconsidered', in S. Cather, D. Park and P. Williamson (eds.), *Early Medieval Wall Painting and Painted Sculpture in England*, BAR British Series, 216, 1990, pp.89-104.

TURNER ET AL. 2006
R. Turner, C. Jones-Jenkins and S. Priestley, 'The Norman Great Tower', in R. Turner and A. Johnson (eds.), *Chepstow Castle its History and Buildings*, Logaston 2006, pp.23-42.

UNWIN 1963
G. Unwin, *The Gilds and Companies of London*, London 1963.

VALE, J. 1999
J. Vale, 'Arthur in English Society', in W.R.J. Barron (ed.), *The Arthur of the English*, Cardiff 1999, pp.185-96.

VALE, M. 1995
M. Vale, 'An Anglo-Burgundian Nobleman and Art Patron: Louis de Bruges, Lord of la Gruthuyse and Earl of Winchester', in C. Barron and N. Saul (eds.), *England and the Low Countries in the Late Middle Ages*, Stroud 1995, pp.115-31.

VALE, M. 2000
M. Vale, 'Courts and Culture: Europe and her Neighbours, c.1270-1350', in Mitchell and Moran 2000, pp.90-6.

VALE, M. 2001
M. Vale, *The Princely Court. Medieval Courts and Culture in North-West Europe 1270-1380*, Oxford 2001.

VAN DER HORST, NOEL AND WÜSTEFELD 1996
K. van der Horst, W. Noel and W.C.M. Wüstefeld, *The Utrecht Psalter in Medieval Art*, exh. cat., Het Catharijne Convent Museum, Utrecht 1996.

VAN DIJK 1999
A. Van Dijk, 'The Angelic Salutation in Early Byzantine and Medieval Annunciation Imagery', *Art Bulletin*, vol.81, no.3, Sept. 1999, pp.420-36.

VAUGHAN, R. 1958
R. Vaughan, *Matthew Paris*, Cambridge 1958.

VAUGHAN, W. 2002
W. Vaughan, 'Behind Pevsner: Englishness as an Art Historical Category', in D.P. Corbett, Y. Holt and F. Russell (eds.), *The Geographies of Englishness: Landscape and the National Past, 1880-1940*, Studies in British Art, vol.10, New Haven and London 2002, pp.347-68.

VERDIER 1975
P. Verdier, 'Woman in the Marginalia of Gothic Manuscripts and Related Works', in Morewedge 1975, pp.121-60.

VEREY, BROWN AND COATSWORTH 1980
C. Verey, T.J. Brown and E. Coatsworth (eds.), *The Durham Gospels*, Early English Manuscripts in Facsimile, vol.20, Copenhagen 1980.

VERNON 1968
T.E. Vernon, 'Inventory of Sir Henry Sharington. Contents of Lacock House 1575', *Wiltshire Archaeological Magazine*, vol.63, 1968, pp.72-82.

WAGNER 1956
A. Wagner, *Heralds and Heraldry in the Middle Ages*, 2nd ed., London 1956.

WALPOLE 1762-71
H. Walpole, *Anecdotes of Painting in England, with Some Account of the Principal Artists ... 4 vols.*, Strawberry Hill 1762-71.

WAMERS 1999
E. Wamers, 'Insulare Kunst im Reich Karls des Großen', in Stiegemann and Wemhoff 1999, vol.3, pp.452-64.

WARD 1973
B. Ward (trans.), *The Prayers and Meditations of St Anselm*, Harmondsworth 1973.

WARTON ET AL. 1800
T. Warton, J. Bentham, F. Grose and J. Milner, *Essays on Gothic Architecture, by the Rev. T.W., Rev. J. Bentham, Captain Grose and the Rev. J. Milner*, London 1800.

WATKIN 1945-50
A. Watkin (ed.), *The Great Chartulary of Glastonbury Abbey*, 3 vols., Frome 1945-50.

WATSON 1934
A. Watson, *The Early Iconography of the Tree of Jesse*, Oxford 1934.

WATT, D.E.R. ET AL. 1987-98
W. Bower, *Scotichronicon*, ed. and trans. D.E.R. Watt et al., 9 vols., Aberdeen 1987-98.

WATT, T. 1991
T. Watt, *Cheap Print and Popular Piety 1550-1640*, Cambridge 1991.

WAYMENT 1991
H. Wayment, 'Wolsey and Stained Glass' in S.J. Gunn and P.G. Lindley (eds.), *Cardinal Wolsey: Church, State and Art*, Cambridge 1991, pp.116-30.

WEAVER 1901
F.W. Weaver (ed.), *Somerset Medieval Wills (1383-1500)*, Frome 1901.

WEBSTER, B. 1997
B. Webster, *Medieval Scotland: The Making of an Identity*, London 1997.

WEBSTER, C. AND ELLIOTT 2000
C. Webster and J. Elliott (eds.), *'A church as it should be': The Cambridge Camden Society and its Influence*, Stamford 2000.

WEBSTER, L. AND BACKHOUSE 1991
L. Webster and J. Backhouse (eds.), *The Making of England: Anglo-Saxon Art and Culture, AD600-900*, exh. cat., British Museum, London 1991.

WEILER 2002
B.K.U. Weiler (ed.), *England and Europe in the Reign of Henry III (1216-1272)*, Aldershot 2002.

WEIR AND JERMAN 1986
A. Weir and J. Jerman, *Images of Lust: Sexual Carvings on Medieval Churches*, London 1986.

WELANDER 2003
R. Welander, 'The Events of 1996', in R. Welander, D.J. Breeze, T.O. Clancy (eds.), *The Stone of Destiny, Artefact and Icon*, Society of Antiquaries of Scotland, monograph series, no.22, Edinburgh 2003, pp.235-64.

WELLS-COLE 1997
A. Wells-Cole, *Art and Decoration in Elizabethan and Jacobean England. The Influence of Continental Prints 1558-1625*, New Haven and London 1997.

WHARTON 1696
H. Wharton, ed. *Anglia Sacra*, 2 vols., London 1691.

WHEATLEY 2004
A. Wheatley, *The Idea of the Castle in Medieval England*, York 2004.

WHITE 1962
J.F. White, *The Cambridge Movement. The Ecclesiologists and the Gothic Revival*, Cambridge 1962.

WHITELOCK 1961
D. Whitelock (ed.), *The Anglo-Saxon Chronicle, A Revised Edition*, London 1961.

WIECK 1988
R.S. Wieck, *The Book of Hours in Medieval Art and Life*, London 1988.

WILCOCK 1818/1973
Bede, *The Lives of the Abbots of Wearmouth*, trans. Rev. D. Wilcock, London 1818, Newcastle upon Tyne 1973.

WILLIAMS 1992
A. Williams, 'A Bell House and a Burh-Geat: Lordly Residences in England Before the Conquest', in C. Harper Bill and R. Harvey (eds.), *Medieval Knighthood IV*, Woodbridge 1992, pp.221-40.

WILLIAMSON 1995
P. Williamson, *Gothic Sculpture 1140-1300*, London and New Haven 1995.

WILMART 1932
A. Wilmart, 'Prières médiévales pour l'adoration de la croix', *Ephemerides liturgicae*, 1932, pp.22-65.

WILSON, C. 1987
C. Wilson, 'The English Response to French Gothic Architecture, c.1200-1350', in Alexander, J.J.G. and Binski 1987, pp.74-82.

WILSON, C. 1990
C. Wilson, *The Gothic Cathedral: The Architecture of the Great Church 1130-1530*, London 1990.

WILSON, C. 1995
C. Wilson 'The Medieval Monuments', in P. Collinson, N. Ramsey and M. Sparks (eds.), *A History of Canterbury Cathedral*, Oxford 1995, pp.451-510.

WILSON, C. 1997
C. Wilson, 'Rulers, Artificers and Shoppers: Richard II's Remodelling of Westminster Hall, 1393-99', in D. Gordon, L. Monnas and C. Elam (eds.), *The Regal Image of Richard II and the Wilton Diptych*, London 1997, pp.33-59.

WILSON, C. 1998
C. Wilson, 'The Stellar Vaults of Glasgow Cathedral's Inner Crypt and Villard de Honnecourt's Chapter-House Plan: A Conundrum Revisited', in R. Fawcett (ed.), *Medieval Art and Architecture in the Diocese of Glasgow*, British Archaeological Association Conference Transactions, vol.23, Leeds 1998, pp.55-76.

WILSON, C. 2002
C. Wilson, 'The Royal Lodgings of Edward III at Windsor Castle: Form, Function, Representation', in L. Keen and E. Scarff (eds.), *Windsor, Medieval Archaeology, Art and Architecture of the Thames Valley*, British Archaeological Association Conference Transactions, vol.25, Leeds 2002, pp.15-94.

WILSON, C. 2003a
C. Wilson, '"Excellent, New and Uniforme": Perpendicular Architecture c.1400-1547', in Marks and Williamson 2003, pp.98-119.

WILSON, C. 2003b
C. Wilson, 'Royal Patronage of the Visual Arts', in Marks and Williamson 2003, pp.142-5.

WILSON, D. 1985
D. Wilson, *The Bayeux Tapestry*, London 1985.

WILSON, D.M. AND KLINDT-JENSEN 1980
D.M. Wilson and O. Klindt-Jensen, *Viking Art*, London 1980.

WOLFTHAL 1999
D. Wolfthal, *Images of Rape: The 'Heroic' Tradition and Its Alternatives*, Cambridge 1999.

WOLLHEIM 1974
R. Wollheim, *On Art and the Mind*, Cambridge MA 1974.

WOOD, D. 2000
D. Wood, 'Rule from Europe? Four English Views of Papal Authority in the Fourteenth Century', in Mitchell and Moran 2000, pp.97-112.

WOOD, M. 1965
M. Wood, *The English Medieval House*, London 1965.

WOODFORDE 1951
C. Woodforde, *The Stained Glass of New College Oxford*, Oxford 1951.

WOODGER 1984
A. Woodger, 'Post-Reformation Mixed Gothic in Huntingdonshire Church Towers and its Campanological Associations', *Archaeological Journal*, vol.141, 1984, pp.269-308.

WOODS 2003
K. Woods, 'Immigrant Craftsmen and Import', in Marks and Williamson 2003, pp.91-4.

WOOLF 1992
D.R. Woolf, 'The Dawn of the Artifact: The Antiquarian Impulse in England, 1500- c.1730', *Studies in Medievalism*, vol.4, 1992, pp.5-35.

WOOLGAR 1999
C. Woolgar, *The Great Household in Late Medieval England*, London and New Haven 1999.

WORMALD 1973
F. Wormald, *The Winchester Psalter*, London 1973.

WORRINGER 1927
W. Worringer, *Form in Gothic*, trans. and ed. H. Read, London 1927.

WRIGHT 1981
P.P. Wright, *The Parish Church Towers of Somerset*, Avebury 1981.

YATES 1975
F.A. Yates, *Astraea, the Imperial Theme in the Sixteenth Century*, London 1975.

YEOMAN 1999
P. Yeoman, *Pilgrimage in Medieval Scotland*, London 1999.

YOUNG 1997
F.M. Young, *Biblical Exegesis and the Formation of Christian Culture*, Cambridge 1997.

YOUNGS, J. 1971
J. Youngs, *The Dissolution of the Monasteries*, London 1971.

YOUNGS, S. 1989
S. Youngs (ed.), *'The Work of Angels', Masterpieces of Celtic Metalwork, 6th-9th Centuries AD*, exh. cat., British Museum, London 1989.

ZARNECKI 1953
G. Zarnecki, *Later English Romanesque Sculpture, 1140-1210*, London 1953.

ZARNECKI 1984a
G. Zarnecki (ed.), *English Romanesque Art 1066-1200*, exh. cat., Hayward Gallery, London 1984.

ZARNECKI 1984b
G. Zarnecki, 'Henry of Blois as a Patron of Sculpture', in S. Macready and F.H. Thompson (eds.), *Art and Patronage in the English Romanesque*, London 1984, pp.159-72.

ZARNECKI 1988
G. Zarnecki, *Romanesque Lincoln: The Sculpture of the Cathedral*, Lincoln 1988.

ZARNECKI 2000
G. Zarnecki, 'Romanesque Sculpture of Lincoln Cathedral and the Continent', in Mitchell and Moran 2000, pp.28-34.

Timeline 597–1603

Social and political events

Cultural events

597	Sent by Pope Gregory I, St Augustine lands on the Isle of Thanet, Kent and converts Ethelbert, King of Kent. A cathedral is established at Canterbury.
627	St Paulinus converts Edwin, King of Northumbria, in York and builds a church.
c.627	Death of Redwald, King of East Anglia, perhaps interred in the Sutton Hoo ship burial.
635	St Aidan founds the Celtic monastery at Lindisfarne, Northumbria.
664	Synod of Whitby, dealing with liturgical conflicts between the Celtic and Roman Churches.
674	Foundation of monastery at Wearmouth; and at nearby Jarrow in 681 or 682.
687	Death of St Cuthbert, buried at Lindisfarne.
c.698	Lindisfarne Gospels, made by Eadfrith.
late 7th c. or early 8th c.	Durham Gospels.
early 8th c.	Ruthwell Cross.
716	The Codex Amiatinus, produced at the monastery of Wearmouth–Jarrow, is taken to Rome.
731	Bede completes Ecclesiastical History of the English People.
mid-8th c.	Book of Kells.
793	Viking raid on the monastery at Lindisfarne. A century of Danish and Norse raids on the British Isles follows.
800	Coronation of Charlemagne as Holy Roman Emperor.
c.820–35	Utrecht Psalter.
858	Death of Kenneth mac Alpin, who had united the kingdoms of Dalriada and the Picts.
871	Accession of Alfred the Great, King of Wessex (871–99). The Danes are defeated in Wessex and the Danelaw is established in England.
late 9th c.	Beginning of the Anglo-Saxon Chronicle (continued until 1155). Alfred Jewel.
924	Accession of Athelstan, King of Wessex (924–39), first King of England (from 927).
949/50	Death of Hywel Dda, who united Welsh princedoms under his control, and reputedly established Welsh law.
959	Accession of Edgar the Peaceable, King of England (959–75). Monastic reform in England under Sts Aethelwold, Dunstan and Oswald, from mid-century, leads to increased patronage of churches and building work, including at the monastic cathedrals of Canterbury and Winchester, and the abbeys of Abingdon and Glastonbury.
978	Accession of Ethelred II (The Unready), King of England (978–1016). England is subjected to new Viking raids from 980.
991	Battle of Maldon.
995	Community of St Cuthbert settles at Durham.
late 10th c.	Ramsey Psalter.
early 11th c.	Brussels Cross.
c.1010–20	Harley Psalter, first version of the Utrecht Psalter.
1016	Accession of the Danish Cnut, as King of England (1016–35).
c.1023–35	Prayer Book of Aelfwine.
1042	Accession of the Anglo-Saxon Edward the Confessor, King of England (1042–66).
mid-11th c.	Gospels of Judith of Flanders.
c.1050	Work begins on rebuilding Westminster Abbey, in Romanesque style.
1058	Accession of Malcolm III, Canmore, King of Scotland (1058–93), establishing the Canmore dynasty (to 1290).
1063	Death of Gruffudd ap Llywelyn, Prince of Gwynedd (1039–63), who brought much of Wales under his control.
1066	Norman Conquest of England, by William, Duke of Normandy, who is crowned King William I, after defeat of King Harold at the Battle of Hastings, establishing the Norman dynasty (to 1135). Castles are constructed and rebuilding begins of all major churches in England, including the metropolitan cathedrals of Canterbury and York. Creation of the Bayeux Tapestry.
c.1070	Work begins on the White Tower, London.
1072	Foundation of Dunfermline Abbey, burial place of Malcolm III and his wife St Margaret of Scotland, and later kings of Scotland (rebuilt from 1120s).
1086	Domesday Book.
1087	Accession of William II (Rufus), King of England (1087–1100).
1093	Rebuilding begins of Durham Cathedral (largely complete by 1133).
1095–9	First Crusade and capture of Jerusalem.
1097–9	Building of Great Hall at Westminster, for William II.
1100	Accession of Henry I, King of England (1100–35).
c.1120–30	St Albans Psalter.
1124	Accession of David I, King of Scotland (1124–53). Extensive patronage of the church in Scotland follows, including the foundation of Holyrood, Jedburgh, Kelso and Melrose abbeys, and development of burghs.
1128	Arrival of the Cistercians in England, with foundation of Waverley Abbey.
1135	Accession of Stephen, King of England (1135–54); the 'Anarchy' follows (1139–54).
c.1135	Bury Bible, illuminated by Master Hugo.
1136	Geoffrey of Monmouth writes History of the Kings of Britain.
1137	Rebuilding begins of Kirkwall Cathedral.
1140–44	Rebuilding of abbey church of Saint-Denis, by Abbot Suger.
1154	Accession of Henry, Count of Anjou, as Henry II, King of England (1154–89), establishing the Plantagenet dynasty (to 1399); England becomes part of the Angevin Empire.
mid-12th c.	Eadwine Psalter, second version of the Utrecht Psalter.
c.1160–75	Winchester Bible.
1161	Canonization of Edward the Confessor.
c.1162	Work begins on a new cathedral at St Andrews (dedicated 1318).
1165	Accession of William I (The Lion), King of Scotland (1165–1214).
1167	Anglo-Norman intervention in Ireland (1171, submission to Henry II).
1170	Murder of Thomas Becket, Archbishop of Canterbury (canonized 1173).
1174	Fire destroys the east end of Canterbury Cathedral and rebuilding begins, in Gothic style, under mason William of Sens (complete by 1220).
c.1180	Arrival of the Carthusians in England, at foundation of Witham Priory.

1182	Rebuilding begins of St Davids Cathedral.	1249	Accession of Alexander III, King of Scotland (1249–86).	c.1330	Rebuilding begins of the choir of Wells Cathedral (complete by c.1340).
1192	Independence of the Scottish Church from Archbishop of York.	c.1250–60	Amesbury Psalter.	1330s	Macclesfield Psalter.
	Rebuilding begins of Lincoln Cathedral (Angel Choir complete 1280).	1258	Llywelyn ap Gruffud, Prince of Gwynedd (1246–82), becomes Prince of Wales.	c.1331	Rebuilding begins of the transepts and then east end of St Peter's Abbey, Gloucester, in Perpendicular style.
1194	Rebuilding begins of Chartres Cathedral.	1258–65	The Barons' War in England.	1337	Start of the Hundred Years War between England and France (ends 1453).
1199	Accession of John, King of England (1199–1216), who loses Normandy (1202–4) and is defeated by Philip II, King of France, at the Battle of Bouvines (1214).	1259	Death of Matthew Paris, monk of St Albans, author and illuminator.	c.1340	Auchinleck MS, including such romances as *Gawain and the Green Knight* and *Guy of Warwick*.
		1260s	Westminster Retable, for Westminster Abbey.	1346	Edward III defeats the French at the Battle of Crécy.
		c.1264–7	Lambeth Apocalypse.	1348	The Black Death reaches England. Order of the Garter established at Windsor Castle.
early 13th c.	Rebuilding begins of Glasgow Cathedral (choir, begun c.1240; completed early 14th c.).	1266	Treaty of Perth, by which the Western Isles are ceded to the Scottish Crown.		
		1272	Accession of Edward I, King of England (1272–1307).	1356	The Black Prince defeats the French at the Battle of Poitiers.
1201–4	Fourth Crusade, which captures Constantinople.	1277	Edward I campaigns against Llywelyn ap Gruffud, Prince of Wales. When Llywelyn is killed (1282), English conquest of Wales follows.	c.1357	Appearance of *Mandeville's Travels*.
1214	Accession of Alexander II, King of Scotland (1214–49).			c.1363	Death of John of Fordun, who began a chronicle of Scottish history (later called the *Scotichronicon*).
1215	Magna Carta signed by King John. Pope Innocent III holds the Fourth Lateran Council.		Castle building begins in Wales, including at Caernarfon, Conwy and Harlech.	1366/7	Philippa of Hainault, Queen of England (d.1369), commissions her tomb in Westminster Abbey.
1216	Accession of Henry III, King of England (1216–72).	1290	Expulsion of Jews from England.		
		c.1290–1310	Hereford Cathedral's Mappa Mundi.	1371	Accession of Robert II, King of Scotland (1371–90), beginning the Stewart dynasty.
1220	Translation of relics of St Thomas Becket, in Canterbury Cathedral, in the presence of Henry III.	1291	Loss of Acre by the Christians.		
		1292	Construction begins of St Stephen's Chapel, Palace of Westminster, for Edward I (completed mid-14th c.).	1377	Accession of Richard II, King of England (1377–99).
c.1220	Construction begins of Salisbury Cathedral (complete by 1266). Construction begins of St Patrick's Cathedral, Dublin (dedicated 1254).			1379	Foundation of New College, Oxford, by William of Wykeham, Bishop of Winchester (1367–1404); Winchester College, feeder school, founded 1382.
		1296	Edward I defeats the Scots at the Battle of Dunbar and takes the crown.		
c.1223	Death of Gerald of Wales, author of the *Topography of Ireland* and the *Description of Wales*.	1299–1300	Coronation Chair, incorporating the Stone of Scone, made for Westminster Abbey.	1381	Peasants' Revolt in England.
				1390	Accession of Robert III, King of Scotland (1390–1406).
1221	Foundation at Oxford of the first house of the Dominicans, or Blackfriars; the foundation in Norwich follows in 1226.	c.1300	Bologna Cope.	1394	Remodelling begins of Westminster Hall, for Richard II (complete 1401).
		1301	Edward I makes his son 'Prince of Wales'.	c.1395–9	Wilton Diptych, for Richard II.
1224	Foundation at Canterbury of the first house of the Franciscans, or Greyfriars.	1306	Accession of Robert I (Bruce), King of Scotland (1306–29).	c.1395–1405	Sherborne Missal, illuminated by John Siferwas.
		1307	Accession of Edward II, King of England (1307–27).	1399	Henry Bolingbroke usurps the throne, becoming Henry IV, King of England (1399–1413), beginning the Lancastrian dynasty (to 1471).
1239–48	Building of the Sainte-Chapelle, in Paris, for Louis IX.	1309	Beginning of the residence of the Papacy at Avignon.		
c.1240	Psalter of William de Brailes, illuminated by de Brailes.	c.1310	Psalter of Robert de Lisle (complete by 1339).	1400	Revolt of Owain Glyn Dwr, Prince of Wales (largely suppressed by 1409).
1241	Mongol invasion of Hungary and Poland.	1314	Robert the Bruce defeats the English at the Battle of Bannockburn.		Death of Geoffrey Chaucer, author of *Canterbury Tales*.
1244	Loss of Jerusalem by Christians.	c.1315–30	Pienza Cope.		
1245	Reconstruction begins of Westminster Abbey (dedicated 1269), for Henry III.	1320	Declaration of Arbroath.	1405	John Thornton commissioned to glaze the east window of York Minster.
		c.1325–45	Luttrell Psalter.		
		1327	Accession of Edward III, King of England (1327–77).	1406	Accession of James I, King of Scotland (1406–37).
1248–54	Crusade led by Louis IX, King of France (and again 1270).	1329	Accession of David II, King of Scotland (1329–71).		

1413	Accession of Henry V, King of England (1413–22).
1415	Henry V defeats the French at the Battle of Agincourt.
1422	Accession of Henry VI, King of England (1422–61, 1470–71).
1430s or 40s	Doom painting, Holy Trinity parish church, Coventry.
1437	Accession of James II, King of Scotland (1437–60).
1439–62	Creation of the Beauchamp Chapel, Warwick.
1441	Foundation of King's College, Cambridge, by Henry VI; Eton College, feeder school, founded 1440.
1446	Foundation of Rosslyn Chapel, near Edinburgh.
1450–8	Foundation of St Andrews University.
1453	Fall of Constantinople to the Ottoman Turks.
	French victory at the Battle of Castillon leads to the loss of all English possessions in France, except Calais.
1455	Beginning of the Wars of the Roses, between the Houses of York and Lancaster (ends 1485).
	Gutenberg Bible printed.
1460	Accession of James III, King of Scotland (1460–88).
1461	Accession of Edward IV, King of England (1461–70, 1471–83), beginning the Yorkist dynasty (to 1485).
1467	Reconstruction begins of the parish church of Holy Trinity, Long Melford, Suffolk (until 1507).
1475	Building begins of St George's Chapel, Windsor Castle (complete 1528).
1476	William Caxton publishes Chaucer's *Canterbury Tales* (2nd ed. probably 1483); Sir Thomas Malory's *Morte Darthur* is published 1485.
c.1478–9	Hugo van der Goes (attrib.), *The Trinity Altarpiece.*
1483	Accession of Richard III, King of England (1483–5).
1485	Accession of Henry Tudor, as Henry VII, King of England (1485–1509), after defeating Richard III at the Battle of Bosworth; beginning the Tudor dynasty (to 1603).
1488	Accession of James IV, King of Scotland (1488–1513).
1496	Walter Merlioun designs the 'king's house' at Stirling Castle, for James IV.

1501	James IV endows the Chapel Royal in Stirling Castle.
1503	Building begins of Henry VII's Chapel, Westminster Abbey (largely complete by 1509).
1509	Accession of Henry VIII, King of England (1509–47).
1511	Contract for the tomb of Margaret Beaufort, in Westminster Abbey.
1512	Contract for the tomb of Henry VII and Elizabeth of York, in Westminster Abbey, with Pietro Torrigiano.
1513	Battle of Flodden, in which James IV is defeated and killed by the English.
	Accession of James V, King of Scotland (1513–42).
1516	Publication of Thomas More's *Utopia.*
1520	Field of Cloth of Gold.
1521	Diet of Worms, at which Martin Luther defends his doctrine.
1526–8	Hans Holbein the Younger in England (and from 1531/2 to his death in 1543).
1527	Henry VIII seeks divorce from Catherine of Aragon, but meets opposition from the Pope.
1531	Henry VIII named Protector and Supreme Head of the Church in England.
1534	First Act of Supremacy, confirming Henry VIII as Supreme Head of the Church in England.
1536	Dissolution of the Monasteries begins in England (acts of 1536 and 1539).
	First Act of Union between England and Wales.
1536–7	Hans Holbein the Younger, *Henry VII and Henry VIII*, cartoon for the Privy Chamber, Whitehall Palace.
1538	Injunctions outlaw pilgrimage and order destruction of images that are the object of pilgrimage. Destruction of St Thomas Becket's shrine in Canterbury Cathedral.
	Building begins on a new palace at Stirling Castle, for James V.
c.1538–44	Girolamo da Treviso, *The Four Evangelists Stoning the Pope.*
1539	The *Great Bible* is published, in English, and introduced into English churches.
1540	Crown of Scotland made by John Mosman, for James V.
1542	Accession of Mary Queen of Scots (1542–67).
1543	Second Act of Union between England and Wales.

1547	Accession of Edward VI, King of England (1547–53); iconoclasm follows.
	Abolition of chantries in England.
1549	First Act of Uniformity, authorizing Thomas Cranmer's Book of Common Prayer in English (revised 1552).
1550	Publication of Giorgio Vasari's *Lives of the Artists.*
1553	Accession of Mary I, Queen of England (1553–8), who reintroduces Catholicism.
1558	Accession of the Protestant Elizabeth I, Queen of England (1558–1603).
1560	Scottish Parliament creates reformed Protestant Church.
1563	Publication of John Foxe's, *Actes and Monuments* (Foxe's *Book of Martyrs*).
1567	Accession of James VI, King of Scotland.
1570	Excommunication of Elizabeth I by the Pope.
1572	Parliament licences theatre troupes.
1574	Jesuits arrive in England.
1577–80	Francis Drake circumnavigates the globe.
1586	Death of Sir Philip Sidney.
	Publication of William Camden's *Britannia.*
1588	Spanish Armada defeated.
1590–8	Building of Hardwick New Hall, by Bess of Hardwick.
c.1592	Marcus Gheeraerts the Younger (attrib.), *Queen Elizabeth I* ('Ditchley Portrait').
1599	Globe Theatre is built in Southwark.
1603	Union of Crowns; King James VI of Scotland becomes King James I of England (1603–25).

Map of Britain and Ireland

Places shown are mentioned in the text

Kirkwall

Aberdeen

Aberlemno
Scone • Arbroath
Dupplin • St Andrews
Iona • Stirling • Dunfermline
Glasgow • Edinburgh • Berwick
Lindisfarne
Jedburgh
Ruthwell • Chester-le-Street • Jarrow
Carlisle • Durham • Wearmouth
Gosforth • Whitby
Armagh • Ripon • *Gilling Castle*
York
Kells •
Dublin • Rhuddlan • *Hardwick Hall* • Lincoln
Caernarfon • Conwy • Chester
Valle Crucis • *Wollaton Hall* • Nottingham
Harlech • Catfield
Lichfield • Exton • Crowland • Norwich
Mochdre • Ludlow • Coventry • Eye
Llanbadarn Fawr • *Kenilworth Castle* • Warwick • Ely • Bury St Edmunds
Cambridge • Sutton Hoo
Hampton Court • Stratford- • Long Melford
Llanelieu • Hereford upon-Avon • Colchester
Kilpeck • Oxford • *Boston • Hill
Manor* • Hall*
*Lacock • Windsor • London (Westminster)
Abbey* • *Hampton
Bristol • Wilton • Court* • Cobham
Bath • Canterbury
Wells • Amesbury • Sandwich
Glastonbury • Winchester • Hastings
Sherborne • Salisbury
Exeter • Arundel

Key

Cities, towns, villages

Sites

Glossary

ædicule a framing device used in classical and Gothic architecture, which treats a niche or window as if it were a building

alewife a woman who keeps an alehouse

apse a large semi-circular or polygonal recess, usually in a church

archbishopric an ecclesiastical province, led by an archbishop

banner stave locker a tall narrow cupboard in a church, designed to contain the long poles used to carry guild and church banners in processions

blazon a coat of arms

broomcod an heraldic badge in the form of the seed pod of the broom plant

canticle a hymn or chant, especially with a biblical text

carpet page a manuscript page decorated with rich abstract patterns similar to a carpet

cartouche an ornamental tablet

cartulary collection of deeds or charters, especially a register of titles to all the property of an estate or a monastery

chantry an endowment of priests for purposes of commemoration, by the singing of Masses

charterhouse a Carthusian monastery

chemin-de-ronde an architectural feature crowning the top of a tower, characteristic of French castles

chrism a mixture of oil and balsam, consecrated and used for anointing

Christendom the community of people or nations professing Christianity

clerestory the upper storey in the elevation of a large church, containing a series of windows

cloisonné a type of enamel in which the different colours are separated by strips of flattened wire placed edgeways on a metal backing

codex a manuscript text in book form

colonette a decorative column on the side or jamb of a door or window

corbel a projection jutting out from a wall to support a structure above it

Cosmati work a type of architectural inlay that takes its name from the Cosmas family, Rome, c.1100–1300. Most commonly seen on floors, it employs intricate geometric patterns in coloured marble, other stone and glass

cross-nimbed bearing a halo containing a cross

crozier a hooked staff carried by a bishop

die a device for cutting and moulding metal into a particular shape

distich a pair of verse lines; a couplet.

donjon the great tower or keep of a castle

emblem book a book containing combinations of emblematic pictures and accompanying texts

fabliau a metrical story, typically a ribald one

feretory a portable shrine

fibula an ornamented pin, brooch or clasp

frater the refectory or dining room of a monastery

French Rayonnant of French Gothic architecture c.1240–1350, named after the characteristic radiating tracery of the rose window

garth an open space surrounded by covered walkways in a cloister

grisaille a method of painting in monochrome, typically to imitate sculpture

hagiography the biography of a saint or other venerated figure

half-uncial a type of script used in eighth-century England

hexateuch the first six books of the Old Testament

horse-trapper a covering for a horse, for protection or ornament

knop a knob, especially an ornamental one, for example in the stem of a vessel

liturgy a formalized type of worship

mancus a term used in early medieval Europe to denote either a gold coin, a weight of gold or a unit of account of thirty silver pence

mandorla (also known as *vesica piscis*) an almond-shaped frame enclosing sacred figures such as Christ and the Virgin Mary

maniple a vestment worn over the left arm by a priest during Mass

Marian of or relating to the Virgin Mary

mendicant in religious context, any of several religious orders dependent on charitable contributions

misericord a ledge projecting from the underside of a hinged seat in a choir stall, for leaning on

mistery referring to a trade or craft, or the craft guild itself

nave the long central space of a church

ophreys decorative panels found on church vestments

paten a plate, for holding the bread during the Eucharist

pelta an ornamental motif resembling a shield

pile used to make coins. The top of a pile and the bottom of a trussel were engraved with the designs for the two sides of a coin. A coin blank was then placed between them and the trussel was hit with a hammer, transferring the designs

piscina a stone basin near the altar for draining water used in the Mass

pleasance a secluded enclosure or part of a garden

porphyry a hard igneous rock containing crystals of feldspar in a fine-grained typically reddish groundmass

prebend the portion of the revenues of a cathedral or collegiate church formerly granted to a canon or member of the church as his stipend

Psalter book containing the biblical Psalms, for use in services

putto a cherub

pyx the container in which the consecrated bread of the Eucharist is kept

reredos an ornamental screen at the back of an altar

retable decorated panels above or behind an altar

rood loft a gallery on top of the rood screen of a church

rosette diaper a repeating floral pattern used to decorate a surface

sedilia a group of stone seats for clergy in the south chancel wall of a church, usually three in number and often canopied and decorated

Sergeant Painter title of the king's painter

siliqua a Roman silver coin of the fourth and fifth centuries AD

spandrel the space between two arches.

springer the lowest stone in an arch, from which it rises

stoup a basin for holy water, especially on the wall near the door of a church for worshippers to dip their fingers into before crossing themselves

tabernacle an ornamented receptacle in which a pyx containing the reserved sacrament is placed, usually on or above an altar

tallage a form of arbitrary taxation levied by kings on the towns and lands of the Crown, abolished in the fourteenth century

tierceron a decorative rib in a complex rib vault, rising from the vault springer

transept the part of a cross-shaped church which crosses the nave at a right-angle

triforium in a church, the storey above the arcade storey

triradial a type of rib-structure, with three radiating ribs

triskelion (pl. triskeles) a symbol in the form of three bent or curved lines or limbs radiating from a common centre

trussel see 'pile'

tunicle a short liturgical vestment, traditionally worn by a subdeacon at Mass

tympanum the space above the lintel within an arch

undercutting to cut away material to leave a carved design in relief

V-rod a Pictish symbol in the shape of a bent arrow superimposed on a crescent

vinescroll scrolling ornament in the form of a vine

Virgin Hodegetria a representation of the Virgin Mary in which she holds Christ on her left arm and gestures toward him with her right

Völuspá an Old Norse poem

votive prayers devotional prayers offered as part of a vow, or in gratitude

voussoir a wedge-shaped or tapered stone used to construct an arch

Z-rod a Pictish symbol in the shape of a 'z', most often found in combination with a serpent, tomb/door, or double sun

Index

liturgical vestments 88, 90, 168, 169,
233, 240; figs.92-3
opus anglicanum 64, 150, 168, 233
secular 168-9
Emma of Normandy (Aelfgifu), Queen of
England 31, 91, 146; fig. 45
enamelling 74, 183; figs.74, 101
England 55
architecture 38-9, 120
coronations 33, 51, 63, 101, 106, 120;
fig.8
dowry of the Virgin Mary 51
national identity 60, 62
regalia 38, 116
royal arms 35; fig.9
English language 27, 39, 56, 62
engravings 237, 242-3
Enlightenment 254
Episcopal style 257
Erasmus of Rotterdam 67, 163, 177
Erpingham, Sir Thomas 111
Essex, John 158, 162
Ethelbert, King of Kent 82
Eton College (Buckinghamshire) 157, 158, 163
Evesham Abbey (Worcestershire) 86, 95, 103
Ewelme (Oxfordshire) 128
exegesis 176, 184
exemplars and copies 146-7, 148, 158, 160,
162, 165; figs.87-8
Exeter (Devon) 123
Cathedral 153
Exeter Book 194
exported objects 64, 67, 76-7, 145, 162, 165,
168, 233; fig.40
post-Reformation 233
Exton (Rutland) 237; fig.138
Eye (Suffolk) 92, 97, 99; fig.49
Eynsham (Oxfordshire) 215

F
Falkland Palace (Fife) 39, 67, 137
family workshops 153-5, 162
feminist scholarship 251
feretories 9
feudalism 116-17
Field of Cloth of Gold 40, 133; fig.72
Fife casket 38
Finlaggan (Islay) 33
fireplaces 130
Fisher, John 160
Five Wounds of Christ 191, 194, 196; fig.107
flags 168
Fleet Prison, London 149
Flete, John 91
Flint Castle (Flintshire) 34, 155
Flodden Field, Battle of (1513) 23, 137
floor coverings 128
Flower, Barnard 163
Fontevrault (Maine-et-Loire) 31
food 124
Forde Abbey (Dorset) 90
foreign artists 22, 40, 42, 54, 63-4, 67, 78-9,
137, 147-8, 150, 157, 163-4, 242
foreign clerics 56, 62
foreign influences on British arts 22, 64,
146-8
imported artefacts 24, 64, 67, 78-9, 150;
figs.41-2
Fortescue, Sir John 101
Forteviot (Perthshire) 25
Fountains Abbey (Yorkshire) 90, 239
Fox, Richard, Bishop of Winchester 105, 172;
figs.96-7
Foxe, John
Acts and Monuments (The Book of Martyrs)
234-5, 243

Francis I, King of France 40
Franciscans 155
Frankl, Paul 256
Frederick II, Holy Roman Emperor 62-3
freemasons 258
French lands, English claim to 32, 35, 62-3
French language 39, 62, 138
Frey, Dagobert 55
furniture 123, 128-30; fig.67
Fuseli, Henry 249
*Percival Delivering Belisane from the
Enchantment of Urma* 249; fig.146

G
Gaelic 39
Gaelic revival 23
Gainsborough Old Hall (Lincolnshire) 124
Galway 29
gatehouses 123, 137
Geoffrey of Monmouth 42
Historia Regum Britanniae 36; fig.10
George, St 24, 35, 76-7, 78, 107; figs.40, 42
Gerald of Wales 34, 42, 86, 90
The Topography of Ireland 222, 224;
fig.132
Germanic Style II 44
Gervase of Canterbury 86
Gervase of Chichester 90
Gilling Castle (Yorkshire) 129; fig.70
Glasgow Cathedral 34
glass 74, 129, 147, 156, 157, 160, 162, 244
see also stained glass
Glastonbury Abbey (Somerset) 23, 34, 42,
60, 88, 92, 103, 145
Gloucester (Gloucestershire), St Peter's
Abbey (now Cathedral) 64, 239
Gloucester, Humphrey, Duke of 67
Godiva, Lady 92
Godwyn, John 163
Goethe, Johann Wolfgang von 257
goldsmiths 64, 91, 100, 142, 143, 146, 148,
162-3, 172; figs.45, 50, 96-7
Gorleston Psalter 208, 212; fig.118
Goscelin of Saint-Bertin 92-3, 143
Gosforth Cross (Cumbria) 22, 31
Gospels of Judith of Flanders 184, 185, 186;
fig.103
Gothic 59-62, 63-4, 70, 72-3, 105, 152, 166,
256
International Gothic 171
use of term 204, 248, 251
see also architecture
Gothic Revival 249, 254, 258-9
Gower, Henry, Bishop of St Davids 120
Graiguenamanagh (Co. Kilkenny), church 32
Grandisson, John de, Bishop of Exeter 153;
fig.85
Great Bible (1539) 136
Great Britain 43
Great Canterbury Psalter 56
great chambers *see* chambers
great halls 122, 123-6, 148; figs.68-9
great towers 130-4
Gregorian reform movement 59
Gregory the Great, Pope 24, 255
Pastoral Care 31
Grosmont Castle (Monmouthshire) 149
Grosseteste, Robert 256
Gruthuyse, Louis de 39
guilds 162-3, 165, 169, 200
Guillaume le Clerc
Bestiaire 217; fig.127
Gunpowder Plot 233
Guthrum 29
Guy of Warwick 134, 136

H
Haddington (East Lothian), St Mary's 38
Hadrian's Wall 28
halls *see* great halls
Hampton Court (Herefordshire) 240;
fig. 139
Hampton Court Palace (Surrey) 40, 42, 124,
128; fig.69
Hanseatic League 64, 72
Harald Bluetooth, King of Denmark 29
Harald Hardrada, King of Norway 49
Hardwick Hall (Derbyshire) 133, 134, 244-5;
figs.143-4
Harewood (Yorkshire) 139
Harfleur (Seine-Maritime), siege of 24
Harlech Castle (Merioneth) 34
Harley Psalter 56, 146-7, 148; fig.82
Harold, King of England 46-7, 148;
figs.18-19
Harvey, John Hooper 259
Hastings, Battle of (1066) 32, 46, 47, 148
Hastings, Sir Hugh 156
Hastings Hours 7
Heckington (Lincolnshire) 86
Helmingham (Suffolk) 99
Helmingham Herbary and Bestiary 212;
fig.123
Henrietta Maria, Queen of England 232
Henry, Prince of Wales 243
Henry I, King of England 97
Henry II, King of England 22, 31, 42, 59, 60,
70, 86, 88, 126, 163
Henry III, King of England 22, 32-3, 62-3,
70, 74-5, 90, 91, 95, 101, 106-7, 113, 126,
129, 136, 150, 226; fig.55
Henry IV, King of England 88, 129
Henry V, King of England 22, 24, 88, 101,
103, 107, 113
Henry VI, King of England 90, 101, 107, 157
Henry VII, King of England 39-40, 67, 107,
110, 164, 235; fig.29
Henry VIII, King of England 20, 22-3, 40,
42, 43, 67, 70, 116, 128, 133, 160, 165, 232,
243; fig.29
Henry VIII and his Children 135-6
Henry of Avranches 90
Henry of Blois, Bishop of Winchester 60, 68,
90
Henry of Huntingdon 83
Henry of London, Bishop of Dublin 23
Henry of Reyns 63
heraldry 23, 34, 35, 121, 124-5, 129, 134, 158,
245, 256
arms of peace 134
embroidery 168-9
fireplace decoration 130
Henry VII's Chapel 40
interpretation 83
royal arms 236
St Machar's Cathedral, Aberdeen, ceiling
20, 38; fig.1
Wilton Diptych 35, 50
Hereford Castle (Herefordshire) 149
Hereford World Map 196, 224, 226-7;
fig.133
Herefordshire school of sculpture 32
Herland, Hugh 157
Herstmonceux Castle (Sussex) 123
Hexham (Northumberland) 148
Heydour (Lincolnshire) 24
Hill, Nicholas 162
Hill Hall (Essex) 236; fig.136
Holbein, Hans, the Younger 22, 67, 120-1, 163
design for a cup for Jane Seymour fig.66
Whitehall cartoon and mural 67, 234,
235; fig. 29

Hollar, Wenceslaus
View of the Tower of London 31-2; fig.64
Holy Cross Abbey (Co. Tipperary) 38
Holy Roman Empire 22, 35, 38, 54, 59
Holyrood Palace, Edinburgh 39, 79, 137
Hone, Galyon 163-4
Hope, Thomas 258
household 121-6
Hugh de Goldclif 149
Hugh du Puiset, Bishop of Durham 149
Hugh of Avallon, St, Bishop of Lincoln 60
Hugh of St Albans 162
Huish Episcopi (Somerset) 99
humanism 67
Hundred Years War 22, 54, 64

I
iconoclasm 197, 232, 233, 253-4, 259
iconography 254-5
iconology 256
Ile Abbots (Somerset) 99
illuminators *see* books and manuscripts
impressment 155-6
indulgences 96
Insular art 22, 24-9, 31, 56, 144-5, 178-9,
198-9; figs.5, 24, 81, 98, 113
Iona 23, 24, 27, 29, 55
Ireland 22, 23, 142
architecture 32, 34, 36, 38
castles 32, 34, 133
Christianity 27, 176
conquest 22, 34
coronations 33
Gaelic revival 23
Insular art 22, 28
kingdom of 39
monasteries 55-6
Norman architecture 22, 32
stone crosses 22, 29
Viking raids 29
Irish language 27
Isaac of Norwich 218; fig.128
Isabella of Angoulême 31
Islamic art 74
Isle of Man 22, 29
Italian artists 67, 163, 164, 165, 228
Ivo of Narbonne 221
Ivry-la-Bataille (Eure) 31

J
Jacobus de Voragine
Golden Legend 177
James I and VI, King of England and Scotland
35, 38, 39, 43, 79, 245
James I, King of Scotland 137
James III, King of Scotland 38, 64, 78-9; fig.41
James IV, King of Scotland 40, 78, 137; fig.41
James V, King of Scotland 20, 22, 24, 38, 39,
137
James, Montague Rhodes 255-6
James of St George 34, 155
Jarrow *see* Wearmouth-Jarrow monastery
Jean de Liège 54
Jedburgh Abbey (Scottish Borders) 22, 239
Jellinge stone 29
Jerusalem 70, 146
jewellery 121, 172
Jews, depictions of 216-19; figs.127-9
John, King of England 32, 88
John Balliol, King of Scotland 35, 42
John de Cella 152
John of Brampton 156, 163
John of Flanders 152
John of Fordun 36
John of Gaunt, Duke of Lancaster 103, 116,
157; fig.67

Photographic Credits

© 2000 All Souls College, Oxford. All rights reserved 102, 188, 189
By Permission of Ampleforth Abbey Trustees/ photograph G.Hatfield 129
© Blake Anderson 28
Courtesy of the University of St Andrews 100
Museum of Archaeology and Anthropology, University of Cambridge 191
Presented by The Art Fund 1941
© Ashmolean Museum, Oxford 121
© The Ashmoleon Museum, Oxford, courtesy of Corpus Christi College, Oxford 172, 173
© Bildarchiv Monheim GmbH/Alamy 89
© The Bodleian Library, University of Oxford 36
© The British Library Board. All Rights Reserved 2, 42, 91, 94, 122, 135, 136, 147, 151, 185, 186, 192, 193, 198, 199, 205, 208, 209, 214, 218, 222, 223, 242, 255
© The Trustees of the British Museum 44, 45, 64, 118, 154
© Ian M. Butterfield/Alamy 201
© Steve Cadman 249
© Corpus Christi College, Cambridge 24, 37, 62, 220
Country Life Picture Library 117, 119, 129
With permission of Durham Cathedral 144, 179
With permission of Durham Cathedral/photograph © Sam Judson 47
English Heritage Picture Library 41
© English Heritage Picture Library/photograph Jonathan Bailey 236
Reproduction by permission of the Syndics of the Fitzwilliam Museum, Cambridge 195, 229
© Derrick Francis Furlong/Alamy 254
© Andrew Gale 25
© Jon Gruitt 93
© Jessica Harrington 258
All rights reserved © 2008 Her Majesty Queen Elizabeth II 78, 79, 127, 132, 235
© Dean and Chapter of Hereford Cathedral 226
Crown copyright, reproduced courtesy of Historic Scotland 12, 39, 137
© Maurice Howard 237, 238, 241
© David Illiff 85
© IRPA-KIK, Brussels 182
By permission of the Master and Fellows of St John's College, Cambridge 211
© Kenilworth Castle, Warwickshire/John Bethell/ The Bridgeman Art Library 116
© Simon Knott 98

© Lincoln Cathedral Works Department 213
© Julian Luxford 96, 105
© Richard Marks 139
© Stuart Melvin/Alamy 87
© Chris Moore 209
© The National Gallery, London 4-5, 50-1
© National Portrait Gallery, London 66
© NTPL/Andreas von Einsiedel 244
© Shamus O'Reilly 210
© Richard Osbourne 109
Pierpont Morgan Library, New York 185
© Martin Pittard 71
© Gordon Plumb 112
The Pepys Library, Magdalene College, Cambridge 243
Alex Ramsey 196, 260
Photo RMN/Musée nationale du Moyen Âge – des thermes et hôtel de Cluny, Paris 35
Photograph by kind permission of the Chapter of Ripon Cathedral 159
© Robert Harding Picture Library Ltd/Alamy 125
© Steve Sant/Alamy 212
© Scala Archives, Florence 168
© Skyscan Balloon Photography
© South West Images Scotland/Alamy 181
© Alan Stenson 133
© Tate Photography 250
© Musée de la Tapisserie de Bayeux, Bayeux/ With special authorisation of the City of Bayeux/ The Bridgeman Art Library 48, 49
© Glyn Thomas/Alamy 111
© Nick Thompson 21
© Elzbieta Twitchen 70
© Victoria and Albert Museum, London 134, 153, 154, 183, 252
© Wellcome Trust 207
© Wells Cathedral/Paul Maeyaert/The Bridgeman Art Library 60
© Wells Cathedral/Torimages 64
© Dean and Chapter of Westminster Abbey, London 14-15, 74, 75, 107, 165
© The Dean and Chapter of Westminster Abbey, London/The Bridgeman Art Library 33, 54
© Chris Willson/Alamy 119
© Winchester Cathedral/The Bridgeman Art Library 69
Yale Center for British Art, Paul Mellon Collection 131, 212
© Dean and Chapter of York Minster 104, 170, 171

First published in North America by the Yale Center for British Art
P. O. Box 208280
1080 Chapel Street
New Haven, CT 06520-8280
www.yale.edu/ycba

in association with Tate Britain

Distributed in North America by Yale University Press
www.yalebooks.com

ISBN 978-0-300-11670-0
ISBN 978-0-300-14304-1 (three-volume set)

Library of Congress Control Numbers:
2008933921
2008933920 (three-volume set)

General Editor: David Bindman
Designed by LewisHallam
Color reproduction by DL Interactive, London
Printed and bound in China by C&C Offset Printing Co., Ltd.

JACKET
FRONT: The Temptation of Adam and Eve, prefatory miniature in a
Psalter, c.1270–80 (fig.122, p.211)
BACK: (from left to right): Princess Scota reaching Scotland in a ship,
from Scotichronicon, c.1425 (detail of fig.11, p.37); the decagonal chapter
house, Lincoln Cathedral, second quarter of the 13th century (detail of
fig.44, p.89); portrait of St Matthew from the Lindisfarne Gospels, c.698
(detail of fig.113 [far left], p.198); self-portrait of William de Brailes from
the William de Brailes Hours, c.1240 (detail of fig.83, p.151); feast given for
John of Gaunt, Duke of Lancaster, from Jean de Waurin's Chronicle
of England, late 15th century (detail of fig.67, p.122)

FRONTISPIECE: Chi-rho page from the Lindisfarne Gospels, c.698
(fig.113, pp.198–9)
pp.4–5: Detail from the Wilton Diptych, c.1395–9 (fig.22, pp.50–1)
 p.260: The rood loft and chancel screen, 14th century,
 Church of St Ellyw, Llanelieu, Breconshire
 p.269: Folio from the Helmingham Herbal and Bestiary, c.1500
 (see fig.123, p.212)

Unless otherwise stated, measurements of artworks are given in
centimetres, height before width, followed by inches in brackets.